The Making and Meaning of Art

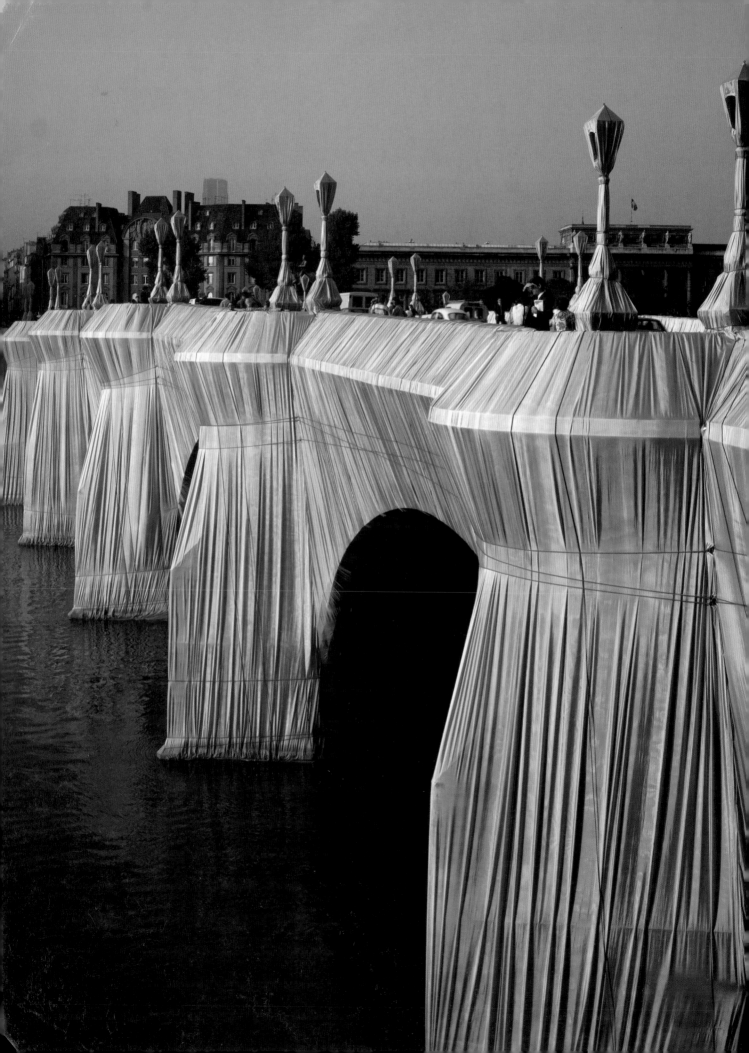

The Making and Meaning of Art

Laurie Schneider Adams

PEARSON

Prentice Hall

Upper Saddle River, NJ 07458

Library of Congress Cataloging-in-Publication Data

Adams, Laurie.
 The making and meaning of art / Laurie Schneider Adams.
 p. cm.
 Contents: Creating and defining works of art—Purposes of art—The artist's visual
language—Two-dimensional media and techniques of art—Three-dimensional media
and techniques—Art in history.
 ISBN 0-13-177919-2
 1. Art—Philosophy. I. Title.

N70.A33 2006
701—dc22

2006047501

Editor in Chief: Sarah Touborg
Acquisitions Editor: Amber Mackey
Director of Marketing: Brandy Dawson
Manufacturing Buyer: Sherry Lewis
Senior Managing Editor: Lisa Iarkowski

Credits and acknowledgments of material borrowed from other sources and reproduced, with permission,
in this textbook appear on page 565.

Pearson Education Ltd.
Pearson Education Australia PTY, Ltd.
Pearson Education Singapore, Pte. Ltd.
Pearson Education North Asia Ltd.

Pearson Education, Canada, Ltd.
Pearson Educación de Mexico, S.A. de C.V
Pearson Education–Japan
Pearson Education Malaysia, Pte. Ltd.

 This book was designed and produced by
Laurence King Publishing Ltd, London
www.laurenceking.co.uk

Every effort has been made to contact the copyright holders, but should there be any errors or omissions, Laurence King Publishing Ltd
would be pleased to insert the appropriate acknowledgment in any subsequent printing of this publication.

Publishing Director: Lee Ripley
Commissioning Editor: Kara Hattersley-Smith
Copy Editor: Nicola Hodgson
Picture Researchers: Julia Ruxton and Sandra Assersohn
Illustrator: Andy Prince
Maps: Advanced Illustration

Cover: Roy Lichtenstein, *Blam*, 1962. Oil on canvas, 5 ft. 8 in. x 6 ft. 8 in. Yale University Art Gallery.
Gift of Richard Brown Baker, B.A., 1935. © The Estate of Roy Lichtenstein/DACS 2006.

Frontispiece: Christo and Jeanne-Claude, *The Pont Neuf Wrapped* (detail), Paris, 1975–1985.
Polyamide fabric and rope. Courtesy of the artists. Photo Volfgang Volz/LAIF.

10 9 8 7 6 5 4 3 2 1
ISBN 0-13-177919-2

Contents

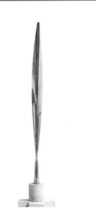
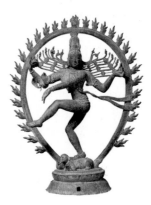

Part III
75
The Artist's Visual Language

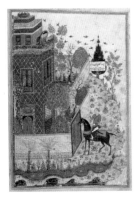

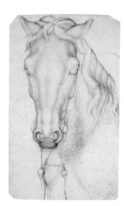

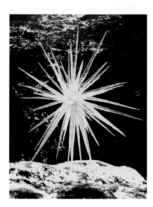
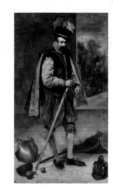

Maps

Timelines

Preface

Of perennial interest to viewers of art are such questions as: What is art? Who creates art? and How and why do they do it? In writing *The Making and Meaning of Art* my goal was to create a dialogue between the reader and the artist with a view to illuminating how art is created and what artists throughout the world are trying to express. Using the voices of the artists themselves, as well as visual analysis and consideration of history and style, I explore connections between the making and meaning of art. In so doing, I aim to show readers that the visual arts are an integral part of everyday life and have been since the beginning of human history. In every culture, images are created to serve a variety of purposes—including religion, politics, documentation, decoration, and illustration. Readers are thus invited to examine ways in which historical context influences artists and their art.

The text covers the span of creative history from the Stone Age to the present and explores traditional categories of painting, drawing, sculpture, and architecture as well as crafts, graphics, photography, film, theater design, and video and computer art. Examples are drawn from Western and non-Western cultures to illustrate the breadth of visual art throughout the world. Consideration is also given to the effects of globalization, spurred by increasing communication and the ease of travel, within the art world. Rather than making this book an encyclopedic survey, I focus on significant works presented in relatively large format illustrations. I have kept the style as simple and accessible as possible, even when discussing complex issues.

Features

Special features have been created to foster the dialogue between reader and artist and illustrate connections between the making and meaning of art. Among the book's key features are boxed interviews entitled **MAKING** and **MEANING** in which contemporary artists speak directly to the reader about the creative process both in relation to their own work and that of the past.

MAKING boxes appear in each of the chapters on media (chapters 8 to 14) and contain an artist's discussion of one of his or her own works. Examples include David Hockney on drawing, Elizabeth Murray on painting, and Claes Oldenburg on sculpture. **MEANING** boxes appear in the historical narrative (chapters 15 to 26). They contain commentaries from artists about the art of the past and its influence on their work. For example, Milton Glaser talks about his poster for the Houston Holocaust Museum, the Christos discuss their *Gates Project for Central Park*, New York, and Graham Nickson compares some of his work to that of Piero della Francesca.

Another pair of key features are the **LOOK** and **CONSIDER** boxes. **LOOK:** In the LOOK boxes (chapters 1 to 14), works are considered in greater formal detail than in the main text, encouraging the reader to look closely at specific aspects of the work. **CONSIDER:** In the CONSIDER boxes (chapters 15 to 26) I discuss different ways of approaching works using the methodologies surveyed in chapter 7. **QUOTES:** I have punctuated the text with short, lively quotes by artists and authors to reinforce the sense of dialogue between artists and readers. **COMPARE:** Where necessary, I have included thumbnail images of artworks (entitled COMPARE) that are discussed in greater detail and shown larger elsewhere in the book to remind readers of images previously illustrated.

Terms are placed in bold at their first mention in the text and defined in a glossary at the end of the relevant chapter. There is also a combined glossary of all the terms at the end of the book. Each of the historical narrative chapters contains at least one timeline and one map, showing events and sites discussed in the chapter.

Above all, this book encourages readers first to look, and then to see. In seeing, viewers begin to appreciate and understand the aesthetic, intellectual, and cultural impact of imagery.

Laurie Schneider Adams
May 2006

Features

The features of this book are designed to set up a dialogue between readers and the artists discussed.

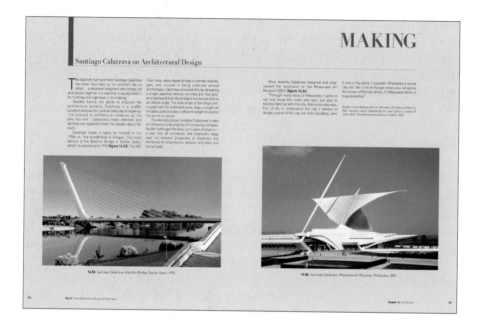

Making

This feature presents live interviews with comments by contemporary artists about their creative process.

Meaning

This feature presents live interviews with contemporary artists or authors about the influence of earlier artists on their own work.

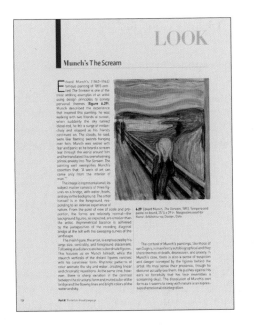

Look

This appears in each of the first 14 chapters and encourages readers to look more closely at individual works.

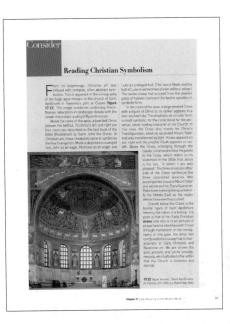

Consider

This feature appears in each art history chapter (15–26) and contains a methodological analysis of one or more key works from the period covered in the chapter.

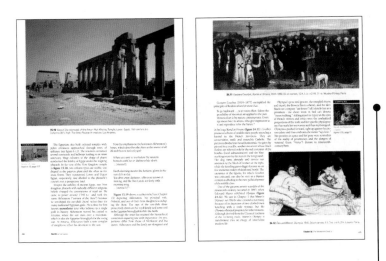

Compare

Each chapter contains thumbnail images of works previously discussed and illustrated in a larger format.

Quotes

Each chapter contains short, lively quotes by artists and others involved in the arts to elucidate how artists work and what they seek to express.

Faculty and Student Resources

Prentice Hall is pleased to offer an outstanding array of high quality resources for teaching and learning with Adams' *The Making and Meaning of Art*. Please contact your local Prentice Hall representative for more details on how to obtain these items, or send us an email at: art@prenhall.com

Digital and Visual Resources

The Prentice Hall Digital Art Library

Instructors who adopt Adams' *The Making and Meaning of Art* are eligible to receive this unparalleled resource. The Prentice Hall Digital Art Library contains images from the book in the highest resolution (over 300 dpi) and pixellation possible for optimal projection and easy download. Developed and endorsed by a panel of visual curators and instructors across the country, this resource features images in jpeg and in PowerPoint, an instant download function for easy import into any presentation software, along with a zoom feature, and a compare/contrast function, both of which are unique and were developed exclusively for Prentice Hall.
ISBN: 0136131433

OneKey

OneKey is Prentice Hall's exclusive course management system that delivers all student and instructor resources in one place. Powered by Blackboard and WebCT, OneKey offers an abundance of online study and research tools for students, and a variety of teaching and presentation resources for instructors, including an easy-to-use gradebook and access to an image library. For more information, go to: www.prenhall.com/onekey

Discovering Art CD-ROM

This interactive CD-ROM offers students a visual exploration of art. Students will see and hear video demonstrations of studio processes, view 200 images in a virtual image gallery, and learn how—and where—to visit a museum. Plus, interactive exercises help students to review and reinforce the material under study. Available in a special package with the text.
Stand alone ISBN: 0131930974

Classroom Response System (CRS) In Class Questions

Get instant, classwide responses to beautifully illustrated chapter-specific questions during a lecture to gauge students comprehension—and keep them engaged. Contact your local Prentice Hall sales representative for details.

Vango Notes

Study on the go with VangoNotes—chapter reviews from your text in downloadable mp3 format. You can study by listening to the following for each chapter of your textbook: Big Ideas: your "need to know" for each chapter; Practice Test: a check for the Big Ideas—tells you if you need to keep studying; Key Terms: audio "flashcards" to help you review key concepts and terms; Rapid Review: a quick drill session—use it right before your test. VangoNotes are flexible; download all the material directly to your player, or only the chapters you need. For more information, go to: www.VangoNotes.com

Companion Website

Visit www.prenhall.com/adams for a comprehensive online resource featuring a variety of learning and teaching modules, all correlated to the chapters of Adams' *The Making and Meaning of Art*.

Prentice Hall Test Generator

Is a commercial-quality test management program on CD-ROM available for both Microsoft Windows and Macintosh environments, containing hundreds of sample test questions.
ISBN: 0131841831

Fine Art Slides and Video

Are also available to qualified adopters. Please contact your local Prentice Hall sales representative to discuss your slide and video needs. To find your representative, use our rep locator at: www.prenhall.com

Print Resources

TIME Special Edition: Art
Featuring stories like "The Mighty Medici," "When Henri Met Pablo," and "Redesigning America," Prentice Hall's TIME Special Edition contains thirty articles and exhibition reviews on a wide range of subjects, all illustrated in full color. This is the perfect complement for discussion groups, in-class debates, or writing assignments. With the TIME Special Edition, students also receive a three-month pass to the TIME archive, a unique reference and research tool.
ISBN: 0131918486

Understanding the Art Museum
By Barbara Beall. This handbook gives students essential museum-going guidance to help them make the most of their experience seeing art outside of the classroom. Case studies are incorporated into the text, and a list of major museums in the United States and key cities across the world is included.
ISBN: 0131950703

Prentice Hall Guide to Research Navigator
In addition to offering handy information on citing sources and avoiding plagiarism, this guide helps students with finding the right articles and journals in art. Students get exclusive access to three research databases: The New York Times Search by Subject Archive, ContentSelect Academic Journal Database, and Link Library.
ISBN: 0132437538

Instructor's Manual and Test Item File
An invaluable professional resource and reference for new and experienced faculty, containing chapter overviews and objectives, lecture and discussion ideas, assignments and projects, and hundreds of sample test questions.
ISBN: 0131428357

Study Guide
A valuable tool for student learning. For each chapter of the book, the study guide provides students with review exercises as well as practice tests using a variety of question formats.
ISBN: 0131428365

Acknowledgments

Author's Acknowledgments

Ken Burchett (Professor of Art, University of Central Arkansas) served as both consultant and reader. He was extremely helpful in lending his expertise to the chapters on visual elements, media, and techniques and in his extensive reviewing of the manuscript.

I would like to thank Bud Therien at Prentice Hall, and Laurence King and Lee Ripley at Laurence King Publishing for encouraging this project from its inception, and the editorial and production teams at Laurence King Publishing for seeing it through from raw manuscript to final book. The copyediting of Nicola Hodgson improved the text, while the tireless picture research of Julia Ruxton improved the picture quality. John Adams read the entire manuscript and advised on all aspects of production.

Publishers' Acknowledgments

The publishers would like to thank all those who reviewed the manuscript:

Frederick Behrens (Columbia State Community College), Vince Bodily (Brigham Young University–Idaho), Frank Breneisen (Morningside College), Ken Burchett (University of Central Arkansas), Dennis Dykema (Buena Vista University), Mary F. Francey (University of Utah), Herbert R. Hartel, Jr (John Jay College, CUNY), Marleen Hoover (San Antonio College), Tonya Kehoe (Kirkwood Community College), Ted Kerzie (California State University), Teresa Langley-Caswell (University of North Carolina, Pembroke), Kathryn Lansing Vaughn (Calhoun Community College), Pamela A. Lee (Washington State University), Claire McCoy (Longwood University), Lynn Metcalf (St. Cloud University), Alberto Meza (Miami-Dade Community College), Christie Nuell (Middle Tennessee State University), Lindsey Pedersen (Arizona State University), Scott Robinson (North Central Texas College), Barbara Ryan (Broward Community College), Lori Sears (Radford University), James Slauson, (Milwaukee Institute of Art and Design), Gay Sweely (Eastern Kentucky University).

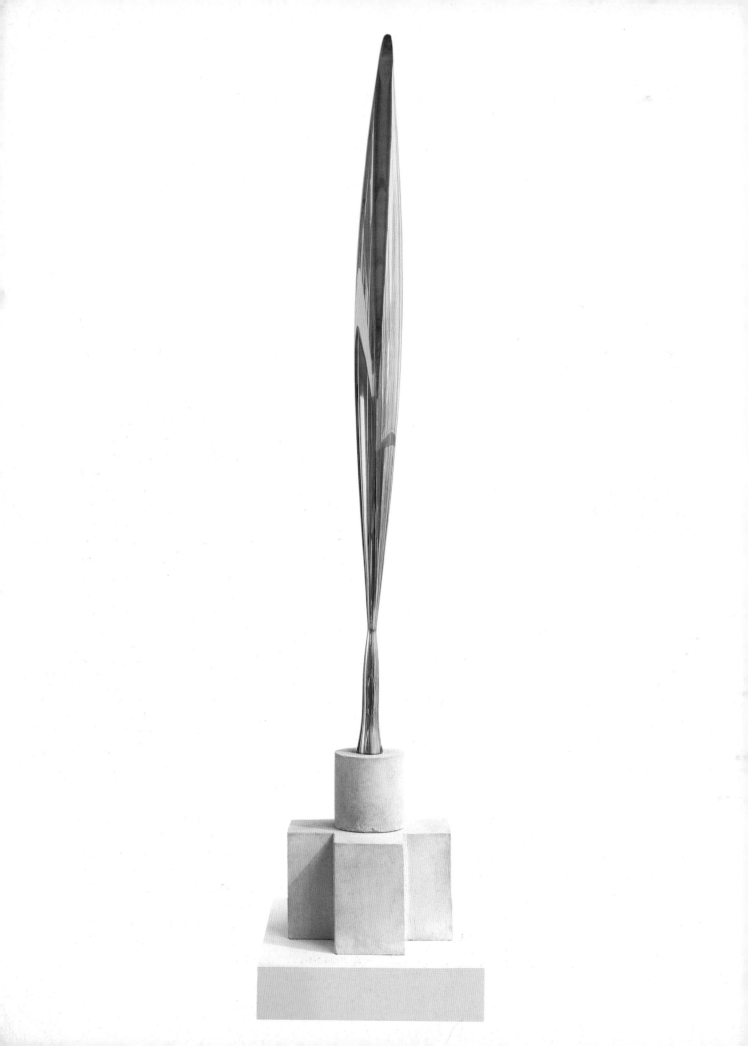

Part I Creating and Defining Works of Art

Look at the figure opposite. Does it resemble a bird? And more to the point, does it look like art? This question is quite a familiar one. We ask it in art galleries, in museums, in private homes, and in public spaces. We are most likely to ask this question when we dislike or disapprove of a work, or when we doubt the ability of the person who made it.

"What is art?" is a question people have been trying to answer for centuries. Perhaps the broadest definition of art is that it is an expressive product made by an artist and it communicates its expressiveness to viewers. We often think that art should be beautiful and impressive in some way. But art can also be disturbing, frightening, and even ugly. Whatever our reaction to a work of art, we must recognize that it is expressive and imaginative. Every work of art begins as an idea in the mind of the artist, who gives the idea a form. When the work is completed, it arouses the imagination of the viewer—hence the term "**image**."

There are many categories of art, including architecture, painting, sculpture, drawing, printmaking, photography, crafts, performances, and digital images. One distinction made in the Western tradition since the Renaissance is between the so-called fine arts, which are appreciated for qualities such as **aesthetic** appeal and statements about the human condition, and applied arts—such as graphic and industrial design. We should also be aware that few non-Western cultures make this distinction and that, even in the West, modern and contemporary artists often blur these boundaries. Works in all these categories will be considered in this text, although our main focus is on the fine arts.

Definitions of what art is have changed over time as perceptions and values evolve. Because opinions differ, it is difficult to arrive at a fixed definition of art that satisfies everyone. As you read this text, think about whether your own views of art are changing. Consider how you would define art and how your definition develops according to what you learn about the arts and their history.

Arguments over the definition of art can become quite heated and generate intense controversy. This reflects the degree to which people are engaged with imagery and the difficulty of arriving at a consensus of what art is. How often have we heard someone say, when looking at a modern abstract painting, that their six-year-old child could have made it? How often have artists been unable to sell their works only to have them become highly valued after their death? How do we explain the ups and downs of the art market? Or the fact that van Gogh sold at most one painting in his lifetime, but that in the 1980s his works sold for as much as $80 million?

Artists and writers on art have offered their own definitions of what art is. The nineteenth-century French poet and art critic Charles Baudelaire (1821–1867) defined art as the expression of a child's imagination combined with the adult's intellect, control of material, and talent to mold the material into aesthetic form.

In a similar vein, addressing the issue of creativity, the sculptor Constantin Brancusi (1876–1957) has been quoted as saying that when we cease to be children we are dead.

> ... genius is ... childhood recovered at will—a childhood now equipped for self-expression, with manhood's capacities and a power of analysis that enables it to order the mass of raw material that it has involuntarily accumulated.
>
> Charles Baudelaire, poet (1821–1867)

(Opposite) Constantin Brancusi, *Bird in Space*, 1928. Bronze, unique cast, 54 in. x 8 ½ in. x 6 ½ in. Museum of Modern Art, New York. Given anonymously. Photograph © The Museum of Modern Art.

KEY TOPICS

The difficulty of defining art
The range of artistic expression
Changing views of art
Controversy and censorship

What is Art?

Brancusi v. United States

Attempts to define art are sometimes difficult, and works of art have even been taken to court. For example, on October 21, 1927, the celebrated case of *Constantin Brancusi v. United States* went to trial in the United States Customs Court, Third Division. This trial exemplified the conflict between conservative and progressive views of art in early twentieth-century America as to what constitutes a work of art.

During a visit to France, the American photographer Edward Steichen (1879–1973) purchased the bronze sculpture entitled *Bird in Space* (see p. xviii) from the Paris studio of the Romanian artist Constantin Brancusi. In 1926, Steichen brought the *Bird* to New York, assuming that, because it was an original work by a professional sculptor, he would not be charged import duty. (Under United States law, original works of art are not taxed when they enter the country as long as they are declared at customs.) The customs officer, however, did not agree that the *Bird* was a work of art: he admitted it into the country under the category of "Kitchen Utensils and Hospital Supplies" and charged Steichen $600 in import duty. Efforts by leading artists and critics to persuade U.S. government officials that the bronze was, in fact, a work of art fell on deaf ears.

The following year, Gertrude Vanderbilt Whitney, herself an artist and a prominent patron of the arts,

> They are imbeciles who call my work abstract; that which they call abstract is the most realistic, because what is real is not the exterior form, but the idea, the essence of things.

Constantin Brancusi, sculptor (1876–1957)

offered to have her lawyers take the issue to court. Six witnesses testified for the plaintiff (Steichen) and two for the defense (the United States). First, it was established that Brancusi had actually made the *Bird*, since Steichen had seen him working on it in his studio. **Figure 1.1** shows Steichen's photograph of Brancusi in his studio; the artist is surrounded by his sculptures, including a white marble version of the *Bird*.

The court established that Brancusi was a professional sculptor with works in European and American museums. Next came the question of whether the *Bird* represented a bird. The defense witnesses agreed that Brancusi was a "wonderful polisher of bronze," but objected to the lack of identifiable birdlike features such as wings and tail feathers. Steichen was questioned on this very point when asked:

"If you would see it on the street, you never would think of calling it a bird, would you? If you saw it in the forest, you would not take a shot at it?"

"No, your Honor," Steichen admitted.

Of course, *Bird in Space* is not a bird—it is a bronze sculpture that purports to express the sense of a soaring bird in space. As an artist, Brancusi wanted to convey the essence of an idea, in this case, by giving form to the graceful freedom of movement we associate with the flight of birds. The more mundane discussion of whether or not the *Bird* could reasonably be called a bird was settled when the presiding judge, Justice Waite, asserted that he knew of no law stating "that an article should represent the human form or any particular animal form or an inanimate object...."

"It has," testified one art critic, "the suggestion of flight, it suggests grace, aspiration, vigor, coupled with speed, in the spirit of strength, potency, beauty, just as a bird does.... But the title ... of this work ... does not affect at all the aesthetic quality of the work as a work of art if it has **proportion**, **balance**, workmanship, and **design**."

When Steichen testified, he tried to define exactly why the *Bird* was a work of art: "It is a work of art because it has form and balance; form is something that is achieved in the mind of the sculptor, and balance is in length, breadth, and thickness. Balance is the relationship of these forms to each other. The whole of it has harmonious lines; the base is very good in proportion to the top. It has proportion, that is, harmony."

The judge handed down his decision, taking into account the development of **modernism** and recognizing that **abstraction** was being pursued by many contemporary artists. "[The *Bird*] is," he concluded, "beautiful and **symmetrical** in outline, and while some difficulty might be encountered in associating it with a bird, it is nevertheless pleasing to look at and highly ornamental, and as we hold under the evidence that it is the original production of a professional sculptor and is in fact a piece of sculpture and a work of art ..., we sustain the protest and find that it is entitled to free entry...."

Steichen's explanation of why Brancusi's *Bird in Space* is art is a matter of record; it is part of the trial transcript. Brancusi himself believed that he had succeeded in conveying the essential quality of a bird as it moves through space. But, as we shall see, this is only one artist's view. The nature of art varies according to time, place, and purpose, as well as to the tastes, ideas, and talents of the artist. We also have to consider the **medium** of the work (what it is made of) and its **technique** (how it was made). Brancusi's *Bird* is made of highly polished bronze, which gives it a shiny, mirrorlike surface that glistens as if reflecting bright sunlight. It seems to soar upward and at the same time to hover weightlessly in space—as its title suggests. In addition, as the judge pointed out, *Bird in Space* was made in the context of emerging modernism in the arts. He also considered the work to be harmonious and balanced, and thus pleasing to look at. In a word, for Justice Waite, Brancusi's sculpture was ART.

1.1 Edward Steichen, *Brancusi in his Studio*, Paris, 1927. Royal Photographic Society Collection/ NMPFT/ SSPL. Reprinted with permission of Joanna T. Steichen.

Art Takes Many Forms: Variations on the Imagery of Birds and Flight

Whether or not we like the way an image looks, most images express ideas. Rather than becoming involved in strict definitions of art, we will have more fun and learn more if we are open to different forms of expression and we allow a variety of imagery to connect us to artistic ideas around the world. This activates our imaginations. If we allow them to, works of art can have enormous power over us—they are links to our own creativity and to the creativity of others, and they provide bonds between ourselves and people of very different times and places.

Bird in Space was Brancusi's way of expressing the graceful qualities he associated with birds. But this is

only one form of expression. There are many other forms, which depend on the taste of a particular artist, the ideas he or she wishes to communicate, the cultural context and purpose of the work, and the time when it was created.

Taking the theme of the bird and of flight through different periods and cultures, we discover the enormous variety in the ways creative artists express their ideas.

A more realistic approach to bird imagery than Brancusi's can be seen in the work of the American artist John James Audubon (1785–1851), whose famous pictures of birds accurately document their physical appearance. In *Wild Turkey* (**figure 1.2**), he shows the bird in its natural environment; both the turkey and its habitat are precisely delineated. In contrast to the generalized, or "essential," quality of Brancusi's *Bird*, the wings and tail feathers of the turkey are clearly defined. Audubon has also recorded the texture of the neck and the details of the head. The depiction of the turkey, in fact, is so precise that one can identify the species from the image. In Brancusi's case, without the title we might not know that the bronze represents a bird at all. Once we know the title, however, we recognize qualities of "birdness" in the sculpture. Brancusi captured the essence of a bird in space without describing its every detail.

During the Italian Renaissance, the artist and scientist Leonardo da Vinci (1452–1519) was so interested in solving the problem of flight that he filled many notebook pages with drawings of birds accompanied by descriptions of the physics of their wing movements (**figure 1.3**). His drawings are scientifically precise as well as having aesthetic quality and they exemplify his view that art is also a science. Leonardo's creative impulse included trying to invent a flying machine, although he never succeeded in producing a machine that could actually fly.

Today, we can see the appeal of flight and the human wish to fly in a number of ways—from the impulse to conquer outer space to popular heroes of mass culture. In literature, we are familiar with characters such as Peter Pan who can fly on his own and Harry Potter who can do so with the aid of a streamlined broomstick. Fairy tales are filled with winged creatures endowed with a magical ability to fly. Visual artists who create for a mass audience have produced images of powerful flying figures, such as Superman, Wonder Woman, and Mighty Mouse. Dumbo the Elephant defies his enormous bulk by using his ears as wings. All these figures have been creatively designed as heroes of stories, comic strips, and films.

Artists the world over have been inspired by birds and the power of flight. In this section, we consider different ways of representing birds and the theme of

1.2 John James Audubon, *Wild Turkey*, 1822. Watercolor on paper, 3 ft. 2 ³/₄ in. x 2 ft. 1 ⁷/₁₆ in. New York Historical Society.

flight by artists from diverse cultures. **Figure 1.4** shows a bird as conceived by a Scythian artist. A nomadic people who lived in southern Russia from the eighth through the fourth centuries B.C., the Scythians created portable animal art, often made of bronze or gold. This object was placed at the top of a pole; bells attached to the pole announced the approach of its owner. The owner was probably a **shaman**—an important member of certain societies believed to have spiritual qualities. Shamans were thought to cure diseases and be able to transform themselves into animals. The shaman was considered able to access the animal world, and, in this case, the shaman carrying the pole would have been associated with the bird's power to fly.

As a work of art, the Scythian bird more closely resembles Brancusi's expressive qualities than Audubon's, even though the image has certain features, such as a beak, a crest, and an eye, that are lacking in *Bird in Space*. However, both the eye and the crest are **stylizations**, which means that they are depicted as simplified, abstract surface elements, rather than as they appear in reality. For example, the eye has been moved from its natural position to below the crest and rotated ninety degrees. As with Brancusi's *Bird*, the Scythian sculpture evokes a general sense of birdness rather than precisely delineating every feature of a bird.

1.3 Leonardo da Vinci, detail of *Drawings of the Flights of Birds*, 1506. Ink on paper. Biblioteca Reale, Turin.

CHRONOLOGY

For dating works of art and time periods, we use the standard Western chronology, designating works made before the birth of Christ as **B.C.** and those after his birth as **A.D.** When neither B.C. nor A.D. are indicated, A.D. is assumed. Some textbooks, preferring a more religiously neutral designation, use B.C.E. (meaning "Before the Common Era") instead of B.C. and C.E. (the Common Era) instead of A.D. In this text, however, we use A.D. and B.C., because they are more historical. When a date is uncertain or approximate, we use **c.**, which stands for *circa* (the Latin word for "about" or "around").

1.4 Flat Scythian pole-top in the shape of a schematic bird head with two bronze bells, 7th/6th century B.C, from Scythian Kuban. Bronze, 10 ¼ in. high. Hermitage Museum, St. Petersburg, Russia.

1.5 Royal *osun* (spirit head), early 18th century. Bronze, 10 ¹/₂ in. high. British Museum, London.

1.6 Tlingit *Raven Barbecuing Hat*, early 19th century, from Sitka, Alaska. Wood, deerskin, ermine, spruce, root, iron nail, bird beak, 20 ¹/₂ in. high. University Museum, University of Pennsylvania, Philadelphia.

In the arts of Benin, an African kingdom west of modern Nigeria, artists represented birds as signs of royal power. First brought to the attention of the European world in the fifteenth century by Portuguese missionaries and mercenaries, Benin artists produced impressive works in metal and ivory. But, as with the Scythian pole-top, these cannot be understood or fully appreciated out of context. One example can be seen in the royal *osun* ("spirit head") (**figure 1.5**), which is "crowned" by three birds, two in **profile** (side view) and the central one facing front (**frontal**). The appearance and arrangement of the birds echo the natural symmetry of the human head. Because they can fly, birds symbolize the Benin king's control of nature.

Among the Tlingit of the American Northwest Coast, another bird—the raven—is used in crest art to denote the lineage of a clan. (The term "crest" here means the right to display the image of a supernatural **totem**—ancestor). The early nineteenth-century *Raven Barbecuing Hat* (**figure 1.6**) is an elaborately carved, colorful wooden hat worn by the lineage chief at ceremonial feasts. It identifies the raven clan as legitimately entitled to its clan names, its origin myths, ceremonial rites, territory, houses, and other spiritual and material property. The myth alluded to here tells of a raven who killed a large salmon, which he did not want to share with other animals. So he ordered them to search for cooking utensils, and ate the entire salmon in their absence.

This was a metaphor equating the raven's right to its prey with the clan's exclusive ownership of its raven crests.

The crest hat emphasizes the forceful character of the raven through the prominent blue beak edged with red. The raven surmounts a cap covered with masklike imagery decorated with blue and red patterns. Elegant, stylized forms reflect the symbolic character of the hat, which includes the notion that the clan chief has power associated with the flight of birds.

Returning to the twentieth century, where we began this chapter, we now consider how the theme of birds can be expressed via the playful character of creativity, which Baudelaire associated with childhood. The American artist Alexander Calder (1898–1976) conveyed the creative aspects of play in many of his works. He grew up making his own toys and from an early age learned to use his imagination in creative ways. His friends described his attempt to make a mechanical bird that could pull a worm out of the ground. One called it "excruciatingly funny and remarkably beautiful." **Figure 1.7** shows Calder's *Chock*, which is a **mobile** (a sculpture that hangs from the ceiling and moves with air currents). Using everyday materials, he made it out of wire and a Chock Full O' Nuts coffee can. It conforms to his assertion that nature, rather than modern machinery, inspired his work.

— ◆ —

These few examples of bird imagery and the theme of flight give us some idea of the wide variety of artistic form. Whereas Brancusi sought to convey the "essence" of a bird, Audubon wanted to document the physical characteristics of birds.

Leonardo's drawings of birds are not only pleasing to look at, but they also reflect his scientific interest in the physics of flight. The Scythian bird apparently signified the ability of the shaman to move from the human to the animal world, whereas in Benin culture birds embodied the king's power over nature. Among the Tlingit, the raven hat reflects the legitimacy of the clan chief to control and display clan images. For Calder, bird imagery was one means of transforming the world of nature into creative playfulness.

As we learn more about how artists create imagery, we will find that tastes change. Often what is considered art and highly valued by one generation is ignored or despised by another—and vice versa. If we are afraid of what is new and unfamiliar, or reject it, we limit ourselves. The more willing we are to consider what an image means, what an artist is trying to convey, and how an image functions in a particular society, the more we learn and the richer our lives become.

1.7 Alexander Calder, *Chock*, 1927. Tin can and wire, 28 x 28 1/2 x 26 1/2 in. Whitney Museum of American Art, New York. Gift of the artist.

You see nature and then you try to emulate it.... The basis of everything for me is the universe.

Alexander Calder, sculptor (1898–1976)

Controversy and Changing Views of Art

The question "What is art?"—and the related questions: "Is it *good* art?" "Is it *appropriate* art?" "Is it *immoral* art?"—is by no means restricted to our own time. These issues have preoccupied people for centuries. We can see this if we consider two works by the revered Italian Renaissance artist Michelangelo Buonarroti (1475–1564): the *Pietà* and the *Last Judgment*. Responses to these works have been fraught with intense emotion, some of it positive and some of it negative, and have been revised over time.

Michelangelo

In 1498, at the age of twenty-three, Michelangelo was commissioned by the French ambassador to the Holy See (the governing body of the Roman Catholic Church) to carve a marble statue of the *Pietà*—the scene in which the dead Christ lies across the lap of his mother, the Virgin Mary. The ambassador wanted the work for his tomb in Saint Peter's, in Rome, and the contract stipulated that it be the most beautiful statue in the city.

When Michelangelo completed his *Pietà* (**figure 1.8**), it was admired for its formal unity, for the high quality of the marble, and for the depiction of Christ as a relaxed, youthful figure. It is also the only work Michelangelo signed: his signature is inscribed in the band crossing Mary's torso.

Previous images of the *Pietà*, produced mainly in northern Europe, had represented Christ's body stiffened by *rigor mortis*. Instead, Michelangelo shows the dead Christ harmoniously contained within the large pyramidal form of his mother, the limbs and drapery folds gracefully echoing each other. This Christ appears to be asleep, rather than dead, and is an **idealized**, timeless image. In addition, the somber figure of Mary seems eternally youthful.

Times, however, change, and tastes change with them. Forty years after its creation, the *Pietà* aroused controversy. In 1517, the German Augustinian monk, Martin Luther, objected to corruption in the Roman Catholic Church and his call for reform led to the religious upheaval known as the Protestant Reformation. Political unrest and religious conflict swept Europe. The Catholic Church launched the Counter-Reformation (also called the Catholic Reformation) and, during the 1540s, established rules governing religious imagery. Fearing that the arts had become too focused on humanity, the Church required that imagery emphasize spirituality and mysticism. Images of saints and martyrs, the Church decreed, should evoke the viewer's identification with suffering, inspire faith, and reinforce the desire for salvation. The task of carrying out these rules was assigned to the Inquisition, an official body of the Church established in the twelfth century to combat heresy. Members of the Inquisition could be quite zealous in pursuing artists who failed to obey the rules.

With regard to Michelangelo's *Pietà*, the Counter-Reformation Church was offended by Mary's youthful appearance and thought it made the statue seem incestuous. When asked about her youth (for she would have been middle-aged at the time of her son's death), Michelangelo piously replied that chastity preserves youthfulness. But his response did not impress the Inquisitors. Therefore, to protect the work from possible destruction by the Inquisition, it was removed from public view until such time as prevailing taste would permit its display.

This was not the only time Michelangelo provoked controversy. In 1534, the progressive Pope Paul III (papacy 1534–1549) commissioned Michelangelo to paint a monumental *Last Judgment* on the altar wall of the Sistine Chapel in the Vatican (**figure 1.9**). Michelangelo completed this huge image of the end of time in 1541, when he was sixty-six. He filled the vast wall space with a powerful scene of dynamic nudes, some finding salvation in heaven and others facing eternal damnation.

Michelangelo's conception of heaven consists of saints and martyrs carrying instruments of their martyrdom and other identifying attributes. A vigorous, youthful Christ, enveloped in a glow of light, presides over the scene as he sends sinners to their doom. Below Christ's upraised arm we

1.8 Michelangelo Buonarroti, *Pietà*, 1498/9–1500. Marble, 5 ft. 8 ½ in. high. Saint Peter's, Vatican, Rome.

1.9 Michelangelo Buonarroti, *Last Judgment*, 1534–1541. Fresco. Altar wall of the Sistine Chapel, Vatican, Rome.

can see the Virgin wearing red and blue—her characteristic colors in Renaissance painting. The bearded Saint Peter carries the gold and silver keys to heaven at Christ's left. Twisting around to gaze at Christ is Saint Bartholomew, who was flayed alive; he brandishes a knife and holds his own flayed skin. The face of the skin is Michelangelo's **self-portrait** (a likeness of himself), which suggests that the *Last Judgment* had personal meaning for the artist as well as cultural and religious meaning in the context of the period.

Above Christ, in the **lunettes** (the curved areas at the top of the wall), angels carry instruments of the Passion—the Crown of Thorns, the Cross, and the column on which Christ was flagellated. Below, at the lower right, Michelangelo merged the mythological Underworld (Hades) of ancient Greece with a dark and fiery Christian hell. Damned souls are ferried across the River Styx that borders Hades by the boatman Charon. At the lower left, saved souls climb from their tombs and rise weightlessly toward heaven.

Today, millions of people flock to Rome to view the Sistine Chapel and Michelangelo's *Last Judgment*. But in the sixteenth century, after the death of Paul III, the image drew criticism. One prominent art critic, Pietro Aretino (1492–1556), eloquently voiced his objections. He cited Michelangelo's failure to distinguish between men, women, and children—probably referring to the powerful muscles of all the figures. Aretino recommended that parents refrain from exposing their children to the work lest it corrupt their morals. He pronounced it fit for a bathhouse ("*un bagno*") but not for the pope's private chapel.

Pope Paul IV (papacy 1555–1559) was more conservative than Paul III, and he agreed with Aretino. He also believed that the *Last Judgment* failed to obey the rules of the Counter-Reformation. The pope considered the display of nudes offensive and wanted the entire fresco erased. Fortunately, however, an alternative solution was found—many of the genitals were obscured and the nudes were painted over with draperies. These remained until the 1980s, when the Vatican undertook a controversial restoration of the frescoes. Today, Michelangelo's *Last Judgment* is considered one of the world's greatest paintings and a monumental expression of the human condition.

Manet

Another heated artistic controversy arose in nineteenth-century Paris, then the center of the Western art world, when certain works by Edouard Manet (1832–1883) were first exhibited. At the time, state-sponsored juries controlled public exhibitions (known as the Salon). This led to a number of conflicts over issues of taste and propriety, as well as style, pitting the new ideas of young artists against the traditional ideas of conservative officials. In 1863, the Salon jury rejected more than 4,000 paintings submitted for consideration. This raised such an outcry of protest that, even though the French ruler, Napoleon III, personally disliked the new work, he authorized a separate exhibition, known as the "Salon des Refusés" (the Salon of the rejected). As it turned out, this exhibit consisted of work by artists who proved to be the most important of the new generation.

If we look closely at one of Manet's rejected paintings—*Le Déjeuner sur l'Herbe* (*Luncheon on the Grass*) (**figure 1.10**)—we gain some insight into contemporary tensions between tradition and innovation. The French public was shocked by the image of a nude woman casually picnicking with two fully clothed men in a public park, and by the remains of a meal visible at the lower left. A further irritant was the fact that the figures were **portraits** (likenesses) of contemporary Parisians and therefore quite recognizable to viewers. The two men were Manet's brother, Gustave, and Ferdinand Leenhoff, who later married Manet's sister. The nude woman was Manet's favorite model, Victorine Meurend. Her assertive gaze, directed at the viewer, was seen as accentuating the challenge to propriety that the picture posed. In addition, the presence of recognizable contemporary portraits made the *Déjeuner* seem too close to home and was another source of offense to viewers. Despite Napoleon III's "Salon des Refusés," he himself said of Manet's *Déjeuner*: "It offends against modesty."[1]

Even though the *Déjeuner* seemed to disregard traditional taste and to flaunt the nude woman in an outrageous manner, the picture actually contains echoes of styles that were very much admired in nineteenth-century France. One example is the *Fête Champêtre* (*Pastoral Concert*) (**figure 1.11**), by the Italian Renaissance painter Giorgione da Castelfranco (c. 1477–1510). As in the *Déjeuner*, Giorgione shows a nude woman seated in a landscape with two clothed men. But he includes another nude woman pouring water into a stone basin, whereas Manet's second nude wades in a stream behind the picnickers.

Manet's figures and their arrangement were inspired by traditional works, but are placed in a new context and given new clothes. Their forms are less idealized than Giorgione's. Not only were the identities of Manet's figures known to the viewing public, but his seated woman appears lumpy and the solid blacks of the men's jackets make them seem flat. One critic objected to what he saw as "fingers without bones, heads without skulls, and sideburns painted like two strips of black cloth glued on the cheeks."[2] In other words, the figures struck the

1.10 Edouard Manet, *Le Déjeuner sur l'Herbe* (*Luncheon on the Grass*), 1863. Oil on canvas, 6 ft. 9 in. x 8 ft. 10 in. Musée d'Orsay, Paris.

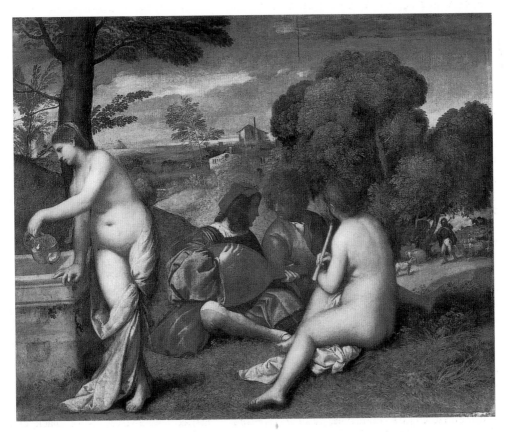

1.11 Giorgione da Castelfranco, *Fête Champêtre* (*Pastoral Concert*), 1511–1512. Oil on canvas, 3 ft. 7 in. x 4 ft. 6 in. Louvre, Paris.

critic as lacking in anatomical structure. In addition, although Giorgione's figures occupy a mysterious, idyllic landscape, Manet's are set in a park in nineteenth-century Paris.

Spatially, too, there is an important difference between Manet's painting and Giorgione's. Renaissance artists tended to extend landscapes back in space toward the horizon, but Manet reduces the distance and places his figures toward the front of the picture where they confront the viewer more directly. To the nineteenth-century French public, this reinforced the insult to tradition, driving home the newness of the work.

Manet was working on the threshold of a new generation of **avant-garde** (modernist) artists interested in portraying present-day society. Like many such innovators, he was challenging an entrenched establishment resistant to change. The newness of his work was received with distaste, and its traditional aspects apparently went unnoticed.

Censorship and the Arts

One lesson of the "Salon des Refusés," like the controversy over Brancusi's *Bird* and the changing opinions of Michelangelo's work, is that, as the traditional saying goes, "you can't legislate taste." Whereas the objections to Michelangelo's *Pietà* and *Last Judgment* were moral and the resistance to Manet's *Déjeuner* was aesthetic as well as moral, other conflicts about art revolve around politics. In some cases, these issues merge and on occasion lead to outright censorship.

1937: Hitler's Exhibition of "Degenerate Art"

In the early decades of the twentieth century, the avant-garde flourished in the German cities of Munich, Dresden, and Berlin, where modern artists presented the art-going public with exciting new visual ideas. But the political climate changed in the 1930s, when Hitler rose to power. The Nazi party considered modern art deviant and degenerate.

On July 19, 1937, Hitler's "Great German Art Exhibition" opened in Munich. This was to be an example to the German people of degenerate art and it included more than 650 paintings by major European artists. A pamphlet accompanying the exhibition attacked the morality of modernism and accused the artists of representing the world as a brothel inhabited by pimps and prostitutes. Modern music, films, books, architecture, and theater were also declared subversive.

Hitler, himself an unsuccessful painter, considered modern art incomprehensible and declared that "'works of art' that are not capable of being understood in themselves but need some pretentious instruction book to justify their existence... will never again find their way to the German people." He vowed to wage war against the cultural disintegration reflected in modern art. Ironically, as with the "Salon des Refusés," the artists branded as degenerate were among the most important innovators of their time. In June 1939, modern art was summarily removed from German museums and auctioned off to foreigners.

1989: Mapplethorpe Goes to Cincinnati

In the United States, the most heated artistic controversies in recent decades have centered on government funding for the arts. Compared with Europe, the United States allocates relatively little public money to the arts, and when conflicts arise, they involve First Amendment protection (guaranteeing freedom of speech) and the degree to which it applies to the visual arts. In the 1970s, during the era of the Vietnam War, paintings, sculptures, and performances sometimes used the American flag in protests against the war. In one lawsuit brought against an exhibition in which flags were draped over sexually explicit sculptures, the court ruled that the works were protected by the First Amendment.

In 1989, the photographer Robert Mapplethorpe (1946–1989) received a government grant of $15,000 and the Philadelphia Institute of Contemporary Art received $30,000 for a show entitled "Robert Mapplethorpe: the Perfect Image." Three portfolios were included in the show—the *X-Portfolio*, containing homosexual and sado-masochistic images; the *Y-Portfolio*, containing pictures of flowers; and the *Z-Portfolio*, of black men in classically inspired poses.

We can see from Mapplethorpe's self-portrait (**figure 1.12**) that he challenged expected notions of representation. In this case, the challenge is not so much formal as gender-based. Mapplethorpe shows himself as an androgynous figure, with smooth, powdered skin and soft, wavy hair contrasting with the clearly male musculature of his neck and chest. He merged his own male–female identity in a single figure. Mapplethorpe is made-up so that his masculinity appears ambiguous, thus conveying the contemporary artistic interest in challenging the boundaries of gender.

Bowing to lobbying efforts by conservatives, Congress curtailed public funding for the arts by $45,000, which was equivalent to Mapplethorpe's $15,000 grant plus the $30,000 paid to the

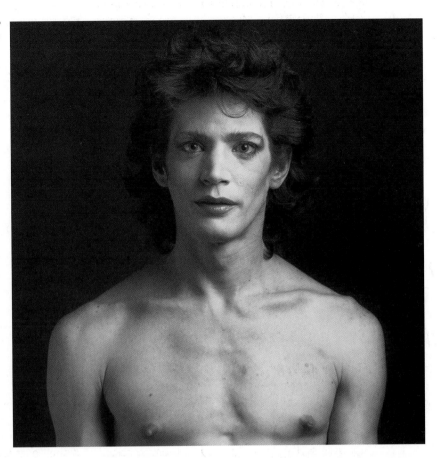

1.12 Robert Mapplethorpe, *Self-Portrait*, 1980. Unique gelatin print, 30 x 30 in. © The Robert Mapplethorpe Foundation. Used with permission. Courtesy Art & Commerce.

Philadelphia Institute. A one-year ban on government grants to artists depicting perverse or obscene content was also enacted.

When the Mapplethorpe show arrived in Cincinnati, Ohio, new objections were raised, notably by the Cincinnati Citizens for Community Values. But the director of the Cincinnati Museum decided that the show would go on. This flew in the face of law enforcement officials who had declared Mapplethorpe's photographs "criminally obscene."[3]

On April 7, an Ohio grand jury indicted the Cincinnati Arts Center and its director for obscenity, despite the fact that the director had placed the *X-Portfolio* in a separate room closed to viewers under 18. He also posted a notice warning parents that the photographs were sexually explicit. The trial opened on September 24 and, as in the 1927 Brancusi trial, the defense in Cincinnati argued that works in museums made by professional artists are, by definition, art. Furthermore, the defense insisted, the arts are protected by the First Amendment guarantee of free speech.

The prosecution, echoing certain Counter-Reformation views of Michelangelo's *Last Judgment*, argued that Mapplethorpe's photographs were offensive, obscene, and damaging to the welfare of children. After five days of testimony, the case went to the jury, and the judge instructed the jurors on the legal test for obscenity. The operative point was whether a work "taken as a whole, lacks serious literary, artistic, political, or scientific value." On that basis, the jury deliberated for two hours before acquitting the museum and its director. They decided that even though there were sexually explicit images among Mapplethorpe's photographs, the work had serious artistic value.

Although no one on the jury was particularly interested or trained in art, they came to understand an important aspect of assessing imagery. They discovered that it is possible for something to qualify as art without being beautiful.

The recognition that "art doesn't have to be pretty" is crucial to the understanding of the history and character of the visual arts. We have seen that tastes change over time and that an artist who is highly valued by one generation may be ignored by another. The risks of legislating taste are abundantly illustrated by the lessons of history. Nevertheless, artistic imagery continues to create controversy today. Viewers with preconceived ideas about the arts may find themselves shocked or challenged by certain trends. But this should not prevent us from enjoying the educational process of learning about the arts. And we may find that as we learn, our tastes change, our eyes open, and our minds expand.

Self-Portraits: Rembrandt and Picasso

When artists create portraits and self-portraits, they express something about their subjects and themselves. If we compare two self-portraits, one by the seventeenth-century Dutch artist Rembrandt van Rijn (1606–1669) and one by Pablo Picasso (1881–1973), who was born in Spain but lived most of his adult life in France, we are aware that each picture conveys different qualities of character. They are painted in very different styles, each of which reflects its time and place. Comparing them reveals the range of expression that can be produced by creative thinking and the talent to transform an idea into a concrete work.

Rembrandt shows himself as an energetic young man, whose face, especially his bulbous nose, is highlighted against a darker background (**figure 1.13**). He emphasizes details of dress—the gold threads in the collar, the gold chain, and the elegantly feathered hat. He seems about to speak

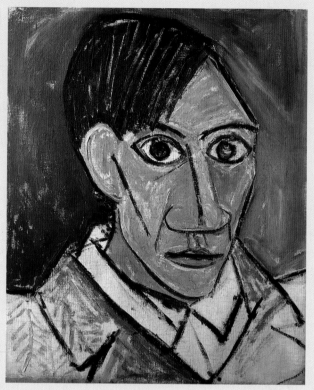

1.14 Pablo Picasso, *Self-Portrait*, 1907. Oil on canvas, 19 ¼ x 18 ⅛ in. Nárdoni Galerie, Prague.

as he turns his head abruptly and parts his lips. This is the self-image of a dynamic artist, who portrays inner character by gradual shifts in light and dark playing over the face. But he also has a flair for drama, which is reflected in his taste for flamboyant self-display and the fact that he kept costumes in his studio for his sitters—including himself—to wear when posing for a portrait.

Picasso, like Rembrandt, painted many portraits and self-portraits. His self-portrait in **figure 1.14** was painted in 1907, when he was twenty-six years old. Picasso was in the forefront of the same modernist movement as Brancusi (see pp. 2-3). In this image, Picasso seeks to challenge tradition with a new kind of formal structure. The face is geometric rather than natural, with a triangular forehead and cheeks. Despite this departure from the appearance of nature, the self-portrait is a recognizable likeness. It emphasizes Picasso's penetrating gaze and reflects his genius for creative seeing.

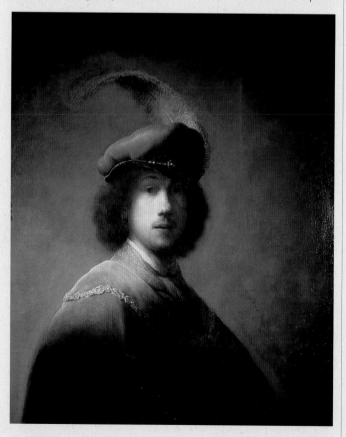

1.13 Rembrandt van Rijn, *Self-Portrait*, 1629. Oil on panel, 35 ⅓ x 28 ⁹/₁₀ in. Isabella Stewart Gardner Museum, Boston.

Looking at Art

The best way to learn about art is to look closely at images and think about how you react to them and what they might mean. Consider what ideas might be connected with a particular work, which of your senses it might appeal to, and whether it expresses something significant.

In 1919, the French artist Marcel Duchamp (1887–1968) emphasized the importance of looking in a now-famous work entitled *L.H.O.O.Q.* (**figure 1.15**). He took a reproduction of Leonardo da Vinci's *Mona Lisa* and penciled a mustache and beard on the face. This raises questions about the boundary between creation and destruction: by defacing the figure, did Duchamp ruin the reproduction, or was he telling us something about the nature of art? In either case, Duchamp startled viewers and produced another challenge to traditional ideas about the artistic process. In addition, he addresses the viewer in the title by telling us to look (*LHOOQ*) at the work.

In this text, keeping in mind Duchamp's instruction to look, we will pursue the theme of drawing attention to different aspects of a single work. Each chapter contains a boxed section entitled LOOK in which we focus on one or two works in depth and consider them from different points of view.

We have seen that there are many ways to represent similar subjects and ideas. These tend to vary according to time and place, as well as according to the individual style, technique, and materials used by artists. In order to express our own views about art, we have to learn how to describe it. This can be difficult, because words and images are different kinds of expression. We thus need a vocabulary to help us translate our experience of a work of art into words. When, for example, one critic testifies to the beauty of Brancusi's *Bird in Space* while another calls him "a wonderful polisher of bronze" but not an artist, what are we to think? Without knowing the vocabulary of art, it is easy to become confused and frustrated.

—◆—

The following chapters attempt to familiarize readers with the terminology used to describe images. In addition, we discuss ideas about the origins of the arts, the creative process, the vocabulary of the visual arts, their social, political, religious, and personal contexts, and their history. It is even possible that your own tastes may change and you will explore new ways of thinking about imagery.

There may always be controversy about the nature, meaning, and value of art. The question "What is art?" will probably never go away, nor will the fact that art means different things to different people. Perhaps the only universal quality that can be attributed to all works of art is creative expressiveness. Artistic images may be beautiful, ugly, offensive, provocative, irritating, restful, frightening, or amusing. But all express something, and all have a particular form. The nature, context, materials, and history of visual expression are the subjects of this text.

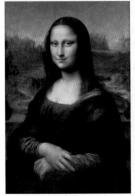

COMPARE

Leonardo, *Mona Lisa*.
figure 5.5, page 78

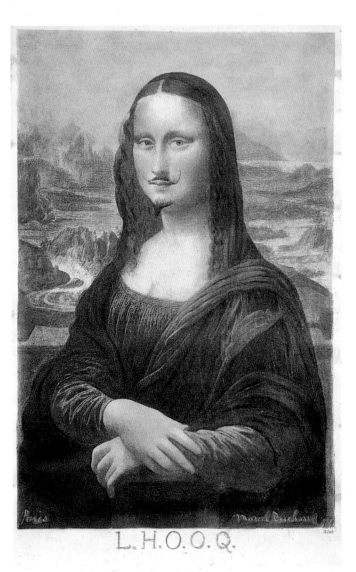

L.H.O.O.Q.

1.15 Marcel Duchamp, replica of *L.H.O.O.Q.* from *Boîte-en-Valise*, 1919. Color reproduction of the *Mona Lisa* altered with a pencil, 7 ³/₄ x 5 in. Philadelphia Museum of Art, Philadelphia.
Louise and Walter Arensberg Collection, no. 1950-134-934.

Chapter 1 Glossary

abstract—having a generalized form with only a symbolic resemblance to real objects

A.D.—*anno domini* (in the year of our Lord), designating time after the birth of Jesus

aesthetic—having an artistic quality

avant-garde—literally "the advance guard"; the innovators or nontraditionalists in a particular field

balance—aesthetically pleasing equilibrium in the arrangement or combination of elements

B.C.—before Christ, designating time before the birth of Jesus

c.—*circa* (latin for "around" or "about"), denoting an approximate date

design (or **composition**)—arrangements of visual elements in a work of art

frontal—facing front

idealized—represented according to ideal standards of beauty rather than to real life

image—reproduction of a person or a thing

lunette—(a) a semicircular painting, relief sculpture, or window; (b) a semicircular area formed by the intersection of a vault or wall

medium—material of a work of art

mobile—sculpture that hangs from the ceiling and is moved by air currents

modernism—expression, practice, or usage characteristic of modern times; the philosophy of modern art

portrait—likeness of a specific person; can also be a likeness of an animal

profile—side view

proportion—relation of one part to another, or of parts to the whole, in respect of size, height, width, and scale

self-portrait—likeness of the artist

shaman—member of society believed to have spiritual qualities, including the power to heal and to change into animal form

stylization—distortion of a representational image as a simplified surface detail to conform to certain artistic conventions or to emphasize certain qualities

symmetry—aesthetic balance that is achieved when parts of an object are arranged about a real or imaginary central line (the axis) so that parts on one side correspond with those on the other like a mirror-image

technique—way in which an artist creates a work of art

totem—ancestor

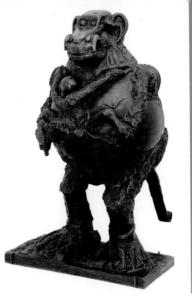

2

KEY TOPICS

Sources of creativity

Visual metaphor

Art inspired by nature

Art inspired by the city

Art inspired by myths and dreams

The Creative Impulse

The question "Where does art come from?" is almost as persistent as the question "What is art?" We can answer the question in part by observing that children are naturally creative. They draw, paint, carve, model, and build. If given a set of crayons, children draw on walls, floors, furniture, and any other available surface. At the beach they build sandcastles, in their backyards they make tree houses, and in the snow they make snowmen. All of these creations are efforts to order the environment either for practical purposes or for decoration. They also suggest that creativity is inborn.

Creative products express ideas, which is quite easy to see in the art of children. A child who is angry at his or her mother might draw a witch. A girl who admires her father might represent him as a prince or a king. And a boy who feels positively about his mother might draw her wearing a royal robe and a crown. These examples illustrate the child's natural impulse to be expressive, which is a universal human phenomenon. They do not, however, define the beginnings of art on a cultural or historical level; that is, they not identify the first artist or the first work of art. Nor can we hope to do so, for the beginnings of art are lost in prehistory.

We *can* say that creative people seem endowed with an ability that we call talent, or genius. If we think this talent comes from an inner source, we might say that someone has inborn genius. Or we might say that artists are divinely inspired, implying that talent and genius are divine gifts.

The ancient Greeks embodied this idea in the myth of the **Muses**, the nine daughters of the sky-god Zeus who were believed to be the inspiration of

> It is my conviction from having watched a great many babies grow up that all of humanity is born a genius and then becomes de-geniused very rapidly by unfavorable circumstances and by the frustration of all their extraordinary built-in capabilities.
>
> Richard Buckminster Fuller, architect (1895–1983)

human creativity. Later, during the Renaissance, Michelangelo was called *il divino*, meaning "the divine one." Today we speak of a female opera star as a *diva*—a divine woman. There is thus a universal tendency to equate artists with powerful beings such as gods; there are also many legends in which gods are described as the first artists. These legends comprise some of the attempts to answer the question "Where does art come from?" They reflect the traditional association between gods and artists, although they do not give us the actual, historical beginnings of art.

Gods as Artists/Artists as Gods

Various traditions identify gods as the first artists. According to the book of Genesis in the Bible, God fashioned Adam from clay, making the first man and the first sculpture one and the same. In Greek mythology, the sculptor Prometheus stole fire from the gods so that he could breathe life into his statues. Whereas the God of the Bible had the power to create life as well as form, Prometheus could create form but not life.

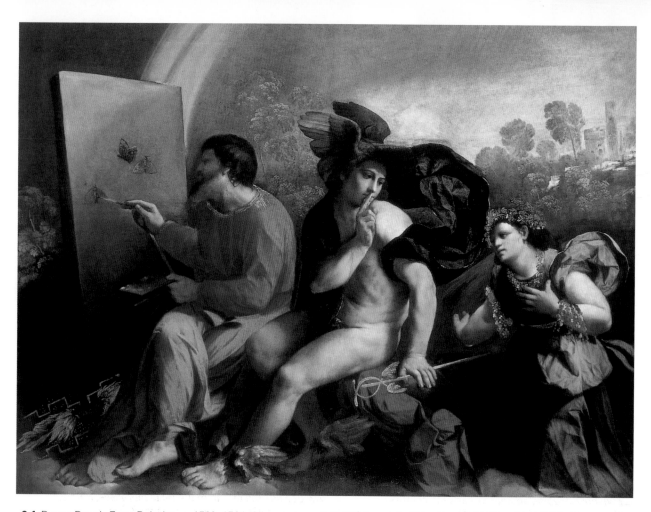

2.1 Dosso Dossi, *Zeus Painting*, c. 1523–1524. Oil on canvas, 3 ft. 8 ⅛ in. x 4 ft. 11 in. Zamek Królewski na Wawelu, Krakow.

> **Artists are chosen by the gods....**
>
> James McNeill Whistler, artist (1834–1903)

> **Create like a god, command like a king, work like a slave.**
>
> Constantin Brancusi (1876–1957)

Zeus is shown as a painter of nature by the Italian artist Dosso Dossi (c. 1479/90–1542) in *Zeus Painting* (**figure 2.1**). Here Zeus paints butterflies, which were ancient symbols of the soul. Butterflies were considered a necessary component of divine creation and linked the world of nature with the human race, both being conceived of as the work of the gods. Since Zeus paints in color, Dosso shows by the rainbow that color is part of nature and that the rainbow contains the seven colors of the visible spectrum (see p. 99).

In Hinduism, the god Vishnu is the architect of the universe. Stimulated by his female counterpart Lakshmi, Vishnu dreamed the universe into existence while sleeping on the endless serpent, Ananta (**figure 2.2**). In the sculpture illustrated here, the cobra hood of the serpent frames Vishnu's head and a lotus flower emerges from his navel, which sets time in motion. Above Vishnu is the god who holds the building tools with which he will construct the world.

During the Middle Ages in Western Europe, God was also conceived of as the architect of the universe. The **manuscript** page in **figure 2.3** depicts God drawing the universe with a compass and the universe is shown as a flattened circle, which is often a symbol of perfection. In Christian art, the circle embodies the notion that the Church is universal and never-ending.

Over four thousand years ago, in Egypt, the architect Imhotep built a sacred precinct containing the colossal step pyramid of the pharaoh Zoser (**figure 2.4**). Imhotep inscribed his name on a wall of the pyramid, adding the designation "First after the King of Upper and Lower Egypt." Since the Egyptian pharaohs were themselves considered gods, being next in line after the king accorded Imhotep nearly divine status. So great was Imhotep's renown that he was deemed the first to have constructed monumental works of architecture in stone. Later, a cult grew up around his memory and he was worshiped as a god. In Imhotep's case, the human architect was elevated to divine status through his art.

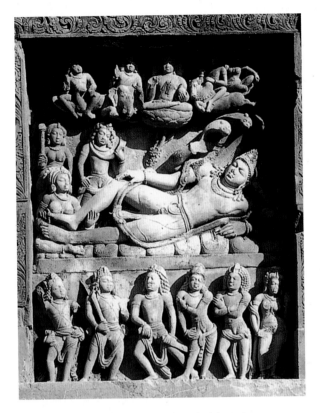

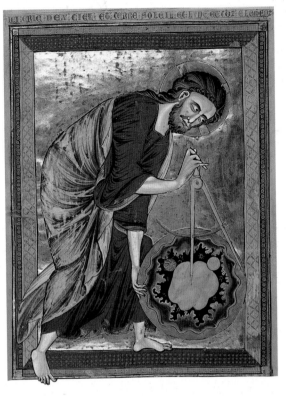

2.2 *Vishnu Sleeping on Ananta*, early 6th century. Relief panel, south side, temple of Vishnu, Deogarh, Uttar Pradesh, India.

2.3 *God as Architect*, from the *Bible moralisée*, Reims, France, mid-13th century. Illumination, 8 ½ in. wide. Osterreichische Nationalbibliothek, Vienna.

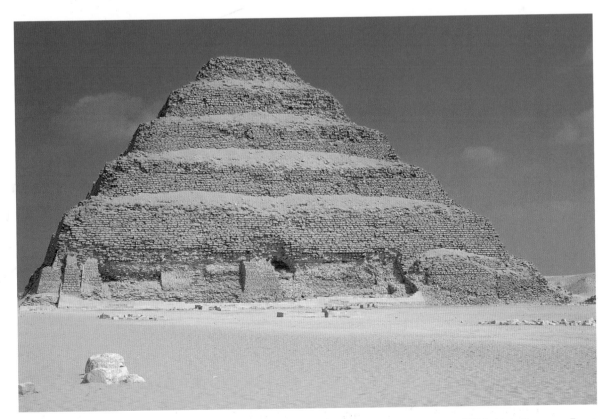

2.4 Imhotep, step pyramid in the funerary complex of King Zoser, c. 2750 B.C. Limestone, 200 ft. high. Saqqara, Egypt.

Creative Thinking and Visual Metaphor

Because gods were conceived of as the creators of nature, Leonardo da Vinci wrote that artists are grandsons of God and create replicas of nature. Other artists and art writers have also sought the origins of artistic creativity. Most attempts to define the origins of art emphasize **visual metaphor** as a significant source of creative thinking. The notion of metaphor is perhaps more familiar in literature—for example, in Carl Sandburg's famous lines:

> The fog comes on little cat feet.
> It sits looking over harbor and city
> On silent haunches and then moves on.

We understand Sandburg to mean that the fog is *like* a cat, that it has the feline quality of a quiet, stealthy approach, and we appreciate the poet's artistic use of language. He has created a picture out of words.

In visual metaphor, forms rather than words inspire imagery and associations are made between one image and another. According to Leonardo, an artist has the ability to look at stains on the surface of a wall or patterns on stones and see a resemblance to landscape. He demonstrates this "resemblance" in **figure 2.5**, in which an old man contemplates the flow of water around a stake. The movement of the water resembles a woman's flowing hair, making the water a visual metaphor for the hair. It is likely that the man represents Leonardo's idea of the artist, studying nature intently, and envisioning possibilities for transforming observed natural images into works of art.

> The mind of the painter must resemble a mirror....
>
> Leonardo da Vinci (1452–1519)

A twentieth-century example of visual metaphor can be seen in Picasso's bronze sculpture *Baboon and Young* (**figure 2.6**). Remarkable for his visual wit, as well as for his vast creative range, Picasso took the image of a small car and merged it with the face of a mother baboon. He enlarged the back wheels to resemble ears, while the front wheels broaden the "grin" of the curved grill and are transformed into cheekbones. The "nose" of the hood matches the baboon's nose and the eyes are formed from the heads of the two figures occupying the front seat of the car. All in all, the mother seems to smile contentedly as her infant clings to her shoulders.

2.5 Leonardo da Vinci, *Old Man Contemplating the Flow of Water*, c. 1513. Ink on paper. The Royal Collection © 2006, Her Majesty Queen Elizabeth II.

2.6 Pablo Picasso, *Baboon and Young*, 1951. Bronze, 21 in. high. Museum of Modern Art, New York. Mrs. Simon Guggenheim Fund.

Art Inspired by Nature and the Environment

Picasso's mind was unusually creative and his ability to transform nature into brilliant, often humorous, works of art was prodigious. In the case of the baboon, he took a visual reference—the small car—and gave it artistic form.

Artists have been making similar types of association since the **Stone Age**. We can see that this is a universal quality of creative thinking by looking at certain prehistoric cave paintings. At Altamira, in Spain (**figure 2.7**), the prehistoric artist was apparently inspired by natural bulges in the cave wall. Black outlines are drawn around a bulge in the rock, delineating the broad shape of the animal's body, which is filled in with earth colors. Details such as the facial features, mane, and legs were then added. The cave artist, like Leonardo, looked at the wall and recognized shapes in its rough stone surface. In this case, the shape reminded the artist of a massive, monumental bison. Using paint and charcoal, he transformed a section of the wall into a convincing, recognizable image. From this example, we realize that creativity is not limited by time or place. It is an aspect of being human.

This connection between art and nature interested the first-century-A.D. Roman author Quintilian.

2.7 Altamira Bison, c.15,000 B.C. Santander, Spain.

2.8 Joseph Wright of Derby, *The Corinthian Maid*, 1782–1784. Oil on canvas, 3 ft. 5 ⁷/₈ in. x 4 ft. 3 ¹/₂ in. National Gallery of Art, Washington, D.C. Paul Mellon Collection.

In his view, though art was inspired by nature, a work of art differs from nature because the artist transforms nature into art. Quintilian imagined a "first artist," who was inspired by the human shapes of shadows. Quintilian's "first painting" was thus made by tracing a line around a person's shadow. A similar notion provided the Roman historian Pliny (A.D. 23–79) with the legendary account of the "first sculpture." This story was depicted by Joseph Wright of Derby (1734–1799), the eighteenth-century English artist, in *The Corinthian Maid* (**figure 2.8**).

In Pliny's account, a young woman of Corinth, in ancient Greece, traced the shadow of her lover on a wall. Her father, who was a potter, filled in the outline with clay and fired it. In Wright's painting, both the girl and her lover are highlighted against a dark wall. The girl traces the shadow of the sleeping youth as her own shadow is cast on the wall. Off to the right, in another room, the fire in which her father will bake the clay is visible.

The legends we have discussed so far assume that art originated with **figurative** images. But this is not

always the case. In Judaism, the second commandment prohibits "graven images," and in Islam, Mohammad forbids the representation of humans and animals on the grounds that God alone has those creative rights. But Islamic artists are nevertheless inspired by nature, especially the shapes of plants and foliage. In the dome of the **mosque** illustrated in **figure 2.9**, the lively, **curvilinear** designs are derived from floral forms. They seem to dance around the curve of the dome like flattened garlands.

In nature, rock formations, cloud formations, constellations, shifting sands, trees, mountains, rivers, oceans, and sky are constant visible elements. Spiders weave intricately designed webs, bees build hives, ants build hills with tunnels and passageways, and birds construct nests. Such natural structures are not art in the sense used in this book, because they are not made by people. They are instinctive to a

2.9 Dome of the Safavid Royal Mosque (Masjid-e-Imam), 1611–1637. Isfahan, Iran.

species rather than being products of an individual creative human mind.

In the remainder of this chapter we look at and compare various ways in which the world of nature and the manmade environment inspire art. Here we examine three sources of inspiration: the natural landscape, the urban landscape (cities and towns), and the psychological landscape—which includes myths and dreams.

The Natural Landscape

Among the categories of paintings inspired by nature are **landscapes** and **seascapes**.

Two seascapes that reflect very different cultures are *Shore and Surf, Nassau* (**figure 2.10**) by the American Winslow Homer (1836–1910) and *The Great Wave of Kanagawa* (**figure 2.11**) by the Japanese artist Katsushika Hokusai (1797–1858). In Homer's picture, the viewer is a short distance from the water's edge, slightly above it and separated from it by a narrow strip of shoreline. We see whitecaps, indicating that the sea is rough, and a gray sky that signals a coming storm. The water seems fluid, an effect made possible by the medium of watercolor. Homer has applied a thin layer of

paint to the paper surface so that it seems transparent, as water is in reality. In addition, the whitecaps and shifting blues and greens have a flowing quality, showing that the waves rise and fall as the winds change. Far away on the horizon a small steamboat is a reminder of industry gradually encroaching on nature.

In *The Great Wave of Kanagawa*, the viewer seems to be under the wave, which rises upward in a sweeping, forceful curve, nearly reaching to the top of the picture. Hokusai emphasizes the dynamic swell of the wave by its large size and the sharp contrasts between the dark blue and the patterns of white foam. Because this work is a print, it lacks the fluid surface texture and impression of spontaneity that we see in Homer's watercolor. Instead, Hokusai's print has a rather static quality, as if the artist captured the scene with the blink of a camera shutter. In Homer's seascape, on the other hand, we have the impression that the water is churning before our very eyes.

Hokusai's boats, unlike Homer's, are not located on the distant horizon. They are closer to the viewer and manned by numerous figures depicted in the same blue and white as the water. The boats appear to be riding the waves as their long, graceful curves

2.10 Winslow Homer, *Shore and Surf, Nassau*, 1899. Watercolor, 15 x 21 ³/₈ in. Metropolitan Museum of Art, New York. Amelia B. Lazarus Fund, 1910 no. 10.228.5.

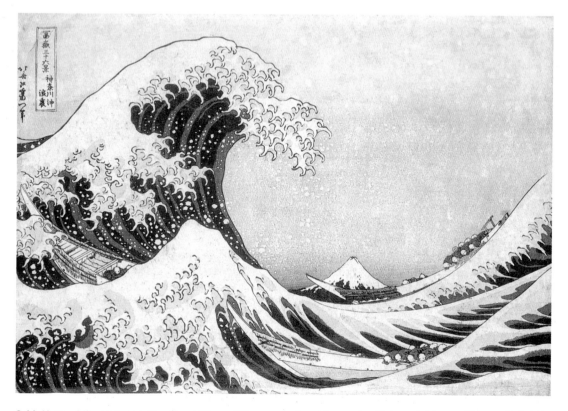

2.11 Katsushika Hokusai, *The Great Wave of Kanagawa*, from the series *Thirty-six Views of Mount Fuji*, 1831. Woodblock print, 9 ⁷/₈ x 14 ⁵/₈ in. Victoria and Albert Museum, London.

Part I Creating and Defining Works of Art

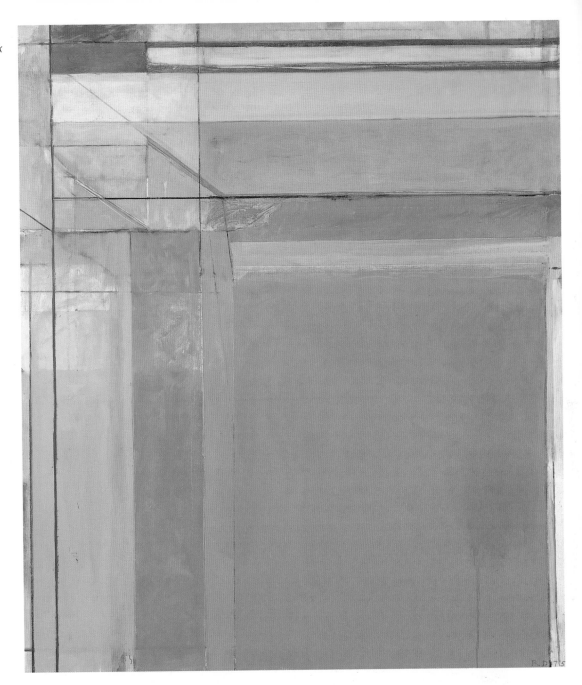

2.12 Richard Diebenkorn, *Ocean Park No. 79*, 1975. Oil on canvas, 7 ft. 9 in. x 6 ft. 9 in. Philadelphia Museum of Art. Purchased with a grant from the National Endowment for the Arts and funds contributed by private donors, no. 1977-28-1.

conform to the natural movement of the swell and their union with the forces of nature adds to the impact of the image. This, together with the close-up viewpoint, makes us identify with Hokusai's boatmen. In contrast to Homer, who does not identify a specific location other than in the title, Hokusai makes it explicit that his wave is in Japan. Visible in the distance is the snow-capped Mount Fuji that has become an icon of the Japanese landscape.

We saw in the patterns of the Islamic dome (see figure 2.9) that representations derived from nature are not always figurative. For example, in the 1970s the American West Coast artist Richard Diebenkorn (1922–1993) began a series of abstract landscapes and seascapes known as *Ocean Park* (**figure 2.12**). They are composed mainly of geometric shapes— rectangles, squares, and triangles. In this case, a

> **All paintings start out of a mood, out of a relationship with things or people, out of a complete visual impression.**
>
> Richard Diebenkorn, artist (1922–1993)

large bluish-purple area is bounded by slimmer rectangles at the top and on the left, with a few triangles in the upper left corner. Diebenkorn was inspired by the vast expanse of the Pacific Ocean and the California coastline. This is conveyed by the juxtaposition of a broad area of blue, the surface of which is slightly textured by thick oil paint and the weave of the canvas. At the lower right, the paint has been allowed to drip, suggesting the flow of water. Toward the top, the strips of yellow and red suggest a sunset, and we have the sense of the sea meeting the horizon.

A different approach to landscape can be seen in the work of the contemporary British artist Andy Goldsworthy (b. 1956). Nature is not only the theme and subject of his work, but also his medium. Some of his work is permanent, but much of it is temporary and changes with the weather. *Japanese Maple Leaves* (**figure 2.13**) lasted for about two days—November 21–22, 1987—and is recorded only in photographs. Here Goldsworthy arranged brilliant red Japanese maple leaves stitched together on the ground in a circular pattern. They contrast with the dark earth and are framed by stones, creating a kind of transient nature-sculpture that is also strikingly pictorial.

> **Nature goes beyond what is called countryside—everything comes from the earth.**
>
> Andy Goldsworthy, artist (b. 1956)

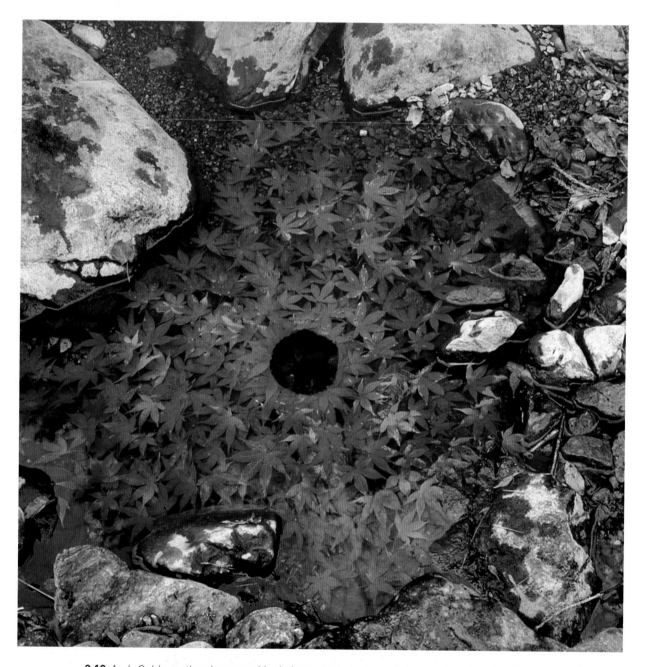

2.13 Andy Goldsworthy, *Japanese Maple Leaves stitched together to make a floating chain*, November 21–22, 1987. Ouchiyama-Mura, Japan. © Image by Andy Goldsworthy.

Gérome's *Pygmalion and Galatea*

Nature and art informed many traditions and myths in the ancient world equating gods with artists and artists with gods. One well-known legend is the Greco-Roman myth of Pygmalion and his statue *Galatea*.

Pygmalion was a sculptor who was discouraged rather than inspired by nature, especially the nature of women. He felt that they could not be trusted and were bound to be unfaithful. So he decided to improve on nature and create his own woman. He carved a beautiful statue out of marble, which he named Galatea.

Pygmalion was enchanted with his statue in all but one way: she was not real. He prayed to Venus, the Roman goddess of love and beauty, to bring Galatea to life. Venus obliged, illustrating that whereas artists create art, only gods can create life.

The myth of Pygmalion and Galatea is the subject of a painting by the French artist Jean-Léon Gérome (1824–1904) (**figure 2.14**). The scene takes place in Pygmalion's studio, furnished with the artist's tools, boxes, and a stepladder. Toward the right background we can see two Greek theater masks and a Greek shield. Greek subjects are also visible on the wall to the left. Kneeling on a cloud above the masks is an illuminated Cupid (the Roman god of love and the son of Venus) aiming his bow and arrow at Pygmalion and Galatea.

Gérome has depicted a moment of transition as Galatea is in the process of coming alive. From the waist down she is still a cold marble statue, but from the waist up she is flesh and blood and she bends over to receive Pygmalion's embrace. By showing this impossible transformation from a statue to a living woman, Gérome creates a sense of the uncanny. He also achieves an image that fulfills the artist's wish to control nature—but, in this case, instead of nature becoming art, art becomes nature.

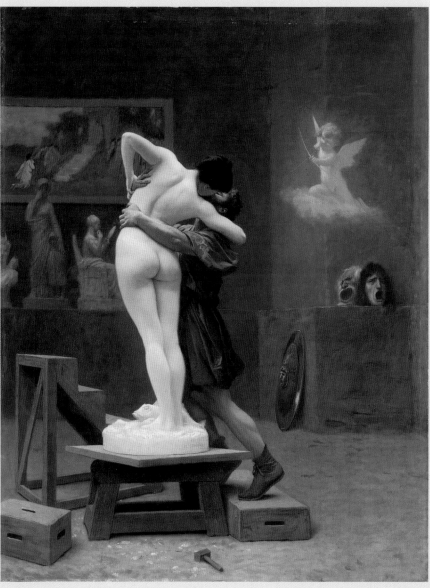

2.14 Jean-Léon Gérome, *Pygmalion and Galatea*, c.1890. Oil on canvas, 35 x 27 in. Metropolitan Museum of Art, New York. Gift of Louis C. Raegner, 1927, no. 27.200.

27

The Urban Landscape

The urban environment, like the natural environment, has inspired artists in a variety of ways and has been depicted in many different styles. Painters have represented concepts, or ideas, of the city, as well as views of actual cities. In fifteenth-century Italy, for example, the ideal city was based on the perfection of the circle. It was conceived of as a symmetrical arrangement of buildings radiating from a central point. Although such cities were rarely realized, the notion of an ideal city became the basis of Renaissance urban design. One such work, the *Painting of an Ideal City* (**figure 2.15**), shows an urban space devoid of people. At the center stands a round building, the open door of which draws the viewer's attention into the painted space. The overall impression of this particular city is one of clarity of form and light, and regularity of design.

The *View of Delft* (**figure 2.16**) by the seventeenth-century Dutch painter Johannes Vermeer (1632–1675) represents an actual city—the artist's native town of Delft. Because Holland is below sea level and its survival depends on a system of dikes, the ever-present sea and the relative smallness of human figures are features of Vermeer's painting. In contrast to the expansive, dynamic seascapes of Homer and Hokusai described above, Vermeer emphasizes the stillness of the water, which mirrors the houses, walls, and drawbridge along the shore. Small beads of light sparkling on the buildings are typical of Vermeer's attention to intimate detail. Compared with the painting of the ideal city, Vermeer's Delft shows the irregular distribution of houses and conveys the fact that the town is inhabited by people going about their daily lives.

Very different in style from Vermeer's quiet town of Delft is *The City* (**figure 2.17**) of 1919 by the French artist Fernand Léger (1881–1955). Léger depicts the fragmentation of the modern industrial city. He shatters the buildings into a jumble of steel girders, poles, stairways, and dislocated sections of billboards with large stenciled letters. The human figures are flat **silhouettes** and robotlike, making us aware of the fast-paced anonymity and mechanization of urban life in the early twentieth century.

> ... art consists of inventing and not copying.
>
> Fernand Léger, artist (1881–1955)

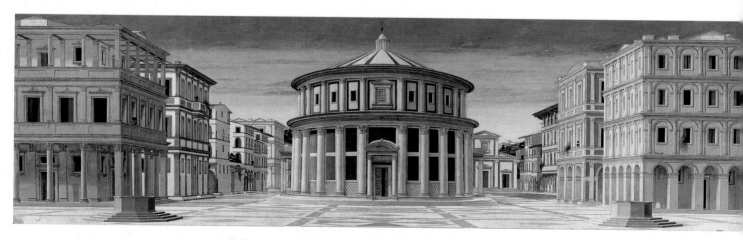

2.15 Anonymous, *Painting of an Ideal City*, mid-15th century. Panel painting, 23 1/2 in. x 6 ft. 7 in. Ducal Palace Museum, Urbino.

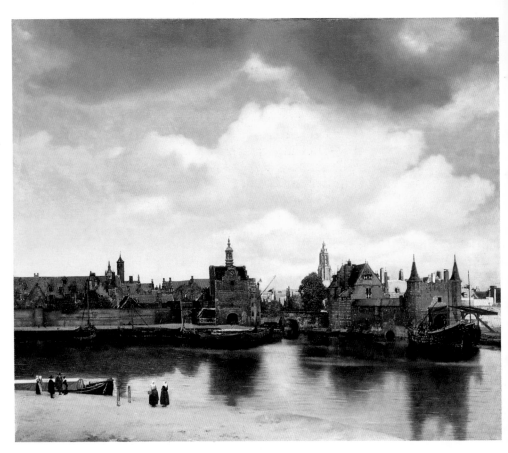

2.16 Johannes Vermeer, *View of Delft*, c.1660–1661 (after restoration). Oil on canvas, 3 ft. 2 in. x 3 ft. 9 ½ in. Royal Cabinet of Paintings, Mauritshuis, The Hague.

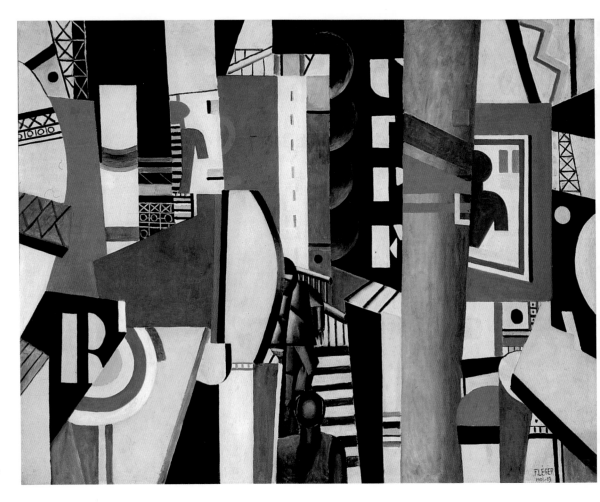

2.17 Fernand Léger, *The City*, 1919. Oil on canvas, 7 ft. 7 in. x 14 ft. 9 ½ in. Philadelphia Museum of Art. A.E. Gallatin Collection, no. 1952-61-58.

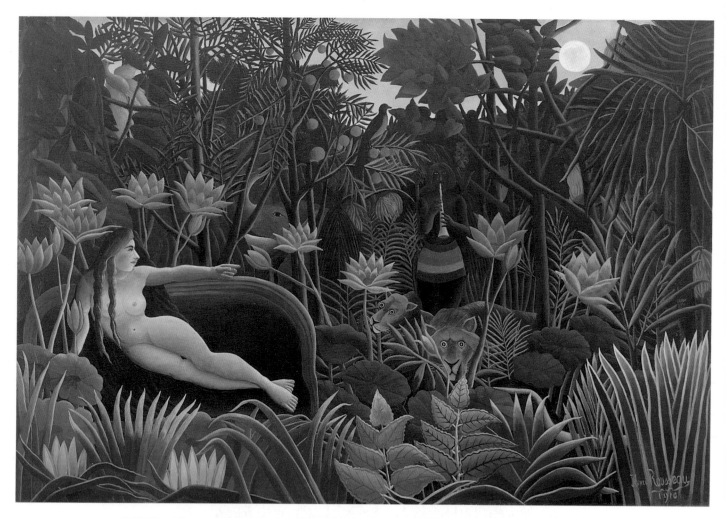

2.18 Henri Rousseau, *The Dream*, 1910. Oil on canvas, 6 ft. 8 ½ in. x 9 ft. 9 ½ in. Museum of Modern Art, New York. Gift of Nelson A. Rockefeller.

The Psychological Landscape: Dream and Myth

In addition to the external environment, artists are inspired by internal, psychological images. Since we dream in pictures, we are surrounded by images when we sleep—even if we do not remember them when we wake up. Some dreams illustrate cultural myths whereas others are personal; both have been depicted by artists around the world.

In 1910, the French artist Henri Rousseau (1844–1910) painted *The Dream* (**figure 2.18**). It shows a nude woman reclining on an upholstered French divan in the middle of a jungle. She points anxiously toward a dark gray figure emerging from the forest. He plays a pipe and wears a brightly colored tunic. Even though he stands upright like a human, he is covered with fur like an animal. The jungle is filled with wild beasts who behave as if they are tame; there is a moon in the bright, daylight sky; and the female dreamer, who is actually asleep, appears wide awake.

It is not known if this represents a real dream dreamed by the artist, a dream that someone related to him, or a dream he imagined. In any case, Rousseau's picture is typical of dream imagery in its unlikely combinations and impossible juxtapositions. Although we do not know exactly what inspired Rousseau to paint *The Dream*, we can read it on its own terms. If the inspiration were a personal one, we would not be able to explain it without knowing relevant biographical details about the artist. Rousseau did, however, partly explain the painting in a letter to an art critic:

> The woman sleeping on the sofa dreams that she is transported into the forest, hearing the music of the snake charmer's instrument. This explains why the sofa is in the picture....[1]

Some dream depictions are inspired by cultural myths. One example is the dream of the Buddha's mother, Queen Maya of the Shakya clan in modern Nepal. She dreamed of a white elephant—a sign of

Part I Creating and Defining Works of Art

power, longevity, and spiritual purity. This is interpreted in Indian tradition as an omen of the birth of Maya's son, Siddhartha, Prince of the Shakya clan.

Siddhartha's mythic birth took place through Maya's side when she reached up toward a sal tree in the Lumbini Grove, near the palace. When Siddhartha grew up and encountered the suffering of humanity outside the palace, he renounced his life of leisure and embarked on a quest for knowledge. He achieved enlightenment while meditating under a *pipal* tree (henceforth called the sacred *bodhi*, or enlightenment, tree), became the Buddha (the enlightened one), and founded Buddhism. He lived, like the elephant, a long time, dying at the age of eighty-eight. When the Buddha was cremated, it was said that his ashes sparkled like pearls.

Maya's dream is illustrated in the carved stone image in **figure 2.19**. It shows Maya from above, while her attendants, seated in the foreground by her bedside, are rendered in back view. A large elephant in profile hovers above the sleeping queen. The artist thus alters our experience of waking reality by showing the elephant floating in space and by shifting the viewpoints from which we see Maya and her attendants. This divergence from the natural laws of gravity is a feature of the dream world.

Another kind of "dream" image inspired by myth is found in the rock art of the Australian Aborigines. This is not a dream in the strict sense, but rather is a sacred plane of existence in Aboriginal mythology, which has been translated as "Dreamtime," or "the Dreaming." This connotes both the order of the Aboriginal universe and its span from the beginning to the end of time. It includes the deceased ancestors of living Aborigines and, like the human unconscious, is a repository of the past. Humans access Dreamtime by performing certain rituals and creating rock paintings. Dreamtime imagery, like images in many cultures, is a means by which the living relate to a timeless, spiritual world.

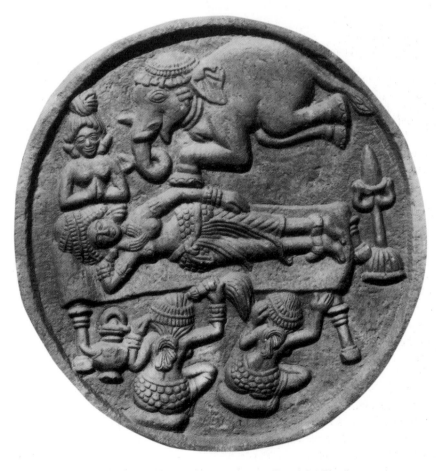

2.19 *Dream of Queen Maya*, detail of a *vedika* of the Bharhut stupa, Shunga period, 2nd century B.C., from Madhya Pradesh, India. 19 in. high. Indian Museum, Calcutta.

Among the most impressive examples of Dreamtime imagery in Aboriginal rock painting are *wandjinas*, or cloud spirits (**figure 2.20**). They are not individual dreams, but rather are a kind of cultural dream inspired by the Aboriginal imagination. The *wandjina* depicted here has a large white body outlined in red and looms upward like a billowing cloud, as if from the cave floor. The outline around the head represents feathers and lightning and the powerful eyes evoke the anger of a fixed, disapproving gaze. *Wandjinas* are believed to be Aboriginal ancestors who created the world and the human race. When the *wandjinas* are offended, they bring rainstorms and thunder. In their more benign state, they are fertility spirits. The *wandjina*'s power thus lies in its control of nature's ability to destroy as well as to create.

2.20 *Wandjina* rock painting. Mount Barnett Gorge, Kimberly, Australia.

To return to the question posed at the beginning of this chapter, we conclude that art comes from the creative imagination, which can be inspired by a number of sources. Images are inspired by nature and the manmade environment, by conscious ideas, by childhood memories, by dreams, by events of all kinds, and by myths. They can be translated into a variety of creative arts, including music, literature, dance, theater, and film. In the visual arts, expression takes the form of imagery.

So far we have surveyed several examples of artists extracting elements from the environment and transforming aspects of them into works of art. As society has become more compartmentalized, the visual arts have been organized into certain broad categories according to form, subject matter, and content. Major categories of visual art include pictures, sculpture, and architecture—as well as crafts and furniture, stage design, video, performance art, and film. Their subject matter includes landscape, portraiture and self-portraiture, history painting, religious and mythological scenes, **genre** (scenes of everyday life), and **still life** (images of inanimate objects). The content of works of art refers to their theme: that is, what artists express and what the viewer thinks or feels about the subjects portrayed.

———◆———

In the following chapters, we consider the nature and evolution of these categories. We will discover that they vary according to social, cultural, and historical contexts, because the purpose, function, and value of art depends, to a large extent, on the time and place in which it is made. The arts are also influenced by the quality and character of artists who produce the work and on the wishes of patrons who commission the works.

Chapter 2 Glossary

curvilinear—composed of curved lines

figurative—representing a human (or animal) figure in a recognizable way

genre—scenes of everyday life

landscape—image of natural scenery

manuscript—book written by hand; mainly referring to medieval and Renaissance books. A manuscript having painted images is known as an **illuminated** manuscript.

mosque—characteristic place of worship for Muslims

Muse—one of nine daughters of Zeus in Greek mythology who inspire creativity; more generally, a source of inspiration

seascape—image of a scene of, or at, the sea

silhouette—outline of an object, usually filled in with black or some other uniform color

still life—representation of inanimate objects such as fruit, flowers, or pottery

Stone Age—prehistoric period dating from approximately 1,500,000 B.C., when people used stone tools

visual metaphor—association (usually formal) between one image and another

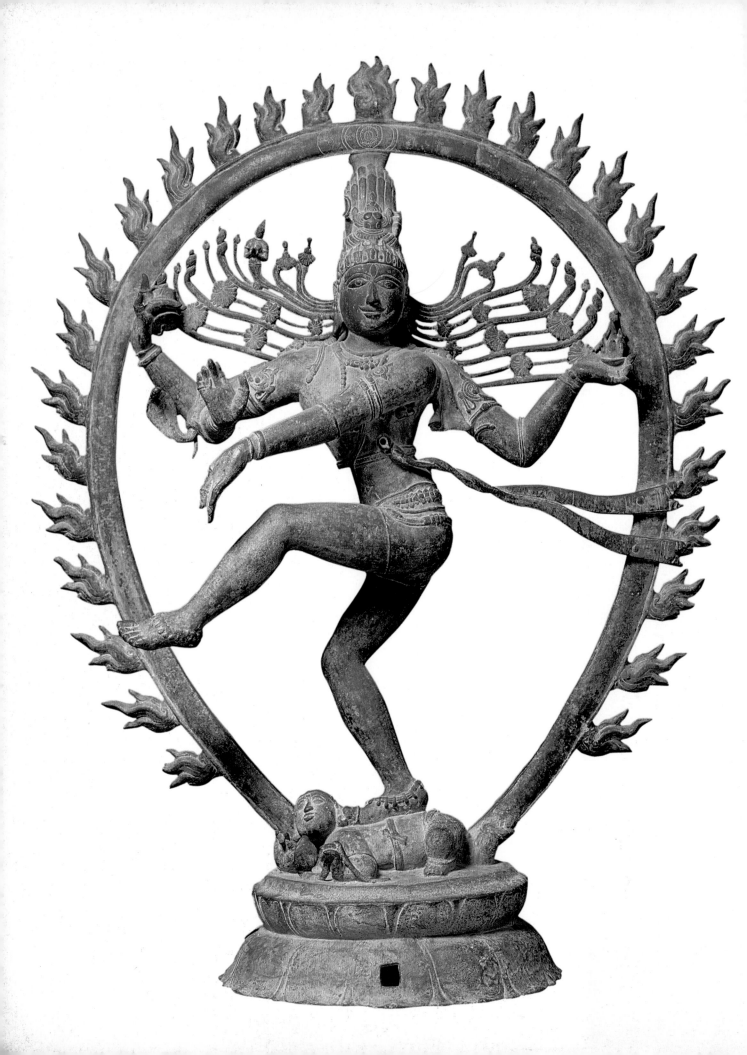

Part II Purposes of Art

People make art for many reasons. We saw in Chapter 2 that children make art naturally, which leads us to conclude that the creative impulse is inborn. If children grow up to be professional artists and architects, they study the history of style and learn techniques of creating pictures and sculptures, and of designing buildings, usually with an audience in mind. If artists are commissioned to make a work, then they have to consider the wishes and needs of their **patron** (the person or institution that hires them). Thus, an architect working for a pharaoh in ancient Egypt might design a palace for his family and his court, a temple for worship, and a pyramid for burial. A medieval architect working for a lord or lady would probably build a castle, whereas a master builder would supervise the construction of a cathedral.

Today, we continue to build private and public buildings, we decorate our private and public spaces, and adorn our own bodies. The purposes of art thus range from the cultural to the personal and they assume many different forms. Some works are clearly original and serious and their appeal is lasting; other creative products do not demand to be considered as important or original works of art. For example, there are utilitarian objects such as clothing and furniture that are expressive, ornamental, and endowed with aesthetic quality. Industrial design—automobiles and motorcycles—can be quite artistic, but is rarely understood to be art in the sense of a great painting, sculpture, or building.

> Art is not made for anybody, and is, at the same time, for everybody.
>
> Piet Mondrian, artist (1872–1944)

We must, however, be wary of making too sharp a distinction between these categories. For just as the value of major works of art can rise and fall from one generation to the next, so it is often the case that what is made for a utilitarian purpose at one time might be considered a serious work of art at another time. To some degree, what we consider art is a matter of personal taste, although our tastes are likely to change as we learn more about the nature and history of art and the people who produced it. As you read on, think about which works strike you as having major significance, which are merely attractive or utilitarian, and why.

(Opposite) *Siva Nataraja*, 11th–12th century. Bronze, 3 ft. 1 ³⁄₄ in. high. Dravidian. Musée Guimet, Paris. MG. 17472.

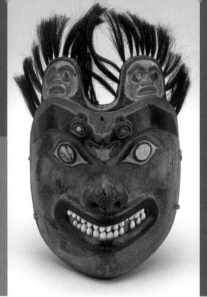

KEY TOPICS
Portraits and self-portraits
Commemoration and documentation
Art as religious expression
Art as political expression
Art as social commentary

3

Cultural Purposes of Art

People make art for individual reasons as well as for cultural purposes such as politics, religion, and commerce. We recognize the importance of images in our personal lives when we think of all the occasions on which we take photographs or make videos. We photograph and film our friends, our families, our weddings, our sports events, our social events, our political events, and our wars. We also take pictures of things we find beautiful, odd, frightening, and interesting. We do this because we want to preserve the likeness of a person or the memory of an event. Similar motives inspire image-making on a broader, cultural level.

In this chapter we consider personal and cultural reasons for creating works of art. At the same time, however, we should bear in mind that despite the distinction between private and cultural imagery, society is composed of individuals. As a result, categories of artistic subject matter often overlap. Rulers, for example, might commission portraits of themselves to project certain political images, but they might also take a personal interest in how they appear in the final product. Beginning in the nineteenth century in western Europe, artists were commissioned to create **posters**, which were designed to advertise events and sell products.

Portraits and Self-Portraits

There are private portraits made for personal viewing and cultural portraits, which are intended for public viewing. When we photograph, draw, sketch, or sculpt ourselves, a close friend, or a

member of our family, or make home videos of our children, we do so mainly for private enjoyment. We can see the difference between a private and a public portrait by comparing two portraits by Francisco Goya (1746–1828), the official court painter in Spain. In 1820, he painted a private self-portrait entitled *Goya Attended by Doctor Arieta* (**figure 3.1**) to record a significant moment in his life. The inscription at the bottom of the painting thanks the artist's doctor for his skill in having cured him of a potentially fatal illness the previous year. Goya was seventy-four when he made the painting, and he gave it to Dr. Arieta as a present.

The work is actually a double portrait of the artist and his doctor surrounded by a group of figures. Goya shows himself hovering between life and death as his doctor supports him physically, emotionally, and medically. The near-death condition of the artist is reflected in his limp demeanor, barely opened eyes, and lips parted to sip the liquid Arieta offers him. Compared with Goya's pallor, Arieta's complexion is rosy and his lips are highlighted by a rich red brushstroke echoing the color of the bed covering.

Goya's self-portrait with Dr. Arieta is very different from his *Conde de Floridablanca* (**figure 3.2**)—the artist's first commissioned portrait. This is an official, political portrait that has cultural meaning beyond the personal boundaries of *Goya Attended by Dr. Arieta*. Although the *Conde de Floridablanca* contains more than one portrait, the main figure is the count, who was prime minister to King Carlos III of Spain. Floridablanca is dressed for the occasion of the portrait in his official uniform; its bright red color, gold-embroidered white silk waistcoat, and

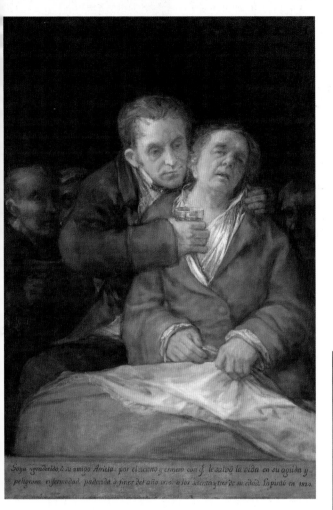

3.1 Francisco Goya, *Goya Attended by Doctor Arieta*, 1820. Oil on canvas, 3 ft. 10 in. x 2 ft. 7 in. The Minneapolis Institute of Arts. The Ethel Morrison Van Derlip Fund.

blue sash, along with the silk stockings and velvet shoes, accentuate his commanding presence.

A portrait on the back wall of the painted room depicts Carlos III presiding over Goya's picture as he presided over the kingdom of Spain. The large clock at the right signifies the orderliness of the kingdom under Carlos, and a third portrait on the other side of the table probably represents an architect working for the king. Maps on the table and the plan on the floor allude to an engineering project supervised by the count.

Goya has also inserted his self-portrait into the painting. Whereas Conde de Floridablanca is posing for a wide audience, Goya's pose is calculated to show both his subservience to the count and his genius as a painter. Hoping that this first commission would advance his career, Goya diffidently approaches the count from the shadows at the left and holds up a painted canvas. Goya is self-effacing and, at the same time, very much present. His aim to please the count by his double offer of a picture—his action *in* the picture and his painting *of* the picture—makes him a supplicant as well as an artist.

3.2 Francisco Goya, *Conde de Floridablanca*, 1783. Oil on canvas, 8 ft. 6 in. x 5 ft. 5 in. Banco Urquillo Collection, Madrid.

Commemoration and Documentation

Recording important events is one of the main motives for making images. Today we can record current events having global significance using the news media and modern technology. Reading newspapers and magazines, watching television, and calling up news items on the internet reveal the fact that images make the news come alive. They also preserve events and can become historical documents in their own right. Throughout history, artists have been commissioned to create such documents in the form of pictures, sculptures, and works of architecture.

Imperial Rome produced a monumental type of record-keeping, which was also designed to glorify the reigning emperor. A citizen of ancient Rome, for example, would probably have been impressed by the height of Trajan's Column (**figure 3.3**) and by the emperor whose deeds it commemorated. Huge, freestanding columns such as this were erected to record imperial victories—in this case, the emperor Trajan's conquest of the Dacians (a group of people located in modern Romania) and the plunder of their gold and silver.

Trajan's military campaign against the Dacians is illustrated in the long spiral frieze of relief sculpture that winds around the surface of the column. We read the narrative through the images, rather than through words. In **figure 3.4**, for example, we can see a unit of armed soldiers crossing the river on a pontoon bridge. Below are waves representing water and boats propelled by oars.

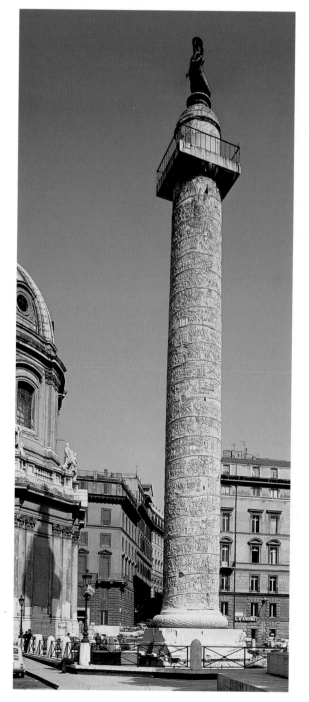

3.3 (Left) Trajan's Column, A.D. 113. Marble, 125 ft. high. Trajan's Forum, Rome.

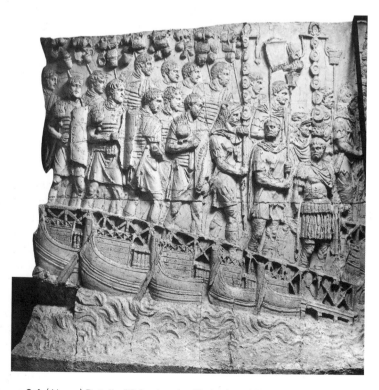

3.4 (Above) Detail of 3.3, showing Trajan's soldiers crossing the Danube on a pontoon bridge.

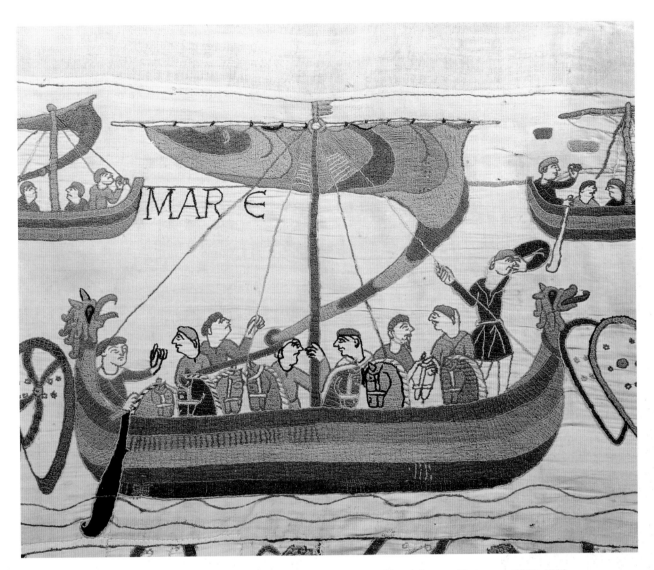

3.5 Detail of the Bayeux Tapestry showing Viking longboats with soldiers and horses, c. 1070–1080. Wool embroidery on linen, 20 in. high, more than 230 ft. long. Musée de l'Evêché, Bayeux.

In 1066, when William the Conqueror sailed from northern France to England and defeated the Saxon king, Harold, the event was commemorated in the Bayeux Tapestry—actually a very long embroidery. It was commissioned by William's half-brother, Bishop Odo of Bayeux, for Bayeux Cathedral in Normandy (northern France). The "Tapestry" is an extended visual narrative showing the bravery in battle, the naval brilliance, and the technical achievements of the Norman invaders of England. Like the Column of Trajan, therefore, the Bayeux Tapestry is a political document as well as a work of art.

Figure 3.5, which contains the Latin word *mare* ("sea"), shows the long-boats that carried William's army across the English Channel. They were derived from Viking ships propelled by a sail and oars; the prows are decorated with heads of fantastic animals and are protected from being rammed by a shield at each end. Notice that the Normans had to bring their horses with them; imagine how sturdy such a boat would have to be to accommodate the eight horses shown here, along with their riders, weapons, and other heavy equipment.

In the nineteenth century, with the development of photography, people began to take advantage of a quicker way to make pictures than drawing or painting. When Mathew Brady (c. 1822–1896) photographed the American Civil War, he left a visual legacy of the conflict using black and white film.

His *Ruins of Gallego Flour Mills, Richmond* (**figure 3.6**) captures the gutted buildings of the flour mill factories in Richmond, Virginia, after the Union Army had razed the city. The factories stand as a memorial to a proud but defeated civilization, majestic and silhouetted against a stark, light background. Brady has captured different textures, contrasting the rubble at the left with the sharper edges and smooth surfaces of the ruined buildings. The absence of people in the photograph accentuates the isolated emptiness of what has been reduced to the skeleton of a city.

In the twentieth century, the American photographer James Van Der Zee (1883–1964) used photography as a way of documenting aspects of contemporary life. He recorded life in New York City during the period of black cultural revival known as the Harlem Renaissance (**figure 3.7**). This photograph shows an elegant middle-class couple wearing fur coats and posing with their shiny, polished car on West 127th Street in Harlem. Particularly striking are the distinctive textures of the fur, the sleek body of the car, and the shine of the chrome. In contrast, the townhouses across the street are muted by the soft focus of the camera.

Romare Bearden (1914–1988) recorded his recollections of urban life using **collage**—a picture created by pasting paper cut-outs on **masonite** (**figure 3.8 a, b**). The colorful houses are shown from both inside and out, so that the rich tapestry of the city block comes alive. The buildings range from the liquor store at the far left (figure 3.8a), to a mirror barber shop at the right (figure 3.8b), to a Sunrise Baptist Church with a giant light bulb on the top floor. People gather on the street, an isolated figure strolls past a green building. He stops to converse with a woman leaning out of the window, children play, and a truck drives by. This is a nostalgic image, assembled from fragments of memory and juxtaposed to combine Bearden's past with contemporary life in the city.

> Art is artifice....
>
> Romare Bearden, artist (1914–1988)

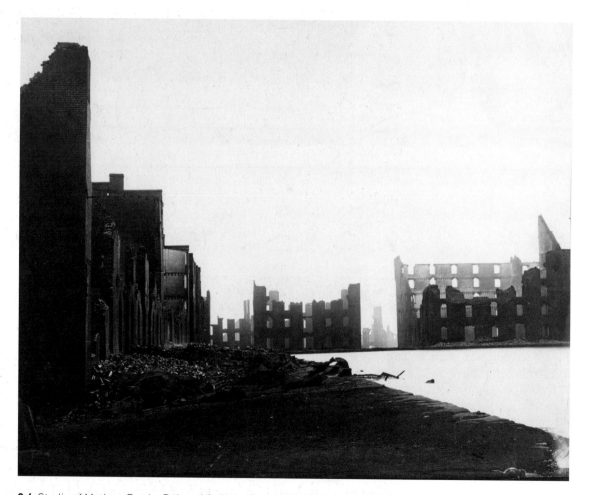

3.6 Studio of Mathew Brady, *Ruins of Gallego Flour Mills, Richmond*, 1863–1865. Albumen-silver print from a glass negative, 6 x 8 ³/₁₆ in. Museum of Modern Art, New York. Purchase.

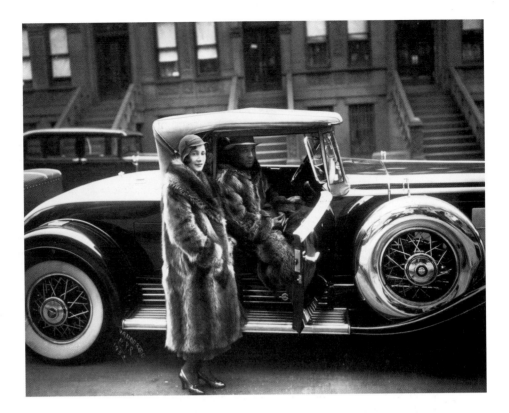

3.7 James Van Der Zee, *Couple with a Cadillac*, 1932. Photograph. © Donna Mussenden Van Der Zee.

3.8 a, b Romare Bearden, *The Block*, 1971. Paper on masonite, all six panels 4 x 18 ft. Metropolitan Museum of Art. Gift of Mr. and Mrs. Samuel Shore no. 1978.61.1-6.

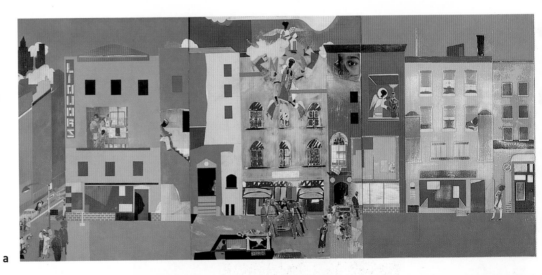

a

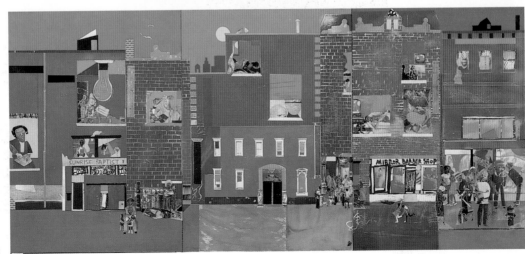

b

Commemoration and Religion

The religious beliefs of a society can be powerful motives for creating works of art. As early as around 7000 B.C., the Neolithic (New Stone Age) people of Jericho (in the modern West Bank), refashioned skulls by modeling facial features in plaster, adding hair, and embedding shells into the empty eye sockets (**figure 3.9**). Scholars believe that these skulls were part of an ancestor cult. With aspects of the face thus restored, the dead person seemed more alive.

This was also the reason given by the German Renaissance artist Albrecht Dürer (1471–1528) for making art when he said: "I paint to preserve the likeness of men after their death." Apparently Dürer had this in mind when he created the portrait *Saint James* (**figure 3.10**), an image of Jesus's apostle. Saint James's relics are located in northern Spain, at the pilgrimage site of Santiago de Compostela, which

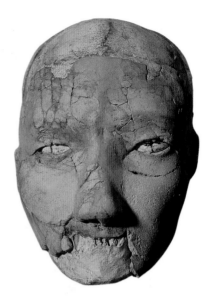

3.9 Neolithic plastered skull, c. 7000 B.C. Lifesize. Jericho, Archeological Museum, Amman, Jordan.

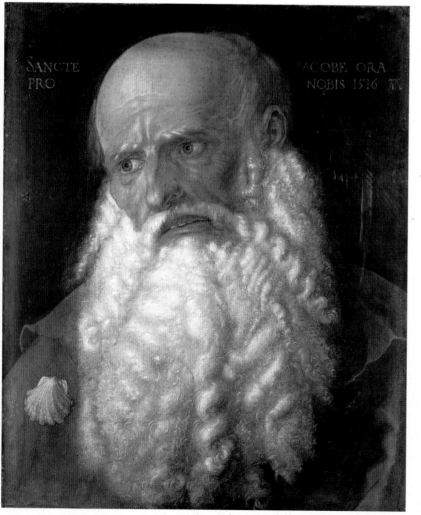

3.10 Albrecht Dürer, *Saint James*, 1516. Oil on canvas, 18 in. x 15 in. Uffizi, Florence.

explains the scallop shell, a symbol of pilgrimage in Christian art, on the shoulder of the saint's habit.

Dürer depicts James as a heroic figure, whose frown and downturned lips create a sober expression. The elaborate, weighty beard accentuates the gravity of the saint's character. But the fact is that Dürer did not know what Saint James looked like any more than we do. There were no cameras in the first century A.D. and there are no surviving portraits of Jesus's twelve apostles that were painted during their lifetime. In any case, it is unlikely that anyone ever made a portrait of an apostle using the apostle himself as the model. Dürer's picture is thus an imaginary portrait, based on his impression of Saint James from reading the Bible and legends of the saints. Nevertheless, as with all portraits, Dürer's is intended to preserve a likeness, in this case the artist's mental image, or idea, of Saint James's appearance and character.

Whereas the Jericho skull is probably a type of ancestor portrait, *Saint James* is a Christian portrait. Its purpose is to convey the powerful presence of the apostle and to remind viewers of the important role of pilgrimage for Christians hoping to attain salvation. Dürer emphasizes this aspect of the image with text; at the top he has written *Sancte Jacobe ora pro nobis* ("Saint James, pray for us"), dated the work 1516, and signed with his **monogram**—a D inside an A.

Another way of preserving memory in a religious context can be seen in the totem poles of Native American crest art. Some of these are sixty feet high. The crests belong to a particular clan—a group of matrilineal households—and represent ancestors (totems). Typically, such households own many crest

poles carved in animal and human forms that signify the clan's mythological past. The totem pole in **figure 3.11** from Vancouver, in British Columbia, was carved by the modern Kwakiutl artist Tony Hunt in 1988. The pole is composed of a birdlike figure with an **anthropomorphic** face and extended wings crouching on a stylized bear head. In turn, the bear head is connected to another anthropomorphic figure that is grasping a human form with a painted face. Characteristic of such works are the broad, brightly colored, stylized shapes and exaggerated expressions.

Religions such as Christianity, Buddhism, and Hinduism use figurative imagery on the interiors and exteriors of places of worship as a way of connecting gods with people. Some Christian churches are decorated with pictures and statues of sacred figures. For example, the semi-dome of the apse in the church of San Vitale, in Ravenna, Italy, contains an impressive **mosaic** showing Christ suspended over a globe (**figure 3.12**). He is flanked by Saint Vitalis (San Vitale, to whom the church is dedicated), Bishop Ecclesius (holding a model of the church), and two angels. The gold background reflects light and denotes the presence of divinity. In this mosaic, Christ is connected with the saint and the bishop of Ravenna by their placement on

either side of him and with the worshipers he faces.

In Hindu temples in India, sculptures of gods are designed to be beautiful so that the gods will be moved to inhabit them. Hindu priests clothed, jeweled, and decorated the sculptures with garlands of flowers. Such sculptures are believed to embody the god in a literal way. Consider, for example, the bronze Siva Nataraja (**figures 3.13**), Lord of the Dance. He is shown dancing in a circle of flame symbolizing the cosmos. The multiple arms reflect the god's superhuman power and also enhance the illusion of movement.

In Hinduism, Siva was both a creator and a destroyer, who creates and destroys the cosmos by dancing in a circular motion. In his upper right hand he holds a drum shaped like an hourglass signifying time, while his second right arm is entwined with a serpent. The second right hand is in the position of the *mudra* (hand gesture) denoting reassurance and protection. Siva holds a flame in his upper left hand, and the lower left hand points to his raised left foot, which symbolizes freedom from the weight of the earth. The right foot stands on a dwarf, showing that Siva has conquered the demon of ignorance.

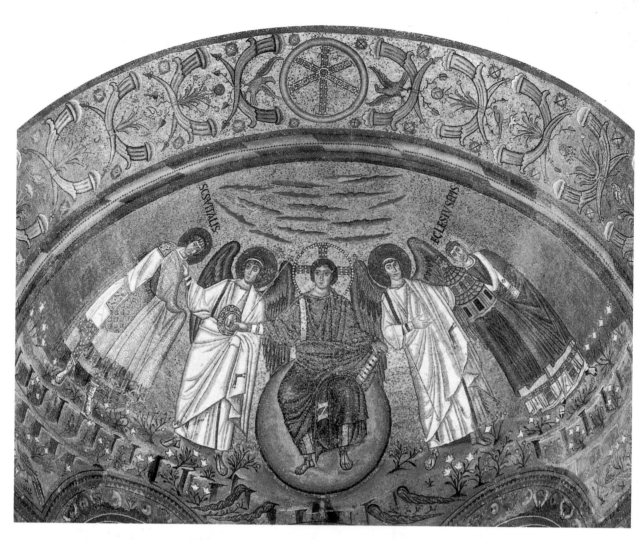

3.12 Apse mosaic, 6th century. San Vitale, Ravenna.

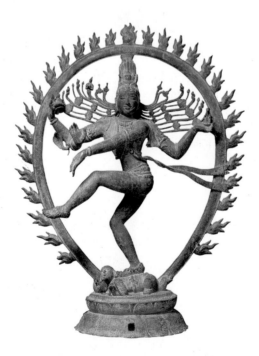

3.13 *Siva Nataraja*, 11th–12th century. Bronze, 3 ft. 1 ³/₄ in. high.
Dravidian. Musée Guimet, Paris.

Illuminating the Word of God

Muslims believe that the writings in the *Koran* (*Qu'ran*) were revealed by Allah to Mohammad in Arabic and that its sacred text cannot be translated into other languages. The *Koran* is thought of as the literal Word of God, and Islamic calligraphic texts of the *Koran* of the kind illustrated in **figure 3.14** constitute a highly developed art form. Such texts are designed to convey the divine beauty of Allah's Word.

In Christian convents and monasteries, the Word of the Judeo-Christian God was illustrated by monks and nuns who decorated written texts. These texts are called **illuminated manuscripts** and, in contrast to the Koranic texts, often contain figurative as well as abstract images. The opening page of the Gospel of John from the Early Medieval Irish *Lindisfarne Gospels* is such an image (**figure 3.15**). The text opens with *In Principio* ("In the beginning" in Latin), and the rest of the sentence reads "was the Word, and the Word was with God, and the Word was God." Since the Word and God are one, illuminating the Word is a sacred task and, as with Islamic calligraphy, is designed to be beautiful.

The Christian artist has enlarged the *IN* and the *P* of *principio* and created a kind of monogram filled with colorful **interlace** (entwined) patterns. The *I* is the vertical of the left frame, the *N* is turned on its side, and the curve of the *P* has been doubled. The remaining text is also decorated, its spaces filled either with smaller interlace or with solid color. Tiny human and animal heads are woven into the letters, reflecting the imaginative, metaphorical quality of such imagery.

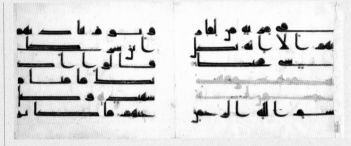

3.14 (Above) Kufic calligraphy from the *Koran* (*Qu'ran*), 9th–10th century, from Persia. Ink and gold leaf on vellum, 8 ½ x 21 in. Nelson-Atkins Museum, Kansas City, Missouri. Purchase: Nelson Trust.

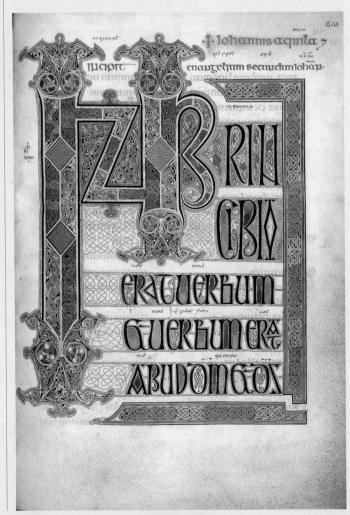

3.15 Lindisfarne Gospel of Saint John, folio 211. Vellum, 13 ½ x 9 ⅜ in. British Library, London.

The Healing Power of Religious Imagery

Images have also been used to heal disease. Among the Navajo of the American Southwest, sand paintings were created by shamans to exorcise disease-causing evil spirits from a sick person. **Figure 3.16** illustrates the process of creating a Navajo sand painting; it is made of colored rocks ground to the consistency of sand. Traditionally, the shaman continues to make pictures, usually at night, until the patient either is cured or dies. Because of the sacred nature of these images, as well as to preserve cultural tradition, however, photographing sand painting is forbidden except when officially sanctioned for reproduction.

According to Navajo belief, Holy People—who existed before the human race created such images—can be summoned when a shaman makes a sand painting. The patient sits on the ground inside the painting and faces east, the direction from which the Holy People enter the image. Sand paintings are called *iikaah*, meaning "the place to which gods come and from which they go."

Shamans were particularly powerful among the Tlingit of southeast Alaska. They diagnosed and cured illness with the assistance of spirits summoned through masks. The richly painted example in **figure 3.17** depicts a human head with stylized features and a broad, tooth-filled grimace. Two smaller, frontal heads surmount the face and appear to be frowning. Just below these are two animals, doubling as eyebrows, with profile faces and frontal eyes. The repetition of the frontal eye is designed to ward off evil.

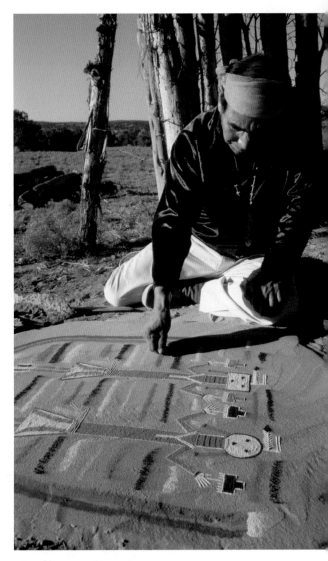

3.16 Navajo sand painting.

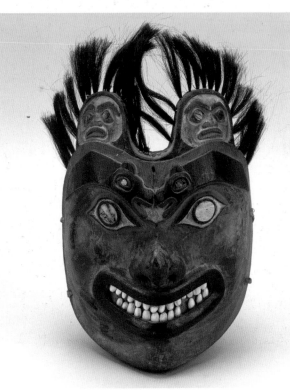

3.17 Tlingit shaman's mask, 1830–1850, from southeast Alaska. Painted wood and opercula, 13 in. high. National Museum of the American Indian, New York.

Certain Christian images are endowed by the faithful with healing powers. In medieval Europe, **relics** (parts of the body or objects associated with the body of a holy person) of saints and martyrs were endowed with curative power. The relics were housed in **reliquaries** (containers of relics) that were elaborately decorated. The Saint Andrew reliquary in **figure 3.18** was believed by medieval Christians to contain the sandal of the apostle. The gold and gemstones of which it is made reflected the power and importance of the saint and his relic. For Christians, the reliquary was the intermediary through which the healing properties of the relic were transferred to the worshiper.

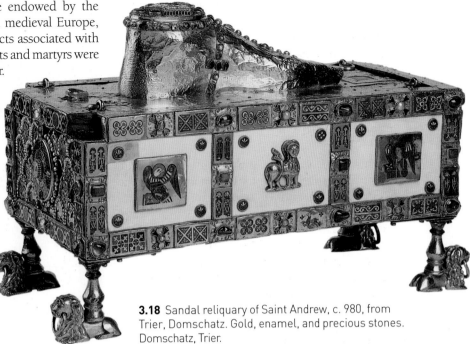

3.18 Sandal reliquary of Saint Andrew, c. 980, from Trier, Domschatz. Gold, enamel, and precious stones. Domschatz, Trier.

Political Purposes of Art

Today it is a matter of course that politicians employ spin doctors as imagemakers. Politicians are nearly always on view—in news photos, on television, on posters, and on the internet. They think carefully about what to wear, how to arrange their hair and their make-up, who to be seen with, and where to be seen. As a result of the importance of image in politics, virtually every society throughout history has created political imagery designed to show its rulers in a certain light.

In sixteenth-century England, King Henry VIII hired the German artist Hans Holbein (c. 1497–1548) to be his court painter. Famous for marrying six wives, for defying the pope, and transforming England from a Catholic to a Protestant nation, Henry wanted his portraits to emphasize his wealth and power. This they did—in particular, Holbein's portrait of around 1540 (**figure 3.19**) showing Henry in all his finery, upright and self-confident. The king is barely contained by the space of the painting, which accentuates his massive proportions and conveys his commanding presence.

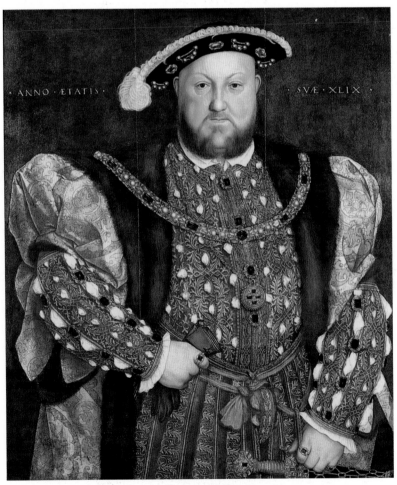

3.19 Hans Holbein the Younger, *Henry VIII*, c. 1540. Oil on panel, 34 ³/₄ x 29 ¹/₂ in. Galleria Nazionale d'Arte Antica, Rome.

Seventeenth-century Europe was an age of absolute monarchs, who designed their images to reinforce the impression that they had complete control over their subjects. These rulers had their own version of modern spin doctors—called "ministers of culture." Louis XIV of France (ruled 1661–1715) reigned for more than fifty years and the image that he strove to project was that of the sun. As "*Le roi soleil*" (the Sun King), he danced the role of the sun in court theatricals (**figure 3.20**). Louis performed a public ritual in which he rose from bed in the morning and returned to bed in the evening—rising and setting like the sun. Louis wanted to be thought of as the central, life-giving force of France. He is alleged to have proclaimed himself and the state one—"*L'état, c'est moi*" ("I am the state"). The immense gardens of his palace at Versailles, a few miles south of Paris, radiate from the palace like the sun's rays. And the garden fountains contain statues representing myths of Apollo, the Greek sun god (see p. 411).

Imagine the impression that Versailles would have made on an ambassador to Louis XIV's court. Having ridden a long way, probably in a horse-drawn carriage over a dusty, bumpy road, the ambassador would arrive at Versailles' famous *Galerie des Glaces* (Hall of Mirrors), where visitors awaited audiences with the king (**figure 3.21**). Scenes of Louis's military victories decorate the ceiling, while gilded wall reliefs and mirrors reflect the sun's light. The mirrors also alluded to the role of the king as the solar eye of the universe, for they permitted Louis's spies to observe visitors surreptitiously and to identify potential conspirators.

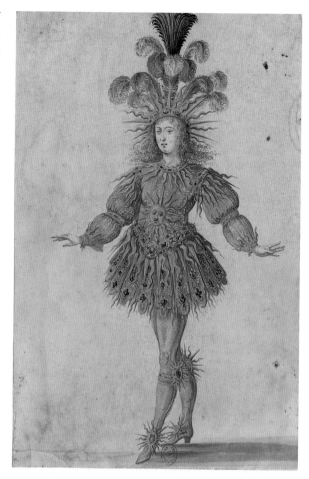

3.20 (Above) King Louis XIV as the sun in the 1653 *Ballet de la Nuit*. Bibliothèque Nationale, Paris.

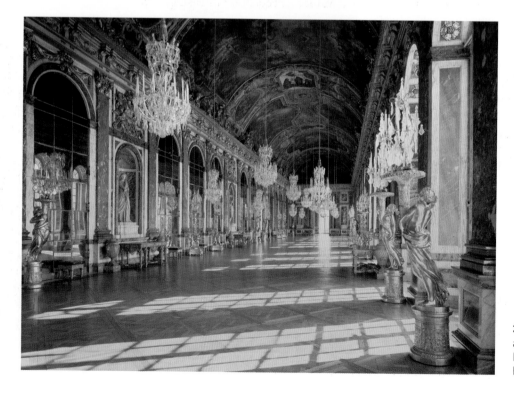

3.21 Jules Hardouin-Mansart and Charles Le Brun, Hall of Mirrors, c. 1680. Palace of Versailles.

One of the most prevalent political images in Western art is the **equestrian portrait**, a painting or sculpture showing the ruler on horseback. Philip IV (ruled 1621–1665), the monarch of Spain, was shown in this way by his court painter, Diego Velázquez (1599–1660) (**figure 3.22**). Here Philip controls the horse with the *levade*, a complex maneuver indicating the king's equestrian skill. The king's control of the animal is a metaphor for his control over unruly subjects, while the vast distant landscape signifies the territory Philip controlled. Velázquez was a courtier as well as Philip's court painter, and part of his job was to flatter the king. He did so in the portrait by minimizing Philip's unattractive, jutting jaw.

As with the religious purposes of art, the political purposes are quite varied and have evolved over time. They conform to changes in political systems, to the character of a ruler, and to the skill and style of the artist.

Every culture has a legal system and the arts are often used to convey aspects of law as the vehicle of political and social order. Sometimes images are used to deter crime, which is another facet of politically inspired art. Consider, for example, the fourteenth-century fresco by Ambrogio Lorenzetti in the town hall of Siena, in Italy (**figure 3.23**), showing the effects of good government in the country.

This is part of a much larger wall-painting depicting the advantages of a well-run, peaceful society and it is located in Siena's town hall for political reasons. Ambrogio's scene reflects the good government of Siena in the early fourteenth century. Horsemen ride out of the city into the country on a

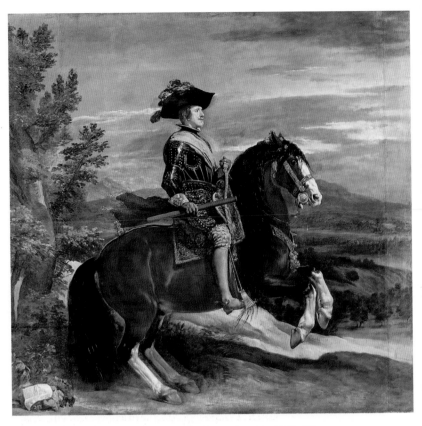

3.22 Diego Velázquez, *Philip IV on Horseback*, 1629–1630. Oil on canvas, 9 ft. 10 ½ in. x 10 ft. 5 ¾ in. Prado, Madrid.

hunting expedition. The landscape is filled with plowed fields indicating good husbandry and economic prosperity. Fluttering overhead in the sky is an allegorical image of Security (*Securitas*), a winged female in white carrying a gallows. The inscription warns against disrupting social order and the gallows shows the consequences of breaking the law.

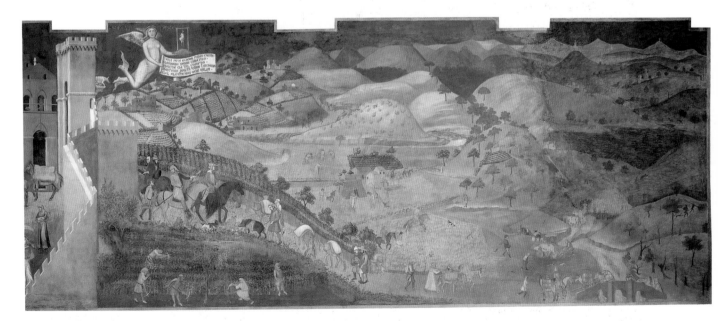

3.23 Ambrogio Lorenzetti, *Good Government in the Country*, from the *Allegory of Good Government*, 1338–1339. Fresco, 23 ft. long. Sala della Pace, Palazzo Pubblico, Siena.

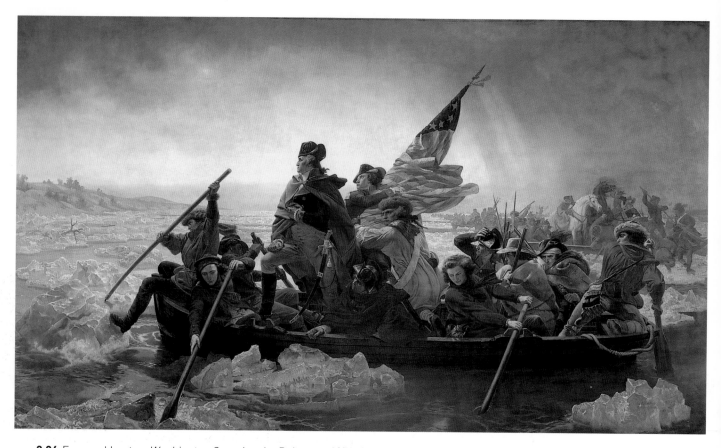

3.24 Emanuel Leutze, *Washington Crossing the Delaware*, 1851. Oil on canvas, 12 ft. 5 in. x 21 ft. 3 in. Metropolitan Museum of Art, New York. Gift of John Stewart Kennedy, 1897 no. 97.34.

In American art of the nineteenth century, one of the best-known politically motivated history paintings is *Washington Crossing the Delaware* (**figure 3.24**) by the German-born American artist Emanuel Leutze (1816–1868). The picture commemorates and idealizes George Washington's Christmas Eve victory over British and Hessian forces at Trenton in 1776. The choppy water of the Delaware River is filled with ice floes and a long line of rowboats carrying horses and soldiers stretches into the distance. The company is comprised of bedraggled, freezing soldiers struggling to steer through the ice under a dark and stormy sky. At the same time, however, they are clearly advancing in the direction of light, which reflects the enlightenment of political liberty and rises over Washington like a huge halo. By representing his army in this way, Leutze shows that they are ordinary men from all walks of life, who are united in the single cause of freedom from colonial rule.

Two officers struggle to keep the flag upright and flying. They are reminders that Washington was fighting a war for national identity—symbolized by the flag. To do so, he had to defeat the foreign army of King George III and German mercenaries fighting on his side. Later Washington would refuse to become the American king, agreeing instead to become president under a constitution. Leutze thus ennobles Washington not by accident of royal birth, but by his distinguished demeanor and moral character. Despite the hardships of the crossing, George Washington stands proudly upright, his uniform unruffled by the elements. Gazing forward at the distant shore, he resembles the prow of a ship, alluding to his future role as captain of the ship of state.

Art as Political and Social Protest

Art can be used to express political and social protest. Perhaps the most famous political protest painting of the twentieth century is Picasso's *Guernica* of 1937 (**figure 3.25**). He painted this complex picture in Paris after learning that the Spanish town of Guernica had been bombed by the Nazis, killing thousands of civilians. (The Nazis sided with Spain's Fascist leader, Francisco Franco, during the Spanish Civil War.)

Guernica has been interpreted in many ways—aesthetically, politically, and autobiographically. Its place in the history of art has also been widely discussed. From the point of view of current events, which inspired the picture, the imagery has been shown to be a forceful protest against the rise of Fascism in Europe in the 1930s. Formally, *Guernica* is divided into three main sections: at the left, a mother with a dead infant (reminiscent of Michelangelo's *Pietà*) is dominated by a bull with human features, and at the right a figure in a burning building echoes the pose of Jesus on the Cross. The bull-man behind the mother and infant is the Minotaur, the tyrant of Crete in Greek myth, and was, for Picasso, a symbol of Fascism and of Franco.

The jumble of figures in the large central triangle includes a dead warrior, a dying horse, a running woman, a woman with a lamp (representing a cry for liberty), and a light bulb in an eye at the apex. In this central section Picasso shows the death, destruction, and dismemberment caused by war, while also raising the hope for an eventual defeat of Fascism. Here, as elsewhere in Picasso's pictures, the horse represents civilization, in this case being nearly destroyed by tyranny. The light above the horse combines several meanings, including the sun, the light of enlightenment, and the all-seeing eye of God. The dead warrior at the bottom of the central triangle has been interpreted in a number of ways—in one reading, he is related to ancient Greek sculptures of dying warriors and thus to the Classical tradition. As such, the fragmented forms of *Guernica* can be read as Picasso's attempt to overthrow traditional artistic styles and formal conventions.

Picasso also protested the possibility that *Guernica* would be exhibited in Spain under a Fascist regime. He loaned the painting to the Museum of Modern Art in New York until such time as a democratic government was restored to Spain. In 1981, *Guernica* was returned and is now on view in the Queen Sofia Museum, in Madrid.

COMPARE

Michelangelo, *Pietà*.
figure 1.8, page 8

> ... the bull ... represents brutality, the horse the people.

Pablo Picasso, artist (1881–1973), on *Guernica*

3.25 Pablo Picasso, *Guernica*, 1937. Oil on canvas, 11 ft. 5 ½ in. x 25 ft. 5 ¾ in. Queen Sofia Museum, Madrid.

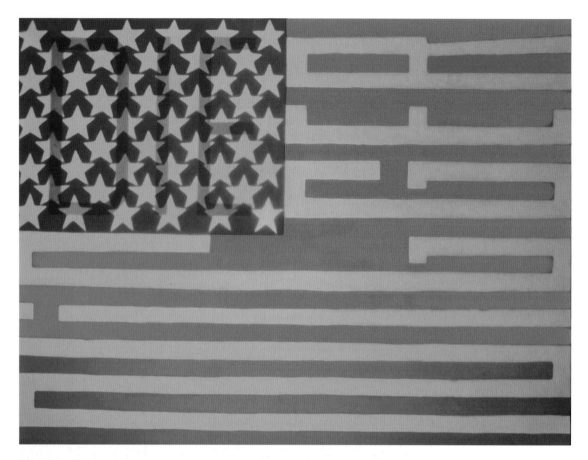

3.26 Faith Ringgold, *Flag for the Moon: Die Nigger*, 1969. Oil on canvas, 3 ft. x 4 ft. 2 in. Artist's Collection
© Faith Ringgold Inc. 1969.

> I'm not trying to be aesthetically pleasing, I'm trying to be relevant.
>
> Faith Ringgold, artist (b. 1934)

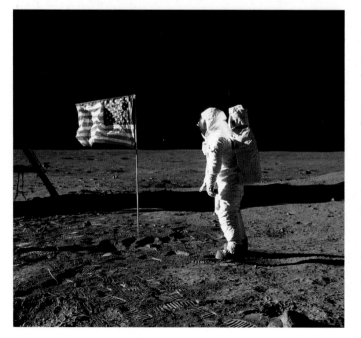

3.27 Moon walk photograph, 1969.

Sometimes artists create imagery to effect social change. In the United States, the Civil Rights Movement came to the fore in the 1960s and challenged racist views held by whites toward blacks. The next decade witnessed violent protests against the Vietnam War. In 1969, Faith Ringgold (b. 1934) painted *Flag for the Moon: Die Nigger* (**figure 3.26**). This was a protest against racism as well as against U.S. expenditures on space exploration, which the artist felt would better be spent on social programs. 1969 was the year of the first moon walk, which was memorialized in the popular imagination by the photograph of the astronaut Neil Armstrong with the American flag (**figure 3.27**).

Using painted color, Ringgold protests social discrimination based on skin color. In her flag she has eliminated the white stripes, superimposing in black letters the word *Die* over the stars and the word *Nigger*, the letters of which alternate with the red stripes. Because of its associations, as well as its formal design, the flag has been a persistent theme in American art. And, as we saw in Chapter 1, the use of flags (including

flag-burning) in protests against the Vietnam War led to a number of controversial lawsuits. In 1970, Ringgold was herself jailed, along with two other artists, following the exhibition of *Die Nigger* at New York's Judson Memorial Church. All three were found guilty of desecrating the flag and fined.

Another example of protest against racial discrimination can be seen in the 1972 work *The Liberation of Aunt Jemima* by Betye Saar (b. 1926) (**figure 3.28**). This work protests the notion of the black "mammy" who cared for white children and worked in white homes. The background consists of repeated images from the familiar Aunt Jemima pancake box, and the middle ground is filled with a large, grinning figure of Aunt Jemima in her characteristic polka-dot bandana and dress. She holds a pistol and a green broom in her right hand, balanced formally by the rifle in her left hand. The picture within the picture contains another Aunt Jemima with a white infant. The raised black fist in front of her, like the slightly sinister quality of her grin and the juxtaposition of the rifle with the broom, belies the jolly Aunt Jemima stereotype and reveals the underlying rage caused by social injustice and racial discrimination.

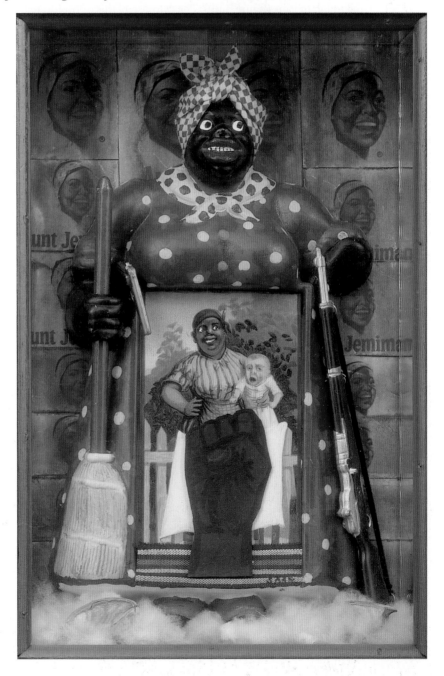

3.28 Betye Saar, *The Liberation of Aunt Jemima*, 1972. Mixed media, 11 ³/₄ x 8 x 2 ³/₄ in. University of California, Berkeley Art Museum.
Purchased with the aid of funds from the National Endowment for the Arts (selected by The Committee for the Acquisition of Afro-American Art).

The Art of Communication

We tend to distinguish advertising imagery from the arts. But, in the nineteenth century, posters designed by the French painter Henri de Toulouse-Lautrec (1864–1901) became a popular form of communication. Toulouse-Lautrec elevated posters to an art form by conceiving of the image as a painting rather than as a purely utilitarian communication. Some of his most famous posters advertise "La Goulue," a can-can dancer who performed nightly at the Moulin Rouge nightclub in Paris (**figure 3.29**). The purpose of this example was to persuade viewers to buy tickets for the performance. Toulouse-Lautrec combined the image with text—the written announcement. The top of the poster reads "*La Goulue*" (the dancer), "*bal*" (her dance), "*Moulin Rouge*" (the place), and "*tous les soirs*" (the time—"every evening").

By slanting the floor of the stage upward, Toulouse-Lautrec shows the dancer from a viewpoint that makes most of her form visible to us. Between ourselves and the dancer we see the shaded figure of the owner, whose presence in the foreground creates a transition leading our gaze to *La Goulue*. He leans back slightly, allowing us a good view of her, and gestures in a way that echoes and reinforces her pose.

On the other side of *La Goulue* we see an arc of figures silhouetted by the yellow lights in the background. Their hats identify them as eight men (in top hats) and two women. This tells us that the dancer draws a crowd and that women as well as men enjoy her performances. The purpose of Toulouse-Lautrec's message is to encourage people to buy tickets for the Moulin Rouge. In addition, because the dancer is at the center of the poster and her form highlighted with variations of color and light, she is literally the "center of attention." This, together with her pose and the fact that she is looked at from multiple viewpoints, makes her the visual focus of the poster.

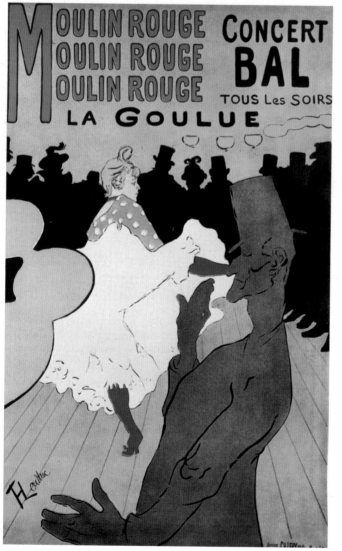

> I have tried to depict the true and not the ideal.
>
> Henri de Toulouse-Lautrec, artist (1864–1901)

3.29 Henri de Toulouse-Lautrec, *La Goulue at the Moulin Rouge*, 1891. Color lithograph, 6 ft. 3 in. x 3 ft. 9 ²/₃ in. San Diego Museum of Art.

Another type of advertisement endowed with aesthetic quality is the *Bob Dylan* poster by Milton Glaser (b. 1929) (**figure 3.30**) designed to accompany an album of songs by the popular American singer Bob Dylan. In contrast to Toulouse-Lautrec's posters, this was not conceived of as a painting, but rather as a visual statement reflecting Dylan's appearance and the style of the songs in the album.

Dylan's profile is a black silhouette and his hair is composed of brightly colored curves associated with psychedelic imagery popular in the 1960s and 1970s. The brilliance of Glaser's conception, besides its aesthetic appeal, lies in its correspondence with Dylan's music. His songs are pleas for peace and social justice, the seriousness of which is indicated by the singer's sober expression and downward gaze. But the songs are also lyrical, like the curvilinear hair, and optimistic and witty, like the colorful forms. At the bottom of the poster, Glaser has blocked out in large brown letters the name "Dylan."

— ◆ —

We have seen that people produce works of art for many reasons. Some are personal and intended purely for private viewing, whereas others are intended for public display. In nearly every case, there is a degree of illusion and seeming magic underlying the ability to create an image. But in the preceding chapters, we have only skimmed the surface of the thousands of examples of imagery throughout the world. In Chapter 4, we consider the impulse to decorate our own bodies as well as the environment we inhabit.

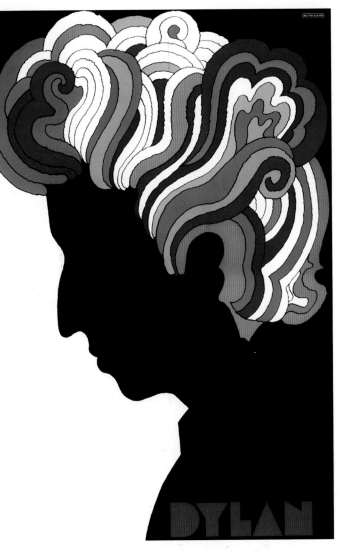

3.30 Milton Glaser, *Bob Dylan*, 1966. Columbia Records' poster. © Studio Milton Glaser.

Chapter 3 Glossary

anthropomorphic—having a human shape

collage—work of art formed by pasting together fragments of printed matter, cloth, and other light-weight materials on a surface

equestrian portrait—portrait of a person on horseback

illuminated manuscript—handwritten book with painted illustrations produced in the Middle Ages

interlace—form of decoration composed of strips or ribbons that are intertwined

masonite—type of fiberboard used in insulation and paneling

monogram—character consisting of two or more letters combined or interwoven

mosaic—image made by embedding small glass or stone tiles into a flat surface, such as a floor or wall

mudra—symbolic hand gesture made by a deity in Buddhist or Hindu art

patron—person or group that commissions a work of art

poster—image intended for display in a public place to advertise an event

relic—object (such as a bone or an article of clothing) venerated because of its association with a martyr or saint

reliquary—casket or container for sacred relics

4

Decorating Ourselves and Our Environment

People have always found ways to decorate themselves and the environment. Enhancing the beauty of our surroundings, as well as our own appearance, serves an aesthetic purpose, but also reflects our cultural context. Imagine a purely utilitarian world with no decoration, a bedroom with blank walls, a city composed of drab, plain buildings. Imagine if people wore gray sacks all the time. Imagine if there were no paintings in the world, no photographs, films, videos, drawings, or statues. The world would be intolerably dull, and we would probably go insane from boredom.

In this chapter we discuss aspects of making art to decorate our own bodies, our homes, our public spaces, and our modes of travel. We include in the discussion jewelry, furniture, glassware, and other utilitarian household objects made with a sense of artistic quality. Although we might feel that such objects are not generally considered "high art," or "fine art," they nevertheless express the creative impulses of their makers and appeal to the aesthetic sense of those who use them. They also improve the appearance of our surroundings and make the world a better place.

Personal Decoration

One of the things we like to decorate is ourselves. In addition to jewelry, people get tattoos and wear make-up, pierce their ears, noses, lips, and other parts of their bodies to accommodate ornaments.

Among the Ngere, in the Ivory Coast, Africa, girls paint their torsos white and their faces and hair in colored patterns following certain initiation rites (**figure 4.1**). In this case, the lively color seems to express the girl's exuberance at having made the transition from childhood to adulthood.

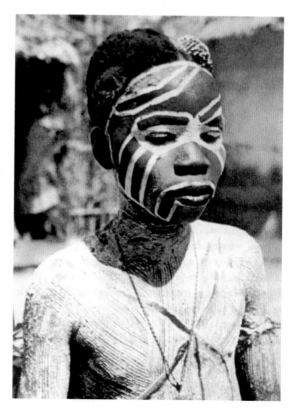

4.1 Ngere girl, Ivory Coast.

In many cultures, royal status is reflected in personal adornment. Archaeologists have found elaborate objects of personal adornment in the third-millennium-B.C. royal tombs at Ur, in Mesopotamia (modern Iraq). **Figure 4.2** shows the reconstructed bust of a young woman wearing a royal headdress and several necklaces, which indicate that she was a queen or a princess. Imagine how she would look without any decoration at all. Not only would her appearance be plainer, but her royal status would be less evident. The three floral forms rising from her headdress signify her importance. They are upright behind the foliate shapes echoed in the cascading braids. Animating the surface of her neck and chest are several strings of beads. The predominance of gold leaf and lapis lazuli (a semiprecious blue stone) denotes her high status, for in addition to being costly materials, gold and lapis lazuli were endowed in antiquity with cosmological significance—as symbols of the sun and the sky, respectively.

Among the Yoruba in modern Nigeria, beading and beadwork are highly valued means of self-adornment. Beaded garments can connote the divine status of a king: **figure 4.3** shows a pair of beaded boots originally worn by a Yoruba chieftain in early twentieth-century Nigeria. These boots are decorated with beadwork arranged in geometric patterns with four beaded birds at the front. We saw in Chapter 1 that the bird is a universal motif and that, because it has the power of flight, it can symbolize a ruler's ability to control nature.

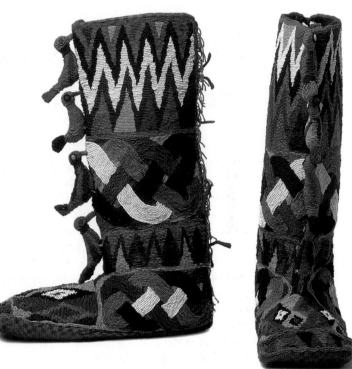

4.3 Beaded boots, formerly belonging to Chief Elepe of Epe, Yoruba, early 20th century. British Museum, London.

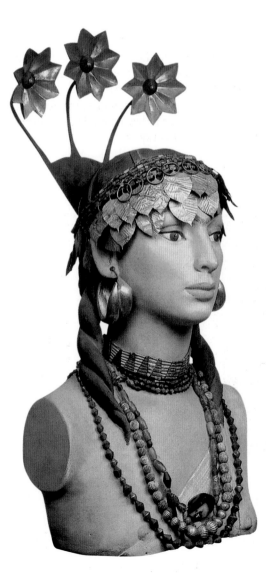

4.2 Reconstruction of funerary ornaments worn by a royal personage, Early Dynastic Period, 3rd millennium B.C., from the Cemetery at Ur. Iraq Museum, Baghdad.

In the Yoruba capital of Ife, the arts revolved around the court and the person of the king. Beaders who worked for the royal and priestly classes belonged to a **guild** (an organization of workers) associated with Obalufon, the god of beading. Beaded fabrics were reserved for the king (the Oba) (**figure 4.4**), and their use was expanded at the turn of the twentieth century. At that time, as colonial powers encroached on the authority of local kings, the kings reasserted their authority by increasing their symbols of royal status. This photograph shows the ruler of Orangun-Ila, Oba Airowayoye I, enthroned in full regal costume.

The Oba holds a staff of kingship and rests his feet on a beaded stool. This prevents his feet from polluting the ground and from being polluted by it. He wears a beaded conical crown, a beaded veil, and a dark red robe with beaded embroidery. His crown and robe are decorated with bird images, which were associated with order and justice, triumph and strength. Birds also denote maternal ancestors transformed into "birds of night" who transmit power to the king. Another purpose of the maternal bird image is to demonstrate the cosmic balance between male and female forces in nature. Like the king himself, who is both benevolent and fearsome, the bird-woman is potentially dangerous as well as protective.

The beaded veils hide the Oba's face, protecting his subjects from the dangerous power of his gaze. The hidden aspect of the king also distances him, making him an image of mystery. He thus remains ritually "unknown," which enhances the enigmatic force of his political image.

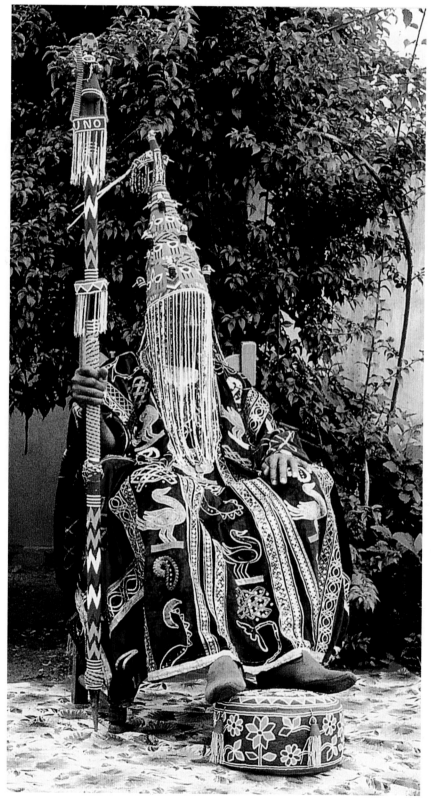

4.4 Airowayoye I, the Yoruba ruler of Orangun-Ila, Nigeria, enthroned in a beaded costume, 1977.

Going to War

Throughout the world, self-adornment often has meaning beyond pure decoration. When preparing for battle, for example, we find that warriors in quite different cultures lavish a lot of time, expense, and effort on dressing themselves up.

Native American warriors wore feathered headdresses and decorated their shields when going into battle. **Figure 4.5** illustrates a Crow war shield painted green, red, and white and adorned with eagle and hawk feathers and porcupine quills. The warrior who owned such a shield would not only have enjoyed its aesthetic value, but, like the Yoruba king, he would have felt empowered by the symbolic meaning of its decoration. The hawk and the eagle are known for their swift flight, sharp eyesight, and aggressiveness, all of which are valuable assets in a warrior. Porcupines attack their enemies by ejecting their quills, just as a Crow warrior would shoot arrows in battle.

Now consider a wax-crayon rubbing taken from the monumental brass tomb **effigy** of Sir Robert de Bures, a medieval English knight who died around 1331 (**figure 4.6**). His tomb was placed in All Saints Church in Acton, Suffolk. He is shown wearing chain-mail armor and his crossed feet rest on a lion (denoting his death in battle and associating him with leonine courage). The hem of his gown is decorated with **trefoils** (three-leaf clover shapes) and the material covering the chain mail on his knees and thighs is embroidered with **fleur-de-lys** (a French royal emblem) and **rosettes** (which also decorate the spurs). The **pommel** of Sir Robert's sword contains a small image of a cross inside a rosette, indicating that he is a Christian soldier. His shield is decorated with his family coat of arms—ermine on indented sable and two gold lions. In this case, the armor serves the utilitarian purpose of protecting the warrior, but, as with the Crow shield, it has aesthetic form imbued with allusions to military strength and bravery.

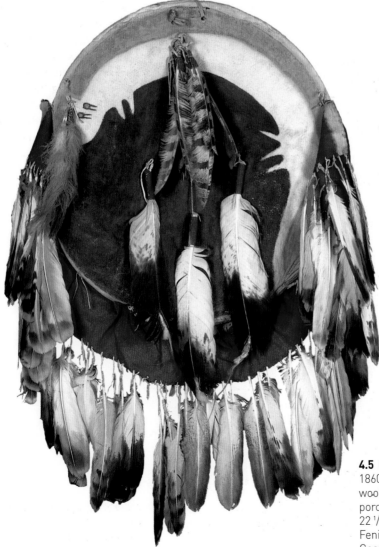

4.5 Crow war shield from Montana, 1860s. Buffalo rawhide, antelope skin, wool fabric, eagle and hawk feathers, porcupine quills, and paint, 22 ½ in. diameter. Thaw Collection, Fenimore House Museum, Cooperstown, New York.

The photograph of the twentieth-century Islamic African ruler Nana Diko Pim III shows him dressed in the great war shirt and helmet of the Akan culture in Ghana (**figure 4.7**). Covering the costume are hollow amulets made of hardened leather. The amulets contained verses from the Koran and medicinal substances. Like the Crow shield and Robert de Bures' armor, the Akan war shirt has both a practical and a ritual purpose. It protects the wearer in two ways—by its physical properties and its symbolic meaning.

> ... painting is not done to decorate apartments. It is an instrument of war for attack and defense against the enemy.
>
> Pablo Picasso (1881–1973), on the difference between art and decoration

4.6 Brass rubbing from the brass of Sir Robert de Bures, c. 1331. Original brass at All Saints Church, Acton, Suffolk. Studio 69 Monumental Brass Facsimiles.

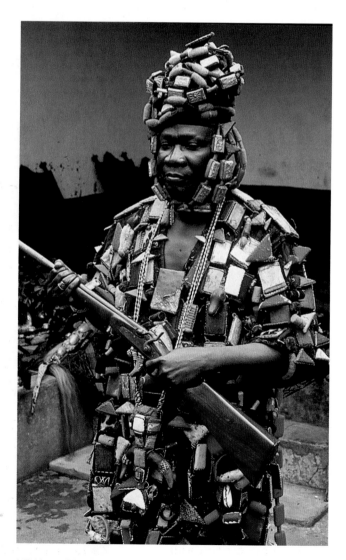

4.7 Nana Diko Pim III, ruler of Ejisu, 1976. Akan (Ghana).

Decorating our Personal Spaces

In addition to decorating ourselves and dressing up for certain occasions such as war, we like our homes to be attractive. We shop for everyday items such as furniture, dishes, glasses, coffee pots, and clocks. We might put rugs or tiles on our floors, paint our walls and ceilings, and even renovate the space to suit our needs and aesthetic preferences. We might even describe these objects and decorations as utilitarian applied arts.

If we were lords and ladies living in the Middle Ages, our home would literally be our castle. Since medieval castles did not have central heating, we would cover our cold stone walls with woven tapestries to add warmth and color to the interior.

Decorating Walls and Floors

Some of the most famous medieval tapestries, now in the Cluny Museum in Paris, represent the theme of the Lady and the Unicorn (**figure 4.8**). They were probably made in northern Europe, most likely in Brussels (in Belgium), but this is not documented, nor is the identity of the artist or workshop that produced them. The patron, on the other hand, has been identified as Jean le Viste from Lyons, in France, whose family had served the French king. His coat of arms is prominently displayed on the banners held by the lion and unicorn flanking the two female musicians.

This tapestry is one of a series believed by some scholars to represent the senses—in this case, the sense of sound. The lady plays a portable organ and her maidservant pumps the bellows. Both the women and their musical instruments occupy a lush garden filled with flowers, dogs, rabbits, and four

fruit trees in bloom. Surrounding the garden is a rich field of red, lavishly populated with flowers, dogs, and rabbits.

Imagine the room of a castle warmed and enlivened with the entire set of six large Unicorn tapestries. In addition to stimulating our imagination, these images might transport us into the garden pictured on the walls. The unicorns (there is a little one perched on the side of the organ) are intended to remind viewers of the lady's purity; the lion represents the bravery of the le Viste family in the king's service; the dogs symbolize fidelity; and the rabbits are signs of love and fertility.

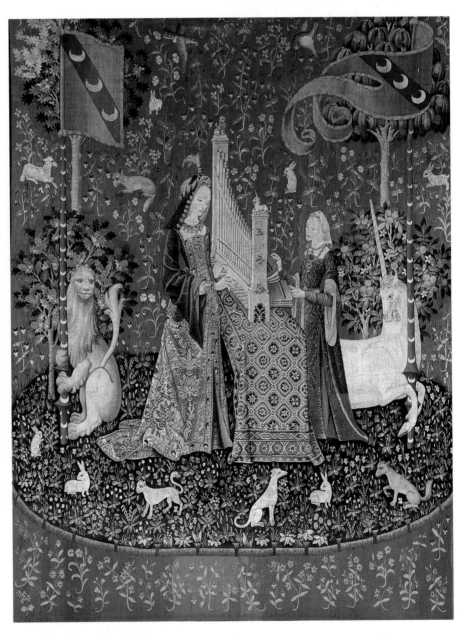

4.8 *Lady and the Unicorn* tapestry (panel showing sense of sound), late 15th century. Tapestry, 12 ft. 1 5/8 in. x 9 ft. 6 in. Cluny Museum, Paris.

If we lived in a house in an ancient Roman city, we would also have had wall decorations. But instead of hanging pictures or tapestries on the walls, we would commission artists to paint directly on the wall. **Figure 4.9** illustrates the section of an upper- or upper-middle class bedroom from a country house near the Roman city of Pompeii, on the southwest coast of Italy. The bedroom and its decoration are well preserved because in A.D. 79 Pompeii was covered with ash from the volcanic eruption of nearby Mount Vesuvius. The ash and lava erupted so rapidly that many people had no time to escape and were buried in the midst of their daily activities or as they attempted to flee. As a result, the rediscovery of Pompeii in the eighteenth century, and subsequent

excavations, revealed a time capsule of life in an ancient Roman city.

The wall-paintings shown here are **fresco**, which is made by mixing pigments with water and applying the mixture to a wall of damp lime plaster. As the plaster dries, the paint bonds with it, making the picture particularly durable. The rich reds are characteristic of Pompeian fresco painting.

The Romans who slept in this bedroom would not have had an actual view of the outdoors. Instead they saw an illusionistic view of an architectural

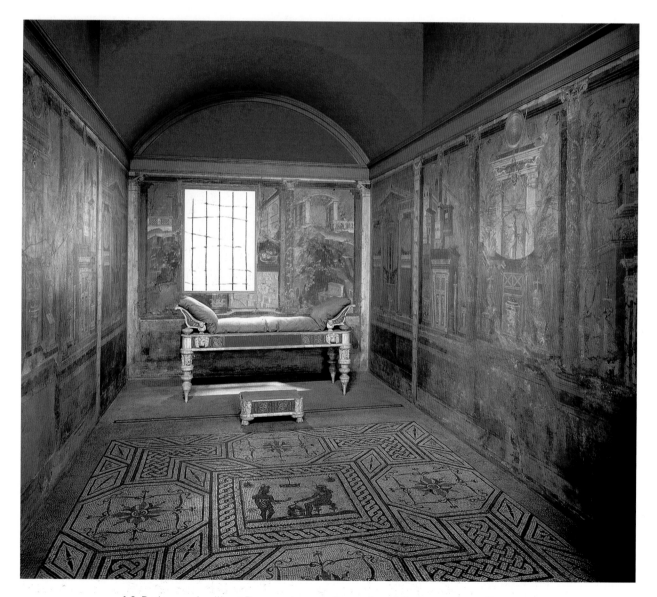

4.9 Bedroom of a villa at Boscoreale, near Pompeii, mid-first century B.C. Fresco. Metropolitan Museum of Art, New York. Rogers Fund. 1903 no. 03.14.13a–g.

complex, including **colonnades** (rows of columns), rooftops, walls with doors and windows, columns, and plants. Notice that the painted exterior seems to recede into the distance; this effect is achieved by the diminishing size of the architecture and landscape.

Wealthy Romans decorated their floors, often with mosaics, which we can also see in figure 4.9. One of the most spectacular examples of this technique is the mosaic of sea life discovered in House VIII at Pompeii (**figure 4.10**). As we walk on this mosaic floor, we see a variety of fish, eels, octopuses, and squid against a black background suggesting the depths of the ocean. At the left, we notice that a little bird is perched on a rock, its beak pointed downward as if poised to dive for its supper.

Household Objects

We do not usually think of utilitarian household objects as serious works of fine art. Nevertheless, every object we use in the house has been designed by someone and sometimes these items are quite artistic. Some have become collectors' items and are now found in major museums. Think about the designs of early cameras, for example, and of the telephones and typewriters that our grandparents used. At the time, such objects were thought of as purely functional. And while they are not on the aesthetic or symbolic level of the Unicorn Tapestries or Roman wall-paintings and mosaics, some are the work of major artists and others appeal to us simply because we like their appearance.

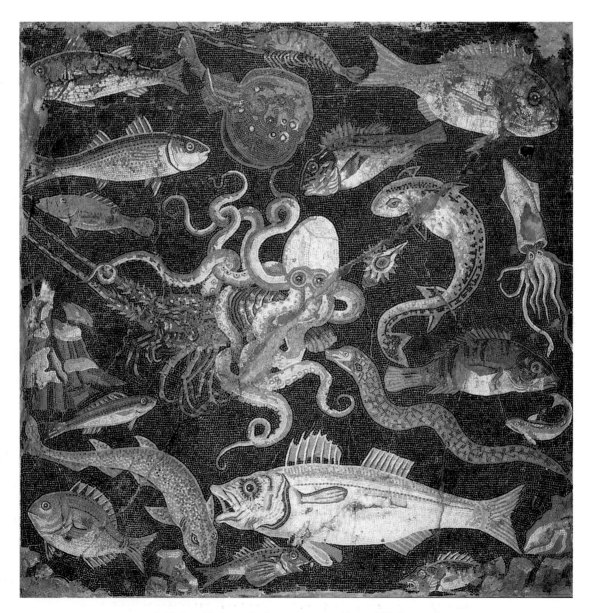

4.10 Sea-life mosaic, 1st century A.D. House VIII, Pompeii.

4.11 Michael Graves, Pepper mill designed for Alessi, 1988.

The pepper mill in **figure 4.11** was designed by the twentieth-century Post-modern architect Michael Graves (b. 1934). Its top section, the part that turns in order to grind the pepper, resembles the ears of Mickey Mouse. The forms are sleek and clear, and the reflective silver pepper container is juxtaposed with the matte surface of the blue "ears." Accentuating the ears is the shiny red ball between them. As we contemplate the pepper mill, we are reminded that Mickey Mouse is an icon of American culture, that he is a cheerful fellow whom most of us have known since childhood, and we are amused and reassured to find an abstract version of him on our dinner table.

Although Graves' pepper mill is a contemporary design, the tradition of creating useful objects in human or animal form is ancient. The gold drinking vessel of the fifth century B.C. in **figure 4.12** exemplifies the metalworking skill of Achaemenid Persia. Made in a royal workshop, the vessel was almost certainly intended for a king. This is suggested by the gold material and intricate, costly workmanship—more than 144 feet of gold threads were used. In addition, the fact that the cup merges into the form of a rampant, open-mouthed lion denotes the ruler himself.

One important difference between the pepper mill and the gold vessel is the process by which they were made. The pepper mill was designed by an individual, but is mass-produced. The lion, on the other

hand, is one of a kind. It is more intricately made and, one could argue, has greater symbolic meaning than the pepper mill. It is also, in and of itself, an image of power, for it conveys a sense of compressed energy, at once roaring and restrained, mirroring the might and steadfastness of a king.

Another everyday object is the vase, which, like other household items, is as old as civilization itself. The earliest known vases, made before the invention of the potter's wheel—around 4000 B.C.—were of sun-dried or baked clay.

From 1870 to 1933, the American artist Louis Comfort Tiffany (1848–1933) made elaborate glass vases that drew on designs from many different cultures, including those of the Far East, Venice, Egypt, Greece, and the Middle East. Tiffany traveled widely in search of inspiration for his work. Particularly attracted to floral forms, he created the cut-glass vase in **figure 4.13**, which is decorated with lily pads and Queen Anne's lace. Typical of Tiffany's style are the slender, curvilinear forms embedded in

4.12 Persian drinking vessel in the shape of a lion, Hamadan, 5th century B.C. Gold, 6 ³/₄ x 9 in. Metropolitan Museum of Art, New York. Fletcher Fund 1954.no. 54.3.3.

4.13 Louis Comfort Tiffany, Tiffany Glass and Decorating Company, Vase, late 19th century. Cased, cut, and engraved Favrile glass, 12 ¹/₄ in. high. Metropolitan Museum of Art. Purchase, William Cullen Bryant Fellows Gifts 1997. no. 1997.409.

the fabric of the glass. Imagine how such a vase would look if it were filled with long-stemmed flowers. Its tall, graceful contour as well as its surface design would create a unified whole with the real flowers and this would be enlivened by light filtering through the textured glass.

Furniture Design: Chairs

So far, we have considered relatively small household objects, and wall and floor decorations. But we also use furniture—tables for eating, beds for sleeping, chests for storage, and so forth. Let's look at some examples of chairs. As with other types of created objects, a chair can have meanings related to its function and an aesthetic appeal that goes beyond pure function.

In the 1960s, the Finnish designer Eero Aarnio (b. 1932) created the red *Ball*, or *Globe, Chair* (**figure 4.14**). This chair clearly goes beyond the function of providing a place to sit. Its womblike enclosure invites us to curl up with a good book or a video game and feel protected. When we imagine sitting in this chair, we have a sense of safety, comfort, and warmth—we are literally enclosed in a world of our own. Viewing the chair from the outside, we might admire the sleek, smooth shape, rich red color, and shiny fiberglass surface. Such a chair is not only practical, but is also designed as an aesthetic object to enhance the appearance of a room.

Aarnio, who designed the chair, hoped for a future when tradition and modernity would form a new aesthetic—when "the personal approach of the past and the robot manufacture of the future [would] clasp hands."[1]

In contrast to the *Globe Chair*, the *Getsuen Chair* (**figure 4.15**) is derived from floral forms. It resembles the open petals of a blue flower expanding outward from its green and yellow support. For the artist, Masanori Umeda (b. 1941), the chair evokes the world of nature and also reflects the traditional Japanese interest in garden design. As with the *Globe Chair*, the *Getsuen Chair* does more than fulfill the function of sitting down. It appeals to an aesthetic sensibility.

4.14 Eero Aarnio, *Ball*, or *Globe, Chair*, 1963. Fiberglass. Produced by Asko Oy, Lahti, Finland. Die Neue Sammlung Staatliches Museum für Angewandte Kunst, Munich.

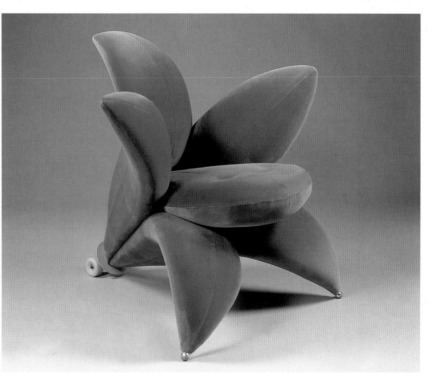

4.15 Masanori Umeda, *Getsuen Chair*, 1990. Cotton velour polyurethane foam, Dacron, polyethylene, lacquered iron, steel. Produced by Edra. 32 ¾ x 39 ½ x 36 ¼ in. The Montreal Museum of Fine Arts. Liliane and David M. Stewart Collection, gift of Maurice Forget.

Royal Chairs

We now consider the purpose of a royal chair, or throne. It serves the same literal function as any household chair by providing a place to sit. But thrones also have symbolic meanings related to the importance of the person who occupies them. A throne does more than decorate a space; it also has cultural and political significance.

In ancient Egypt, where the pharaoh was thought of as a god on earth, a lot of attention was paid to the throne. **Figure 4.16** shows the Golden Throne of the young pharaoh Tutankhamon, which is made of gold, silver, and lapis lazuli. The front legs of the throne are in the shape of a lion's head at the top and a lion's paw at the foot—the lion, like the Persian drinking vessel, stands for the king. But it also has another meaning: it is a guardian figure, protecting the pharaoh from harm. In so doing, the lion fulfills a traditional role based on the belief that lions never sleep. As a result, even today images of lions guard entrances—to public buildings such as libraries, courts, and post offices, as well as to private homes.

Another type of royal seating arrangement can be seen in the Akan (Ghana) stool of the late nineteenth century (**figure 4.17**). This is the royal stool of an Akan king; its five supports symbolize the king himself (at the center) and his four lesser chieftains (the four curved legs). Another reading of this configuration identifies the stool as a cosmic allusion to the sun and the four cardinal points of the compass. The seat itself was

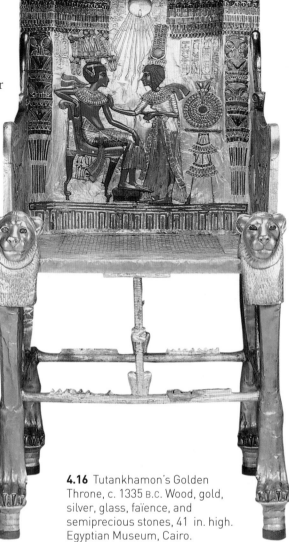

4.16 Tutankhamon's Golden Throne, c. 1335 B.C. Wood, gold, silver, glass, faïence, and semiprecious stones, 41 in. high. Egyptian Museum, Cairo.

4.17 A royal stool, late 19th century, from Akan (Ghana). Wood and silver, 15 x 23 ½ x 13 ¼ in. The Nelson Atkins Museum of Art, Kansas City, Missouri. Purchase: Nelson Trust.

conceived of as a head, or face, the extensions as the ears, and the central support as the neck. As such, the stool was a symbolic head, just as a king is thought of as the head of state, or head of the "body politic."

Through the holes, according to Akan belief, power could be transmitted to the person of the king who sat on the stool. In Western Europe, when a king died, succession was traditionally reflected in the pronouncement: "the king is dead, long live the king!" In Akan, one said "the stool has fallen," and the stool was turned over to denote the death of the king. The stool then underwent a ritual transformation into a permanent memorial for the dead king and was placed on an altar.

Utility or Art?

The study of the visual arts raises questions of meaning, value, and aesthetic quality. As we have seen, these are vexing and complex issues because tastes and views of what art is tend to change. We can see this in the furniture produced in the United States by the Shaker community (**figure 4.18**).

In the eighteenth century, the spiritual leader of the English United Society of Believers in Christ's Second Appearance, also known as "Shaking Quakers" or "Shakers" because dancing formed part of their religious services, emigrated to America. A Shaker community was established in 1785 in what is now Mount Lebanon, New York, and was followed by other communities in eight states.

The Shakers believed in self-sufficient communities, isolated from the world of technology. To this end, they lived by their own labor, worked farms, built their own homes, and designed their own furniture to reflect the Shaker motto "Hands to Work and Hearts to God." In 1871, they established a factory to make chairs, which they planned to market as a way of keeping their community economically viable.

Shaker designs are known for their formal simplicity and utilitarian value. The rocking chair illustrated in figure 4.18 has a rich brown color and is made of stained maplewood, with a woven seat. Shakers used these chairs for relaxation and for rocking their children to sleep.

The Shakers thought of their furniture as purely functional. Nevertheless, when we look at Shaker furniture today, we are impressed by the clear lines and straightforward appearance, which strike us as having aesthetic quality.

If we compare the Shaker chair with the *Globe* and *Getsuen Chairs*, can we say that one chair is more artistic than the other? All three are equally useful and serve a similar purpose. One has straight lines, open spaces, and a prim appearance. We might imagine our grandmother or grandfather rocking on the porch in the Shaker chair. The others are colorful, curvilinear, and invite us to sink comfortably into their forms. In the end, the answer to the question is largely a matter of opinion.

4.18 Shaker rocking chair from the Mount Lebanon Factory, c. 1880. Stained maplewood. Die Neue Sammlung Staatliches Museum für Angewandte Kunst, Munich.

4.19 Gianlorenzo Bernini, *Fountain of the Four Rivers*, 1648–1661. Travertine and marble. Piazza Navona, Rome.

Decorating our Public Spaces

Think about walking down a city street. What do you see? And what would you like to see?

In addition to decorating ourselves and our interior spaces, we like our outdoor spaces to be aesthetically pleasing. In seventeenth-century Europe, fountains became a popular way of ornamenting urban spaces. The elaborate marble *Fountain of the Four Rivers* (**figure 4.19**) in Rome was created by Gianlorenzo Bernini (1598–1680), the leading Italian sculptor and architect of his generation. It is located at the center of Piazza Navona, which today is ringed with outdoor cafés popular among tourists and students. Imagine sipping a cappuccino or a glass of Chianti while watching the play of the water over the sculptures. Without the fountain, the square would be a lot less lively.

Bernini's fountain is composed of four marble personifications of rivers—the Nile (in Egypt), the Ganges (in India), the Danube (in Eastern Europe), and the Plata (in South America). The figures recline in twisted poses, reminiscent of ancient river gods, who evoke the heritage of pagan Rome. At the same time, however, the fountain has Christian meaning, for it was commissioned by Pope Innocent X (papacy 1644–1655) and was intended to reflect the power of the papacy throughout the world. Over the central rock, the **obelisk** (an Egyptian feature) rises upward, leading the viewer's gaze to the sky. A dove and an olive branch at the top of the obelisk are motifs from Pope Innocent's family crest and also allude to the transformation of an element associated with pagan Egyptian temples into a Christian fountain.

Compare Bernini's animated river gods with Henry Moore's (1898–1986) *Reclining Figure* of 1957–1958 in front of the UNESCO building in Paris (**figure 4.20**). In Moore's sculpture, a wall of the UNESCO Building is visible through two large holes carved out of the stone. The flowing contours and bulky, white mass of Moore's figure create a striking contrast with the rectilinear planes and patterned effect of the building. Both Bernini's *Fountain* and Moore's *Reclining Figure* were created with international significance in mind. But, whereas Bernini intended the *Fountain* as an allusion to the power of the pope and his influence in four regions of the world, Moore described the formal power of his figure as a majestic reminder of the aims of the United Nations.

> The first hole through a piece of stone is revealing.
>
> Henry Moore, sculptor (1898–1986)

4.20 Henry Moore, *Reclining Figure*, 1957–1958. Roman travertine, 16 ft. 8 in. long. UNESCO Building, Paris.

Those of us who live in big cities and take the subway to school or to work often complain about the noise, the dirt, and the crowds. Some of us also complain about graffiti, and the authorities look on graffiti as vandalism. But in the 1980s a group of New York artists began to make graffiti into an art form. Keith Haring (1958–1990), who died of AIDS, liked to paint on subway walls, to convey political messages, to arouse consciousness of the AIDS crisis, and to decorate the otherwise drab underground spaces.

In **figure 4.21** Haring is shown drawing on a wall panel in a New York City subway station. Next to his drawing is a poster, and at the right is a purely functional sign announcing the direction of Fifth and Madison Avenues. A seated man watches intently as Haring draws one of his characteristic, outlined figures. It is a cheerful, dancing figure, at first glance with a heart for a head. But if looked at in another way, the heart could be a head reversed, as if the figure were looking up and shouting. In either case, the merging of head and heart is a plea for a better society and the act of drawing in the subway was considered by Haring to be a creative one.

Graffiti artists challenged the notion that outdoor surfaces are not there to be decorated without authorization. Here, as in Duchamp's *L.H.O.O.Q.*, the question of the boundary between creation and destruction is raised and the proliferation of graffiti

has raised controversy throughout American cities. The answer to another question, namely, can graffiti be works of art?, rests with the beholder. It also depends on the graffiti, some of which have aesthetic quality and some of which do not.

Designing our Means of Travel

Another issue concerning the standards by which we judge creative products is whether industrial design should be considered art. Such works originate with utility in mind, but often have an aesthetic quality that transcends functionality. The original design of a car or a bus might reflect the creative impulse of the designer, but they are intended for mass production and mass use. They are not unique. And in matters of art, we, in the West, traditionally place higher value on what is unique and original than on replicas.

In addition to urban spaces, we like to decorate our travel spaces. This has been true for as long as people have been designing modes of transport. When people traveled on horseback, they decorated their horses with embroidered coats, gold bridles, and other trappings. With the development of automation, industrial design evolved and was applied to means of travel. The invention of the automobile and other motor-powered vehicles proved a rich field for creative designers. Besides having both

COMPARE

Duchamp, *L.H.O.O.Q.*
figure 1.15, page 15

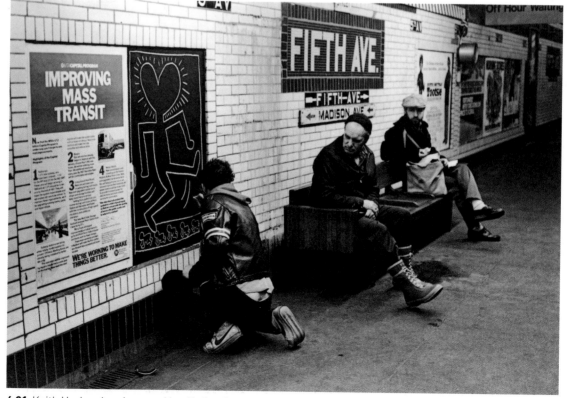

4.21 Keith Haring drawing on a New York subway panel, 1980s. Photo by Tseung Kwong Chi.
© 1984 Muna Tseung Dance Projects Inc. New York.

functional and aesthetic qualities, modes of transportation project a certain image of the person who uses them.

In 1914, Henry Ford's Model T (**figure 4.22**) came onto the market. Although produced on an assembly line, the Model T reflected Ford's wish to create a car that would be both useful and attractive. The rectangular, upright quality of the car conveys an impression of stateliness, suggesting a sense of purpose and direction. The plush leather seats, chrome grill, headlights, mirrors, and elegant FORD logo standing out prominently at the front reveal Ford's interest in aesthetic design. Henry Ford had in mind a car that would be inexpensive enough for general use, but also composed of high-quality material.

After a few decades, with the proliferation of cars and increased crowding on the roads, buses were developed for long-distance travel. In 1954, the Greyhound Bus Scenicruiser (**figure 4.23**) began service in the United States. It was conceived by Raymond Loewy (1893–1986), who emigrated to the United States from Paris in 1919 and became an influential industrial designer. His sleek design aesthetic came from his belief that the simplest objects are the most difficult to things to design.

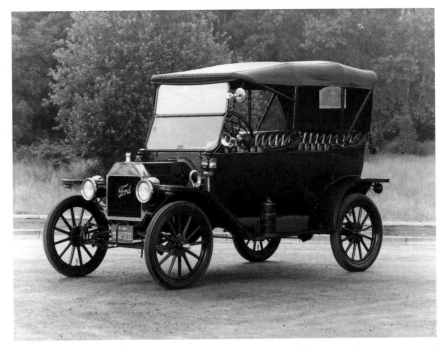

4.22 Henry Ford, Model T Cabriolet, 1914.

... one man is now able to do ... more than four did only a few years ago.

Henry Ford, automobile manufacturer (1863–1947), on the assembly line

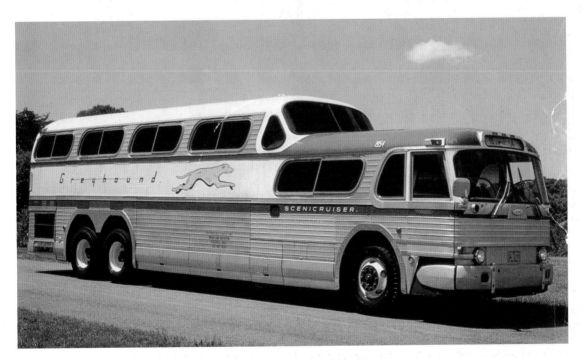

4.23 Raymond Loewy, Greyhound Bus Scenicruiser, 1954.

In contrast to driving a car, travel by bus projects an image of community. The Greyhound motto "Leave the driving to us" requires a willingness to cede the wheel to someone else and to give up a measure of privacy. You might even strike up a conversation with the person sitting next to you. Bus travel made it possible to sit back, relax, and enjoy being a passenger. The Greyhound also became a symbol of speed and efficient travel, which was enhanced by the streamlined appearance of the bus and the racing Greyhound dog painted on it. The bus in figure 4.23 is a double-decker, on which Loewy began working in 1944 in preparation for the end of World War II when domestic travel was bound to increase. His Greyhound accommodated up to fifty passengers and was equipped with bathroom facilities. It offered scenic cruising along America's highways, through crowded cities, suburbs, small towns, and open fields and farms.

Perhaps the greatest sense of independence in road travel comes from riding a motorcycle. Motorcycles are designed to create an image of high speed, rugged individualism reminiscent of the Old West, and risk. The most impressive of these is the Harley Davidson "Easy Rider" Chopper (**figure 4.24**), now known only in replicas. The original Harley Davidson "Easy Rider" was made for the 1969 film *Easy Rider*, starring Dennis Hopper and Peter Fonda. It was destroyed at the end of the film and the only other model has disappeared.

The design of the Harley Davidson "Easy Rider" reinforces its image as a source of power and independence. In contrast to Ford's Model T and Loewy's Greyhound, whose motors are hidden from view, the motorcycle's motor is visible as a source of industrial energy and roaring sound. The chrome spokes of its wheels form an intricate pattern, whereas the Greyhound and Model T wheels are smooth; they

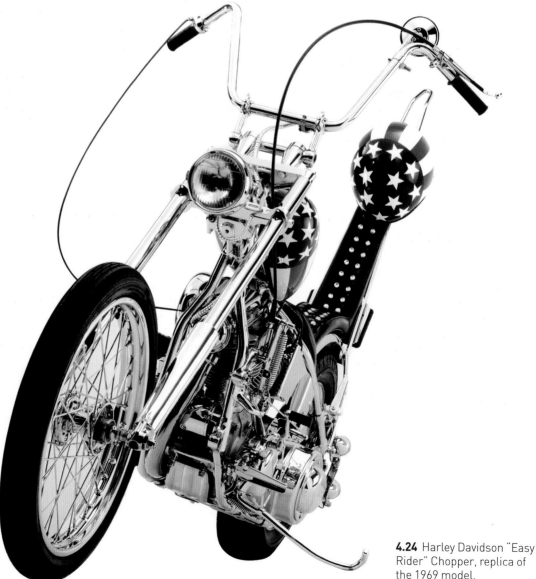

4.24 Harley Davidson "Easy Rider" Chopper, replica of the 1969 model.

72

look as if they are quieter, and they are. Adding to the image of the motorcycle are the outfits worn by some of the riders who cultivate a rebel image— leather jackets, chrome helmets, and chain metal. In addition, the prominence of the stars and stripes conveys the impression that the Harley Davidson is a distinctly American product.

Although there are a number of transportation museums, few people would consider cars, buses, and motorcycles to be great art. However, from June 26 to September 20, 1998, the Guggenheim Museum of Art in New York mounted an exhibition entitled "The Art of the Motorcycle," which featured 114 motorcycles dating from 1885 to 1998.

> It is absolutely useful since it's pretty.
>
> Antoine de Saint-Exupéry, author (1900–1944)

So what are we to think when a major art museum exhibits motorcycles? We have to revisit our notion of what art is. Some critics dismissed the show as a dumbing-down exercise in nostalgia, while others praised the aesthetic qualities of the motorcycles. We could try out the idea that great art, in contrast to utilitarian products, is not only aesthetic, but is symbolic and has cultural significance, and that it fits into a historical sequence of style. But the same could be said of a car, bus, or motorcycle.

We might venture to say that in the West, in recent centuries, artists consciously deal with what are called artistic ideas. That is, they search for new ways to project space on a flat surface, they study color theory, they explore form, and they create works primarily with these elements in mind. Utility is not their first consideration. But what if you are an architect? You want your building to stand up and be useful as well as aesthetically appealing. If your painting or sculpture is someone's portrait, you might want the sitter to be satisfied.

Furthermore, one could question the very question we are posing. Even though we have a sense that there is such a thing as great art, and a car isn't it, we have to admit that a car can be beautiful, symbolic, and express cultural ideas. At the same time, works considered to be fine art are often useful in and of themselves, since they serve many practical purposes. For example, a religious work can evoke a spiritual response, a political work can project the desired image of a ruler, and a humorous work can amuse us.

— ◆ —

In the next section, we consider the formal elements of art and the language we use to describe it. We also look at different ways of reading works of art—which are called the methods, or methodologies, of artistic analysis.

Chapter 4 Glossary

colonnade—row of columns set at regular intervals
effigy—sculptured likeness
fleur-de-lys—(a) white iris, the royal emblem of France, or (b) stylized representation thereof used in art or heraldry
fresco—technique of painting on the surface of a wall or ceiling while the plaster is still damp. As the paint dries it bonds with the wall.

guild—organization of workers
obelisk—tall, pointed square pillar
pommel—ornamental knob found, for example, on the hilt of a sword or on a saddle
rosette—stylized rose
trefoil—ornament in the form of a leaf with three lobes (such as a clover)

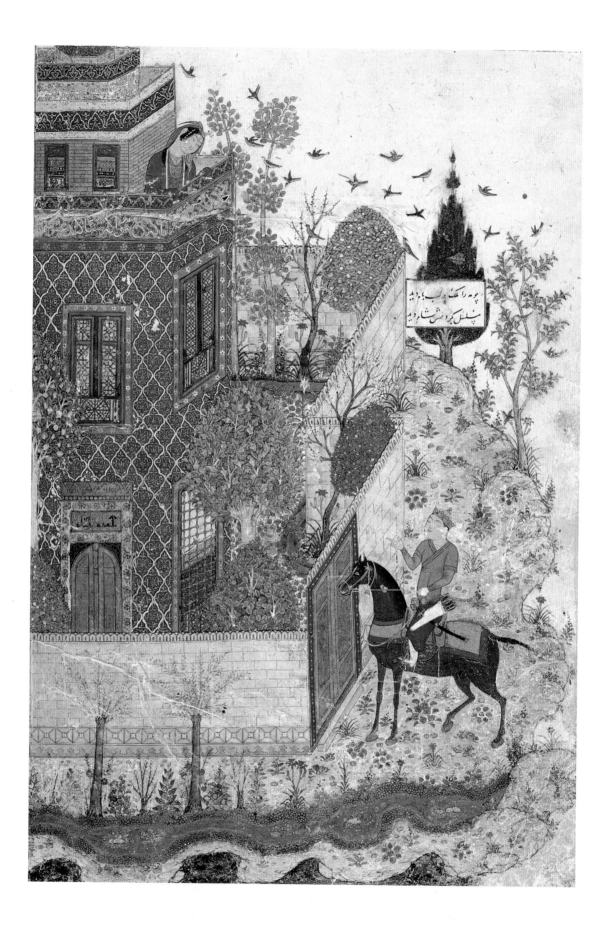

Part III The Artist's Visual Language

Imagine if we had to communicate in images instead of in words. How would we tell someone we were mad, sad, or happy? This is what visual artists do. They convey not only their own feelings in their work, but also those of the forms and figures they depict, and they evoke responses in their viewers. Just as a writer thinks in words, a musician in sounds and rhythms, and a mathematician in numbers, so an artist thinks visually. The elements of visual thinking include line, shape and volume, texture, space, time and motion, light and value, and color. The way in which artists organize these elements may be called design or composition. A work of art is designed to convey what the artist wants to communicate. This can be achieved in a variety of ways, and there are no exact rules for doing so. Many artists explore new ways to organize the visual elements and one mark of a great artist is his or her ability to find new expressive modes. The visual tools at the artist's disposal, on the other hand, are relatively constant.

We, as viewers, need to be familiar with the artist's visual language and, if we want to understand and communicate our own responses to works of art, we have to apply words to what we see. To do so, we must learn the basic terminology of visual thinking. In this section, therefore, we first consider the elements of the artist's visual language, and then the terminology of art and the principles of design. Finally, we review ways in which works of art have been interpreted—the so-called methods, or methodologies, of artistic analysis.

> Painting presents its essence to you in one moment....
> Poetry presents the same thing but by a less noble means than the eye ... hearing is less noble than sight, in that as it is born so it dies, and is as fleeting in its death as in its birth.
>
> Leonardo da Vinci (1452–1519)

(Opposite) *Princess Humayun spies Humay at the Gate*, from *Three Poems of Khwaju Kirmani*, 1396. 15 x 9 ³/₄ in. British Library, London.

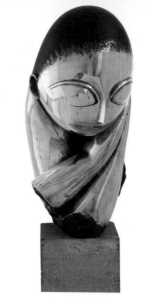

KEY TOPICS
Line
Perspective
Shape and mass
Texture
Time and space
Color and light

The Visual Elements of Art

We are all familiar with such terms as line, shape, space, texture, time, and motion. They are common, everyday terms, but they are used by artists in specific ways to create certain impressions and convey ideas. The more we view different kinds of images, the more familiar we become with the variety of works of art and the inventiveness of visual artists. We begin our survey of visual elements with line.

Line

As is true of words, the visual elements of art are designed to communicate. A basic element is line, which is a component of writing as well as of image-making. Westerners write primarily to communicate ideas. But in China artists spend years learning to embellish their written characters long after they have mastered the communicative function of writing. **Figure 5.1** shows an example of Chinese **calligraphy** (literally "beautiful writing"). Even though we may not be able to read the text—in this case part of a late thirteenth- or early fourteenth-century poem—we can appreciate the pictorial elegance of the script.

Technically, a line is a path traced by a moving point. Visual artists draw the path (or line) with brushes, pens, pencils, crayons, or other pointed instruments. In **figure 5.2**, the French artist Honoré Daumier (1808–1879) used lines to stand for the edge (the **contour**) of the young man. In reality, we do not have outlines framing our bodies, but in a drawing such as this we read certain lines as if they

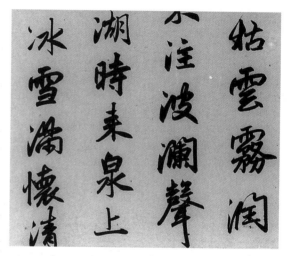

5.1 Detail of running script, *hsing-shu*, from Chao Meng-fu's (1254–1322) *Spring Poem* (*Pao-t'u*). Handscroll, ink on paper. National Palace Museum, Taipei.

> **To draw is in fact to make appear.**
>
> Claes Oldenburg (b. 1929)

are there. We understand that the lines distinguish the young man from the space around him. Imagining the same page without lines, we realize that the image would cease to exist.

Lines Used to Create Shape and Mass

Lines define shapes by enclosing them; they indicate direction; and, if they are drawn or painted lines on a flat surface, they may create illusions of solid, **three-dimensional** form (mass or volume). **Shapes** are generally thought of as two-dimensional—they are enclosed spaces. **Mass**, on the other hand, denotes volume, or bulk.

Daumier's drawing creates the impression of a young man running across an open landscape. His torso and legs form a series of diagonals creating shapes that allow our eyes to move freely from the figure into the air space around him. By combining open shapes with diagonals, Daumier creates the impression of swift movement. This is accentuated by the nervous curves outside the edge of the figure and by their repetition on the sleeves and trouser legs.

The wide-eyed, apprehensive expression of Daumier's young man suggests that he is afraid of falling over and he seems to be trying to regain his balance. Daumier solves the tension between the boy's swift movement and his efforts to stabilize himself by manipulating the lines. He combines the steadying pressure of the right foot and the horizontals of the outstretched arms with the more agitated exterior lines.

Lines create an entirely different mood in Rembrandt's *Woman at the Bath* (**figure 5.3**). This figure is calm, her eyes are downcast, and she turns her head from the viewer's gaze. The lines defining her form are not so much outlines, as in the Daumier, but rather are **modeling** lines. Parallel lines (**hatching**) and intersecting lines (**cross-hatching**) define

5.3 Rembrandt van Rijn, detail of *Woman at the Bath*, 1658. Etching. Private Collection.

5.4 Henri Matisse, *Study of a Woman's Back*, 1914. Lithograph, 16 ⁵/₈ x 10 ³/₈ in. Metropolitan Museum of Art, New York. Rogers Fund, 1921. no. 21.97.6.

the curves of the body and create an effect of mass— as if the figure had been modeled and occupies three-dimensional space. The darkened bulge of the right hip reinforces the impression that the woman's flesh expands outward by the slight turn of her torso.

If we compare Rembrandt's figure with the *Study of a Woman's Back* (**figure 5.4**) by the French artist Henri Matisse (1869–1954), we can see that Matisse uses no modeling lines, no hatching, and no cross-hatching. Instead, he conveys a sense of three-dimensional mass by manipulating curved outlines to suggest the natural contours of human form. Matisse varies the width of the shapes and spaces defined by the curves, which we recognize by association with our own bodies. We follow the relatively sharp curve of the shoulder, through the longer, more gradual curve of the side, to the waist, which is slightly concave and then flows out to become the outline of the hips and buttocks.

Matisse's line tells us that the woman leans more heavily on her right hip than on her left. We know this because the line of her right hip is straighter than the curved left hip and because her torso slants to the right. The outline of the woman's left hip continues upward and defines her left leg, which appears to

be slightly raised as she rests her right hand on the visible thigh. We do not see the other hand, but we read it as being there because we assume it to be in front of the torso. The rudimentary character of Matisse's line shows us how few cues we need to recognize a familiar form.

Changes in lighting designed to convey the impression of contour were of particular theoretical interest to Leonardo da Vinci and other Renaissance artists. In their efforts to replicate nature, these artists defined solid form by shading, or **chiaroscuro** (literally "light–dark"), rather than by line. Leonardo's *Mona Lisa* (**figure 5.5**), which we mentioned in Chapter 1, exemplifies the artist's genius for subtle shading. The side of the nose, the corners of the eyes and mouth, and the neck are gradually shaded, creating the illusion of the three-dimensional contours of the face. In the landscape, Leonardo uses the technique of **sfumato** (smokiness) to create the soft hazy atmosphere of mist.

5.5 Leonardo da Vinci, *Mona Lisa*, 1503–1505. Oil on wood panel, 30 ¼ x 21 in. Louvre, Paris.

Lines Used to Create Light and Dark

In addition to defining form, lines can indicate the implied location and source of light and dark. In *Woman at the Bath* (see figure 5.3) Rembrandt uses lines to create shade, or **shading**, which is a gradation from light to dark. The shading is darker on the left, and the white surface indicates where the light hits the figure directly. A **shadow** is cast when light is blocked by a solid form. There is a cast shadow behind the woman's left arm and on the ground below Daumier's running figure.

In the *Self-Portrait* by Francisco Goya (**figure 5.6**), the face and collar are the lightest areas because they have the fewest hatching lines. These lines are placed at the edge of the nose, the corners of the eyes, and the curves around the mouth and chin to express the three-dimensional character of the features. The lines indicating the hair, the silk top hat, and the curve of the shoulder, in contrast, are close together, producing a rich black. In Matisse's drawing of the woman's back (see figure 5.4), on the other hand, because there is no shading, we have to imagine it. We have no trouble doing so because we identify with the structure of the human form and automatically fill in the visual blanks.

Implied Lines

Explicit lines are generally more characteristic of drawings than of paintings. This is because drawings are composed primarily of lines. In nature, we see edges not by actual lines, as in a drawing, but by shifts in color and lighting. Shifts in color to produce form can be seen in Paul Gauguin's (1848–1903) *Tahitian Landscape* (**figure 5.7**). The white cloud, for example, is not an actual line. It is a shape that moves in a **linear** direction, carrying our gaze diagonally across the sky beginning at the upper left and descending behind the mountains. We call this an **implied line**. Similarly, the orange pathway, along which walks a solitary figure, cuts a curved swath through the field. This orange is not a pure line, but it takes us through the field in a curvilinear motion. In other words, we read it as an implied line, because it travels between two points and moves our eye across the surface.

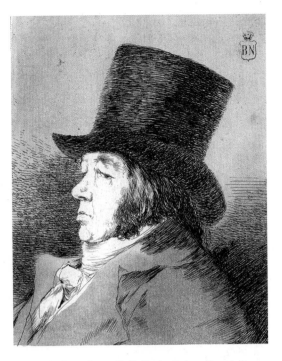

5.6 Francisco Goya, *Self-Portrait*, *Los Caprichos*, Plate I, 1799. Etching, aquatint, drypoint, and burin, 8 1/2 x 5 in. Biblioteca Nacional, Madrid.

> The straight line indicates the infinite, the curve limits creation....
>
> Paul Gauguin, artist (1848–1903)

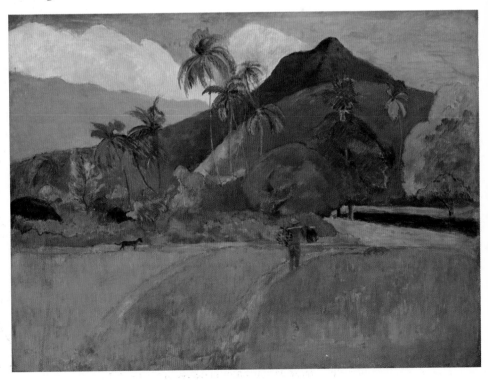

5.7 Paul Gauguin, *Tahitian Landscape*, 1891. Oil on canvas, 26 3/4 x 36 3/8 in. Minneapolis Institute of Arts, Minneapolis. The Julius C. Eliel Memorial Fund.

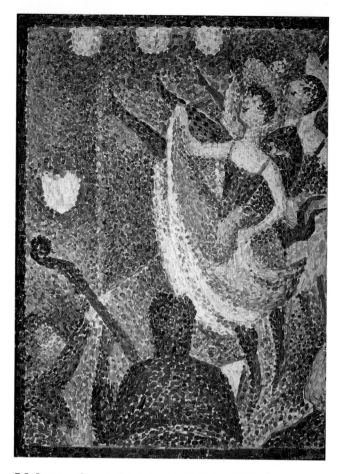

5.8 Georges Seurat, Study for *Le Chahut*, c. 1889.
Oil on panel, 8 ¹/₂ x 6 ¹/₅ in. Courtauld Institute of Art Gallery,
London. © The Samuel Courtauld Trust.
Courtauld, Samuel; bequest; 1948.

When the cloud in Gauguin's landscape meets the mountain, the color shifts from white to brown, without the intermediary of an outline. The same is true of other areas in the painting. As our eye moves from the path to the field, we note a change in the distribution of color. To the right of the path, additional yellows and greens indicate changes in terrain. More abrupt changes define the edges of the palm trees against the sky, the trees against the mountains, and the dog against the landscape.

Now consider the notion of implied line in a painting study by the French painter Georges Seurat (1859–1891) (**figure 5.8**). Here the implied line is used in two ways: as a visual connection between elements, and to create edges that contribute to the structure of the image. We enter the picture visually through the silhouette of the man seen from the back. He is facing away from us, toward the raised legs of the dancers. We thus follow the implied line

> The good painter has to paint two principal things, that is to say, man and the intention of his mind.
>
> Leonardo da Vinci (1452–1519)

of his gaze, which is also implied, for we do not know for sure what he is looking at.

Secondly, we note that in fact there are no lines at all in this drawing. The forms are composed of dots of color, which is characteristic of Seurat's **pointillist** technique (also called **divisionism**). Here, the dancers' legs, which echo the neck of the musical instrument, create implied diagonal lines. They carry our gaze to the left of the picture, counterbalancing the weight of the figures at the right. Notice that the painted frame is missing on the right side. This suggests either that it was removed or that for some reason Seurat decided to eliminate it.

Lines Used to Create Emotional Expression

Lines can convey emotion, especially in the rendition of human features. Thus, Goya appears a bit haughty in his self-portrait (see figure 5.6); the corners of his mouth turn down slightly, as if expressing mild disapproval. The slight squint of his eyes, indicated by the diagonal of his eyebrows, suggests that he is looking down at something or someone. This hint of superiority conveyed by Goya's features is enhanced by the formality of the coat and top hat that elevates him above the assumed object of his own gaze.

In the *Mona Lisa* (see figure 5.5), on the other hand, where *chiaroscuro* is used, the lines are implied rather than actual. At the corners of the mouth, for example, we do not see a literal line. We see instead a line implied by diagonal shading, which conveys the impression of upturned lips that we associate with a smile. Reinforcing this reading is the corresponding diagonal at the corners of the eyes and the edge of the cheekbones. We do not know why Mona Lisa is smiling, any more than we know why Goya looks slightly disapproving, but we sense that she is quite contented and that perhaps she knows something that we do not. In both images, actual and implied lines convey an impression of inner emotion and character.

Now consider the use of line in the set-up **cel** for Walt Disney's 1950 movie *Cinderella* (**figure 5.9**). At this point in the story, Cinderella has been trying to sew her gown so that she can go to the ball. But she is running out of time, because she first had to finish the gowns of her wicked step-sisters and stepmother. The little blue birds perched on the rim of her sewing basket look glum, literally "blue"; the lines of their faces and bodies curve downward, and the idle threads falling from the basket also seem weighted down. But the mice seem hopeful. They have just arrived with a tape measure and a new spool of thread and are confident that with their help Cinderella will make it to the ball. The lines of their

cheerful faces curve upward, and their bright yellow tape measure forms buoyant curls in optimistic anticipation of Cinderella's success.

Space

The cel for *Cinderella* is composed of flat, unshaded areas of color. In the Daumier, Rembrandt, and Goya, however, modeling lines create the illusion of depth, or three-dimensional space. Other techniques are also used to produce the sense of depth on a flat surface. These include:

■ overlapping. In Goya's drawing (see figure 5.6), the figure overlaps the shaded space behind him and thus appears to be in front of it. In Gauguin's landscape, the mountains overlap the sky (see figure 5.7).

■ varying the size of figures or objects in the picture. A larger form generally appears nearer than a smaller form. The woman in the Mona Lisa is larger than the distant landscape forms.

■ placing the base of the nearer figure toward the bottom of the picture. Mona Lisa is also placed at (indeed, is cut off by) the bottom of the picture.

■ foreshortening, or drawing a form in perspective. This makes a form appear to move back and forth, rather than sideways, which compresses the air space in a picture. The torso of Daumier's figure in Young Courier, for example, is foreshortened, creating the impression that his body is turned and occupies three-dimensional space. Similarly, his right arm is foreshortened and appears to extend toward the viewer.

One-Point Perspective

Artists in the Renaissance developed a mathematical theory of **linear perspective** (also called geometric or scientific perspective) to create the illusion of distance. The simplest of these systems is **one-point perspective**. Imagine a person standing in the

> Linear perspective embraces all the functions of the visual lines....
>
> Leonardo da Vinci (1452–1519)

5.9 Disney Studio, Set-up cel for *Cinderella*, 1950. © Disney Enterprises, Inc.

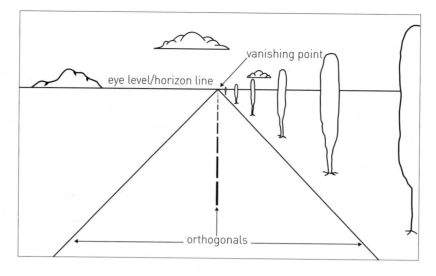

5.10 Diagram of one-point perspective.

middle of a straight road (**figure 5.10**). As the road vanishes into the distance, it seems to narrow, even though in reality its width is constant because the sides of the road are parallel to each other. The illusion of depth is enhanced by the fact that equal-sized and equally spaced objects along the side of the road (trees and shrubs) diminish in size as their distance from the viewer increases.

In a diagram such as this, the **picture plane** (the surface of a painting or relief sculpture) functions as a window, through which the natural world seems visible. When we look out onto nature and see two trees of the same size, the one that is closer to our window will appear larger than the more distant one. This illusion was achieved in the Italian Renaissance through the use of a mathematical system by placing receding lines, called **orthogonals**, at right angles to the picture plane and parallel to each other. The orthogonals can be extended to converge either

within the picture or outside it. The point of convergence is called the **vanishing point**.

Now consider again the diagram in figure 5.10. Notice that the vanishing point is on the horizon, where the sides of the road and the center line (all three of which are orthogonals) converge. This system is used when one side of the objects providing orthogonals is parallel to the picture plane and the other side perpendicular to it. Architectural objects or features, which are typically square or rectangular, are often used for this purpose. The vanishing point draws our attention to a particular area of the picture and places the viewer, like the artist, at a fixed spot, or **vantage point** (**figure 5.11**).

Leonardo da Vinci's great **mural** (wall-painting) of the *Last Supper* (**figure 5.12**) in Milan is a good example of one-point perspective. The scene takes place as if in a three-dimensional rectangular space, with the side walls perpendicular to the back wall

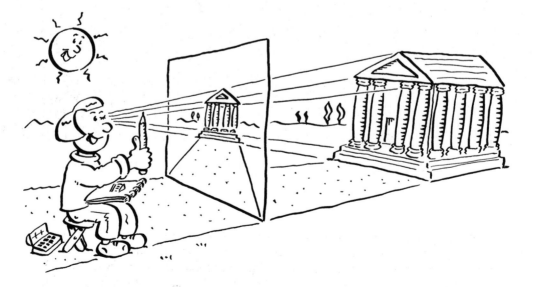

5.11 Alan Pipes, Picture plane diagram, 2003. Pen and ink on paper.

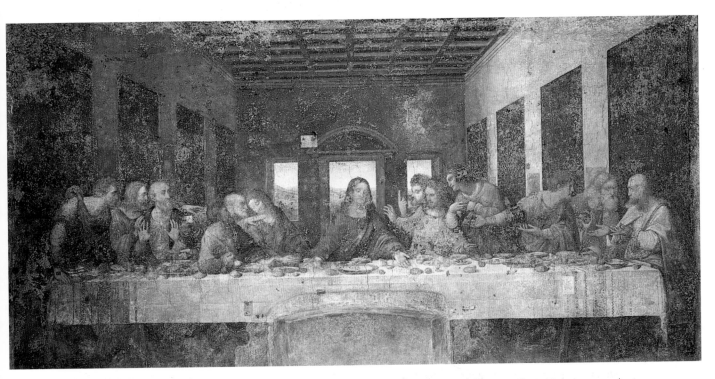

5.12 Leonardo da Vinci, *The Last Supper*, 1495–1498 (before the latest restoration). Fresco, oil, and tempera on plaster, 15 ft. 1 ⅛ in. x 28 ft. 10 ½ in. Santa Maria delle Grazie, Milan.

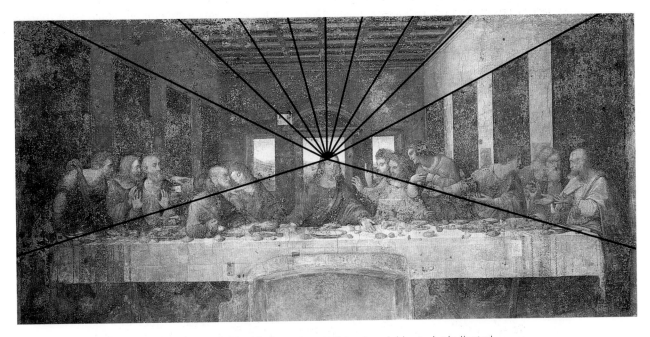

5.13 Figure 5.12 with the orthogonals and vanishing point indicated.

and therefore also to the picture plane—which is equivalent to the actual wall of the room. The side walls in the picture are parallel to the receding lines of the ceiling **coffers** (indented shapes) and to the short sides of the table. If you take a ruler and extend the sides of the table, the receding

coffer lines, and the tops of the tapestries on the side walls, you will find that they all meet at a single point. This is diagrammed in **figure 5.13**. The vanishing point falls at Christ's right eye, which, because the painting is symmetrical, is located at the mathematical center of the picture.

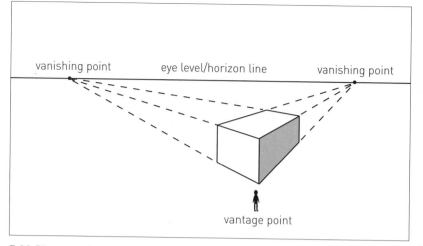

5.14 Diagram of two-point perspective.

Two-Point and Multiple-Point Perspective

Two-point perspective is used when objects in a picture are set at an angle that may not be a demonstrable perpendicular to the picture plane. For example, if the artist stands at a street corner and paints a building diagonally across the intersection on the opposite corner, there will be no facing surface parallel to the picture plane (**figure 5.14**). One-point perspective will not work in this case, because there are two vanishing points widely separated from each other on the horizon. We can see this in Edward Hopper's (1882–1967) *Conference at Night* (**figure 5.15**), where the interior orthogonals are formed by the window ledge and the sides of the tables. These draw us toward the figures and the bright light on the back wall. But outside the room to the left, there are additional lines of sight—in the implied line from one column to another and in the background furniture. These in turn indicate another, mysterious space beyond the main scene that we are made aware of but that we cannot see.

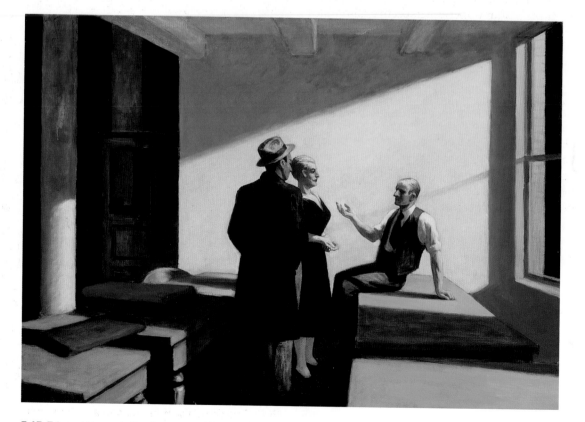

5.15 Edward Hopper, *Conference at Night*, 1949. Oil on canvas, 2 ft. 3 ³/₄ in. x 3 ft. 3 ³/₄ in. Wichita Art Museum, Wichita, Kansas. Roland P. Murdock Collection.

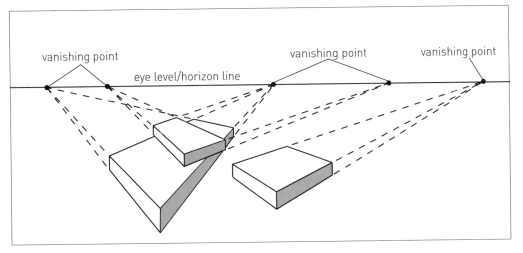

5.16 Diagram of multiple-point perspective.

If a picture contains several buildings or objects, each with its own orthogonals, there can be several vanishing points (**figure 5.16**), in which case the artist has used **multiple-point perspective**. This tends to increase the illusion of distant space even more than one- and two-point perspective, especially if vanishing points are located outside the picture.

Atmospheric Perspective

Another approach to representing depth in a picture is known as **atmospheric perspective** (also called **aerial perspective**). This is used by some Western artists, but is more prevalent in Far Eastern art. There is no single vanishing point or consistent horizon line in atmospheric perspective. Instead, as in **figure 5.17**, the observer looks down on the foreground landscape and straight ahead toward the distant mountains. The near forms are not larger than the distant forms, as they would be in linear perspective, but they are defined more clearly and painted more densely. What makes the distant mountains appear distant is that they fade into a mist, thus losing definition.

> The same thing seen at equal distances will appear larger or smaller according to the extent that the air interposed between the eye and the object is thicker or thinner.
>
> Leonardo da Vinci (1452–1519)

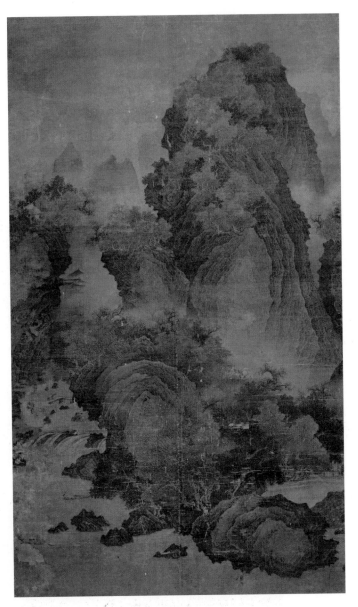

5.17 Tradition of Fan K'uan, *Landscape*, 10th century. Hanging scroll, ink and colors on silk, 5 ft. 9 ⅞ in. x 3 ft. 5 ¾ in. Princeton University Art Museum. DuBois Schanck Morris Collection.

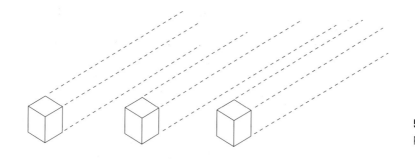

5.18 Diagram of isometric perspective.

5.19 *Princess Humayun Spies Humay at the Gate*, from *Three Poems of Khwaju Kirmani*, 1396. 15 x 9 ³/₄ in. British Library, London.

Isometric Perspective

Isometric perspective is, like atmospheric perspective, more characteristic of Eastern than Western painting, although it is often used by industrial designers in the West. It is a system of indicating depth without a fixed viewpoint, as shown in the diagrams of cubes in **figure 5.18**. The scene in **figure 5.19** illustrates a Persian poem in which Prince Humay is inspired by a dream to seek the beautiful Princess Humayun. Here, he has just arrived at her castle gate and addresses her as she appears on a tower balcony overlooking the walled gardens. The excitement implied in their meeting is reflected in the birds flying overhead. Notice that the receding lines of the gate, as well as those of the castle, will never meet, and we thus have the impression of a potentially infinite distance.

Absence of Perspective in Ancient Egypt

Artists who use perspective systems tend to represent views of the natural, three-dimensional world. But suppose an artist does not want to represent the natural world. What if the artist prefers to represent a conceptual rather than a perceptual world? How would he or she do this?

In ancient Egypt, artists did not use perspective. They represented forms and figures as they are conceived in the mind and not as they are perceived in nature. This can be seen in an illustration from the *Book of the Dead* (**figure 5.20**), texts that were buried with the dead as guides for the journey through the Egyptian Underworld to the afterlife.

The example in figure 5.20 shows four blue baboons squatting around a lake of fire. In contrast to a picture using perspective, we do not see the baboons as we would if we were looking at them from a fixed vantage point. Instead, we look down on the lake from above, so that it appears flat—like a floor plan; the zigzags represent water and their dark red color denotes fire. Two of the baboons are right side up, and two are upside down, indicating that each is at a corner of the lake. But we see them as the Egyptian painter conceived of them, and not in the way they would appear to an actual observer.

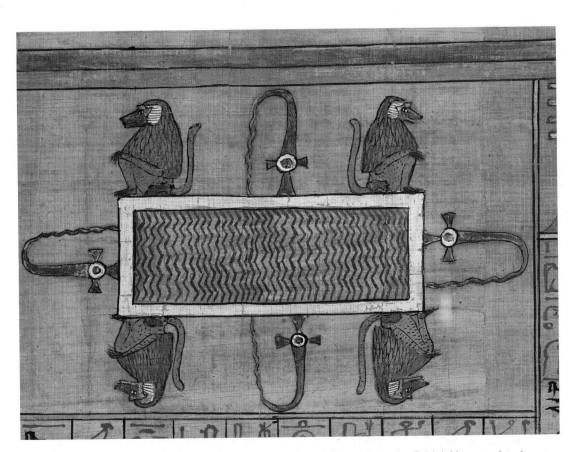

5.20 Spell 126 from the *Book of the Dead*, New Kingdom, Egypt. Papyrus. British Museum, London.

Shape and Mass in Sculpture

So far we have considered how lines create illusions of shape, mass and depth, light, dark, and shading in drawings and paintings, which are flat, two-dimensional surfaces. Sculptures, however, are three-dimensional and their space and depth are real.

The wide variety of spatial possibilities available to the sculptor can be seen in a comparison of the bronze *Chariot* (**figure 5.21**) of 1950 by the Swiss artist Alberto Giacometti (1901–1966) with the Early Classical Greek *Charioteer* from Delphi (**figure 5.22**). Both figures stand in strong vertical planes, but Giacometti's charioteer is thin and appears frail. He is nearly overwhelmed by the large, circular chariot wheels. Although they have real weight, and rest on thick blocks, their thin proportions, open spaces, and delicacy create an impression of lightness.

> **Art and science mean trying to understand.**
>
> Alberto Giacometti, sculptor (1901–1966)

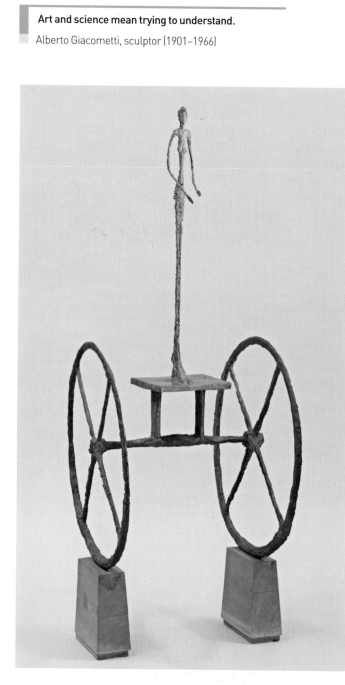

5.21 Alberto Giacometti, *Chariot*, 1950. Bronze, 57 in. x 26 in. x 26 ⅛ in. Museum of Modern Art, New York. Purchase.

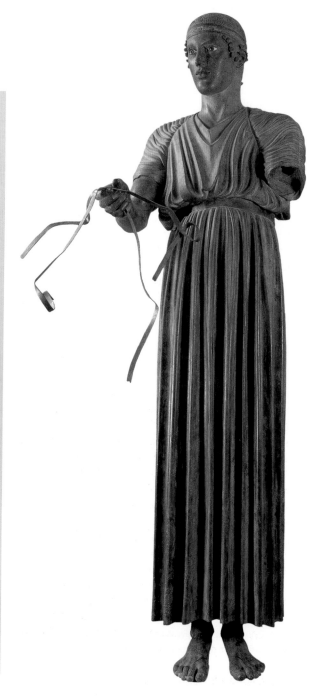

5.22 *Charioteer of Delphi*, 470s B.C. Bronze, 5 ft. 11 in. high. Delphi Museum, Greece.

The *Charioteer* from Delphi, by contrast, is a massive columnar form. This is consistent with the figure's character, as he grasps the reins and focuses intently on driving the chariot and controlling the horses. Giacometti's figure seems tentative in comparison, lost in the open spaces surrounding its form, whereas the figure from Delphi seems assertive. We might say that the Giacometti is a more linear figure—that is, it is more like a line—than the Delphic *Charioteer*. We might even conceive of it as a "drawing" in space. When we view the Greek figure, on the other hand, we do not focus on its lines, although they are there in the drapery folds, the hair, and the facial features. The actual bulk of the form and its closed contour increases the charioteer's volume.

An interesting aspect of these two sculptures is that both figures have a strong sense of presence despite very different degrees of mass. Because they represent human figures, they evoke our physical identification with them. The Delphic *Charioteer* strikes us as forceful, sturdy, and solid. But if we put ourselves in the place of Giacometti's charioteer, we can almost imagine fading out of existence. Although the curved arms of the charioteer create the impression that he is alive and grasping the reins, he is so thin that he seems to defy physical reality. He is at the very border between presence and absence. As a result, the sculpture has a psychological force that summons it back into existence and denies its own frailty.

Texture

Another visual element at the artist's disposal is texture, a term that comes from the Latin word *texo* (meaning "I weave"). Texture refers to the sense of **tactility** (the degree to which the surface of an object has, or seems to have, a particular feel). Surface textures may be described by adjectives such as rough or polished, hard or soft, firm or fluffy, coarse or fine, cold (like steel) or warm (like wood), shiny or matte, stiff or pliable.

In the visual arts we talk about actual (real) and simulated (implied) textures. The former depends on the physical material of the medium and the artist's manipulation of it, whereas the latter is an illusion of texture. As with other formal aspects of the visual arts, we enter into the fiction of simulated texture through a combination of what we perceive with our eyes and our previous experience of a given texture.

Actual Texture in Sculpture

With sculpture, in contrast to painting, texture generally refers to the actual surface quality of a work.

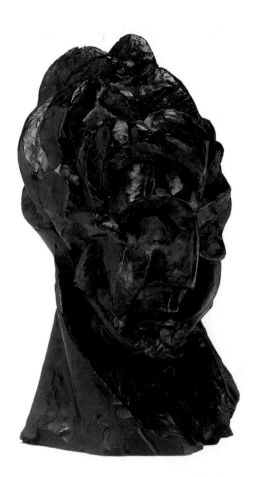

5.23 Pablo Picasso, *Head of a Woman*, (Fernande), model, 1909, cast before 1932. Bronze (cast), 16 ¼ x 8 ¹/₁₆ x 10 ¹/₁₆ in. National Gallery of Art, Washington, D.C. Patrons Permanent Fund and Gift of Mitchell P. Rales.

> An idea is a beginning point and no more. If you contemplate it, it becomes something else.
>
> Pablo Picasso (1881–1973)

We can see this by comparing two bronze statues having different textures. Picasso's *Head of a Woman* of 1909 (**figure 5.23**) is a **Cubist** work and reflects the twentieth-century style in which artists used fragmented planes to create solid geometric shapes. This work is thought to have been the first Cubist sculpture. Notice that Picasso has disrupted the natural relationship of the facial features to each other, that the neck is to the side of the head rather than directly below it, and that the hair resembles a crystalline structure rather than strands.

From the point of view of texture, our eyes tell us that the surface of the bronze is rough and uneven. We sense that, if we ran our hands over the sculpture, we would feel the shifting planes, the sharp point at the tip of the nose, and the textured surface of the material itself.

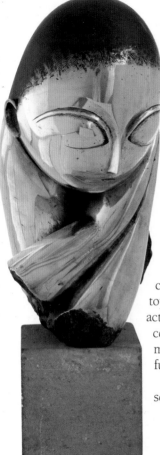

5.24 Constantin Brancusi, *Mademoiselle Pogany*, Version I, 1913, after a marble of 1912. Bronze on limestone base, 17 ¹/₄ x 8 ¹/₂ x12 ¹/₂ in. Museum of Modern Art, New York. Acquired through the Lillie P. Bliss Bequest.

Brancusi's famous *Mademoiselle Pogany* (**figure 5.24**), in contrast to Picasso's *Head of a Woman*, is highly polished bronze. Only the top of the head, which resembles hair, and the space below the detached arms are unpolished. We can see that the polished surface is shiny and smooth in contrast to the rougher texture of the top of the head. As a result of these actual textures, and the smooth, curved contours, Brancusi's bronze appears more elegant, sleeker, and more graceful than Picasso's.

Most of us are used to the idea that sculptures are made of hard materials such as bronze, marble, and wood. But in the 1960s, the American sculptor Claes Oldenburg (b. 1929) created many works out of vinyl, cloth, and canvas. The results are often unexpected. In *Soft Typewriter* of 1963 (**figure 5.25**), for example, we are surprised and amused by the unlikely idea of trying to type on a soft typewriter. Not only are real typewriters (and computers) made of hard materials, but they would be unusable as Oldenburg creates them.

Those of us who spend hours at our computers (or typewriters, if we are over 60) often feel weary at the end of a day. Think how the typewriter (or computer) feels. That is part of Oldenburg's humor in this sculpture. He displaces the fatigue of the worker onto the machine. His typewriter also seems to be watching us, and the more we look at it, the more it looks like a face. The ribbon spools resemble eyes, the keyboard resembles a large grimacing mouth with teeth, and the bunched-up vinyl at the center resembles a nose. Our response to the sculpture is thus two-fold: it is both visual and tactile, for we realize that, in contrast to works made of hard materials, we could actually squeeze the *Soft Typewriter* and change its shape.

> The reason I have done a soft object is primarily to introduce a new way of pushing space around in a sculpture or painting.
>
> Claes Oldenburg (b. 1929)

5.25 Claes Oldenburg, *Soft Typewriter*, 1963. Vinyl, kapok, cloth, and Plexiglas, 27 ¹/₂ x 26 x 9 in. Private Collection.

5.26 Jean-Auguste-Dominique Ingres, *Napoleon on his Imperial Throne*, 1806. Oil on canvas, 8 ft. 8 in. x 5 ft. 5 ¼ in. Musée de l'Armée, Paris.

Implied and Actual Texture in Painting

The portrait of Napoleon enthroned (**figure 5.26**) by the French painter Jean-Auguste-Dominique Ingres (1780–1867) is an example of implied (simulated) texture. In this case, if we touch the painting, we will feel a smooth surface, since the paint is uniformly applied to the canvas. But when we focus on the painted materials, we see a number of textural illusions. Napoleon is represented as an ancient Roman emperor and the textures are designed to convey his imperial power. He wears a gold laurel-wreath crown, a delicate lace collar, a red velvet cape with ermine lining and a wide ermine collar, and elaborately embroidered shoes in gold. Beneath his throne is a thick carpet containing the image of an eagle, which was the emblem of the ancient Roman legions. We recognize and can imagine the feel of these materials because of the artist's skill in creating illusions of texture.

Texture in a painting can be actual as well as implied. In the brilliantly colored *Angry Landscape* (**figure 5.27**) by the Dutch artist Karel Appel (1921–2006), for example, real texture is created by the use of dense **impasto** (thickly applied paint). Appel varied the thickness of the paint, as well as the bright colors and energetic diagonals, to convey a dynamic mood propelled by a sense of anger. Accentuating this mood are the expressions on the three faces embedded in the paint. Appel's actual paint texture contributes to the animated vitality of the image.

5.27 Karel Appel, *Angry Landscape*, 1967. Oil on canvas 4 ft. 3 ¼ in. x 6 ft. 4 ¾ in. Private Collection.

Time

Time and Motion

Time and motion in paintings and sculptures are expressed in a number of different ways. Most paintings do not actually move, and therefore the sense of time can be implied. In Duchamp's *Nude Descending a Staircase* (**figure 5.28**), for example, a sequence of time—the time it takes to walk down a staircase—is implied by superimposed images of a single figure. She is shown in different stages of descent, beginning at the upper left and proceeding to the lower right. Her geometric shapes create a mechanical appearance, and the repetition is derived from still sequences of film. We can see from the tilt of her head and the shifting diagonals of her torso and legs that she is meant to be in motion—an impression enhanced by the curves to her right.

In describing his *Nude*, Duchamp wrote:

> My aim was a static representation of movement—a static composition of indications of various positions taken by a form in movement—with no attempt to give cinema effects through painting.[1]

Figure 5.29 shows the use of film to record actual motion by a sequence of still scenes. In this case, Thomas Edison (1847–1931) recorded *Fred Ott's Sneeze*, which is thought to be the earliest example of a motion picture. As with Duchamp's nude, the sequence of the sneeze is shown , but in a series of individual frames rather than within a single frame.

5.28 Marcel Duchamp, *Nude Descending a Staircase No.2*, 1912. Oil on canvas, 4 ft. 10 in. x 2 ft. 11 in. Philadelphia Museum of Art. Louise and Walter Arensberg Collection. no. 1950-134-59.

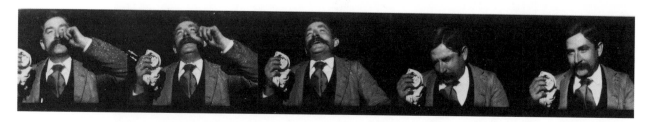

5.29 Thomas Edison and W.K. Dickson, *Fred Ott's Sneeze*, 1889. Film frames.

With the development of **kinetic** (moving) sculpture in the early twentieth century, actual motion became possible. Alexander Calder was a pioneer of this technique, having created works that are moved by air currents (see figure 1.7). He hung them from the ceiling and credited Duchamp with naming them mobiles. In *Sea Scape* (**figure 5.30**), Calder used thin wires suspended from rods of sheet metal and attached them to wooden shapes that evoke the sea. The abstract representations of red, yellow, green, and blue fish, white bones, and a blue star are reminiscent of the colorful children's toys that Calder constructed. They have a playful quality, which is accentuated by the chance movements caused by changes in air currents.

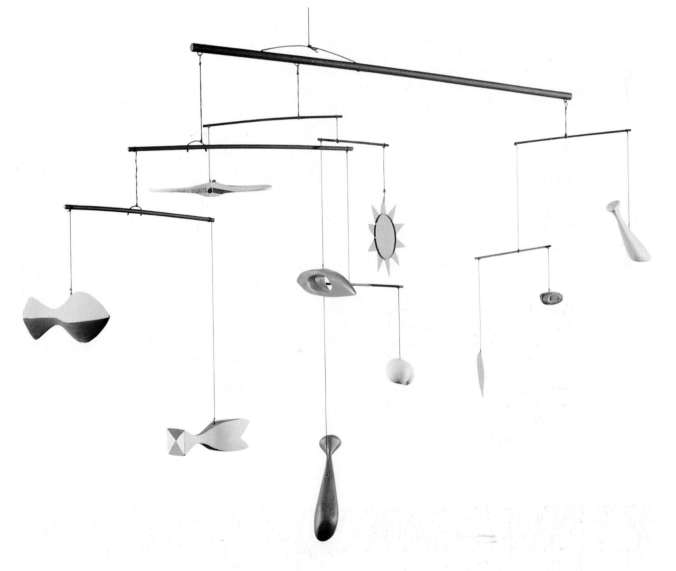

5.30 Alexander Calder, *Sea Scape*, 1947. Painted wood, sheet metal, string, and wire. 36 ½ x 60 x 21 in. Whitney Museum of American Art. Purchase with the funds from the Howard and Jean Lipman Foundation Inc.

Time and Space in Renaissance Painting

During the Italian Renaissance, Sassetta (c. 1400–1450) depicted the passage of time by including two scenes in a single frame in his *Marriage of Saint Francis to Lady Poverty* (**figure 5.31**). The first and main scene takes place in the foreground. It shows Saint Francis placing a ring on Lady Poverty's finger; she is flanked by women personifying Obedience and Chastity. The saint's faithful companion, Brother Leo, observes the ceremony from the left. In the second scene, which occurs *after* the ceremony, the three women fly off to the upper right

and Lady Poverty gazes wistfully back at her spiritual wedding. Sassetta thus shows the passage of time by repeating the three women. When we first see them, they face Saint Francis (to our left), and then we see them again turned around, soaring upward (in the opposite direction) and forming a graceful diagonal curve.

Italian Renaissance artists, concerned with three-dimensional space, often used space as a means of showing different periods of time. In Fra Angelico's *The Annunciation* (**figure 5.32**), for example, time corresponds to space. The main scene, in which the angel Gabriel announces to Mary that she will be the mother of Jesus, occurs in the present. The Holy Spirit (the white dove) hovers over Mary's head. The **roundel** over the central column contains the stone figure of an Old Testament prophet, signifying that he has outlasted human time.

In the upper left corner of the painting, we can see the stonelike figures of Adam and Eve being expelled from the Garden of Eden. The Bible marks the Expulsion as the beginning of human time, when the primal couple entered the real world of work and suffering. In Christian tradition, Mary and Jesus redeem the Original Sin of Adam and Eve, making them the new Adam and Eve. Fra Angelico shows the distant past in a distant space. The past is small and far away, and the present, which is here and now, looms large in our consciousness.

Renaissance painters also used distance to denote the future. This is the case in Masolino's fresco illustrating *The Feast of Herod* and *Salome Presenting the Head of John the Baptist to Herodias* (**figure 5.33**). Here, as in *The Annunciation*, the present events take place in the foreground, where Herod feasts and Salome offers the head of John the Baptist to her mother, Herodias. Far in the background, on a distant mountain, is the small scene of John's burial. In contrast to the Fra Angelico, where we are reminded of the past by a distant image, in the Masolino we look into the distance and see a future event.

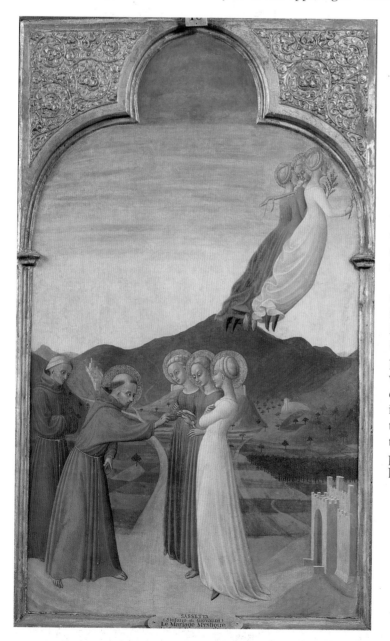

5.31 Sassetta, *Marriage of Saint Francis to Lady Poverty*, from the *San Sepolcro Altarpiece*, 1437–1444. Tempera on panel, 34 5/8 x 20 1/2 in. Musée Condé, Chantilly, France.

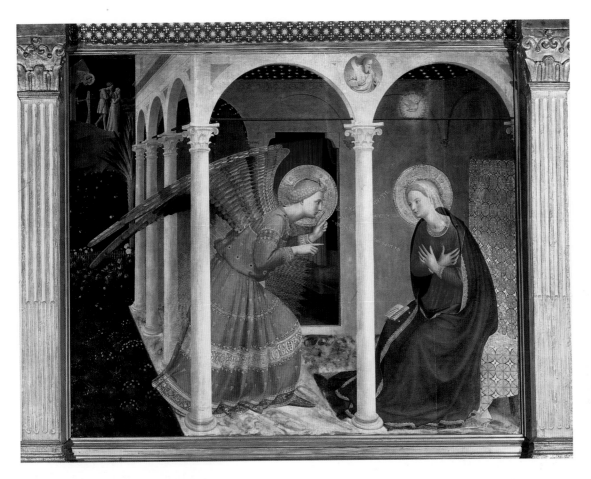

5.32 Fra Angelico, *The Annunciation*, 1430s. Tempera and gold on wood panel, 5 ft. 3 in. x 5 ft. 11 in. Museo Diocesano, Cortona, Italy.

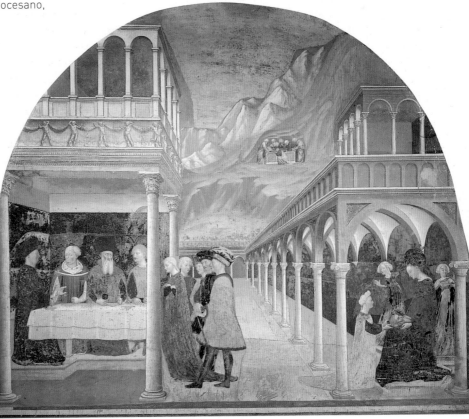

5.33 Masolino da Panicale, *The Feast of Herod* (left) and *Salome Presenting the Head of John the Baptist to Herodias* (right), 1435. Fresco. Baptistry, Castiglione d'Olona, Italy.

Another way in which Renaissance artists dealt with time was to combine two scenes so that they appear to be one. This is what Castagno did in *The Youthful David* (**figure 5.34**). The biblical hero David launches the stone from his slingshot at the giant Philistine Goliath. We do not see Goliath alive, but we know from the story that he is David's opponent. Instead, we see Goliath's severed head between David's feet and we know that time must have elapsed. David's stone has hit its mark and Goliath has been felled. David has decapitated his enemy and now stands over Goliath's head. These intervening events have been eliminated from the picture, enabling us to see the beginning and the end of the episode simultaneously.

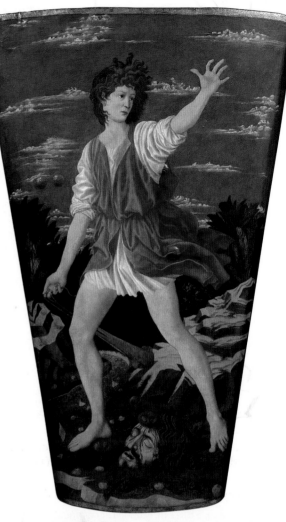

5.34 Andrea del Castagno, *The Youthful David*, c. 1448. Tempera on leather mounted on wood, 45 in. x 20 ¼ in. x 16 ⅛ in. National Gallery of Art, Washington, D.C. Widener Collection.

> ... we see that the quality of colors is revealed by means of light.

Leonardo da Vinci (1452–1519)

Light and Color

The most striking visual elements are light and color. Trying to imagine a world in black and white makes us realize the extent to which we are surrounded by different colors. In order to see color, we need light, and in order to see three-dimensional form, we need gradations of light and dark, or shading.

Expressive Qualities of Light and Color

Although personal responses to color vary, certain colors appear to have intrinsic qualities. Bright or warm colors can convey gaiety and happiness. Red, orange, and yellow are considered warm colors, whereas blue is considered a cool color. Associations to color differ in different cultures. In China, for example, red is the color of weddings. In the West, white is the traditional color of weddings, because it is associated with purity. In China, however, white is the color of funerals.

In the West, blue can evoke sadness and pessimism, which is characteristic of Picasso's Blue Period works of 1901 to 1903. His *The Blind Man's Meal* of 1903 (**figure 5.35**) is essentially **monochromatic**; that is, a single color predominates. In this case the predominant color is blue, which corresponds to the "blue" mood of the blind man who holds a piece of bread in one hand and gently feels the surface of a jug with the other. An empty

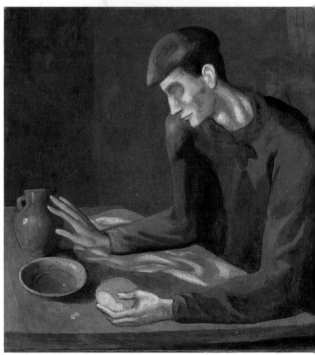

5.35 Pablo Picasso, *The Blind Man's Meal*, 1903. Oil on canvas, 3 ft. 1 ½ in. x 3 ft. 1 ¼ in. The Metropolitan Museum of Art, New York. Purchase, Mr. and Mrs. Ira Haupt. Gift, 1950 no. 50.188.

blue dish echoes the emptiness of the man's existence without sight, a subject that interested Picasso early in his career and is an obvious preoccupation for a painter. The blue is consistent with the man's mournful expression and quiet demeanor and it reinforces the pessimistic character of the subject matter.

Now compare Henri Matisse's *The Roofs of Collioure* (**figure 5.36**) with *The Blind Man's Meal*. In Matisse's picture, the colors are vibrant, consistent with the bright light of the Mediterranean coast in summer. The rich oranges, bright patches of pure yellow and red, and strong juxtapositions of warm color make this picture seem to pulsate with heat. Red predominates, not only in its pure form, but also as a component color of orange, pink, and lavender. Note that in the foreground a red-orange also contains patches of green, while there are yellows in the lavender mountain across the water. By placing cool colors next to warm colors, Matisse emphasizes their difference and accentuates the vivid intensity of summer in the South of France.

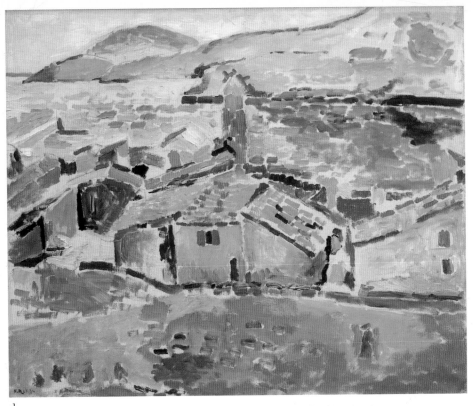

5.36 Henri Matisse, *The Roofs of Collioure*, 1905. Oil on canvas, 23 ³/₈ x 28 ³/₄ in. The Hermitage Museum, St. Petersburg, Russia.

> When I have found the relationship of all the tones, the result must be a living harmony of tones, a harmony not unlike that of a musical composition.
>
> Henri Matisse (1869–1954)

Symbolic Meanings of Light and Color

Keeping in mind cultural differences, we recognize that colors can have many symbolic meanings, some of which are reflected in everyday language. Red is associated with fire, which can be both dangerous and exciting. A "red-letter day" is one that is filled with excitement. "Waving a red flag in front of a bull" is a sign of provocation, but "rolling out the red carpet" denotes welcoming a distinguished visitor. We also use red to warn of danger in our traffic signs; the STOP sign is a red octagon, and a red light means "stop." A green light, on the other hand, means "go," and to "give a green light" denotes giving permission.

Even within Western culture, specific meanings of color can vary according to time and place. Green can indicate envy and we might call a jealous neighbor "green with envy" if we have an expensive new car parked in our driveway. Similarly, we might say that our neighbor is "purple with rage" if our car drives over his flowerbed. When we tell jokes that are both funny and negative, we acknowledge their contradictory nature by referring to them as examples of "black humor."

In ancient Greece and Rome, the color purple had a special status that does not necessarily apply today. In antiquity, purple was considered beautiful because its brilliant luster was believed to contain an inherent heavenly light. Produced from the murex (a species of shellfish), purple was an expensive dye that retained its color for a long time. Purple was also associated with high status. At first its use in Rome was restricted to senators and other high government officials; later, only the emperor had the right to wear purple cloth. Any one else found wearing, or even owning, purple garments risked a stiff fine.

In Byzantine art, when Christ wears purple, he is depicted as both royal and divine. In the apse of San Vitale, in Ravenna, which we discussed in Chapter 3, he is the king of heaven, extending a crown in his right hand. The red clouds suspended above Christ allude to the colors of sunrise and the tradition of Christ's death and resurrection in the East (where the sun rises). They also show that this scene is taking place in a spiritual, rather than a natural, space. This reflects the ancient association of red with divine light. Like purple, red was related to gold, all three having royal and heavenly connotations. Red was the color of the sun and of the sun god Apollo in

COMPARE

Apse mosaic, San Vitale.
figure 3.12, page 44

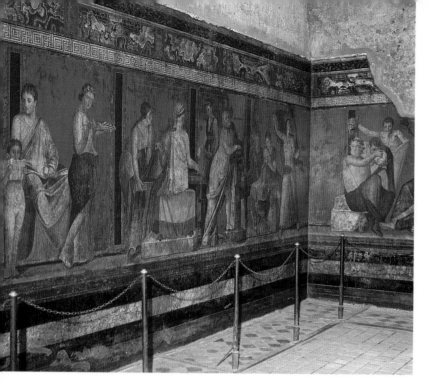

Greece, and was used in Rome on walls of buildings where sacred rites were performed. In the Roman Villa of the Mysteries (**figure 5.37**) in Pompeii, for example, we can see the rich red background against which a mystery rite is being enacted.

Black also has a number of symbolic meanings. In the ancient world, it was associated with bile, believed to be the body's depressive or melancholic humor. Christian symbolism tends to associate black with darkness and evil. White, on the other hand, denotes spirituality and purity in Christian art. In Filippino Lippi's (1457/8–1504) *Vision of Saint Bernard* (**figure 5.38**), the saint wears the white robe of the Carmelite Order with light-orange highlights as the Virgin and a group of angels appear to him beneath an aura of heavenly light. Hiding under a rock at the right is a barely visible devil who reinforces the association between evil and darkness.

5.37 Ritual scene from the Villa of the Mysteries, near Pompeii, c. 65–50 B.C. Fresco.

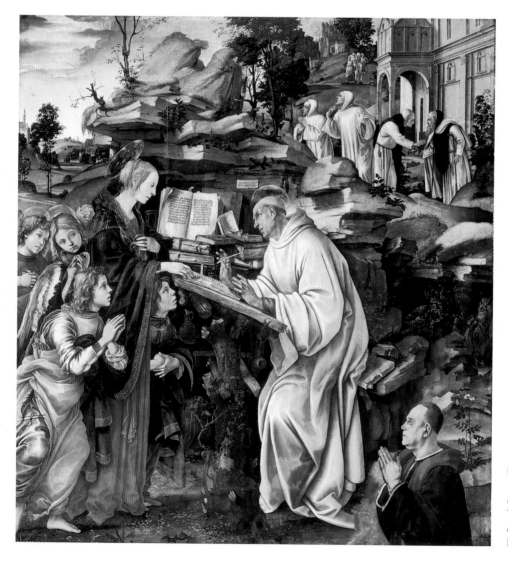

5.38 Filippino Lippi, *Vision of Saint Bernard*, c. 1485–1490. Tempera on wood panel, 6 ft. 10 in. x 6 ft. 4 ¾ in. Badia, Florence.

Light as the Source of Color: the Visible Spectrum

For centuries, the exact connection between light and color was a subject of intellectual debate. Complex color scales were constructed; light was considered more important than color by some and less important by others.

According to modern color theory, light is the source of visible color. This was discovered by the English scientist Sir Isaac Newton (1642–1727) in 1666, when he observed that a ray of light passing through a prism is refracted (split up) into what we call the visible spectrum (**figure 5.39**). In other words, Newton found that a single beam of white light is composed of all the colors of the spectrum.

Angelica Kauffmann's (1741–1807) *Self-Portrait as "Colour"* (**figure 5.40**) shows her identification with the colors of the rainbow. A rainbow is formed when light is refracted through raindrops, which act like a prism, to produce the visible spectrum. In Kauffmann's allegory, the painter paints the rainbow, whose arc echoes the frame of the picture, displaying a formal linear unity as well as color harmony. The refracted light of the rainbow becomes color, which recurs elsewhere in the painting—the rich red cloak, the yellow skirt, the muted greens of the foliage, and the blues defining the sky. As the embodiment of Painting, Kauffmann depicts herself in command of nature's color, which is the source and inspiration for the painter's color.

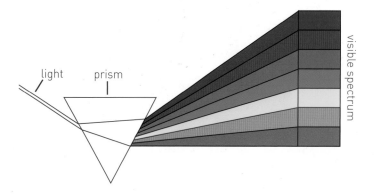

5.39 The visible spectrum.

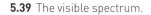

5.40 Angelica Kauffmann,
Self-Portrait as "Colour", 1778–1780. Oil on canvas,
4 ft. 4 in. x 4 ft. 11 in. © Royal Academy of Arts, London 2001.

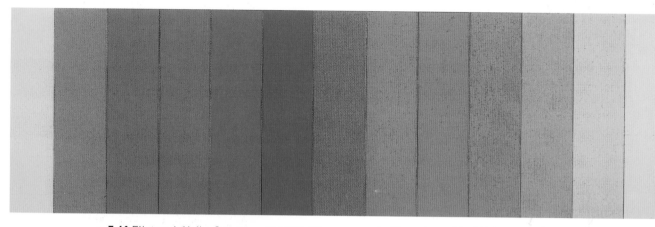

5.41 Ellsworth Kelly, *Spectrum III*, 1967. Oil on canvas in 13 sections, 2 ft. 9 ¼ in. x 9 ft. ⅝ in. Collection of Anne and John Marion, Fort Worth, Texas.

In *Spectrum III* by Ellsworth Kelly (b. 1923) (**figure 5.41**), the subject of the work is color—in this case, the colors of the rainbow. We see a progression, as in a musical scale, that moves from one color to another in logically graduated steps.

Although a single beam of light contains the colors of the spectrum, individual objects have different colors. This is because they absorb certain color waves and reflect others. When light is completely absorbed by an object, we see it as black. Conversely, if no light is absorbed by an object (because it is completely reflected), then we see white. Pure white reflects all color waves; absolute black reflects no light at all; and shades of gray reflect gradations of light. The more the light is reflected, the lighter the gray. We see a green pepper as green because it absorbs all colors except green, which is reflected. Green is the **local color** of the pepper, that is, its color under normal lighting conditions.

> In my work, it is impossible to separate the edges from the mass and color.
>
> Ellsworth Kelly, artist (b. 1923)

The Color Wheel

Relationships between color have been diagrammed in a number of ways throughout history. **Figure 5.42** is the conventional **color wheel**, which is based on the relationships of the **primary**, **secondary**, and **tertiary colors** to each other. These are indicated in the diagram by the numbers 1, 2, and 3, respectively. The farther away from each other hues are on the color wheel, the less similar they are and the stronger their contrast. Colors opposite each other on the wheel (**complementary colors**) create the strongest contrasts. This can be seen in the diagram juxtaposing the complementary colors (**figure 5.43**).

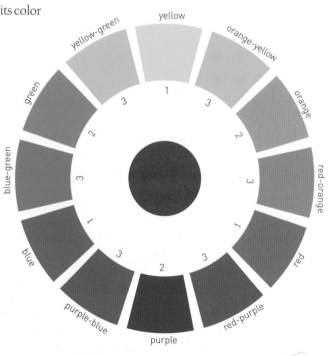

5.42 The conventional color wheel.

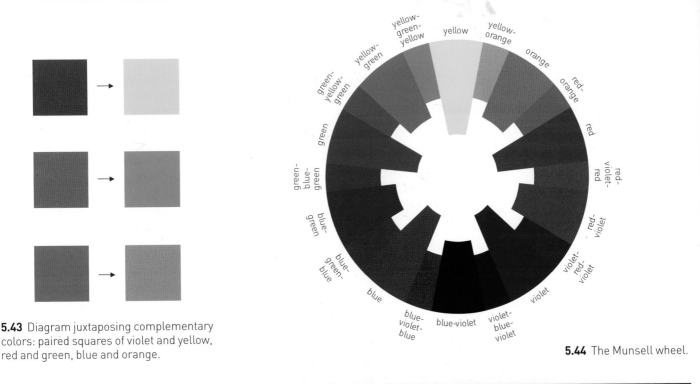

5.43 Diagram juxtaposing complementary colors: paired squares of violet and yellow, red and green, blue and orange.

5.44 The Munsell wheel.

5.45 The 10-step value scale.

But this is only one of many different color wheels. Consider the wheel in **figure 5.44**, which has twenty colors. It was designed by the color theorist Albert Munsell (1858–1918), who called five main colors **principals** (rather than primaries); in addition, there are five secondaries, and ten tertiaries. The principals are red, violet, blue, green, and yellow. The secondaries are based on the **afterimage** effect of looking at certain colors; these afterimages occur when we stare at a single color and then look at a plain white. When we stare at a yellow, the afterimage is blue-violet, which is the secondary color opposite yellow on Munsell's wheel. When we stare at a red, the afterimage is blue-green. When we stare at a green, the afterimage is red-violet. Munsell designed his wheel so that the color of the afterimage would be opposite the original color. His system became the standard used in the United States and it reflects the way we perceive colors in nature.

The **value**, or **tone**, of a color—or of blacks and grays—refers to its relative lightness or darkness. The ten-step value scale in **figure 5.45** shows the absolute value of different lights and darks. Colors, as we see them on the conventional color wheel, are relatively pure values, but they can be brightened or darkened by adding white or black. When artists darken colors, they **shade** them by adding black. To lighten a color, the artist **tints** it by adding white.

Intensity, or **saturation**, depends on a color's relative brightness or dullness. In total darkness we are unable to perceive any color (or light) at all. In a dimly lit room, we see muted colors, and on a bright, sunny day, colors are intense. Artists alter the intensity of colors by adding white, black, or gray, according to a desired amount of value. Adding white to pure blue creates light blue, which decreases the intensity of the blue and reduces value. Adding black lessens the intensity, but increases the value. If gray of the equivalent value to the blue is added, the blue is less intense but the value is the same. Another way of changing a color's intensity is to add its complementary color. This reduces intensity and creates a more neutral color than either of the two component colors.

Physical Properties of Color

The colors in the spectrum vary according to three characteristics: hue, value, and intensity.

Hue is the name of a color—red, yellow, blue, and green designate different hues. In modern color theory, red, yellow, and blue are the primary colors of the conventional color wheel. They cannot be made by mixing other colors, but all other colors can be created by mixing primary colors in different proportions. The twentieth-century Dutch painter Piet Mondrian (1872–1944) believed that balance and

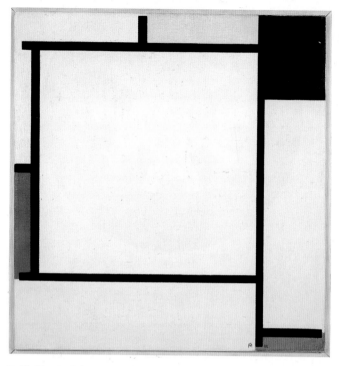

5.46 Piet Mondrian, *Tableau 2 with Yellow, Black, Blue, Red, and Gray*, 1922. Oil on canvas, 21 ⅞ x 21 ⅛ in. The Solomon R. Guggenheim Museum, New York. © 2006 Mondrian/Holtzman Trust c/o HCR International, Warrington, VA.

5.47 Juxtaposed analogous colors.

5.48 Juxtaposed complementary colors.

5.49 Juxtaposed triangles of different colors.

harmony in a painting were achieved by purity of form, line, and color. His signature style thus consists of works composed of black verticals and horizontals and pure primary colors. With these, he was able to create images of impressive vibrancy, which are at once carefully balanced and imbued with tension (**figure 5.46**).

Mixing two primary colors produces a secondary color. Yellow and blue produce green; blue and red produce purple; red and yellow produce orange. A tertiary color is a mixture of a primary color and an adjacent secondary color. Mixing green (a secondary, which already contains blue) with more blue (a primary) produces a blue-green; mixing purple (a secondary also containing blue) with more blue produces a blue-purple. The number of colors is limited to what the eye can see, but proportions of each mixture can be varied indefinitely. In most cases, assuming good lighting conditions, the average viewer can distinguish several thousand different colors.

Analogous hues contain a common color in different proportions; their combination results in an impression of color harmony. Since green contains blue, they are analogous. The diagram in **figure 5.47** shows the impression of harmony produced by juxtaposing analagous colors.

Optical Effects of Color

Color has a strong impact on our perceptions, a fact that is reflected in language. We might say, for example, that our ideas have been "colored" by something or by someone. Similarly, when certain colors are juxtaposed in a work of art, or in any image, we perceive them differently than when we see them individually. If complementary colors are juxtaposed, we perceive them as more intense (**figure 5.48**). The result is called **simultaneous contrast**.

Since bright color is more eye-catching than muted color, it appears to advance in space. A bright yellow, red, or orange triangle next to a dull blue, green, or blue-green triangle of the same size will seem closer to the viewer (**figure 5.49**). Color thus affects ("colors") the way we see size and space.

Our eyes can also simulate the effect of mixing colors, a process known as **optical mixing**. This happens when two hues are placed next to each other and our eyes combine them as if they are actually mixed. The effect is particularly convincing when the artist uses dots of color as Seurat did. Dots of color placed next to each other tend to merge into their combined color (**figures 5.50 a, b**, and **c**). Notice that the colors seem to change depending on the degree to which the figure at the right is enlarged.

Now that we have surveyed individual visual elements of art, we turn to ways in which artists

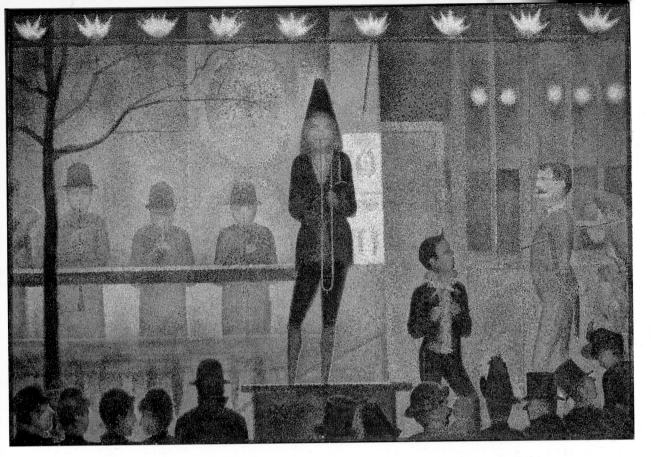

5.50a Georges Seurat, *Circus Sideshow*, 1887–1888. Oil on canvas, 3 ft. 3 ¾ in. x 4 ft. 11 ⅛ in. The Metropolitan Museum of Art, New York. Bequest of Stephen C. Clark, 1960. no. 61.101.17.

5.50b (Left) Detail of 5.50a, showing the enlargement of the standing figure at the right.

5.50c Detail of 5.50b showing further enlargement of the head of the standing figure.

organize them into a final product. Ordinarily, when we look at an image, we do not think of it in terms of its individual elements. Rather, we apprehend it as a totality, and only explore its structure when attempting a visual analysis. This is a useful learning exercise, because it teaches us the components of the visual artist's thought. In addition, to enable us to describe the effect of a work, we will consider the terminology of art as well as its design.

Van Gogh's *Starry Night*

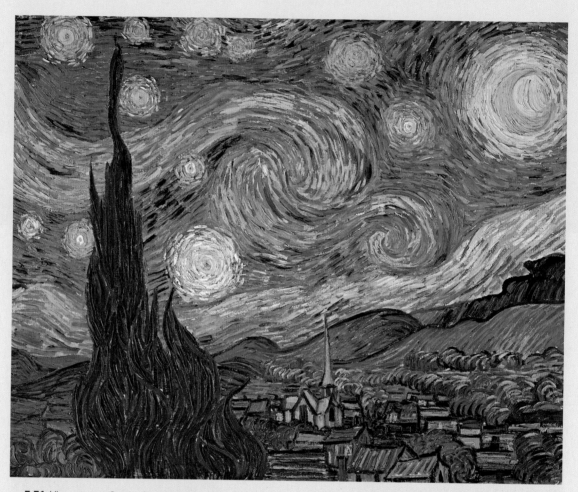

5.51 Vincent van Gogh, *Starry Night*, 1889. Oil on canvas, 2 ft. 5 in. x 3 ft. ¼ in. The Museum of Modern Art, New York. Acquired through the Lillie P. Bliss Bequest.

Vincent van Gogh's (1853–1890) *Starry Night* (**figure 5.51**) represents a landscape of rolling hills, a small village nestled in a valley, a pair of cypress trees in the foreground, and a star-studded sky with a bright orange moon. Since we recognize the subject matter with no difficulty, we conclude that the painting is relatively naturalistic. The theme, or content, of the picture, however, has been the subject of much discussion. It has been suggested that the village is imaginary, possibly van Gogh's memory of a Dutch village from his childhood. But the rolling hills are more reminiscent of the French landscape than of flat Holland. Furthermore, the night-time setting is unusual, although by no means unprecedented. What is unique is the combination of dynamic brushstrokes with structured form and the way in which the motion of the stars seems to engulf the sky.

Van Gogh has combined the moon with the bright star to create a form that resembles a shining sun. His swirling, visible brushstrokes evoke the movement of eddying water. The lines of the sky and the hills, the wavering trees, and the energy of the spirals animate the surface beyond natural reality. Two densely packed, dark green cypresses are textured with thin yellow highlights.

Spatially it is clear that van Gogh used perspective, although not the linear perspective of the Renaissance. The cypresses are larger than the village houses and reach higher than the mountains. They are also interrupted by the lower edge of the picture, as is part of the village. This tells us both that the cypresses are in the foreground and that our viewpoint shifts; we see the trees head-on and the village from an elevated position.

Van Gogh has structured the painting so that the various lines and shapes are orchestrated into a harmonious whole. The cypresses comprise a large solid form and their vertical thrust is echoed by the church steeple in the valley. At the right, the bright orange moon and the weight of the mountains below the moon counterbalance the strong forms of the trees. These shifts contribute to the intense rhythms of the picture. As the mountains seem to roll from the upper right down to the lower left, dividing the picture into two unequal trapezoid shapes, the staunch vertical of the cypresses provides a stabilizing presence (**figure 5.52**). Opposing the rolling hills is the cataclysmic spiral composed of whites, blacks, yellows, oranges, violets, and blues that rips across the picture from left to right, builds to a crescendo in the center, and then stops abruptly as it curls in on itself.

The predominant color of the landscape of *Starry Night* is blue, which creates a somewhat somber mood. This is reinforced by dark greens,

> The most beautiful pictures are those one dreams about when smoking a pipe in bed, but which one will never paint.
>
> Vincent van Gogh, artist (1853–1890)

violets, and browns. But the color shifts dramatically in the sky, into which bursts of white and yellow erupt around the stars. By the technique known as **broken color**, which was developed in the nineteenth century, van Gogh splits his forms into individual strokes of color rather than making each a solid color. The sky is thus not a solid blue, but a blue broken into brushstrokes of blue, black, white, yellow, orange, and other colors. Van Gogh also creates progressions of color—for example, in the moon. The moon is an orange crescent curving around a yellow and black interior circle. At the outer edges of the crescent, the yellows and blacks are repeated, with the addition of greens that form a chromatic transition to blue.

In this painting, as in many by van Gogh, line and color merge, so that their formal energies increase exponentially. The visibility of the brushstrokes and their vivid color and energy animate the surface in such a way that we feel the potential of nature's force. But we also feel that, with his control of the formal elements of painting, his intense focus, and his brilliant imagination, van Gogh has harnessed this force into a striking and powerful work of art.

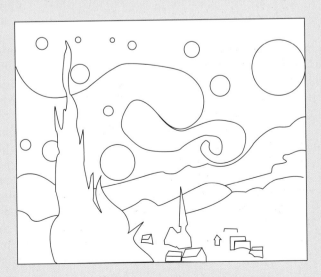

5.52 Diagram of shapes and lines in *Starry Night*.

Chapter 5 Glossary

afterimage—visual sensation that persists after the external stimulus that first caused it has ceased

analogous hues—hues containing a common color, though in different proportions

atmospheric perspective (also known as **aerial perspective**)—technique for creating the illusion of distance by the use of less distinct contours and a reduction in color intensity

broken color—color whose pure hue has been "broken" through the addition of another, often complementary, color

calligraphy—handwriting designed to be beautiful

cel—one of the transparent celluloid sheets on which the figures and objects in animated cartoons are drawn

chiaroscuro—"light–dark" in Italian; the subtle gradation of light and shadow to create the effect of three-dimensionality

coffer—recessed geometrical panel in a ceiling, often used as a decorative element and forming a continuous pattern; also used to reduce the weight of a ceiling

color wheel—circular, two-dimensional model illustrating the relationships of the various hues

complementary colors—hues that are directly opposite each other on the color wheel

contour line—line representing the outline of a figure or form

cross-hatching—pattern of superimposed parallel lines (hatching) on a two-dimensional surface to depict shading and shadow

Cubism—artistic style developed in the early twentieth century by Braque and Picasso, in which the artist changed the traditional notion of space by fragmenting planes into solid geometric shapes

divisionism—painting technique in which color is built up through the use of dots of color (also known as **pointillism**)

foreshortening—use of perspective to represent an object extending back in space

hatching—close parallel lines used in drawings and prints to create the effect of shading on three-dimensional forms

impasto—thick application of paint, usually oil or acrylic, to a canvas or panel

implied line—movement in a linear direction caused by a visual element other than an actual line

intensity (or **saturation**)—degree of purity of a color

isometric perspective—system of perspective in which diagonal lines convey the effect of distance

kinetic—having to do with, or incorporating, movement

linear—style in which lines are used to depict figures with precise, fully indicated outlines

linear perspective (also known as **geometric perspective** or **scientific perspective**)—mathematical system devised in the Renaissance to create the illusion of depth in a two-dimensional image through the use of straight lines converging toward a vanishing point in the distance

local color—color sensation imparted by a nearby object in clear daylight

mass (or **volume**)—three-dimensional form, often implying bulk, density, and weight

modeling—(a) in two-dimensional art, the use of value to suggest light and shadow and thus create the effect of mass and weight; (b) in sculpture, the creation of form by manipulating a pliable material such as clay

monochromatic—having a color scheme based on shades of black and white or on values of a single hue

multiple-point perspective—system of perspective in which there are a number of vanishing points caused by multiple buildings or other objects

mural—painting applied to, and made integral with, the surface of a wall

one-point perspective—system of perspective in which every orthogonal leads to a single vanishing point

optical mixing—tendency for the eyes to blend individual colors placed close to one another and to see a different, combined color

orthogonals—converging lines, perpendicular to the picture plane, that meet at the vanishing point in the system of linear perspective

picture plane—flat surface of a drawing, painting, or relief

pointillism—technique developed by Seurat and his followers in the late nineteenth century of applying to a surface dots of color that, when seen from a distance, seem to blend together

primary colors—the pure hues (blue, red, and yellow) from which all other colors can in theory be mixed and that cannot be created by mixing other hues

principal colors—the five main colors (red, violet, blue, green, yellow) in the color wheel of Albert Munsell

roundel—circular panel, window, or niche

secondary colors—hues produced by combining two primary colors (e.g. red and yellow to form orange)

sfumato—"vanished in smoke" or "toned down" in Italian; the definition of form by using gradations of light and shadow to produce a hazy effect

shade—to darken a color by adding black

shading—gradual change from light to dark on a surface

shadow—area of dark created when an object blocks light

shape—two-dimensional area enclosed by lines or denoted by changes in color or value

simultaneous contrast—phenomenon in which two complementary colors, if juxtaposed, intensify each other

tactility—quality of being perceptible by the sense of touch

tertiary colors—colors made by combining a primary and a secondary color that are adjacent on the color wheel (e.g. yellow and orange to form yellow-orange)

three-dimensional—having height, width, and depth

tint—color that is lighter than a hue's normal value (e.g. pink is a tint of red)

two-point perspective—system of perspective in which there are two vanishing points

value (or **tone**)—degree of lightness (high value) or darkness (low value) in a hue

vanishing point—in the linear perspective system, the point at which the orthogonals, if extended, would intersect

vantage point—point of view of the observer

KEY TOPICS
Form
Subject matter and content
Elements of design

6

Terminology and the Principles of Design

Now that we have surveyed the individual elements of the artist's visual language, we turn to the ways in which these elements are organized to create a work of art. In order to translate what we see into words, however, we have to be familiar with the vocabulary of art. Once we have considered the terms of art, we turn to principles of design.

This chapter begins with some of the terms we use to describe works of art, especially those that designate **style**. Style refers to categories of similarity. These are usually formal, but can also be thematic. The recurring organization of the visual elements, such as the choice of color, line, shape, texture, and so forth, creates an impression of style. Similarly, in everyday life, we speak of someone's style of dress, of speaking, of behaving, and so forth. People who are loud and assertive have an aggressive style, whereas those who are meek and mild have a timid style. If a man regularly wears suits and ties, we might say that his style of dress is traditional, conservative, or formal. The punk style, on the other hand, calls for spiked hair dyed an unnatural color, body piercing, and provocative dress. For the sake of convenience and also of discussion, art historians have categorized art styles by artist, by period, and by culture.

The vocabulary of art can be roughly divided into terms related to **form**, **subject matter**, and **content**. Form is related to style and can be elusive, as we saw in the testimony given at the Brancusi trial (see Chapter 1). It refers to the visual and physical appearance of a work. Subject matter can be anything from portraits, landscapes, and still lifes, to illustrations of a story and visual records of events, and can include theme and narrative. Content includes underlying themes, meanings, and ideas, whereas subject matter is manifest. Historically, most artists have combined form and content with subject matter, but some artists eliminate subject matter and convey meaning solely through form and content.

Great artists create new and original combinations of form and content in ways that make us experience the world, as well as works of art, differently than we had before seeing their work. Consider, for example, whether Duchamp's *L.H.O.O.Q.* (see figure 1.15) alters your experience of Leonardo's *Mona Lisa*, or whether Brancusi's *Bird in Space* (see p. xviii) affects the way you experience seeing actual birds in flight.

Form

Naturalistic, **realistic**, **representational**, **objective**, figurative, abstract, stylized, and idealized are some of the formal terms denoting categories of visual art. Many works combine elements of more than one category. One painting that has inspired numerous discussions about form and content is René Magritte's (1898–1967) *The Betrayal of Images* (**figure 6.1**).

Representational Art

Magritte's approach to his subject matter is naturalistic; it appears to us as we see it in reality. The painting is representational (also called objective, or

6.1 René Magritte, *The Betrayal of Images* ("*This is not a pipe*"), c. 1928–1929. Oil on canvas, 23 ⁵/₈ x 37 in. Los Angeles County Museum of Art, California. Purchased with funds provided by the Mr. and Mrs. W.P. Harrison Collection. 1996.

figurative) because the artist has emphasized the fact of the pipe as a solid object having a shape that we recognize and associate with our experience of "pipeness." The pipe's elegant, curved contour and rich black and brown color produces a convincing appearance of mass. We can see that light hits the bowl, which flows gracefully into the stem, and that shading solidifies the form.

In this painting, there is no question that Magritte was representing a pipe. But now let's reconsider Brancusi's *Bird in Space*; one of the issues at the trial was whether a work of art should be an exact replica of what it purports to represent. What, then, is the meaning of Magritte's written statement below the pipe—"*Ceci n'est pas une pipe*" ("This is not a pipe")? What, we might wonder, was Magritte trying to tell us? He said, for example: "People who look for symbolic meanings fail to grasp the inherent poetry and mystery of the image."[1]

In other words, he tells us not to look for meaning, but rather to let the picture penetrate our senses and our imagination. However, he also said that: "One object suggests that there is another lurking behind it."[2]

As with any painting by Magritte, there is always more than meets the eye. Like Duchamp's *L.H.O.O.Q.*, Magritte's *Pipe* addresses the viewer verbally as well as visually. But whereas Duchamp tells us to "look" at his image, Magritte asserts that his pipe is not real—it is a painting of a pipe, not an actual pipe. In so doing, he reminds us that art is art and reality is reality, that they are very different, and that we should not confuse them. He also communicates this idea by the space between the pipe and the statement, which addresses the gap between words and pictures, as well as between art and reality. This is a metaphorical gap; it is the gap that artists must cross in order to create art. Even though Magritte presents us with a representation of a pipe that appears real, he warns us that we can be fooled by pictures—hence the title of the painting: *The Betrayal of Images*.

Nonrepresentational Art

Nonrepresentational (also called nonfigurative and nonobjective) images do not attempt to replicate the way we see. By eliminating the object, some nonrepresentational imagery tries to capture emotions and ideas rather than portray concrete, recognizable subjects. A work such as *Picture with White Border* (**figure 6.2**) by the Russian artist Wassily Kandinsky (1866–1944) contains no recognizable objects. There are no shapes that we easily associate with figures, objects, or events in reality, but there is content. The image is about light (the white paint), movement (the curves and diagonals), color, and texture—that is, the visual elements stand on their own. The color is exuberant, the curves and diagonals are endowed with dynamic energy, and the abrupt shifts in color and direction hold our attention.

> The form is the outer expression of the inner content.
>
> Wassily Kandinsky, artist (1866–1944)

6.2 Wassily Kandinsky, *Picture with White Border*, 1913. Oil on canvas, 4 ft. 7 ¼ in. x 6 ft. 6 ⁷/₈ in. Solomon R. Guggenheim Museum, New York. Gift of Solomon R. Guggenheim, 1937.

In being nonrepresentational, Kandinsky's painting reflects his philosophy of art. He belonged to a group of artists interested in the spiritual qualities of art, which he conveyed by eliminating allusions to the physical world. In Kandinsky's view, the "creative spirit" was also the "abstract spirit." He believed in the spirituality of certain visual elements, such as the triangle, the pyramid, and color. In his book *On the Spiritual in Art*, he wrote that: "The spiritual Triangle advances and rises slowly."[3] Kandinsky also believed that the move toward abstraction in the early twentieth century was a landmark in the history of art.

Matisse approached abstraction in terms of truth, when he asserted in 1947 that:

> There is an inherent truth which must be disengaged from the outward appearance of the object to be represented. This is the only truth that matters.[4]

6.3 Ellsworth Kelly, *Pony*, 1959. Painted aluminum, 2 ft. 7 in. x 6 ft. 6 in. x 5 ft. 4 in. Collection of Miles and Shirley Fiterman. © Ellsworth Kelly.

There is no abstract art. You must always start with reality.

Pablo Picasso (1881–1973)

Abstract Art

Abstract art is based in nature, but does not replicate nature. Abstraction simplifies or reorders nature in some way.

We see this in *Pony* (**figure 6.3**) by Ellsworth Kelly. With a stretch of the imagination, we can recognize certain qualities of a pony in the sculpture. The flat, sloping shapes are derived from a real pony and faintly suggest the curved mass of its back. Kelly's forms are thus simplified abstractions of a reality, with which we can identify. He also has merged the back of the horse and the saddle on which the rider sits.

Nevertheless, *Pony* is not as convincing an image of the real thing as Magritte's pipe. We would probably not think of mounting this pony for a ride through the countryside any more that we would take a shot at Brancusi's bird if we were hunting in a forest. As with Brancusi's *Bird in Space*, Kelly's *Pony* is abstract; it conveys a quality of the "essential" rather than enumerating the individual features of the animal. However, Brancusi objected to the term "abstract" being applied to his work, because for him the "essential" was more real than external appearance. It was Brancusi's stated opinion that: "They are imbeciles who call my work abstract."[5]

Abstraction can be derived from feelings and actions, as well as from solid forms, for all are part of nature. In *The Climb* (**figure 6.4**) by the German-born artist Hans Hofmann (1880–1966), the sensation of ascent is conveyed by a series of bold, predominantly rose-colored, brushstrokes. Their vertical and diagonal directions echo the energetic motion of climbing. Hofmann creates a dynamic tension between the white background and the brushstrokes, each of which concludes with the brush being gently lifted from the surface. When asked about abstraction, Hofmann replied:

> What goes on in abstract art is the proclaiming of aesthetic principles. What do I mean by aesthetic? Now a line can have millions of variations—thin, thick, short, long, sinuous, staccato; but heretofore a line always represented something else. Today it is the line for itself, and that's what I mean by the aesthetic experience.[6]

6.4 Hans Hofmann, *The Climb*, 1960. Oil on composition board, 7 x 4 ft. Ameringer-Yohe Fine Art, New York.

Stylized Art

Stylization refers to images that do not portray the natural appearance of an object, but that we recognize nonetheless. An image can be stylized in its structural as well as in its surface detail. We can see this in an ancient Sumerian figure from Mesopotamia (modern Iraq) (**figure 6.5**). The head is somewhat rectangular and the hair and beard do not flow naturally, but are structured as horizontal ridges. We know that the ridges represent the beard and hair because of their respective locations on the chin and the head, but they do not replicate the way these features would look in reality. Imagine the beard detached from the face; it would no longer be identifiable as a beard. The eyebrows, which are surface elements, consist of a continuous, incised curve that would also not be recognizable if removed from the context of the face. The huge eyes dominating the face resemble actual eyes, but are somewhat flattened. With regard to this statue, therefore, we would say that the features are examples of stylization.

6.5 Head of a figure dedicated to the god Abu, c. 2700–2500 B.C. Limestone, alabaster, and gypsum, 30 in. high. Iraq Museum, Baghdad.

Idealized Art

Idealized art conforms to an idea of something, such as beauty, status, power, or another quality that might be derived from reality but does not, on careful inspection, represent that reality accurately. The term usually refers to a standard of perfection in depicting the human figure; in Western art this is associated most often with the Classical style of fifth-century-B.C. Greece.

The Classical idealization of human form is exemplified in the *Discus Thrower* (**figure 6.6**) by Myron. He represents a young male athlete pivoting as he prepares to launch a discus. In this case the work is representational and naturalistic. At first glance, the statue might seem realistic, because it shows the human body with anatomical accuracy. Unfortunately, however, no one looks like Myron's statue. The head is a perfect dome shape, and there is not a single blemish on the smooth skin—no warts, pimples, scratches, freckles, or other imperfections such as knobby knees, swollen ankles, unwanted flab, wrinkles, or crossed eyes. Furthermore, this figure has no personality or expression; he shows no sign of effort or strain, and he is youthful. The timeless character of his representation removes him from our natural experience of a perspiring, straining athlete, having a facial expression and a less than perfect form. The appeal of Myron's athlete, which idealizes the human body, has contributed to the long-lasting, traditional quality that the term "Classical" has come to signify.

> **Man is the measure of all things.**
>
> Protagoras, Greek philosopher (5th century B.C.)

6.6 Myron, *Discus Thrower* (*Diskobolos*), 460–450 B.C. Marble copy of a bronze original, 5 ft. high. Museo Nazionale delle Terme, Rome.

Subject Matter and Content

Subject matter is what is manifestly represented in a work of art—including figures, objects, narrative, shape, color, and other visual elements. Content refers to the theme and meaning of a work. In a well-designed work of art, the subject matter and content are reinforced by visual elements.

In the figure from the Abu Temple (see figure 6.5), the subject is a bearded male. The content is what the figure signifies—namely, the man's awe in the presence of a god. He was found in a temple and appears to be gazing upward at a presence larger than himself. His hands, which are not visible in this reproduction, are folded in prayer. In the case of the *Discus Thrower*, the athletic content is an expression of the ancient Greek admiration for physical perfection and the importance accorded to individual athletic performance. In both statues, content is reinforced by form.

Now consider a more complex example of subject and content—Roy Lichtenstein's (1923–1997) *Little Big Picture* (**figure 6.7**) of 1965. Here the subject is brushstrokes and drips, which are more usually thought of as visual elements of painting. But the theme is about the American-ness of the image. It is particularly American in at least three ways. First, it relates to Abstract Expressionism, a nonrepresentational style that originated in New York City in the 1940s—a period when the center of the Western art world shifted from Paris to New York. Second, *Little Big Picture* is a work in the Pop Art style of the 1960s, when artists began to represent everyday popular and commercial objects. It is thus a Pop Art painting about Abstract Expressionism, both being distinctively twentieth-century American styles.

6.7 Roy Lichtenstein, *Little Big Picture*, 1965. Oil and synthetic polymer on canvas, 5 ft. 8 in. x 6 ft. 8 in. Whitney Museum of American Art, New York.

Third, the title of the work alludes to the famous battle of 1876, in which the Sioux Indians under Chief Sitting Bull defeated the troops of General George Armstrong Custer. Known in the history books as Custer's Last Stand, the Battle of Little Bighorn reverberates in Lichtenstein's title and is a reminder of the uniquely American character of the artist's style and theme. We might also say that the subject of the picture is of little consequence in so far as it represents brushstrokes and drips, but that it is a big picture from the point of view of its thematic content.

Design

Design refers to the organization or composition of a creative work. It denotes relationships between component parts, whether chapters of a book, movements of a symphony, or the visual elements of a picture, sculpture, or building. Design may be related to subject matter and content, but it is mainly about perception. The artist has to create a sense of good design in order for the work to hang together as a unified whole. Artists achieve this by coordinating relationships between the visual components of a work.

> There are certain things that are usable, forceful, and vital about commercial art.
>
> Roy Lichtenstein, artist (1923–1997), on the relationship of Pop Art to mass culture

Unity and Variation

One aspect of design is the sense of harmony between parts and the whole. Shared qualities among the parts create the impression that they belong together and are unified. The opposite of unity is variation, which can reinforce the sense of unity while also creating a dynamic tension between similarity and difference. In music, we are familiar with the idea of variations on a theme: the theme persists through disparate sounds and connects them into a totality. A narrative story can have many characters and episodes, but if the plot is to hold our interest, it must have a unifying thread. In the visual arts as well, parts need to be connected by content, by form, or by both.

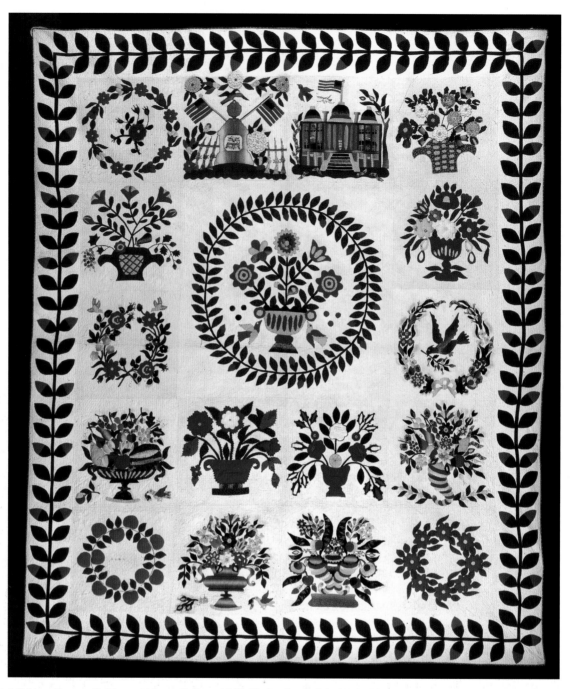

6.8 Mary Evans, *Baltimore Album Quilt*, c. 1847–53. Appliqué, 8 ft. 3 in. x 7 ft. Abby Aldrich Rockefeller Folk Art Museum, Williamsburg, Virginia. Gift of Marsha C. Scott.

As an example of variety within a tightly organized unity, consider the quilt in **figure 6.8**. Several nineteenth-century women contributed squares, which were then combined into a whole. In the very process of creating the quilt, therefore, there is a natural combination of unity and variety. It is called a *Baltimore Album Quilt*, because it was made in or around the city of Baltimore, Maryland.

The foliate frame forms a rectangle of red and green leaves linked by two vertical and two horizontal black lines. The same forms recur in the frame of the large circle containing a vase of flowers flanked by red and orange birds. Circles recur in five of the squares, but they are composed of different floral and fruit shapes. Two of these circles contain additional designs—flowers at the upper left and a bird carrying a branch at the center right—and the rest are empty. Nine of the squares contain unframed vases of flowers, but the type of flower varies. At the center of the top row, flanked by a floral wreath on the left and a vase of flowers on the right are two buildings: a war memorial and the United States Capitol building. Both fly the American flag.

The quilt combines unity and variation in form and color. Reds, greens, oranges, light yellows, and browns, as well as circular and rectangular framing devices, are repeated throughout, but always with considerable variety. No two squares are identical, and each square is both an actual component of the quilt and the background surface of an individual image. Sewn together, they are fused into a unified whole.

There is also a thematic unity based on American patriotic sentiment that binds these images together. Birds, fruit, and flowers might imply fertility and prosperity. The architecture and flags are direct references to the United States as a nation willing to fight and die for freedom.

In *I Saw the Figure 5 in Gold* (**figure 6.9**) by the American Precisionist painter Charles Demuth (1883–1935), unity is created by the clear lines and structured, precise geometry that gave the style its name. Demuth shows us the linear quality of an urban street, with the round light bulbs of its lamp posts, rectangular windows, and advertising signs. Circles recur in the bulbs as well as in the curl at the tail of the three number 5s. They overlap, and are overlapped by, diagonals that move up and down the street. Since all the number 5s are gold, they also impose a color unity on the composition. Diversity, or variation, is shown in the shifts from circular to linear elements, from sharp lights to darks, and from bright to muted color.

Thematically, as well as visually, the letters and numbers reinforce and unify both the idea and the appearance of a dynamic city. The painting was inspired by a poem about a red fire truck racing through the night in the rain. The light broken up by their drops is conveyed in the prismlike structure of the diagonals. The poem by the American William Carlos Williams is, like the painting, fragmented and pulsating, but the overall image it creates is unified:

> The Great Figure
> Among the rain
> and lights
> I saw the figure 5
> in gold
> on a red
> firetruck
> moving
> tense
> unheeded
> to gong clangs
> siren howls
> and wheels rumbling
> through the dark city.

As in the poem, there are implied sound effects in the painting. For as the number 5 recedes into the distance, the volume of the fire gongs also decreases. As it approaches the foreground, the number 5, like the sound, expands and fills up the space. Finally, another source of unity amid the variety of shape and color is the use of words and letters as well as numbers. Demuth changed "William" to "Bill" (possibly also a reference to billboards) and painted "Carlos" in small neon lights. In so doing, he created a unity between the poem and the painting, between the poet (Carlos) and the artist (Charles), and between the components of the city. Notice that the words *BILL* and *CARLOS*, as well as the signature (*C.D.*) and the initials W.C.W. (William Carlos Williams) are all painted in red.

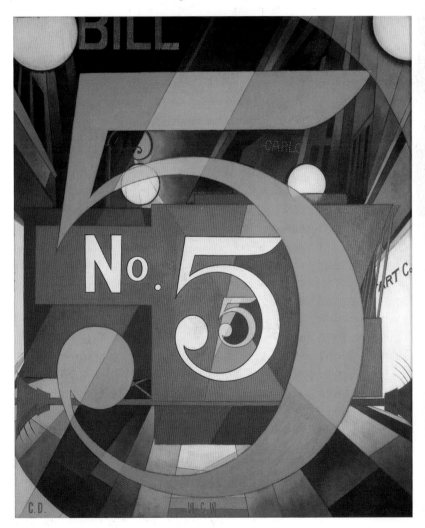

6.9 Charles Demuth, *I Saw the Figure 5 in Gold*, 1928. Oil on cardboard, 35 ½ x 30 in. Metropolitan Museum of Art, New York. Alfred Stieglitz Collection, 1949 no. 49.51.1.

Focus, Emphasis, and Subordination

In most works of art, some elements are given more emphasis and catch our eye. As a result we tend to focus on what has been emphasized. Other elements reinforce the area of emphasis or focal point but do not compete with it. Artists manipulate visual elements to organize works so that some areas are emphasized and others are subordinated to them. The methods they use include linear perspective, actual and implied lines, bright color, repetition for effect, relative size, placement within a design, the presence of an unexpected element, and various kinds of emphasis.

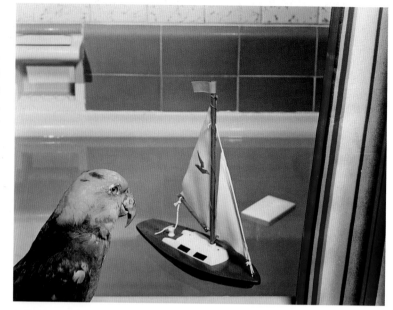

6.10 Jo Ann Callis, *Parrot and Sailboat*, 1980. Dye imbition print, 17 ⁵/₈ x 22 ³/₄ in. Los Angeles County Museum of Art. Ralph M. Parsons Fund.

We have seen that perspective systems provide ways of directing our vision toward areas inside or even outside a picture (see Chapter 5). In *Parrot and Sailboat* (**figure 6.10**), Jo Ann Callis (b. 1941) uses various devices to focus our attention on three principal objects: the parrot, the sailboat, and the shower curtain. The subordinate objects are muted, but identify the setting of the scene as a bathroom. These are the soap dish, the gray-green tiles reflected in the water, and the edge of the tub. The parrot, curtain, and boat are all depicted in bright, eye-catching colors—reds, blues, oranges, yellows, and bright green. Whereas the background wall and rim of the tub are subordinated verticals and horizontals, the diagonals of the parrot, boat, curtain, and white square in the water predominate. They show more movement than the background and stand out (**figure 6.11**).

Since most Westerners read pictures from left to right, we would be likely to enter this picture from the left and follow the gaze of the parrot. The bird's eye and the curve of its beak form an implied line and focus our attention on the boat, which is central. It is framed on either side and thus accentuated by the colorful diagonals of the parrot and the shower curtain. Finally, the parrot itself, perched by a bathtub, is an object of emphasis and focus by virtue of its unexpected presence in such a setting. It is also possible that the image contains a pun on the notion of a "bird's eye view," since the parrot is actually looking downward, toward the tub and the sailboat.

If we review works we have already considered, we might note that the unusually large eyes of the figure from the Abu Temple (see figure 6.5) are also a means of focusing the viewer. The eyes are emphasized, whereas the nose and mouth are subordinate features.

6.11 Diagram of the linear structure of *Parrot and Sailboat*.

In the quilt (see figure 6.8), the image of the vase in the circular frame is emphasized by its large size (it occupies four squares) and its central position. It is reinforced by the images on the single squares. In the painting by Demuth (see figure 6.9), the repetition and centrality of the number 5 reflects its importance within the overall design of the work and this, together with its brightness, makes us focus on it.

Similar techniques are used in buildings to achieve emphasis and focus. Often these direct our focus to the entrance by emphasizing it in some way. In the

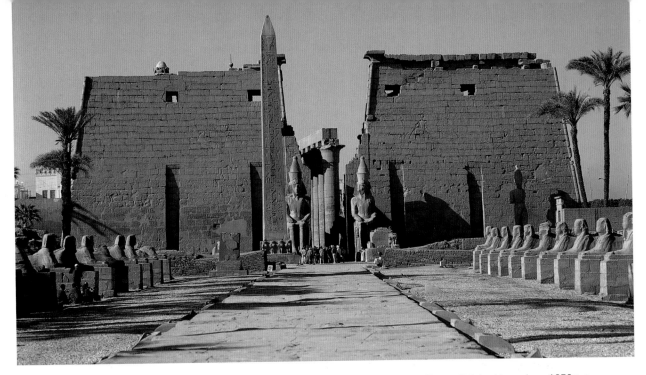

6.12 Pylon and avenue of sphinxes at the entrance to the temple in Luxor, Egypt. Original temple c. 1250 B.C. Pylon and sphinxes added c. 370 B.C.

Egyptian temple at Luxor (**figure 6.12**), for example, the entrance is emphasized in at least three ways. The door is flanked by colossal statues of the pharaoh (ruler) and accentuated by the tall pointed obelisk that leads our gaze toward the sky. Another source of emphasis is produced by the rows of repeated **sphinxes** (human-headed lions) that create an avenue of space ending at the trapezoidal temple wall (the **pylon**). The sphinxes create a line of sight akin to the orthogonals used in linear perspective .

Another way of accentuating an entrance can be seen in the nineteenth-century photograph of the United States Capitol building (**figure 6.13**). A second front resembling that of a Greek temple has been superimposed over the main wall. It is emphasized by an imposing flight of stairs leading to the entryway, suggesting that the capitol is accessible to visitors. The steps begin a progression of visual movement toward the columns and up to the crowning **pediment** (the triangle) that points to the

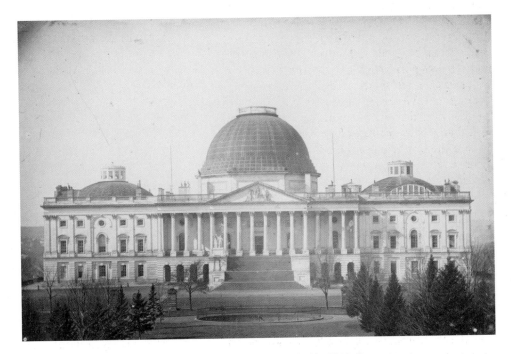

6.13 John Plumbe, Jr., The United States Capitol in 1846. Daguerreotype. Library of Congress, Washington, D.C.

dome and is aligned with it. But the curved sides of the dome also carry our eye downward, bringing us visually back to the entrance.

The style of this particular entrance is significant from the point of view of content as well as design. Greek forms are associated with the culture that produced the first Western democracy. As such, the building's design alludes to the United States form of government and the political character of America.

Scale and Proportion

Scale refers to actual size, or to an expected actual size. So if Man A is nine feet tall and his friend, Man B, is three feet tall, we would say that Man A is unusually large and Man B is unusually small.

I am making symbols of my time.

Claes Oldenburg (b. 1929)

Claes Oldenburg (see p. 90) worked in the Pop Art style and experimented with scale. **Figure 6.14** shows a view of his 1962 one-man show at the Green Gallery in New York City. Several of the objects, such as chairs and tables, are made according to scale; that is, they conform to an expected size. But some of the works, such as the *Giant Chocolate Cake*, the hamburger, and the hanging ice cream cone, are larger than normal. The effect is amusing and startling because our expectations have been disrupted.

Proportion refers to the size relationship between parts of a whole and their relation to the whole. So, for example, if a man's left arm is twice as long as his right arm, we would say the left arm is disproportionately long in relation to the right arm and to the rest of the body. In Oldenburg's installation, the suspended cone is small in relation to the cake, but larger than a normal cone would be.

Romare Bearden (see p. 40) altered the expected proportions of his figures to create certain psychological effects. In *Of the Blues: Carolina Shout* (**figure 6.15**) of 1974, for example, he enlarged the heads and hands of the figures. By this technique he emphasized the exuberance of shouting and gesturing among the figures. Discussing his proportions, Bearden said that:

6.14 Claes Oldenburg, Installation of one-man show at the Green Gallery, New York, fall 1962, including pieces from The Store and the first large-scale "soft" sculpture.

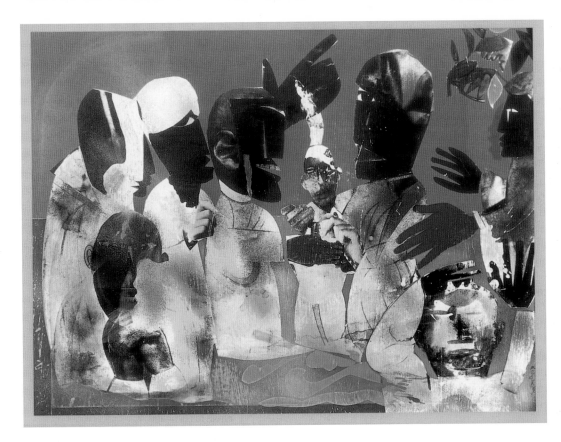

6.15 Romare Bearden, *Of the Blues: Carolina Shout*, 1974. Paper collage with paint and surface abrasion on fiberboard, 3 ft. 1 ½ in. x 4 ft. 3 in. Mint Museum of Art, Charlotte, North Carolina. National Endowment for the Arts Matching Fund and the Charlotte Debutante Club Fund.

… such devices of artificiality as distortion of scale and proportion, and abstract coloration, are the very means through which I try to achieve a more personal expression than I sense in the realistic or conventionally focused photograph.[7]

There are several categories of scale and proportion in art. In **hierarchical scale**, size is determined by relative importance, although, taken by themselves, figures are normally proportioned. This technique is found in ancient Egypt in works such as *Senwosret-senbefni and his Wife* from Memphis (**figure 6.16**). Blocklike cubes of stone to which a head and feet are added were originally made for Egyptian tombs and later for temples. In this example, the husband is proportionally much larger than his wife, who stands between his feet. As such, he is a reflection of the hierarchical structure of Egyptian society, in which kings were considered more important than queens.

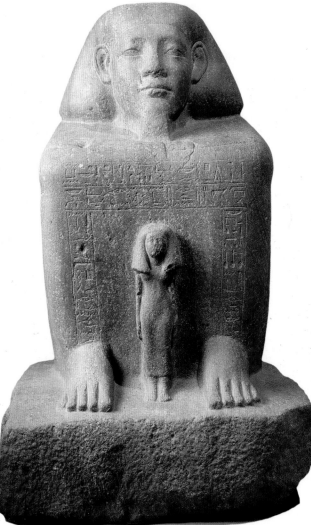

6.16 *Senwosret-senbefni and his Wife*, c. 1850 B.C. Quartzite, 25 ⅛ in. high. Brooklyn Museum, New York. Charles Edwin Wilbour Fund.

Artists also use different kinds of **symbolic proportion**. In the example of the figure from the Abu Temple (see figure 6.5), the scale of the eyes conveys symbolic meaning. It is meant to show that the worshiper represented is in the presence of a deity and that his eyes are opened wide in awe. In Early Christian, Byzantine, and Medieval art, the infant Jesus seated on the lap of his enthroned mother is shown as a baby with the normal proportions of an adult man (**figure 6.17**). His scale and proportions are thus symbolic: they merge infancy with adulthood, indicating that Jesus was born with the wisdom of a grown-up and was literally a baby-king.

Balance

In sculptures and buildings, structural balance is necessary or the works will be unsteady and fall down. But we also like to see aesthetic balance, because it contributes to the sense of harmony in a work. The two main categories of balance are symmetry and **asymmetry**.

A successful composition usually conveys the impression of balance, or equilibrium. If you are a picture straightener, then you know how annoying it can be if an object is tilted and appears unbalanced. The simplest form of balance is symmetry, in which there is an exact correspondence of parts on either side of a central axis. In other words, the left side of a work is a mirror image of the right side. The human body is an example of symmetry (although not exact symmetry), as shown in Leonardo da Vinci's *Vitruvian Man* (**figure 6.18**). With the exception of the turned feet, if we draw a line down the middle, this is a mirror image. But effective as Leonardo's drawing may be as an example of balance, think how boring the arts would be if every work was exactly symmetrical.

> The length of a man's outspread arms is equal to his height.
>
> Leonardo da Vinci (1452–1519)

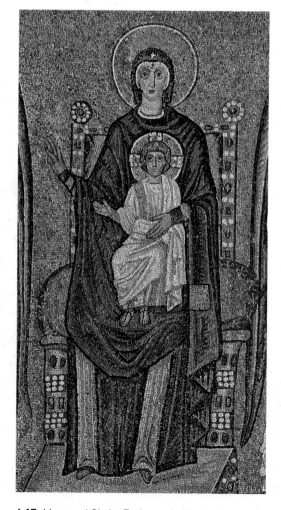

6.17 *Mary and Christ Enthroned*, 6th century. Mosaic. Sant'Apollinare Nuovo, Ravenna, Italy.

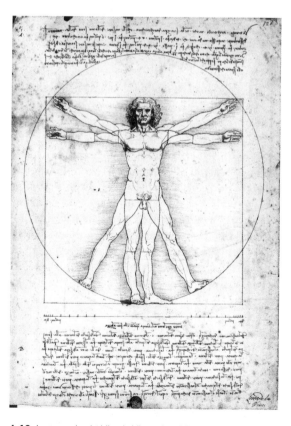

6.18 Leonardo da Vinci, *Vitruvian Man*, c. 1485–1490. Pen and ink, 13 ¹/₂ x 9 ⁵/₈ in. Galleria dell'Accademia, Venice.

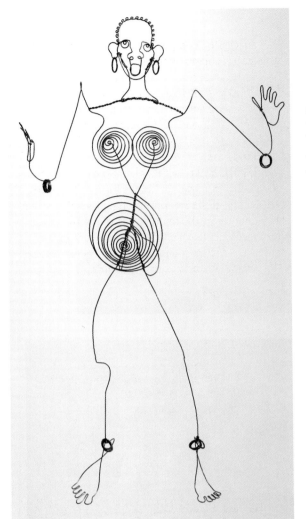

6.19 Alexander Calder, *Josephine Baker*, 1927–1929. Wire, 3 ft. 3 in. high. Museum of Modern Art, New York. Gift of the artist.

compositional weight of the figure is not evenly distributed on either side of the central axis. The acrobat's actual weight rests mainly on the support leg placed at the center of the composition. The diagonal of the left arm reaches to the lower corner and adds support to the leg. Counterbalancing the three limbs to the right of the head is the more animated leg composed of zigzags at the left. Note that Picasso has disrupted the natural symmetry of the human body by having the head and right arm emerge from the thighs; the other arm also doubles as a leg. Although the limbs of Picasso's acrobat are far from symmetrical, there is an equilibrium between them, which conveys the contortionist stretching of an acrobat and produces an aesthetically satisfying, harmoniously balanced image.

In buildings, as in drawing, painting, and sculpture, balance is an important aesthetic consideration as well as a structural one. In the photograph of the US Capitol (see figure 6.13), the building's symmetry is accentuated by the superimposed temple front. Its central position functions visually as a divider between the two identical sides, creating a mirror image.

Many works of art are relatively, but not exactly, symmetrical. Consider Alexander Calder's wire sculpture portrait of the American dancer Josephine Baker (**figure 6.19**), who delighted French audiences with her performances in the 1920s, 30s, and 40s. The work conveys a sense of symmetry in the frontal (front-facing) stance, raised arms, and slightly turned-out feet. But Josephine Baker is actually less symmetrical than Leonardo's *Vitruvian Man*. Her left hand turns toward the viewer, whereas her right hand is sideways and less extended. The spiral of her lower torso shifts to the left, and the two banana-shapes, which represent Josephine Baker's famous banana skirt, are slanted. Her feet echo the position of her hands, but in reverse; the right foot is shown more fully than the left, which is slightly bent. By virtue of these small shifts, Calder conveys the impression of a swaying dance movement.

Picasso's *Acrobat* of 1936 (**figure 6.20**) is an example of **asymmetrical balance**, in which nonequivalent forms balance each other. In this case, the

6.20 Pablo Picasso, *Acrobat*, 1936. Oil on canvas, 5 ft. 8 5/8 in. x 4 ft. 3 1/4 in. Musée Picasso, Paris.

6.21 Aerial View of Saint Peter's, Rome, begun 1546.

6.22 Frank Gehry, Solomon R. Guggenheim Museum at night, Bilbao, Spain, 1993–1997.

If we compare the two architectural views in **figures 6.21** and **6.22**, we see that Saint Peter's in Rome, like the US Capitol building in figure 6.13, was designed as a perfectly symmetrical building. It has two small domes in front of the large central dome, a symmetrical façade, and steps that descend toward a narrowing trapezoidal area that expands sideways into a wide oval. The Guggenheim Museum in Bilbao, Spain, on the other hand, lacks symmetry and appears more organic. It has been compared to a flower growing in an irregular pattern—pushing, pulling, and stretching outward from the interior. Nevertheless, the building is balanced structurally and aesthetically because the architect Frank Gehry (b. 1929) has calibrated the movements of each element into a unified, harmonious whole.

At Saint Peter's, the aim of the design was to convey an impression of the imposing authority of the Roman Catholic Church. The large oval square was conceived by the architect, Gianlorenzo Bernini (see p. 69), as a place for worshipers to gather and hear the pope's message. Bernini described the curved colonnades on either side of the piazza as the arms of Mother Church, reaching out to embrace the faithful. From a practical point of view, passageways behind the colonnades allow crowds to circulate, entering and exiting the main square with relative ease.

The Bilbao Guggenheim, in contrast, is a modern art museum. Its setting, on the Nervion River in Spanish Basque country, increases the dramatic quality of the undulating shapes. Gehry wanted the building to reflect its purpose as a space for the exhibition of modern art. The modernism of the art is thus echoed in the modernism of Gehry's design.

From the point of view of formal and structural balance, Saint Peter's and the Guggenheim express very different aesthetic ideas. The ensemble of Saint Peter's, with its oval piazza and curved colonnades, projects an image of steadfast permanence consistent with both a symmetrical design and the aims of the Catholic Church. The museum, in contrast, appears fluid, experimental, and in the process of continual transformation, which is more in tune with the nature of the modern art it houses.

Rhythm and Pattern

Rhythm and **pattern** are related formal elements that share the qualities of repetition and movement. We are familiar with patterns on wallpaper, upholstery, and other fabrics, as well as with the patterns of nature that we see in landscape. We also speak of "traffic patterns" in connection with urban planning and "behavior patterns" when describing characteristic actions.

Generally speaking, pattern denotes pure formal repetition, whereas rhythm, which is also associated with music, dance, and poetry, allows for greater variation. In the visual arts, effects of pattern and rhythm are achieved by arranging lines, shapes, and colors. We can see this by comparing two works from the *Migration Series* of 1941 by the Harlem Renaissance painter Jacob Lawrence (1917–2000). Entitled *The Migration of the Negro,* this is a group of paintings illustrating the movement of thousands of blacks from the American South to northern cities between 1900 and 1930. Scores of intellectuals, artists, and performers settled in Harlem, in New York, giving rise to new cultural and creative energies in the black community.

Number 18 in the series (**figure 6.23**), subtitled "*The Migration gained in momentum,*" shows the determined advance of people who have gathered up their belongings in sacks and suitcases and are heading out. Two groups of figures, creating patterns of shape and color through repetition, and rhythm through a sense of pace and beat, are clearly on the move. The large group marches in an upward direction, denoting both the fact of going north and traditional symbolism associating upward movement with optimism. The smaller group at the upper left enters the picture space like a minor variation in a piece of music.

In this work, Lawrence combines, on the one hand, warm colors (oranges, yellows, and reds) with cooler blues and greens and, on the other, repeated diagonals with flat shapes to create the sense of a mass exodus. He contrasted the flattened figures with the patterned background, which consists of textured and rippling browns and whites. Two types of pattern are thus juxtaposed, which emphasizes the sense of motion. In addition, the tree at the left seems to be waving goodbye to the departing crowd.

Number 55 in the series (**figure 6.24**) shows that tragedy clouded the optimism of the Great Migration. Entitled "*The Negro being suddenly moved out of doors and cramped into urban life, contracted a great deal of tuberculosis. Because of this the death rate was very high,*" this scene contains a pattern reduced to three large black triangles alternating with muted gray-blue triangles. The three figures carry a single wooden coffin strewn with flowers. Two sets of rhythms dominate this picture. Echoing the slow waves of gray above the coffin are the blues and greens of the flower stalks. Their

6.23 Jacob Lawrence, *The Migration gained in momentum*, No. 18 from the *Migration Series*, 1941. Tempera and gesso on composition board, 18 x 12 in. Museum of Modern Art, New York. Gift of Mrs. David M. Levy.

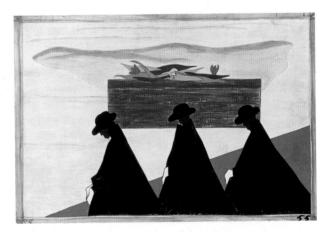

6.24 Jacob Lawrence, *The Negro being suddenly moved out of doors and cramped into urban life, contracted a great deal of tuberculosis. Because of this the death rate was very high*, No. 55 from the *Migration Series*, 1941. Tempera on hardboard, 12 x 18 in. The Phillips Collection, Washington, D.C. Acquired 1942.

mournful tones are interrupted only by the relatively colorful staccato of the reds and yellow. The repeated bowed heads and slow pace of the pall-bearers, accentuated by the downward slant of the blues, contrast dramatically with the upward movement and sense of optimism that energized Number 18 in the series. In addition to the formal downward motion, the narrative flow from right to left is echoed visually by the horizontal wooden coffin and the rise and fall of the long gray brushstrokes across the white area.

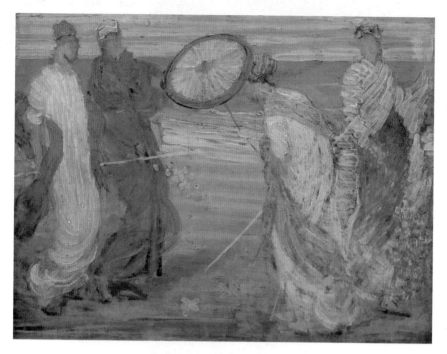

6.25 James McNeill Whistler, *Symphony in Blue and Pink*, c. 1868. Oil on canvas, 18 ³/₈ x 24 ³/₈ in. Freer Gallery of Art, Smithsonian Institution, Washington, D.C. Gift of Charles Lang Freer.

Rhythm, Color, and Music

There is a long history of interest in the West in the formal parallels between music and color. In ancient Greece, musical scales were devised to link color with sound. Both were recognized as capable of creating moods and arousing passions. Both, as we saw in Kelly's *Spectrum III* (see figure 5.41), can be arranged in rhythmic sequences. In the Renaissance, theories relating color-mixing to musical harmony developed, as did ideas about combining color in the Baroque Age (seventeenth century). The late eighteenth- and nineteenth-century Romantics emphasized the subjective qualities of both music and color, and the artist's palette became a metaphor for the musical keyboard. At the turn of the twentieth century, the psychological relation of music and color came to the fore and, with the advent of jazz, many artists made use of the music/art relationship in their work.

Compare, for example, two paintings using line and color to create patterns and rhythms by the American James McNeill Whistler (1834–1903). Their titles indicate that they were designed as symphonies in color. In *Symphony in Blue and Pink* (**figure 6.25**), blue is the predominant color, recurring in the green, and varied by the reds and pinks. In *The White Symphony* (**figure 6.26**), white predominates, with striking oranges but more muted blues and greens. In both works there is a repeated background rhythm composed of straight color lines—horizontal in one and vertical in the other. Overlapping these are the curvilinear rhythms of the women, accentuated by the circular motion of the parasols.

Whistler expressed his passionate view of color by declaring:

Drawing, by God! Color is vice, although it can be one of the finest virtues. When controlled by a firm hand, well-guided by her master, Drawing, Color is then like a splendid woman with a mate worthy of her.[8]

In the twentieth century, a number of artists used musical rhythms as both the subject and form of their work. In 1918, influenced by the introduction of American music

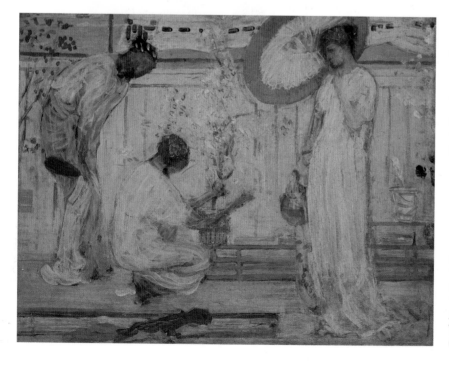

6.26 James McNeill Whistler, *The White Symphony: Three Girls*, c. 1868. Oil on canvas, 18 ¹/₄ x 24 ¹/₄ in. Freer Gallery of Art, Smithsonian Institution, Washington, D.C. Gift of Charles Lang Freer.

into Europe, a Dutch artist of the De Stijl style (see pp. 522–523), Theo van Doesburg (1883–1931), painted *(Ragtime) Composition in Gray* (**figure 6.27**). A medley of shaded gray rectangles seems to slide effortlessly through the picture space, echoing the steady but muted rhythms of ragtime. The achromatic quality of the painting and the regularity of its forms reinforce the sense of a background ragtime beat.

Van Doesburg's compatriot and contemporary, Piet Mondrian (1872–1944), painted *Victory Boogie Woogie* (unfinished) in 1944 after moving to New York (**figure 6.28**). In contrast to Mondrian's earlier work, this eliminates the black vertical and horizontal lines separating the squares of color and, unlike the van Doesburg, erupts into energetic, though controlled, color. As a result, the pace is more rapid as the colors shift directly from one to another. As in *Ragtime*, Mondrian's rhythm is patterned and repetitive, but there is also variation. Here the variation is given visual form in the changing sizes of the squares. Threads of small squares seem to weave a route through the larger squares in a continual series of movements. On the one hand, the grays at each corner provide a sense of finite structure while, on the other, the color squares seem to slide off the edge of the canvas.

———— ◆ ————

Now that we have discussed the visual elements of art and the principles of design, we are ready to consider some of the ways in which imagery has been interpreted. In the next chapter, we explore the so-called methodologies of art. Each method approaches works according to a particular point of view—formalism; social, political, and economic context; the artist's life and psychology; and more recent philosophies dealing with signs, symbols, and deconstruction.

6.27 Theo van Doesburg, *(Ragtime) Composition in Gray*, 1919. Oil on canvas, 37 ³/₈ x 23 in. Peggy Guggenheim Collection, Venice. Solomon R. Guggenheim Foundation, N.Y.

COMPARE

Piet Mondrian, *Tableau 2 with Yellow, Black, Blue, Red and Gray*, 1922. **figure 5.46, page 102**

6.28 Piet Mondrian, *Victory Boogie Woogie* (unfinished), 1944. Oil and paper on canvas, diagonal 5 ft. 10 ¹/₄ in., sides 4 ft. 1 ⁵/₈ in. x 4 ft. 1 ⁵/₈ in. Haags Gemeentemuseum, The Hague © 2006 Mondrian/Holzman Trust c/o HCR International, Warrenton, VA.

... destruction of melody which is the equivalent of destruction of natural appearance; and construction through the continuous opposition of pure means— dynamic rhythm.

Piet Mondrian (1872–1944)

Munch's *The Scream*

Edvard Munch's (1863–1944) famous painting of 1893 entitled *The Scream* is one of the most striking examples of an artist using design principles to convey personal themes (**figure 6.29**). Munch described the experience that inspired this painting: he was walking with two friends at sunset, when suddenly the sky turned blood-red, he felt a surge of melancholy and stopped as his friends continued on. The clouds, he said, were like flaming swords hanging over him. Munch was seized with fear and panic as he heard a scream tear through the world around him and he translated this overwhelming primal anxiety into *The Scream*. The painting well exemplifies Munch's assertion that: "A work of art can come only from the interior of man."[9]

The image is representational; its subject matter consists of three figures on a bridge, with water, boats, and sky in the background. The artist himself is in the foreground, responding to an intense experience of nature. From the point of view of scale and proportion, the forms are relatively normal—the background figures, as expected, are smaller than the artist. Asymmetrical balance is achieved by the juxtaposition of the receding diagonal bridge at the left with the sweeping curves of the landscape.

The main figure, the artist, is emphasized by his large size, centrality, and foreground placement. Following at a distance are two subordinate figures. This focuses us on Munch himself, while the staunch verticals of the distant figures contrast with his curvilinear form. Rhythmic patterns of color animate the sky and water, creating linear and chromatic repetitions. At the same time, however, there is sharp variation in the contrast between the structural form and muted color of the bridge and the flowing lines and bright colors of the water and sky.

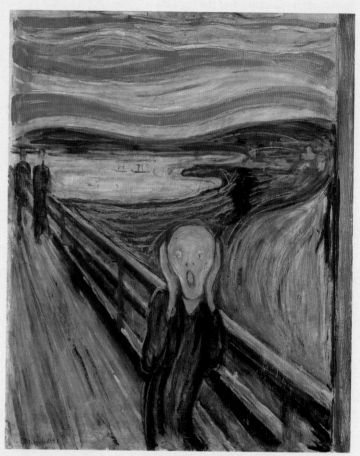

6.29 Edvard Munch, *The Scream*, 1893. Tempera and pastel on board, 35 7/8 x 29 in. Nasjonalmuseet for Kunst, Arkitektur og Design, Oslo.

The content of Munch's paintings, like those of van Gogh's, is manifestly autobiographical and they share themes of death, depression, and anxiety. In Munch's case, there is also a sense of suspicion and danger conveyed by the figures behind the artist. He may sense their presence, though he does not actually see them. He pushes against his ears so forcefully that his face resembles a screaming skull. The dissolution of Munch's own form as it seems to sway with nature is an expression of emotional disintegration.

Chapter 6 Glossary

asymmetrical balance—lack of precise symmetry in a balanced work

asymmetry—sense of balance achieved by placing dissimilar objects or forms on either side of a central axis

content—themes or ideas in a work of art, as distinct from its form

form—overall plan or structure of a work of art

hierarchical scale—representation of more important figures as larger than less important ones

naturalistic—representing objects as they appear in nature

objective—representing the visible world

pattern—repetitive arrangement of forms or designs

pediment—(a) in Classical architecture, the triangular section at the end of a gable roof, often decorated with sculpture (see Chapter 16); (b) a triangular feature placed as a decoration over doors and windows

pylon—one of a pair of trapezoidal towers flanking the entrance to an Egyptian temple

realistic—representing objects from everyday life as they actually appear

representational—representing natural objects in recognizable form

rhythm—relationship, either of time or space, between recurring elements of a composition

scale—size in relation to the real size of some object or to some objective standard

sphinx—in ancient Egypt, a creature with the body of a lion and the head of a human

style—in the visual arts, a manner of execution that is characteristic of an individual artist, a school, a period, or some other identifiable group

subject matter—underlying content (figures, incident, scene, etc.) of a work of art

symbolic proportion—sizing of an object within a composition based on its relative importance as a symbol

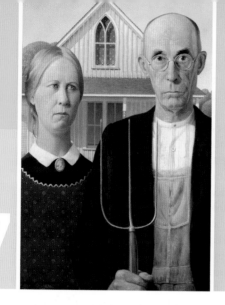

7

The Methodologies of Art

Have you ever thought about taking more than one approach to understanding works of art? People often interpret art from different points of view, which are called the methods or methodologies of art. The most common methods of interpretation are **Formalism**, **Iconography** and **Iconology**, **Marxism**, **Feminism**, **Biography** and **Autobiography**, **Semiotics** (which includes **Structuralism**, **Post-Structuralism**, and **Deconstruction**), and **Psychoanalysis**.

This mouthful of terms reminds us that imagery is complex and has multiple layers of meaning. In this chapter we will explore a few individual works primarily from one methodological approach and then apply several methods to a single work. As we consider each methodology, ask yourself whether you agree or disagree with its point of view. Think about which approach or combination of approaches you prefer—and why.

Formalism

The formalist method regards form as inseparable from content. Formalists derive meaning from the arrangement of visual elements, such as line, color, and shape, rather than from the subject matter. This method was inspired by the nineteenth-century philosophy of "art for art's sake," which reads content in formal terms and considers the aesthetic impact of a work to be its most significant quality. We will now look at a Japanese woodblock print and consider the interplay of form and content.

A formal approach to Keisei Eisen's *Oiran on Parade*

In 1830, during the Edo period in Japan, Keisei Eisen (1790–1848) produced the impressive woodblock print in **figure 7.1**. It shows an *oiran*, the highest-ranking Japanese courtesan, proudly parading through the streets of Edo (the old name for Tokyo). Eisen belonged to the *Ukiyo-e* ("floating world") tradition of painting, a term that refers to the vanity and transience of everyday life. His *oiran* wears the white make-up and ornate hairpins of a geisha and an elaborate kimono signifying her high rank within that profession.

If you were to approach Eisen's *oiran* formally, you might note that she occupies a strong vertical pose, that her contours are defined by broad, gradual curves, and that she fills the picture space. Her verticality accentuates her height, as do her platform shoes. The forward thrust of the kimono directs our eye beyond the left edge of the picture, so that the *oiran* seems to be advancing in that direction. We also note that the train of her voluminous kimono is cut off by the picture's right edge, which creates the impression that we are watching her as she passes by the imaginary, windowlike opening of the rectangular frame.

The rich colors of the *oiran*'s kimono are elaborate and eye-catching. Since orange and blue are opposites on the color wheel (see figure 5.42), they produce a striking chromatic effect when juxtaposed, as they are here. In addition, the rich Prussian blue provides a background for the design of the kimono and the hairpins.

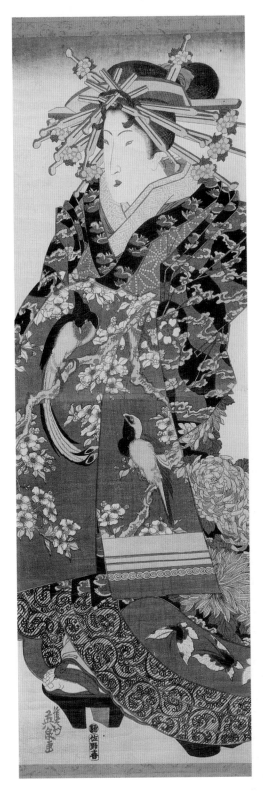

7.1 Keisei Eisen, *Oiran on Parade*, c. 1830. Woodblock print, 29 x 9¾ in. Victoria and Albert Museum, London.

Pattern and rhythm are also significant formal qualities, which are abundantly displayed on the *oiran*'s kimono. The intricate curvilinear rhythms of the patterns engage us, and we become caught up in viewing the details of the flowers, leaves, and cloud formations as well as the abstract geometric designs. The patterns on this kimono are particularly energetic because of the motion created by the curved lines, their shifting widths, and the sharp contrasts of color. The visual elements of the *oiran* thus define her character and also reinforce it. If we consider how the artist arranges form to convey meaning, we might note that the upright pose connotes self-confidence, that the direction of the curves indicates forward movement, and that the pictorial quality of the kimono shows that the figure herself is on display.

If we factor in the subject matter on the design of the kimono, which is not strictly part of a purely formalist approach, we see that a bird is sewn into the material. Both the bird and the *oiran* seem to be "strutting their stuff." Furthermore, the downward slant of the *oiran*'s eyes and nose, in contrast to the upturned head of the bird, creates the impression that she is looking down from above, and therefore that she is self-assured. Her pose corresponds to the popular expression "to look down your nose at someone," meaning to consider yourself superior.

In these last two observations, we have strayed from a purely formalist approach to the image because we have introduced the meaning of subject matter. This leads us to the next topic, which is called the iconographic method.

Iconography and Iconology

Iconography literally means the "writing of the image" and refers to the layers of meaning embedded in subject matter. When the iconographic method was first used, it was assumed that works of art were based on a written text such as the Bible. But now iconography has been expanded to include a broader notion of text. Today, iconographic studies of art can be based on oral traditions, on the social context of a work, on dreams and fantasies, and even on an artist's biography. In every case, however, the iconographic method assumes that a work is based on some type of narrative. So before undertaking an iconographic reading of an image, we have to identify the underlying narrative. Iconology is the study of imagery in its broader cultural or artistic context.

The Iconography of Giotto's *Adoration of the Magi*

Consider the picture in **figure 7.2**, which is one scene of a fresco cycle by the fourteenth-century Italian artist Giotto di Bondone (c. 1266–1327). Without knowing the text, or story, of the scene we might be startled by what we see. Who, we ask, is the old man kneeling down to kiss the feet of the swaddled infant? Who is standing next to the woman holding the infant? Why does the camel look surprised? Who is the winged figure in the long white robe? In short, what is going on?

If we are familiar with the biblical account of the life of Jesus, we recognize the scene: Mary is the mother of Jesus, whom she holds on her lap, and her husband Joseph is the old man standing beside her. The winged figure is an angel, and we expect angels in the story of Jesus's birth and childhood. All of these figures are sheltered beneath a wooden shed, which stands before a large triangular rock. We also read in the Bible that three kings, or wise men (the Magi), followed a star (above the shed) to Bethlehem to see the newborn Jesus and bring him gifts—gold, frankincense, and myrrh. The kneeling king has set

his gift on the ground, while the other kings still carry theirs. This event takes place in the Middle East, much of which is desert—hence the camels and the camel-drivers.

The iconographic reading of the scene can now be taken a step further, beyond the literal illustration of Jesus's life to a symbolic level of interpretation. This is based on allusions to traditional Christian meanings. We note, for example, that Mary is quite a bit larger than Joseph and the angel; if she were to stand up, she would tower over them. This is a reference to Mary's role as the Church building, the House of God, and links her with the architectural shed in Giotto's fresco. She holds Jesus forward, not as one would an ordinary baby, but as an offering, possibly even as a sacrifice. Her expression is downcast, alluding to her foreknowledge of the Crucifixion, of Jesus's destiny to die on the Cross. Referring, in turn, to the Cross is the wood of the shed, for the Cross was made from the wood of a tree. The prominence of the rock formations evokes the future Church, the Rock of Ages.

Giotto's camel appears pleasantly surprised. He has stopped short and pulls his neck and head backward, presumably because he has never seen an old king bowing before an infant. Giotto has thus

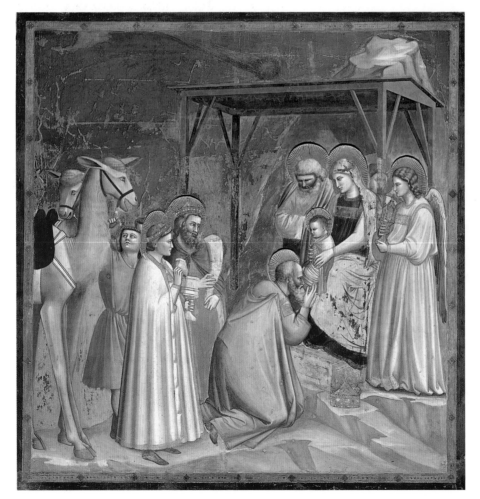

7.2 Giotto, *Adoration of the Magi*, c. 1305. Fresco. Arena Chapel, Padua.

endowed the camel with a human personality and expression, which was unusual in early fourteenth-century painting. This element is a feature of what we know about Giotto's style and personality; he was an astute observer of human nature, and he often introduced elements of humor into his pictures.

The iconology of the *Adoration of the Magi* would include its relationship to and position within the entire fresco cycle. It is only one scene in a narrative of Jesus's life and therefore is set in a particular time and place. On the wall of the chapel, the *Adoration* follows the *Nativity* (the birth of Jesus) and precedes the *Presentation in the Temple* (when Mary and Joseph present Jesus to the old priest Simeon, who had been promised by God that he would see the Savior before his death). Reading the vertical alignment of the frescoes, we would see that the *Adoration* is above *Jesus Washing the Feet of the Apostles*. In the latter scene, Jesus the adult kneels before the apostles, whereas in the former the kings kneel before the infant Jesus.

The Iconography of Andy Warhol's *U.S. Dollar Signs*

Our approach to Giotto's *Adoration* is based on the traditional iconographic method, which, in this case, takes the text of the Bible as its source. But now let's consider a twentieth-century work of art and apply a broader iconographic interpretation to it. *U.S. Dollar Signs* (**figure 7.3**), by the Pop artist Andy Warhol (1928–1987), shows a series of colorful dollar signs on a mauve background. Warhol's iconography is based on his view of American consumer culture and his interest in the theme of repetition. By varying the colors of the signs and their positions in space, Warhol animates the image. Some of the dollar signs have a single vertical descending through the S-shape, while others have two verticals, which suggests the strings of a musical instrument. The diagonal placement of the signs, their different colors, and their shifting spatial positions evoke the musical idea of variations on a theme.

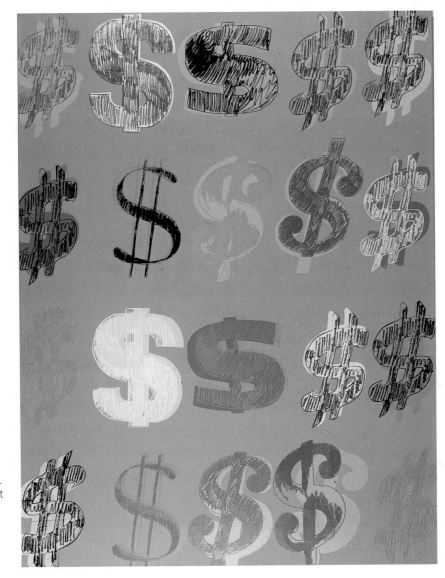

7.3 Andy Warhol, *U.S. Dollar Signs*, 1981. Synthetic polymer paint and silkscreen ink on canvas, 7 ft. 6 in. x 5 ft. 10 in. The Andy Warhol Foundation Inc.

The subject matter of the print is dollar signs, but the content and its meaning include associations to money. Like the culture of marketing, which relies on repetition as a means of persuading consumers to buy products, the dollar signs are themselves repeated. Warhol, who famously declared "I want to be a machine," made many prints, which are themselves produced in multiples. As a result, with prints there are more images for sale than with a unique work such as a painting or a sculpture. In either case, however, Warhol made a great deal of money selling his art, and that, too, is embedded in the iconography of *U.S. Dollar Signs*. The subject of money brings us to the next method we shall consider: the Marxist method.

Marxism

Marxist interpretations read the visual arts primarily in light of their economic and social contexts. Marxist art history considers both the making of art and its iconography in social, political, and financial terms. This approach is derived from the writings of the German economist Karl Marx (1818–1883), who viewed history as a dynamic struggle between an alienated working class (which he called the proletariat) and the wealthy (which he called the bourgeoisie). He argued that, in the context of the art world, artists belong to the proletariat and are exploited by the wealthy, who commission and buy works of art.

A Marxist Reading of Daumier's *First- and Third-Class Carriages*

Now we consider a Marxist approach to two paintings by Honoré Daumier, whose drawing of a young man running we have already discussed (see figure 5.2). Daumier earned his living by making caricatures of nearly every aspect of French society and publishing them in the popular press. Like Marx, Daumier was aware of class distinctions and their effect on individuals. Daumier sympathized with the working classes and satirized the pomposity of lawyers, the narcissism of actors, the dishonesty of businessmen, the incompetence of physicians, and the tyranny of kings.

In *The Third-Class Carriage* of around 1863 (**figure 7.4**), Daumier shows the bleak interior of a third-class French railway car. The uncomfortable conditions reflect the fact that third-class fares were the lowest available. Two working-class women in the foreground appear tired and dejected; one is nursing a child as the other gazes blankly into space. Next to her, an exhausted young boy has fallen

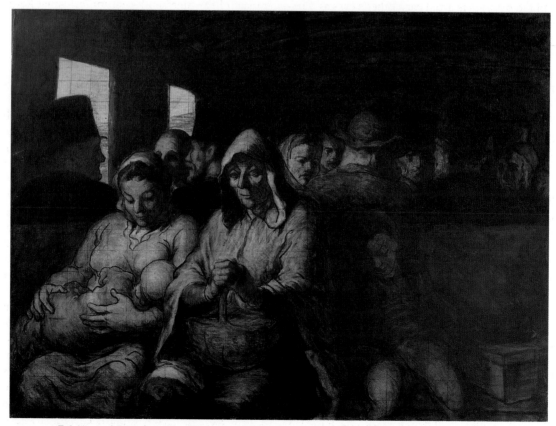

7.4 Honoré Daumier, *The Third-Class Carriage*, c. 1863–1865. Oil on canvas, 25 ³/₄ x 35 ¹/₂ in. Metropolitan Museum of Art, New York. Bequest of Mrs. H.O. Havemeyer, 1929. no. 29.100.29.

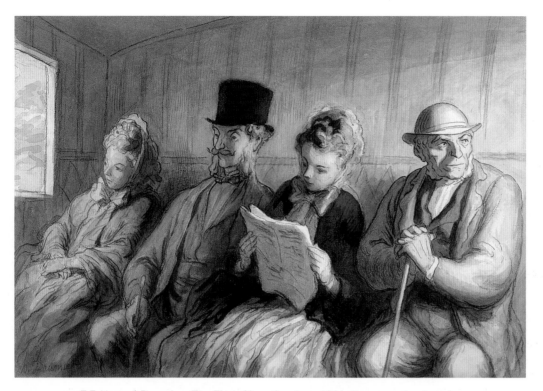

7.5 Honoré Daumier, *The First-Class Carriage*, 1864. Crayon and watercolor, 8 ¹/₁₆ x 11 ³/₄ in. Walters Art Gallery, Baltimore.

asleep. The background is cramped and crowded, and the passengers avoid each other's eyes as if trying to withdraw into a personal space. The contrast between the dark, claustrophobic interior and the brightly lit exterior is emphasized by sharp contrasts of light and dark. But the outdoors seems remote and almost irrelevant to the passengers. They, like Marx's proletariat, appear alienated.

In *The First-Class Carriage* (**figure 7.5**), Daumier portrays a more open space. There are only four figures in first class, and they are well-dressed and comfortably settled in for the ride. In contrast to the working-class occupants of the third-class carriage, those in first class belong to the wealthy class (Marx's bourgeoisie). The two men have elegant walking sticks, one woman reads a newspaper, and the other looks out of the window at the passing landscape. There is no sign of exhaustion or alienation in these figures as there is in those riding in third class.

Daumier's use of color and light in the two pictures reinforces their meaning. The third-class carriage is dark and drab—mainly composed of deep browns and thick black lines. In first-class, on the other hand, the tones are light gray and there is more open space. Daumier has thus arranged the visual elements in ways that emphasize his social point. He invites us to imagine how we would feel in the two cars, and he leaves no doubt that we would be more comfortable in first class. By choosing the subject of

a railroad car, Daumier also shows us the social impact of the nineteenth-century Industrial Revolution on French society.

Feminism

Another contextual approach to art history is Feminism. Feminist art historians believe that art is influenced by gender—the gender of the artist as well as that of the viewer. In addition, Feminism has opened up new avenues of research, identifying women artists and patrons who have been ignored or underappreciated by a male-dominated art-historical canon. So, if you are a man, you might think about how you envision women, and how you would like them to be, compared to your experience of real women. And if you are a woman, you might consider how you would like to be seen by men, how men actually see you, how you see yourself, and whether there is a discrepancy between the three views.

Although important women artists have been known since antiquity, feminism *per se* did not become a distinctive way of looking at—or creating—art until the twentieth century. One of the characteristics of feminism in the visual arts is the rejection of traditional male stereotypes of women. We can see this by comparing Raphael's *The Fornarina* (**figure 7.6**), apparently a portrait of his mistress, with a work by the modern feminist photographer Cindy Sherman (**figure 7.7**).

7.6 Raphael, *The Fornarina*, c. 1518. Oil on panel, 33 ¹/₂ x 23 ¹/₂ in. Galleria Nationale (Palazzo Barberini), Rome.

7.7 Cindy Sherman, *Untitled*, 1989. Color photograph, 5 ft. 1 ¹/₂ in. x 4 ft. ¹/₄ in. Courtesy the artist and Metro Pictures Gallery, New York.

Raphael is thought of as the most "Classical" of the High Renaissance artists in Italy. He described to a friend his method of creating pictures of beautiful women as follows:

> … to paint one beautiful woman, I must see several beautiful women…. But since there are not enough beautiful women, I use an idea.[1]

In other words, Raphael's beautiful women are composites. They do not conform to real women, but are a combination of features found in several women and arranged by the artist into an ideal woman.

Raphael's *Fornarina* may be a portrait, but it is also idealized. We know this from the woman's smooth, blemish-free skin, the symmetry of her form, her firm breasts, and her graceful proportions. Her drapery is delicate and transparent, and her headscarf is neat and of high-quality material. The precisely rendered armband contains one of Raphael's rare signatures, suggesting that he "owns," or has a sense of entitlement in regard to, the woman.

The title of the painting, *Fornarina*, is Italian for "baker's wife," although the actual identity of the painted woman is unknown. Nevertheless, a baker is a provider of food, and this is consistent with another traditional notion about artists and their female models—namely, that the model is a Muse, who

nurtures and inspires the male artist. Notice that Raphael refers to this tradition by merging several aspects of his ideal woman. The *fornarina* is proffering her breast as one might to a nursing infant. She thus combines the idea of female beauty with maternal nourishment and artistic inspiration.

In the nineteenth century, the French artist Ingres, who was himself influenced by the Classical tradition and whose portrait of Napoleon we saw in Chapter 5 (see figure 5.26), alluded to the idea that the *fornarina* was Raphael's Muse. His painting entitled *Raphael and the Fornarina* (**figure 7.8**) shows the *fornarina* seated on Raphael's lap as he turns to gaze at his painting of her. The visual and narrative sequence designed by Ingres begins with the woman (since in the West we tend to read pictures from left to right). By her closeness to Raphael, the *fornarina* infuses him with inspiration, which he absorbs. But then he turns from the real woman to his painted woman, and it is she who holds his attention. The *fornarina* faces us, the viewers, drawing our attention into the painting. Our gaze then moves to the artist and we follow his gaze to his painting. In so doing, we repeat Raphael's own creative sequence from the source of his inspiration through his mind to his creation.

Now consider Cindy Sherman's (b. 1954) contemporary comment on Raphael's *Fornarina* and

the Classical idealization of women. *Untitled* is both a criticism of the idea behind Raphael's image and a work of art in its own right. The photograph is actually a self-portrait; Sherman represents herself as a pregnant, dowdy, frumpy housewife with a rag on her head and coarse, transparent mesh drapery. She wears false breasts and has replaced the *Fornarina*'s elegant armband with a garter. Her pursed lips suggest that she is somewhat dissatisfied with her lot in life. Reinforcing this impression is the fact that Sherman sits in front of a patterned curtain which seems to "hem her in," whereas behind the *fornarina* we can see trees and an open sky.

If we compare *Untitled* with the *Fornarina*, we begin to understand Sherman's message. As a feminist, she satirizes the idealized view of women. As an artist, she couches her criticism in visual terms. She satirizes the Classical tradition and her photograph is a visual pun on that tradition. It is also a protest against the disservice she feels has been done to women by idealizing them, rather than by recognizing and dealing with their reality.

Sherman takes another step beyond the traditional relationship between artists and their work. We generally think of the artist as being the creator, and therefore separate from the work. In self-portraiture, we think of the artist as looking in a mirror and painting a relatively straightforward, recognizable self-image. But Cindy Sherman approaches her photographs differently. They are not self-portraits in the traditional sense. Instead, she steps out of herself as an actor does, in order to play a role. She has produced a series of photographs of herself in different roles, including the Hollywood vamp, ingenue, fashion model, gangster's moll, and even cadaver. In the case of *Untitled*, her role is a satire on a well-known art historical icon. We realize that Sherman herself is the subject of her work, but she is also its author. She thus blurs the boundaries between artist and model, viewer and viewed, and passive subject and active creator. Her feminist approach to art is not only as an artist and a critic, but also as a subject.

Sherman's personal relationship to her version of Raphael's *Fornarina* brings us to the biographical and autobiographical approaches to art.

7.8 Jean-Auguste-Dominique Ingres, *Raphael and the Fornarina*, 1814. Oil on canvas, 25 1/2 x 21 in. Fogg Art Museum, Harvard University Art Museums, Cambridge, Massachusetts. Bequest of L. Winthrop.

Biography and Autobiography

The biographical and autobiographical methodologies are interrelated and they assume that an artist's life and personality give meaning to works of art. To apply this method it is necessary to know something about the artist's life and thought. Although such information is not always available, a work itself can sometimes provide clues to the artist's life. This is especially true when artists create self-portraits or place themselves in the narrative of a work, in which case they reveal aspects of autobiographical content.

7.9 Gianlorenzo Bernini, *David*, 1623. Marble, lifesize. Borghese Gallery, Rome.

Bernini's *David* as Autobiography: A Biographical Reading

Gianlorenzo Bernini (see p. 69) was the leading sculptor working in the Baroque style in seventeenth-century Italy. One of his most famous works is the marble *David* (**figure 7.9**), which shows the biblical hero launching a stone from his slingshot at the giant Goliath. Knowing the text of the story, we recall that David decides to fight Goliath without armor, which we see on the ground behind Bernini's figure. We can also tell from David's expression that he is concentrating intensely as he stretches the sling and twists to one side.

Considering this work from a biographical point of view involves relating the character of David to what we know about Bernini himself. We know, for example, that Bernini made several drawings of himself as David. In one drawing, the victorious David holds the head of Goliath, whom he decapitates after the stone hits its mark. In other drawings, Bernini shows himself as David strangling a lion. This tells us that the artist identified with David's heroic strength. But he also identified with David's intelligence, for in rejecting the armor David had only his skill with the slingshot and a knowledge of tactics at his disposal.

What we know of Bernini's life is consistent with his depiction of himself as the heroic David. Bernini's father, in contrast to the fathers of many aspiring artists, thoroughly supported his son's ambition to be a sculptor. Recognizing Bernini's genius, his father used his connections to introduce him to important patrons in Rome, including influential members of the Catholic Church. Cardinals as well as Pope Urban VIII commissioned Bernini to create sculptures such as the *David* for their collections. One of Bernini's biographers asserted that the pope himself held up a mirror so that the artist could draw a self-portrait. As a result of his towering genius and the lifelong support of his father and his patrons, Bernini felt himself to be an artistic hero. In the lifesize statue of David, Bernini superimposed his identity as a hero among artists on that of a hero among warriors—in this case, a warrior who became a powerful king.

The actual facial features of the *David* are not demonstrably those of Bernini, even though it is clear from his drawings that he identified with the biblical hero. In the case of Gauguin's *Self-Portrait with Yellow Christ*, however, the artist has placed himself in a painting whose autobiographical meaning is readily apparent.

Gauguin's *Self-Portrait with Yellow Christ*

Gauguin's self-portrait in this painting (**figure 7.10**) reflects his struggle with two worlds—the Christian world of Western Europe and the South Sea island of Tahiti. He also struggled within himself. Gauguin looms large in the foreground, a forceful figure racked by uncertainty as he gazes at the viewer. He turns to the right, but shifts his gaze to the left—a visual metaphor for the artist's internal conflicts.

Behind Gauguin's head, we can see two works of art. One is his own painting, the *Yellow Christ*, which is set in a French landscape. Christ's head echoes Gauguin's, with its masklike appearance and geometric nose. The artist's identification with Christ reflects the feeling that he suffered because the French public did not appreciate his art. The other work resembles an Oceanic mask, and its slightly distorted features are juxtaposed with those of the

artist. Gauguin thus depicts himself between two worlds—his native France, bound by the constraints of Western civilization, and Tahiti, which he saw as an idyllic paradise. He uses the device of art within art to convey his own conflicted character. The works behind Gauguin divide the background into two areas of space, thereby reflecting his own "split" between Europe and the South Seas, between social constraint and sexual freedom, and between artistic tradition and innovation.

The assumption of the biographical and autobiographical methodologies is that artists are present in their works, even when we cannot identify them as such. But the next method we consider calls that assumption into question and considers works from the point of view of signs that have little or no relation to the artists who create them. In literary studies, this approach is referred to as the Death of the Author and the method used is called Semiotics.

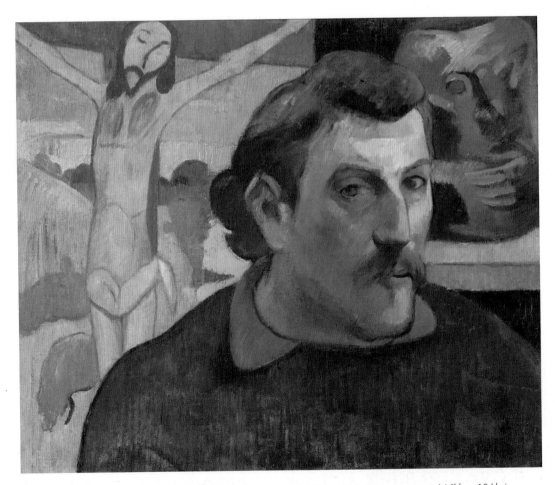

7.10 Paul Gauguin, *Self-Portrait with Yellow Christ*, 1890–1891. Oil on canvas, 14 $^{15}/_{16}$ x 18 $^{1}/_{8}$ in. Musée d'Orsay, Paris.

7.11 Claude Monet, detail of 7.12.

Semiotics

Semiotics was originally a system of interpretation applied to the structure of language. Later it was applied to societies, to myths, and to the visual arts. Semiotics is a system of signs. The semiotic sign has two parts: the signifier and the signified, which are like two sides of a coin.

This sounds complicated, so let's try an example. Have you ever thought about the relationship of letters and words to what they refer to? If you think of a haystack, you probably cannot see a relation between the letters h-a-y-s-t-a-c-k and your mental picture of a stack of hay. For a semiotician, the letters are the signifier and your mental image of the haystack is the signified—the signified is what the letters refer to. The relation between signifier and signified is purely arbitrary; that is, they have no logical connection to each other. But if you saw a picture of a haystack, you would probably agree that the picture is closer to your concept of a haystack than the word *haystack* is.

In **figure 7.11**, we can see colorful brushstrokes of paint on a canvas, but we cannot identify the shape of a recognizable object or figure. The individual brushstrokes comprising a painting are similar to the letters that make up a word and the words that make up a sentence. But if we step back from the detail, the whole picture comes into view (**figure 7.12**). We now see that the brushstrokes are components of a painting of a haystack by the French Impressionist Claude Monet (1840–1926). The image of a haystack is now comprehensible, because we have some perspective on it. We see that the haystack stands in a snowy field and casts a diagonal shadow toward the lower right of the canvas.

The relationship of letters to words resembles the relationship of brushstrokes to completed images. And the relationship between the component parts of both a literary work and a picture can be thought of as arbitrary. Monet himself referred to this idea when he noted that a painted tree is not actually a tree, but rather a vertical brushstroke on a canvas. A semiotician would say that Monet's brushstrokes, like the letters of a word, are the signifiers and the haystack, like the mental image conveyed by the word, is the signified. Together they comprise the sign, which points us toward visually comprehending Monet's rendering of the haystack.

This method conceives of works of art in terms of objective signs—capable of analysis as sign systems, or structures.

7.12 Claude Monet, *Grainstack (Snow Effect), Morning*, 1891. Oil on canvas, 25 ³/₄ x 36 ³/₈ in. Museum of Fine Arts, Boston. Gift of Miss Aimée and Miss Rosamon Lamb in memory of Mr. and Mrs. Horatio Appleton Lamb.

Post-Structuralism and Deconstruction

One branch of semiotics is Structuralism, which tends to eliminate a consideration of the artist or author in interpreting a work. Most structuralists believe that the artist or author does not impart ultimate meaning to a work—hence the term "Death of the Author." After a time, however, structuralist interpretations evolved into Post-Structuralism, in which the author/artist is again considered in conferring meaning.

In Post-Structuralism, readings of works are not restricted to "objective" systems. Instead, personal elements, including the response of the viewer and the role of the author/artist, are taken into account. One facet of Post-Structuralism, which is called Deconstruction, opens up the structural systems and questions traditional assumptions about what we see, or think we see.

We can see how this works if we try to deconstruct Leonardo's *Mona Lisa*, which we discussed in Chapter 5. The subject of the painting is the wife of the Florentine nobleman Francesco del Giocondo. Since we know that Leonardo painted very slowly, it would not be surprising if Mona Lisa became impatient at the length of time she had to pose. Leonardo's biographer, Giorgio Vasari, wrote in the sixteenth century that Leonardo hired musicians and jesters to keep Mona Lisa entertained while she sat for her portrait.

As we study the picture, we observe that Mona Lisa is seated on a balcony, overlooking a landscape. But on closer inspection, we recognize that the view through the window is neither the city of Florence nor its surrounding territory. So a deconstructionist might ask: where exactly is Mona Lisa sitting? It appears that her landscape is imaginary. No such landscape is known to exist, even though, when we look at the painting, the mountains and valleys are believable. On further inspection, we would have to admit that we do not even know if Leonardo intended the view to represent a landscape at all. Maybe he conceived of Mona Lisa as seated before a painting of a landscape, a notion suggested by the shifting viewpoint—we look at the woman head-on, but we have a bird's eye view of the landscape.

This raises questions about the woman herself. Maybe she, too, is a fiction; maybe Vasari's account is a fiction. She may have posed for her portrait for a long time, or Leonardo may have painted the picture from a drawing or sketch—in which case she might have posed only briefly.

Another issue that has fascinated viewers of the *Mona Lisa* ever since it was painted is the meaning of her smile. Leonardo does not tell us why she is smiling, although, as we said, Vasari suggests that she is smiling at the jesters. This is consistent with the designation *La Gioconda*, another name for Mona Lisa, which in Italian means both the "wife of Giocondo" and "the smiling one."

By asking such questions, to which the available documents provide no answers, we are deconstructing the painting. We are taking it apart, element by element, but we are unable to come to definitive conclusions. This is not the case with the next method we will consider, namely, the psychoanalytic method. Psychoanalysis, in contrast to Deconstruction, bases interpretations on the artist's personality and unconscious mind. Like Deconstruction and the iconographic method, psychoanalysis considers the meaning of individual elements in a work of art. But psychoanalysis differs in that it re-constructs meaning by showing relationships between the parts of the whole and, in contrast to Structuralism, by assuming that nothing is coincidental or arbitrary.

Leonardo, *Mona Lisa*.
figure 5.5, page 78

Psychoanalysis

The psychoanalytic approach to art considers the underlying unconscious meaning of a work. This can involve both an analysis of the artist's personality in relation to the work and the consideration of a work independently of the artist.

The first psychoanalytic study of an artist was Sigmund Freud's psychobiography of Leonardo da Vinci, published in 1910. Freud showed how the artist's childhood and personality influenced his iconography, his style, and his working methods. Using dreams, memories, fantasies, jokes, and slips of the tongue as evidence, Freud analyzed the underlying meanings of Leonardo's imagery. In Freud's view, the core of child development is the Oedipus complex, which comprises the various facets of the child's relationship to his or her parents (or other adult substitutes for parents).

The French psychoanalyst Jacques Lacan (1908–1981) also influenced approaches to art, particularly from the point of view of the gaze. Because art is about looking, and looking can be erotically charged, Lacan called a picture "a trap for the gaze." In other words, works of art "trap" the viewer, thereby transforming sexual curiosity into aesthetic response.

We now return to Brancusi's *Bird in Space*, which we discussed in Chapter 1. The *Bird* has been analyzed from many points of view, one of which takes the psychoanalytic approach. The author of this particular interpretation is the art critic and Brancusi expert Sidney Geist (1913–2005).

Geist's reading of *Bird in Space* takes the artist's life as a starting point. He noted that Brancusi was born in rural Romania, and that his father was an abusive peasant who wanted his son to be a girl. At an early age, Brancusi ran away to Bucharest, where he met an educated man who recognized his talent and encouraged him to pursue art. Brancusi then went to France and studied sculpture. He remained in France and worked mainly in Paris.

Brancusi's early works were figurative, but he soon evolved his own signature style of smooth, highly polished, abstract sculptures. We have seen that the forms of *Bird in Space* convey the "essence," or idea, of a graceful bird suspended in the air. Geist read the bird as a symbolic phallus, reflecting the fact that in some languages—Italian, German, and English—the term "bird" can be slang for phallus. He also points out that Brancusi's *Bird* stands erect, as if proudly asserting itself.

The sun is a traditional image of fertilizing power, and in mythology is nearly always a male god. The *Bird in Space*, of which Brancusi made several versions in marble as well as bronze, seems to be standing up to the sun—in Geist's view, the artist is symbolically facing down, and showing his triumph over, his abusive father. By remaining a man and becoming a famous sculptor, the artist defeated his father's efforts to feminize him and to destroy his creativity.

Finally, Geist pointed out that Brancusi himself reinforced this interpretation of the *Bird*'s meaning in an unusual way. The artist arranged his sculpture so that it reflected the sun and then photographed it (**figure 7.13**). He shows the sun repeatedly bouncing off the *Bird*'s highly polished surface so that it is the sculpture, rather than the sun, that appears to be the source of light and power.

COMPARE

Brancusi, *Bird in Space.*
page xviii

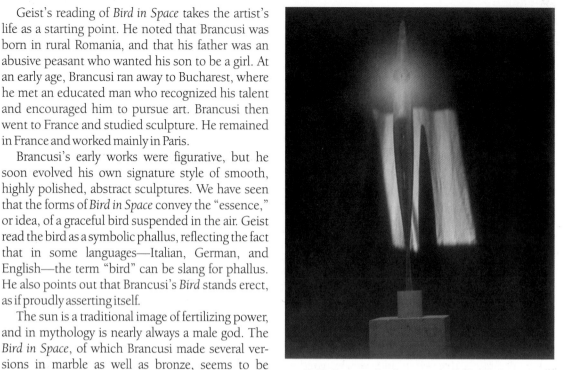

7.13 Brancusi's photograph of *Bird in Space* reflecting the sun, c. 1933. Centre Georges Pompidou, Paris.

— ◆ —

Now that we have surveyed the visual elements of art, the terms used to describe these elements, and different interpretive approaches, we turn to categories of media. First we consider two-dimensional media such as drawing and painting, printmaking, and camera arts, and then we proceed to three-dimensional media. These include sculpture, certain types of craft, and architecture.

A Medley of Methods:
Grant Wood's *American Gothic*

Now that we have surveyed several modern approaches to interpreting works of art, we will try to integrate them by applying all of them to one work, namely the familiar American painting *American Gothic* (**figure 7.14**). The artist, Grant Wood (1892–1941), painted in the Regionalist Style popular in the United States during the 1920s and 1930s. Regionalism, as its name implies, is a style that emphasizes the identity of a particular region of the country.

A formal approach to *American Gothic* would consider how the lines, shapes, colors, and other visual elements convey content. If we diagram the shapes and lines in the painting (**figure 7.15**), we see that there are two prominent verticals—the man and the woman. The figures are in the foreground and their near frontality and forthright appearance make a forceful impression on the viewer. The middle-ground architecture is comprised of geometric shapes—mainly triangles and rectangles—softened somewhat by the rounded green trees in the background.

If we look closely at the colors, we note that they are arranged to achieve a sense of balance and order. For example, the orange of the woman's cameo brooch is repeated in the barn at the right, in the flowerpots on the porch at the left, in the man's tiny collar stud, and in his hand. The man wears a black jacket, and the woman wears a black dress under a patterned apron; his strong black eyebrows and intense black pupils repeat the black of his jacket. From a formalist point of view, therefore, the forthright forms of this couple and the austere background impress us.

An iconographic approach to *American Gothic* would try to identify an underlying text. In this case, there is no written text aside from the title, which actually is quite informative. It tells us that Wood's image is both American and Gothic. The verticality of the figures and their rigid poses are reminiscent of early Gothic sculptures. But Wood's figures are not saints or royal personages from the Bible. These are Americans, and there are no kings and queens in America. They are serious, hardworking Midwesterners, who are tied to the land.

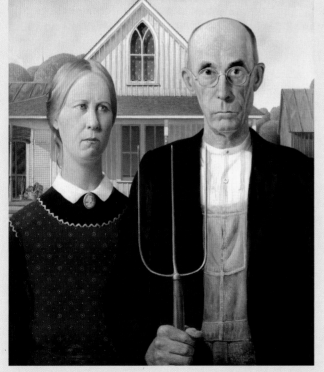

7.14 (Left) Grant Wood, *American Gothic*, 1930. Oil on beaverboard, 30 ¹¹/₁₆ x 25 ¹¹/₁₆ in. Art Institute of Chicago. Friends of American Art Collection.

7.15 Diagram of shapes in *American Gothic*.

A Medley of Methods:
Grant Wood's *American Gothic*

The architecture of the house is in the style known as Carpenter Gothic, which was an inexpensive type of clapboard structure developed in the early twentieth century. The second-story window is shaped like a church window and, like windows and arches in Gothic cathedrals, is pointed at the top. Despite the American character of the figures, therefore, they and their house are reminiscent of qualities associated with the Gothic style. By combining elements of medieval and American cultures, Grant Wood reminds us that although America is American first, it is also a melting pot and it was settled by people with prior cultural histories.

A Marxist approach to *American Gothic* would point out that the farmers are wearing work clothes. They are identified as members of the working class, and belong to Marx's proletariat. Even though they might own the farm, they do not benefit from it as much as the people who process and sell the finished goods. The man's denim overalls suggest that he works hard, which is also conveyed by his lined face and the firm grip of his hand on the pitchfork. Marxists would observe that these farmers live in a modest house (Carpenter Gothic in style), and probably keep animals in the barn.

A feminist approach to American Gothic would note that the man is given more prominence than the woman. He stands slightly in front of her and is taller than she is. He also looks directly ahead, at the viewer, whereas she glances sideways. This arrangement makes him appear more assertive than she, which is accentuated by the fact that he holds the pitchfork. This indicates that he does the outdoor work, which in this case entails bringing home food as well as money. Her association with the interior of the house is suggested by the fact that the pattern and color of her apron match the window shade. Her apron alludes to the woman's traditional role in the kitchen as the one who prepares the food. All in all, the woman appears somewhat subordinate to the man, less important than he in the grand scheme of maintaining and running a farm.

A Structuralist looking for signs in *American Gothic* will find several. The verticality of the figures signifies their upright character and implies moral rectitude. The images of the figures denote, or identify, them as farmers, and they connote hard work. The rhetoric of this image is the moral virtue of work within a Christian tradition that advocates the work ethic.

A viewer wishing to deconstruct Grant Wood's painting would have much food for thought. Are these people actually Iowa farmers, one might ask? How do we *know* that they are Iowa farmers? Maybe they are just dressed up to resemble Iowa farmers. And, in fact, it turns out that they are not Iowa farmers at all. The woman was the artist's sister, and the man was his dentist. Wood dressed and posed them to *look like* Iowa farmers.

Why, one might ask, did Wood impose this fiction on viewers? One answer might take a biographical approach and point out that the artist was himself born in Iowa. His ties to the Midwest were strong; he studied at the Chicago Institute of Art school and worked in Cedar Rapids, Michigan. He also traveled to Europe, where he would certainly have seen Gothic cathedrals. He did not, however, absorb the avant-garde European styles evident, for example, in Brancusi's *Bird in Space*. He preferred the older European styles, and it was these that he assimilated into the American scene. Politically, Grant Wood was a socialist, which may account for his focus on the workers in *American Gothic*.

A psychoanalytic approach to the painting would consider its relation to the artist's inner life. We know that, as a child, Wood loved studying the patterns on his mother's inexpensive china known as Willow-Ware. Its scenes of bushy, rounded trees recur in the background of *American Gothic*. The artist's childhood interest in patterning is found again in the woman's apron and the window shade. Since there is no sequentially ordered time in the unconscious, childhood recollections can surface when triggered by something in the present. Possibly using his sister as a model evoked Wood's memories of his family.

The gaze is a particularly strong aspect of this painting. A couple standing in front of a house, from the point of view of a child, suggests parents. These would be rather stern parents; both are frowning slightly and are tight-lipped. The man peers through a pair of steel-rimmed glasses, which accentuate his gaze. We, the viewers, cannot help but return the gaze, possibly resurrecting our own memories of being observed by stern parents.

Chapter 7 Glossary

Autobiography—related to the biographical method, this method works from the basis that the artwork is an expression of the artist's life

Biography—related to the autobiographical method, this method works from the basis that an artist's life and personality give meaning to the art he or she produces

Deconstruction—branch of the semiotic method that opens up structural methods (structuralism and post-structuralism) and questions traditional assumptions about what we see, or think we see

Feminism—contextual method that works from the basis that an artwork's meaning is influenced by the gender of both the artist (usually female) and viewer

Formalism—method that regards form as inseparable from content, placing emphasis in the interpretation of an artwork's meaning on its arrangement of visual elements such as line and color rather than on its subject matter

Iconography—meaning literally the "writing of the image," this method focuses on the layers of meaning of an artwork's subject matter

Iconology—method that takes as its basis the significance of an artwork within its broader cultural or artistic context.

Marxism—method that interprets artworks in the light of their economic and social contexts

Post-Structuralism—branch of the semiotic method where the response of the viewer and the role of the artist are taken into account when interpreting an artwork

Psychoanalysis—method that considers the underlying unconscious meaning of an artwork.

Semiotics—method that interprets an artwork according to a system of signs perceived in the artwork; each sign is further broken down into two parts: the signifier and the signified. Structuralism, post-structuralism, and deconstruction are all branches of this method.

Structuralism—branch of the semiotic method that maintains that artists impart no meaning to their artwork, and that interpretations should be devoid of all such considerations

Part IV Two-Dimensional Media and Techniques of Art

Everyone who creates art requires some type of material. The material (the medium) has characteristics that affect the appearance of a work. Technique, which refers to the way an object is made, functions together with the medium and ideally they complement each other. Both can convey meaning, and both have practical as well as aesthetic consequences. We would not, for example, want to live in a paper house even if it were attractive. We would prefer to live in a house that is both sturdy *and* attractive. We would not want the paint to flake off a picture hanging on our wall, and we would not want a piece of furniture or a statue to topple over because of poor balance.

We have seen that most people create images naturally, that children draw and paint, carve and mold, and build when they can get their hands on the necessary material. Artists choose materials for a variety of reasons, whether aesthetic, psychological, financial, or practical. Usually the decision is based on some combination of these factors. But the choice of material must take into account its availability, which may depend on where a work is made, when it is made, and its cost.

A work of art, like all images, begins as an idea. The idea then has to be transformed into concrete form: in art the form is visible; in music it is auditory; in literature it is written, and so forth (although there is also intentionally temporary art, such as the Navajo sand paintings, which we discussed in Chapter 3, as well as oral traditions in music and literature). As long as a work is given form, however, there is a necessary transfer from the brain to the hand (or even foot) that has to take place. The mind conceives the idea, then selects a medium, and the hand executes the work (the technique). Sometimes artists go to great lengths to produce a work. The French Impressionist painter Pierre-Auguste Renoir (1841–1919), for example, suffered from rheumatoid arthritis and was unable to move his fingers as he grew older. In order to continue working, he strapped a brush to his hand and controlled it from his shoulder and arm.

This section of our text will focus on two-dimensional works of art: drawing, painting and related techniques, printmaking, and camera arts. These are images on flat surfaces and any suggestion that they have depth is an illusion created by the artist. When more than one medium is used, we say that a work is composed of **mixed media**.

We begin with drawing. The fifteenth-century Italian artist and author of the classic *Craftsman's Handbook*, Cennino Cennini (c. 1370–c. 1440), believed that one should practice drawing a little bit each day:

> … set yourself to practice drawing, drawing only a little each day, so that you may not come to lose your taste for it, or get tired of it.[1]

(Opposite) Pisanello, *Head of a Horse*, 1433–38. Pen and ink on paper, 10 ½ x 6 ½ in. Louvre, Paris.

KEY TOPICS
Purposes of drawing
Dry media
Liquid media
Mixed drawing media

8

Drawing

We all draw at some point in our lives. Some of us doodle while talking on the telephone or when listening to a boring lecture, and some of us make graffiti on subway walls, lamp posts, or sidewalks. Before the invention of photography, people took visual notes by making drawings of things they wanted to remember. In all such cases, people make marks on a surface (called the **ground**), which is the essence of drawing.

The visual element that predominates in drawing is line. The surface of a drawing with which we are most familiar is paper, but artists (and children) have used many other surfaces, such as walls, floors, furniture, mirrors, blackboards, even their own bodies. In China, silk has long been a popular drawing surface; in ancient Egypt, artists drew on **papyrus**, a paperlike material made from plants growing along the Nile; and in Europe during the Middle Ages, monks and nuns illuminated manuscripts on **parchment** (made from sheep or goat skin) or **vellum** (made from young calfskin). Parchment and vellum are more expensive than paper and are rarely used today.

Functions of Drawing

For professional artists, drawings serve particular purposes and can be works of art in their own right. They may illustrate a text, whether a comic strip, a book, or a popular myth. Drawings may be preparations for a more durable work, such as a painting, sculpture, or building. In that case, a drawing can be a valuable record of an artist's process as he or she works out an idea. Since drawing is one of the least

> The sketching out of the narrative should be rapid, and the arrangement of the limbs ... confined to suggesting their disposition. Later, at your leisure, you can finish them to your liking.
>
> Leonardo da Vinci (1452–1519), on preparatory drawing

expensive techniques available to artists, it lends itself to experimentation. As a result, when we look at preparatory drawings, we can often see what the artist was thinking and how an idea developed from its inception to the final product.

Picasso was a prodigious draftsman as well as a prodigious painter and he kept drawing records of his ideas for paintings. By comparing one of several sketches for his famous, but enigmatic, Blue Period *La Vie* (*Life*) of 1903, we can identify some of the changes that evolved between the drawing illustrated here and the finished painting (**figures 8.1** and **8.2**). In the drawing, a young couple stands before a picture of an embracing couple on an easel. A mysterious, undifferentiated figure seems to enter the drawing at the right, extending a hand toward the easel picture. Since for Picasso painting *was* life, we might think that this ghostly figure is the artist himself. In another drawing, however, the figure turns out to be a portrait of someone else. The head of the young man, however, is Picasso's.

In the final painting, the ghostly figure is gone. It has been replaced by a stern, statuesque matron holding a sleeping infant. Her large feet and the columnar folds of her drapery endow her with an architectural quality—as if she is the pillar of the

discussed at great length by scholars and many interpretations have been proposed. One thing we can say for certain is that, in the transition from the drawing to the painting, Picasso changed his mind in a number of ways. We might say that his process conformed to Leonardo's recommendation and that, after many revisions of the preliminary drawings, Picasso finished the work "to his liking." He altered the identity of his figures, indeed altered the very figures themselves and their disposition in the picture space. By eliminating the easel and placing the two pictures-within-the-painting in the background, Picasso made the final iconography less specific and more elusive than in the preparatory drawing.

8.1 Pablo Picasso, Sketch for *La Vie*, 1903. Brown ink on paper, 6 ¼ x 4 ⅜ in. Musée Picasso, Paris.

family. One implication of this iconography is that the infant belongs to the young couple, whose intimacy is conveyed by their closeness to each other. But the physiognomy of the man is no longer Picasso's; now it resembles that of Picasso's friend Carlos Casagemas, who had committed suicide two years earlier, in 1901.

The painting within *La Vie* has also changed. It no longer rests on an easel. Instead it has become two paintings, one depicting an embracing couple, and the other a single crouching figure curved in on itself. One question these background pictures raise is whether they represent times before and after Casagemas's suicide. In one, the man is there, in the other he is absent. The meaning of *La Vie* has been

> An idea is a beginning point and no more. If you contemplate it, it becomes something else.
>
> Pablo Picasso (1881–1973), on the evolution of a work of art

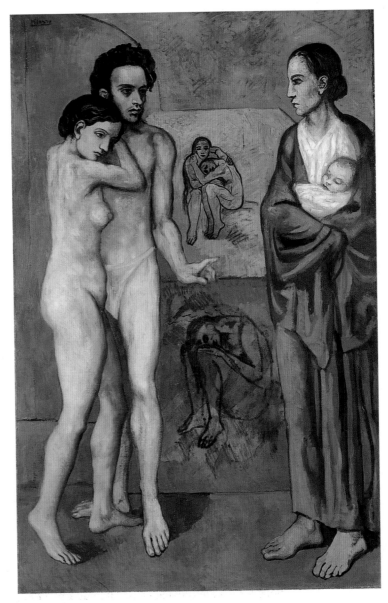

8.2 Pablo Picasso, *La Vie*, 1903. Oil on canvas, 6ft. 5 ⅜ in. x 4 ft. 2 ⅞ in. The Cleveland Museum of Art. Gift of the Hanna Fund.

The preliminary quality of many drawings, like those for Picasso's *La Vie*, makes them seem closer to the artist's original creative idea. They are also likely to be smaller in scale, less edited, and more spontaneous than more permanent works. For this reason, drawing is sometimes used in psychotherapy as a route to the intimate thoughts and feelings of children and adults in treatment. Often an image can convey what is on someone's mind as effectively as talking about it, and sometimes even more so.

Drawing materials have pigment and texture and each produces characteristic types of lines. The width of the lines, areas of light and shade, and color depend on how the artist manipulates the drawing instrument. A pencil or brush with a fine tip, for example, will make a thinner line than one with a dull tip. The drawing instrument is controlled by the artist's hand, which determines the width, density, shading, and precision of a line. More pressure increases the density of the line, and lighter pressure reduces it.

Drawing media are of two types: dry and liquid. Dry media include charcoal, metalpoint, chalks and pastels, crayons and pencils. The most common liquid media are inks, which are typically applied with a pen or brush. **Figure 8.3** shows some commonly used drawing tools and the lines they can produce.

Dry media such as pencils and charcoal scratch into a surface more or less firmly depending on the pressure exerted by the artist, whereas a liquid medium such as ink is fluid. As a result, liquid media can be applied independently of a drawing instrument; they can be poured, dripped, sprayed, or splattered, as well as applied with an instrument. Most Westerners also use dry media such as pencils when they write. Poor handwriting is sometimes referred to as a *scrawl*, which conveys the abrasive quality of dry media. In the Far East, as we have seen (see figure 5.1), calligraphy is produced with a brush and ink, and transforms handwriting into a fine art.

Dry Media

Charcoal

One of the oldest of the dry media is **charcoal**, which comes in different grades, from hard to soft, and is suited to creating different visual effects. Charcoal is made of burnt or charred wood (which is carbon), usually in the form of short, thick sticks, and can be used to create a strong impression of texture. The degree of pressure that an artist exerts on the charcoal also affects the appearance of light and dark. Values created with charcoal range from light grays to silky blacks. One characteristic of charcoal that you might consider a disadvantage, though it could also be used for certain effects of blurring, is that it smudges easily.

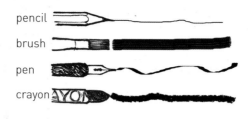

8.3 Instruments used for drawing and their characteristic lines.

This is because the charred wood of which it is made cannot be bound as tightly as other dry media and its particles flake off as it is used.

Charcoal is an ancient medium. A form of charcoal was used by the cave artists during the Paleolithic period—for example, the stags in **figure 8.4**, which date to around 12,000 B.C. In this case, the surface is the rough wall of the cave, which gives the charcoal lines an uneven texture. As we follow the outlines of the stags' heads, we see that the wall is visible under the lines. Where the artist pressed more firmly on the charcoal, as in the eyes, a rich black was produced and the wall surface does not show through the lines. One effect of the uneven lines is to make the animals seem to be literally part of the background, as if they are in the process of emerging from the wall. This sense of coming into being is reinforced by the broad diagonals of the necks and antlers that create an illusion of movement. The stags appear to be running across the wall, just as the cave artist would have seen them running in life.

More recent artists tend to use charcoal for preparatory studies rather than finished works.

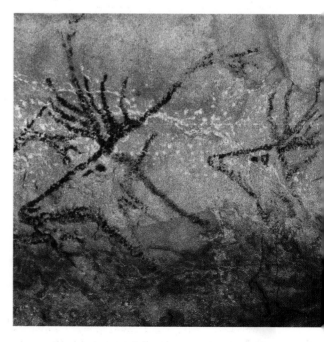

8.4 *Frieze of Stags' Heads*, Lascaux Cave, c. 12,000 B.C. Dordogne, France.

Chao Meng-fu, *Running script.*
figure 5.1, page 76

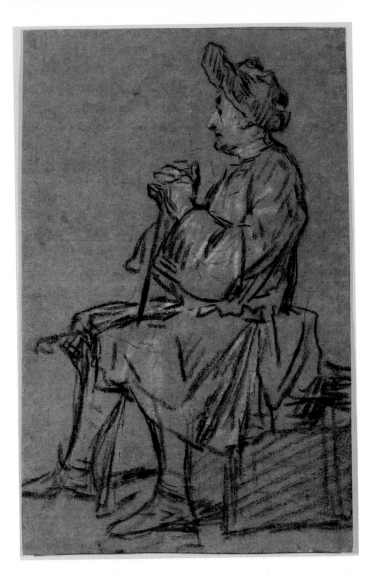

8.5 Jean-Baptiste-Siméon Chardin, *Study for a Seated Man* (recto), c. 1720–1725. Charcoal and white chalk, 10 ¹/₁₆ x 6 ⁹/₁₆ in. J. P. Getty Museum, Los Angeles, California.

When they are finished works, drawings can be sprayed with a fixing agent to prevent the charcoal from smudging. From the sixteenth century, charcoal began to be soaked in oil, in which case the lines do not smudge and can be rich and dark.

Figure 8.5 illustrates a charcoal drawing by the eighteenth-century French artist Jean-Baptiste-Siméon Chardin (1699–1779). He has taken advantage of the variety of light and dark that is possible with charcoal by emphasizing the lines on the man's cloak and lightening those on the cube where he sits. The facial features are composed of short, precisely drawn lines, with a smudged effect on the chin and neck to suggest sagging folds of flesh. The weight of the man's hands on his walking stick and the stick itself indicate that he is elderly, which is reinforced by the tints of white on his face and hands. Similar tints also highlight his costume.

Chardin has sketched in two cast shadows behind the man's feet, showing that there is a light source to the left. Throughout, there are areas of roughly sketched, undefined passages that create a sense of process. Even though this drawing is a completed work of art in its own right, we still have the impression of seeing how the artist was thinking as he went along.

Silverpoint

Silverpoint is a type of **metalpoint**. It was most often used in the fourteenth and fifteenth centuries in Western Europe. Medieval handbooks on art recommended that students learn drawing before painting and that they begin with silverpoint. For reasons of economy, beginning students practiced on tablets that could be easily erased rather than on the more expensive parchment, vellum, or paper (which, at the time, was a more expensive material than it is today). As a result, many preliminary drawings no longer exist.

A silverpoint pen consists of a thin, silver wire in a cylindrical casing like a pen or pencil. The lines made by silverpoint are extremely fine, usually a pale gray, and cannot be erased. They can be highlighted with white lead or darkened, but pressure does not vary their density or thickness. Their tones are fairly uniform. As a result, the silverpoint artist needs a light, controlled touch. When applied to paper or parchment, silverpoint requires that the surface, or ground, be prepared, usually with a coating of white pigment made of powdered bone.

The even tonality of silverpoint lends itself to subdued subject matter and a minimum of motion. The

8.6 Domenico Ghirlandaio, *Portrait of an Elderly Lady.* Silverpoint with white on orange prepared paper, 9 x 7 ¼ i n. The Royal Collection © 2006, Her Majesty Queen Elizabeth II.

8.7 Domenico Ghirlandaio, detail of *The Birth of the Virgin*, 1490s. Fresco. Cappella Maggiore, Santa Maria Novella, Florence.

> ... the darker you want to make the shadows in the accents, the more times you go back to them. And let the helm and steersman of this power to see be the light of the sun, the light of your eye, and your own hand....
>
> Cennino Cennini, artist and author (c. 1370–c. 1440), on the use of silver to create light

fifteenth-century silverpoint drawing of an elderly woman by Domenico Ghirlandaio (1449–1494) is a case in point (**figure 8.6**). This portrait shows a full-faced woman wearing a hood and gazing downward. The evenness of the silverpoint lines is highlighted and darkened in certain areas to create the illusion of fleshy features and a firm underlying bone structure. A single point of white in the left pupil conveys the viscous consistency of the eye and makes it appear reflective.

Somewhat enlivening the expression are the graceful white curves of the hood flowing into the cape under the woman's chin. The overall character of the figure remains weighty, calm, and introverted. Silverpoint drawings such as this create the impression of a finished work because we are aware of the artist's precision. But Ghirlandaio's woman may have been drawn in preparation for a figure in his monumental wall-painting *The Birth of the Virgin* (**figure 8.7**).

Pencil

Pencils have been used for drawing since the sixteenth century, when they began to replace silverpoint. They can be colored or, if made of **graphite** (a mixture of carbon and clay heated in an oven), black and gray. This is what we mean when we refer to a "lead pencil." When we "sharpen" a pencil, we remove some of its wood casing, freeing the graphite and making its tip more pointed. The point creates a thin line, but it can be slanted so that the artist's pressure on the side of the graphite produces a wider line. Pencil lines are also easy to repeat when hatching and cross-hatching. Today, pencils are made with different degrees of hardness and softness, the most usual being the Number 2 pencil. The harder the grade of the pencil, the sharper and more precise its line. Softer pencils create a more textured line. Pencils have the advantage of being inexpensive and easy to erase.

Van Gogh had very little money and was always worried about of the cost of materials. For this as well as for aesthetic reasons he often drew in pencil. Compare, for example, van Gogh's pencil drawing of the head of a young peasant (**figure 8.8**) with Ghirlandaio's elderly woman. In the van Gogh, we can see the variety of line and texture that is possible with pencil. The artist conveys the rugged character

8.8 Vincent van Gogh, *Young Peasant, Head*, 1885. Pencil on paper, 13 ³/₄ x 8 ¹/₄ in. Vincent van Gogh Museum, Amsterdam.

of the peasant's face by manipulating the pencil lines. He has a long nose with a lump on the bridge, heavy black eyebrows, and wisps of shaggy hair at the back of his neck. The latter were made by turning the pencil point sideways and increasing its pressure. The same distinction can be seen in the fine strokes on the top of the cap and the surface of the face compared with the thicker texture of the jacket. On the sleeve, van Gogh drew the pencil back and forth without lifting it off the paper to make a smooth, ziz-zag pattern. To create the contour of the back, van Gogh cross-hatched the lines at the shoulder and back. He then pressed firmly on the pencil to darken the collar.

Now let's look at a pencil drawing by Ellsworth Kelly entitled *Five-Leaved Tropical Plant* (**figure 8.9**). We read the long, slightly wavy parallel lines as the stem and the curvilinear outlines of the irregular shapes as leaves. Kelly has not filled in the surface of the leaves, but he has made them appear thin and flexible like living foliage. With no shading, and only a few darkened tips, Kelly has conveyed the movement of leaves in three-dimensional air space so that we imagine them fluttering in the wind. He also reminds us how few cues we need to read the drawing of a familiar object.

8.9 Ellsworth Kelly, *Five-Leaved Tropical Plant*, 1981. Pencil on paper, 18 x 24 in. Private Collection.

8.10 Edgar Degas, *Portrait of Friends in the Wings of the Opéra (Ludovic Halévy and Albert Boulanger Cavé)*, 1879. Pastel on five pieces of joined paper, 31 1/8 x 21 5/8 in. Musée d'Orsay, Paris.

Chalk

Chalk is a soft, calcium-based drawing medium made of pulverized minerals and fossilized shells mixed with gum or resin and compressed. Chalks are usually prepared, like charcoal, in the form of short cylindrical sticks such as those we use to write on blackboards. As with charcoal, chalks were used in the prehistoric era to draw on cave walls. Later artists, especially during the Renaissance, used white chalks for light highlights, as we saw in the charcoal drawing by Chardin (see figure 8.5). Chalks, like charcoal, smudge easily and are sometimes fixed with a preservative.

Modern chalks are colored as well as black and white. **Pastel chalks**, or simply **pastels**, have been used since the fifteenth century. The nineteenth-century French Impressionist artist Edgar Degas (1834–1917) produced many works in pastel. His *Portrait of Friends in the Wings* (**figure 8.10**) contains particularly rich contrasts of color and strong silhouetting. Degas' two school friends stand talking in the wings of a theater—Cavé, who loved theater, is a sturdy vertical, whereas the politician Halévy forms a diagonal as he leans on his umbrella.

When the painting was exhibited in April 1879, Halévy wrote that Degas had made him look "serious in a place of frivolity." Indeed, the "frivolity" of theater is conveyed by the thick green strokes of pastel chalk, highlighted with accents of white. The nearly solid figures created by the artist's firm pressure on the dark chalk, the density of their forms, and the heavy beards help to structure the picture visually. They thus appear to be more sober than the exuberant greens and whites of the background stage set.

Some pastels contain oil, which is a variation of the chalk or pastel medium. Oil pastels are more tightly bound, and produce a shinier texture than colored chalks. They do not smudge naturally as a result of particles detaching from the stick. The effects created by oil pastels thus resemble those made by **crayons**.

Crayon

Crayons have a fatty texture (children use wax crayons), which gives them a glossier surface than chalks and charcoal. Drawings made of crayon usually have a shiny surface, especially if the artist presses firmly. The French Post-Impressionist painter Georges Seurat used **conté crayons** (invented by Nicolas Jacques Conté in 1795) for preparatory drawings (**figure 8.11**).

Conté crayon is made of chalk bound with oil so that it holds to a paper surface. A disadvantage of conté crayon is its limited range of color (it comes only in black, brown, and red), but at the same time it makes possible a wide variety of textures and does not smudge easily. In this example, Seurat depicts two traditional characters from French theater: Pierrot, the lovesick clown, and Colombine, whom he loves. Here they are engaged in a lively dance beneath a row of illuminated gas jets. Seurat, we remember from *Le Chahut* in Chapter 5 (see figure 5.8), used the technique known as pointillism, or divisionism, in his finished paintings. For Seurat, a major advantage of conté crayon as a preliminary medium was its similarity to the textures of painted dots—providing the crayon was used on paper having a rough surface. In addition, it allowed Seurat to create subtle shifts in light and dark so that forms appear modeled rather than constructed with line.

By varying the pressure of his crayon—for example, at the edges of the curvilinear arms and legs—Seurat created an illusion of contour. This enhances the sense that the figures are moving and turning freely in space. Colombine's costume, on the other hand, is nearly a solid black and therefore the area of greatest pressure on the crayon. But the patterning of the hem adds to the impression of movement. Pierrot's costume is more muted, the result of lighter pressure, whereas his face and hat are nearly pure white, indicating that the crayon touched the paper surface only

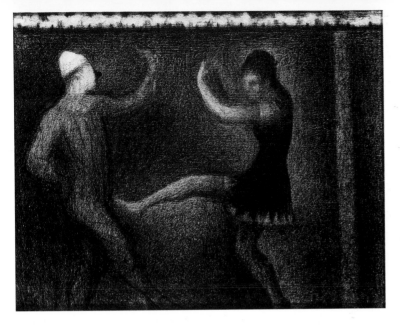

slightly or not at all. His nose, however, is a solid black triangle—which we associate with the usual red nose of a clown. The absence of facial features, aside from the nose, emphasizes the anonymity of the clown. Colombine, in contrast, is shown with features which, though muted, give her a greater sense of identity.

Despite the exuberant quality of the dancers, there is an aura of sadness pervading the drawing. This is partly the result of Seurat's pointillist technique, which makes the figures seem engulfed in grays and blacks. But it is also typical of the atmosphere of the circus and of the character of Pierrot, whose expressions vary from hilarity to melancholy.

Liquid Media

Drawings made with brushes and pens (from the Latin word *penna*, meaning "feather") are not as correctable as the dry media (with the exception of silverpoint, which cannot be erased). Both the pressure of the artist's hand and the width of the pen or brush determine the character of the line. The versatility of pen and ink drawings can be seen by comparing two fifteenth-century Italian pen drawings.

Pisanello (c. 1395–1455) produced many drawings of animals. His study of a horse's head in **figure 8.12** is a finely controlled image. The lines seem to disappear into the organic structure of the head, especially above the eyes and on the bridge of the nose. To depict the mane, Pisanello drew repeated wavy lines at greater intervals, and varied their density. This replicates the coarser texture of the mane as compared with the head and neck, and shows that it is composed of flowing, rather than smooth, hair. Because of the artist's careful control of the pen and attention to details such as veins, nostrils, and the delicate bridle, as well as the verticality of the turned head, we have the impression that the horse is standing absolutely still and staring directly at us.

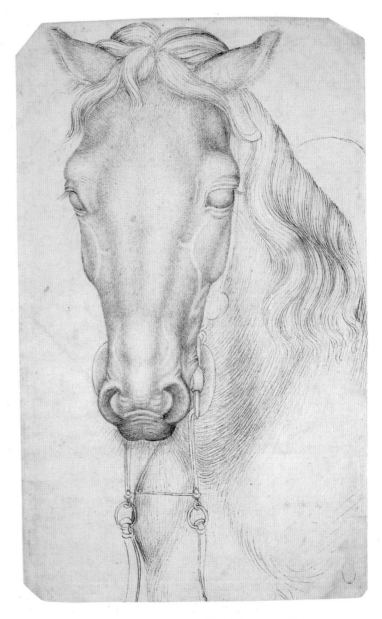

8.12 Pisanello, *Head of a Horse*, 1433–38. Pen and ink on paper, 10 ¹/₂ x 6 ¹/₂ in. Louvre, Paris.

David Hockney on Drawing

David Hockney has been described as one of the world's "most popular serious artists." His subject matter ranges from Pop Art paintings of packets of tea, to sun-drenched Californian landscapes, Los Angeles swimming pools, and meticulous portraits of friends, lovers, and dogs. Yet despite the breadth of his subject matter, and forays into various media, the one constant of Hockney's career is his dedication to drawing.

Hockney draws "all the time." Numerous notebooks crammed with small, quick sketches document his daily life. He often draws across two pages, and always on both sides in an effort to prevent them being "torn up" and mounted for sale.

Drawing has even been the subject of his painting. In *Self-Portrait with Blue Guitar* Hockney paints himself within a half-drawn/half-painted environment in the act of creating an outline of a guitar on a piece of paper (**figure 8.13**).

Hockney is insistent about the importance of drawing: "No machine can reproduce the complex and delicate movements of elbow, wrist, body-weight, and those pressures produced by freehand drawing." In a conversation with fellow artist Allen Jones, Hockney discusses the child's impulse to draw: "Children want to draw. They pick up a marker—it's no good telling them, 'Oh, you don't have to draw now.' It's an impulse. In 1953 I sat the Schools Certificate … my mother must have kept the question papers. They're full of drawings, all round—I don't know whether I did the questions. If in the music world somebody from the

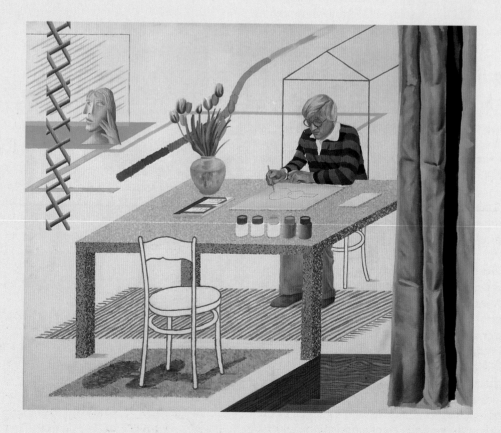

8.13 David Hockney, *Self-Portrait with Blue Guitar*, 1977. Oil on canvas, 5 x 6 ft. Courtesy David Hockney. © David Hockney.

MAKING

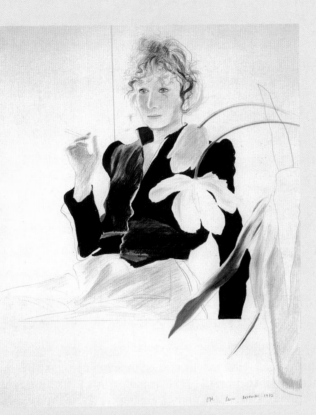

8.14 David Hockney, *Celia in a Black Dress with White Flowers*, 1972. Crayon on paper, 17 x 14 in. Collection of the artist. © David Hockney

department of education had gone along and said 'We think people should just start learning the piano at age 18,' the music world would have told them where to go ... but the art world didn't do that. They caved in very quickly. The music world knew that you have to start earlier."

Although Hockney has evidently been drawing from an early age, his first experience of "life drawing" was as an art student in Bradford, England, in the mid-1950s, and afterwards at the Royal College of Art (RCA) from 1959 to 1962. Hockney noted that, at that time, it was "unfashionable" to stick with observational drawing and painting, and so he strove to join the "bright young things" of the RCA—who were imitating the American Abstract Expressionists. However, it was not long before Hockney was incorporating the human figure back into his work.

Hockney's friend, Celia Birtwell, who was a textile designer, was a frequent subject of his

portraiture. In *Celia in a Black Dress with White Flowers*, the artist used crayon to create a vivid portrait (**figure 8.14**). At first glance, this seems to be an unfinished work: Celia's black dress is black only on the bodice and sleeves. The skirt is very lightly drawn and shaded. Hockney thought twice about the position of Celia's raised arm: an initial outline of a raised sleeve has been sketched in just below the final, black one.

The vase is as barely modeled as the skirt of the dress, and the flowers only burst into color and form as they bloom. Yet the power and subtlety of this portrait rests exactly in its unfinished quality. By giving his subject a finished form only in parts of the portrait, Hockney imbues the figure—and the flowers—with a sense of coming to life before our eyes.

Quotations from *David Hockney: My Early Years*, 1988.

8.15 Andrea del Verrocchio, *Studies of a Child*, 15th century. Pen and ink on paper, 5 ¾ x 8 in. Louvre, Paris.

A very different impression is conveyed by the sheet of ink drawings in **figure 8.15**. Here the lines are rougher and more generalized than those used to delineate Pisanello's horse. Andrea del Verrocchio (1435–1488), who cast several bronze sculptures of smiling, playful children, used a broader sweep of ink than Pisanello to capture the energy and exuberance of a toddler's movements. The children seem to be tumbling through the picture in a variety of poses. They stand, recline, twist, and turn in space. Their fluid outlines capture the curly quality of their hair and convey the fleshy contours of their forms. The drawings reveal the organic structure of the chubby young bodies, but without the linear precision of Pisanello's horse.

Pisanello used a fine point and drew lines to produce an image of stasis, whereas the wider point used by Verrocchio and the variety and motion of his lines conform to the movements and poses of his toddlers. In both instances, therefore, the choice of medium and technique is consistent with the visual message of each drawing.

Rembrandt often combined ink drawings with a wash effect (made by diluting the ink) as in the *Study of a Syndic* (**figure 8.16**). The wash effect seen here is made by covering a broad area of the paper with a brush. Generally the brush creates a thinner, more fluid impression than thinned ink, although both are

spread out over the surface. This study for one of Rembrandt's best-known paintings shows the syndic standing firmly, like the column beside him, and leaning on a table. In the column, the ink has been diluted and applied with a brush, as have the back wall and parts of the figure. Where the syndic rests his arm, the table is a solid black, indicating formal stability at a point of support. Elsewhere in the costume there are continual shifts from darks to lights that create a rather rumpled appearance.

The hat, in contrast, endows the syndic with an air of authority that reflects his status in seventeenth-century Holland. In so doing, it echoes the serious expression and slightly downturned mouth. The sturdy, commanding appearance of the hat is suggested by its broad horizontal, mainly dark rim, which is crowned by the small, lightened cylinder above. In sum, where the ink is thickest and applied with a brush, the area it covers is a dense black; where the pen is used, there is a scratchy texture; and in the background where the ink is most diluted, the fabric of the paper is visible and becomes part of the image. Where the paper has not been touched and remains white— the collar, lower table, and top of the hat—we have the impression of bright light.

Compare the effects achieved in the twentieth-century ink drawing by Saul Steinberg (1914–1999),

who was a frequent contributor to the *New Yorker* magazine (**figure 8.17**). He used the thickest lines in the feathers, feet, and head of the hen, while the thinner landscape lines are consistent with its relatively small scale. By varying the widths of the feather lines and leaving clear white spaces between them, Steinberg created a sense of enormous volume, which contributes to the humor of the image. The feathers swell to such a large size that the thin feet barely seem able to support the bulky hen. She dominates the picture space, towering over the trees and houses in the background.

—◆—

In the drawing media and techniques described in this chapter, artists convey meaning through process. When we see a finished work of art, on the other hand, we lose some sense of process and experience the image as a completed statement. In the next chapter we consider several types of images made by more permanent media than drawing and the techniques used to create them. These include painting, collage, stained glass, and mosaic.

8.16 Rembrandt van Rijn, *Study of a Syndic*, 1660. Pen and wash. Museum Boijmans van Beuningen, Rotterdam.

> **Drawing is a way of reasoning on paper.**
>
> Saul Steinberg, artist (1914–1999)

8.17 Saul Steinberg, *Hen*, 1945. Pen and brush and India ink on paper, 14 ½ x 23 ⅛ in. Museum of Modern Art, New York. Purchase.

Mixed Drawing Media

Artists frequently use combinations of media—called mixed media. Rembrandt's *Syndic* combines pen and ink with brush and wash. In Degas' *The Violinist* (**figure 8.18**), chalk and charcoal are used together with a gray wash, which creates a lightly colored background. In this work, the most definition is given to the face; the beard and forehead are highlighted with white tints. Two short vertical lines over the nose indicate that this rather portly musician is frowning slightly as he adjusts his instrument, the wood surface of which is replicated by the gray wash. But he also seems to be enjoying himself.

The lines of the musician's shirt and trouser legs indicate that he has not quite assumed the formality of a violinist performing in public. Degas repeated the outlines of the left leg, indicating that it is moving to the rhythm of the music. He also repeated the edges of the violin and the musician's left hand, as if to create an afterimage of their previous position in space. Degas thus shows visually the movements of the musician and his instrument while suggesting various musical rhythms.

8.18 Edgar Degas, *The Violinist*, c. 1879. Chalk, charcoal heightened with white, and gray wash on blue-gray paper, 18 ¹/₂ x 11 ¹³/₁₆ in. Museum of Fine Arts, Boston. William Francis Warden Fund no. 58.1263.

Chapter 8 Glossary

charcoal—piece or pencil of black carbon used as a drawing instrument

conté crayon—improved brand of crayon invented in 1795 using less graphite than previously

crayon—stick of white or colored chalk (or clay and graphite) used for drawing

graphite—mineral consisting of soft black carbon used in lead pencils

ground—in painting, the prepared surface of a support to which paint is applied

metalpoint—technique in which an instrument with a point of gold, silver, or other metal is used to draw on a specially prepared ground

mixed media—use of more than one medium in a work of art

papyrus—paperlike writing material used in ancient Egypt and made from the pith of a plant

parchment—paperlike writing material made from bleached and stretched animal hides

pastels—crayons made of ground pigments and a gum binder

vellum—smooth, cream-colored writing surface made from calfskin

9

Painting and Related Techniques

Painting is what we tend to associate with art, in large part because many paintings are made with color, which is the most eye-catching visual element. We also tend to think that famous paintings are in museums or important private collections, but, in fact, we are surrounded by paintings. As with drawings, people around the world paint on a wide variety of surfaces. We see paintings on exterior walls of buildings and in graffiti; we see sidewalk artists who paint (and draw) on the streets, and children's paintings on refrigerator doors. In Chapter 4 we discussed examples of body painting—for ritual purposes, as well as for going to war. In this chapter we will examine the different kinds of painting media and the primary ways they are used to create works of art.

Painting Media

Paint is made of two components: a pigment and a vehicle. The **pigment** is basically particles of color ground from natural or synthetic material. Substances such as chalk can be ground to create a white pigment, or magnesium to create yellow. The **vehicle** is a liquid, and it serves as the body in which the ground particles of the pigment can be suspended. The vehicle is usually called the **binder**, since it binds the pigment to the painting surface and also helps prevent the mixture from flaking.

Paint is applied to a surface or **support**, which, as we have seen, can be anything from paper and **canvas** to walls, floors, lampposts, subway cars, and human bodies. When a support such as a canvas or wall surface is prepared by an artist before the paint is applied, it is said to have a ground. The ground is usually some kind of sealer to make the support less porous. This prevents the paint from being absorbed into the material of the support and helps to preserve the finished work. The ground can be either a **sizing**, which is a mixture of glue or resin, or a **primer**, which is a preliminary coat of white paint. If the support is made of wood, it can be reinforced by glueing onto it a piece of linen, which is then coated with **gesso** (a mixture of white chalk and either glue or Plaster of Paris) to prevent warping.

There are a number of painting media, including encaustic, fresco, tempera, oil, watercolor, gouache, and acrylic. How they are used will be surveyed in the following pages.

Encaustic

One of the oldest known painting media is **encaustic**, from a Greek word meaning "burning in." Encaustic paint is made by mixing pigment with a binder of hot, liquid beeswax. When the paint dries, it is bonded ("burned in") to the surface of the support with additional heat. In antiquity, artists used encaustic because its waxy texture increased the lifelike appearance of figures.

A number of mummy cases dating to the second century B.C. have been found in the Fayum region of Hellenistic Egypt. These contain vivid, lifelike portraits of the deceased on the exterior (**figure 9.1**). This one dates to the 2nd century A.D. and is known as the *Jewelry Girl*. One eye of the vibrant figure is slightly higher than the other, and she seems to be raising her eyebrow as she turns to observe something we cannot see. The slight asymmetry of her mouth suggests that she is about to speak.

By placing a lifelike image on the outside of a mummy case, the Fayum artist exemplifies one traditional use of portraiture. He makes the absent seem present "and the dead seem alive," as the Renaissance art theorist Leon Battista Alberti declared in his book of 1435, *On Painting*. In the mid-sixth century B.C., the Greek poet Anacreon wrote a poem in which he asks an artist to paint a picture in encaustic of his absent girlfriend:

Come, best of Painters!
Paint my absent girl according to my instructions.
First paint her soft black hair; and if the wax is able, make it smell of perfume.
Paint her whole cheek and then her ivory brow beneath her dark hair.
Do not part her eyebrows nor run them together, but let her keep, as in real life, the black rims of her eyes meeting imperceptibly.

. . .

Paint her nose and her cheeks, mingling like roses and cream.

. . .

Dress the rest of her in robes of light purple, but let her skin show through a little to prove the Quality of her body. Enough—I can see her! Soon, wax, you will be talking too.[1]

The Fayum figure, like the girl in Anacreon's poem, is naturalistically depicted. The artist used subtle shading to create the contours of her face and neck. She is well-dressed, coiffed, and decked out in fine jewels. Her hair forms a mass of black curls framing her head and she wears pearl earrings and three elaborate necklaces. The striking immediacy is enhanced by the encaustic medium, which makes her seem very much alive, as if denying the fact of her death.

Encaustic was not used again in Western painting until the nineteenth century. In the twentieth century, the medium was taken up by the American Pop artist Jasper Johns (b. 1930). His famous *Three Flags* of 1958 (**figure 9.2**) is made of strips of canvas painted with encaustic in red, white, and blue. As with the Fayum portrait, the waxy medium produces a shiny surface, which, in this case, confronts the viewer with a familiar emblem presented in a new way. Combining the popular imagery of Pop Art with a taste for the tactile sensation of paint, Johns revitalizes a traditional, and distinctly American, image. In a sense, he gives the flag new meaning; for in addition to recognizing the flag as a patriotic sign,

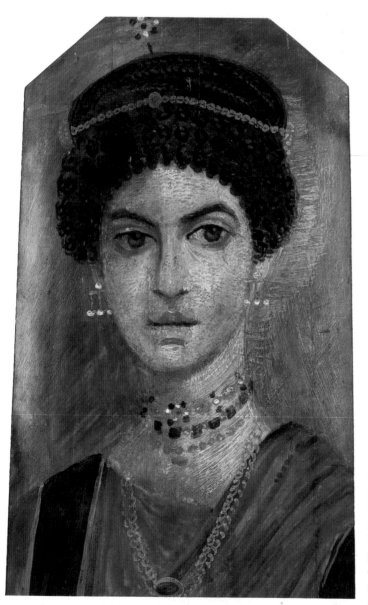

9.1 The so-called *Jewelry Girl*, c. A.D. 110–117. Encaustic on panel, 17 1/4 x 9 1/2 in. Royal Scottish Museum, Edinburgh.

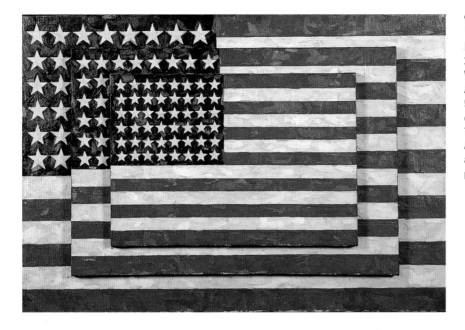

9.2 Jasper Johns, *Three Flags*, 1958. Encaustic on canvas, 30 ⁷/₈ x 45 ¹/₂ x 5 in. Whitney Museum of American Art, New York. 50th Anniversary Gift of Gilman Foundation, Inc., The Lauder Foundation, A. Alfred Taubman, anonymous donor, and purchase.

> ... the painting of a flag is always about a flag, but it is not more about a flag than it is about a brush-stroke or about a color or about the physicality of the paint, I think.
>
> Jasper Johns, artist (b. 1930)

we are invited to observe its formal arrangement as an abstract design of stars and stripes. It thus takes on aesthetic as well as political meaning.

Fresco

In fresco painting, pigments are mixed with water and then applied to a plaster support, usually a wall or a ceiling. Paint applied to dry plaster is called *fresco secco* ("dry fresco" in Italian). The problem with *fresco secco* is that the paint does not adhere to the wall in a durable way. *Buon fresco* (true fresco) is more permanent than *fresco secco*, because it is applied to damp lime plaster and bonds chemically with the support as it dries. The color of fresco can be rich and deep or pale, depending on what the artist wishes to convey.

The earliest known use of true fresco is found in the ancient Minoan culture that flourished on the Mediterranean island of Crete around 1400 to 1200 B.C. **Figure 9.3** shows a fresco fragment from the Palace of King Minos that has lasted more than 3,000 years. Its good state of preservation is due to the durability of true fresco. The woman seems to have been an aristocrat, judging from her elegant dress, self-confident pose, and elaborate coiffure. Her lips are painted a rich red, and her eye is outlined with kohl, a black eye makeup that the Minoans imported from Egypt and that is still used today.

The ancient Greeks, like the Minoans, painted in fresco, but very little monumental Greek painting survives. During the Middle Ages in Europe and in

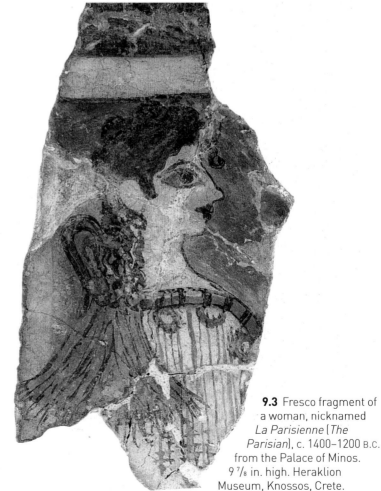

9.3 Fresco fragment of a woman, nicknamed *La Parisienne* (*The Parisian*), c. 1400–1200 B.C. from the Palace of Minos. 9 ⁷/₈ in. high. Heraklion Museum, Knossos, Crete.

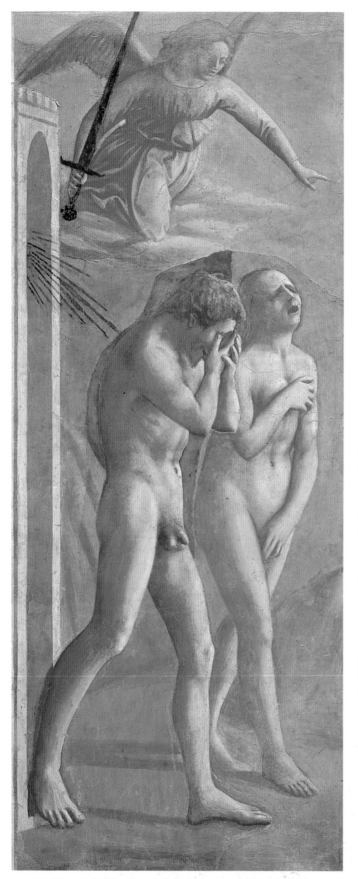

9.4 Masaccio, *The Expulsion of Adam and Eve*, c. 1425. Fresco. The Brancacci Chapel, Church of Santa Maria del Carmine, Florence.

the Renaissance, true fresco was one of the most popular painting media. Many examples of these frescoes on church walls, in palaces, and in public buildings have survived in good condition.

Since true fresco must be applied while the plaster, which dries in a day, is damp, artists have to plan their work carefully on a daily basis. They may do this by painting directly on the plaster, but more usually they make a **cartoon** (a full-size preliminary drawing) as a guide. Traditionally, fresco painters transferred the cartoon to the plaster using the **pouncing** technique. Pounce is a fine powder spread over a perforated stencil in order to transfer an image to a surface below it—in the case of fresco, the image is transferred to a wall. To prepare for each day's work, the fresco artist plasters only the area of the wall that can be painted in one day—hence the Italian term *giornata* (*giorno* means "day" in Italian), denoting both the section painted on a particular day and, more generally, a day's work.

Masaccio's (1401–1428) monumental fifteenth-century fresco *The Expulsion of Adam and Eve* (**figure 9.4**) was painted on a chapel wall in Florence. This depicts an angel driving Adam and Eve from the Garden of Eden. Rays of light (which were originally painted gold) can be seen emerging from the arched gateway separating Paradise from the world of work and suffering. They have been interpreted as an allusion to God's voice condemning the original sinners to reality.

Adam is shown as a powerful image of introverted shame, whereas Eve wails openly and covers her nudity. Both appear horrified as they realize what they have lost. Shading creates the sense that the figures are three-dimensional and the cast shadows show that they are striding across solid ground—in this case, the barren earth they are destined to cultivate.

The pale hues of Masaccio's fresco are consistent with the fresco medium. Beginning at the back of Adam's waist and continuing around his and Eve's head we can see the edges of the *giornata*, indicating an area painted in a single day.

Tempera

Another medium known in ancient Egypt, Greece, and Rome, and used for altarpieces throughout the Middle Ages and Renaissance, is **tempera**. Originally, tempera pigments were mixed with water thickened with egg, and they dried quickly. Artists using tempera today, which is rare, are more likely to suspend the pigments in milk, glue, or tree sap. Tempera painting was traditionally a lengthy process, beginning with a wood panel carefully sanded, sized, sealed, and coated with gesso. Artists first outlined their forms, and then applied the paint in layers with fine, animal-hair brushes. Once dry, the painting was varnished. The advantages of tempera include the richness and durability of its color and the potential for clear, precise forms. A disadvantage of tempera is that its colors can change as it dries and it is difficult to rework.

One of the most engaging examples of a work in tempera is Ghirlandaio's *Old Man with a Child* (**figure 9.5**). This has the same precise forms and character delineation as his *Portrait of an Elderly Lady* (see figure 8.6). The old man gazes fondly at a young boy, who looks up at him. Their intimacy suggests that they are grandfather and grandson and the closeness of their gaze is echoed by the light touch of the boy's hand on the man's cloak. The translucency of the boy's golden curls is characteristic of tempera, as is the finely depicted hair of the old man, his mole, and his cauliflower nose. In the distance, through the open window, a road winds through a mountainous landscape dotted with trees. In view of Ghirlandaio's taste for rich color and his mapping of delicate surface detail, whether physiognomy, landscape, or fabric, tempera was an appropriate medium for him to use.

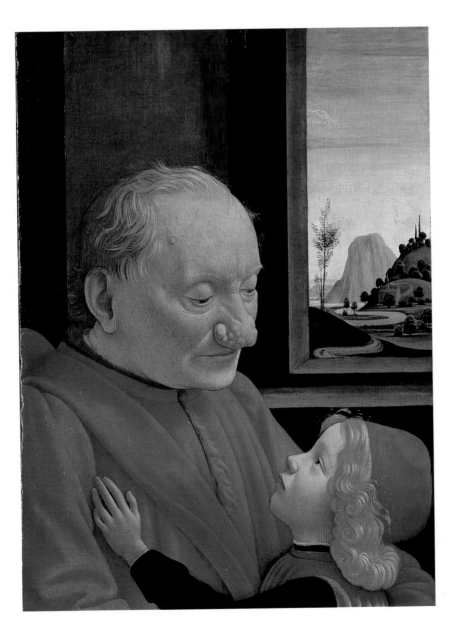

9.5 Domenico Ghirlandaio, *Old Man with a Child*, c. 1480. Tempera on panel, 24 3/8 x 18 1/8 in. Louvre, Paris.

Oil

Oil paint was known, though rarely used, before the fifteenth century, when it became the medium of choice in the Netherlands. In Italy, oil was not in general use until the following century. Oil paint is made by binding pigments with one of various oils, usually linseed oil, and was originally applied, like tempera, to wood panel. From the sixteenth century, however, canvas became the standard support for oil paintings. Canvas is typically stretched over a wood frame and sized (sealed). Since canvas is a relatively light-weight, flexible surface, it can be removed from its frame and rolled up, making it easier to transport than tempera paintings on wood.

Most oil paint is **opaque** (nontransparent) and can be applied thickly (as in impasto) with a brush or knife, squeezed directly from a tube, or thinned with turpentine to increase transparency. Oil dries more slowly than fresco and tempera, and thus can be reworked before drying. Its colors are the richest of any paint medium and it offers the greatest variety of textural possibilities, but it can be difficult to control. In order to demonstrate the versatility of the oil medium, we compare two portraits of a woman.

Vermeer's *Girl with a Red Hat* (**figure 9.6**) is placed against a dark background and is defined by color, gradations of light and dark, and texture. She wears a blue and yellow jacket with a white collar and a dramatic, bright red hat that lies in a diagonal

plane. Using a limited range of color, Vermeer created lights and darks by varying the tones and varnishing them. He used pinpoints of white—in the pupils, lips, and the back of the chair—to indicate reflected light. The oil paint was applied smoothly to the canvas so that the strong impression of three-dimensional form is achieved by subtle shifts in lights and darks creating gradations of color. In this painting, we can also see the network of minute cracks on the paint surface (crackle, crazing, or **craquelure**), which can appear early from incorrect application of the paint or because the paint becomes brittle with age.

In *Young Woman in Green, Outdoors in the Sun* (**figure 9.7**), Mary Cassatt (1845–1926) uses a different technique than Vermeer, particularly as regards the application of the paint. In contrast to Vermeer's uniformly smooth surface, Cassatt varies the thickness of the paint. There are areas of impasto on the striking green dress, and there are translucent areas on the lace collar. Whites create dramatic tinting, especially in the rim of the hat. Throughout the painting we are aware of the presence of brushstrokes that appear to have been vigorously applied. This attention to the paint itself is characteristic of nineteenth-century Impressionism. The sense of texture is created not only by illusion, as in Vermeer, but also by the actual thickness of the paint. As a result, the medium intrudes into the image and influences our reading of it.

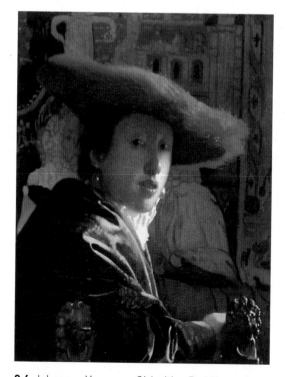

9.6 Johannes Vermeer, *Girl with a Red Hat*, c. 1666–1667. Oil on wood, 9 x 7 in. National Gallery of Art, Washington, D.C. © 1992 National Gallery of Art, Andrew W. Mellon Collection.

9.7 Mary Cassatt, *Young Woman in Green, Outdoors in the Sun*, c. 1909. Oil on canvas, 18 1/4 x 21 11/16 in. Worcester Art Museum, Massachusetts. Gift of Dr. Ernest G. Stillman through the Metropolitan Museum of Art.

De Kooning's *Woman VI*

Having seen the progression in the use of oil paint from Vermeer to Cassatt, let us consider the twentieth-century *Woman VI* (**figure 9.8**) by the Dutch-born American artist Willem de Kooning (1904–1997). This is painted in the Abstract Expressionist style that developed in New York in the late 1940s. The artists who worked in this style are often referred to as the New York School because they came to New York from different parts of the United States and Europe during and after World War II. A new feature of Abstract Expressionism was the evidence of the artist's dynamic gesture in creating a work. Hence the term **gesture painting**, or **action painting**, to describe the technique used here. Films showing the action painters at work confirm the unconventional, energetic gestures, and even the artists' use of their entire bodies, to apply paint. De Kooning typically stood his canvas against a wall and "attacked" it with broad gestures.

In de Kooning's *Woman VI*, the paint literally tears through the figure of the woman, so that the artist's aggression is reflected in his technique. There is a lot of action in this picture, which is created by sharp variations in color, in lights and darks, in the thickness of surfaces, and in the different directions of the lines. These are not the carefully outlined forms of tempera, or the smooth surfaces of the Vermeer, and they seem less controlled than the Cassatt. De Kooning's brushstrokes vary in width, in color, and in intensity. Thick black brushstrokes overlap the rich reds of the dress. The face, except for the menacing round eyes, nearly dissolves into the paint. And the blocklike, stumpy form of the figure barely resembles a woman at all. Ironically, de Kooning creates a strong sense of the figure's presence, while at the same time assaulting it with splatters, drips, and fiercely thick paint. He thus makes the

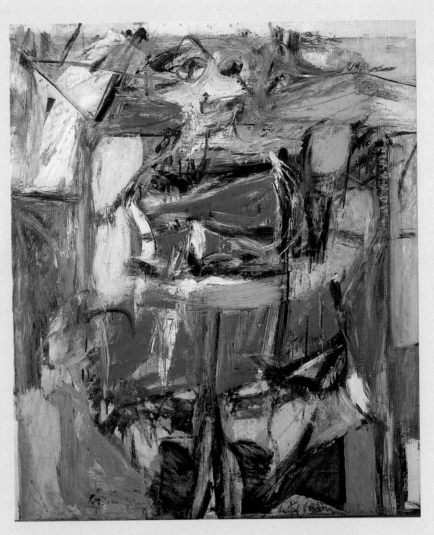

9.8 Willem de Kooning, *Woman VI*, 1953. Oil on canvas, 5 ft. 8 ½ in. x 4 ft. 10 ½ in. Carnegie Museum of Art, Pittsburgh. Gift of David Thompson.

> Everything is already in art—like a big bowl of soup
> Everything is in there already:
> And you just stick your hand in, and find something for you
> But it was already there—like a stew.
>
> Willem de Kooning, artist (1904–1997)

Watercolor

Watercolor is pigment mixed with water and gum arabic and is usually applied to paper. As with ink washes, watercolor is a thin medium and has a naturally transparent quality that results in a brilliant expression of color. It is a difficult medium, because the changes that can be made with oil paint are almost impossible to achieve. It is also difficult to control watercolor, because, like water, it is fluid and tends to spread quickly over the paper support.

Later in the nineteenth century, the best of the "pure" watercolorists was Winslow Homer, whose *Shore and Surf, Nassau* we discussed in Chapter 2. In Homer's paintings, light penetrates the pigment and is reflected from the paper, giving the color a unique brilliance. We can see this in his watercolor of 1894 entitled *The Adirondack Guide* (**figure 9.9**). It is painted on lightly textured cream wove paper, on which Homer built transparent layers of color. Opaque color was added to emphasize the details of the guide's suspenders, his hat, trousers, and the oarlocks.

Homer enjoyed fishing in the Adirondacks and was, like Turner, interested in water as both a subject and a medium. Here, the old guide has raised his oars and the boat is still. The water is like glass, reflecting the trees and the boat. But the water also reveals its fluid, colorless reality as Homer makes us very much aware that there are objects above and below the water's surface.

COMPARE

Winslow Homer, *Shore and Surf, Nassau*.
figure 2.10, page 24

9.9 Winslow Homer, *The Adirondack Guide*, 1894. Watercolor on cream wove paper, 15 $^3/_{16}$ x 21 $^1/_2$ in. Museum of Fine Arts, Boston. Bequest of Mrs. Alma H. Wadleigh.

9.10 Joseph Mallord William Turner, *San Giorgio Maggiore from the Dogano: Early Morning*, 1819. Watercolor, 7 ³/₄ x 11 ¹/₄ in. Tate, London 2006.

The British painter Joseph Mallord William Turner (1775–1851) produced many seascapes in watercolor. His attraction to scenes of Venice, a city built on water, can be seen in *San Giorgio Maggiore: Early Morning from the Dogano* (**figure 9.10**) of 1819, which depicts Venice bathed in the pervasive yellow of an early morning sun. This effect is achieved by building up layers of paint on a light surface and allowing the presence of the surface to be felt. Visible as if through a mist, the city has a jewellike quality, enhanced by the delicacy of the artist's brush. Barely visible in the water is the washed, gray reflection of the church. The sky to the left of the church of San Giorgio Maggiore is a warmer yellow and the paint is applied with greater opacity than elsewhere. As a result we have the impression that this is where the sun will first appear. Adding structure to the composition is the opaque paint used on the boats, the strong verticals of their masts, and the prominent tower and dome of the church.

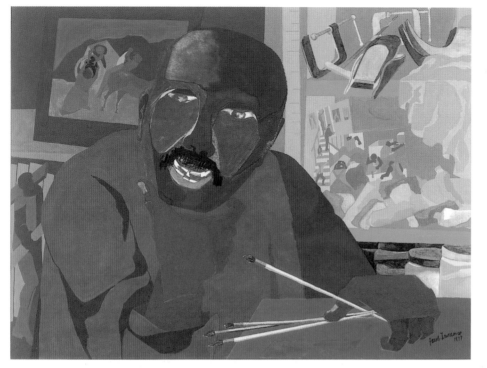

Gouache

Gouache is a type of watercolor to which white pigment (either white chalk or zinc) is added. The white is invisible to the viewer, so that it does not function as a tint, but it prevents the translucency of the pure watercolors of Homer and Turner. Gouache is usually applied in washes, or in flat areas of rich color. In Jacob Lawrence's powerful *Self-Portrait* (**figure 9.11**), the color is bright and strong, especially the rich red of his outfit. This is unified with the brown skin tones and the purple table through shared reds. Lawrence shows himself as a painter, with bright brushes, alert eyes, jars of paint, and a large, foreshortened left hand. He appears to be scratching his beard and speaking to the viewer in a lively manner.

In the background, there are two works that, as in Gauguin's *Self-Portrait with Yellow Christ*, enrich the meaning of the image. Here they are behind the head of the artist, making it likely that they reflect what Lawrence himself is thinking or imaging in his mind. The picture at the left, painted in subdued color, is the *Flight into Egypt*, in which the Holy Family (Mary, Jesus, and Joseph) flee Bethlehem when an angel warns them that, having learned that a newborn (Jesus) will destroy his kingdom, King Herod intends to slaughter all the infant boys in Israel.

At the right, in more exuberant color, is a scene of urban fragments and carpentry tools, which suggest building and construction. The bright colors may reflect a present hope for a better future. Taken together, the three main images in Lawrence's *Self-Portrait* can be read syntactically in terms of tense and visually in terms of color. Lawrence is the vividly present creator–artist in the foreground; the *Flight into Egypt*, in darker tones, is in the past with its connotations of escape from oppression; the fragmentary forms and lively colors of the urban scene connote a wished-for future.

The flight of the Holy Family also finds echoes in Lawrence's own life and work. We remember from Chapter 6 that Lawrence painted the *Migration Series*, chronicling the migrations of American blacks to the North in search of opportunity. Here, the little *Flight into Egypt* suggests that for Lawrence, as for many others, the story of Jesus resonated with the plight of blacks in America. In this case, therefore, Lawrence has manipulated the opacity and richness of the gouache medium to convey a powerful social and political message— and also a creative one.

Acrylic

The most popular of the modern synthetic media is **acrylic**—a water-based paint applied to a variety of supports. The versatility of acrylic enables it to produce effects similar to those of oil and watercolor, depending on the degree to which it is thickened or diluted. Acrylic is easier to use and less messy than oil; it can be washed off with water and it dries quickly. However, its hues are somewhat less subtle than those of oil-based paint.

COMPARE

Gauguin, *Self-Portrait with Yellow Christ*.
figure 7.10, page 137

Acrylic is an important innovation in modern painting media. Artists can apply the paint directly to the canvas as a thin stain, which creates a new appearance. Some artists use an airbrush to spray acrylic onto the canvas. This produces a misty effect and also eliminates the sense of the artist's hand controlling a brush.

In *Blue Veil* (**figure 9.12**), Morris Louis (1912–1962) took advantage of the flowing quality of diluted acrylic. He thinned the paint to the point of translucency and produced a watery texture. Like de Kooning, Louis was one of the gestural painters of Abstract Expressionism. But he "stained" the canvas, rather than assaulting it, and he allowed the paint to be absorbed by the fabric of the support. The resulting image resembles jets of cascading purples, greens, blues, and grays. Louis's paint thus seems to rise and fall, as if taking on a life of its own.

Techniques and Media Related to Painting

In addition to painting, there are a number of image-making techniques and media that involve arranging visual elements on a flat surface. In this section, we discuss collage, **stained glass**, and mosaic. In contrast to drawings, these do not show the artist's process, but, like paintings, they appear "finished." They are similar in that in each case the artist has to organize material other than paint to create an image. Of the three techniques, only collage uses paper. Stained glass and mosaic are more durable than drawings and more so than most collages.

Collage

Perhaps as a child you made collages in school or at home, pasting anything from dried pasta, rubber bands, paperclips, old socks, to cut-outs from magazines and comic books onto paper or cardboard supports. Today children make collages as a matter of course. But collage did not exist before around 1912, when modernist European artists, notably Picasso, originated the technique.

The term collage comes from the French word *coller*, meaning "to paste" or "to glue." It involves pasting light-weight material such as paper, cloth, or string, onto a support. When paper is used, the term *papier collé* (French for "glued paper") denotes the collage technique. Picasso and his contemporaries also cut out pieces of newspaper, making use of the

9.12 Morris Louis, *Blue Veil*, 1958–1959. Acrylic resin on canvas, 7 ft. 7 ³/₄ in. x 13 ft. ¹/₂ in. Fogg Art Museum, Harvard University Art Museums, Cambridge. Gift of Lois Orswell and Purchase from the Gifts for Special Uses Fund.

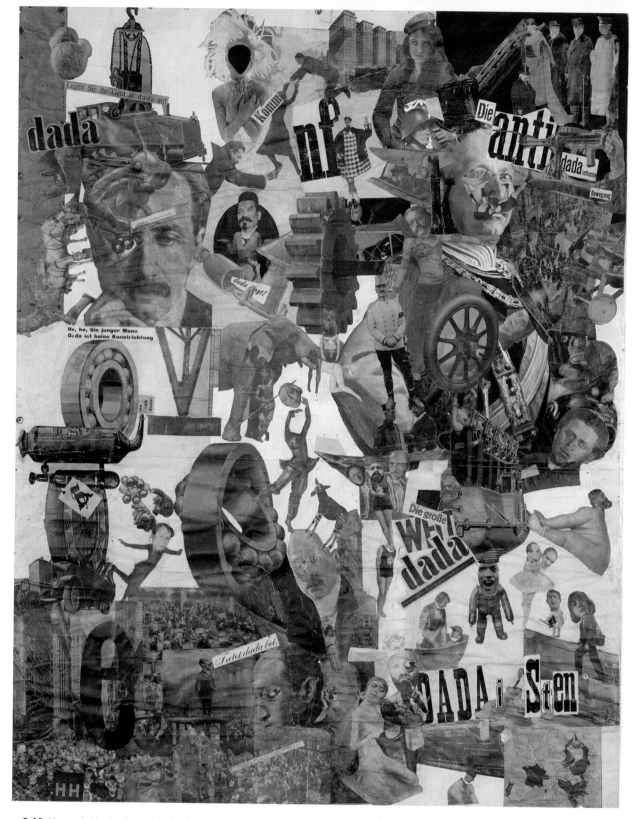

9.13 Hannah Höch, *Cut with the Kitchen Knife Dada through Germany's Last Weimar Beer Belly Cultural Epoch*, 1919. Collage, 3 ft. 8 7/8 in. x 2 ft. 11 3/8 in. Staatliche Museen, Preussischer Kulturbesitz, Nationalgalerie, Berlin.

Our whole purpose was to integrate objects from the world of machines and industry in the world of art.... We used to bring together elements borrowed from books, newspapers, posters, or leaflets, in an arrangement that no machine could yet compose...

Hannah Höch, artist (1879–1978), on photomontage

Dada was an extreme protest against the physical side of painting. It was a metaphysical attitude ... It was a sort of nihilism....

Marcel Duchamp, artist (1887–1968), on Dada

abstract nature of letters and numbers as part of the formal design or to convey verbal messages. As a technique, therefore, collage can be combined with more traditional media—for example, by drawing or painting on the surface of the pasted image or its support.

Many early collages are associated with the Dada movement. This began just before World War I in politically neutral Switzerland when an international group of artists, writers, and performers gathered regularly in a Zurich café. After the war, Dada continued for a while in certain cities, including war-torn Berlin.

Hannah Höch's (1879–1978) Berlin Dada collage entitled *Cut with the Kitchen Knife Dada through Germany's Last Weimar Beer Belly Cultural Epoch* (**figure 9.13**) expresses both the fragmentation of a society devastated by the war it started and the artist's own dynamic use of imagery. She herself had worked as a journalist and she cut up newspaper and magazine photographs to produce this collage. The energy inherent in the design and placement of the fragments reflects the vitality as well as the dehumanized mechanization of modern urban life.

Höch's choice of verbal messages in her collage can be seen as a journalistic summary of contemporary Berlin. There are references to Weimar (the pre-war German government), the beer halls, and the Dada movement. The origin of the term Dada is somewhat elusive, although its philosophical method of destruction and deconstruction followed by creative acts is apparent in Höch's collage. Several meanings of *Dada* have been proposed: the infant's first spoken syllables (*da-da*) and Russian words meaning "yes, yes," both denoting new beginnings. *Dada* has also been considered random nonsense, meaning nothing and expressing the arbitrary nature of existence. This reflected the widespread sense of despair, helplessness, and pessimism following World War I.

A later development of collage, known as **cut-out**, *papiers-coupés* (paper cut-outs), or *découpage*, can be seen in the technique that Matisse adopted late in his career. From the 1940s, Matisse began cutting brightly colored paper shapes and arranging them on backgrounds. At first the cut-outs were small and intended as stencil designs for books. But eventually Matisse expanded the scale of the cut-outs and created large murals. From 1950, when he was too sick to paint, cut-outs became his sole technique. His *Zulma* (**figure 9.14**) is typical of his life-long taste for exuberant color, and here he used opaque gouache paint to emphasize the flat hues. A woman stands at the center of the composition, her jet-black hair contrasting with the bright green background. By placing shapes of color adjacent to each other, Matisse enhanced the sense of movement, making our eyes shift to register the abrupt chromatic changes.

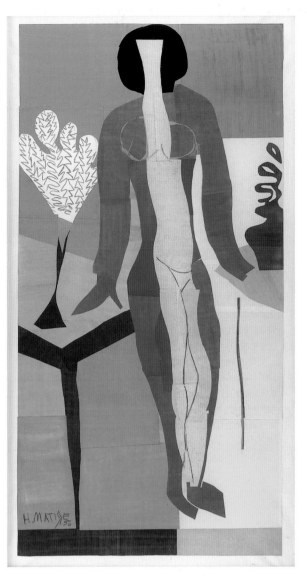

9.14 Henri Matisse, *Zulma*, 1950. Cut-outs painted with gouache, 7 ft. 9 ³/₄ in. x 4 ft. 4 ³/₈ in. Statens Museum for Kunst, Copenhagen.

Zulma herself is a tall, mainly blue form with a slim interior shape. The breasts are indicated by a double curve (a sideways figure 8), and the general nude form resembles the shape of an elongated vessel. This parallels the vases of flowers and implies that the woman herself is a sexual and reproductive vessel. She leans on the two tables, but the one at the right is supported only by an insubstantial curve. Matisse's crisp lines and flat shapes are deceptively simple, because in fact his imagery is psychologically and spatially complex.

I have achieved more completely and abstractly a form reduced to the essential, and have retained the object, no longer in the complexity of its space, but as the symbol which is both sufficient and necessary to make the object exist in its own right.

Henri Matisse (1869–1954), on paper cut-outs

Elizabeth Murray on Painting

Considered one of the most important abstract artists working today, Elizabeth Murray (b. 1940) has been called a pioneer in painting for her shaped canvases that break the tradition of creating the illusion of three-dimensionality on a two-dimensional surface. Murray's paintings are sculptural in form; they jut out from the wall and often incorporate seemingly chaotic ensembles of domestic objects such as chairs, tables, and cups, conjuring up visions of domestic tension.

The subject of the majority of Murray's work—the domestic space—allies her with certain women artists of the twentieth and twenty-first centuries such as Judy Chicago (see figure 26.13). However, unlike Chicago, who rejected minimalist formalism, Murray acknowledges its place in her work, combining it with the bright, flat color of Pop Art and a hint of expressionism and narrative. The cartoon-like forms of many of her works trace a narrative fleshed out by personal experience.

Murray's technique involves the traditional media of oil-on-canvas-on-wood and watercolor. However, though the medium may be traditional, the end result is not. In *Bop*, for example, thickly impastoed surfaces abut smooth, vivid yellows and electric blues (**figure 9.15**). A medley of jagged forms with faces embedded in the shapes and reminiscent of graffiti in relief, *Bop* was meant, according to the artist, to scream for attention against the white gallery walls. Murray originally decided to go "beyond" the flat surface, because

9.15 Elizabeth Murray, *Bop*, 2002-2003. Oil on canvas, 9 ft. 10 in. x 10 ft. 10 ½ in. Private Collection © Elizabeth Murray, Courtesy of PaceWildenstein Gallery, New York.

she was "bored with flat shapes." She sees her paintings as: "demanding, really demanding to work on. Working over those surfaces and those bumps is really interesting but it's very different ... even the light and the shadows are totally different from when you have a flat painting."

As Murray's career progressed, she built larger and more complicated works that are demanding for her to work on, and challenge the viewer to interpret and resolve the relations between the different surfaces and "to reconcile physical and visual forms with narrative."

During 1996 and 1997 Murray's desire to experiment led her to produce her first free-standing "painting sculpture:" *Red Shoe* (**figure 9.16**). It measures twelve feet by nine feet and is made of painted concrete, fiberglass, and wood. For Murray, the work was a natural progression from paintings that were literally twisting themselves off their canvases and away from the wall. It also gave her the chance to indulge in her favorite subject matter—the shoe. Smooth and shiny on the outside, the inside is roughly hewn like the worn leather of an old boot. Evoking images from familiar nursery rhymes and fairy tales, the tone of the work is located somewhere between child-like humor and a monumental fetish.

Quotations from an interview with Greg Masters, 1998.

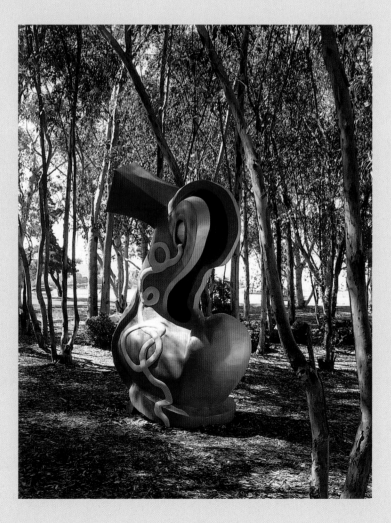

Dreams are like paintings: they are completely unpredictable.

Elizabeth Murray, artist (b. 1940)

9.16 Elizabeth Murray, *Red Shoe*, 1996–1997. Concrete, fiberglass, wood, and paint. 12 x 9 x 9 ft. Stuart Collection of Sculpture, University of California, San Diego.

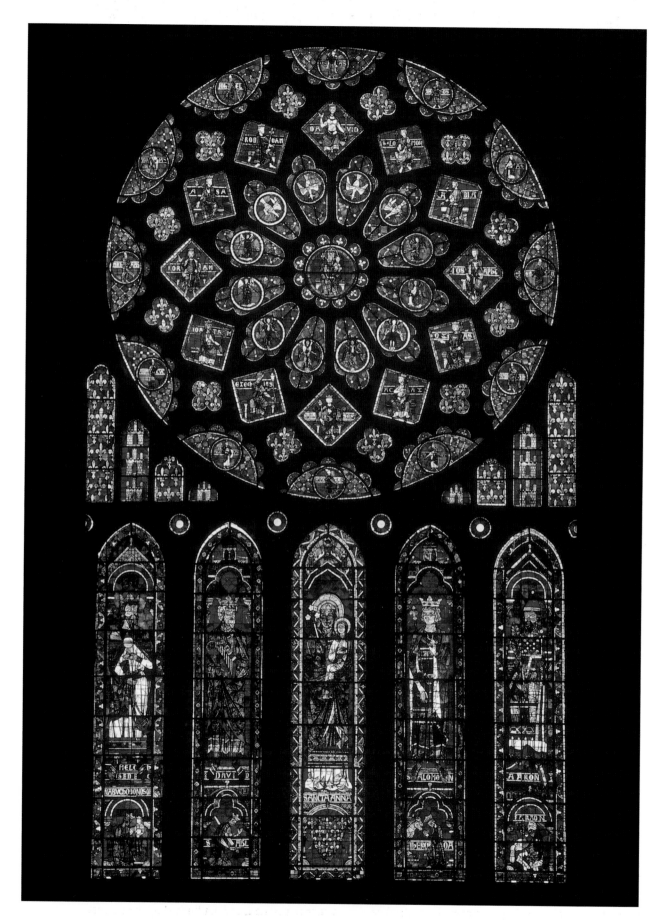

9.17 North transept wall with stained glass windows, Chartres Cathedral, 13th century. France.

Part IV Two-Dimensional Media and Techniques of Art

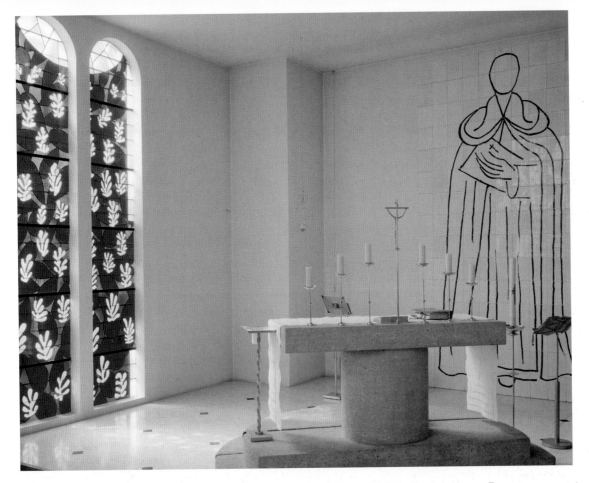

9.18 View of Matisse's Chapel of the Rosary, 1948–1951. Saint Paul de Vence, France.

Stained Glass

Stained glass creates the effect of a space filled with light and color. Traditionally stained-glass windows were used in churches and cathedrals, but more recently they appear in secular buildings as well. A stained-glass window is like a collage in that it is made by arranging elements—in this case, pieces of colored glass held together with strips of lead. The colored glass fragments are organized to form an image and are fitted into an open wall space. When sunlight passes through a stained-glass window, the interior space erupts into a blaze of bright color.

During the Middle Ages, the most spectacular stained-glass windows were created for the soaring Gothic cathedrals that expressed the power of the Catholic Church. One of the best preserved of these is the thirteenth-century Cathedral of Chartres, in France. The north wall is decorated with a huge, round **rose window**, five tall **lancet windows**, and smaller filler windows containing royal coats of arms (**figure 9.17**). This shows the variety of geometric shapes used in medieval windows and the arrangement of color to create the biblical figures depicted in them. The rich blue and red windows, which are typical of Chartres, filter the outdoor light and transform it into color as it penetrates the wall. The medieval builders thus created a sense that, when

worshipers enter a cathedral, they enter a new, spiritual realm of time and space.

Figure 9.18 shows a view of the twentieth-century Chapel of the Rosary of Dominican nuns at Vence, in the South of France. Beginning in 1948, Matisse created the interior decoration. In this view we can see a large image of Saint Dominic at the right, which is composed of simple black lines. The pair of stained-glass windows at the left bears a striking resemblance to the bright, flat colors of Matisse's collages.

The windows depict the biblical *Tree of Life* and are composed entirely of blue, green, and yellow glass. The downward curve at the top of the windows suggests a curtain hung in front of a yellow window, while the design suggests foliage. Matisse fragmented the elements of a tree, creating organic, biomorphic shapes that seem to dance weightlessly through space. His *Tree of Life* takes on a new meaning; it is not only the biblical Tree, it is all trees, which, in turn, expresses the universal character of the original Tree. In the same way, Matisse's *Tree* is a link to the life and color of nature as well as to a specific biblical narrative. Matisse said of the Chapel of the Rosary:

I wanted to inscribe a spiritual space, one whose dimensions are not limited by the objects represented.[2]

9.19 Georg Meistermann, *Sun Spiral*, Heilis Kreutz Church, Bottrop, Germany, 1952. Stained-glass window, 738 sq. ft. Designed by Georg Meistermann and made by Glasmalerei Derix Düsseldorf-Kaiserweren.

The German artist Georg Meistermann (1911–1990) was at the forefront of a movement to create abstract stained-glass windows after World War II. **Figure 9.19** shows a view of his so-called *Sun Spiral* created for a church in Bottrop, Germany. The energetic spiral composed of blacks is animated with bright geometric reds, yellows, and purples arranged to fit the circular motion of the overall design. Like the rose windows of Gothic cathedrals (see figure 9.17), this alludes to the traditional meaning of the circle as universal and unending.

Mosaic

Mosaics are images made by arranging stones, tiles, or pieces of colored glass (***tesserae***) and embedding them into a surface. As with stained glass, the image is formed by the organization of color. In ancient Mesopotamia, artists created mosaics by inserting cones with colored round ends into walls. This both increased the durability of the wall and made patterns of colored circles on the exterior of a building (**figure 9.20**).

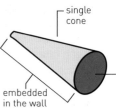

single cone

visible on wall surface

embedded in the wall

9.20 Diagram of cone mosaic technique.

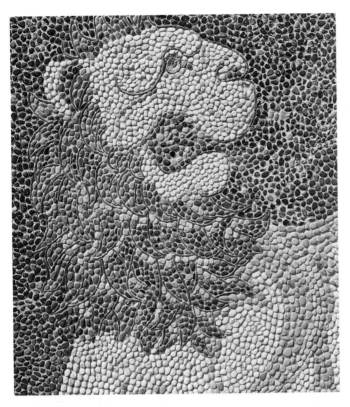

9.21 Detail of a lion head, late 3rd century B.C., from Pella, Greece. Pebble mosaic. Photo: Alix Barbet.

... take little leaves of gilded or silvered paper, or thick gold or silver foil.
Cut it up very small, and lay in with these tweezers, ... wherever the ground calls for gold.

Cennino Cennini (c. 1370–c. 1440), on creating mosaic

In ancient Greece and Rome, mosaics made of pebbles decorated the floors and walls of shrines and upper-class houses. The surfaces of floor mosaics were evened with a level or a ruler and then polished to keep the surface smooth and prevent the stones from becoming dislodged as people walked on them.

It is not known where the technique of pebble mosaics originated. Early examples have been found as far east as Afghanistan and as far south as North Africa. At Pella, in third-century-B.C. Greece, fragments of several high-quality pebble mosaics have survived. **Figure 9.21** shows the detail of a lion head from Pella. The outlines around the mane and features are indicated with strips of lead and terracotta, which separate the discrete areas of color. The muscle structure underlying the white body is indicated with shades of gray and blue, whereas the mane is rendered in browns and yellows.

Byzantine-style mosaics, dating from the fifth through the fifteenth century, are made of reflective colored glass. By tilting each tile slightly, it was possible to multiply the reflective effect and thus enhance the impression of gold light (**figure 9.22**). Here again, the image was made by arranging colored shapes in an imaginative way. A brightly colored bird with one black foot and one red foot stands in a light brown space. The black tiles form the bird's outline, and the blues, greens, and whites form its feathers, eye, and neck. The beak is red, orange, and black.

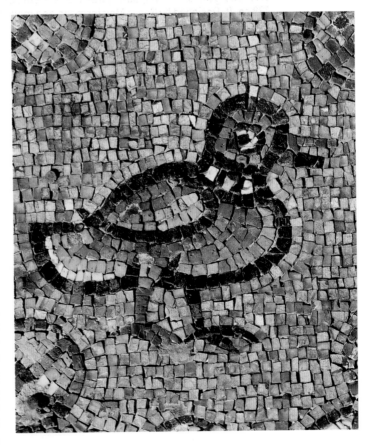

9.22 Detail of the ceiling of the Chapel of the Archbishop, 5th–6th century. Mosaic. Ravenna, Italy.

In contrast to the stained-glass windows of Gothic cathedrals, windows in Byzantine churches were small. For the Byzantine worshiper, the gold light reflections of the *tesserae* denoted the divine presence of God inside the church. Byzantine artists created spectacular large scenes using mosaic, often covering entire interiors with dazzling light and color. **Figure 9.23** illustrates the interior of the dome of the Arian Baptistery in Ravenna, which is made entirely of mosaic tiles.

In the center circle, John the Baptist baptizes Jesus and the Holy Spirit appears in the symbolic form of a white dove. The outer circle is ringed with twelve saints in white robes and Roman sandals. They stand on a green surface and are separated by stylized palm trees that identify the Middle Eastern setting. The empty throne above Jesus supports a jeweled cross and alludes to a time when Christ takes his place on the throne of heaven after his death and resurrection. The gold background removes the entire scene from earthly space and indicates the divine character of the events and figures.

—◆—

The techniques and media we have described in this chapter are all used to create unique works of art. In the next chapter, we turn to media and techniques used to produce multiples of a single image. These are referred to as prints and the techniques are called printmaking.

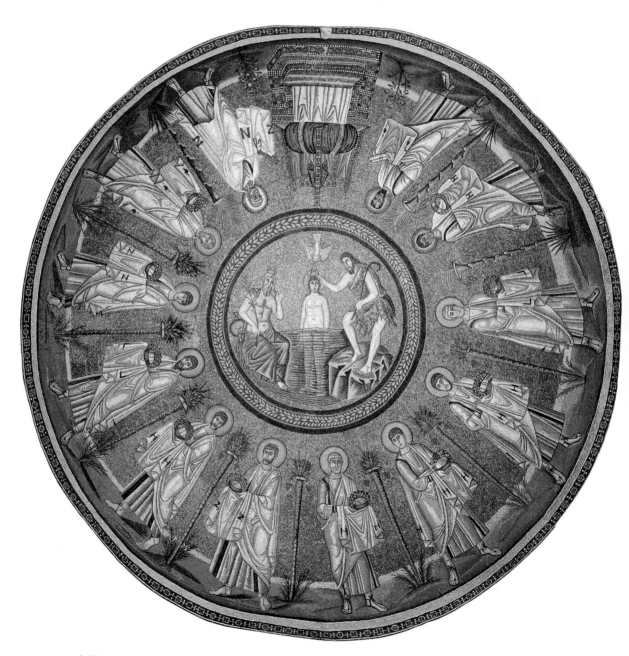

9.23 Interior of the dome, late 5th century. Mosaic. Baptistery of the Arians, Ravenna, Italy.

Chapter 9 Glossary

acrylic—fast-drying synthetic paint medium

action painting (or **gesture painting**)—technique of twentieth-century painting characterized by the artist's dynamic gestures in applying the paint

binder—liquid substance used in paint and other media to bind particles of pigment together and make them adhere to the support

canvas—closely woven cloth, usually of linen, hemp, or cotton, frequently used as a support for a painting

cartoon—(a) full-scale preparatory drawing for a painting; (b) comical or satirical drawing

craquelure(also known as **cracking** or **crazing**)—fine cracks (of paint, varnish, enamel) on the surface of a work of art

cut-out—image or design cut out of paper, wood, or other material

encaustic—painting medium or technique in which pigment is mixed with a binder of hot wax and fixed by heat after application

gesso—white coating made of substances such as chalk, plaster, and size that is spread over a surface to make it more receptive to paint

gouache—opaque, water-soluble painting medium

lancet window—tall, narrow arched window

opaque—not allowing light to pass through

pigment—powdered substance used to give color to dyes, inks, and paints

pounce—fine powder used to transfer a design from a perforated pattern to another surface

primer—in painting, a preliminary coat applied to a support in order to improve the adhesion of the paint

rose window—large circular window decorated with stained glass and tracery

size (or **sizing**)—mixture of glue or resin that is used to make a ground (such as canvas) less porous so that paint will not be absorbed

stained glass—pieces of colored glass held together by strips of lead used to form windows

support—in painting, the surface to which pigment is applied

tempera—water-based painting medium made with egg yolk, often used to paint fresco and panels

tesserae (sing. *tessera*)—small tiles arranged to create a mosaic

vehicle—liquid in which pigments are suspended to form paint

KEY TOPICS
Relief printing
Intaglio
Lithography
Serigraphy
Monotype
Offset printing
Graphic design

10

Printmaking

Creating two-dimensional images by **printing** differs from other imagemaking methods we have discussed in a few important ways. First, the equipment needed is different; printing requires some form of pressing instrument, which can be large and complex or quite small and relatively simple. We are all familiar with fingerprints and footprints used for identification. But those are direct prints using a part of one's body. When an artist prints an image, he or she needs an intermediary piece of equipment, some form of **press** or

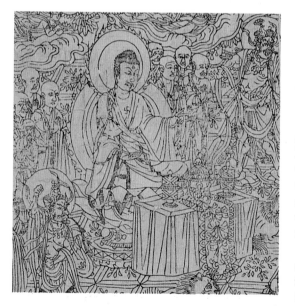

10.1 Detail of frontispiece from the *The Diamond Sutra*, 868. Woodblock handscroll. The British Library, London.

transfer system. This adds a step to imagemaking and removes part of the process from direct contact with the artist's hand.

Like other artists, the printmaker conceives and designs the image, and traditionally produces it. But there are several ways in which printmaking differs from painting and sculpture. First, because the printing can be done without the artist being present, the original image is sometimes given to a professional printer or printing studio to produce. Second, most (but not all) prints are made in multiples, are easily portable, and light-weight. As a result, they can be more widely disseminated and used to convey information to a greater number of people than a unique work of art. Third, although the media of printing are often the same as those used in painting and drawing, the support of a print is usually paper. And fourth, most (but not all) printing processes reverse the original image.

If we imagine a world without printing, we realize that there would be little in the way of commercial advertising, no posters, and no billboards along our highways. Everything from labels to playing cards would have to be individually designed by hand—as they were before printing. There would be no junk mail, and we would have to travel to see original works of art instead of being able to study them through reproductions.

Printing images and printing using moveable type are ancient techniques. Although the oldest surviving printed book in China, *The Diamond Sutra* (**figure 10.1**), dates to A.D. 868, the technique was perfected in Europe only in the fifteenth century. The development of printing technology led to the establishment of printing presses, which increased

literacy and made books widely available—first in Europe and later in America. Similarly, the ability to make multiples of images expands visual literacy.

Printing has had a strong impact on visual culture. But the process raises certain issues of value and quality, as well as authenticity. With unique works of art such as oil paintings, there is always the possibility of forgery; with prints, the quality generally declines after a certain number have been made. This is not an issue with items such as food labels and other reproductions that are commercially produced by the thousands. But with art prints, the **plate**, or original printing surface, is supposed to be destroyed after a given number of images has been printed. This assures that the quality of the print is retained, because after a while the image begins to deteriorate. The desired print-run can vary from a few to several hundred, depending on the medium, the wishes of the artist, and other factors.

The number of prints determined by the artist to be pulled (printed) from a single plate is called an **edition**. A good way to safeguard the authenticity, and therefore the value, of an art print is for the artist to number, date, and sign each one. A 3/100 mark, for example, identifies print number three from an edition of one hundred. In the early nineteenth century, artists began marking the first prints pulled with *AP*, which stands for "Artist's Proof." These are usually the most valuable prints in an edition. After completing an edition, many artists destroy the original plate, often by scratching through it. A print made after the plate has been destroyed is called a **cancellation print**, which proves that the plate can no longer be used—it has been cancelled by the artist. Sometimes, however, plates are retained and unauthorized prints are pulled from a press.

Printing techniques, in which the artist "has a hand," have been divided into four basic categories: **relief**, **intaglio**, **lithography**, and **serigraphy** (also called **silkscreen** and **screenprinting**) (**figure 10.2**). As with drawing and painting, some modern artists combine printing techniques to produce new kinds of images.

Printing is also used in graphic design, which usually (but not always) has a commercial purpose. Graphic artists often use words as well as images to communicate their message.

The art critic Walter Benjamin (1892–1940) had the following to say about the mechanical reproduction of images:

> The uniqueness of a work of art is inseparable from its being imbedded in the fabric of tradition....[1]

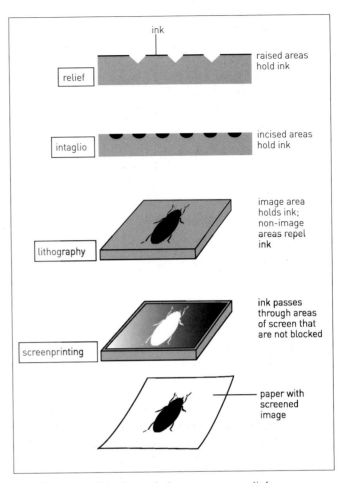

10.2 Diagrams of the four printing processes: relief, intaglio, lithography, and screenprinting.

Relief Prints

In relief printing, the artist outlines the image on a surface and then cuts away the material around it. The result is a raised image, or relief, such as images on coins or manhole covers, both of which could be used to make a print. If we put ink on a penny and press it onto a piece of paper, only the raised part will print because the remainder does not come into contact with the paper.

Woodcut

The earliest known printing technique is **woodcut**. It was first used on paper during the fifteenth century, but had previously existed for hundreds of years as a way of printing on textiles. Since woodcut is a relief method, the image is first outlined on the block of wood and the areas around the image are cut away. The block is then covered with ink and pressed onto a paper support to transfer the image from the block to the paper.

10.3 Albrecht Dürer, right half of the small *Triumphal Car of Maximilian I* (*"The Burgundian Marriage"*), c. 1518. Woodcut.

A well-known exponent of black-and-white woodcuts, and one of the greatest Western printmakers, was the German artist Albrecht Dürer. **Figure 10.3** shows the right half of a woodcut Dürer made for the wedding of the Holy Roman Emperor Maximilian (1459–1519) to Mary of Burgundy. The left half (not shown) illustrates the imperial couple in their triumphal car. The section visible here is enlivened by the energetic figure of Victory driving the chariot and waving a laurel wreath, and the four leaping horses. The predominantly curvilinear lines are clear and precise, and the designs are fanciful. Dürer's enthusiasm for animal pictures is apparent in this print, for several forms of Victory's chair metamorphose into animal heads and the horses are decked out in elaborate trappings adorned with royal insignia. The style of this woodcut, with its animated lines and imaginary forms, is clearly designed to convey the exuberance as well as the pomp and circumstance of the emperor's wedding.

Dürer has controlled the thickness and thinness of the lines by the degree to which he incised them in the wood. This control of line and the potential for variety is one of the advantages of woodcut printing. By leaving certain areas white and densely hatching others, Dürer created an impression of contour. Thus, for example, the tails of the horses appear to be waving in the air, and their bodies seem massive. The greater amount of white on the horses' trappings

10.4 Wassily Kandinsky, Title print of the *Blue Rider Almanac*, 1911–1912. Woodcut, 11 x 8 ½ in.

makes them seem flat and decorative, while the closely hatched parallel lines on the ground indicate cast shadows.

A very different effect is created in Kandinsky's title print of the almanac for *The Blue Rider* (*Der Blaue Reiter* in German) (**figure 10.4**), the modernist art movement that he founded in Munich in 1911. Kandinsky believed that material values were destroying traditional culture and he used art as a route to spirituality. The name of the movement, which is also the title of the almanac, referred to the emblem of Moscow: Saint George slaying the dragon, shown here in abstracted form. At the time, this image was associated with the Apocalypse (Revelation—the last book of the Bible), which describes the end of the world and Christ's thousand-year rule. The Blue Rider group identified the city of Christ's future reign as Moscow.

In contrast to the slim, graceful lines of Dürer's woodcut, Kandinsky's lines are harsh. They are thick and flat, and the horse is plain. Whereas Dürer's horse and rider race horizontally across the picture plane, Kandinsky's are foreshortened and seem to be coming toward us on a diagonal. In the Kandinsky, there is a threatening quality that is consistent with the apocalyptic nature of the image and is conveyed in part by the thick, aggressive lines made from wide cuts in the wood. In the Dürer, on the other hand, the thin, elegant lines invite us to admire the regal opulence of the horses and driver as they seem to pass us by.

Woodblock

Woodblock printing was used in China beginning in the fourteenth century and was later imported into Japan. In the eighteenth century, Japanese printmakers elaborated on the technique and added color. The *Ukiyo-e* School in Edo (the former name of Tokyo) produced many images of entertainment and nightlife, portraits of actors, landscapes, and erotica during the nineteenth century. One master of the *Ukiyo-e* tradition, Hokusai, made the woodblock of the *Great Wave* (see figure 2.11).

The market for these works was the middle and upper-middle class of Edo. Eventually they would influence the nineteenth-century Impressionist painters in Europe and America.

The Japanese woodblock technique began with inking a picture on thin paper, and placing it ink-side down on the block. Then the artist rubbed the back of the paper to transfer the image to the block. Next, the wood around the image was carved away, creating the so-called **key block**. Additional copies of the key block were made for each color and the printer printed each color block over the key block design. Great care was taken to assure precise **registration**—that is, matching up the edges of each area of color—in order to avoid irregularities and blurring. When the blocks had been completely colored, they were printed on paper. Sometimes powdered and dampened mica was added to achieve shiny surfaces.

Utagawa Hiroshige (1797–1849), another artist of the *Ukiyo-e* tradition, produced the *View of Nihonbashi Tori-itchome* as one of his famous woodblock series entitled *One Hundred Famous Views of Edo* (**figure 10.5**). He shows a busy, shop-lined

COMPARE

Hokusai, *The Great Wave of Kanagawa*
figure 2.11, page 24

10.5 Utagawa Hiroshige, *View of Nihonbashi Tori-itchome*, from *One Hundred Famous Views of Edo*, 1858. Woodblock print, 13 3/8 x 9 3/8 in. Brooklyn Museum, New York. Gift of Anna Ferris.

street in old Tokyo on a hot day and a colorful medley of costume. We actually see very few faces, aside from the man at the right sampling a small melon at a fruit stand. Even the man delivering a tray of food is without an identity. We mainly see the line of shops at the right, broad yellow hats, and blue parasols protecting pedestrians from the sun.

In the foreground, a woman carries a *samisen*, a type of instrument resembling a banjo and often used to provide muscial accompaniment in theatrical and dance performances of the period. Such professional *samisen* players were often of very low, or no, social rank. Unsurprisingly, therefore, the *samisen* player in the print walks alone, following a group of *Sumiyoshi* dancers grouped under a large, red, white, and blue umbrella. The *Sumiyoshi* originated as dancers associated with the Sumiyoshi shrine in Osaka, but by this time they had evolved into street performers who could be found throughout Japan.

The lively color designs of this print are composed of the flat color typical of woodblock and they express the energy of a busy street on a clear day. However, Hiroshige added some gradations of light and dark, and of mass and volume, by varying the color on the block before it was printed. The precision of the registration is evident in the absence of blurring, in the delicate costume patterns, and in the decorative calligraphy on the buildings.

Linocut

Linocut is a newer technique than woodcut. In linocut, the artist begins with a piece of linoleum— a synthetic material that is softer than wood. As with woodcut, the linocut artist designs the image and then cuts away the rest. The flexibility of linoleum lends itself to broader, more rounded cuts than wood. In contrast to the woodcutter, the linocut artist does not have to take into account the grain of wood.

Picasso's *Head of a Woman (Jacqueline)* (**figure 10.6**) has the characteristic jagged edges of his paintings produced in the 1960s, which is an effect readily achieved with linocut. This portrait of the artist's last wife shows her in two tones of brown, and from two viewpoints—in profile and viewed from the front. Each brown would have been printed with a separate block as in Hiroshige's *View of Nihonbashi*. Here the double viewpoint corresponds to the doubling of the color tones, and the shifting, distorted quality of the face matches the rubbery character of linoleum.

10.6 Pablo Picasso, *Head of a Woman (Jacqueline)*, 1961. Linocut, 25 $\frac{3}{16}$ x 20 $\frac{7}{8}$ in. Museo Picasso, Barcelona.

> **Nature and art, being two different things, cannot be the same thing. Through art we express our conception of what nature is not.**
>
> Pablo Picasso (1881–1973), on the difference between art and nature

Intaglio

Intaglio (from the Latin verb *intagliare*, meaning "to cut into") reverses the relief process. Instead of cutting *away* from the image, intaglio cuts *into* a hard material that is pressed against a surface to make a print. Examples of intaglio are found as early as 3000 B.C. in the Ancient Near East. **Figure 10.7** shows the impression made by a Sumerian cylinder seal of around 2600 B.C. from Mesopotamia (modern Iraq). This seal is one of thousands from the ancient Near East, where they were used to prove authenticity and ownership as well as for official records. They are also valuable sources of style and iconography.

The design was carved into the cylinder, which was then rolled across a soft waxy surface, leaving a raised image. The seal illustrated here depicts a queen and her consort attended by servants at a banquet; all wear the flounced Sumerian skirts typical of the period. Arranged in two levels, the former are larger and seated, the latter smaller and standing— an example of hieratic proportions, in which size connotes rank. The seal is made of lapis lazuli, a semiprecious light blue stone imported from Afghanistan.

10.7 Detail of impression of an Early Dynastic III cylinder seal, c. 2600 B.C., from the Royal Cemetery at Ur, in modern Iraq. Lapis lazuli, 2 x 1 in. British Museum, London.

Later Western artists used the intaglio technique by cutting into metal plates and inking them. The ink flows into the cut areas and the uncut surface is wiped clean, leaving the ink only in the cut lines. The artist then lays a piece of paper on the plate and presses it (usually with a mechanical press). This forces the inked lines to transfer the image to the paper, but in reverse. It is also possible to dampen the paper to make it more pliable and easier to press into the intaglio cuts.

There are several types of intaglio printing: **engraving**, **drypoint**, **mezzotint**, **aquatint**, and **etching**.

Engraving

Engraving metal is another ancient technique. Etruscan women, for example, used mirrors with bronze backing decorated with engraved (usually mythological) scenes (see Chapters 12 and 16). Metal armor, sword hilts, and helmets were also traditionally engraved, sometimes with complex imagery and elaborate designs. But transferring the image to a paper surface is a later technique and dates from the Renaissance. When artists engrave on metal plates, they incise lines into the plate by pushing a sharp instrument such as a **burin** across the surface. Then they ink the lines and press the plate against paper to make the print.

The eighteenth-century English engraver William Hogarth (1697–1764) produced many images satirizing social hypocrisy. He also created a series of studies of criminals, in which he conveyed the personality of the criminal. The engraving of which Hogarth sold the most copies represents Simon Fraser Lovat at an inn on his way to trial and execution in 1745 for inciting the Scottish clans to support the Pretender to the English throne (**figure 10.8**).

Lovat is shown as a gross, dishonest character, counting on his fingers the clans supporting him. He sneers malevolently and raises his eyebrows as if to hint at his treasonous plot. Ironically, the back of his chair is decorated with two **putti** (small, nude boys found mainly in Roman and Renaissance sculpture) carrying a crown, alluding to Lovat's association with a false monarch.

Note the variety of tones and textures Hogarth achieves with the engraving technique. Most of the back wall is hatched, making it lighter than the gridlike cross-hatching behind the table. In Lovat's costume, Hogarth created the impression of folds, buttons, lace cuffs, and a wig by varying the width of the spaces between the lines. The stocking at the right, for example, is filled in with parallel lines, whereas the one of the left is whitened, with short dark curves added so that it appears to sag. Areas of white on the floor, as well as on the costume, and the cast shadows suggest that light comes from the right front of the engraving.

10.8 William Hogarth, *Simon Lord Lovat*, 1746. Engraving, 13 1/16 x 8 3/4 in.

Wood Engraving

Wood engraving is an eighteenth-century form of woodcut, which was frequently used in book illustration. The wood engraver uses a hard wood surface and pushes a **graver** (a type of burin) across the grain. As with woodcut, the wood engraving print is made by a relief (rather than an intaglio) process, but produces finer and more detailed images. Whereas woodcut, as we saw in Dürer's *Triumphal Car*, is composed of black lines on a white surface, the wood engraving is read as composed of white forms on black (**figure 10.9**).

This example of 1865 is an allegorical scene entitled *Amor Mundi* (*Love of the World*). It shows a couple, whose forms are created by black curves surrounded by areas of white paper. The figures seem to be in a state of rapture—the man lost in the music of his lute and the woman in adoration of him. She holds an apple and a mirror, both of which are traditional symbols of love.

The figures tower above a landscape rich in foliage—like the Garden of Eden—with a serpent ominously rearing its head in front of them. In the foreground, a girl lies dead, and toads perch on her discarded instrument, alluding to the misfortunes of love. The enormous variety of texture and line, of shape and contour, is typical of the pictorial quality that can be achieved in wood engraving.

Drypoint

In drypoint the artist draws on a metal plate with a special needle that leaves a rough edge (a **burr**) in its wake. Because of the burr, when the drypoint plate is printed, the lines are more textured—even slightly blurred—than in an engraving. This technique thus allows for more variety, unevenness of form, and softness of shadow.

We can see the effects of drypoint in Dürer's *Saint Jerome by the Pollard Willow* (**figure 10.10**), one of three drypoints he made in 1512. Compared with Hogarth's *Simon Lord Lovat*, Dürer's print has more gradual shifts from light to dark, which mutes the varied textures. It shows the hermit Jerome praying in the wilderness amid sharp rocks and tree trunks that contrast with his soft robe and beard. The saint's characteristic large, round hat and cape lie to the right of his makeshift desk and his lion companion sleeps at his feet.

Jerome's expression is intensely meditative, as he gazes fiercely into space. We have to look closely to

10.9 Joseph Swain, after Frederick Sandys, *Amor Mundi* (*Love of the World*), 1865. Wood engraving, 6 ⅞ x 3 ⅞ in. British Museum, London.

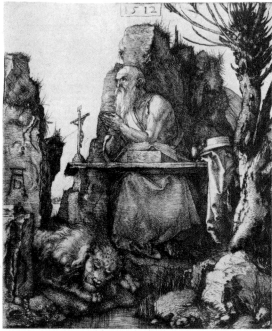

10.10 Albrecht Dürer, *Saint Jerome by the Pollard Willow*, 1512. Drypoint, 8 ⅜ x 7 ⅛ in.

catch sight of the faint crucifix at the corner of the desktop. This, we know, is an object of Jerome's devotion, but it is not the object of his gaze. Jerome looks past the crucifix at an unseen, possibly divine presence, and it is the viewer who sees the crucifix. The artist, however, makes *his* presence known by his slightly blurred signature monogram, the *D* inside the *A*, engraved into the rock at the left.

Mezzotint

Mezzotint (literally "middle tint") is a type of intaglio printing that is difficult to master. It was popular in eighteenth-century England for reproducing portraits, because of its ability to capture subtle lights and darks. In mezzotint, the artist pockmarks (roughs) the surface of the metal plate with a hatching or **rocking instrument** (a tool with a serrated edge) and applies ink, which prints a rich black. To add light, the artist scrapes parts of the plate, removing ink in various degrees. The shallower the indentations in the plate, the lighter the final print will become. By polishing the raised areas between the indentations, the artist can produce white. Mezzotint is the reverse of etching and engraving, in that the artist works from a black background to white. Texture is determined by the definition of the burr; once the surface

of the plate becomes worn, the quality of the impressions deteriorates.

The *Defense Worker* (**figure 10.11**) by the Philadelphia printmaker Dox Thrash (1893–1965) is a predominantly dark print. Thrash's figure looms up on a darkened platform and works his large drill. His massive, foreshortened form and elevated viewpoint convey a sense of enormous masculine power. The all-over texture of the print is created by soft shifts in dark and light arranged in swirled patterns of folds on the clothing.

Thrash was himself a veteran of World War I, and he made this print for President Franklin Roosevelt's WPA (Works Progress Administration) Program. This was a government-funded plan to provide work for artists, writers, and other creative people during the Great Depression and subsequently to organize the work force with the coming of World War II. Thrash ennobles the worker by elevating him visually, by his monumental proportions, and by the glow of white light emerging from a velvety black background. Here the light is symbolic; it glorifies the defense of the nation in wartime, and accentuates the forward thrust of the patriotic worker.

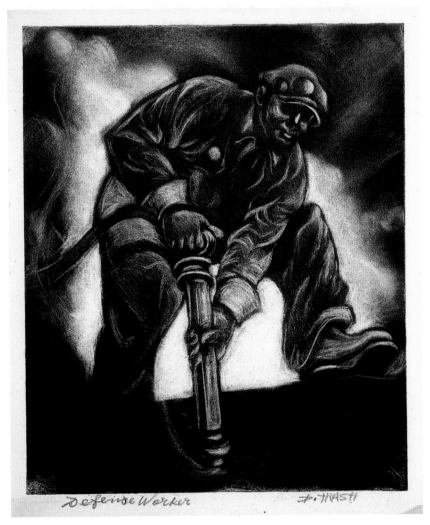

10.11 Dox Thrash, *Defense Worker*, c. 1941. Carborundum mezzotint over etched guidelines. Federal Works Agency, Work Projects Administration, on deposit at the Philadelphia Museum of Art. 2-1943-275 (18).

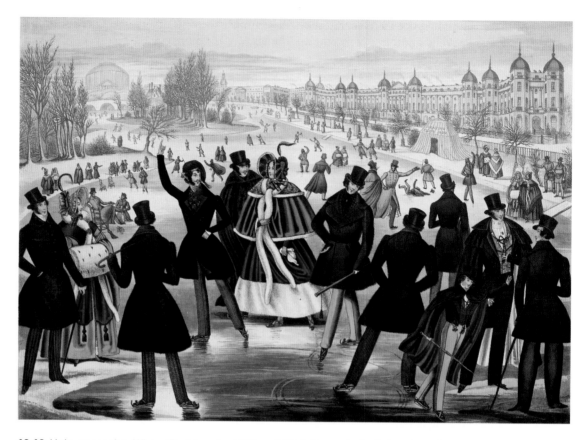

10.12 Unknown artist, *Winter Fashions for 1838 and 1839, Regent's Park, London*, 1838. Hand-colored aquatint, 17 ³/₁₆ x 22 ⁷/₈ in. British Museum, London.

Aquatint

A much more delicate process than mezzotint, aquatint literally means "tinting, or toning, with water." It was first used in eighteenth-century France. Aquatint is a type of etching in which the metal plate is partially covered with powdered, acid-resistant resin melted with heat. The plate is then dipped in an acid bath to erode the uncovered areas of the plate. As in etching, the density of tone depends in part on the thickness of the resin dust and on controlling the process of erosion by shortening or lengthening the amount of time in the acid bath. However, aquatint allows for more gray tones than etching and engraving and is often used together with other media.

The lively aquatint by an unknown artist in **figure 10.12** has been hand-colored. The richest colors occupy the foreground and become muted as the scene recedes into the distance. The pale whites and cool blues of the background reflect the cold, crisp air of winter, at which time Londoners are sporting the season's fashions for 1838 and 1839. The figures all seem to be enjoying their new outfits as they glide about in Regent's Park. In the foreground, an ice-skater has just made a figure 8.

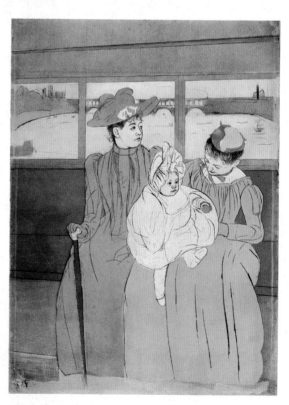

10.13 Mary Cassatt, *In the Omnibus*, 1890–1891. Drypoint and aquatint on laid paper, 14 ³/₈ x 10 ¹/₂ in. National Gallery of Art, Washington, D.C. Chester Dale Collection.

Cassatt's *In the Omnibus* (**figure 10.13**) combines the relative flatness and opacity of aquatint with the fine lines of drypoint. The artist used brown to indicate the prim, upright, sober quality of the woman at the left, but added color to the hat of the more animated woman tending the squirming infant. All three are well-covered for their outing, as propriety in nineteenth-century France required. In the distance, through the window of the bus, Cassatt shows us the watery texture of the Seine River and the silhouette of a bridge.

Etching

Etching is a technique that more closely approximates drawing than engraving does. The artist covers a metal plate with an acid-resistant substance and scratches only through the covering with a sharp needle to expose the metal. The plate is then submerged in an acid bath and the acid eats into the lines. The longer the plate remains in the bath, the deeper and darker the lines become. By removing the plate at various intervals, covering some of the lines and leaving others exposed, the artist can control the character of each line.

Rembrandt's most famous etching, the so-called *Hundred Guilder Print* (named for its auction price), shows Jesus healing the sick (**figure 10.14**). The interest in light and dark that characterizes Rembrandt's portraits recurs here. He took advantage of the subtleties of light and dark available in the etching process and used it in a formal and symbolic way. Jesus dominates the center of the image; he is the tallest figure, and his torso is highlighted in light. A haloesque glow emanates from his head and signifies his divinity. The face is in bright light and the cross-hatching at the back of the head is arranged in a circular motion, indicating that Christ himself is the light source—the biblical "Light of the World."

At the far right, people hoping to be healed enter into the scene through a rich, dark, triumphal arch and approach the lighter area occupied by Christ and the Pharisees at the left. The latter are discussing Christ's commandment to give away their worldly goods in order to enter the Kingdom of Heaven. Next to Christ, Saint Peter tries to exclude a woman who is carrying an infant; but Christ admonishes him and welcomes the children as well as the adults.

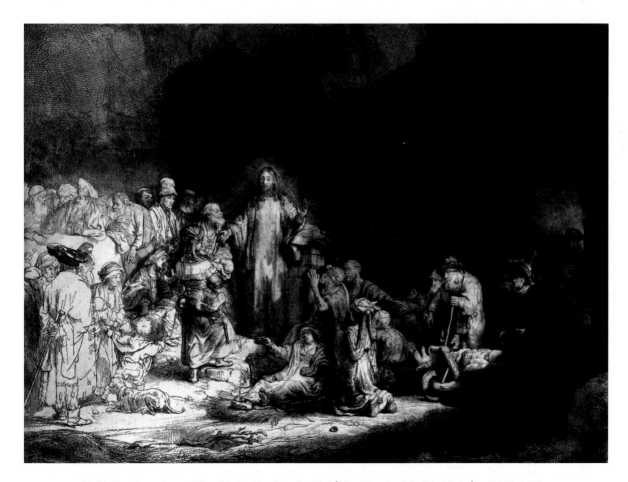

10.14 Rembrandt van Rijn, *Christ Healing the Sick* (*The Hundred Guilder Print*), c. 1647–1649. Etching, drypoint, burin, 10 $^7/_8$ x 15 $^1/_4$ in. Rijksmuseum, Amsterdam.

Lithography

Literally "writing on stone," or "stone-writing," lithography is a flat **planographic process** based on the principle that water and grease repel each other. Lithography was invented in late eighteenth-century Germany and developed in France. Among the advantages of lithography is its relationship to the drawing process, both in the appearance of the lines and in the impression of immediacy. Of the various lithograph techniques the basic one can be described as follows: the artist draws on a flat stone (usually limestone, which is porous) with a grease crayon, adds a nitric acid fixer, and moistens the stone with water. The water rolls off the parts of the stone marked by the wax crayon, but adheres to the unmarked stone. Oil-based ink, which adheres only to the crayon, is then rolled over the stone. Paper is pressed against the stone, transferring the ink from the stone to the paper.

In Daumier's *Monsieur Colimard* (**figure 10.15**), we can see the expressive qualities of black-and-white lithography and its similarity to drawing. Areas of light on the costumes are loosely hatched, whereas the darkened areas are a rich, silky black.

The sketchy curves of the dancer emphasize her movements through space, with lighter lines suggesting scenery and the presence of other dancers at the back of the stage. The patterned, repeated curves representing the audience in the middle ground are firmly drawn to indicate that the viewers' heads are immobile as they watch the performance. In the foreground, we can see the disapproving expression, created by downward curves, of the woman in the box. She is clearly displeased by her husband's enjoyment of the younger, lightly clad dancer. The caption reads: "M. Colimard, if you continue to peer at the dancers in such an undignified manner, I will take you home before the end of the performance." The *h.D.* signature on the back of M. Colimard's chair suggests that Daumier himself identified with Colimard's gaze, conflating erotic looking with the eye of the artist and witty social observation.

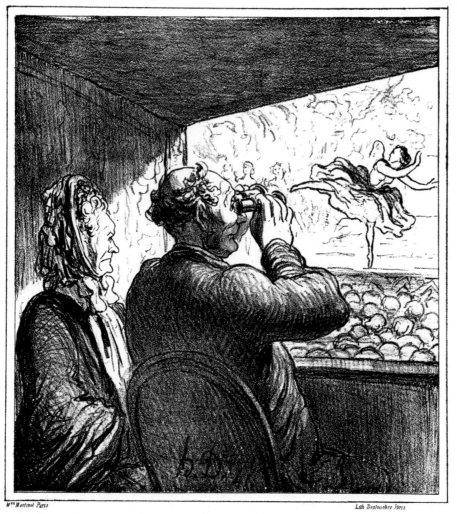

CROQUIS PRIS AU THÉÂTRE par DAUMIER

_Monsieur Colimard si vous continuez à lorgner les danseuses d'une façon aussi inconvenante je vous ramène à la maison avant la fin du spectacle.

10.15 Honoré Daumier, *Monsieur Colimard*, 1864. Lithograph, 9 ¼ x 8 ½ in. L.D., No. 3266 from *Sketches of the Theater*.

Klimt's *Music* of 1901

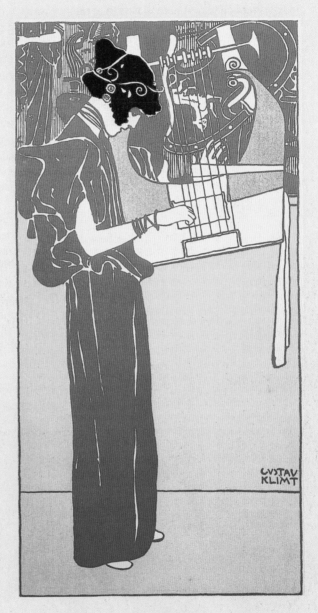

Lithography, like woodblock, can be a color process where different surfaces (in this case, stones) and different inks are used for each color. Color lithographs became popular in the nineteenth century and were often used for poster announcements designed by professional artists. The example of 1901 by Gustave Klimt (1862–1918) (**figure 10.16**) is a lively print composed of flat, unshaded areas of bright yellows and rich oranges with white highlights. Klimt juxtaposes warm colors, accentuating the yellows, the muted oranges, and the whites with a firm orange edge. The girl in Grecian costume with Greek-style hair personifies the art of music. She plays a harp, which overlaps images derived from ancient Greek iconography in the upper background. We can make out a Greek vase, a Greek shield, and the cropped view of another figure at the upper left.

The style of the print is typical of turn-of-the-century Vienna and the period known as the *belle époque*, when the conflict between overt decadence and moral restraint came to the fore. Music has a long tradition of erotic allusions in Western art, because of its singular association with courtship and romance. Erotic undertones, combined with danger, are suggested here not only by the warm colors, but also by the slightly sinister masklike eyes of the girl and her serpentine bracelet. She bows her head and appears to be concentrating intently on the music. Her coiffure, like the background, combines organic, floral forms characteristic of the Art Nouveau style with references to antiquity. She is clearly related to these forms by virtue of sharing their red color and linear quality. Klimt has portrayed the girl with a sense of hidden secrecy and inner malevolence. These qualities were typical of the beautiful but deadly *femme fatale* who attracts and destroys men, which was a popular theme in the art and literature of the period.

10.16 Gustave Klimt, *Music*, 1901. Lithograph. Private Collection.

Serigraphy

Serigraphy (also known as silkscreen or screenprinting) is literally "silk-writing" with the aid of stencils, and lends itself to producing smooth areas of color. Originally the silk was placed over a sheet of paper or canvas; then a **stencil** was laid over the silk and the ink pressed through the silk with a squeegee (a rubber-edged tool such as we use to remove water from the windshields of our cars). Other variations can be used, including painting directly on the silk.

Silkscreen was first used for posters and commercial labels, but artists were soon drawn to its versatile, easily mastered technique. The process became popular in the United States during the 1930s, partly because it is inexpensive and relatively simple. And, in contrast to lithography, silkscreen does not reverse the artist's original image. Beginning in the 1960s, artists introduced the use of photostencils, thereby combining photography with screenprinting.

Andy Warhol, whose *U.S. Dollar Signs* we discussed earlier (see figure 7.3), transformed advertising images into works of art. His *Cow Wallpaper* (**figure 10.17**) is a humorous play on the repetitious patterning of wallpaper. The bright red forms of the cows, which seem to peer out at us from behind strips of yellow paper, challenge traditional notions of high art. As an iconographic motif, the

bull has a long and distinguished history in Western imagery and myth. In antiquity, bulls represented the power and fertility of kings and for Picasso, who never missed a bullfight, the part-bull Minotaur of Minoan myth became a symbol of tyranny, as we saw in his *Guernica* (see figure 3.25). Here, however, Warhol has turned the motif into satire, for his bulls have become benign commodities, decorative, rather garishly colored multiples just as silkscreen itself is a medium of multiples.

Monotype

Monotype (literally "one type", or "one kind") is the only print technique that does not produce multiple impressions. Made by a relatively crude process, but one with experimental potential, monotypes are single, unique images. The artist applies printing ink to a metal plate with brushes and incises details with a sharp instrument. Paper is placed over the plate while the ink is still wet, and rubbed or run through a press to transfer the image.

Degas created a number of monotypes, the textures of which were suited to the Impressionist taste for visible brush marks. In the small-scale *Woman Leaving her Bath* (**figure 10.18**) of around 1876, Degas depicted a theme that occupied him for much of his career, namely, intimate scenes of female bathers. Often, as here, the woman assumes an awkward pose in order to maneuver in a cramped tub. Such poses appealed to Degas' interest in depicting forms moving through space. In this print, he has also created a variety of textures that range from solid black to solid white, with a wide range of in-between lights and darks.

The irony of Degas' image is that, although a servant holds up a towel to shield her eyes from her nude mistress, we are in the front of the scene and see the figure clearly. The action of the servant thus highlights the forbidden nature of invading the bather's privacy. Degas further eroticizes the picture by focusing the viewer on the nude through the sharp diagonal of the tub and the tilted floor. At the same time, the formal arrangement of the monotype creates the Impressionist cropped view that resembles an asymmetrical candid photograph. This also accentuates the sense that our gaze is intrusive and

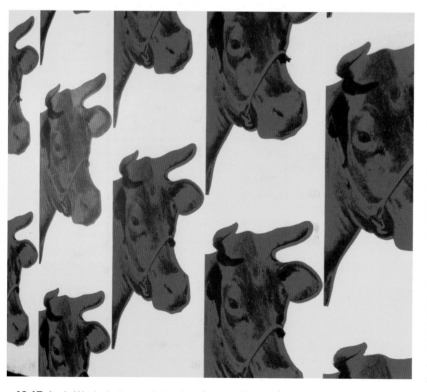

10.17 Andy Warhol, detail of *Cow Wallpaper*, 1966. Silkscreen print on canvas, 3 ft. 8 in. x 2 ft. 6 ¾ in. The Andy Warhol Foundation for the Visual Arts, Inc.

that we have caught the bather unawares, for neither she nor her maid seems to know that we are present. Degas announces his own presence as both artist and viewer in his prominent signature penciled over the white area of the chair in the foreground.

Offset Printing

The offset lithography printing process has made it possible to produce high-speed commercial prints in large quantities. In this process, the artist places the design on a metal plate (or, more rarely, on stone) and inks it. The image is then printed on a rubber-covered cylinder drum, from which it is transferred to paper. As a result, offset printing, like silkscreen, does not reverse the image. The use of the cylinder speeds up the process, which is used for many types of printing, in addition to reproducing works of art. Today, offset lithography is the leading method of commercial printing. In the United States, most books are printed using cylinder-based **web-fed machines**. They print on both sides of a large paper-roll sheet that is later cut into pages.

One of the best-known offset lithographs is the Bob Dylan poster (see figure 3.30) designed for Columbia Records by Milton Glaser.

Graphic Design

Two-dimensional graphic design refers to images intended to communicate messages to a wide audience. They do not have the value of unique works and are not generally considered to be fine art (although there are exceptions). Sometimes graphic design is in the form of a complete picture and sometimes it is in the form of a sign or symbol. Street signs, for example, are simple and abbreviated so they can be apprehended quickly by the average motorist. We would not want to stop our cars and read a full description or study a complex painting to figure out that a particular street goes in only one direction. Instead we are shown a one-way sign, a single arrow in a field of solid color. We might also see a red circle with a white horizontal rectangle, indicating that we are not allowed to enter the street from a particular direction.

We have seen in Chapter 5 that the color red can be associated with danger. Hence we have red Stop signs, and to indicate that something such as smoking, drinking, or parking is not allowed we might see a cigarette, a martini glass, or a red letter "P" inside a red circle with a red line drawn through it. All such signs have been created by graphic designers.

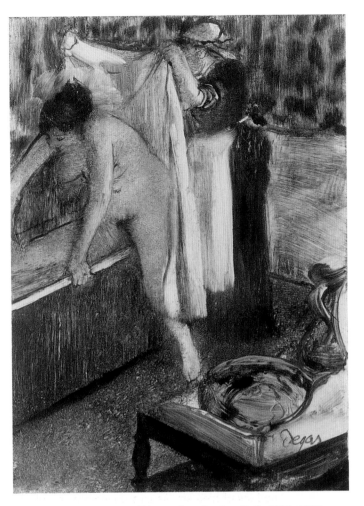

10.18 Edgar Degas, *Woman Leaving her Bath*, 1876–1877. Monotype in black ink on off-white wove paper, 10 x 6 ⅞ in. Bibliothèque Nationale, Paris.

Many graphic designs depend on the techniques described above, especially lithography and silkscreen. Printing is done in much greater quantities for graphic design, however, than for art prints because they are aimed at a larger audience and are much less expensive. Our contact with graphic design occurs on a daily, even hourly, basis. Advertisements, posters, menus, playing cards, book illustrations and covers, corporate logos, and web pages are all examples of graphic design.

The graphic designer has to come up with an image that will communicate a message as effectively and efficiently as possible, to as many people as possible. If text accompanies the design, then typeface comes into play. Think of the design of a book such as this one; the designer decides on a layout, which is the overall plan determining the appearance of the pages. A typeface also has to be selected. Imagine how different this page would look if the text were in all uppercase letters, or in italics, if the sentences began with lowercase letters, if there were no paragraph divisions, or if the text were arranged vertically instead of horizontally, or in three columns rather than two.

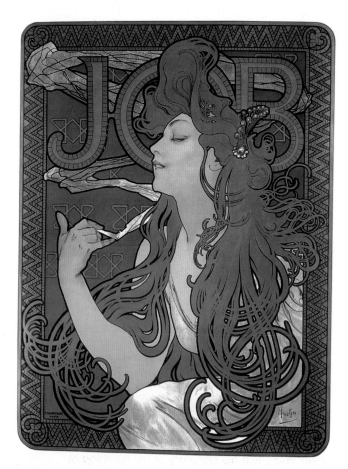

10.19 Alphonse Mucha, Poster for Job cigarettes, 1896. Private Collection, London.

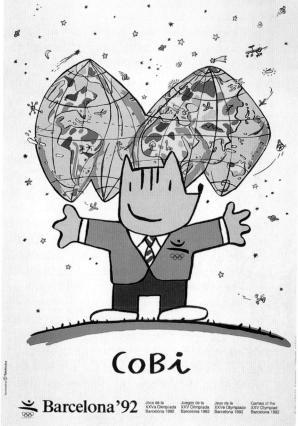

10.20 Javier Mariscal, Cobi poster for the XXVth Olympic Games in Barcelona, 1992.

Consider the Job cigarette poster of 1896 (**figure 10.19**). It was created by Alphonse Mucha (1860–1939), who painted theater sets in Vienna, and designed stamps and freestanding furniture screens in the flowing Art Nouveau style we saw in the Klimt *Music* poster (see figure 10.16). The elaborate, curvilinear hair of Mucha's smoker takes on a life of its own as its swirls mingle with those of the smoke rising from the cigarette and wafting behind the Job sign. The three uppercase letters are designed to match the green and brown colors of the frame, with the brown framing the green. The woman in front of the letters tilts her head back and closes her eyes, as if to suggest that smoking has transported her into a realm of drug-induced pleasure. Mucha's message is thus clear: smoking Job cigarettes produces a state of peaceful rapture.

Javier Mariscal's (b. 1950) Cobi poster (**figure 10.20**) is based on the figure of Cobi, who was the mascot for the 1992 Olympic Games in Barcelona,

Spain. A colorful cartoon character, who looks forward and sideways simultaneously, Cobi stands with outstretched arms, the Olympic logo on his jacket, and welcomes the world. What started as a national Greek event in 776 B.C., for which all wars on Greek soil were halted so that contestants could travel safely to the Games, has evolved into an international event. The worldwide appeal of the Olympic Games is shown by the maps behind Cobi's head. That the Games have universal significance is shown by the planets and stars in the sky. Mariscal also alludes to travel—no longer Greek chariots, but rather airplanes and other flying objects.

———◆———

In this chapter, we have briefly surveyed the wide variety of available printing techniques. We now turn to related media, such as photography, film, video, and digital processes, which also produce printable images.

MAKING

Milton Glaser on Printing

In an interview with Laurie Adams 27 July 2005

LA: Your artistic work has been prodigious. Is there a recent work that reflects your belief in the merger of aesthetic form and the ideas that form expresses?

Milton Glaser: There is my 2006 *Poster for the Tenth Anniversary of the Holocaust Museum* in Houston (**figure 10.22**). The museum, which is the fourth largest Holocaust museum in the United States, was founded in 1996. It houses a permanent exhibition of works related to the Holocaust, a library of more than 4,000 books and oral histories, a Garden of Hope in memory of the 1.5 million children who died in the Holocaust, and a family memorial room for meditation. The message of the museum, conveyed by the title of its permanent exhibit, is *Bearing Witness: A Community Remembers.* It bears witness to the more than six million Jews exterminated by the Nazis, along with homosexuals, Gypsies, and the mentally disturbed.

The most imposing part of the museum (**figure 10.21**) is the huge cylinder that rises from its angular, sloping core and is a metaphorical allusion to the ovens in the concentration camps of World War II. I wanted to create an image that would be a memorial, but would not be depressing. I wanted the image to transcend the subject matter without trivializing it.

In the Holocaust poster, I superimposed a tan grid over a light background of modulated rose, yellow, and pale blue. The spaces of the grid increase as they approach the center, which creates the illusion of a cylindrical form reminiscent of the museum's architecture. At the center, the colors behind the grid rise upward like a flame, referring to both the fires of the ovens and the sense of transcendent hope. I first had the idea of transforming the cylinder into a mourning candle, but rejected it as too gloomy.

Text is written across the horizontal lines of the grid. This comes from Viktor Frankl's famous account of his life, *Man's Search for Meaning* (published 1946), and his discovery of the meaning of life—while in a concentration camp. Frankl was born in 1905, in Vienna, where he became interested in psychology and psychoanalysis, went to medical school, and specialized in neurology. During World War II, he was arrested by the Nazis and spent three

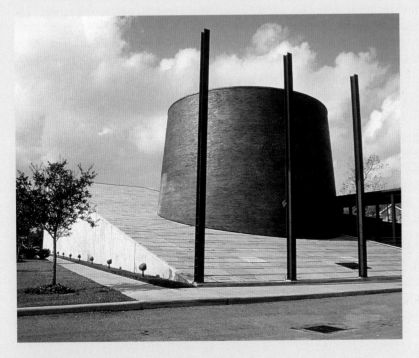

10.21 Holocaust Museum, 1996, Houston, Texas. © Scott Frances/ESTO.

Milton Glaser on Printing

years in four different camps, including Dachau and Auschwitz. Frankl discovered that, despite the degradation of his situation, he retained the most basic freedom of all—namely, the freedom to choose his personal response to the intolerable conditions imposed on him. That, for Frankl, was the transcendent source of spiritual freedom and of moral action. After the war, Frankl developed the clinical technique of logotherapy, the basic tenet of which is that the search for meaning is the driving force of human life.

Inspired by Frankl's views, I superimposed text from his book on the horizontals of my grid:

"One day, a few days after the liberation, I walked through the country past flowering meadows for miles and miles toward the market town near the camp. Larks rose to the sky and I could hear their joyous song. I called to the Lord from my prison and he answered me in the freedom of space."

The text is small in scale, which encourages viewers to approach the poster and read it. The design is fairly complex and layered, which demands visual (and spiritual) thinking as well as focused "looking." It functions on two levels, distant and up close—first you see it as form and color from a distance, and then up close you can read the text. I also wanted the poster to reflect the transcendent significance of Frankl's experience. The aesthetic of the work is thus inseparable from its formal and narrative message.

LA: Your Dylan poster (see figure 3.30) is an offset-lithograph. What technique did you use to create the Holocaust poster?

Milton Glaser: The Holocaust poster was computer-generated, which is relatively new in my work. It is nevertheless a principle of mine that no one under the age of forty should be allowed to use a computer. Many students today are not prepared to solve questions of form, because they have not studied the basic means of dealing with the formal elements of design. Contemporary design education is guided by employment opportunity—computers have replaced such fundamental skills as drawing and the knowledge of color. At the same time, the computer does have the capacity to create "accident and chance," but less so than working directly through one's hand. Computers can change one's mindset about design, because

you begin to think about what the computer is capable of—just as you do when using paint or charcoal. Both the advantage and the detriment of the computer is that it makes some things easier.

LA: How do you see your work in the history of art?

Milton Glaser: My ambition has been to discover how I could work within the framework of art to create commonalities. I agree with the assertion of the great art historian Ernst Gombrich that there is no ART, there are only artists. Artists are workers, a conviction of mine that is reflected in the title of my book *Art is Work*. The uncoupling of art and work causes mischief, because it preempts creativity from daily life.

I have been fascinated by a quotation from the Roman poet Horace, who wrote that the purpose of "art is to *inform* and delight." Delight, which is aesthetic, comes first and inform is not the same as *persuade*. Of course, if there is "not ART," then design is not art. There are, however, many artists hiding underground in the realm of design.

In our society, ART is used for social, religious, and economic purposes. Why, I sometimes wonder, do rich people like art, when in fact the impulse to make art is basic to the human condition? Great works of art change the world. We don't need a word for art. In many cultures, notably in Africa, there is no word for art, because it is such an integral part of the society. It is not conceived of as separate from the core of human life.

LA: Do you have a favorite artist?

Milton Glaser: I like all good art, whatever "good" means. My view on this is expressed in a poster I created for the School of Visual Arts in New York. It is entitled *Art is ... WHATEVER*. Inspired by iconography of Magritte (see figure 6.1), it shows a hat floating in space above the shadow of a man, wearing the same hat, shown from the shoulders up.

Historically speaking, Leonardo certainly stands out, but I also love the power of the paleolithic cave drawings and paintings and gracefulness of Japanese art. And my wife and I collect African art. My life in art is the story of my affinity with all of world art.

10.22 (Opposite) Milton Glaser, *Poster for the Tenth Anniversary of the Holocaust Museum*, 2006, Houston, Texas. © Milton Glaser.

MAKING

ONE DAY, A FEW DAYS AFTER THE LIBERATION, I WALKED THROUGH THE COUNTRY PAST FLOWERING MEADOWS,

FOR MILES AND MILES, TOWARD THE MARKET TOWN NEAR THE CAMP. LARKS ROSE TO THE SKY AND I COULD HEAR

THEIR JOYOUS SONG. THERE WAS NO ONE TO BE SEEN FOR MILES AROUND; THERE WAS NOTHING BUT WIDE EARTH

AND SKY AND THE LARK'S JUBILATION AND THE FREEDOM OF SPACE. I STOPPED, LOOKED AROUND, AND UP TO THE

SKY - AND THEN I WENT DOWN ON MY KNEES. AT THAT MOMENT THERE WAS VERY LITTLE I KNEW OF MYSELF OR OF

THE WORLD - I HAD BUT ONE SENTENCE IN MIND - ALWAYS THE SAME: "I CALLED TO THE LORD FROM MY NARROW

PRISON AND HE ANSWERED ME IN THE FREEDOM OF SPACE." HOW LONG I KNELT THERE AND REPEATED THIS

SENTENCE MEMORY CAN NO LONGER RECALL, BUT I KNOW THAT ON THAT DAY, IN THAT HOUR, MY NEW LIFE

STARTED. STEP FOR STEP I PROGRESSED, UNTIL I AGAIN BECAME A HUMAN BEING. THE WAY THAT LED FROM THE

ACUTE MENTAL TENSION OF THE LAST DAYS IN CAMP (FROM THAT WAR OF NERVES TO MENTAL PEACE) WAS

CERTAINLY NOT FREE FROM OBSTACLES. IT WOULD BE AN ERROR TO THINK THAT A LIBERATED PRISONER WAS NOT

IN NEED OF SPIRITUAL CARE ANY MORE. WE HAVE TO CONSIDER THAT A MAN WHO HAS BEEN UNDER SUCH

ENORMOUS MENTAL PRESSURE FOR SUCH A LONG TIME IS NATURALLY IN SOME DANGER AFTER HIS LIBERATION,

ESPECIALLY SINCE THE PRESSURE WAS RELEASED QUITE SUDDENLY. THIS DANGER (IN THE SENSE OF PSYCHOLOGICAL

HYGIENE) IS THE PSYCHOLOGICAL COUNTERPART OF THE BENDS. RIGHT TO DO WRONG, NOT EVEN IF WRONG HAS

BEEN DONE TO THEM. WE HAD TO STRIVE TO LEAD THEM BACK INTO THIS TRUTH, OR THE CONSEQUENCES WOULD

HAVE BEEN MUCH WORSE THAN THE LOSS OF A FEW THOUSAND STALKS OF OATS...BUT FOR EVERY ONE OF THE

LIBERATED PRISONERS, THE DAY COMES WHEN, LOOKING BACK ON HIS CAMP EXPERIENCES, HE CAN NO LONGER

UNDERSTAND HOW HE ENDURED IT ALL. AS THE DAY OF HIS LIBERATION EVENTUALLY CAME, WHEN EVERYTHING

SEEMED TO HIM LIKE A BEAUTIFUL DREAM, SO ALSO THE DAY COMES WHEN ALL HIS CAMP EXPERIENCES SEEM TO HIM

NOTHING BUT A NIGHTMARE. THE CROWNING EXPERIENCE OF ALL, FOR THE HOMECOMING MAN, IS THE WONDERFUL

FEELING THAT, AFTER ALL HE HAS SUFFERED, THERE IS NOTHING HE NEED FEAR ANY MORE - EXCEPT HIS GOD.

TEN YEARS: REMEMBRANCE. EDUCATION. HOPE. HOLOCAUST MUSEUM HOUSTON, EDUCATION CENTER AND MEMORIAL

Chapter 10 Glossary

aquatint—print taken from a metal plate on which certain areas have been "stopped out" to prevent the action of the acid

burin—metal instrument with a sharp point used to incise designs on pottery or metal plates

burr—in etching, a rough ridge left projecting above the surface of an engraved plate on which a design has been incised

cancellation print—print made after the plate has been destroyed or defaced by the artist

drypoint—engraving in which the image is incised directly onto the surface of a metal plate with a pointed instrument

edition—batch of prints, usually limited in number, made from a single plate

engraving—(a) process of incising an image on to a hard surface such as wood, stone, or a copper plate; (b) print made by such a process

etching—(a) printmaking process in which an impression is taken from a metal plate on which an image has been etched (or eaten away by acid); (b) print produced by such a process

graver—type of engraver's burin

intaglio—printmaking process (including engraving and etching) in which lines are incised into the surface of a plate

key block—one of a set of color-printing blocks that contains greater details than the others (also key plate)

linocut—print made from a design cut on a piece of linoleum

lithography—printing medium using a stone press on which areas are made receptive to ink

mezzotint—method of engraving in which parts of a roughened surface are burnished to produce an effect of light and shade

monotype—unique impression on paper from a design painted on a metal or glass surface

planographic process—printmaking technique (e.g. lithography and monotype) in which the image areas are level with the surface of the printing plate

plate—in printing, a smooth, flat surface (usually of metal) to which a design is to be applied by engraving or other means

press—apparatus or machine for transferring an image from one surface to another by compression

print—work or art produced by one of the printmaking processes—engraving, etching, and woodcut

putto (plural *putti*)—chubby male infant, often naked and winged, popular in Renaissance art

registration—bringing together of two or more images in color printing, animated films, etc., so that their positions match precisely

relief—in printmaking, a process in which the areas not to be printed are carved away, leaving the desired image raised

rocking instrument (or **rocker**)—instrument with a serrated edge used to roughen the surface of the plate

screenprinting (also **serigraphy**, **silkscreen**)—printmaking technique in which the image is transferred by forcing ink through a fine mesh of silk or other material

stencil—sheet of material (e.g. paper or fabric) that is perforated with lettering of a design and through which pigment (ink, paint) is forced on to a surface to be printed

transfer—(a) image produced by affixing to a support an image originally on another temporary support; (b) technique for transferring an image from one surface to another

web-fed machine—machine designed to print a continuous roll of paper

woodblock—technique in which images are carved on the surface of wooden blocks before being printed on paper

woodcut—relief printmaking process in which an image is carved on to the surface of a wooden block by cutting away the parts that are not to be printed

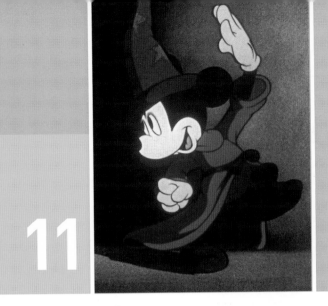

KEY TOPICS

Still photography
Motion pictures
Animation and special effects
Video and digital imagery

Still Photography, Film, Video, and Digital Imagery

Have you ever considered what life would be like without cameras, movies, televisions, home videos, or the images we see on our computers? None of those things existed before the nineteenth century. To a large extent, the images produced by these means are related to print technologies in so far as most can be made in multiples and are accessible to a much wider audience than unique works. One advantage of the photographic media is that they can record and reproduce unique works of art (as indeed they do in this book), although looking at a reproduction never measures up to the experience of seeing the real thing.

The power of a photograph resides largely in the impression that it is an instantaneous record of reality. We tend to believe in the truth of a photograph, whereas we are apt to conceive of a painting, mosaic, stained glass window, or other hand-crafted work as an artist's fiction.

The Post-Structuralist French philosopher Roland Barthes (see Chapter 7) echoed these sentiments when he described his astonishment at seeing a photograph of Napoleon's brother:

One day, quite some time ago, I happened on a photograph of Napoleon's youngest brother, Jerome, taken in 1852. And I realized then, with an amazement I have not been able to lessen since: "I am looking at eyes that looked at the Emperor."[1]

We recognize that paintings, drawings, and other works are interpretations by an artist, whereas with photographs we have the impression of "being there," in Barthes' words, as a witness to an actual event. And although this may not always be the case, because photography is also an interpretive art, we tend to persist in our conviction that a photograph records reality. In fact, however, photographers make formal choices depending on the messages they wish to convey, and they use the formal visual elements to do so.

In this chapter, we consider the development of photography, and offer a few examples of media that have evolved from photography, namely, motion pictures, video, and digital images. We begin with the still photograph.

Still Photography

Most of us are familiar with cameras, whether film cameras or digital cameras. The word *camera* means "room" in Latin and Italian, and *camera obscura* means "dark room." The small cameras we use in everyday life are essentially just that—portable dark rooms that we can carry around with us when we travel, celebrate family gatherings, record important events, and even create works of art. The word "photograph" literally means "light-writing," and refers to the technique of making pictures by manipulating darks and light (blacks, whites, and grays)—color was a later development.

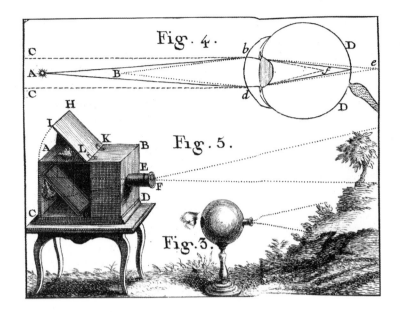

11.1 Engraving of an 18th-century *camera obscura*, from Abbé Nollet, *Leçons de physique expérimentale*, Paris 1755, vol. V, lesson xviii, p. 480. Bibliothèque Nationale, Paris.

Historical Development

The earliest known mention of using light as a way of creating images is by the fifth century B.C. Chinese philosopher Mo Ti. He is traditionally credited with observing that light passing through a small hole into a dark room inverts the image. In the fourth century B.C., the Greek philosopher Aristotle was watching a solar eclipse when he noticed that the crescent shape of the sun was reversed as it passed through spaces between the leaves and was reflected on the ground.

The idea of the *camera obscura* was known in the Middle Ages to Western and Arab scientists interested in astronomy. They observed that a circular hole in the wall of a dark room let in rays of sunlight that produced an upside-down image of the sun on the opposite wall. During the Renaissance, Leonardo, who wanted to replicate nature in his paintings, published the following description of the *camera obscura*:

> When the images of objects which are illuminated penetrate through a small hole into a very dark room, these images are received in the inside of the room on a white paper, situated some distance from the opening. You will see on the paper all these objects in their proper form and color. They will be reduced in size, they will present themselves in a reversed position, owing to the intersection of the rays…[2]

The next step consisted of placing a glass lens over the hole, which clarified the projected image and recorded nature more accurately. Multiple lenses introduced focal length and made it possible to control the size of an image, and therefore also the size of the room (the *camera*). By the seventeenth century, the *camera obscura* became a box rather than an entire room, and this box was the ancestor of the modern camera (**figure 11.1**). Artists such as Vermeer (see p. 28) are thought by some scholars to have used the *camera obscura* to achieve their unique light effects. By the nineteenth century, artists frequently used cameras as an aid to portraiture.

The light box functioned in much the same way as a modern film camera. Today the opening (the **aperture**) contains a glass **lens**, which admits light onto light-sensitive film (originally a glass plate) that holds the image. By adjusting the aperture, we control the amount of light entering the camera. This determines the **depth of field**, which is the area of sharpest focus (**figure 11.2**). The **shutter speed** (the amount of exposure time) determines how long the light-sensitive surface is exposed to light.

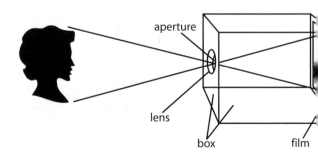

11.2 Diagram of a camera showing the lens, aperture, box, and position of the film.

Before the nineteenth century, there was no way to hold the image permanently. This was the next step in the evolution of photography and it required a knowledge of chemistry as well as of the physics of light. Photographs could be taken and the image imprinted on a glass plate, but it faded after a time. One problem was thus how to preserve (or fix) the image so that it would last. In the early nineteenth century, especially in France and England, a number of inventors began to research the problem of fixing photographic images.

In around 1826 the French photographer Joseph-Nicéphore Niepce (1765–1833) exposed a light-sensitive metal plate to light for eight hours and produced a blurred image of the view from his window. He was able to fix the image, but the exposure time needed to be drastically shortened. Another step was achieved by Louis Jacques Mandé Daguerre (1789–1851), when he placed a coated copper plate in the camera and then submerged it in a chemical bath. This fixed the image permanently.

Daguerre's pictures, called **daguerreotypes**, had a number of drawbacks. For one thing, they were unique, and for another they were reversed and often obscured by a glare. The daguerreotype in **figure 11.3** reflects the nineteenth-century interest in collecting and classifying natural objects. Recording nature and classifying natural forms was thus one of the earliest scientific uses of photography. Daguerre's picture also has a certain aesthetic quality created by the shapes and textures of the shells and fossils.

Photographic techniques further improved with the invention of negative film by the English scientist Henry Fox Talbot (1800–1879). Because the negative reversed the image, it could be printed on paper and re-reversed back to its original orientation. From then on, advances in still photography were rapid and many types of images became possible, although color photography had to wait until the twentieth century. In 1907, the positive color transparency was invented and in 1932 Eastman Kodak made color film for commercial purposes. By 1936, with the development of Kodachrome, color film was available for general use. Today, many pictures are taken with digital cameras, in which light-sensitive sensors turn the image into pixels stored as a binary digital file on the camera's memory card.

One interesting process for printing photographs that was developed in England in 1842 is the **cyanotype**. This involved coating a sheet of paper with ferric ammonium citrate and potassium ferricyanide and leaving it to dry in the dark. An object (or a negative) is then placed on the sheet and exposed to sunlight. After some minutes in the sun, the object (or negative) is removed and the paper is bathed in water. This turns the paper blue (cyan—hence the term "cyanotype") and the area covered by the object or the darkened sections of the negative remains white.

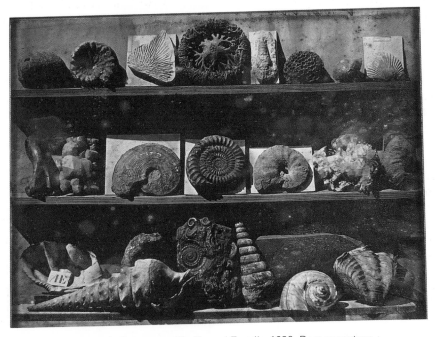

11.3 Louis Daguerre, *Shells and Fossils*, 1839. Daguerreotype. Musée des arts et métiers—CNAM, Paris.

11.4 Anna Atkins, *Halydrys Siliquosa*, plate 19, from *Photographs of British Algae*, 1840s. Cyanotype, 4 ¹⁵/₁₆ x 4 in. British Library, London.

An example of a cyanotype using an object can be seen in **figure 11.4** by Anna Atkins (1799–1871). This, like Daguerre's *Shells and Fossils*, illustrates the early use of photography by natural scientists. At the same time, however, Atkins captured the delicate elegance of the alga, arranged so that the organic forms expand gracefully from the stem and animate the picture space. In some areas, the sun has penetrated the thin texture of the alga, creating different shades of blue within the plant forms.

The aesthetic quality of this cyanotype raises a question that vexed artists, critics, and the general public in the nineteenth century, especially in France. Today we accept that photography is an art form, but this was not always the case. In the nineteenth century, arguments raged over whether photography was art or merely a form of mechanical reproduction. Discussions became quite heated and for a time public exhibitions, which were controlled by official juries, excluded photography from being shown at the Salon (see Chapter 1). Photographs were relegated instead to scientific and industrial spaces.

By the late nineteenth century, photography began to be accepted as a new art form with great potential for influencing, and being influenced by, new painting techniques. In addition to being an exciting new art medium, photography has served many purposes, including documentation, portraiture, and fine art.

One of the first to create artistic photographs was the French photographer Gaspard-Felix Tournachon, known as Nadar (1820–1910). During the 1850s, Nadar established himself in Paris as a portrait photographer interested in revealing the psychological depth of his sitters. One of his most famous series consisted of portraits of Pierrot, the character from the Italian *Commedia dell'Arte* and French theater that also attracted Seurat (see figure 8.11). In the first of the series (**figure 11.5**), Nadar shows Pierrot against a brown backdrop, removing a glass plate from a camera placed on a tripod. Pierrot wears a voluminous jacket with large buttons, baggy trousers, and a form-fitting cap. By accentuating the gestures, Nadar reminds viewers that Pierrot is a mime, here miming the role of a photographer. His gaze is downward and he points to the camera, whose lens functions as an eye, indicating that the camera and tripod are a metaphor for the clown-as-photographer.

11.5 Nadar and Adrien Tournachon, *Pierrot the Photographer*, 1854–1855. Gelatin-coated salted paper print, 10 ³/₄ x 7 ⁷/₈ in. Musée Carnivalet, Paris.

> Photography altered ways of seeing and thinking. Photographs were regarded as true, paintings as artificial. The painted picture was no longer credible; its representation froze into immobility, because it was not authentic but invented.
>
> Gerhard Richter, artist (b. 1932)

11.6 André-Adolphe Disdéri Cabanès, *carte de visite*, 1858. Collodion negative print. Bibliothèque Nationale, Paris.

Portraiture

Portraiture was an early use of photography. Traditionally, this genre had been reserved for rulers and other wealthy patrons who could afford to commission paintings and statues. Photography made portraiture less expensive and more accessible to the general public. Artists also painted from photographs of their sitters to reduce the time spent posing. Before telephones and email, polite social introductions were made in the form of a small visiting card (*carte de visite*), which included inexpensive photographs of the sender, along with his or her name, address, and a brief message (**figure 11.6**).

Gertrude Käsebier's (1862–1934) **photogravure** entitled *Indian Chief* of 1902 (**figure 11.7**) is a portrait, but it also alludes to a vanishing civilization. Trained as an artist, Käsebier used subtle light–dark transitions to create the noble structure of the sitter's face, the lively feathers of his headdress, and the cloak. There are areas of blurred form that impart a dreamlike quality to the portrait and suggest that the chief belongs to a fading culture. He stares straight ahead into an unseen distance, as if gazing on the former glory of Native American civilization. By using the visual elements of photography to portray the subject's character, Käsebier conveyed a social message while also producing a memorable work of art.

Photogravure was invented in 1876 to produce high-quality multiple editions. It is a complex and repetitive process combining photographic techniques with engraving. The artist begins by coating a tissue paper with gelatin and potassium bichromate, a combination that hardens in proportion to its exposure to light. The areas of gelatin corresponding to the light parts of the image harden,

11.7 Gertrude Käsebier, *Indian Chief*, 1902. Photogravure. In *Camera Notes*, July 1902, vol. 6, no. 1, p. 53.

while the unexposed parts of the gelatin dissolve. The gelatin side of the tissue is pressed onto a copper plate dusted with resinous powder, immersed in warm water, and the tissue backing peeled off. The plate is then dipped in a series of acid baths, which eat away at the copper. Where the gelatin is thick, the acid eats away the copper slowly; where the gelatin is thin or totally dissolved, the acid works faster. The end result is a plate etched to different depths that, when inked and run through an intaglio press, produces a photograph with tonal variations corresponding to the original image.

If we compare Charles I. Berg's (1856–1926) *Coquette* (**figure 11.8**) photogravure with the *Indian Chief*, we can see how two photographs made with the same process convey very different messages,

11.8 Charles I. Berg, *Coquette*. Photogravure. In *Camera Notes*, April 1898 vol. 1, no. 4, p. 90.

depending on how the visual elements are used. The relative clarity of the coquette's gaze, which is directed at the viewer, places her very much in the present. Although there is some blurring, it is relegated to the background. The figure's illuminated flesh, the tilt of her head and hat, her parted lips, and seductive eye combine to create the character of a coquette. In contrast to the nobility of Käsebier's *Indian Chief* and the implication that he stands for a dying but proud civilization, Berg's coquette flirts with the viewer and offers herself as an erotic object.

Read in terms of narrative tense, the *Indian Chief* alludes to the past, whereas the coquette communicates directly with the viewer in the present and offers a promise of future pleasure. We might also say that the upright stance of the Indian is a sign of moral uprightness and noble character. The undependable nature of the coquette, in contrast, is signified by the formal instability of the diagonals, so that the shifting planes of the hat and head signal the elusive and unreliable personality of a sexual tease.

The major journal of photography in the United States from 1897 to 1903 was *Camera Notes*. The editor of most of the issues was the German-born Alfred Stieglitz (1864–1946), a seminal figure in promoting the avant-garde in America. He opened an art gallery at 291 Fifth Avenue in New York to introduce modern European art to American viewers and to encourage modern art in America.

Stieglitz was himself a prominent photographer, known for so-called **straight photography**, meaning that he printed his pictures directly from the negative without cropping or other forms of manipulation in the developing process. One of his main subjects was New York City. For Stieglitz, photography was art, and he was horrified by attempts to make the medium a commercial endeavor. He objected to George Eastman's commercialization of the Kodak box camera, which originally sold for one dollar. Stieglitz's views are reflected in the following statement, in which he referred to Eastman's box camera:

… an instrument had been put on the market … called the "Kodak" and … the slogan sent out to advertisers read "You press the button and we do the rest." The idea sickened me. There was the shooting away at random, taking the chance of getting something. To me it seemed rotten sportsmanship.[3]

Recording the City

From the nineteenth century, the character of different cities began appealing to photographers. New York was Stieglitz's city of choice. He responded to New York as a center of the avant-garde, energized by a dynamic commitment to modernism. Sometimes, as in *From the Shelton* (**figure 11.9**), Stieglitz's New York photographs are devoid of people: the focus is on the visual arrangement of urban forms. In this case, the absence of people also evokes their presence as occupants of the buildings. What we see is a view from the Shelton Hotel, where Stieglitz lived, showing the city as a ghost town composed of geometric (mainly rectangular) structures varied by an occasional round window or church spire. Large areas of black seem to envelop the structures, as if an ominous shadow is engulfing them. In the distance, the tall, illuminated skyscrapers echo the vertical church spires, imparting a sense of spiritual aspiration to the scene.

The city of Paris has also inspired a wealth of photographic images documenting its famous monuments, its people, store windows, interiors, parks,

11.10 Eugène Atget, *Notre Dame, Quai de Montebello (5e Arrondissement)*, 1922. Gelatin silver print.

fountains, fairs, ancient squares, and narrow streets. One of the most profound photographers of Paris, Eugène Atget (1857–1927), created perhaps the greatest visual biography of the city from 1897 until his death.

Atget's view of Notre Dame (**figure 11.10**), the Gothic cathedral located on the Ile de la Cité in the River Seine, has become an icon of Paris. Shot from the Quai de Montebello, the famed cathedral stands as a soaring testament to thirteenth-century Paris. Its muted tones and complex architectural features are in sharp contrast to the strongly silhouetted foreground trees, one of which leans to the right and directs our gaze across the river to the cathedral. At the same time, the receding cobblestoned quai, stone wall, and river create a counter-movement into a distant, fading light. Clearly, Atget did not "press a button" and allow the camera "to do the rest" as the Kodak advertisement asserted. He carefully arranged a viewpoint, adjusted the depth of field, and created an impressive visual arrangement designed to convey meaning.

11.9 Alfred Stieglitz, *From the Shelton*, 1933–1935. Gelatin silver print. The J. Paul Getty Museum, Los Angeles.

Landscape

Photographers, like painters, have always been inspired by the natural landscape. We can see two very different approaches to landscape photography by comparing Ansel Adams' (1902–1984) *Sand Dunes, White Sands National Monument, New Mexico* (**figure 11.11**) of around 1942 with William Eggleston's (b. 1939) *Black Bayou Plantation, Near Glendora, Mississippi* of 1971 (**figure 11.12**). Adams' black and white landscape is an abstract pattern of rippling sands rising diagonally toward a solid black biomorphic shape that points toward the soft, muted clouds. The absence of people, animals, and vegetation creates the impression that the image is timeless, removed from an identifiable context, and composed of pure form. When describing his pictures of the Southwest, which inspired many of his greatest images, Adams declared:

> … something filtered through may heart as well as my mind and eye. My Southwestern experience has been more or less continuous; the images are arranged for the flow of meaning rather than of location and time.[4]

In contrast to the black and white abstraction of Adams' *Sand Dunes*, Eggleston's conception of landscape creates an illusion of reality enhanced by color. In *Black Bayou Plantation*, he captures a deceptively casual area of brown earth strewn with empty plastic containers and an open cardboard box. As in Adams' *Sand Dunes*, there are no people in Eggleston's photograph, but their presence is implied in the debris they leave behind. Formally, the white containers echo the white clouds, juxtaposing pure nature with traces of humanity.

Both Adams and Eggleston have had a major influence on American photography. Although Adams' imagery records the American landscape, especially the Southwest, it can have an otherworldly appearance, as is the case with *Sand Dunes*. With Eggleston, in contrast, we have the impression of precision and exactitude. In a landscape by Adams, there tends to be a sense of shifting motion, change and potential change, even visual metaphor. Eggleston leads us to believe in a static permanence, reinforced by his emphasis on clearly defined objects.

11.11 (Left) Ansel Adams, *Sand Dunes, White Sands National Monument, New Mexico*, c. 1942. Gelatin silver print. Ansel Adams Publishing Rights Trust.

11.12 William Eggleston, *Black Bayou Plantation, Near Glendora, Mississippi*, 1971.
© 2006 Eggleston Artistic Trust, courtesy Cheim & Read, New York. Used with permission. All rights reserved.

Photojournalism and Social Documentation

With the ability of photography to document current events, our view of the world expanded and our access to news increased rapidly. In some cases, the power of imagery made it possible for photographers to document social injustice and bring about change. During the American Civil War (1861–1865), for example, Mathew Brady became one of the most important early war photographers. With assistants covering military operations in different areas, Brady produced a visual history of the war that was fought to preserve the Union. He carried a camera and a portable darkroom tent through the battlefields, photographing the dead, the living, the officers, and enlisted men on both sides of the conflict.

Above all, Brady photographed the president and became known as "Mr. Lincoln's Camera Man" (**figure 11.13**). Here Brady shows a bearded Lincoln in his characteristic black suit, coat, and top hat at Sharpsburg. On the left is Pinkerton, head of the Secret Service, and on the right stands Major-General John A. McClernand. All appear against a backdrop of tents and trees, but Brady represented Lincoln formally as the mainstay of the war and the country. He does this by Lincoln's central placement and the stable vertical tent pole rising behind the president's hat and carrying our gaze upward through the sturdy tree trunk. At the same time, however, reflecting the enormous devastation of the war are the slightly downcast expressions and the slouched poses of the men.

When asked by a friend why he would undertake such a risky assignment as photographing the war, Brady replied: "I felt I had to go, a spirit in my feet said go, and I went."[5]

11.13 Mathew Brady, *President Lincoln at Sharpsburg, October 1862.*

Some eighty years later, World War II, like other twentieth-century wars, drew a number of courageous photographers determined to make their mark on visual history. The American Margaret Bourke-White (1904–1971) developed the **photo essay** by assembling sequences of photographs into a readable narrative. An intrepid war photographer and one of the first women in the field, she became a staff member of *Life Magazine* when it was founded in 1936.

At the end of World War II, photographers present at the liberation of the concentration camps felt compelled to record the evidence of one of the darkest moments in the history of Europe. Bourke-White's famous photograph entitled *The Living Dead*

> There is nothing else like the exhilaration of a new story boiling up. To me this was food and drink.
>
> Margaret Bourke-White, photographer (1904–1971), on photojournalism

of Büchenwald, April 1945 (**figure 11.14**). documented the emaciated survivors of the concentration camp at Büchenwald. She captured their dull stares, numbed by years of inhumane treatment, the systematic extermination of their friends and relatives, and the barbed wire still in place.

11.14 Margaret Bourke-White, *The Living Dead of Büchenwald, April 1945. Life Magazine*, 1945.

11.15 Dorothea Lange, *Migrant Mother*, 1936.

One purpose of photojournalism, in addition to visual reportage, is to shock viewers and promote political and social change. This was also a motive in the FSA (Farm Security Administration) under Franklin D. Roosevelt, which hired photographers during the Great Depression to document the poverty sweeping the United States. The photographs of Dorothea Lange (1895–1965) were calculated to evoke the viewer's empathy with the plight of the rural poor. A good example is the *Migrant Mother* (**figure 11.15**), who interested Lange as a paradigm of poverty rather than as a specific individual:

I saw and approached the hungry and desperate mother, as if drawn by a magnet … I did not ask her her name or her history….[6]

The mother is posed as a **close-up**, so that we clearly see her worried, pensive expression accentuated by the gesture of the right hand. She holds an infant across her lap, as two older children turn away from the camera. All are bedraggled, unkempt, and wearing fraying clothes. The maternal role associated with nourishment and support is called into question by this mother's inability to provide adequately for her family. The absence of a father reinforces the mother's predicament and conveys a message of helpless need that characterized a large proportion of American workers in the 1930s and early 1940s.

11.16 Andres Serrano, *Klansman (Imperial Wizard III)*, 1990. Cibachrome print, edition of 4: 5 ft. x 4 ft. 1 ¹/₂ in.; edition of 10: 3 ft. 4 in. x 32 ¹/₂ in. Courtesy Paula Cooper Gallery, New York.

The color **Cibachrome** photos of Andres Serrano (b. 1950) often arouse controversy. They have challenged the Catholic Church, and dealt with the homeless, issues involving AIDS and body fluids, and the Ku Klux Klan, in an effort to arouse an awareness of injustice and effect change. **Figure 11.16** shows a dramatic close-up of a klansman wearing a pointed green hood and cloak. He is faceless, except for the black eyeholes, threatening, and sinister, which forces the viewer to confront him directly. Nevertheless, Serrano claims that his attitude when doing the series was without bias, and that he felt the costumes both glorified and mystified the klansmen. Above all, he said, he was aiming for a direct relation between the photograph and the viewer.

I'm interested in bridging the gap between art and photography and its audience, eliminating a feeling of removal. I like raw and real images.

Andres Serrano, photographer (b. 1950)

11.17 Henri Cartier-Bresson, *Priests*, Castille, Spain, 1953.

The Decisive Moment

Henri Cartier-Bresson's (1908–2004) notion of the "decisive moment" is related to photojournalism. Having traveled widely as a photojournalist and studied film and painting, Bresson became interested in capturing moments of visual and psychological significance. He said:

> For me, the camera is a sketch book, an instrument of intuition and spontaneity, the master of the instant which—in visual terms—questions and decides simultaneously. In order to 'give meaning' to the world, one has to feel oneself involved in what one frames through the viewfinder....[7]

He did not experiment with darkroom techniques, but rather recorded "decisive" moments, which for him was the genius of the camera. Even though Cartier-Bresson's photographs stand on their own, they nevertheless imply a before and after. The pleasure they give to the viewer is the impression of immediacy and of truth, as well as of an implied narrative. We can see this, for example, in his photograph of a group of priests on an outing in Castille, Spain (**figure 11.17**). He has achieved an impression of spontaneity, but also leaves us in no doubt about his own involvement in what he framed through the viewfinder. In do doing, he engages us in the obvious pleasure visible in the faces of the priests, who otherwise lead an enclosed, meditative life. Although they walk together and are dressed identically, they breathe the open air and enjoy the expanse of landscape surrounding them. The sharp contrast of black and white in their outfits is somewhat muted in the patterned shadows on the road and is juxtaposed with softer textures of the background hills. There is thus implicit irony in this photograph, which resides in its series of oppositions.

Advertising and Fashion

The commercial advantages of photography were soon obvious to the business world. In the 1920s and 1930s, photography became an important asset to capitalism. Artistic photographers often worked in advertising to supplement their income. Some adopted modernist aesthetics and thereby enriched consumer culture. In 1928, for example, Edward Steichen (who, we remember from Chapter 1, purchased Brancusi's *Bird in Space*), photographed three Douglas Cigarette Lighters for an advertisement (**figure 11.18**).

In this image, three lighters are placed on a diagonal, simultaneously casting dark shadows and radiating bright light. They are encircled by a haloesque glow that makes them appear alluring, even spiritual and otherworldly. They stand firmly, insisting on their presence, and are decorated with elegant surface designs. The implication of this particular advertisement is that the aura of the lighters is somehow transmitted to the consumer, who thereby gains a certain desirable status.

One aspect of commercial photography with which we are all familiar is fashion. In the hands of Richard Avedon (1923–2004), who was also a well-known portrait photographer, advertising became art. He used dramatic, often exotic settings such as the Egyptian pyramids for his models. In August 1955, Avedon posed the model Dovima between two elephants (**figure 11.19**). She wears a Dior evening gown, juxtaposing her smooth white skin, tall, slim proportions, and dramatic gesture with the massive bulk and wrinkled hides of the elephants. By this unusual combination of form and texture, Avedon created a classic advertising image, imbued with striking aesthetic qualities.

11.18 Edward Steichen, *Douglas Cigarette Lighters*, 1928. Courtesy George Eastman House.
Bequest of Edward Steichen by direction of Joanna Steichen.
Reprinted with permission of Joanna Steichen.

11.19 Richard Avedon, *Dovima with Elephants*, 1955. Evening dress by Dior, Cirque d'Hiver. Avedon Foundation, New York.

New Approaches and Techniques

As with painters, major photographers strive for new approaches to their medium that advance style as well as technique. One of the most innovative twentieth-century photographers was the American Surrealist Man Ray (1890–1937). He moved from his native Philadelphia to Paris, where he worked in film and fashion. A member of the Dada movement that flourished between the two World Wars, Man Ray enjoyed verbal as well as visual punning and famously published two works: *Art is Not Photography* and *Photography is Not Art*.

One of Man Ray's technical inventions, the **rayograph**, was made in the darkroom by placing objects on light-sensitive paper and exposing them to the light of the enlarger. When the light penetrated the object, it created a muted texture; where the object blocked the light, the shape of the object remained in white. The area around the object turned black when placed in the developing solution. The resulting image, although taking the form of an actual object, often appeared abstract and mysterious. Such is the case with the rayograph illustrated in **figure 11.20**.

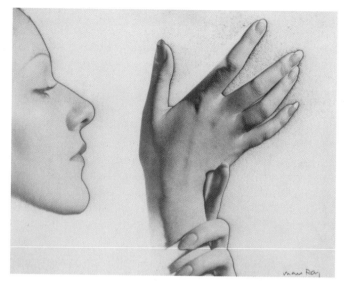

11.21 Man Ray, *Profile and Hands, Solarization/Sabattier Effect*, 1932. Gelatin silver print, 7 ¹/₁₆ x 9 in. J. Paul Getty Museum, Los Angeles.

In this case, the object, which is also the subject, is a roll of negative film that appears randomly spread out on the light-sensitive paper. On further inspection, however, we can see that Man Ray emphasized the circular shape—alluding both to the camera lens and the eye—and created a wide range of lights, darks, textures, and patterns by curling the film. In so doing he produced a photograph about photography, including in it some of the visual elements that enhance the potential subtleties of the medium and its techniques.

Another darkroom technique used to create unusual aesthetic effects is known as the **Sabattier effect**, first discovered in 1862. Named for its inventor, this procedure involved partially developing a negative in print, then briefly exposing it to light in the darkroom before finishing the development process. This has the effect of reversing the expected tones of a print. Today this is referred to as **solarization**, which darkens the normally light areas and often results in an eerily surreal image. Such is the case in Man Ray's *Profile and Hands, Solarization/Sabattier Effect* of 1932 (**figure 11.21**). Here, the brief exposure to light in an otherwise dark room produced an artificial black outline around the profile and hands, leaving the intervening spaces white, so that parts of the body appear oddly disconnected.

11.20 Man Ray, *Rayograph*, 1923.

"Bored housewife" is the theme of the feminist film still number 16 (**figure 11.22**), devised by the contemporary American photographer Cindy Sherman, whose *Untitled* we discussed in Chapter 7 (see figure 7.7). The still is one of a series begun in 1977. Inspired by B-movies, Sherman explores the roles of women in American society. Although Sherman used straightforward techniques, her relationship as an artist to her subject was new. In the film stills, she plays the starring role and challenges the expected roles of women in film and in society. The very notion of a film still as an independent photograph was a new conception; it suggests a before and after, so that the viewer reads the image as a moment frozen in time.

Here, Sherman is in the guise of a bored 1950s housewife, primly and passively smoking in front of a television set. Her plain surroundings, in which a chair is the only visible piece of furniture, accentuates her boredom and her detachment. She directs her attention not to the viewer, but to the unseen TV screen, and manipulates the channels with the remote control. In contrast to the neatly dressed man in the portrait on the wall, Sherman appears frumpy, as in *Untitled*, and her silver shoes seem at odds with the rest of her outfit. In addition, her static pose, varied only by the implied (and minimal) motion of changing channels and smoking, makes her seem more of an object than a person engaged with life.

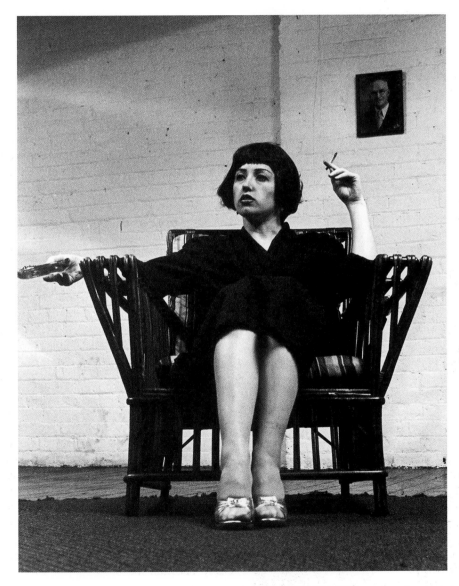

11.22 Cindy Sherman, *Untitled Film Still #16*, 1978.
Courtesy the artist and Metro Pictures Gallery, New York.

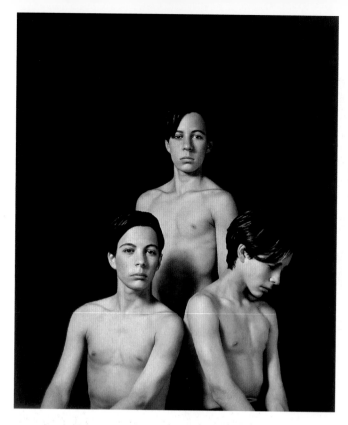

11.23 Keith Cottingham, *Untitled (Triple)*, 1993. Digitally constructed color photograph. Courtesy Ronald Feldman Fine Arts, New York.

The recent appeal of digital photography has led to new kinds of visual manipulation. Digital cameras now on the market do not use flexible film. An important advantage of digital photography is that it can be sent over the internet, altered in various ways, and printed like a traditional photograph. In place of light-sensitive silver salts, digital images are produced by **pixels**, which are small, light-sensitive squares that can transmit electrical signals determined by the intensity of received light. The pattern of squares—the grid—is then scanned, electronically stored, and can be reproduced on a screen, a print, or sheet of paper. Usually the pixel grid is not visible to the naked eye, creating the impression of a photographic image.

In the digital *Untitled (Triple)* of 1993 (**figure 11.23**), Keith Cottingham (b. 1965) creates a pyramid composed of three androgynous figures; their age and gender appear somewhat elusive. The boundary between reality and constructed identity is uncertain, with shadows revealing the unnatural appearance of the three figures. Their enigmatic expressions and the copper streaks in their hair accentuate their odd, surreal quality.

Still photographs have been used to create elaborate installations. In such cases, the images become part of a constructed environment that can be entered by the viewer. In Christian Boltanski's (b. 1944) *Monuments (The Children of Dijon)* of 1985 (**figure 11.24**), individual photographic portraits of children are memorialized by illuminating each image as if it were a religious icon. Enhancing this memorial iconography are the candles. Born a year before the end of World War II, Boltanski pays tribute to children who did not survive the Holocaust, while at the same time linking them and their fate by the wires connecting the lights and the pictures.

11.24 Christian Boltanski, *Monuments (The Children of Dijon)*, 1985. Installation. Marian Goodman Gallery, New York.

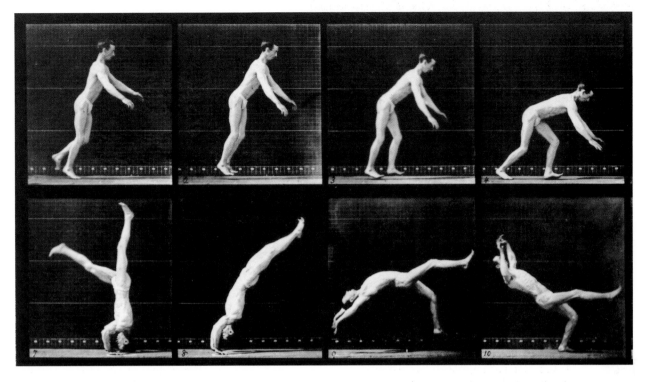

11.25 Eadweard Muybridge, *Motion Study*, 1877.

From Still Photography to Motion Pictures

Since the nineteenth century, photographers have been interested in making the transition from still photography to motion pictures (movies). As a prelude to cinema, photographers created multiple frames, each showing different stages of a single action. They photographed the flights of birds, galloping horses, people walking up and down stairs, and athletes in motion. One such motion study by Eadweard Muybridge (1830–1904) shows sequences of nude men in action (**figure 11.25**). As we read the frames from left to right, we have the impression of motion through time and space.

Another early approach to showing motion depicted multiple views of the same action within a single frame. In Harold Edgerton's (1903–1990) *Multiflash Backdive* (**figure 11.26**), for example, the swimmer is executing a back flip off a diving board. He himself is a blur of multiple images, but taken together they form an elegant spiral pattern. In contrast to Muybridge's nude men, we do not read *Multiflash Backdive* as a sequence of frames, but rather as stages of a single motion merged into one frame.

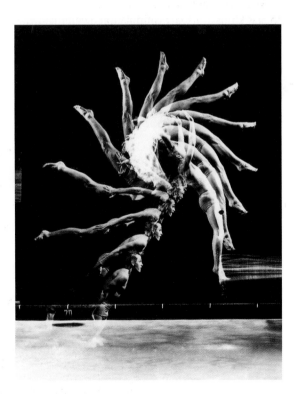

11.26 Harold Edgerton, *Multiflash Backdive*, undated.

Motion Pictures

As with still photography, we now take movies for granted, whether we watch them on big screens in theaters, on video, DVD, or on television. The history of movies developed as the result of many researchers and artists pursuing the potential of a new medium. There was a ready-made audience for film, which has become an enormous, worldwide industry, as well as a global form of communication.

Beginnings

COMPARE

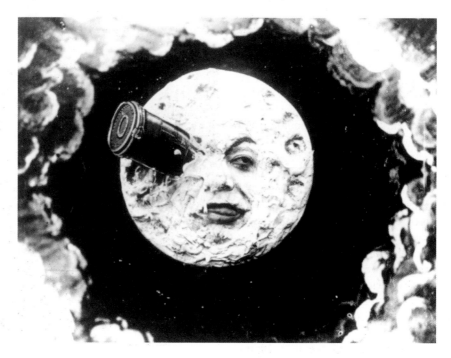

Edison and Dickson, *Fred Ott's Sneeze.*
figure 5.29, page 92

Film became a concrete possibility when people realized that flipping through pages of related pictures—so-called "flip-books"— produced the illusion of movement. Moving pictures evolved after George Eastman produced celluloid film; then a series of celluloid stills was run through a light and projected onto a surface (such as a wall or screen). These were the first "moving pictures." The earliest known example of such an experiment, which we saw in Chapter 5, was *Fred Ott's Sneeze.*

The technique that made it possible to project the film strip was devised by the French Lumière brothers in 1895. In 1902, Georges Méliès (1861–1938) produced a memorable fantasy film, *A Trip to the Moon*, creating an early **special effect** with the surreal image of a rocket ship landing in the eye of the man in the moon (**figure 11.27**). In addition to special effects, Méliès introduced fantasy and science fiction to film, and these have remained popular genres to the present day.

Once the basic principles of film technology had been achieved, a new art form was off and running. There is an enormous variety of cinematic styles, and moviemaking is a collaborative effort involving directors, producers, actors, camera-operators, sound technicians, editors, composers, continuity supervisors, and many assistants. Motion pictures, like still photography, serve many purposes—from the newsreels of the 1940s and 1950s to political propaganda, documentaries, fictional narratives, Westerns, musicals, science fiction, horror, romance, police and mystery stories, fantasy, comedy, animation, and more.

D.W. Griffith

In the early stages of the genre, movies were silent and dialogue was projected onto the screen between episodes. In 1914, D.W. Griffith (1875–1948) made America's first silent epic film, *Birth of a Nation*, which chronicles the fortunes of a Northern and a Southern family during the Civil War. Despite its transparent anti-black bias, the film was a technical masterpiece. Griffith experimented with different viewpoints: the close-up, the **fade-out**, the **pan** (in which the camera rotates in a broad sweep), and the **traveling shot** (in which the camera moves from the front to the back of a scene). By varing the direction and distance of the camera, Griffith conveyed a sense of expansive visibility, giving audiences the impression of witnessing a vast panorama and of being present at history in the making.

11.27 Georges Méliès, film still from *A Trip to the Moon*, 1902.

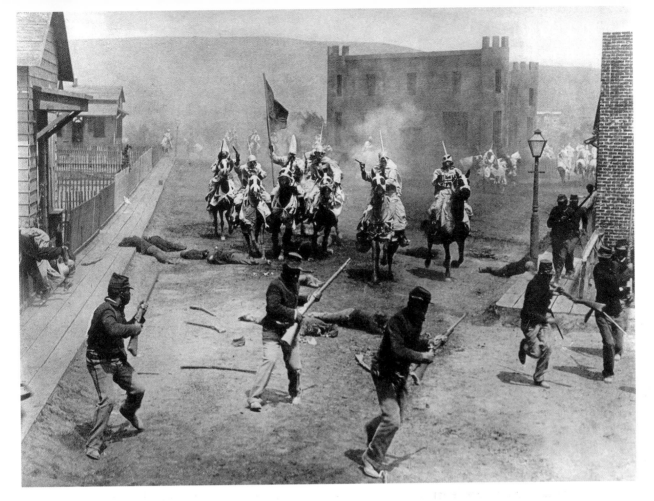

11.28 D.W. Griffith, film still from *Birth of a Nation*, 1914.

A Southern sympathizer and supporter of the Confederate cause, Griffith staged his scenes accordingly. The still in **figure 11.28** shows hooded members of the Ku Klux Klan riding like Christian Crusaders against black soldiers fleeing in disarray. Griffiths' political and racial bias, which considered black men a danger to white women, is clearly shown in this scene.

Charlie Chaplin

One of the greatest exponents of silent comedy was British-born Charlie Chaplin (1889–1977), whose persona of the Little Tramp, wearing a baggy, ill-fitting suit, embodied the down-trodden nice guy who triumphs in the end. A champion of social justice, Chaplin made many films documenting the dehumanizing effects of modern industry and the poverty of the Depression. In 1925, he made and starred in *The Gold Rush*, in which he plays a hopeful prospector in the Klondike. He occupies a small hut surrounded by snow. His roommate, Big Jim, is so hungry that he hallucinates that Chaplin is a chicken and chases him around the hut with a knife. Chaplin manages to escape, but in the film's most famous scene he dreams the dance of the rolls (**figure 11.29**). Having boiled his shoes and used the laces

for spaghetti, Chaplin created a sadly lyrical scene in which, although he is starving and living in abject poverty, he is formally dressed for dinner. In this still he stabs two rolls with forks and choreographs a poetic dance. At the end of the film, Chaplin strikes it rich and wins the girl.

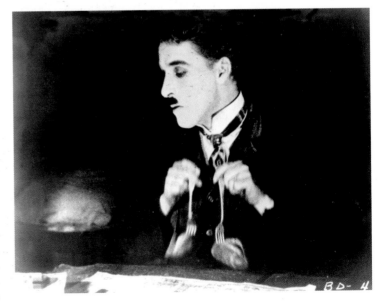

11.29 Charlie Chaplin, film still from *The Gold Rush*, 1925.

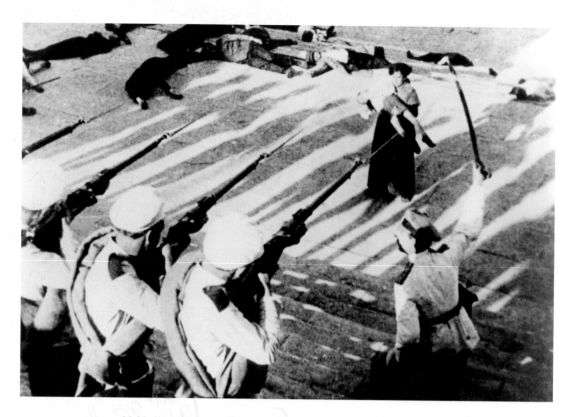

11.30 Sergei Eisenstein, film still from *Battleship Potemkin*, 1925.

Sergei Eisenstein

The greatest early twentieth-century filmmaker in Russia, Sergei Eisenstein (1898–1948), sympathized with the Bolshevik Revolution of 1917. In 1925, Eisenstein produced the silent classic *Battleship Potemkin* to commemorate Bloody Sunday—the aftermath of a mutiny and riots in Odessa (on the Black Sea).

The still in **figure 11.30** is staged to evoke sympathy with the dead at the bottom of the steps and with the mother carrying a wounded infant as she approaches the cossacks. Eisenstein intended this film as a political protest against centuries of brutality under the Russian czars. In this episode, we see the army in back view; they are an anonymous and deadly force aiming their guns at the helpless, unarmed mother. That they have already executed the scores of people lying dead on the steps tells us that the mother and her child are about to meet the

same fate. In fact, we can see that the officer at the right is giving the command to fire. Reinforcing the military force of the cossacks are the patterns of their repeated shadows on the illuminated pavement.

Eisenstein was not only a filmmaker of great power, he was also a theorist. He wrote two classic works on technique: *The Film Sense* in 1942 and *The Film Form* in 1948. He stressed the aesthetic effect of **montage**, by which he meant the significant juxtaposition of scenes for maximum effect. He pioneered the technique of synchronizing music with images to evoke feelings of terror, patriotism, victory, and defeat:

> In matching music with the sequence … general sensation is a decisive factor, for it is directly linked with the imagery perception of the music as well as of the pictures. This requires constant corrections and adjustments of the individual features to preserve the important general effect.[8]

The "Talkies" and Color

In 1927, sound was introduced into film and launched the era of the so-called "talkies." This changed movies in a number of ways, including ending the careers of silent screen stars whose voices were not suitable for sound. In 1941, Orson Welles (1915–1985) produced *Citizen Kane*, an unflattering portrayal of William Randolph Hearst and his media empire. Welles, who played the corrupt Kane, used a number of new techniques, including beginning the story with the death of the main character and making the rest of the film a **flashback**. He also used low-angle shots to emphasize the towering power of the media giant (**figure 11.31**). In this still, Kane extends his right hand in a gesture made by Roman generals when addressing their troops. He stands before a huge poster of himself, projecting a serious, pensive expression and his name in large, clear upper-case letters.

Color movies were developed in the 1930s. One of the best known is *Gone with the Wind*, the Civil War epic based on the novel by Margaret Mitchell and produced by David O. Selznick in 1939. Seven cameras were used to create the famous burning of Atlanta scene (**figure 11.32**). In this still, Rhett Butler and Scarlet O'Hara are dramatically silhouetted from the back against the reds, yellows, and oranges of the conflagration. By placing the hero and heroine in the foreground and elevating their viewpoint, the director evokes our identification with them for we see the destructive blaze through their eyes and can empathize with the loss of their civilization.

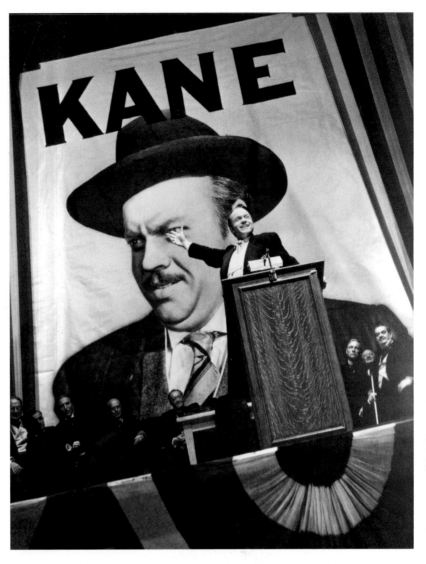

11.31 Orson Welles, film still from *Citizen Kane*, 1941.

11.32 David O. Selznick, film still from *Gone with the Wind*, 1939.

11.33 Ingmar Bergman, film still from *The Seventh Seal*, 1957.

Ingmar Bergman

As certain directors, such as Charlie Chaplin, Orson Welles, and others, became associated with particular styles of film, the term *auteur* (the French word for "author") was used to indicate their recognizable authorship. The Swedish director Ingmar Bergman (b. 1918) was a landmark *auteur* who achieved international acclaim with his 1957 production of *The Seventh Seal*. Set in the Middle Ages, the film tells the story of the hooded figure Death, who comes to claim a knight who has returned from the Crusades. In order to delay his death, the knight challenges Death to a game of chess. Among the many memorable elements in Bergman's film are scenes of the chess game, the moody atmosphere, and the dreamlike Dance of Death that was a staple of the medieval imagination (**figure 11.33**).

Alfred Hitchcock

The English-born Sir Alfred Hitchcock (1899–1980) was a master of camera techniques used to create psychological suspense. He surprised audiences by evoking terror, even when unwarranted, with sudden twists in the plot. In *Vertigo* (1958), for example, the

revolves around a former detective (played by James Stewart) who becomes obsessed with a woman (played by Kim Novak), who might or might not be involved in a murder. The detective, who has previously lost a case because of his fear of heights, finds himself having to overcome his phobia in order to solve a mystery. In **figure 11.34**, James Stewart is on top of a building, and the audience is unsure whether he is risking his life to rescue a heroine or to control a villain. Dramatically framed by the arched opening in the wall, Stewart gazes intently at Novak, as she echoes his own phobia by fearfully gazing downward, where a body has already fallen. Through this ambiguity of character and situation, Hitchcock maintained the suspense until the very end of the film.

11.34 Alfred Hitchcock, film still from *Vertigo*, 1958.

Animation and Special Effects

We have seen from George Méliès's *Man in the Moon* that special effects date to the early days of film. With improved technology, special effects have become more and more sophisticated. Today, the art of animation, pioneered by Walt Disney (1901–1961) in the 1920s, has evolved into an enormously successful international genre.

In the original animation technique rough sketches of each scene in the narrative were placed in a sequence on a **storyboard**. Then artists drew every stage of a movement onto a cel (a clear sheet of plastic). Each second of running time is typically equivalent to 24 drawings (frames).

The detail of Dopey from *Snow White and the Seven Dwarfs* (**figure 11.35**) shows the rich, flattened color typical of Disney animation. It also conveys the dopey quality of Dopey himself. He is so dazzled by the search for diamonds (the Dwarfs are diamond miners) that he sees the world through the crystalline facets of the stones, which multiply his eyes like mirrors and create a startling, rather eerie, impression.

In 1940, Disney produced *Fantasia*, in which he experimented further with special effects and animation. He created images of dinosaurs and the early history of the world and combined them with the story of the *Sorcerer's Apprentice*, in which Mickey Mouse, Disney's most memorable character, tries out his master's magic only to be overwhelmed by an army of broomsticks carrying buckets of water (**figures 11.36, 11.37**).

In figure 11.36 we see Mickey in the sorcerer's hat

11.36 Walt Disney, frame from *Fantasia*, 1940. © Disney Enterprises, Inc.

11.37 Walt Disney, frame from *Fantasia*, 1940. © Disney Enterprises, Inc.

enjoying his command over the obedient and helpful broomstick. But by the moment illustrated in figure 11.37 the broomstick has multiplied and some of them tower over Mickey. He has clearly lost control of the situation, his hat begins to droop and his open, optimistic gesture in the earlier frame has changed. He now tries in vain to hold back the onslaught of broomsticks he no longer controls. In *Fantasia*, Disney coordinated music with the film's visual elements and its mood. In one of the best-known scenes, Mickey shakes hands with the

11.35 Walt Disney, frame from *Snow White and the Seven Dwarfs*, 1937. © Disney Enterprises, Inc.

11.38 Peter Jackson, film still from *The Lord of the Rings*, 2001.

conductor Leopold Stokowski.

Special effects have become standard fare in contemporary movies through the use of industrial lighting, computers, and other modern digital techniques. The immensely popular trilogy *The Lord of the Rings* (2001), based on J.R.R. Tolkien's novels and directed by the New Zealander Peter Jackson, won eleven Academy Awards. Computer-generated special effects were used to create the creepy subhuman character of Gollum, the Ents (trees) that joined the forces of good, the Orcs (who embody evil), the pointy-eared elves, and the epic battle scenes. **Figure 11.38** shows the good wizard Gandalf. His impressive white beard, tall pointed hat, and the sword carried by the horse, evoke medieval tales of King Arthur and Merlin the Magician, who have traditionally exemplified the forces of good triumphing over evil. Gandalf's association with good is shown by his venerable age as well as by the use of bright color—the cheerful blue hat, rich green foliage, and glowing sunlight reflected in the yellows and reds on the horse. At the same time, Gandalf's penetrating, focused gaze and serious expression reveal his concern for the future and his knowledge of the continuing presence of evil.

Video

Video (a Latin word meaning "I see") is a relatively recent artistic medium. It began with television, which literally means "distant" (from the Greek word *tele*) and "vision," because the images can be electronically transmitted from great distances. Television, like the worldwide web, has the advantage of making information instantly available to a mass audience. By the 1950s, many American homes had television sets (first in black and white, and later in color), and today homes, banks, elevators, bars, and airports around the world are equipped with television.

From the 1960s, the Korean-born artist Nam June Paik (1932–2006) began using television monitors as an expressive medium—ranging from individual sculptures to vast installations. Recognizing the future of television as an art medium, he asked the following questions about a work called *A New Design for TV Chair*:

> DO YOU KNOW…? How soon TV-Chair will be available in most museums? How soon artists will have their own TV channels? How soon wall-to-wall TV for video art will be installed in most homes?[9]

Although the video image itself is two-dimensional, the medium is often used in three-dimensional installation spaces. To the degree that videos are moving pictures, they, like films, incorporate the element of time.

In 1988, Paik installed a tower composed of television monitors to celebrate the 1988 Olympic Games and the opening of the Tadaikson Tower for the National Museum of Modern Art, in Seoul (**figure 11.39**). A circular, elegant, zigguratlike structure made of steel, Paik's tower is a dramatic display of over a thousand framed, colorful moving images of Korean dance that animate the interior of the Tadaikson tower. The images are accompanied by sound, which creates an art environment and invites the viewer to circle the monument, which has no beginning or end. As such, it evokes the universality of the circular shape that has appealed to artists since the Stone Age. It is also, more specifically, a tribute to Korean culture.

11.39 Nam June Paik, *The More the Better*, 1988. Three-channel video installation with 1,003 monitors and steel structure, color, sound, approx. 60 ft. high. National Museum of Modern Art, Seoul, Korea.

> Video art imitates nature, not in its appearance or mass, but in its intimate "time-structure" … which is the process of AGING …
>
> Nam June Paik, artist (1932–2006)

11.40 Joan Jonas, *Organic Honey's Visual Telepathy/Vertical Roll*, 1972/1994. Courtesy of the artist.

Another mixed-media artist who works with video is Joan Jonas (b. 1936). She integrates film and video into performances, in which she herself is often a participant. Her *Organic Honey's Visual Telepathy/Vertical Roll* (**figure 11.40**) takes place in a broad interior space. The main "character" is the mannequin Organic Honey (the artist's alter ego). She wears an embroidered shift and an elaborate, feathered headdress, and the room itself reflects the changing images of Organic Honey's imagination. It is thus a kind of dreamed installation, filled with symbolic elements, whose meaning is continually in flux. In a 1995 interview, Jonas said the following about her relationship to sculpture and installation space:

I gave up making sculpture and I walked into the space … What attracted me to performance was the possibility of mixing sound, movement, image, all the different elements to make a complex statement. What I wasn't good at was making a single, simple statement—like a sculpture.[10]

— ◆ —

The mixed-media installations to which video lends itself carry over into other artistic categories, as we shall see in Part V. We now turn to sculpture, architecture, and crafts. These are primarily three-dimensional media, although today the arts, like the world itself, are beginning to challenge traditional boundaries of form and definition.

LOOK

The Sleep of Reason—Viola and Goya

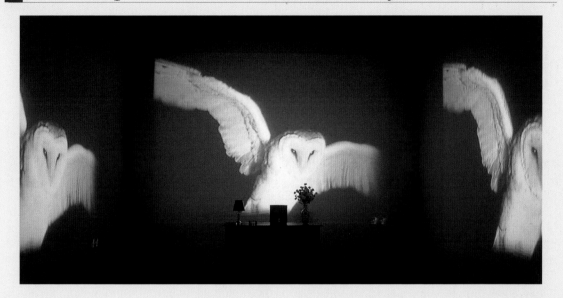

In 1988, a leading video artist, Bill Viola (b. 1951), created *The Sleep of Reason* (**figure 11.41**). This installation consisted of an empty room furnished with a black-and-white television monitor projecting images and sounds of sleep. A vase of white roses stood to the right of the monitor and a small lamp to the left. When the light in the room was extinguished at random times, roaring sounds could be heard and television images were reflected against the walls of the room. Some of the images showed frightening scenes such as burning buildings, attack dogs, x-rays, and a white owl with outspread wings flying toward the light.

The title and the owls are the key to the meaning of Viola's video installation. They allude to Goya's well-known etching of 1799, *The Sleep of Reason Produces Monsters* (**figure 11.42**). In Goya's image, a sleeping figure dreams of bats, owls, and a staring feline. The message, which is both political and psychological, is that when reason sleeps, the irrational mind takes over, here in the form of frightening, nocturnal animals. Inspired by a similar idea, Viola transformed the message using modern video media. He set a stage, the room, and transformed the viewer into the sleeper who experiences the loss of reason. That Viola recognizes the unconscious meaning of his image is clear from the following statement:

> My work is centered on a process of personal discovery and realization. Video is a part of my body; it's intuitive and unconscious.[11]

11.41 (Above) Bill Viola, *The Sleep of Reason*, 1988. Video/sound installation. The Carnegie Museum of Art, Pittsburgh, Pennsylvania. © Bill Viola.

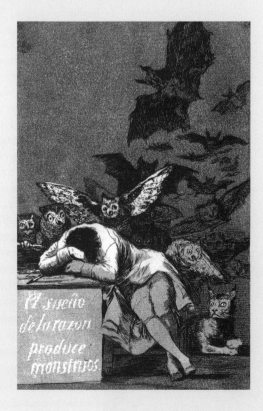

11.42 Francisco José de Goya, *The Sleep of Reason Produces Monsters* (*Los Caprichos*, plate 43), 1799. Etching. Metropolitan Museum of Art, New York. Gift of M. Knoedler and Co. 1918, 18.64(43).

MAKING

Tracey Moffatt on Photography

Tracey Moffatt's artistic practice is divided between film making and photography. Her staged photographs have earned her comparisons with artists such as Cindy Sherman, although much of her work could be said to reflect her concern with her Aboriginal ancestry and the representation of her people in art and the media. Moffatt shies away from neither controversy nor tough subject matter and her work often concerns issues of race, gender, and domestic violence.

It is perhaps unsurprising to learn that Moffatt is less concerned with the technical side of photography—the lighting, lens and focus, and more interested in what she is actually shooting. She confesses: "Technically, I'm quite stupid. I hardly know how to use a camera. I often use technicians when I make my pictures. I more or less direct them. I stand back and call the shots."

The staged photograph with its implicit narrative is a constant of Moffatt's career. One of the most well known of the many series she has produced is *Scarred for Life*. She produced the first version in 1994 and revisited the theme in 1999. Moffatt explains: "I made the *Scarred for Life* series, which is a series of images about tragic, funny tales of childhood—all true stories, by the way, told to me by friends—the images are just so ordinary, and the artwork itself doesn't even look like art. It looks like pages in a magazine.

It became such a smash hit. I couldn't understand why, but I think it's because everyone has a tragic tale to tell. And over the years people have come up to me. They couldn't wait to tell me their tragic story. I thought I could make another series of this work and it could be an ongoing project. In *Scarred for Life* there's something straight forward and snapshot-ish about the work, it had to feel ordinary, everyday, because that's how incidents happen in our lives."

The photographs are all set in the past (from the late 1950s to the 1980s), and if it was not for the disturbing nature of the subject matter and the telling captions that accompany them, they could be drawn from a family album. One of the most striking images from the first series is "Mother's Day—1975," which depicts a young girl, reeling, as she turns away her face from the camera (**figure 11.43**). The shot is blurred as if the subject has moved too suddenly for the camera, and this explanation is supported by the caption which reads: "On Mother's Day as the family watched, she copped a backhander from her mother." The lack of focus reinforces the shocking suddenness of the "mother's" brutal treatment of "her" child and lends a reality to what is in fact a performance.

Quotations from an interview with Michael Cathcart on Australian National Radio, 9 January 2001.

11.43 Tracey Moffatt, "Mother's Day—1975" from *Scarred for Life*, 1994. Offset print, from a series of nine images. 24 x 31 in. © Tracey Moffatt. Courtesy of the artist and Victoria Miro Gallery, London.

Chapter 11 Glossary

aperture—the opening in a photographic lens that admits light

Cibachrome—a photographic process, developed in the 1960's, for making high-quality color prints

close-up—(a) a photograph taken at close range; (b) a scene in a movie in which action is focused on the facial expression of characters

cyanotype—a photographic print in white on a blue ground, often used for copying maps, architects' plans, etc. (also called a blueprint)

daguerreotypes—an early photograph produced on a light-sensitive metal plate

depth of field—the range of distances of an object from a camera which produces an acceptable degree of sharpness

fade-out—in cinematography, a reduction in visibility of an image to signal a conclusion or transition

flashback—a theatrical technique, often used in movies that involves the interruption of a chronological sequence by interjecting earlier events or scenes

lens—a lozenge-shaped piece of glass commonly used in an optical instrument (camera, microscope, etc.) to form an image by focusing rays of light

montage—a process of combining several distinct pictures to produce a blended composite picture

pan—(a) to rotate a movie camera so as to keep an object in the picture or to produce a panoramic effect; (b) a sequence of shots taken by means of panning

photo essay—a photographic narrative consisting of a series of related images

photogravure—a printing process in which an image is photographed through a screen on to a sensitized printing plate that after development is etched

pixels—in digital photography, a small light-sensitive square which transmits electronic signals based on the intensity of received light

rayograph—a photograph made without a negative by exposing objects to light on light-sensitive paper (a technique used by Man Ray)

Sabattier effect—the effect produced by exposing a partly developed negative to light

shutter speed—the amount of exposure time in taking a photograph

solarization—the exposure of a photograph to light during the developing process

special effect—in cinematography, a feature (often artificial or illusory) that is added to a film during its processing

storyboard—in cinematography, panel(s) to which is attached a series of rough drawings depicting the principal changes of scene or action in a story

straight photography—photography in which pictures are printed directly from the negatives with no cropping or other manipulation

traveling shot—in cinematography, a sequence in which the camera moves from front to back of a scene, or vice versa

Part V Three-Dimensional Media and Techniques

In the last few chapters we have considered two-dimensional works such as paintings, drawings, and prints. In this section, we turn to media and techniques used by artists who make three-dimensional works—that is, in addition to height and width, they have depth. The categories of three-dimensional works that we will discuss are craft, sculpture, and architecture. But we should note that the first of these is a rather fluid category, for some crafts are two- and some are three-dimensional. In certain cases, craft is both. Crafts are also traditionally made for utilitarian purposes.

It has been said that useful objects, such as utensils, furniture, clothing, and tools, are crafts, whereas objects made to be appreciated aesthetically are works of art. Although there is an element of truth in this view, it is not always the case. We know that a useful object can also be a work of art and that a beautiful object can be useful. Some people would say that beauty itself is useful and that beautiful objects serve an important purpose in our lives.

In our daily experience, we can see many examples of the fluidity of the categories we use to talk about craft and art. When we buy household objects or shop for clothes, we use aesthetic judgment (as well as cost considerations) in making our choices. When we enter a house, we notice its appearance; buildings are always useful, but only some are beautiful. A doll's house would generally be considered a craft, because it is not made for human habitation. But it is made for dolls, which are replicas of people, and dolls are used by children when they play. Similarly, a doll or a puppet in the shape of a human being is considered craft, but many other images of humans—especially large-scale statues made of bronze, marble, or wood—are in the category of art.

So where do we draw the line between art and craft? If you think back to the Brancusi trial (see Chapter 1), you may remember that his *Bird in Space* was considered a utilitarian object ("kitchen utensil or hospital supply") by the U.S. customs officer, a work of art by some of the witnesses, and nothing more than a good example of highly polished bronze by others. As you read through the next chapters, think about where you would draw the line, or even if you would draw a line at all.

Most people sense that there is a difference between art and craft, but the distinction can be difficult to pin down. Is it a matter of utility versus pure aesthetics? Of cultural viewpoint? Of size and scale? Of material? Of purpose? Of the training and talent of the artist? Many of the greatest artists have made works that we would usually categorize as crafts: Picasso made plates and vases, and Leonardo da Vinci made mechanical toys. Some contemporary artists intentionally combine categories in their work.

For the sake of convenience, we consider craft, sculpture, and architecture in separate chapters. Sculpture (Chapter 13) is generally defined as a three-dimensional work of art, and architecture (Chapter 14) as the organization of space for human use. We begin with a consideration of different types of craft.

(Opposite) Andy Goldsworthy, *Icicles*, January 12, 1987. Scaur Water, Dumfriesshire, Scotland. Image by Andy Goldsworthy.

KEY TOPICS
Art and craft
Clay
Ceramics
Wood and bamboo
Metal
Fiber
Glass

12

Craft

Craft has not always been considered a category separate from art, any more than art has always been thought of as distinct from utility. The term comes from the Old English word *craeft*, meaning "strength," and is distinct from the Old English word root of "art" (-ar) meaning "to put together." Linguistically, therefore, craft emphasizes physical effort and skill, whereas art has the quality of an idea, or concept, in which making something involves creating new combinations. The term "handicraft" tells us that a craft is a hand-generated skill and implies that it is less conceptual than so-called high art or fine art.

Complicating the issue is the fact that different cultures vary in the way they regard art and craft. In ancient Greece, the term used for creating objects was *techne*, from which the English word "technique" is derived. But the Greek philosopher Plato (427–347 B.C.) considered painters and sculptors of less value than craftsmen, on the grounds that a craftsman makes something useful, whereas an "artist" only makes replicas. Plato even wanted to have artists banished from his ideal state—the Republic.

Greek myth accorded great importance to the crafts gods—especially Hephaestos (Vulcan in Roman myth) and Athena (Minerva). Hephaestos was the blacksmith god of the forge; he made armor for gods and heroes, and taught people how to transform metals into utilitarian objects. Athena taught people the art of **weaving**. Because of their creativity, as well as the usefulness of the objects they created, these gods were credited with having "civilized" humanity.

In Western culture, the distinction between art and craft is first known to have become a major issue as the Middle Ages evolved into the Renaissance

(c. 1300–1600). Medieval sculptors, painters, and builders were considered artisans and craftsmen. Today we call the same painters and sculptors "artists," while we call the master-builders of medieval churches and cathedrals "architects."

During the Renaissance, when the notion of individual genius evolved, painters, sculptors, and builders wanted to elevate the intellectual status of their work as well as their own status in society. They believed that artists should be well-educated and wanted to be considered gentlemen. They eventually succeeded in their aims, although it took longer in some countries than in others.

The Arts and Crafts Movement

The "Arts and Crafts" Movement in nineteenth-century England rebelled against the effects of the Industrial Revolution and the mechanization of production. Led by the artist and social reformer William Morris (1834–1896), this movement advocated making well-designed, handcrafted utilitarian objects. Morris wanted to revive the pride in craftsmanship that he associated with the Middle Ages and early Renaissance. He considered a handicraft any product that could claim to be beautiful. In 1861, he founded Morris and Co. to pursue this idea, and other firms followed.

A good example of what Morris had in mind is the detail of wallpaper in **figure 12.1**. This exemplifies Morris's notion of the useful and the beautiful, for it functions practically as a wall-covering, but is also aesthetically pleasing. The curvilinear, organic forms and the dark green and yellow colors create an attractive,

12.1 William Morris, Pimpernel pattern wallpaper of 1876, sample printed c. 1934. 22 ½ in. wide. Victoria and Albert Museum, London.

object, it is necessary to fire (heat) it in a **kiln** (a kind of oven) at a certain temperature. Ceramics can be **glazed** by applying to the surface of the clay a silicate preparation (composed of silicon and metals) that fuses in the kiln. Glazing, which can be glossy, matte, opaque, or transparent, adds color and is partially resistant to penetration by liquids or acids. Before the development of modern synthetic clay, firing was harder to control and colors often changed in the kiln.

Another type of surface decoration used on ceramics is a **slip**, which is a combination of clay and water that can be colored with pigments.

Three main types of ceramics are **earthenware**, **stoneware**, and **porcelain**. Earthenware, which is porous, is made from kaolin (white china clay), crushed flint, and clay, and fired at relatively low temperatures. Stoneware is fired at high temperatures, is not porous, and is much sturdier than earthenware. Porcelain is made from kaolin and feldspar (also called china stone) and heated at temperatures as high as 1,350 degrees centigrade. It is the most costly type of ceramic and is typically translucent and white. Because this technique was first used in China, we continue to speak of "china" when discussing porcelain objects.

Ceramics is an ancient craft: thousands of years ago, people hollowed out clay to use for vessels or flattened it for plates. Some 6,000 years ago in the ancient Near East, the **potter's wheel** was invented, which increased the versatility of the technique (**figure 12.2**). The wheel is a flat disk attached to a flywheel manipulated by the potter's foot or, now, turned electrically. The potter places a lump of clay on the wheel, molding it into the desired shape as the wheel spins—a process referred to as "throwing a pot."

exuberant, lyrical design. As such, the wallpaper satisfied the principles of the Arts and Crafts Movement.

In this chapter, we shall see that while the examples we discuss have aesthetic quality, they too were often made with a particular practical purpose in mind. We group these examples by media—clay, wood, metal, fiber, and glass—although many challenge the strict boundary separating art from craft.

Clay

One of the most basic craft media is clay, a mineral composed of alumina and silica mixed with water. Clay is formed in the earth as igneous rock decomposes. It is soft enough to be molded and shaped by hand. When hardened, a work made of clay is called a **ceramic** and the person who makes the work is a **ceramicist**, or **ceramist**. In order to harden a clay

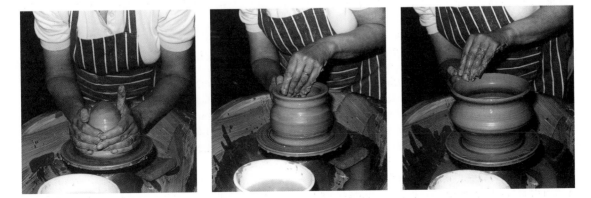

12.2 Three views of a potter throwing a pot.

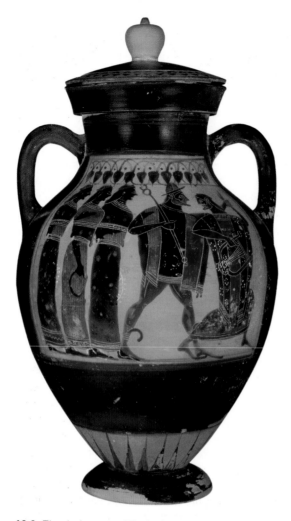

12.3 *The Judgment of Paris*, Attic black-figure amphora, c. 575–550 B.C. Terracotta, 18 in. high. Louvre, Paris.

But if you (potters) turn shameless and deceitful, then do I summon the ravagers of kilns, both Syntrips (Smasher) and Smaragos (Crasher) and Asbestos (Unquenchable) too, and Sabaktes (Shake-to-Pieces) and Omodamos (Conqueror of the Unbaked), who makes much trouble for this craft …[1]

*Kotyloi and kanastra are types of vessels.

The amphora shown here escaped the "ravagers of kilns," for it is well proportioned and symmetrical. It is also well painted, with its overall surface the same rich black as the figures participating in the narrative. The details of their dress, the foliate designs at the top of the scene, and the geometric design at the foot of the vase are clearly delineated.

Chinese porcelain ceramics were especially elegant during the Ming Dynasty (1368–1644). **True porcelain** is made of **hard-paste** and the high temperatures in which it is fired fuse the kaolin and feldspar into a glassy substance. In the early eighteenth century, this technique was imported into Europe. The Ming bowl in **figure 12.4** is typical of the animated blue-on-white design that originated in China had become popular in Europe by the seventeenth century.

The surface of the bowl is decorated with a lively floral pattern. At the foot, another smaller and more densely packed curvilinear design provides a visual base, whereas the outside of the rim is ringed by a geometric **meander pattern** consisting of verticals and horizontals. By combining framing devices with the expansive organic forms on the body, the designer has made the images on the bowl correspond formally to the shape of the bowl. In a similar manner, the potter who created the Greek amphora in figure 12.3 matched the shape of the painted scene to the contour of the pot.

One of the most prolific pottery-making cultures was ancient Greece. Greek potters used the potter's wheel and created specific types of pots out of **terracotta** (literally, "cooked earth") and painted them. Terracotta is red-brown in color and works made of terracotta are typically unglazed and fired at a low temperature.

In contrast to many ancient artists, the Greeks signed their pots, indicating whether they had made the pot, the painted decoration, or both. **Figure 12.3** shows a Greek **amphora** (two-handled storage jar) decorated with a scene from Greek mythology painted in black on a red ground.

An ancient Greek *Life of Homer* dated to the second or third century B.C. includes a poem, in which the potters ask Homer to trade a song for a group of vases. Homer obliges with the following verse:

If you will pay me for my song, O potters, then come, Athena, and hold thy hand above the kiln!
May the kotyloi and all the kanastra* turn a good black, may they be well fired and fetch the price asked,

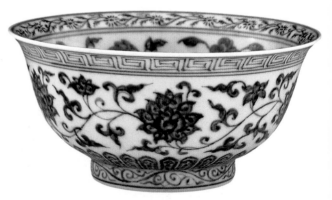

12.4 Ming bowl, imperial factory, Jingdezhen, 1426–1435. Porcelain, 3 1/8 high x 10 3/4 in. diameter. British Museum, London.

MAKING

Mary Roehm on Ceramics

Throughout her career, Mary Roehm has remained faithful to ceramics. Her work is clearly influenced by traditional celadon-glazed ceramics from East Asia. Her "signature pieces" are large, thrown bowls with small feet that appear poised between stability and flight: "It is the nature of the vessel to be drawn/defined from the inside out. I think of this as 3-D drawing and the visual tension that is created with a small but balanced foot enhances the visceral reaction between the form and viewer. It also speaks to the volume of the form in the line drawn. The bowl is a rich, generous form, strong, giving and a great reference for life." (**figure 12.5**)

Roehm's work owes much to Asian ceramics—both historically and in terms of its contemporary practitioners. She explains: "My travel to Asia confirms my own thinking about working with clay and its potential for (individual) expressiveness. In a larger sense, I am interested in the material as content and the history of porcelain which begins in Asia."

On the relationship between material and process, Roehm has the following to say: "The forms I make are particular to the clay. I have this uncanny ability to throw very thinly, any kind of clay, but it is most appropriate to porcelain. The translucency is innate, the way light is reflected is very revealing and does not tolerate overwork. I have a base porcelain that I use, grolleg/potash based, that I add lithium to for more 'color/drama' in the clay I make the bowls with. Lithium in different forms gives different colors of flashing in the wood-firing. Sometimes I add lithium carb or petalite.

"The clays are 'form' appropriate for me. I don't use a lot of glaze. When I do, I work with basic celadon and rely on the potash feldspar in both the clay and glaze to give me a pale blue celadon in a good reduction firing such as the woodfiring. When I woodfire, I fire in a catenary style woodkiln where the work is stacked up in the middle and on both sides, still within the arch/chamber, are the fire boxes. We fire for up to 20 hours. I am open to trying all clays and tend toward more primitive styles of firing where the results are a bit unpredictable."

Quotations from email exchanges with Mary Roehm

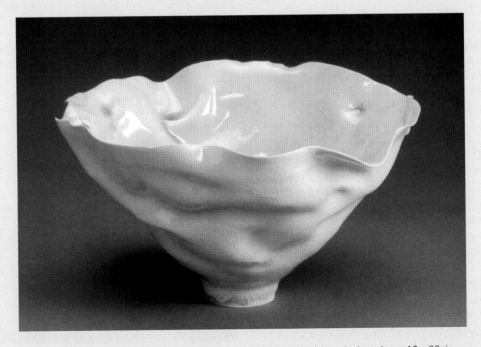

12.5 Mary Roehm, *Bowl*, 1999. Porcelain, woodfired, pale blue celadon glaze, 12 x 20 in. Courtesy of the artist.

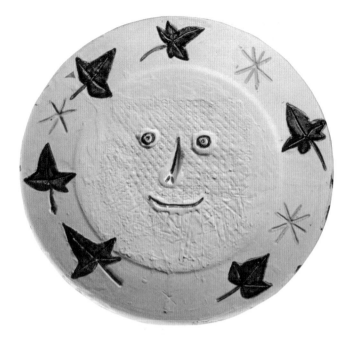

12.6 Pablo Picasso, *Face with Leaves*, 1956. Glazed ceramic plate, 16 ⅝ in. diameter. Private Collection.

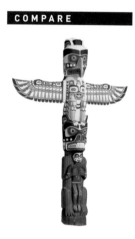

Kwakiutl, Totem Pole.
figure 3.11, page 43

The totem pole (see Chapter 3) is an example of wood carved into large, imposing animal shapes and painted. A more delicate style of carving can be seen in the Viking ships of the Early Middle Ages (seventh to tenth centuries) (**figure 12.7**). The Vikings inhabited Scandinavia (mainly Norway and Iceland) and made sturdy wooden warships (called knarr) that were, at the time, the most efficient in Europe. They served a political purpose because they reinforced the political power of the Vikings, who invaded Europe in the eighth and ninth centuries. In 1066, when the Normans (from northern France) invaded England, they used boats inspired by Viking ships (see figure 3.5). Besides being faster and lighter than other boats in the Early Middle Ages, the Viking ships had religious significance, for the dead were buried in boats and sent out to sea.

The Oseberg Ship in figure 12.7, which was part of a well-preserved royal burial (probably of a queen), was found in Norway. We can see from this detail that wooden ribs were attached to the hull with nails. Openings at the sides could be used for inserting oars, but were closed when sails were raised. The carved borders of the hull and the stem post (a replica of the lost original) shows the interlace patterns characteristic of the Early Middle Ages. The patterns are composed of organic and abstract forms that seem to be in a state of continual transformation. They extend to the spiral stem post and merge into the flattened face of a fantastic animal.

A rougher kind of ceramic can be seen in the plate by Picasso (**figure 12.6**) that reflects his artistic wit. After World War II, he bought a house at Vallauris in the south of France, just inland from the Mediterranean Sea. He set up a ceramics studio and lived at Vallauris for seven years, working among local artisans. In the plate shown here, Picasso has joined the idea of the circle with that of a human face in a way reminiscent of children's art. The rim is decorated with blue leaves and yellow star-shaped figures. For the texture of the face in the center, Picasso pressed chair caning into the clay and painted it white. The cheerful features are indented and painted with blue lines that echo the color of the leaves. In this plate, we have an example of craft produced by a major artist who clearly enjoyed the aesthetic potential of ceramics.

Wood and Bamboo

Wood, like clay, is an organic material with a long history of use for crafts. It is simple, readily available, and can be easily cut and shaped with a sharp instrument. It has a variety of textures and colors (mainly shades of black, brown, and white) as well as of different grain patterns. One drawback of wood is that it can disintegrate over time, resulting in few surviving ancient examples of wooden crafts. Wood rots and warps, and it can be eaten away by insects, gnawed by beavers, and pecked by woodpeckers. Some types of wood, such as the cedar used by Native Americans of the Northwest Coast, are relatively durable and tend to resist insects.

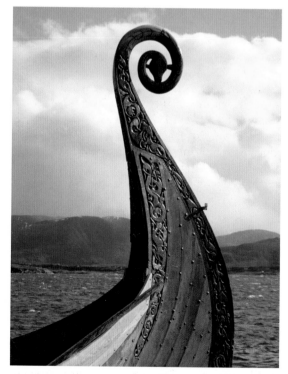

12.7 The Oseberg Ship, c. A.D. 820. 70 ft. long. Replica.

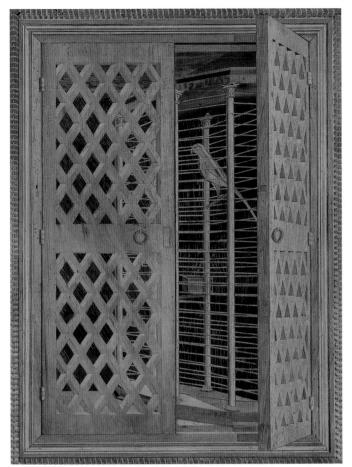

12.8 *Parrot in a Cage*, detail of Federico da Montefeltro's Liberal Arts *Studiolo*, Ducal Palace, Gubbio, Italy, 15th century. Intarsia of walnut, beech, rosewood, oak, and fruitwood on walnut base, whole *studiolo* 15 ft. 11 in. x 17 ft. x 12 ft. 7 in. The Metropolitan Museum of Art, New York. Rogers Fund, 1939. no. 39.153.

where Federico's friend Pope Sixtus IV awarded him the Golden Rose, an honor usually reserved for princes.

Patterns of wood grain enhance the aesthetic appearance of the teak ice-bucket made for Dansk International Designs in 1960 (**figure 12.9**). It was designed by the Danish craftsman Jens Quistgaard (b. 1919), who studied carpentry, ceramics, and silversmithing. Quistgaard's style, often referred to as Danish Modern, is characterized by simple elegance, smooth surfaces, and graceful contours. We can see the variety of wood grain and its tones comprising the vertical strips of the exterior. The design of the ice-bucket was influenced by the long curves of Viking ships that are part of the artist's heritage and also by the smooth elegance of Japanese ceramics, which he admired.

Another technique used in creating images of wood is **intarsia** (inlay), in which spaces are cut into a wood surface and filled with wood shapes of a different color or shade. During the Italian Renaissance, intarsia was typically used for the private study (*studiolo*) of a ruler or a pope. The intarsia technique lent itself to decorating a surface with a patron's emblems.

The walls of the *studiolo* commissioned by the Italian Renaissance ruler of Urbino, Federico da Montefeltro (1422–1482), for his palace at Gubbio are filled with intarsia imagery. Federico was well educated, a brilliant politician, and a successful soldier. He wanted a study that would reflect the latest developments in perspective. He also wanted the iconography to convey his high status. The detail in **figure 12.8** shows a parrot in an octagonal cage with a seed box visible through the open door of a wood cabinet. The open door is foreshortened and the orthogonals at the corners of the frame indicate the use of Renaissance perspective.

We seem able to see through the diamond shapes cut out of the doors into the cabinet containing the cage. But, in fact, the entire image is flat and thus illusionistic. The bird, which has a red beak and green feathers, is a type of exotic species collected by wealthy patrons in fifteenth-century Italy. It is an allusion to the Room of the Parrot in the Vatican,

12.9 Jens Quistgaard, teak ice-bucket for Dansk Designs, c. 1958, produced by Dansk International Designs Ltd. Teak and plastic, 15 $\frac{1}{6}$ x 7 $\frac{1}{3}$ x 5 $\frac{9}{10}$ in. The Montreal Museum of Fine Arts. Liliane and David M. Stewart Collection, gift of the American Friends of Canada through the generosity of Geoffrey N. Bradfield.

12.10 Yamaguchi Ryuun, *Sign of Wave*, 2002. Bamboo, 21 x 17 ½ x 22 ½ in. Tai Gallery/Textile Arts, Santa Fe, New Mexico.

In addition to ceramics, Japanese craftsmen are renowned for their bamboo baskets. Although actually a type of grass with a hollow interior, bamboo grows like trees, is readily available in Japan, and is both sturdy and flexible. The bamboo is harvested, cut, heated, cleaned, and dried in the sun. Each stalk is split and stripped until it is thin enough to work (by weaving) into an object.

From 10,000 B.C., the Japanese have made baskets of bamboo for various utilitarian purposes, such as holding grain, rice, or tea. About 500 years ago, these bamboo baskets began to be appreciated also for their aesthetic value, and became highly valued implements in two of Japan's most refined cultural pursuits, the tea ceremony and flower arranging. The status of the best basket makers gradually shifted from complete anonymity to that of recognized and celebrated master craftsmen. In modern times, master bamboo basket makers are accorded the same esteem in Japan as famous painters or sculptors are in the West, and the objects they make are often pure works of art, having no practical use. *Sign of Wave* by the bamboo craftsman Yamaguchi Ryuun (**figure 12.10**) is an example of such a basket that is primarily a work of art, having lost its function. The idea of a wave is evoked by the curving planes of the basket arcing over and through each other.

Metal

In contrast to wood and bamboo, metal is a hard, sturdy material that lasts a long time, although it can rust and become corroded. It is used for a wide variety of purposes, such as containers, tools, furniture, armor and weapons, gates, cars, trains, bridges, horseshoes, and jewelry. Metals are relatively versatile media, which can be heated for casting (see Chapter 13) or forged by being heated and hammered into shape. When the desired product is more delicate, soft metals such as gold and silver can be cut into thin sheets and are often used in jewelry (see figure 4.2).

Gold

Among the Asante of Ghana, who came to power in the seventeenth century, enemy leaders who had been killed were commemorated with portrait heads made of gold (**figure 12.11**). The heads were fixed to military objects, such as swords, and publicly displayed to show the power of the Asante. Gold was associated with the soul and expressed the collective cultural energy. Because of such symbolic meanings, as well as its intrinsic beauty, the metal was an important part of royal dress.

The head is clearly a portrait, with individualized features. The broad extended oval of the mouth is echoed in the eyes and the flattened nostrils. Below a rather fleshy chin, the figure wears a neckpiece with incised lines creating surface patterns. This particular head, part of the treasury of the ruling Asante king, Kofi Kakari, was looted by the British in 1874.

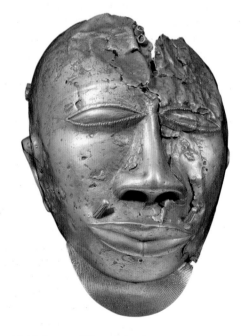

12.11 Asante (Ghana) Gold Head, 19th century. 7 ⅛ in. high. Wallace Collection, London.

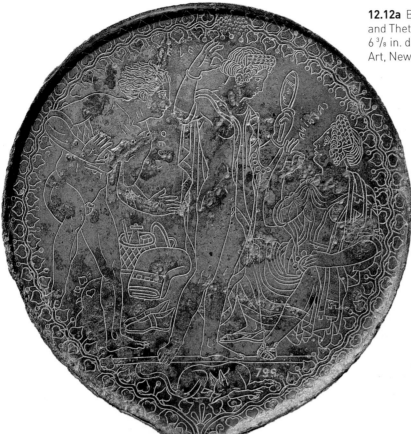

12.12a Back of an Etruscan mirror with Pele and Thethis, c. 350 B.C. Engraved bronze, 6 3/8 in. diameter. Metropolitan Museum of Art, New York. Rogers Fund, 1909. no. 09.221.16.

Bronze

In ancient Etruria (roughly modern Tuscany in Italy), Etruscan women used bronze mirrors engraved on the back with mythological scenes and decorative patterns. These were craft objects made for upper-middle and upper-class Etruscan women, who were known for their attention to fashion. The mirror in **figure 12.12** (**a** and **b**) was created during the fourth century B.C. It shows the Greek sea goddess Thetis (Thethis in Etruscan) arranging her hair as she gazes into a mirror. Reflecting the Etruscan interest in fashion is the mantle and the jewelry—bracelets, necklace, and earrings—worn by Thethis.

Seated at the right is a servant, Calaina (Galene in Greek), who is a sea nymph. The objects on the floor include a pair of shoes and a box containing perfume bottles. At the left, Thethis's muscular, nude, mortal husband, Pele (Peleus in Greek), rushes in with his hair flying. He is either showing surprise at having interrupted the toilet of his wife, or fright because he sees the future in her mirror. In the latter case, the future refers to the heroic, early death of Achilles, son of Pele and Thethis, in the Trojan War.

The person who made the mirror took great care to delineate the details of dress and the foliate design framing the scene, and to convey the three-dimensionality of the figures. The handle has broken off, but the mirror would have been held just as Thethis holds hers. This use of the mirror-within-the-mirror suggests that the craftsman who made it was, in a sense, displaying his skill as a maker of bronze mirrors.

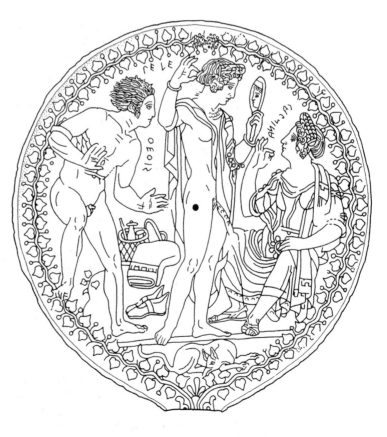

12.12b Diagram drawing of 12.12a.

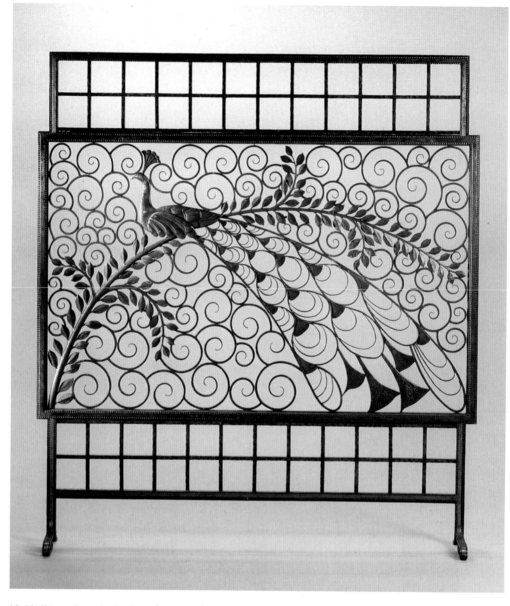

12.13 Edgar Brandt, *Le Paon* (*Peacock*), 1926. Wrought iron firescreen, 19 ³/₄ x 8 ³/₄ x 20 ¹/₄ in. Private Collection.

Iron

Iron, like bronze, is a strong metal, and its ore occurs naturally in the earth. It is extracted from its ore by smelting (heating in a blast furnace to separate the iron). A particularly elegant example of iron craftsmanship can be seen in the wrought iron firescreen created by the French metalsmith Edgar Brandt (1880–1960) in 1926 (**figure 12.13**). Made in the Art Deco style that began in Paris in the 1920s and ended in 1941, the firescreen consists of a two-layer grid of squares above and below the large central rectangle. This is filled with elegant abstract and foliate curves into which the image of a peacock has been incorporated. The crisp eyes of the peacock's elegant tail merge naturally into the abstract forms.

Brandt reflects the Art Deco taste for clear shapes, ornament, and graceful forms used to design a practical object. This notion, based in the Arts and Crafts Movement (see p. 232), is given expression in the firescreen.

Brandt was skilled in traditional metal forging, which he used in conjunction with more modern techniques of torch-welding and power-driven hammering. Although his medium was metal, he was able to combine heavy industrial material with delicate imagery based on organic forms found in nature. He specialized in household objects such as grillwork, furniture, and lighting fixtures. In the *Peacock*, he creates a synthesis of stylized form with refinement and practicality.

Fiber

Fiber is a traditional crafts medium, in which fabric, paper, or other organic material is worked to make textiles such as quilts, tapestries, and carpets. (Today, synthetic fibers are also used.) Such works may be designed with elaborate imagery having complex symbolic meaning or as purely utilitarian objects with little or no aesthetic quality. Techniques of fiber craft include weaving, sewing, some types of basketry, and making handmade paper. Fiber crafts have as wide a range of imagery as painting and the materials are easily accessible, but they are not as durable as metal, wood, or ceramics. Traditionally, fiber crafts have been associated with women, often working in groups, although some of the great weavers and tapestrymakers were men.

One ancient technique of fiber craft is weaving, which, in Greek myth, was given to the human race by the goddess Athena. In Chapter 4, we considered the famous woven *Lady and the Unicorn* tapestry thought to represent the sense of hearing (see figure 4.8).

In this weaving technique, two types of yarn—the **warp** and the **weft**—are arranged at right angles to each other. The weft is cross-woven through the warp, which is held firmly in place by a loom. In the Unicorn Tapestries, the yarn of the weft consists of more than one color and produced detailed symbolic imagery.

In Paracas, in ancient Peru, embroiderers and weavers of wool and cotton yarns used single stitches (**plain stitches**) to produce richly colored, symbolic images (**figure 12.14**). This is a detail of a funerary mantle, used to wrap the dead when placed in a grave. It is composed of a dark red background, and colorful, composite, flattened figures. The heads, which are framed by fishlike shapes, and torsos are frontal, but the legs are in profile. Most of the shapes are geometric and seem to merge unnaturally into each other. On either side of the fish, serpentine figures face each other over the top of the head. The faces of the fish direct our gaze to the necklace; one hand of the main figure holds a knife and the other a severed trophy head; and additional pairs of animals emerge from the head and waist.

COMPARE

Lady and the Unicorn tapestry.
figure 4.8, page 61

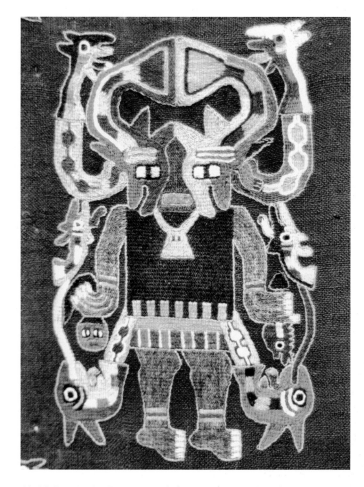

12.14 Detail of a Paracas Necrópolis-style textile, 200 B.C.–A.D. 200. Wool and cotton yarn, weaving, and embroidery. Museo Nacional de Antropología y Historía, Lima.

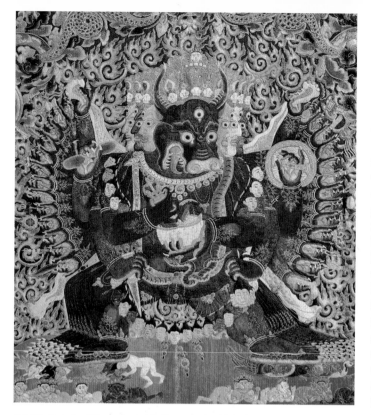

12.15 Detail of Thangka with Yamantaka-Vajrabhairava, early 15th century, Ming Dynasty. Embroidery and weaving, 4 ft. 9 ½ in. x 2 ft. 6 in. Metropolitan Museum of Art, New York. Purchase, Lila Acheson Wallace Gift, 1993. no. 1993.15.

The spectacular use of shimmering gold and rich blues and oranges, combined with the fierce energy of a vengeful god, can be seen in the royal weaving and embroidery of China during the Ming Dynasty (**figure 12.15**). Varied lengths and widths of stitching, as well as an enormous variety of forms and dynamic curves and diagonals, contribute to the tumultuous character of the image. As with the Paracas textile, this figure has religious meaning. The vengeful god Yamantaka has a distorted bull's head, with an open, fanged mouth to the left of the nostrils and three eyes. He is clearly an image of power and danger. Two heads in profile flank the bull-head, which is crowned by white skulls. The god has several arms and clawed feet. He holds a dagger in his lower right hand and severed heads in his lower left. Throughout the image, there are patterns of heads and abstract ornaments, dragons and serpents, and stylized flame shapes. The insistence on repetition, as well as the stance and expression of the god, creates a sense of aggressive rage designed to threaten the viewer.

Rugs and carpets are among the most widespread examples of fiber craft in Islamic cultures. They are typically made by knotting threads to create patterns on a woven ground. Many Islamic carpets were made by local and nomadic weavers, but the most complex, densely patterned, and costly were made for the courts. In the royal workshops, weavers worked with dyers who controlled the color and with designers who supervised the imagery.

One of the most characteristic Islamic carpet designs consists of a large central medallion on a field of foliate and floral motifs (**figure 12.16**). This example shows a royal carpet produced under the rule of the Safavid Dynasty (1501–1732) in Iran. It is made of rich materials such as wool pile and silver thread woven on a silk ground. The predominant colors are dark red and black, and the designs are floral and calligraphic—except for the four lions around the medallion. The placement of the lions creates an implied frame, for we naturally imagine lines connecting them to each other. They occupy a field of black, which is framed by a light tan rectangle filled with calligraphic designs. Around this is a dark red ground framed, in turn, by a black rectangle. The central medallion on a red ground with a lighter scallop-shaped frame has a small black center. The carpet's design is thus a series of framed rectangles around a central, curvilinear medallion, to which our eye is drawn as we follow the design sequence. At the same time, our gaze has to move around the surface to experience the enormous variety of detail that enlivens the basic, relatively simple shapes structuring the image.

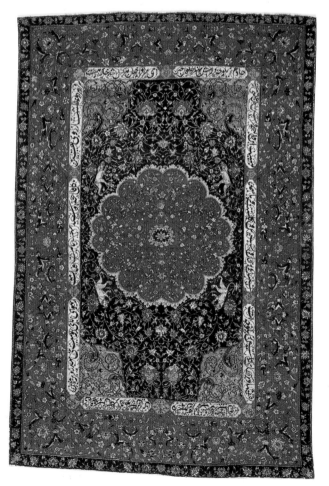

12.16 Medallion carpet, 16th century, from Iran. Wool, silk, and silver thread, 8 ft. 1 ¼ in. x 6 ft. 6 in. Khalili Collection.

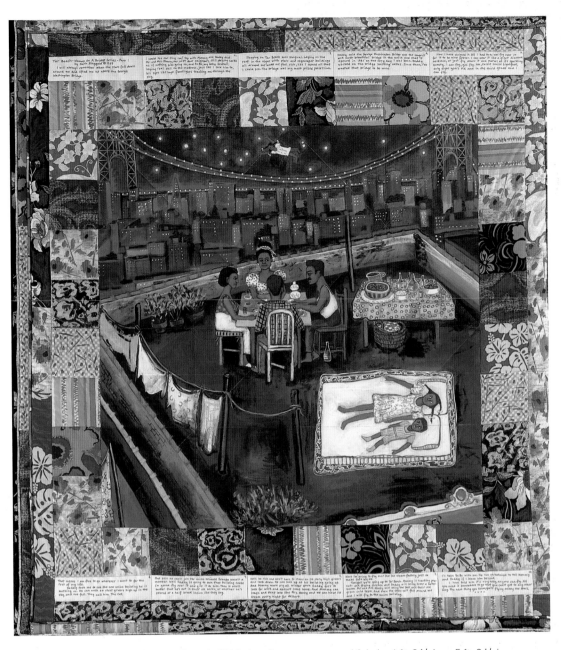

12.17 Faith Ringgold, *Tar Beach*, 1988. Acrylic on canvas and fabric, 6 ft. 2 ½ in. x 5 ft. 9 ½ in. Solomon R. Guggenheim Museum, New York. Gift of Mr. and Mrs. Gus and Judith Lieber, 1988.

A twentieth-century example of fiber work is Faith Ringgold's (b. 1930) mixed-media *Tar Beach* (**figure 12.17**), which reflects the contemporary practice of blurring the boundaries separating traditional categories of art. In *Tar Beach*, Ringgold uses craft techniques and media to create a monumental statement with a political and autobiographical theme that crosses over into "high art." She frames an acrylic painting on canvas with a fabric border. In America quilting, as we saw in Chapter 6, is a traditional female pursuit. Quilts are often made by women who gather in groups known as quilting bees.

The brightly colored border of *Tar Beach* advances, catching the viewer's eye with varied patterns and soft textures. The painted surface is smoother, darker in tone, and alludes to a time in the artist's past. Tar Beach depicts a family scene on the tar roof of a New York City tenement building. Adults play cards while two children—Ringgold and her brother Andrew—lie on the mattress and gaze at the stars. A little girl, representing Ringgold's childhood dreams of success, flies over the Brooklyn Bridge.

The title *Tar Beach* is a pun on the notion of a hot roof made of black tar being transformed into a night-time beach where it is cooler in summer than in a non-airconditioned interior. Strips of text in the lower and upper horizontals of the frame contain written statements by the artist, making her very much a part of the imagery. In her choice of media, as in her iconography, Ringgold merges art with autobiography, both of which converge with cultural history. Her mother had been a seamstress and Ringgold adapted the technique of sewing clothes to sewing and quilting her own works of art.

Glass

Glass crafts are made by heating sand (silica) until it melts into a liquid state. This can then be shaped either by blowing the liquid or by pouring it into a mold. Glass involves light in a way that differs from nearly all other works of art or craft, because it is transparent. Glass has the advantage of absorbing, reflecting, and transmitting light. It can also be reheated in order to be revised or reshaped. But working glass has to be done quickly while it is still in molten form.

Glass-blowing was invented in the first century A.D., and immediately became popular in ancient Rome. The blower dips a long pipe into molten silica and blows it to make a bubble. As long as the bubble is hot, it can be cut, shaped, pushed, pulled, and otherwise manipulated. Once it has cooled and hardened, the glass can be polished, painted, and etched to add surface decoration.

Glass is used for everyday, purely utilitarian objects, for decorative objects such as vases and jewelry, and in building, for windows. We saw in Chapter 9 that stained-glass windows were used in the churches and Gothic cathedrals of medieval Europe (see figure 9.17). In the detail of King Solomon from Chartres Cathedral (**figure 12.18**), we can see the rich colors, especially the reds and blues, juxtaposed with Solomon's yellow crown, that transform outdoor light into colored light. The symbolic meaning of this transformation is the notion that, when entering a cathedral, one enters a new world—a spiritual microcosm of heaven on earth.

In nineteenth-century France, there was a vogue, known as "Orientalism," for exotic Middle Eastern forms and subjects. This was part of a growing interest in global cultures, many of which exhibited works at the international World's Fairs in London and Paris. An example of orientalism can be seen in the lamp created by Philippe J. Brocard (d. 1896), which was inspired by an Arab mosque lamp (**figure 12.19**).

Brocard's vase shows his interest in elaborate, Arabic patterns and rich colors. He uses mainly blues, reds, and golds for floral designs that are reminiscent of Islamic calligraphy. Areas of white accent the design, which dominates the vase and nearly blocks out the transparency of glass. As in Islamic art, Brocard combines geometric patterning with dynamic, curvilinear, organic form.

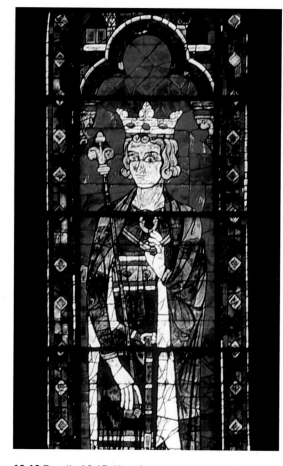

12.18 Detail of 9.17, King Solomon lancet window from the north transept wall of Chartres.

12.19 Philippe J. Brocard, vase in the shape of an Arab mosque lamp, late 19th century. Glass. Art Collection of the City of Coburg.

Dale Chihuly

12.20 Dale Chihuly, *Alabaster Basket Set with Oxblood Lip Wraps*, October 1991. Glass, 18 x 27 x 21 in. © Dale Chihuly.

A crafts artist who has revived the debate over arts versus crafts, Dale Chihuly (b. 1941) is considered to have revolutionized glass-making by changing it from a purely individual process to a collaborative one. He also broadened the scale of glassworks beyond small objects such as vases and lamps or architectural fixtures such as windows. Much of his work, like Ringgold's, is autobiographical, though it is more abstract than narrative.

Chihuly was born in Tacoma, Washington, and studied interior design and architecture at the University of Washington and the Rhode Island School of Design, and glassblowing at the University of Wisconsin. In 1971 he cofounded and then directed the Pilchuck School in Stanwood, Washington, whose emphasis on interdisciplinary approaches to the arts attracted artists from around the world. Chihuly himself works both alone and in teams. His installations are usually team projects, which have been exhibited in many countries and reflect his interest in architecture.

Chihuly's attraction to the sea and its formations dates to his childhood, as does his interest in floral shapes. These were inspired by recollections of his mother's garden. Baskets made by Native Americans of the Northwest Coast, near his birthplace in Tacoma, are also a source of inspiration. Works such as the glass basket in **figure 12.20** reflect Chihuly's use of form to enhance a variety of light effects. Some areas are opaque and reflective, whereas others are translucent. The lights and colors, which range in tone from solid whites and blacks to subtle shades of gray, seem in the process of continual transformation. On the edges of the globular interior shapes, we can also see delicate circles of red. The work is typical of the artist's style in its flowing, organic quality and in the fact that it conveys a sense of movement and change. The richness of such works derives from the beauty of their forms, the wealth of their content, and the variety of their techniques.

In the glass work of Chihuly, as in Ringgold's fabric works, we have examples of an interdisciplinary spirit that challenges traditional categories of media. These artists also contribute to the long-standing debate over arts versus crafts. In the case of Chihuly's *Basket*, the work is based on the utilitarian craft of basketry, but rendered with the aesthetic sensibilities of a fine artist. By enlarging the scale of his works, Chihuly also expands their scope and meaning. As sculptures they become objects to be looked at rather than used, and as installations they become architecture. We consider these latter categories in the next two chapters.

Chapter 12 Glossary

amphora—ancient Greek two-handled ceramic vessel for storing grain, oil, etc

ceramicist (or **ceramist**)—one who engages in ceramic arts

ceramics—general term for pottery made by firing (heating) clay

earthenware—type of porous pottery that has been air-dried or fired at a relatively low temperature

glaze—in ceramics, a material applied to a ceramic object that, when fired, fuses with the surface to produce a nonporous, usually glossy surface

hard-paste—mixture of kaolin with china stone or with feldspar and flint

intarsia—mosaic design or pattern formed through the inlay of decorative pieces of wood

kiln—oven used to bake (or fire) ceramic objects

meander pattern—fret or key pattern originating in the Greek Geometric period

plain stitch—basic knitting stitch

porcelain—type of hard, high-quality ceramic fired at a very high temperature

potter's wheel—revolving horizontal disk that a ceramist uses to model clay objects

slip—in ceramics, a mixture of clay and water used (a) as a decorative finish or (b) to attach different parts of an object

stoneware—opaque, nonporous ceramic, in many respects intermediate between porcelain and earthenware

terracotta—earthenware material, or an object made thereof

true porcelain—porcelain ceramics made from a mixture of kaolin and feldspar

warp—vertical threads in a weaver's loom

weaving—process of making cloth through the interlacing of threads on a loom

weft—horizontal threads in a woven cloth, often representing most of the decorative pattern

13

Sculpture

Sculpture is usually defined as a three-dimensional image, having height, width, and depth. The term comes from the Latin word *sculptura*, meaning "the art of carving or engraving." A sculptor, in Latin, is one who carves or engraves, and the Latin verb *sculpere* means "to shape and decorate material by carving or engraving." Embedded in the Western linguistic history of the term "sculpture," therefore, is the notion of forming material (the medium) into an object having aesthetic quality—that is, into a work of art. The sculptor's choice of a medium has personal as well as practical meaning.

In our everyday lives we are familiar with the natural impulse to form material. As children we may have played with clay, made snowmen, or whittled wood, all of which produce three-dimensional images. From birth, we identify physically with three-dimensional objects in a way that is not possible with pictures, because we too are three-dimensional, and we exist in three-dimensional space.

The recent sculptures made by the Australian artist Ron Mueck (b. 1958) appear particularly realistic in their execution. But their scale is either huge or very small in relation to the expected size of an average person. They are individually modeled in clay and cast in silica or in fiberglass and plastic. The artist then adds realistic details such as hair and surface blemishes (**figure 13.1**).

Mueck generally begins with a clay study, which he photographs from different angles. He draws lines over the photos, and constructs an armature of chicken wire, which he coats with plaster. When the plaster dries, he shellacs it, and makes a mold, into which he pours colored polyester resins. Mueck's *Boy* in figure 13.1 crouches and stares into space. At some sixteen feet in height, with long limbs and toes, *Boy* is monumental in scale and thus at odds with a normal boy of his age. The dark hair, piercing eyes, and prominent ears endow the figure with an uncanny, elfin quality.

13.1 Ron Mueck, *Boy*, 1999. Colored polyester resin on fiberglass, 16 ft. 6 in. high. Shown here as installed in the Millennium Dome, London, 2000. Collection Aros Aarhus, Kunstmuseum, Aarhus, Denmark. Courtesy Anthony d'Offay.

Today, we tend to think of the art of sculpture as the
equal of painting. But this has not always been the
case. Michelangelo's father, for example, wanted his
son to be a painter, which he considered a more
refined pursuit than sculpture. Leonardo da Vinci also
believed that sculpture was less elegant than painting
because of the physical labor involved in working with
stone. Sculpture, according to Leonardo:

> … is an extremely mechanical operation,
> generally accompanied by great sweat which
> mingles with dust and becomes converted into
> mud. His [the sculptor's] face becomes
> plastered and powdered all over with marble
> dust, which makes him look like a baker, and
> he becomes covered in minute chips of marble,
> which makes him look as if he is covered in
> snow. His house is in a mess and covered
> in chips and dust from the stone.[1]

Traditionally, the most common sculptural media
are ceramic, metal (especially bronze), wood, and
stone (such as marble). But during the twentieth
century, types of media expanded enormously, rang-
ing from industrial to synthetic materials. Artists also
use so-called "found objects" gathered from the
environment in creating sculptures.

There are two main categories of sculpture: **relief
sculpture**, and **sculpture-in-the-round** (also called
freestanding). We begin with relief.

Relief

Relief sculpture is not completely cut away from its
original material; one side is retained, resembling
the background plane of a picture. There is thus
always one vantage point from which we cannot see
an image in relief. Examples of relief in our everyday
experience include such objects as coins, manhole
covers, and tombstone designs.

There are three subcategories of relief: **high relief**,
low relief (also known by the French term *bas relief*),
and **sunken relief**. These denote relative degrees of
projection from the background plane.

The high relief by the Italian sculptor Nanni di
Banco (c. 1374/90–1421) in **figure 13.2** is located on
the exterior wall of Or San Michele, the guild church
in fifteenth-century Florence. It illustrates the work
of the Stone- and Woodworkers Guild. Because of
the high degree of relief, these figures barely seem
attached to the background plane. The two guild
members and their nude statue are rendered natura-
listically and seem capable of moving freely in space.
At the right a sculptor wields a hammer and chisel,
and at the left a stonemason holds a carpenter's
square. A capital rests on a platform in front of the
mason. The nude boy being carved by the sculptor
embodies the early-fifteenth-century Italian interest
in human form and the Renaissance revival of Greek
and Roman naturalism.

In low relief, there is less projection from the
background plane than in high relief (**figure 13.3**).
Since low relief is more pictorial than high relief,
Leonardo considered it more intellectual than sculp-
ture-in-the-round:

13.2 Nanni di Banco, *Sculptors at Work*, after 1410. Marble. Or San Michele, Florence, Italy.

It [low relief] approaches painting with respect to its intellectual considerations, because it is indebted to perspective…. it involves less physical exertion than sculpture in the round but much more research, in that you must consider the proportional distances between the parts of objects that come first in sequence and those that come second, and between the second and third, and so on.[2]

The example shown here illustrates a circular limestone sculpture used as a ball court marker by the Maya of ancient Mexico in the late sixth century. It depicts a scene from the dangerous ritual Mayan ball game, which required great skill, had symbolic mythological meaning, and was often played by defeated enemies who were sacrificed when the game was over. This ball player, in the center of the circle, wears a kilt and protective pads on his knees and arms as he prepares to hit the ball with his thigh (players, as in modern soccer, were not allowed to touch the ball with their hands). In this case, the elaborate headdress identifies the player as a god of the Mayan underworld.

The flat surface of the image, as well as the background, is typical of ancient Mayan relief sculpture. In contrast to the high relief of di Banco's figures on Or San Michele, Mayan relief does not depict naturalistic movement in space. The god's head turns sharply one way and his legs the other, masking the twist of the torso that would occur in reality. Although the god is clearly figurative and the scene is a narrative, the formal impact is one of complex stylization, with a sense of patterning and repetition, and dynamic movement.

Sunken relief is characteristic of sculptures on Egyptian temple walls. In sunken relief the image is incised (cut into) the wall and does not project at all beyond the base surface. Initially the images were painted, so that the incised lines functioned visually as outlines and also preserved the image when the paint wore off. **Figure 13.4** shows the ambitious conqueror Pharaoh Thutmosis III, striding forward and destroying his enemies. The artist followed the hierarchical convention of Egyptian art equating size with importance, so that the pharaoh towers over the other figures. Accentuating the pharaoh's power, in addition to his large scale, are the repeated, overlapping enemies who kneel in submission and await their deaths.

13.3 Ball Court Marker, A.D. 591, from La Esperanza, Mexico. Limestone, 22 in. diameter.
Museo Nacional de Antropologia, Mexico.

13.4 *Thutmosis III Smiting Enemies*, 18th dynasty, c. 1458–1425 B.C., seventh pylon from the Temple of Amun, Karnak, Egypt. Sandstone.

Freestanding Sculpture

In contrast to relief, freestanding sculpture (sculpture-in-the-round) does not have a background plane. That means that in order to apprehend completely the freestanding work, we have to look at it from all sides.

We take as an example the marble sculpture representing Samson and the Philistine by the sixteenth-century artist Giambologna (1529–1608) (**figures 13.5a**, **b**, and **c**). The artist shows the biblical strongman, Samson, in the act of smiting his enemy. Figure 13.5a emphasizes the front of Samson as he raises his sword to kill his captive. In figure 13.5b, we see Samson from the side, but more of the front of the captive's torso. In figure 13.5c, Samson's back is more visible, but we see mainly the arms, legs, and only a small part of the Philistine's torso.

The variety of viewpoint makes us aware of the sharply twisting forms and causes the appearance of the work to change as our own position changes. In figure 13.5a, we confront the violence most directly as we are "face to face" with Samson and can identify with the Philistine's contorted pose and fear of impending death. In figure 13.5c, it is still clear that a violent act is being committed, but the sense of the victim's identity is engulfed by the complex arrangement of his limbs as they intertwine with Samson's legs.

a

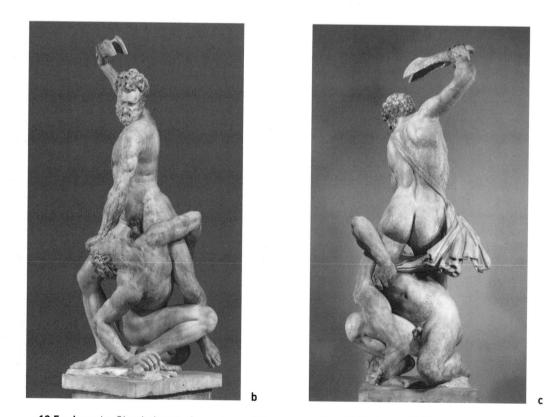

b

c

13.5 a, **b**, and **c** Giambologna, three views of *Samson and the Philistine*, c. 1567–1570. Marble, 6 ft. 10 ⅝ in. high. Victoria and Albert Museum, London.

Media and Techniques of Sculpture

The main traditional techniques of making sculpture are modeling, **casting**, and **carving**. More recent techniques include constructing and **assembling**.

Modeling

When we take a pliable medium and use our hands to form it, we are modeling it. We do this when we play with clay or shape dough before baking it. Modeling is an **additive process**, because the artist can add to the material as long as it remains soft.

For millennia artists have modeled clay figures and then fired (baked) them to create terracotta ceramic sculptures. **Figure 13.6** illustrates a ceramic Mayan player of the game shown in figure 13.3. But this figure is not a god; he wears large rings around his torso and wrist and ankle guards to protect him from being injured by the hard rubber ball. His slight frown reveals the intensity of his focus on what was a life-and-death game. His feathered crown is surmounted by a blue vulture-head that may have been a team emblem.

The artist modeled the figure in clay, paying careful attention to details of cloth hanging from the rings, as well as to the jewelry and the crown. These were probably incised to create the surface designs, whereas the necklace was modeled separately and then placed around the neck.

The face and body are naturalistic, endowed with the sturdy powerful build required for the game. The figure conveys an impression of inherent strength enhanced by the protective rings, the closed space, and the thick proportions of the neck and limbs in comparison with the relatively small feet. The feathers, like the fingers, are somewhat stylized, but the vulture-head, like the player's body, is organically rendered with a sense of underlying anatomical structure. In addition, the vulture-head rises upward, its curvilinear beak elevating the stature of the player.

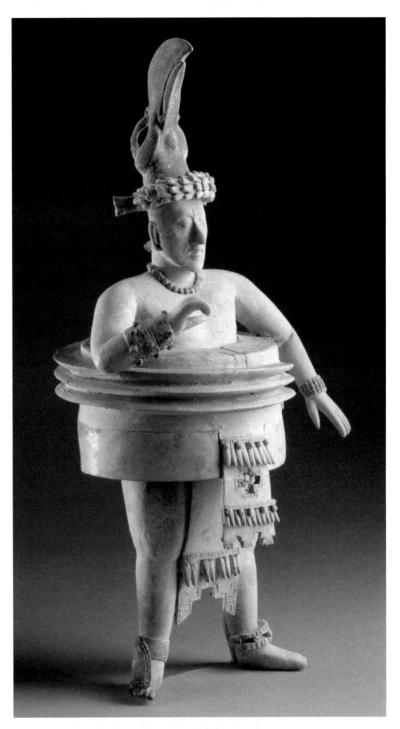

> Modeling is the sister of painting ... being an art of less crashing and labor than the working of stone.

Leonardo da Vinci (1452–1519)

13.6 Maya Ballplayer with tripartite yoke and bird headdress, A.D. 600–900, from Campeche, Jaina, Mexico. Clay with polychrome decoration, 13 1/2 x 7 in. Princeton University Art Museum. Museum purchase, Fowler McCormick, Class of 1921, Fund in honor of Gillett G. Griffin on his seventieth birthday, no. 1998–36.

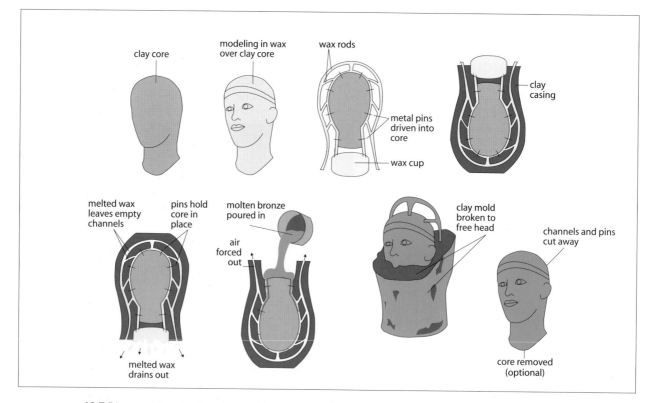

13.7 Diagram showing the stages of lost-wax casting.

Casting

Casting is a substitution process in which the artist traditionally models an image in a soft medium such as wax and then replaces it with a more durable medium such as bronze. The most usual type of casting (used in ancient Greece and parts of Africa) is the **lost-wax** (*cire perdue* in French) **process (figure 13.7)**. (A different process, the piece-mold method used in China, is discussed in Chapter 21.)

The lost-wax method may be summarized as follows:

1 A heat-resistant core of clay is formed, approximating the shape of the sculpture.
2 The core is covered with a layer of wax that the sculptor models.
3 Wax rods and a wax cup are attached to the completed wax sculpture, forming a channel system and also blocking the base of the sculpture. Metal pins are driven through the wax layer into the clay core to hold it in place.
4 The entire assembly is covered in specially prepared clay.
5 When the clay dries, the assembly is heated to allow the wax to melt and run out, leaving an empty image of the sculpture, as well as spaces where the wax rods and block had been.
6 Molten metal (e.g. liquid bronze) is poured into the cup space, filling the empty channels and taking the shape of the original wax model.
7 When the metal has cooled, the mold is broken apart, exposing the sculpture, which is then ready to be smoothed and polished.

Most bronze sculptures are much lighter in weight than marble statues, because they are hollow, consisting only of a thin exterior membrane of metal. The ancient Greek bronze warrior found in the sea off the coast of Riace, in southern Italy, is a particularly well-preserved example of a sculpture made by the lost-wax process (**figure 13.8**). The surface was smoothed and polished, and details of bone, glass, copper, and silver were added to enhance the figure's lifelike appearance. The Riace warrior belongs to the Greek Classical style, in which the human figure is idealized, anatomically accurate, and appears to move naturally in space. Works such as this show that the lost-wax method combines the advantages of the artist's control over the modeled medium with the durability of a hard but relatively light-weight medium. Its good state of preservation after lying for centuries in salt water is a tribute to the durability of bronze and to the skill of its modern restorers.

Bronze sculptures made by the lost-wax method are unique. Since the mold has to be broken, it cannot be reused to make a replica. But more recent bronze-casting techniques retain the mold and permit multiple castings of the same sculpture. In such cases, as with lithographs and other kinds of prints (see Chapter 10), the artist may limit the number of replicas made from a single cast. Casts made without the artist's approval, or after his or her death, are generally less valuable than originals. A case in point is Brancusi's *Bird in Space*, which has been through several approved (and some unapproved) castings—as well as having been carved in marble.

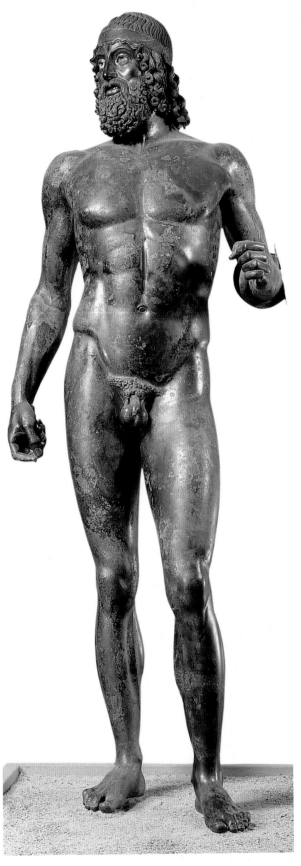

The Riace bronze in figure 13.8 exemplifies the High Classical idealization of the male body. It is anatomically accurate and moves organically in space, but it is more perfect and graceful in its proportions than a real man would be. Beginning in the late nineteenth and early twentieth centuries, artists began searching for new, non-Classical ways to represent the human body. One result of this search was fragmentation and a kind of geometric abstraction, an example of which can be seen in Brancusi's *Male Torso* of 1917 (**figure 13.9**). This has a high degree of polish and a strong sense of symmetrical equilibrium. It corresponds well to Brancusi's statement: "The beautiful is absolute equity."[3]

The *Torso* is a part-body, rendered as three attached cylinders, and conveys an impression of volume, its vertical weighed down by abbreviated cylindrical "legs." In its form as well as in its content, Brancusi's sculpture is both a torso without a phallus and an abstracted erect phallus. The shifting identity of the sculpture engages us with the subject, while the surface dazzles us with its aesthetic appeal.

13.8 Warrior from Riace, c. 450 B.C. Bronze, with bone, glass paste, and copper inlay added, 6 ft. 6 ⁴/₅ in. high. Museo Nazionale, Reggio Calabria, Italy.

13.9 Constantin Brancusi, *Male Torso*, 1917. Brass, 18 ³/₈ x 6 ⁵/₈ in. Cleveland Museum of Art, Ohio. Hinman B. Hurlbut Collection.

13.10 Robert Gober, *Untitled* ("Dismembered" leg), 1991. Wood, wax, leather shoe, cotton fabric, and human hair, 13 ½ x 7 x 38 in. Private Collection. Courtesy of the artist.

A more recent example of the fragmented body can be seen in Robert Gober's (b. 1954) *Untitled* ("Dismembered" leg) of 1991 (**figure 13.10**). Made of wood and wax, and then clothed in a shoe, sock, and trouser leg, Gober's "leg" is placed so that it seems to jut through the solid wall. The spatial arrangement of the leg, as well as its dismemberment, has a more uncanny quality than the *Torso*, because we identify with its form and are confused by its behavior. As a result Gober's leg evokes our own fears of fragmentation, whereas Brancusi's *Torso* is formally distanced from us by virtue of its geometric abstraction and polished surface. At the same time, however, Gober's work shares with the Brancusi a phallic pun. Brancusi's pun resides in the metamorphic character of the abstract shapes, Gober's in the iconographic symbolism of a leg that seems to pierce a wall and in the erect candle placed on the knee.

Carving

Carving is a **subtractive process,** so-called because the artist forms an image by taking away from the original material. It is thus nearly impossible to revise errors, making it necessary for the artist to think three-dimensionally and conceive the sculpture from every angle before starting to carve.

Different types of stone have various degrees of hardness, as well as different textures, grains, and colors. For *Samson and the Philistine*, for example, Giambologna used marble, which can be cut with chisels and then polished (see figure 13.5).

Marble is softer than jade, which is one of the hardest stones and has been popular in China for thousands of years. Because of its hardness, jade is difficult to carve and has to be shaped by **abrading** (filing down) the surface with an even harder stone (**figure 13.11**). This small, sturdy jade elephant is more than 3,000 years old, and was probably suspended from the hole made by the curl of the trunk. The surface was decorated with incised patterns in low relief. The wide open eyes and slightly upturned mouth create a cheerful expression, suggesting that the little elephant may have been a good-luck charm.

Wood is another ancient carving material, which is softer and more easily workable than stone, but it is also less durable. Carved wooden "rhythm pounders" made in the twentieth century by the Senufo of northeast Africa represent pairs of male and female spirit figures (**figures 13.12a and b**). Carried in ritual processions, the pounders are swung in certain rhythms by initiates and hit against the ground to summon ancestors and purify the earth. The male (13.12a) is actually smaller than the female, but wears a large symbolic headdress that increases his

13.11 Elephant from Henan Province, c. 1300–1030 B.C. Jade, 2 ½ in. long. Institute of Archaeology, Beijing.

13.12a and **b**. a: Senufo male rhythm pounder, 20th century. Wood, 3 ft. 9 ⅝ in. high.
b: Senufo female rhythm pounder, 20th century. Wood, 3 ft. 2 ⅛ in. high. Milton and Frieda Rosenthal, New York.

stature. The larger size and prominent breasts of the female (13.12b) reflect her power in a matrilineal society. Both figures have slim proportions, elongated faces, and are composed primarily of geometric shapes. Surface details are carved to portray hands, and facial and body scarification. In some areas, especially the faces and torsos, the artist polished the wood to a smooth shine, whereas in the legs, and even more so the bases, the natural grain of the wood creates a sense of rough texture.

> I love to watch people. I'm interested in their gestures and ... in their experiences and mine.... I spent a lot of time trying to look as bluntly as I could at people in their environments ... against garish light, illuminated signs.
>
> George Segal, sculptor (1924–2000)

Mixed Media

Although many modern sculptors in bronze cast works in traditional ways, a number of new casting techniques have also developed. George Segal (1924–2000), who was associated with the Pop Art style, cast sculptures directly from living people by wrapping them in gauze bandages and wet plaster. When the plaster dried, he removed it, in pieces, from the living model and then reassembled it and reworked the surface to form the final sculpture. Segal almost always kept his plaster molds and later on he would sometimes use them to cast bronze figures.

Segal often placed his figures in mixed-media, everyday surroundings, as in *Diner* of 1964–1966 (**figure 13.13**). The figures are unpainted, creating an eerie, ghostly impression—the more so because of the ordinariness of the diner setting.

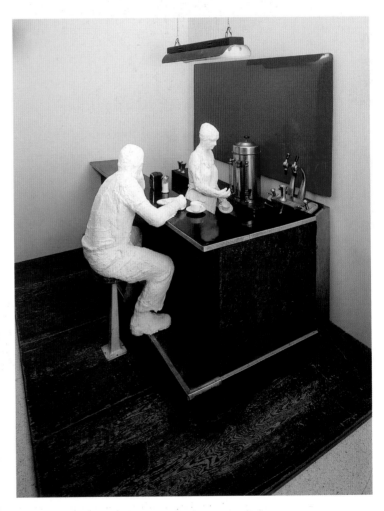

13.13 George Segal, *Diner*, 1964–1966. Plaster, wood, chrome, laminated plastic, masonite, fluorescent lamp, 7 ft. 7 ¾ in. x 12 ft. ¼ in. x 8 ft. Walker Art Center, Minneapolis.

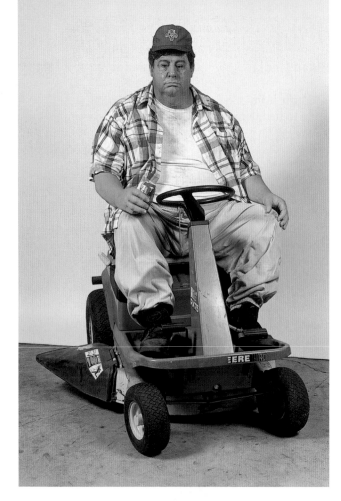

13.14 Duane Hanson, *Man on a Lawn Mower*, 1995. Polychromed bronze with objects, lifesize. Collection the artist's estate, Davie, Florida.

The American Super Realist sculptor Duane Hanson (1925–1996) cast most of his figures by the following complex procedure: he chose a model and established his or her pose, and then cast the model directly in synthetic material. To enhance the realism of the work, Hanson painted the skin, added hair, clothing, and accessories. In *Man on a Lawn Mower* (**figure 13.14**), the artist used direct casting to create his first painted bronze figure, which he placed on an actual John Deere lawn mower. In this case, even the clothes were cast in bronze so that the statue is durable enough to be displayed outdoors.

Hanson's aim was to portray recognizable, real-life American "types." This man is an overweight worker, his sagging flesh an echo of the heavy machinery. His dulled expression suggests that he is bored by the repetitive nature of his work. He holds a soda can in his right hand, and wears a red, white, and blue cap, both of which are typically American accessories.

Hanson's sculptures are often mistaken for real people because they are so lifelike. This disrupts the expectations of viewers, who tend to make an automatic mental distinction between life and art—even if they prefer realism. The effect, when

viewers realize their mistake, is uncanny, but in a different way from the ghostly figures of Segal. We know at a glance that Segal's white plaster people or bronze figures are not real, but, in the case of Hanson, we have to look closely to be sure.

Ready-Mades

Early in the twentieth century, Marcel Duchamp, who created *L.H.O.O.Q.* (see figure 1.15), invented a new type of sculpture, which he called a **ready-made**. This was a manufactured object to which he added a title and sometimes a signature. He thus took familiar objects from the everyday world and transferred them into the world of art.

Duchamp's first ready-made was a shovel he purchased in a hardware store in 1915 and titled *In Advance of the Broken Arm*. The original has been lost, but a replica is shown in **figure 13.15**. In this case, there is an implied narrative in the title, suggesting that whoever uses the shovel might suffer a broken arm. As such, the work reflects Duchamp's taste for creating visual and verbal puns.

Sometimes Duchamp added more than a title and signature to a ready-made object. He called those works "ready-mades aided." Such is *L.H.O.O.Q.*, a reproduction of Leonardo's *Mona Lisa*, which Duchamp "touched up" by adding a beard and a mustache (see Chapter 1). In 1961, Duchamp wrote as follows:

13.15 Marcel Duchamp, *In Advance of the Broken Arm*, 1915. New York. Replica, made1945. Moderna Museet, Stockholm.

In New York in 1915 I bought at a hardware store a snow shovel on which I wrote "in advance of a broken arm." It was around that time that the word "ready-made" came to mind…. Sometimes I would add a graphic detail of presentation which, in order to satisfy my craving for alliterations, would be called "ready-made aided."[4]

Assemblage

In **assemblage**, an additive technique related to collage and to the ready-made, artists construct works by assembling objects and attaching them in some way. This technique greatly expands the materials of sculpture and lends itself to the use of mixed media and **found objects**.

In 1930, the Hungarian-born artist László Moholy-Nagy (1895–1946) constructed his *Light Prop for an Electric Stage* (**figure 13.16**) out of mixed media, including steel, plastic, and wood. He was interested in light reflections from metal surfaces and their movements in space. This work is kinetic, which means that it actually moves rather than being a representation of movement. Whereas Calder's mobiles, which are also kinetic works, move because of air currents, Moholy-Nagy's moves when its electric motor is turned on.

Formally, the emphasis of Moholy-Nagy's work is geometric, especially the rotating circles inside the open cubic frame—inspired by the aesthetics of the machine. The artist was convinced that manually created art belonged to the past and that mechanical art was the way of the future. He expressed that notion in the following statement made during the 1920s:

> … the mechanical and technical requisites of art are of primary importance. Until recently they were condemned on the grounds that manual skill, the "personal touch," should be regarded as the essential thing in art. Today they already hold their own in the conflict of opinions; tomorrow they will triumph, the day after tomorrow they will yield results accepted without question.[5]

Another approach to assemblage, which is sometimes called constructing, can be seen in the *Cubi* series of stainless steel sculpture by David Smith (1906–1965) (**figure 13.17**). He assembled (constructed) sculptures from solid geometric shapes of steel placed at angles to each other. This creates a sense of precarious balance, in which form and space interact dynamically. Smith polished the shapes to a silvery shine, but retained an impression of surface textures that reflect light in varying degrees. He thus endowed his works with a painterly

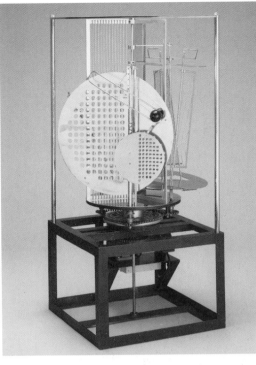

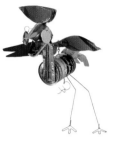

Calder, *Chock*.
figure 1.7, page 7

13.16 László Moholy-Nagy, *Light Prop for an Electric Stage* (*Light–Space Modulator*), 1930. Aluminum, steel, nickel-plated brass, other metals, plastic, wood, and electric motor, 59 ½ x 27 ½ x 27 ½ in. Busch-Reisinger Museum, Harvard University Art Museums, Cambridge, Massachusetts. Gift of Sibyl Moholy-Nagy.

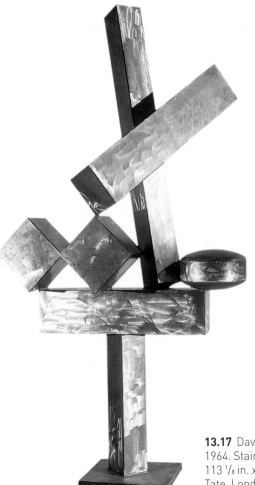

13.17 David Smith, *Cubi XIX*, 1964. Stainless steel, 113 ⅛ in. x 21 ¾ in. x 20 ¾ in. Tate, London 2006.

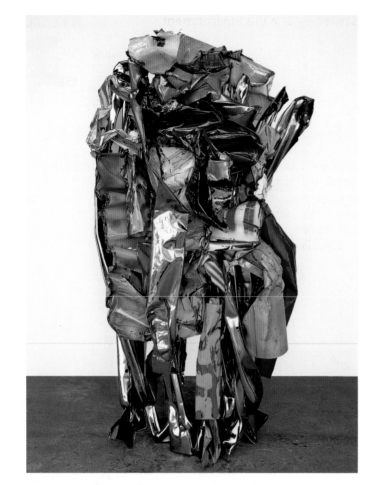

13.18 John Chamberlain, *Debonaire Apache*, 1991. Painted and chromium-plated steel, 7 ft. 10 in. x 4 ft. 6 ³⁄₄ in. x 4 ft. 2 ¹⁄₂ in. Pace Gallery, New York.

surface and believed that strict conceptual distinctions between painting and sculpture were false:

> I do not today recognize the lines drawn between painting and sculpture, aesthetically …. The sculptor is no longer limited to marble, the monolithic concept, and classical fragments. His conception is as free as that of the painter…. There is no conceptual difference between painting and sculpture.[6]

In the assemblages of John Chamberlain (b. 1927), we might say that there has been a democratization of the medium. Chamberlain creates sculptures from one of the most widely used American consumer products—the automobile. His works are composed of crushed, colorful fragments of cars, the tactile quality of which suggests brushstrokes as

13.19 Chryssa, *Ampersand III*, 1966. Neon lights in Plexiglas, 30 ¹⁄₄ in. high. Collection Robert E. Abrams Family.

much as steel and chrome. Because we know what they are made of, we can read the reckless danger of the road and the recycling of parts into the sharp edges and smashed surfaces of Chamberlain's work. In *Debonaire Apache* of 1991 (**figure 13.18**), he has emphasized the color red, infusing it with blues, yellows, and greens, as well as black, white, and chrome. The rich color of this work is consistent with the title, for it is reminiscent of the colorful headdresses worn by Native American warriors.

New Media

Duchamp's ready-mades, like Chamberlain's crushed car parts, are media that were new to the twentieth century. Many other sculptors have produced works in surprising media inspired by industry, by the digital age, and even by nature. The Greek artist Chryssa (b. 1933), for example, uses neon lights as her primary medium. This, like motorized kinetic sculpture, requires electricity, but its aesthetic impact is very different. Chryssa uses "found" fragments of neon light tubes to construct elegant, vividly colored three-dimensional design patterns.

In *Ampersand III* of 1966 (**figure 13.19**), she arranged groups of bright color and encased the forms in Plexiglas. They seem to move upward from a horizontal base as if growing and expanding. The result is a combination of industrial media with lines, colors, and shapes found in nature.

Sculpture and the Environment

Andy Goldsworthy, whose *Japanese Maple Leaves* we discussed earlier (see figure 2.13) uses nature as his medium and subject. Ranging from large to small in scale, and from permanent to temporary, Goldsworthy's works are collaborations with nature. He uses stones, leaves, twigs, snow, icicles, earth, and sand, the aspects of which change as nature itself changes. His temporary works last only in photographs. On January 12, 1987, Goldsworthy created the dazzling ice sculpture in **figure 13.21** and, knowing it was a temporary work, recorded it on film. His caption to the photograph is a description of the process by which he made it:

Thick ends dipped in snow, then water held until frozen together, occasionally using forked sticks as a support until stuck, a tense moment when taking them away, breathing on the stick first to release it.[7]

13.20 Nam June Paik, *Merce*, 1987. Single-channel video sculpture with vintage television cabinets and sixteen monitors; color, silent; 8 ft. x 6 ft. x 1 ft. 8 in. Swig Collection, San Francisco.

We have seen that television monitors are a favorite medium of Nam June Paik (see p. 225). His enormous output includes performance art, individual sculptures, and large-scale installations using a variety of new media, including aquaria with live fish, water, and videos. Paik's *Merce* of 1987 (**figure 13.20**) is one of a series of portraits of famous people—in this case, the modern dancer Merce Cunningham (b. 1922), who figures prominently in many of Paik's video installations.

The body is composed of television monitors, except for the feet, which are vintage TV cabinets. The wit of this sculpture, aside from its medium, is the angular character of a work depicting Cunningham's graceful, curvilinear dance movements. Despite the "electronic," robotlike style of the sculpture, we nevertheless are struck by the dancer's equilibrium as he moves through space and conveys an impression of musical rhythm.

13.21 Andy Goldsworthy, *Icicles*, January 12, 1987. Scaur Water, Dumfriesshire, Scotland. Image by Andy Goldsworthy.

13.22 Nancy Holt, *Sun Tunnels*, Great Basin Desert, Utah, 1973–1976. Two of four concrete tunnels, each 18 ft. long by 9 ft. 4 in. diameter.

Another kind of relationship between sculpture and the environment is termed **site-specific** and requires the viewer to travel to the site to experience the work. In the case of Nancy Holt's (b. 1938) monumental *Sun Tunnels* (**figure 13.22**), four concrete tunnels, each weighing twenty-two tons, are arranged in the Great Basin Desert of Utah. They are oriented to the rising and setting sun at the winter and summer solstices. This age-old practice of aligning structures with the sun or moon at significant times of the year usually has cosmic meaning. The striking effect of one tunnel when the sun's yellow light illuminates the concrete is shown here. Looking through the near tunnel, we can see the distant tunnel perfectly centered and reflecting the light of the sun behind it. The result is a harmonious balance between the earth, the sky, and the mind of the artist. Holt looked for a desert site ringed by a low mountain range and described the process of conceiving the work:

> *Tunnels* became clear to me while I was in the desert watching the sun rising and setting, keeping the time of the Earth. *Sun Tunnels* can exist only in that particular place—the work evolved out of the site.[8]

Installation sculpture is also a form of site-specific work, which can be indoors or outdoors. One of the best-known contemporary installation artists is Jenny Holzer (b. 1950), who uses stone and neon lights as media. She combines messages with structured environments.

In 1989, Holzer marked out a grass rectangle at the Walker Art Center in Minneapolis and placed a series of granite benches around the perimeter (**figure 13.23**). Each bench is inscribed with a text, so that visitors must pause and read in order to experience

> I don't want to control and I don't want complete chaos. But both are there in their extreme forms, not arranged.
>
> Jenny Holzer, artist (b. 1950)

13.23 Jenny Holzer, *Bethel white granite benches*, from the *Living Series*, 1989. Granite, 17 x 36 x 18 in. each. Permanent installation. Walker Art Center, Minneapolis.

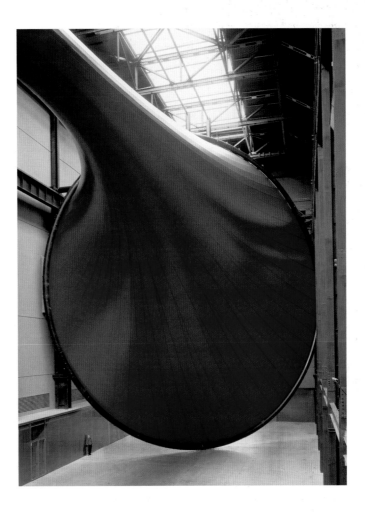

13.24 Anish Kapoor, *Marsyas*, 2003. 8,372 square yards of stitched fabric. Tate, London 2006.

the installation. The benches thus serve a dual purpose: they are seats and texts at the same time. In the illustration shown here, two people pause to read what is on the benches and another is seated. The benches have a quality of simultaneous stasis and motion. They carry our gaze around the rectangle by virtue of their repetition and they arrest our gaze with their text.

In 2003, the Indian-born British sculptor Anish Kapoor (b. 1954) installed a dynamic, monumental work entitled *Marsyas* at London's Tate Modern art gallery (**figure 13.24**). In contrast to the variety of Holzer's installation, the *Marsyas* is a single huge form that expands into the space of the museum. It consists of a red, stitched fabric held in place at one end by a round frame, from which it seems to be pulled toward a long, extended cylinder. The overall shape resembles a trumpet, which may refer to the musical contest that the satyr (half-man and half-goat or -horse) Marsyas lost to the sun god, Apollo, in Greek myth. Marsyas was turned upside down and flayed alive for challenging a god. The red color and stretch of the fabric thus evoke the blood and flayed skin. The taut form of the work is an expression of tension—formally between solid and void and between the widening and narrowing of the sculpture, and possibly also between an artist's

ambition (represented by the satyr's challenge) and the reality of his limitations (losing the contest).

Installation sculpture usually involves more space than individual sculptures. The installation artist requires either a natural or a constructed space in which to create an aesthetic environment. This brings us to another category of three-dimensional work—namely architecture, which is the subject of the next chapter.

———◆———

Traditionally, we think of a freestanding sculpture as a single work, or group of related works, that we experience by observing their visible sides. But an installation implies an existing or created space that is somehow altered by an artist using a range of media, including sculpture. Whereas we see *around* a sculpture, viewers can move *through* an installation. This raises the question of the boundary between sculpture and architecture, which has become blurred during the twentieth century. The Vietnam memorial, for example (see p. 264), is composed of two architectural elements—walls—but is considered a site-specific sculpture. The categorical difference between the two is obvious, but less obvious is the category to which the wall itself belongs.

Claes Oldenburg on Sculpture

Throughout his career, Claes Oldenburg has drawn inspiration from the mundane and banal, using everyday objects to facilitate a process of "visual free-association" by changing their familiar context, substituting their usual material for another, and altering their scale. He undertakes this process in search of what he calls "parallel realities"—"I make my work out of my everyday experiences, which I find as perplexing and extraordinary as can be."

Oldenburg first came to the attention of the art world with the Pop Art generation of the 1960s. Much of his imagery is borrowed from American consumer culture and Oldenburg infuses it with a wry sense of humor—reflecting the sensibility of Pop Art that challenged the notion that art could only be art if it was profound.

Yet though Oldenburg's practice could be described as rooted in Pop Art, it differs from that of Warhol and Lichtenstein, who flaunted the manufactured nature of an object. Oldenburg is more concerned with the act of metamorphosis and visual metaphor. For example, the transformation of a hard-edged, angular object into something soft and pliable, such as the typewriter discussed in Chapter 5, metamorphoses into a face.

Oldenburg's soft sculptures of everyday objects include toilets, saws, light-switches, and fans. They are made of vinyl or canvas and stuffed with kapok—a silky, fibrous material. Regarded as his signature works, the soft sculptures "confound expectation"—partly through challenging the viewer with the strange sight of a familiar object formed from an unexpected material, but also because gravity has caused many of the works to sag. This creates a sense of deflation and vulnerability and endows them with a life-like quality lacking in the "original" mechanical, mass-produced object.

From 1965 Oldenburg began making large works which he described—somewhat ironically— as *Colossal Monuments*. His deliberate decision to depict non-heroic subject matter subverted traditional notions of public sculpture, although by this time, he was also experimenting with more traditional hard media, such as steel. One of the first of these monumental works was the *Geometric Mouse* (**figure 13.25**)—a piece that was to have five incarnations in five different scales, ranging from "D" (ear diameter 6 inches), to "X" (ear diameter 9 inches). Oldenburg's studio at this time was overrun with mice—hence his assertion that "a rodent subject was unavoidable."

Oldenburg returned to the mouse motif after visiting the Disney Studios in 1968. His comments at the time reveal his interest in the process of visual free association and his working method: "Mickey Mouse, as form, is important in the American range of forms. The mouse's personality or nostalgia need not be discussed. The form may derive from the early film camera and that is how I arrived at this version wherein the "eyes" operate as shutters, represented by old-fashioned window shades. Such shades never quite roll up, which accounts for the sleepy look."

Despite the rich associations evoked by Oldenburg's sculpture, it can also function "as pure form." For example, *Geometric Mouse* appears to change character according to the way its various parts are positioned. Although set in what Oldenburg describes as the "basic" position, it reads as an abstract series of rectangles and circles. The all-black version "C" confounds our reading any sense of depth into the work, thereby highlighting the sculpture's linear form. Oldenburg is pleased that his work resists a single interpretation: "I am for an art that is political-erotical-mystical, that does something other than sit on its ass in a museum."

Quotations by Oldenburg in 1960. From the archives of the Frederich R. Weisner Museum of Art, Pepperdine University, Malibu, California.

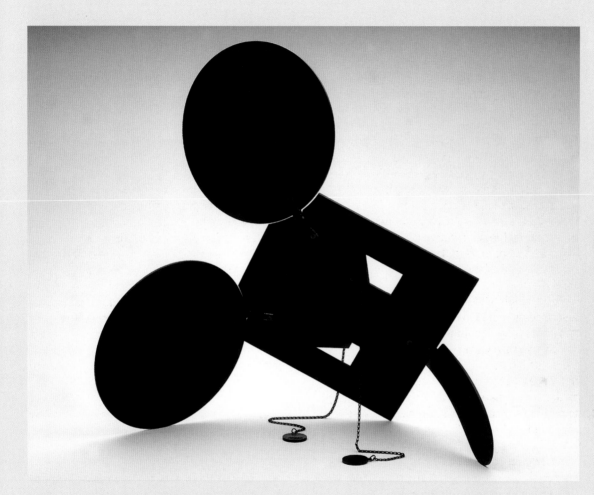

13.25 Claes Oldenburg, *Geometric Mouse, Scale C*, 1971.
24 ¹/₂ x 20 in. Edition of 120. Anodized aluminium.
Published by Gemini G.E.L. Los Angeles.

COMPARE

Oldenberg, *Typewriter*.
figure 5.25, page 90

The *Vietnam Wall* as Site and Text

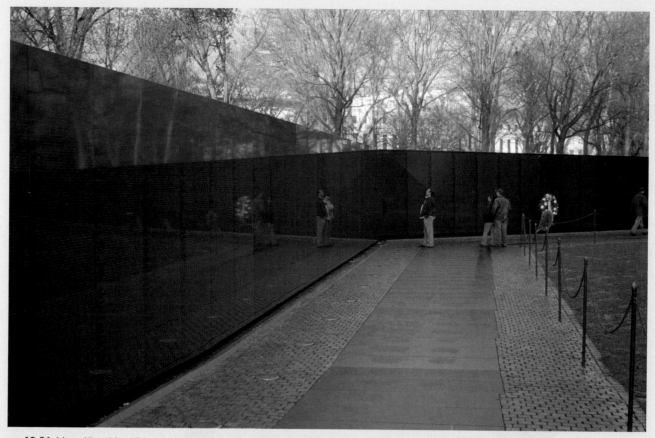

13.26 Maya Ying Lin, *Vietnam Wall,* Dedicated 1982. Black granite, each section of wall 246 ft. long. Washington, D.C. Mall.

The powerful impact of a site-specific work combining aesthetic form with the written word can be seen in the *Vietnam Wall*, dedicated in 1982 (**figure 13.26**). This work, which memorializes the 58,000 Americans dead or missing in the Vietnam War, has become one of the most visited sites in the United States.

In 1979, the Vietnam Veterans Memorial Fund Inc. (VVMF) was founded. The following year, Congress approved the Washington, D.C. Mall as the site for a public memorial sculpture and the VVMF sponsored a blind competition for the commission. The sponsor required that the work blend with the site, evoke contemplative responses in viewers, and contain no overt political message. Of the 1,421 artists who submitted proposals, the jury chose a design by Maya Ying Lin (b. 1959), then a 21-year-old student at Yale University.

Vietnam Wall is a large, expansive V-shape that sinks to a depth of ten feet at its deepest point and gradually slopes upward 250 feet to each end. This, in the view of the artist, represented a "cut" through the earth—a wound in American history that might be healed through time and art.

Maya Lin's medium is black granite, which has been smoothed and polished to a high degree of shine so that it reflects both the site and the visitors to the site. The design itself is minimal; it marks a space on the lawn and draws viewers toward it. Formally, there is no beginning and no end, the only chronology being the order of names inscribed on the surface according to the date of death. Visitors make contact with the dead by reading, touching or rubbing impressions of the inscribed names. And they can see themselves reflected in the wall, which involves them visually in their own experience of the work.

Chapter 13 Glossary

abrading—rubbing away or filing down by friction, usually with a rough-edged tool

additive process—sculptural process in which pliable material (e.g. clay) is molded by hand

assemblage—group of three-dimensional objects brought together to form a work of art

carving—subtractive sculptural technique in which a figure or design is cut out of hard material such as wood or stone

casting—process in which molten material (usually metal) is poured into a mold; the mold is then removed when the material has solidified, producing a cast object

found object—object not originally intended as a work of art, but presented as one

high relief—relief sculpture in which the figures project substantially from the background surface

installation sculpture—three-dimensional environment or ensemble of objects presented as a work of art

lost-wax (*cire-perdue*) process—sculptural technique for casting bronze and other metals

low relief (or **bas-relief**)—relief sculpture in which figures and forms project only slightly from the background surface

ready-made—everyday object presented as a work of art (especially by Duchamp)

relief sculpture—type of sculpture in which an image is developed outward (high or low relief) or inward (sunken relief) from a background surface .

sculpture-in-the-round (also called **freestanding**)— sculptural figures carved or modeled in three dimensions

site-specific—referring to an environmental or other form of sculpture that is integral with a particular site

subtractive process—sculptural process in which parts of a hard material such as wood or metal are removed through carving or cutting

sunken relief—type of relief sculpture in which the image is recessed into the surface

KEY TOPICS
Shell and skeletal systems of architecture
Arches and vaults
Domes
Truss and balloon frames
Cast-iron construction
Steel-frame construction
Cantilever
Suspension
Computer-generated design

Architecture

A rchitecture is the art of building, and people who design buildings are called architects. When we think of the buildings with which most of us are familiar, elements such as walls, floors, ceilings, doors, and windows come to mind.

As with making pictures and sculptures, the wish to build is a natural human impulse. Children begin to build at an early age if they have the materials to do so. Toy manufacturers have produced construction materials in wood, metal, plastic, and fabric for generations of children. Left to their own devices, however, children will use their imagination to find ways of building.

Since play is a fundamental feature of the creative process, many professional architects, like other artists, retain a sense of imaginative play in their work. But architects also have to produce solid buildings that fulfill a function, are structurally sound, and ideally have aesthetic appeal. Architects begin with a **plan**, which is a diagram of the floor level of a building showing where walls and openings (such as doors) meet the ground. They build from the ground up, creating three-dimensional spaces, in which people live, work, and pursue entertainment.

For millennia, people have made or found shelters in nature. The earliest of these have not survived, but they were probably made of impermanent materials such as animal skins and leaves and branches. Evidence of early structures made of animal bones has been found in some parts of the world. Monumental stone architecture made to last is a Neolithic (New Stone Age) development, the dates of which vary in different parts of the world.

Building great cities is associated with periods of high culture—for example, Old Kingdom Egypt, Macchu Pichu in Peru, the Athens of Pericles, and the Rome of Augustus. For Le Corbusier, as for the great builders of antiquity, architecture—by which he means structures having aesthetic quality as well as being functional—gives the cultures that produce them a soul:

> … there does exist this thing called ARCHITECTURE, an admirable thing, the loveliest of all. A product of happy peoples and a thing which in itself produces happy peoples. The happy towns are those that have an architecture.
>
> …
>
> Architecture can be found in the telephone and in the Parthenon. How easily could it be at home in our houses! Houses make the street and the street makes the town and the town is a personality which takes to itself a soul, which can feel, suffer and wonder. How at home architecture could be in street and town![1]

The main architectural systems we will discuss fall into two general categories: shell and skeleton. In the former, the supporting elements comprise the exterior of the structure. In the latter, the main support is interior and is made of a sturdier material than the exterior; as such, skeleton systems resemble the bones (interior) and skin (exterior) of the body. Monumental shell construction is the oldest type,

The Plan is the generator. Without a plan, you have lack of order, and willfulness.

Le Corbusier, architect (1887–1965), on the importance of the architectural plan

14.1 Great Wall of China,
3rd century B.C.
c. 1,500 miles long,
c. 25 ft. wide.
Near modern Beijing.

14.2 Diagram of crenellations.

which begins in the Neolithic Period, whereas skeletal structures were not developed until the nineteenth century. The types we will consider in this chapter are **load-bearing**; **post-and-lintel**; **arches**, **vaults**, and **domes**; **frame-construction** (**balloon**, **cast-iron**, **steel**, wood, and **reinforced concrete**); **truss** and **suspension**. Finally, we cite an example of architecture designed using computer-generated models.

Load-Bearing Architecture

Load-bearing architecture is an example of shell construction, which typically has thick walls and small, if any, openings. The builder stacks materials, such as stone, brick, and earth, beginning with a wide base and constructing upward. One of the most spectacular load-bearing structures is the Great Wall of China (**figure 14.1**), which is supported by stones arranged in regular patterns. When there is no mortar holding the stones in place, as is the case here, the term **dry masonry** is used.

The Great Wall was begun in the early third century B.C. outside modern Beijing to discourage foreign invasion and unify China. During the reign of the first emperor of the Qin Dynasty (221–203 B.C.; pronounced Chin, from which the name China comes), the majority of the 1,500-mile-long wall was completed by some 400,000 workers. The wall was maintained and expanded by succeeding emperors over the next 1,700 years. At various points along the wall, watchtowers were constructed to serve as lookout posts. The top of the wall was further defended by **crenellations** (**figure 14.2**), which provided spaces through which missiles could be fired in times of war.

Post-and-Lintel

Post-and-lintel is an ancient shell system, in which verticals (posts) are separated by a space and support a horizontal beam or lintel (**figure 14.3**). The size of the space depends on the weight and flexibility (**tensile strength**) of the lintel. A post- and-lintel can occur singly as in the Sun Gate at Tiwanaku, in modern Bolivia (**figure 14.4**). This is a stone entrance leading to a larger architectural site built between A.D. 500 and 700. Two rectangular stone posts support the lintel, which is decorated with low relief carving and a higher relief of the sun god at the center. Notice that the opening is relatively small; this is because it is made of stone, which cracks more easily than wood or steel. As a result, lintels made of wood (and, from the nineteenth century, of steel) can be longer than those made of stone.

Post-and-lintels can be aligned and repeated to form a wall of any length. The most commonly used development of the post in Western architecture is the **column**. In ancient Egypt, columns consisted of a round **base** at the bottom, a vertical **shaft**, and a **capital** at the top, or head, of the shaft. The wall detail in **figure 14.5** shows a section of the temple of Pharaoh Rameses II, which was built over 3,000 years ago. The spaces between the columns are narrow, but the wall length is extended by the repetition of the columns into a colonnade.

The temple itself is colossal in size, a result of the availability of stone in Egypt and of the ruler's desire to convey an impression of power. The shapes of Egyptian temple columns were derived from the reeds and other plants growing along the River Nile. In this case, the bulging shafts are the architectural equivalent of stalks and the capitals resemble open and closed papyrus buds. These, like other Egyptian capitals based on plant forms, represent fertility in the land, as well as the pharaoh's prosperity in the afterlife.

In ancient Greece, post-and-lintel construction became highly elaborated and the columns were more abstract than in Egypt. Greek post-and-lintel evolved into three elevation systems called **Orders of architecture**. The oldest and most stable in appearance is the **Doric Order**; the eastern **Ionic Order** is slim and elegant; and the latest—the **Corinthian Order**—has a decorative capital in the form of acanthus leaves (**figure 14.6**). We can see from the diagram that the main differences between the Orders are in the columns and the designs of the **frieze**. Doric has a more austere capital and no base. Its frieze is divided into square segments (**metopes**), which are separated by triple verticals—the **triglyphs**. The Ionic and Corinthian friezes, in contrast, are continuous.

14.3 Diagram of post-and-lintel.

14.4 Sun Gate, A.D. 500–700. Stone, 9 ft. 10 in. high. Tiwanaku, Bolivia.

14.5 Mortuary Temple of Rameses II, 19th Dynasty, c. 1260 B.C. Thebes, Egypt.

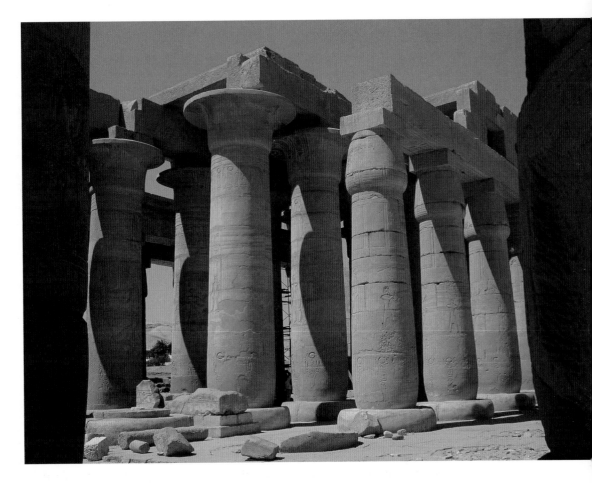

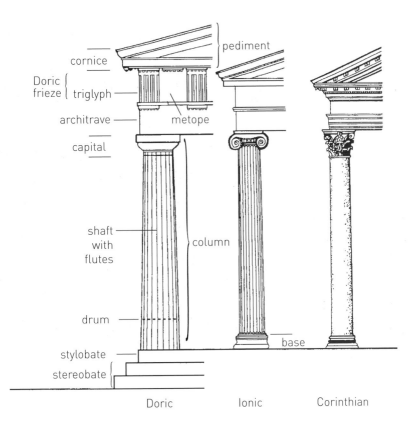

14.6 Diagram of the Greek Orders.

pediment

cornice

Doric frieze — triglyph

architrave

metope

capital

shaft with flutes

column

drum

base

stylobate

stereobate

Doric Ionic Corinthian

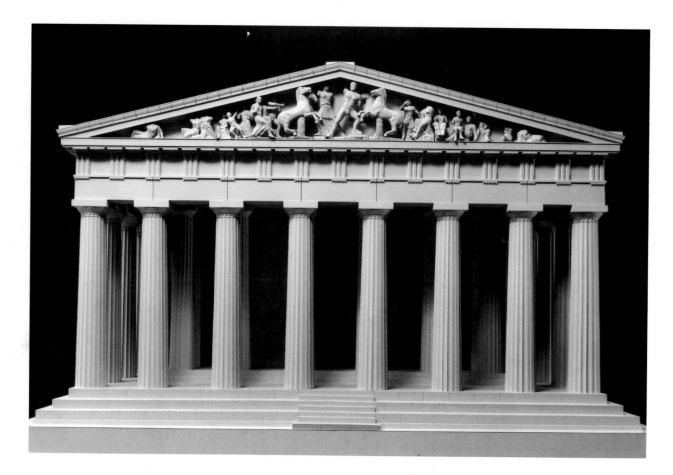

14.7 Plaster cast of the west wall of the Parthenon. Antikenmuseum, Basel und Sammlung Ludwig, Basel.

The most famous Doric building is the fifth-century-B.C. Parthenon in Athens, a temple dedicated to the city's patron goddess, Athena. We discuss the Parthenon in its historical context in Chapter 16. Here we illustrate a cast of the reconstructed west wall of the building (**figure 14.7**). It shows the columns rising directly from the top step (**stylobate**) and the slight bulge of the shafts (**entasis**). The use of entasis, which is the Greek word for "stretching," reveals the Greek view of architecture as having organic, lifelike quality. The Doric Order, in its imposing, sturdy appearance, was associated with the unity and forcefulness of the Greek military formation known as the phalanx.

The Doric capitals consist of a square **abacus** and a curved, trapezoidal **echinus**. Surmounting the capitals is a horizontal lintel (the **entablature**) composed of three sections that continue around all four walls of the building: the plain **architrave**; the sculptural frieze; and the thin **cornice**, which forms the base of the triangular pediment that crowns the two short sides. Compared with the Egyptian post-and-lintel, the Greek forms are both more complex and more geometric. In addition, the Greek Orders have become a foundation of the Classical tradition in Western architecture—evident in many American banks, in Colonial American churches, and in U.S. federal buildings.

Arches and Vaults

Arches have the advantage of being able to support more weight and span a larger space than a horizontal lintel. The arch carries the thrust of weight to the sides, whereas in post-and-lintel it is the lintel that supports all the weight above it. Arches can also be extended through space and intersected to create different types of ceiling vaults.

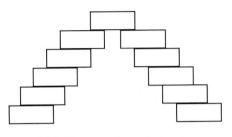

14.8 Diagram of a corbel arch.

Corbel Arches

One of the oldest arch forms is the **corbel arch**, which can be constructed of heavy, uncut stones or highly polished and shaped ones. The diagram in **figure 14.8** shows how the most basic corbel arch is constructed. **Courses** (layers) of stone blocks opposite each other are arranged so that as the layers rise, the blocks project progressively further beyond the edge. When they meet, they form an arch. An example of a corbel arch can be seen in the Lion Gate of Mycenae, in Greece, which we discuss in Chapter 15 (see figure 15.28).

When extended, a corbel arch produces a corbel vault of the type used at the Mycenaean site of Tiryns (**figure 14.9**). Like the Lion Gate, the corbel vault shown here is characteristic of the imposing monumental effect created by building with large, rough stones.

COMPARE

Lion Gate, Mycenae.
figure 15.28, page 314

14.9 Corbel Arch at Tiryns, Greece, c. 1300–1200 B.C.

14.11 Faleri Gate, Tiber Valley, Italy, 3rd century B.C.

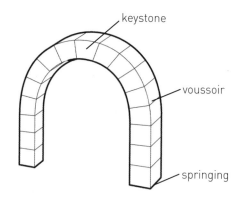

14.10 Diagram of a round arch.

Round Arches, Barrel Vaults, and Groin (Cross) Vaults

Round arches (**figure 14.10**) were first used in ancient Babylon and later became a favorite type of Roman construction. **Figure 14.11** illustrates a simple round arch of the kind the ancient Romans used to span openings in their city walls. The arch begins to curve (the **springing** of the arch) from a narrow horizontal base that projects slightly from the wall (the **impost**). The curve of the arch is made possible by wedge-shaped **voussoirs** (slightly tapering stones), which are locked in place by a central **keystone** at the top. Above the keystone is a small head carved in relief representing Janus, the Roman god of gateways, whose two faces allow him to see forward and backward simultaneously. He thus "keeps an eye" on travelers as they come and go.

The extension of a round arch creates a barrel vault (**figure 14.12**)—so-called because it resembles the inside of a barrel. A good example of a relatively short barrel vault can be seen in the second-century-B.C. dining alcove of an upper-class Roman house in Pompeii (**figure 14.13**). Here the vault springs from a cornice, which is supported by both a solid wall and four columns resting on square bases (**podia**; singular, **podium**). The combination of the curved vault with the vertical element creates an elegant, inviting space that gives the illusion of expanding toward the viewer and receding toward the back wall.

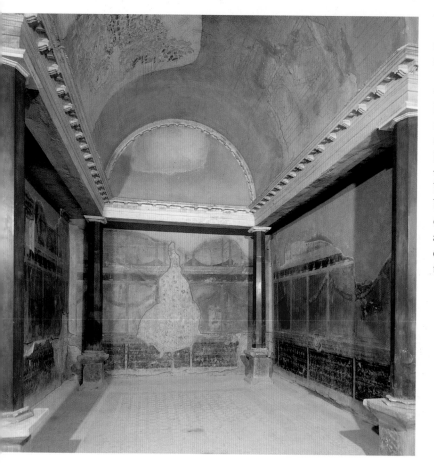

14.13 Dining alcove, House of the Silver Wedding, Pompeii, 2nd century B.C.

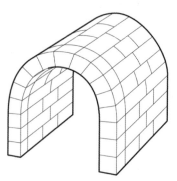

14.12 Diagram of a barrel vault.

When two barrel vaults intersect at right angles, a **groin vault** (also called a **cross vault**) is created. As is shown in **figure 14.14**, a groin vault can span a broader, more varied space than a barrel vault. The groin vault was also developed in ancient Rome and used later by medieval builders in the Romanesque Period (c. 1000–1150). We discuss Romanesque architecture in Chapter 17, but here we illustrate the vast space covered by groin vaults in the High Renaissance church of Santa Maria degli Angeli (**figure 14.15**). This was converted by Michelangelo in the sixteenth century from the central hall of the Roman baths of Diocletian, which were built from A.D. 298 to 306. Note the flowing quality of the ceiling and its expansion toward the huge, elaborate Corinthian columns on the side walls. The rhythms of the vault seem to merge naturally with the decorative features, creating an impressive and animated relationship between solids and voids.

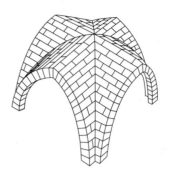

14.14 Diagram of a groin or cross vault.

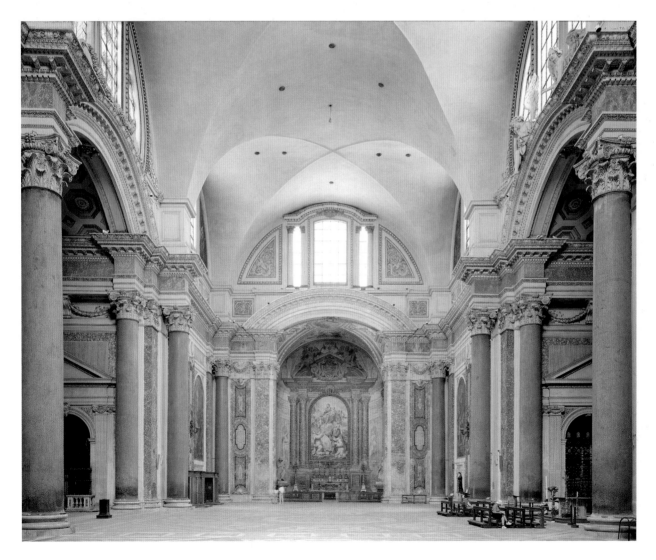

14.15 Santa Maria degli Angeli, Rome, originally the central hall of the baths of Diocletian, A.D. 298–306. Converted to a church in 1563–1566 by Michelangelo.

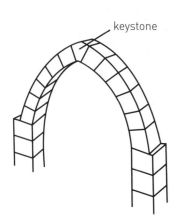

keystone

14.16 Diagram of a pointed arch.

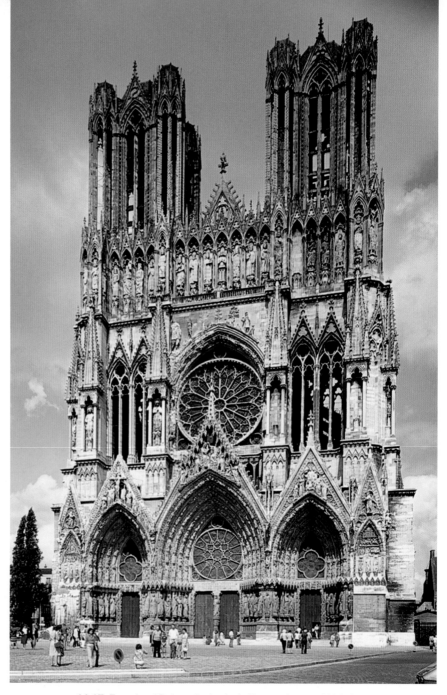

14.17 Façade of Reims Cathedral, France, begun 1211. Stone.

Pointed Arches and Rib Vaults

The disadvantage of using round arches and barrel vaults is that their massive weight limits their height, their interiors are dark, and their windows are small. In the mid-twelfth century, Gothic architects invented the pointed arch (**figure 14.16**), which was mainly used in churches and cathedrals (**figure 14.17**). The pointed arch allowed for taller and wider buildings than had been possible with round arches.

Reinforcing the increased height of buildings constructed with pointed arches were heavy exterior **buttresses**. These carried the thrust of the arches outward and downward. The upper buttressing sections are called **flyers**, or **flying buttresses**, because of their wing-shaped forms (**figure 14.18**). They reinforce the interior upper-story arches and carry their thrust down to the lower sections of the buttresses.

With these new features, Gothic builders were able to open up the walls and fill the spaces with huge stained-glass windows. **Figure 14.19** shows an interior view of the **nave** (center aisle space) of Laon Cathedral. We can see the vertical thrust of the space created by the pointed arches and the **rib vaults** compared with the groin vaulting in Santa Maria degli Angeli. The walls of Laon, which are supported on the outside by the new Gothic buttressing system, have been opened to accommodate the stained-glass windows.

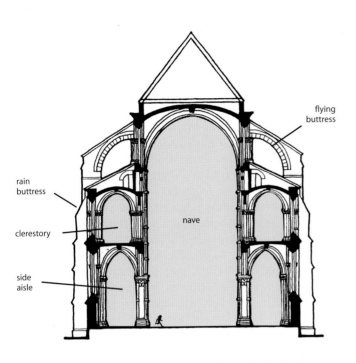

14.18 Transverse section of Laon Cathedral.

rain
buttress

clerestory

side
aisle

nave

flying
buttress

14.19 (Right) Nave of Laon Cathedral, begun c. 1150, later rebuilt.

Another type of arch was developed in Islamic architecture. This arch curves upward and inward, but ends in a point. The combination of a graceful motion with an upward thrust characterizes the arched façade of the Ulugh Beg Madrassa, in Samarkand, Uzbekistan (**figures 14.20** and **14.21**). In contrast to the stone exteriors of Gothic cathedrals, which are decorated mainly with stone sculptures, Islamic exteriors are enlivened with surface patterns of enormous variety. There is more emphasis on color and light inside the Gothic cathedral than outside. With Islamic architecture, on the other hand, there is more attention to exterior color design than in Gothic buildings.

14.21 Diagram of an Islamic arch.

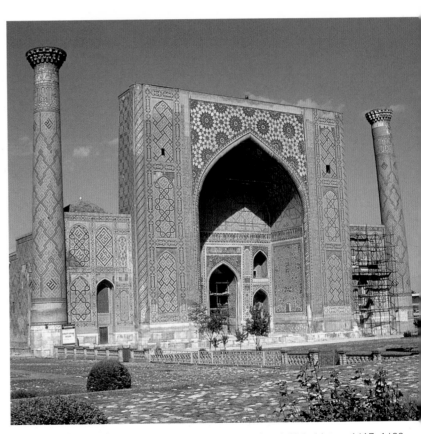

14.20 Ulugh Beg Madrassa, Samarkand, Uzbekistan, 1417–1420.

Domes

Domes are a form of architectural crown. They are generally the uppermost features of a building, to which they impart a sense of grandeur. There are several types of domes, all of which have a downward and outward thrust. **Corbel domes**, made by rotating corbel arches (**figure 14.22**), were used in constructing monumental royal **tholos** (plural **tholoi**) tombs in ancient Mycenae (**figure 14.23**). They were built of large stone blocks, rising upward from a circular ground plan and diminishing toward the center at the top. Since their shape resembles that of a beehive, tholoi are sometimes called beehive tombs. Their monumental size and rugged surfaces reflect the warrior culture ruled by the kings and queens buried there (see Chapter 15).

The 360-degree rotation of a round arch produces a hemispherical dome. Although such domes were designed by the ancient Romans, they are still used today, especially to create an imposing effect. A good example is Thomas Jefferson's dome for the early-nineteenth-century library of the University of Virginia (**figure 14.24**). This dome, like ancient Roman domes, rests on a sturdy cylinder base—the **drum**—and crowns the building (**figures 14.25** and **14.26**).

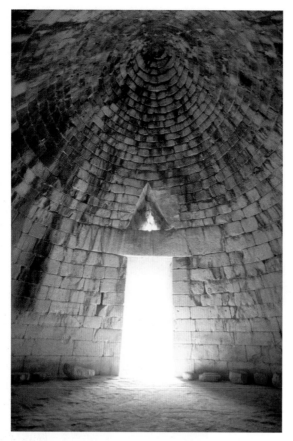

14.22 Interior of corbel dome of the Treasury of Atreus, Mycenae, Greece, c. 1300 B.C. Limestone, c. 43 ft. high.

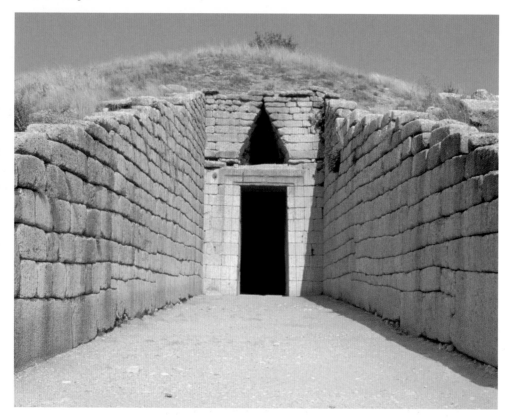

14.23 Exterior of the Treasury of Atreus.

14.24 Thomas Jefferson, University of Virginia Rotunda, Charlottesville, 1817–1826.

14.25 Diagram of rotating a round arch to create a dome.

14.26 Diagram of a dome on a drum.

COMPARE

Pantheon, Rome.
figure 16.23, page 334

COMPARE

Plan of the Pantheon.
figure 16.22, page 334

When Jefferson designed the library (also called the **Rotunda**—a round structure), he used the form and plan of the second-century-A.D. Roman Pantheon as models.

The Pantheon, which we discuss further in Chapter 16, is one of the largest surviving examples of an ancient dome resting on a round drum. In contrast to the exterior of the Pantheon, Jefferson's exterior walls are mainly of red brick, which was a favorite building material in colonial America. The entrance, reflecting the Classical inspiration of Jeffersonian architecture and political philosophy, is a Greek temple front superimposed over the drum, as in the Pantheon.

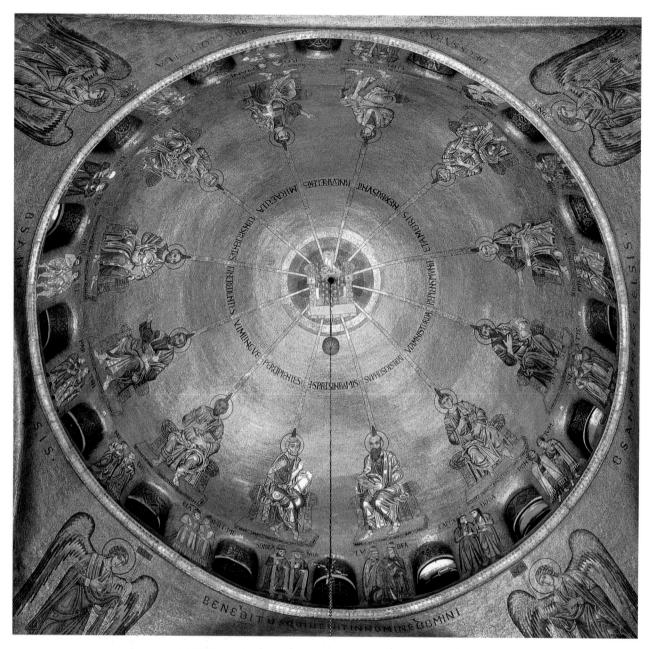

14.27 Pentecost Dome of Saint Mark, Venice, 12th century.

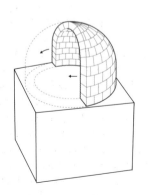

14.28 Diagram of a dome directly on a cube.

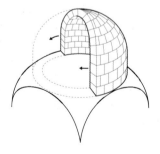

14.29 Diagram of a dome on pendentives.

14.30 Space below the Pentecost Dome of Saint Mark, Venice, 12th century.

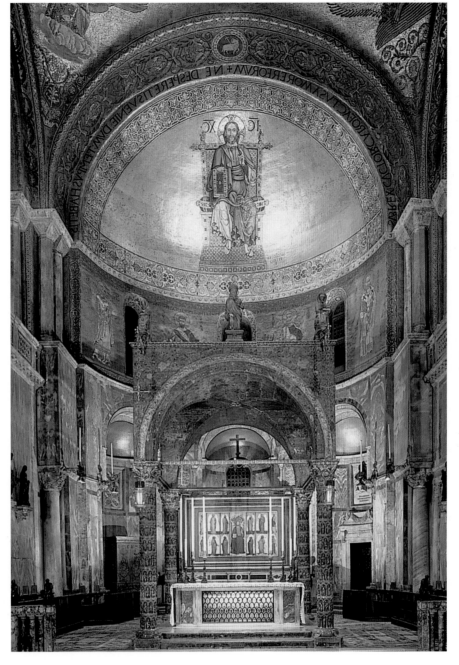

Sometime around the sixth century A.D., Byzantine architects developed a new feature for hemispherical domes suspended over a cube rather than on a round base. Since a dome placed directly on a cube seems to lack formal unity, Byzantine architects invented the **pendentive**. Pendentives are curved triangular architectural elements that transfer weight from the dome to the supporting cube. The pendentives also create a smooth visual movement from the round base of the dome to the square cube. We can see the effect of pendentives on an interior space in the late Byzantine, twelfth-century basilica of Saint Mark in Venice (**figure 14.27**). In this view, we are looking straight up into the Pentecost Dome,

which depicts Christ's twelve apostles receiving the gift of tongues (the ability to speak many languages) through rays of heavenly light extending from the center. The four pendentives, each of which contains the image of an angel, carry the dome's thrust downward. See **figures 14.28** and **14.29** to compare the diagrams of a dome on a cube space with a dome on pendentives. The thrust of the pendentives is carried downward through the heavy rectangular piers framing the open cubed space below (**figure 14.30**). The image on the interior of this particular dome exemplifies the meaning of domes in church architecture generally— namely, to symbolize the dome of heaven.

14.31 Sultan Barsbai's Complex, Mamluk, 1432. Eastern Cemetery of Cairo.

14.32 Diagram of a melon dome.

There are no domes in Gothic architecture, but there are at least two types used by Islamic architects. The so-called **melon dome** rests on drum and surmounts sections like that at the Sultan Barsbai's fifteenth-century Mamluk complex in the Eastern Cemetery of Cairo, in Egypt (**figure 14.31**). It bulges outward like a melon and forms a point at the top (**figure 14.32**). In contrast to the relatively plain domes found in Western architecture, Sultan Barsbai's domes are decorated with elaborate patterns carved in relief.

14.33 Diagram of an onion dome.

Another type of dome used by Islamic architects is the **onion dome**, so-called because of its shape (**figure 14.33**). The most famous Islamic examples of the onion dome surmount the Taj Mahal, in Agra, India, which we discuss in Chapter 20 (see figure 20.24).

During the nineteenth century, in Brighton, on the south coast of England, the Prince Regent commissioned an entertainment pavilion (**figure 14.34**) crowned with several onion domes inspired by the Taj Mahal. Here, the domes had no religious significance, but rather appealed to the playful imagination of the architect John Nash (1752–1835) and conformed to the recreational function of the pavilion. Note also the use of elaborate Islamic-style arches on the exterior.

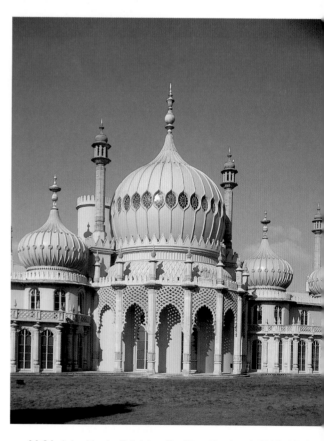

14.34 John Nash, Brighton Pavilion, England, 1815–1818.

The Geodesic Dome

In 1947, the American architect and engineer, R. Buckminster Fuller (1895–1983) invented the **geodesic dome** (**figures 14.35** and **14.36**). Fuller was inspired by polyhedrons (many-sided, solid geometric shapes) that occur in nature and he used their forms to construct a skeleton. His skeleton was of light-weight, prefabricated modules attached together and shaped into a large hemisphere having a diameter of 250 feet. The skin sheath, in the case of the U.S. Pavilion for Expo-67, the Montreal World's Fair held in 1967, was glass. The view shown here reveals both the practical value (it is relatively inexpensive to build) and the aesthetic effect of Fuller's geodesic dome. In addition, the globular form, combined with the interior architectural shapes visible in the illuminated interior, can be read as a metaphor for the Earth and the creative products of humanity. As such, Fuller's Expo-67 dome is perfectly suited to a World's Fair.

Truss and Balloon Frames

A **truss** (**figure 14.37**) is a structural frame composed of triangles. They are arranged as shown in the diagram either to span a space or to reinforce a building, or part of a building. One of the most common uses of trusses is in bridges. **Figure 14.38** shows a railroad bridge spanning the space over a river with a truss support below the tracks.

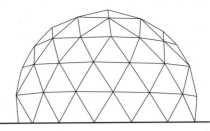

14.35 Diagram of a geodesic dome.

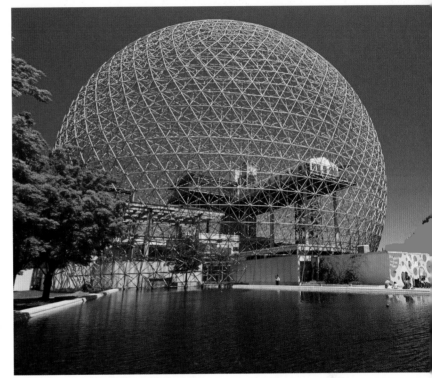

14.36 R. Buckminster Fuller, Expo-67 Geodesic Dome, Montreal, Canada, 1967. Metal and glass, 250 ft. diameter. Photo: Russe Kinne/Comstock.

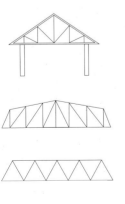

14.37 Truss diagrams.

> The principles governing structure not only prescribe what man can put together, but they are operative at the molecular level, at the atomic level, and at the nuclear level. They are also operative in each of man's life cells and throughout principles of structure in the starry heavens. They are universal, they are purely mathematical, weightless.
>
> Richard Buckminster Fuller (1895–1983), on the geodesic dome.

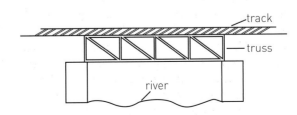

14.38 Diagram of a truss bridge.

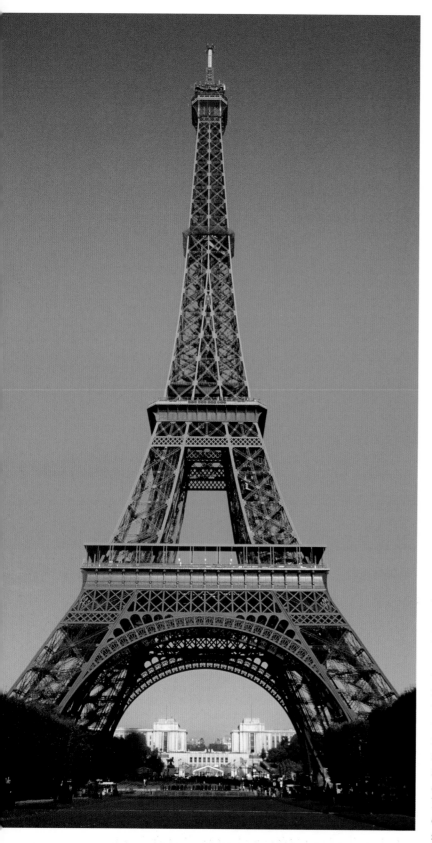

14.40 Alexander Gustave Eiffel, Eiffel Tower, Paris, France, 1889. Iron, 934 ft. high.

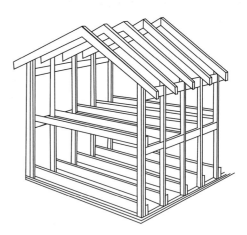

14.39 Balloon frame diagram.

A **balloon frame** (**figure 14.39**) structure is made by nailing together planks of wood (2 by 4s), adding a roof, and sheathing the frame in a skin made of different material. In the U.S., balloon frame buildings have been used since the 1830s—about the same time that iron nails were invented for domestic architecture. The most usual skin sheathing, which covers the load-bearing walls, is wood, especially American-style shingles, but it can also be glass, stone, brick, or stucco. The disadvantage of the balloon frame is that its height is limited, because wood is not strong enough to support tall buildings.

Cast-Iron Construction

Although iron was not a new material in the nineteenth century, it was not until then that the strength and fusibility of iron led to its increased use as an architectural support. This eliminated the need for heavy, load-bearing walls. Perhaps the most famous iron building, in which the skeleton is left unsheathed, is the Eiffel Tower in Paris (**figure 14.40**). Built at a cost of around $1 million, the Eiffel Tower caused controversy when it was first built because it struck people as unattractive and obtrusive. But today it is an instantly recognizable, soaring icon of the city of Paris. The base consists of four, inwardly sloping, broad arches leading to a horizontal story. Four additional curved sections rise from this first level to a second story, from which the skeleton continues in a single, slightly curved vertical to the radio tower at the summit.

Steel-Frame Construction and Reinforced Concrete

With the development of **steel-frame** construction (**figure 14.41**) in the late nineteenth century, architects had a material that could support tall buildings. This, together with cast-iron construction, is a characteristic feature of modern architecture. Designed to resemble a cage, the steel frame made it possible to build skyscrapers, which we take for granted today but which were revolutionary at the time. Skyscrapers could accommodate many more people, using less land at the foundation. This was more cost-effective—especially in cities—than buildings with fewer stories occupying more land.

The earliest major steel-frame skyscraper is the nine-story Wainwright Building (**figure 14.42**) in St. Louis, Missouri. Designed by Louis Sullivan (1856–1924) and built in 1890–1891, its exterior shell is made of stone and brick. Sullivan's famous assertion that "form follows function" is expressed here, as well as in subsequent skyscrapers. Their many stories and consequent height "follow" the practical and cost-effective "function" of providing space for a large number of people, using a relatively small amount of land. Skyscrapers have since become the standard for urban office buildings and apartments. Sullivan himself enhanced the aesthetic quality of the Wainwright Building by making a visual base of the lower stories, accentuating the corners with larger verticals than those separating the windows, and crowning the whole with a cornice that projects at the roof. In addition, below each window and the cornice are decorative, curvilinear friezes that relieve the rectangularity of the building.

> If a building is properly designed, one should be able with a little attention to read through that building to the *reason* for that building.
>
> Louis Sullivan, architect (1856–1924)

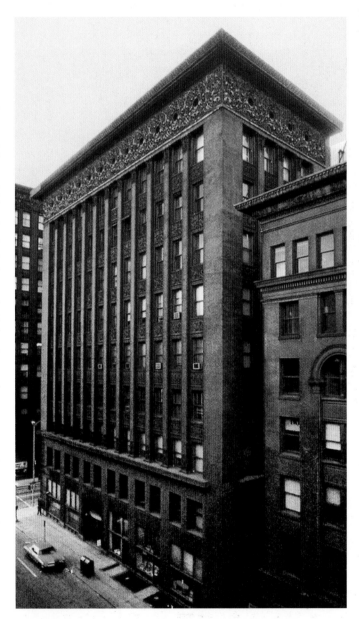

14.42 Louis Sullivan, Wainwright Building, St. Louis, Missouri, 1890–1891.

14.41 Steel frame diagram.

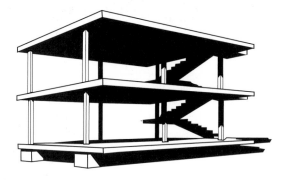

14.43 Le Corbusier, Diagram of domino construction, 1914–1915.

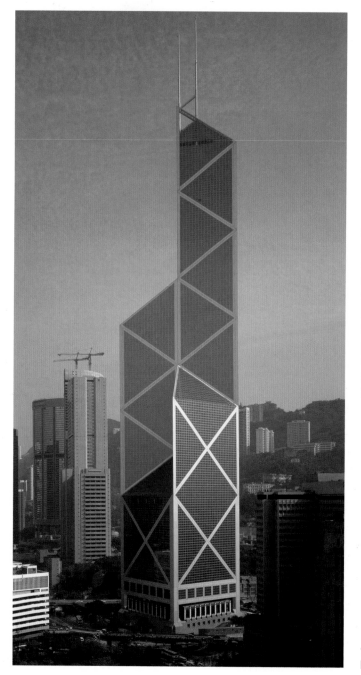

A type of steel skeleton that made use of rein-forced concrete (in which iron or steel rods are inserted into the concrete before it dries) was devised by Le Corbusier around 1914. Called **domino construction** (**figure 14.43**), this used vertical steel supports and horizontal slabs of reinforced concrete connected by stairways. Such features were characteristic of the International Style, a modern style that began in early-twentieth-century Europe to produce reasonably priced houses (see Chapter 25). Le Corbusier conceived of the ideal building in practical terms as a "machine for living." In domino construction the weight is borne by the floors and steel columns, rather than by load-bearing walls. As a result, the position of the interior walls could be altered to suit the practical needs of the occupants without worrying about the structural function of the walls.

In American skyscrapers, beginning in the 1950s, the use of domino construction was combined with steel-frame construction. This led to high-rise apart-ments and office buildings sheathed with glass, rather than with masonry as in the Wainwright building.

One of the most spectacular twentieth-century steel-frame skyscrapers is the seventy-story-high Bank of China building in Hong Kong (**figure 14.44**). Designed by I.M. Pei (b. 1917) and built in 1990 by his son, Sandi Pei (b. 1949), the Bank of China towers over the skyline of Hong Kong. The major portion of the building is a tall rectangular vertical sheathed in glass with a pattern of large squares and triangles superimposed over the reflec-tive surface. Crowning the rectangle is a triangular section from which an additional element rises asym-metrically, ending in a white vertical that seems to pierce the sky. This building, one of many built since the 1950s with a glass shell, has been interpreted as an image of the creative spirit in the British colony that was returned to mainland China in 1997.

14.44 I.M. Pei and Sandi Pei, Bank of China building, Hong Kong, 1990.

In Sydney, Australia, the Danish architect Joern Utzon (b. 1918) designed the Opera House (1956–1973) using reinforced concrete (also called **ferroconcrete**—concrete with iron) (**figure 14.45**). An advantage of this system is that the concrete (a mixture of cement and crushed stones and brick) is malleable before it dries. It can thus be shaped by the builder while it is still flexible and the interior rods reinforce its tensile strength. This allows for a variety of forms, which in the Opera House have a sculptural quality. The white curved shapes rise from the base of the structure like waves from the sea. They are animated, organic in appearance, and seem to flow along with the motion of the water in Sydney Harbor.

14.45 Joern Utzon, Sydney Opera House, Sydney, Australia, 1959–1972. Reinforced concrete, tallest shell 200 ft. high.

Cantilever Construction

In **cantilever** construction a horizontal beam extends past its vertical support (**figure 14.46**). In contrast to post-and-lintel, cantilevers open space and have the potential to increase the formal variety of a structure. During the early decades of the twentieth century, the American architect Frank Lloyd Wright (1869– 1959) used cantilever construction in houses designed to blend with their surroundings. Thus in 1909, when he built the Robie House in Chicago (**figure 14.47**), Wright emphasized horizontal planes that match the horizontal expanse of the street. Called the Prairie Style, Wright's architecture of this period was influenced by his attachment to the American prairies and plains of the West and Midwest. Here the roof sections are cantilevered so that they overhang and reinforce the long, low walls.

Wright believed that good architecture is organic, has a soul, and is related to nature and to the people who inhabit it:

> Beautiful buildings … are true organisms, spiritually conceived, works of art….[2]

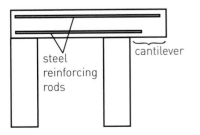

14.46 Cantilever diagram.

steel reinforcing rods

cantilever

14.47 Frank Lloyd Wright, Robie House, Oak Park, Chicago, Illinois, 1909.

14.48 Joseph B. Straus (chief engineer), Irving F. Morrow (architect), Golden Gate Bridge, San Francisco, California, 1937.

Suspension

The technique of creating suspension bridges is an ancient one. People have used flexible materials such as bamboo, rope, vines, and wood for suspension bridges for centuries. But with the development of steel in the nineteenth century, long, curved steel cables could be suspended from vertical supports sunk into a riverbed.

One of the most elegant examples of a steel suspension bridge is the majestic Golden Gate Bridge that spans San Francisco Bay (**figure 14.48**). Here there are only two vertical supports, towering above the rocky outcrops and the smooth surface of the water. The slim cables form long, sweeping curves and carry the viewer's line of sight from one end of the bridge, and from one side of the bay, to the other.

COMPARE

Gehry, *Guggenheim*, Bilbao.
figure 6.22, page 122

Computer-Assisted Design

With the development of computer technology, the design stages of architecture became more efficient. We can see this in Frank Gehry's use of the Catia computer program, which was originally developed for French aerospace projects. **Figure 14.49** shows a Catia model of the Guggenheim Museum in Bilbao, Spain, which we discussed in Chapter 6. Gehry digitized his drawings, rotated them on the computer, and produced a virtual building model. The dynamic, organic forms of the finished product are made of titanium, which resists erosion from the salty sea air. Both the interior and exterior spaces of the museum seem to flow and expand as if in continual motion. The effect of a blossoming flower echoes the notion that museums should expand the aesthetic intellect and visual perceptions of viewers.

14.49 Catia model of the Guggenheim Museum, Bilbao, Spain, 1992–1993. Basswood and paper.
© Gehry Partners, Santa Monica, CA.

———◆———

With our discussion of architectural systems, we conclude the first part of this text. In the next part, we survey the history of art and architecture in chronological order and in historical context. We begin with prehistory and continue to the twenty-first century.

Gateway Arch, St. Louis, Missouri

In 1947 the Finnish-born American architect Eero Saarinen (1910–1961) designed the Gateway Arch in St. Louis, Missouri (**figures 14.50**, **14.51**, and **14.52**). The arch, which cost $15 million, was begun in 1961 and completed five years later. The arch is dedicated to Thomas Jefferson, and is part of a memorial site that includes a 90-acre park beside the Mississippi River. It is located near the departure point of Lewis and Clark, when they set out on their famous expedition westward. Conceived as a gateway from the Midwest to the far West, as well as a memorial, the Arch is made of plated stainless steel and is embedded in sixty feet of concrete. It evokes the notion of entry and departure from the American past and into the artistic future.

The Arch is a striking curve—a **catenary**—made possible by the flexibility of the steel and its uniform density. It rises 630 feet in the air and spans an equal distance. Because the Arch can sway up to eighteen inches, it is flexible enough to withstand earthquakes and storms. Visitors can ride an egg-shaped mechanical car to the top of the arch for an east–west view of the city.

Saarinen used the Gateway Arch as a sculptural element rather than as a supporting one. It bridges the boundary of architecture and sculpture, reflecting the modern fluidity of traditional artistic categories. Figure 14.50 shows the Arch framing a section of the St. Louis skyline, which calls our attention to the urban design of St. Louis. In figure 14.51, the Arch frames the city's Old Courthouse, a good example of the Federal Style conceived by Jefferson, with its Greek Doric temple fronts, crowning dome, and regular symmetry. In figure 14.52, we see the Arch as an independent, reflective structure, surrounded only by the sky. Like many site-specific works, the Arch combines fluidity with permanence, and shows that works of art are both lasting and changing. If they are outdoors, they change with the weather, the seasons, and the time of day. Similarly, their original meaning is part of their history, but new generations of viewers bring new responses.

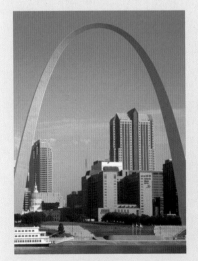

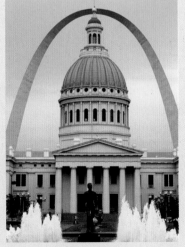

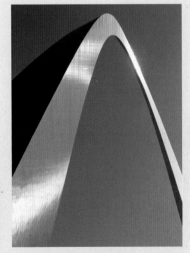

14.50 Eero Saarinen, Gateway Arch, St. Louis, Missouri, 1961–1966. Stainless steel and reinforced concrete, 630 ft. high.

14.51 Gateway Arch framing the Old Courthouse.

14.52 Gateway Arch alone.

Santiago Calatrava on Architectural Design

The Spanish-born architect Santiago Calatrava has been described as "an architect like no other ... a dreamer/ engineer who brings art and nature together in a way that is equally bold in its thinking and ingenious in its making."

Besides having the ability to engineer his architectural projects, Calatrava is a prolific sculptor and painter, and an advocate of drawing: "the practice of architecture combines all the arts into one." Calatrava's many interests and abilities are apparent when he speaks about his work.

Calatrava made a name for himself in the 1990s as "the wunderkind of bridges." His most famous is the Alamillo Bridge in Seville, Spain, which he completed in 1992 (**figure 14.53**). The 820 -foot-long, cable-stayed bridge is slender and elegant, and unusual in being stabilized without anchorages. Calatrava achieved this by designing a single, tapering vertical concrete pier that projects backward from the bridge's horizontal deck at an obtuse angle. The wide angle of the single pier, coupled with its distended base, stays a single set of cables and provides sufficient weight to anchor the entire structure.

The Alamillo project enabled Calatrava to take on infrastructural projects of increasing complexity. He challenged the basic principles of physics—a war that all architects and engineers wage over the inherent properties of materials and the forces of compression, tension, and static and active loads.

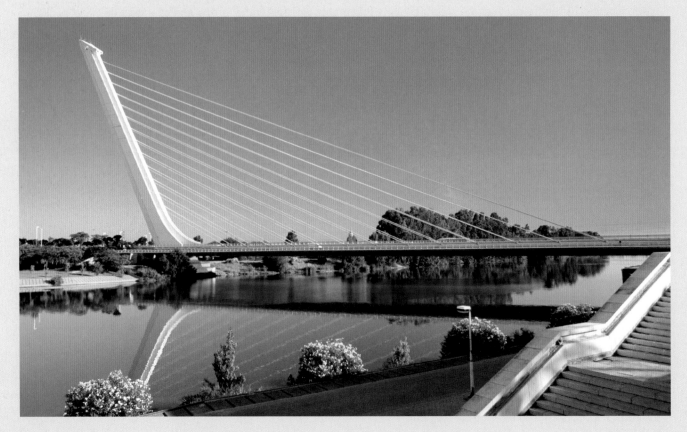

14.53 Santiago Calatrava, Alamillo Bridge, Seville, Spain, 1992.

MAKING

More recently Calatrava designed and engineered the expansion of the Milwaukee Art Museum (2001) (**figure 14.54**).

"Through many visits to Milwaukee, I came to not only know the client very well, but also to become familiar with the site. And so my idea was, first of all, to understand the city. I wanted to design a piece of the city, not only a building, even if only a tiny piece. I consider Milwaukee a young city, not like cities in Europe where you recognize the traces of Roman times. In Milwaukee there is huge potential."

Quotations by Calatrava from an interview in Architectural Record, 2006. Quotation about Calatrava by Dr. Liane Lefairne, curator of "Like a Bird", Kunsthistorisches Museum, Vienna, 2003.

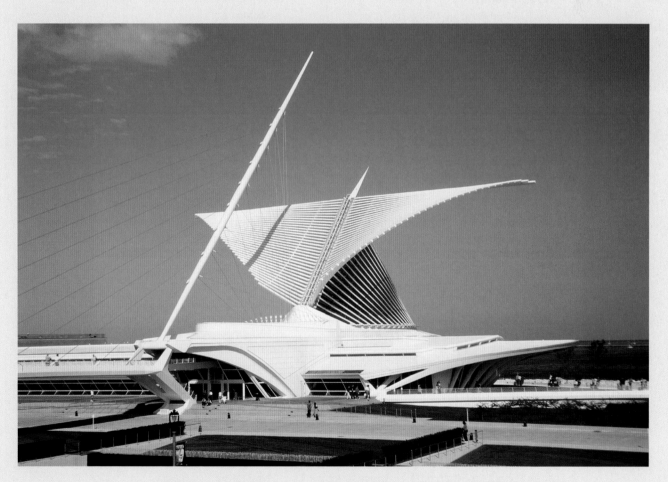

14.54 Santiago Calatrava, Milwaukee Art Museum, Milwaukee, 2001.

Chapter 14 Glossary

abacus—square element of the Doric captial

arch—curved architectural member used to span an opening

architrave—lowest long horizontal part of the entablature, resting directly on the capital of a column

balloon frame—frame for a building consisting of small members (as opposed to large beams) nailed together

base—lowest part of a wall or column considered as a separate architectural feature

buttress—exterior architectural support that counteracts the lateral thrust of an arch or a wall

cantilever—projecting beam or girder supported at only one end

capital—decorated top of a column

cast-iron construction—construction system relying heavily on the use of cast iron

catenary—curve assumed by a flexible cord suspended between two points (as in a cable used in a suspension bridge)

column—cylindrical support, usually with three parts—base, shaft, and capital

corbel arch—an arch formed by brick and masonry courses, each projecting beyond and supported by the one below

corbel dome—a dome formed by brick and masonry courses, each projecting beyond and supported by the one below

Corinthian Order—see **Orders of architecture**

cornice—topmost horizontal part of a Classical entablature

course—layer of stone

crenellation—series of indentations, as in a battlement

dome—hemispherical roof or ceiling made by rotating a round arch

domino construction—system of construction using vertical steel supports and horizontal slabs of reinforced concrete

Doric Order—see **Orders of architecture**

drum—circular support of a dome

dry masonry—stone construction in which no mortar is used to attach the stones

echinus (Greek for "hedgehog")—part of the Doric Order above the abacus

entablature—portion of a column above the capital, including the architrave, frieze, and cornice

entasis (Greek for "stretching")—bulge in the shaft of a Doric column

ferroconcrete—see **reinforced concrete**

flying buttress (or flyer)—buttress in the form of a strut or open half-arch

frame construction—method by which the framework of a building is constructed

frieze—central portion of an entablature in the Classical Orders, often containing relief sculpture

geodesic dome—dome-shaped framework consisting of small, interlocking polygonal units

groin vault (or cross vault)—vault formed by the intersection of two barrel vaults

impost—block, capital, or molding from which an arch springs

Ionic Order—see **Orders of architecture**

keystone—in a round arch, the top center stone which holds the voussoirs in place

load-bearing construction—system of construction in which solid forms are placed one on another to form a tapering structure

melon dome—dome in a shape resembling a melon

metope—square area between the triglyphs of a Doric frieze, often containing relief sculpture

nave—in basilicas and churches, a wide central aisle separated from the side aisles by rows of columns

onion dome—dome in a shape resembling an onion

Orders of architecture—one of the architectural systems (Doric, Ionic, Corinthian) used by the Greeks and Romans to decorate their post-and-lintel system of construction, especially in the building of temples

pendentive—architectural feature resembling a curved triangle that transfers the weight of a circular dome to a cubed support

plan—representation of a horizontal section of a building, usually at ground level (a ground plan)

podium (pl. podia)—masonry forming the base (usually rectangular) of an arch, temple or other building

post-and-lintel—elevation system in which two upright posts support a horizontal lintel

reinforced concrete (or ferroconcrete)—concrete strengthened by embedding an internal structure of steel mesh or rods

rib vault—vault formed by the intersection of pointed arches

rotunda—circular building, usually surmounted by a dome

shaft—vertical cylindrical part of a column that supports the entablature

springing—(a) architectural member of an arch that is the first to curve inward from the vertical; (b) point at which this curvature begins

steel-frame (or **skeletal**) **construction**—method of construction in which the walls are supported by a steel frame consisting of vertical and horizontal members

stylobate—top step from which a Doric column rises

suspension bridge—bridge in which the roadway is suspended from two or more steel cables which usually pass over towers and are anchored at their ends

tensile strength—internal strength of a material that enables it to support itself without fracturing

tholos (pl. **tholoi**)—circular tomb of beehive shape

triglyphs—three verticals between the metopes of a Doric frieze

truss construction—system of construction in which the architectural members are combined, often in triangular units, to form a rigid framework

vault—masonry roof or ceiling constructed on the arch principle

voussoir—wedge-shaped stone used in round arches

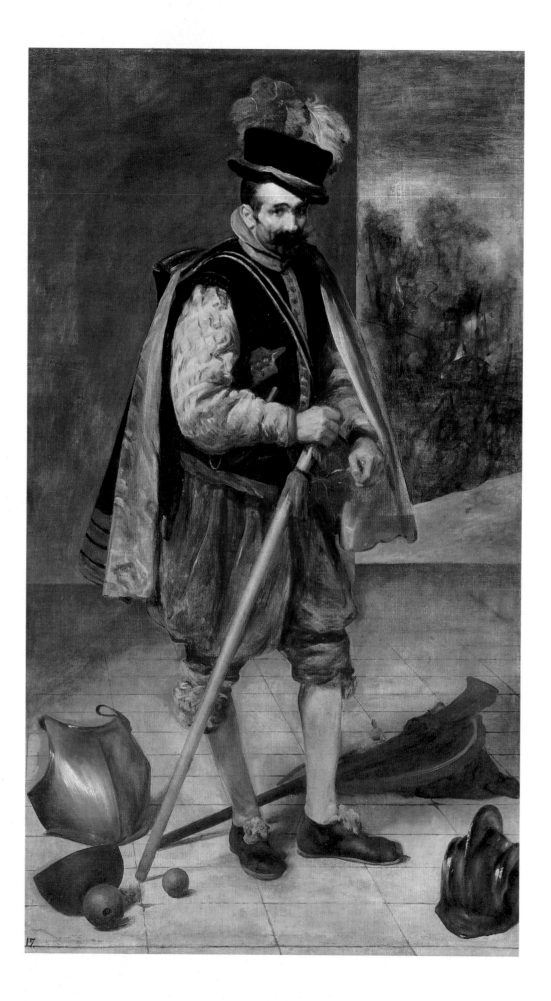

Part VI Art in History

In the first section of this text, we considered the main categories of visual art and ways in which the arts enhance our lives. Since each work of art is produced in a particular time and place, the more we know about the context of a work, the better we know that work. To reinforce our understanding of works of art, we select one example in each of the following chapters and discuss it from the points of view surveyed in Chapter 7: iconography, symbolism, biography and autobiography, and political context. As in Parts 1–5, we include quotes that are relevant to works and ideas presented in the text. Some are from ancient sources, some are from theorists and historians, and some are the words of the artists themselves. All have been chosen to give life to works of art, to the artists who created them, and to their cultural context. We also include brief interviews with artists and writers on art.

Four chapters on non-Western art give readers a sense of the enormous variety of world cultures and their artistic products. Although trade and travel have created cross-cultural contacts between distant and distinctive civilizations for millennia, the advance of modern technology has further increased the speed of international communication. Today the interchange of ideas, imported products, trade and legal agreements, news media, and advertising among disparate regions of the world have become a significant part of modern life. In the arts, as well, there is a new sense of globalization that makes some knowledge of non-Western cultures all the more important to our ability to understand and read imagery.

The traditional monumental arts fall into the categories of architecture, pictures, and sculptures, which comprise most of the works discussed in this section. As in Parts 1–5, we use the traditional Western dating system of B.C. and A.D. for works of art and time periods (see Chronology, p. 5). When a date is approximate or uncertain, we continue to use c., meaning "about" or "around." We begin our chronological survey with the ancient world, in which we include prehistory in Western Europe, the Ancient Near East, Egypt, and the Aegean civilizations. We then proceed to the arts and culture of Greece and Rome, and continue to the present.

(Opposite) Diego Velázquez, *The Jester Don John of Austria*, c. 1633. Oil on canvas, 6 ft. 10 ³/₈ in. x 4 ft. 10 ³/₈ in. Prado, Madrid.

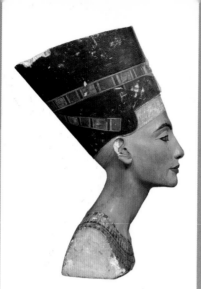

The Ancient World

Prehistory in Western Europe

The term "prehistory" as used here refers to periods of time when a particular culture did not have a writing system. In the absence of written records, scholars rely on physical remains for cultural evidence. Such remains include works of art, which are often the most impressive evidence available about a particular time and place.

In Western Europe (see map), the prehistoric period is far longer than the historical period, which began only about 2,000 years ago. Before that time there were hundreds of thousands of years of civilizations that are all but lost in time. Europe's prehistoric period is known as the Stone Age, when people used tools made of stone. The Stone Age is divided into three periods: the Old Stone Age (**Paleolithic**); the Middle Stone Age (**Mesolithic**); and the New Stone Age (**Neolithic**).

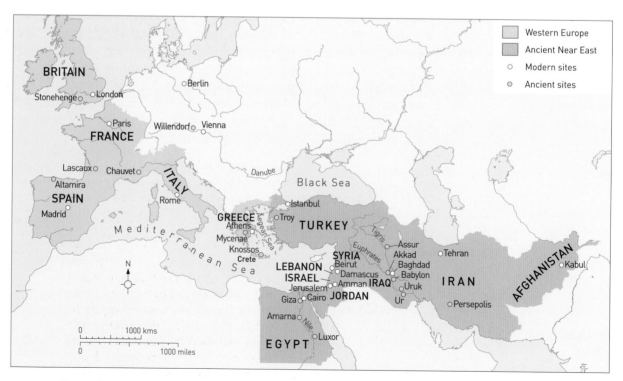

The ancient world.

During the Old Stone Age, which began about 1,500,000 years ago, the population of Western Europe was nomadic; people subsisted by hunting animals and gathering whatever food grew around them. In about 600,000 B.C., people learned to use fire, which provided heat and made it possible to cook food. But, because the Old Stone Age people did not form settled communities, they did not build permanent buildings. They probably made tents of animal skins, which were easily portable, and there is evidence of Old Stone Age structures constructed from animal bones. Most people, however, sought shelter at cave entrances.

Among the earliest works of art found in Western Europe are small-scale sculptures. These are generally dated to around 25,000 B.C. The most famous Paleolithic sculpture from Western Europe (**figure 15.1**) is a mere 4⅜ inches high. This little object was discovered at Willendorf, in modern-day Austria. Carved out of limestone, the figure impresses us with its massive proportions and sense of physical power. It is one of many Paleolithic sculptures of women whose breasts and pelvis are unusually large; they have been named "Venus" after the (much later) Roman goddess of love and beauty.

The nickname expresses the modern view that such statues were fertility figures. In fact, however, we do not know how they were used, although we presume that they had a symbolic purpose. The figure's thin arms resting on her enormous breasts tell us that the "Venus" of Willendorf is not an accurate representation of a fat or pregnant woman. She has no neck, and her face is covered. The artist has thus emphasized those parts of the female body most directly involved with reproduction and nourishment.

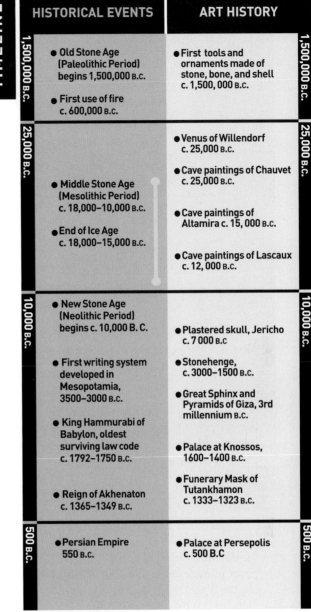

15.1 Venus of Willendorf, c. 25,000 B.C. Limestone, 4 ⅜ in. high. Museum of Natural History, Vienna.

TIMELINE	HISTORICAL EVENTS	ART HISTORY	
1,500,000 B.C.	• Old Stone Age (Paleolithic Period) begins 1,500,000 B.C. • First use of fire c. 600,000 B.C.	• First tools and ornaments made of stone, bone, and shell c. 1,500, 000 B.C.	1,500,000 B.C.
25,000 B.C.	• Middle Stone Age (Mesolithic Period) c. 18,000–10,000 B.C. • End of Ice Age c. 18,000–15,000 B.C.	• Venus of Willendorf c. 25,000 B.C. • Cave paintings of Chauvet c. 25,000 B.C. • Cave paintings of Altamira c. 15, 000 B.C. • Cave paintings of Lascaux c. 12, 000 B.C.	25,000 B.C.
10,000 B.C.	• New Stone Age (Neolithic Period) begins c. 10,000 B. C. • First writing system developed in Mesopotamia, 3500–3000 B.C. • King Hammurabi of Babylon, oldest surviving law code c. 1792–1750 B.C. • Reign of Akhenaton c. 1365–1349 B.C.	• Plastered skull, Jericho c. 7 000 B.C • Stonehenge, c. 3000–1500 B.C. • Great Sphinx and Pyramids of Giza, 3rd millennium B.C. • Palace at Knossos, 1600–1400 B.C. • Funerary Mask of Tutankhamon c. 1333–1323 B.C.	10,000 B.C.
500 B.C.	• Persian Empire 550 B.C.	• Palace at Persepolis c. 500 B.C	500 B.C.

We assume that in Paleolithic Europe, as today, childbirth was an event of great importance. It ensured the preservation of the species and provided new members of the community. We also tend to assume that a female's ability to reproduce must have seemed somewhat magical to societies with little knowledge of biology. We do not know if the work has any religious meaning, for we know little about religious beliefs in the Paleolithic period. There does, however, appear to have been a belief in the afterlife, indicated by burials in which the deceased is arranged in a fetal position facing the rising sun. Birth, like rebirth after death, seems to be a preoccupation of nearly every human society.

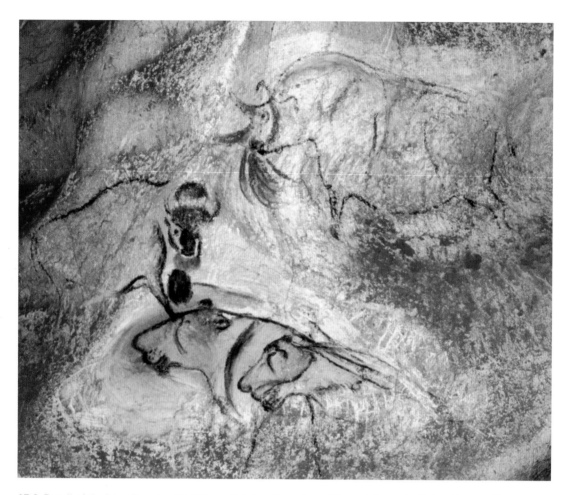

15.2 Detail of the Lion Panel, c. 25,000 B.C. Paint on limestone, Chauvet Cave, Ardèche, France. Chauvet Cave was discovered on 18 December 1994 by Eliette Brunel, Jean-Marie Chauvet, and Christian Hillaire.

In addition to their representations of women, Paleolithic artists carved small animal figures out of stone and bone. They also made monumental paintings, primarily of animals, on the walls of caves, such as the stags' heads we saw in Chapter 8 from the Lascaux cave in France (see figure 8.4). These have been found in modern France, Switzerland, and Spain (see figure. 2.7), as well as in parts of Africa and Australia. One of the oldest known caves containing prehistoric wall-paintings was discovered in 1994 at Chauvet, in the Ardèche region of southeast France. The Chauvet paintings, which may date to c. 25,000 B.C., show the artist's interest in naturalism and perspective (**figure 15.2**).

The detail illustrated here depicts a bison towering over two overlapping lions. The massive, monumental body of the bison is painted on a slight diagonal, but its head turns to assume a nearly frontal position. This compresses the space of the animal's neck and foreshortens it. By juxtaposing two sets of diagonals—defining the static pose of the bison and the forward motion of the lions—the artist creates a dynamic tension that reflects careful observation of nature.

The function of the cave paintings was not primarily decorative, for they are hundreds of feet inside the caves, which were not inhabited on a daily basis. But footprints on the ground suggest that ritual dances were performed in the presence of the paintings, although their meaning is not known. The paintings may have been associated with hunting ceremonies, since killing animals for food, clothing, and tools was necessary for survival. In any case, the prevalence of animal imagery, like the "fertility" figures, argues that the subject matter of Paleolithic art reflected the concerns of early human societies.

Between 18,000 and 15,000 B.C., roughly corresponding to the Mesolithic Period, the last Ice Age ended and the climate of Western Europe became more temperate. The Neolithic era began around 10,000 B.C., by which time the bow and arrow were in use. Societies had made the transition from hunting and gathering to settled farming communities using domesticated animals. The development of boats and fishing also led people to form societies grouped around streams and lakes.

COMPARE

Altamira bison.
figure 2.7, page 21

COMPARE

Frieze of Stags' Heads.
figure 8.4, page 148

The Neolithic Period witnessed advances in potterymaking, weaponry, and tools. In art, the Neolithic Period is noteworthy for the development of large-scale architecture in stone. The best-known and most-visited stone building constructed in the Neolithic Period is Stonehenge (**figures 15.3** and **15.4**), a **cromlech** (circle of stones) located on Salisbury Plain, in southwestern England. In Chapter 14, we discussed the basic post-and-lintel system of architecture, which was used at Stonehenge.

In the aerial view shown here, we can see the original outer ring of earth, which was put in place around 3000 B.C. and contains evidence of burials. The cromlech was built later, beginning around 1500 B.C. Its smaller, inner circle consists of single, upright bluestones (the posts). These are surrounded by five large, individual post-and-lintel units called **trilithons**, because each unit is made of three large stones. The outer ring of stones is composed of a second complete circle made by connecting the posts-and-lintels to form a wall. The larger stones are sarsen, a type of sandstone.

We have no written records of how Stonehenge was built. The wheel had not been invented, making it necessary to drag the stones (each weighing 50–100 tons), possibly using oxen, from quarries that were miles from the site. In addition, the lintels had to be raised and fitted onto the posts without a wheel-driven pulley system.

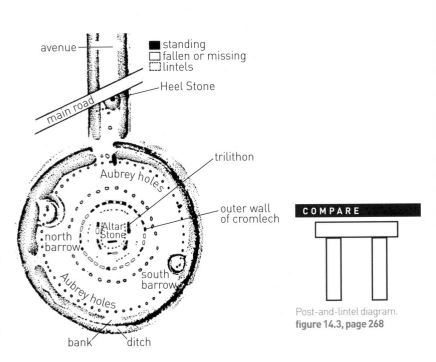

15.4 Plan of Stonehenge.

COMPARE

Post-and-lintel diagram.
figure 14.3, page 268

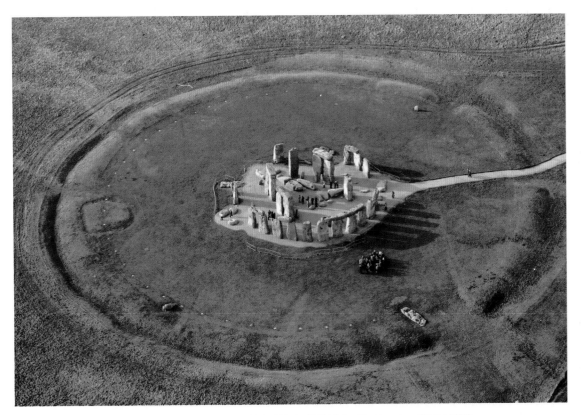

15.3 Aerial view of Stonehenge, Salisbury Plain, Wiltshire, England. c. 3000–1500 B.C. Bluestone and sarsen, height of outer stones c. 13 ft. 6 in., diameter of the cromlech 97 ft.

We also do not know the function of Stonehenge. That it was culturally significant is certain, for great care was taken in selecting the site—a flat plain, uninterrupted by other features of landscape. The building itself rises from the ground and mediates between the earth and sky. Even today, nothing interferes with the view of Stonehenge, for the British government has preserved the original site. People travel from all over the world to visit this remarkable monument, especially on June 21, the summer solstice, to watch the sun rise in alignment with the Heel Stone (see plan on p. 297). This upright stone stands outside the main cromlech to the east. Other stones are aligned with the setting sun at the winter solstice and with the rising moon at its farthest northern and southern points.

We assume that Stonehenge had some kind of religious meaning, possibly related to agricultural rituals, which are performed in virtually all human societies. Although archaeologists continue to investigate Stonehenge, its original purpose is still being debated, and it has been the subject of many interpretations. Empirical observation has revealed that the stones can be related to certain astronomical events in addition to the solstices, such as Halley's Comet and solar and lunar eclipses.

One scholar of ancient art and religion, Mircea Eliade, related the lasting quality of stone to the human wish to be remembered after death:

> … man hopes that his name will be
> remembered through the agency of stone; in
> other words, connection with the ancestors is
> insured by memory of their names and exploits,
> a memory 'fixed' in the megaliths.[1]

So far, Stonehenge, like the Venus of Willendorf and the Paleolithic cave paintings, remains a tantalizing mystery. These works remind us that the human race has a creative history stretching far back in time. Nevertheless, although parts of history may never be completely recovered, it is essential to continue exploring the past. For the more we know of our personal and cultural history, the more intelligent and meaningful our lives will be.

The Ancient Near East

The Ancient Near East includes what is today Turkey, Afghanistan, Egypt, Israel, Jordan, Syria, Lebanon, Iraq, and Iran. In the ancient world, these regions gave rise to some of the greatest civilizations ever known. They witnessed the rise and fall of powerful rulers, the development of cities, flourishing economies enhanced by trade and irrigation techniques, and the invention of the world's first known writing systems. Their religious beliefs were **polytheistic** (that is, they believed in many gods and goddesses).

The focal area of ancient Near Eastern civilization was Mesopotamia (modern Iraq). Literally "the land between the rivers," Mesopotamia is bounded by the Tigris and Euphrates (see map on p. 294). But its open landscape brought disadvantages as well as advantages. In times of war it was vulnerable to invasion, while in peace it profited from foreign trade and commerce.

The earliest literate ancient Near Eastern people were the Sumerians, located mainly in Sumer, in southern Mesopotamia. Beginning between 3500 and 3000 B.C., the Sumerians developed a writing system—**cuneiform**—so-called after its wedge-shaped letters (*cuneus* is the Latin word for "wedge") (**figure 15.5**). This marked the transition from prehistory in the region to the historical period. Cuneiform remained the language of commerce and was used by the intellectual elite throughout Mesopotamian history.

15.5 Diagram of cuneiform.

Since modern scholars can read cuneiform, we know a great deal more about the Ancient Near East than about prehistoric, nonliterate Europe. We know the history of their kings, the names and characteristics of their many gods, and their literature. We also have records of poetry, including the earliest known epic poem, the *Epic of Gilgamesh*. The epic recounts the hero's quest for everlasting life and the recognition that his immortality lies in his accomplishments. In the end, Gilgamesh lives on in the cultural memory as the builder of the walled city of Uruk, "Uruk of the Sheepfold," which reflects the rise of urbanization.

The author of the epic describes the architectural achievements of Gilgamesh:

> He ordered built the walls of Uruk of the
> Sheepfold
> The walls of holy Eanna, stainless sanctuary.
> Observe its walls, whose upper hem is like
> bronze,
> Behold its inner wall, which no work can equal.[2]

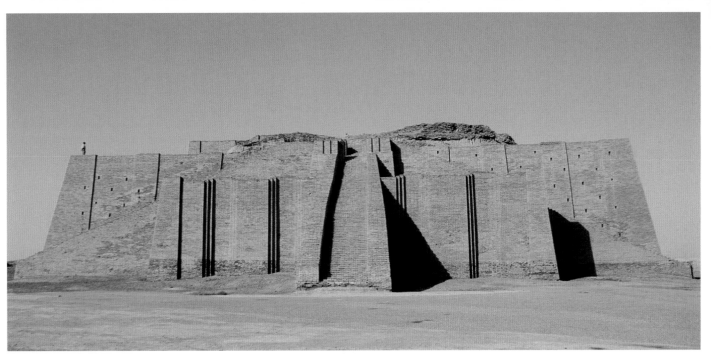

15.6 Nanna Ziggurat, c. 2100–2050 B.C. Ur, Iraq.

The most characteristic Mesopotamian building was the **ziggurat**, a stepped tower and an early example of load-bearing construction (see Chapter 14). Ziggurats usually supported a temple at the top. The third-millennium-B.C. Nanna ziggurat (**figure 15.6**) at Ur, dedicated to the Sumerian moon god, was built of mud-brick. Its temple has disappeared, but it might have been decorated and structurally reinforced with colored cone mosaics of the type discussed in Chapter 4.

Mesopotamians conceived of the ziggurat as a mountain towering over their flat, desert terrain. Each major city had a ziggurat, which was constructed to provide a dwelling place for a god. The god, in turn, would protect the city and be worshiped by its inhabitants.

Most of the major works of art that are preserved from ancient Mesopotamia are the result of royal patronage and religious ideas. In Chapter 4, we saw the gold and lapis lazuli headdress worn by a princess in ancient Ur (see figure 4.2). Many images of Mesopotamian kings have also survived. The bronze head in **figure 15.7**, which was broken off a full-length statue, might represent King Sargon I (ruled c. 2332–2279 B.C.), who founded the Akkadian Dynasty. The firm bone structure, prominent nose, and compressed, stylized forms of the hair and beard convey the impression of a forceful personality.

According to a Mesopotamian legend reminiscent of the biblical story of Moses, the infant Sargon was discovered floating down a river by a man drawing water named Akki, who raised him as his son. When Sargon became a king, he founded the Akkadian Dynasty, named for Akki. Sargon's sense of his own power is reflected in an ancient text, in which he himself is the narrator:

Sargon, the mighty king, King of Agade am I. My …mother bore me in, in secret she bore me. She set me in a basket of rushes, with bitumen she sealed my lid. She cast me into the river which rose not (over) me.

. . .

Akki, the drawer of water, [took me] as his son [and] reared me.

. . .

And for four and [...] years I exercised kingship.

. . .

Mighty mountains with chip-axes of bronze I conquered, The upper ranges I scaled, The lower ranges I [trav]ersed, The sea [lan]ds three times I circled.[3]

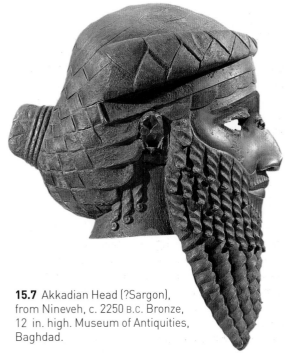

15.7 Akkadian Head (?Sargon), from Nineveh, c. 2250 B.C. Bronze, 12 in. high. Museum of Antiquities, Baghdad.

The Akkadians spoke a Semitic language that was different from Sumerian, and began their rise to power in northern Mesopotamia. Their capital, at Akkad, was located near modern Baghdad. From around 2300 B.C., the Akkadians expanded their influence and power, and conquered parts of Mesopotamia and Syria. They soon extended their control over the entire land.

The military might of the Akkadians is reflected in **steles** (boundary markers) decorated with images and texts that convey political power and moral superiority. The stele of Sargon's grandson, Naram-Sin (**figure 15.8**), for example, marked the victory of the Akkadian ruler over his enemies. It contains a cuneiform inscription and shows King Naram-Sin and his army striding up a mountain. Directly before him are two enemies, one with a spear in his neck and the other pleading for mercy.

Naram-Sin is the largest figure, which indicates his importance. He wears a horned cap of divinity and is protected by sky gods in the form of stars above him. Reflecting the fact that this is a statement of power, Naram-Sin's stance is proud and upright. His right ear and right eye face the viewer, indicating that he both listens to and watches over his subjects. In exposing his entire right side, he shows that he himself is endowed with moral rectitude and political wisdom.

With the rise of the Neo-Sumerian Period (c. 2150–1800 B.C.), Gudea of Lagash came to power, and many of his statues survive. He is typically shown in an attitude of prayer, as he is in **figure 15.9**. In this statue, which is made of hard, black diorite stone, the ruler is seated with his hands clasped in front of him. He wears a bell-shaped skirt covered with cuneiform inscriptions and his upper garment leaves one shoulder bare—a sign of piety in Mesopotamian art. Gudea's distinctive round cap is decorated with small circles on the rim. As is typical of Sumerian style, Gudea is shown with both organic form (the bulging arm muscles and the visible structure of the face) and stylization (the surface design on the eyebrows). The result is a dignified, elegant figure with a sense of tension and power.

Another great ancient Near Eastern king, Hammurabi of Babylon, ruled from around 1792 to 1750 B.C. His artists carved the oldest surviving law code (**figure 15.10**), a stele inscribed with laws that provide a window onto the legal traditions of Sumer. They were designed to reinforce

15.8 Stele of Naram-Sin, c. 2254–2218 B.C. Pink sandstone, 6 ft. 6 in. high. Louvre, Paris.

social stability rather than equality; by modern standards they are quite harsh and sometimes arbitrary. For example:

I: If a seignior accused [another] seignior and brought a charge of murder against him, but has not proved it, his accuser shall be put to death.[4]

153: If a seignior's wife has brought about the death of her husband because of another man, they shall impale that woman on stakes.[5]

At the top of the stele, the sun god, Shamash, is seated on a symbolic palace with his feet resting on a stylized mountain. He wears the horned cap of the gods and emits rays of light from his shoulders. With his right hand, he confers emblems of kingship on Hammurabi, who stands before him. This shows that the king ruled by divine right and that his laws were blessed by the gods.

By the time Hammurabi died, the Assyrian empire had formed in north Mesopotamia. Named for their chief god and capital city of Assur, the Assyrians were known for their cruelty in battle. They built vast, fortified palaces and lined the walls with stone reliefs depicting their military might.

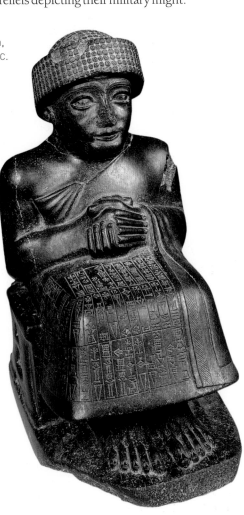

Gudea of Lagash, Telloh, c. 2100 B.C. ite, 17 ⅝ in. high. vre, Paris.

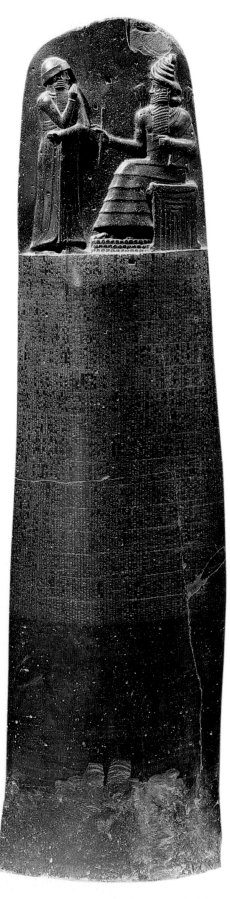

15.10 Law Code of Hammurabi, c.1792–1750 B.C. Black basalt, c. 7 ft. high. Louvre, Paris.

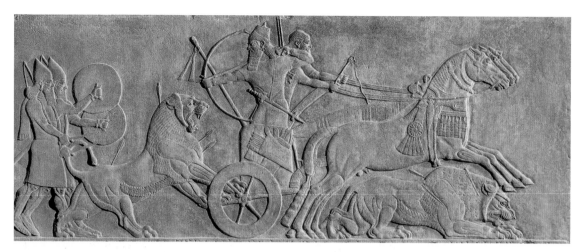

15.11 Assurnasirpal II Hunting Lions, from the palace at Nimrud, 9th century B.C. Alabaster, 3ft. 3 in. x 8 ft. 4 in. British Museum, London.

The relief in **figure 15.11** shows the ninth-century-B.C. Assyrian king Assurnasirpal II hunting lions. Since lions are fierce killers as well as regal animals, the Assyrian kings identified with them, but also wanted to appear more powerful than lions. In this relief, the king stands in a chariot and takes aim at a rearing, roaring lion that has already been shot four times. Another lion lies dead beneath the horses. The symbolic nature of this lion hunt is clear from the degree to which the king is protected—by the fleeing chariot and the armed soldiers behind the lion.

The Neo-Babylonian Empire that flourished in the sixth century B.C. under King Nebuchadnezzar produced the earliest surviving example of a monumental round arch. As we saw in Chapter 14, a round arch can support more weight and span a larger space than a lintel of the same material. **Figure 15.12** illustrates a reconstruction of the Ishtar Gate, named for the Babylonian goddess of love, beauty, and war. It was one of six gates that spanned a processional roadway used for parades and celebrations. The surface of the gate is decorated

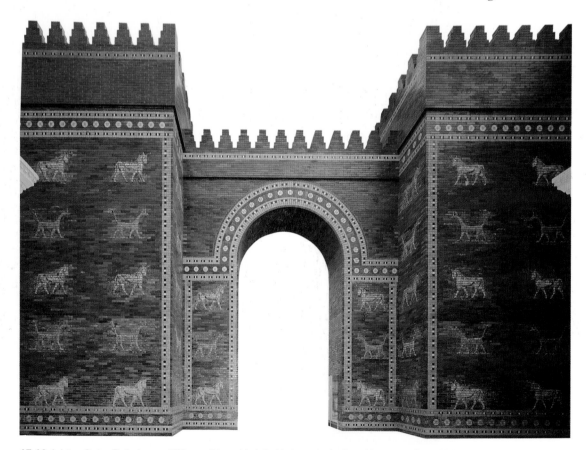

15.12 Ishtar Gate, Babylon, c. 575 B.C. Glazed brick. Voderasiatisches Museum, Staatliche Museen, Berlin.

with a blue background of glazed bricks, across which rows of real and fantastic animals appear to proceed at a slow pace. Framing devices that accentuate the architectural shapes are both floral and abstract. The crenellations at the top probably had a defensive as well as a decorative function.

From the late seventh century B.C., a great empire arose in Persia (modern Iran). The rulers are known as the Achaemenids from their dynastic name. They believed in a world dominated by two forces, good and evil, represented by light and dark, respectively. As a result, the Persians worshiped outdoors at fire altars, which embodied light, and did not build temples.

The primary Achaemenid architectural expression was the palace. Although less cruel than the Assyrians, the Persians shared their taste for elaborate decoration. In addition to their skill in metalwork, which we saw in the gold drinking vessel in Chapter 4 (see figure 4.12), Persian artists carved reliefs on palace walls such as the procession of tribute bearers in **figure 15.13**. They are carved as if mounting the stairs, unifying the sculptures with their architectural setting. The large audience hall, which is now in ruins, originally had 100 forty-foot-high columns. The capitals of the columns, representing the king as head of state, were in the shape of regal animals, especially bulls.

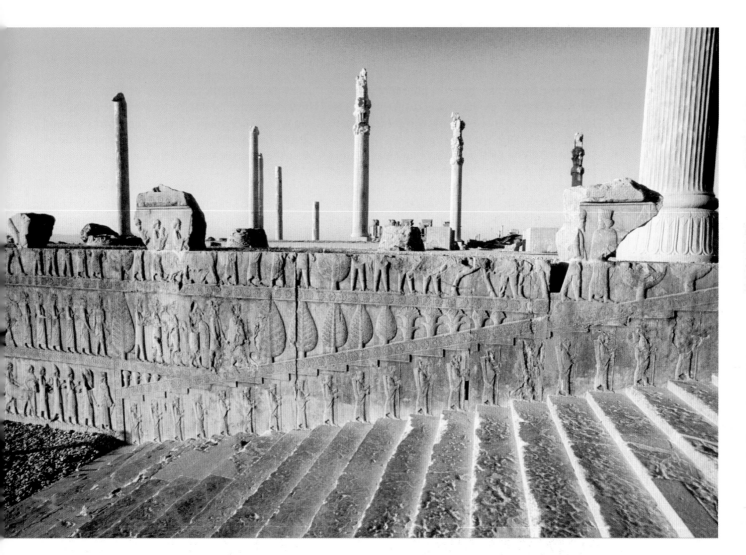

15.13 View of the Palace at Persepolis, showing staircase and apadana, c. 500 B.C.

Ancient Egypt

Contemporary with the history of Mesopotamia and its Persian neighbor, ancient Egypt produced a civilization that lasted for 3,000 years. Located in Northeast Africa, Egypt was unified geographically by the Nile, the world's longest river. It extends from central Africa to its delta, which flows into the Mediterranean Sea. To the east and west, Egypt is bounded by desert and to the south lies Nubia, which is part of black Africa (see Chapter 22). Egypt's geography made the country more isolated than Mesopotamia, which, together with its political system, reinforced the continuity of Egyptian culture.

Egypt, like Mesopotamia, was polytheistic. Virtually every aspect of life—the sky, the earth, the Nile, the family, birth and death, medicine, technology and the arts, and so forth—was under the protection of a god. In contrast to Mesopotamia, however, the Egyptian ruler (the **pharaoh**) was conceived of literally as the sun-god on earth. This increased his power enormously and contributed to the relative stability of ancient Egypt.

The most complete records of Egyptian history begin with the first pharaoh, Menes (also called Narmer), who unified north (Lower) and south (Upper) Egypt in 3100 B.C. With this unification, pharaonic rule was established and dynasties of kings ruled until Egypt was conquered by the Romans in 31 B.C. These dynasties are grouped into three main periods of Egyptian history: the Old Kingdom (2649–2150 B.C.); the Middle Kingdom (1991–1700 B.C.); and the New Kingdom (1550-1070 B.C.). The intervening years are called Intermediate periods. The Third Intermediate Period ended in 660 B.C. and was followed by the Late Dynastic period (688–343 B.C.), a twenty-year period of Persian rule (343–323 B.C.), and the Ptolemaic period (323–31 B.C.), when Egypt was ruled by Macedonian (north Greek) kings after the death of Alexander the Great.

As with Mesopotamia, we know a great deal about ancient Egypt, not only because its picture-writing system (**hieroglyphics**) has been deciphered, but also because the dry climate has helped to preserve an enormous amount of Egyptian art and architecture.

In 3100 B.C., an artist carved the Palette of Narmer (**figure 15.14**) with a relief illustrating the unification of Upper and Lower Egypt. Discovered in a temple and dedicated to a god, its iconography combines religious symbolism with a statement of the pharaoh's power.

Narmer (Menes) is the largest figure (as is Naram-Sin in figure 15.8). His pose is the conventional one for kings in ancient Egypt: the head and legs are in profile, the eye and torso are frontal, and the flat tunic masks the sharp twist that would naturally occur at the waist. The flat character of the relief as well as the king's pose is typical of Egyptian pictorial style. The pose is conceptual rather than natural, for the artist shows us what we know to be part of the king's body rather than what we would actually see in either a front or profile view. The flatness tends to create an air of timelessness, for the figures do not exist in the real space of our everyday experience.

In contrast to Mesopotamia, Egypt possessed a great deal of stone, which made it possible to create architecture and sculpture on a huge scale. The architectural type that is most characteristic of Egypt is the pyramid, a colossal tomb built for the pharaoh, such as the Old Kingdom pyramid of King Zoser that we saw in Chapter 2 (see figure 2.4).

Pyramids have proved to be an important source of information for ancient Egyptian civilization. They were elaborate burials containing statues, paintings, furniture, and texts to accompany the deceased in the afterlife. As early as the third millennium B.C., Egyptian tombs contained Pyramid Texts—hieroglyphs carved on their interior walls. A main theme of the texts was the king joining the gods in the afterlife:

> This is the King, who startles the heart, darling
> of air, far-stretched across the sky, a blinding
> light…
> The king treads the air, strides over earth, kisses
> the waters of the ur-god's high hill,
> Those at the zenith open their arms to him;
> and he stands on the heights of the eastern
> sky …[6]

The texts, which are the oldest known large body of religious literature, praise the king in his many aspects. Pyramid Text 373, "Prayer to King Teti to Rise Up", shows the belief in a material afterlife:

> ….Raise yourself up, O King Teti!
> Take back your head,
> gather your bones;
> Collect your limbs,
> shake the earth from your flesh;…[7]

In Text 486, King Pepi is a primordial god:

> I, King Pepi, was born in that Chaos before there
> was sky, before there was earth,
> Before there were heavenly pillars, or strife,…[8]

COMPARE

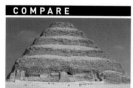

Pyramid of Zoser.
figure 2.4, page 19

Reading the Palette of Narmer:
An Excursion into Egyptian Iconography

The scene on the Palette of Narmer exemplifies the complexity of Egyptian pictorial art. It also conveys the power of the pharaoh through a conventional iconography that an ancient Egyptian would have understood. For us, however, the imagery calls for an explanation.

The scene does not unfold sequentially in narrative fashion. Instead, it contains individual elements compressed into the flat space of the palette. These elements must be read individually in order to arrive at the meaning of the whole.

The use of hierarchical proportions is clear from Narmer's large size in relation to the other figures. Narmer raises a mace to strike an enemy, whose defeat is shown by his lowered position and helplessness. At the bottom of the palette, the nudity of two more figures indicates that they are dead, already killed by the pharaoh's might. Standing behind Narmer, a small servant carries the pharaoh's sandals; this shows that Narmer is on sacred ground (just as modern Muslims remove their shoes before entering a mosque).

The conventional character of hierarchical proportions in ancient art is reflected in an Egyptian poem of the Twelfth Dynasty entitled *The Greatness of the King*:

How great is the Lord of his city!
He is exalted a thousand times over; other persons are small....[9]

To the right of Narmer's head on the palette, Horus, the falcon god of the sky, guards the head of the king. Horus holds a sphinx (a human-headed lion) by a rope. Sprouting from the back of the sphinx are six papyrus plants, symbols of Lower Egypt. Narmer wears the tall crown of Upper Egypt, reminding the viewer that he rules over the entire land.

In addition to royal power, the iconography of the palette is designed to show that the pharaoh is protected by the gods. Just above Narmer's head, in the top register, is a symbol of the king's palace and a hieroglyph for his name. Protecting both are two frontal heads of the horned cow-goddess, Hathor, the powerful wife of the sun-god Re. Hathor was a goddess of fertility and protector of the royal palace. By means of this iconography, the artist confirms not only the might of the pharaoh and his protection by the gods, but also the fact that in Egyptian society the king was seen as ruling by more than divine right. He was literally the supreme god on earth.

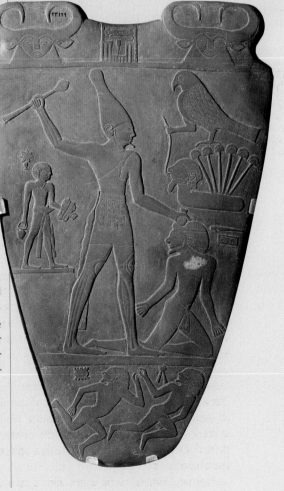

15.14 Upper Egypt side of the Palette of Narmer, c. 3100 B.C. Slate, 25 in. high. Egyptian Museum, Cairo.

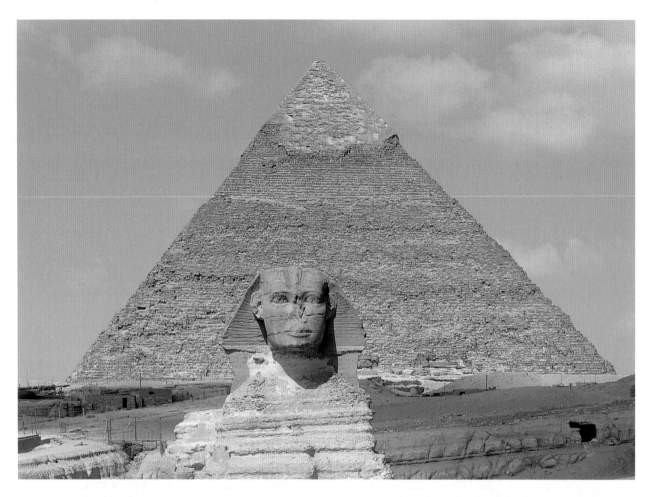

15.15 The Great Sphinx guarding the pyramid complex at Giza, Egypt, 3rd millennium B.C. Sandstone, 66 ft. high. Pyramid of Khufu visible in the background. Limestone, more than 400 ft. high.

The three most famous Old Kingdom pyramids are located in the colossal complex of tombs and temples at Giza just outside modern Cairo on the west bank of the Nile (**figure 15.15**). It contained three huge pharaonic pyramids for the pharaohs Khafre, Khufu, and Khufu's grandson, Menkaure, smaller step-pyramids for other members of the royal family, temples, and causeways.

Guarding the Giza complex was the Great Sphinx, thought to represent Khafre himself. The interior of the sphinx is a temple, with the entrance between the forepaws. In this case, the guardian function of the Sphinx derives from its leonine aspect. Not only were lions regal animals, but they were associated with the sun and were believed to sleep with their eyes open. Behind the Sphinx, we can see the colossal pyramid of Khufu.

The tombs were made of limestone blocks, designed by highly trained engineers and cut and placed by skilled workers. The plan of the pyramid is a simple square; the four triangular walls slant inward, meeting at a point over the center of the square. Originally the walls were perfectly smooth, and the top was capped with gold. Streaks of gold streaming down from the cap seemed to radiate in imitation of the sun's rays. This arrangement reflected the pharaoh's identification with the sun god and the belief that he would cross the Nile to become one with the sun after death.

The interior of the pyramid was filled with a maze of passageways, false corridors, and hidden chambers which were designed to foil grave robbers and protect the body and soul of the deceased. Buried with the pharaoh in the pyramid were thousands of priceless objects to accompany him in the afterlife. Because the Egyptians believed in a material afterlife, they developed a complex method of preserving the dead body, which is known as **mummification**. This involved removing the organs, drying, washing, treating the body with various oils and chemicals, and wrapping it in linen. The **mummy** (mummified body) was then put in an elaborate casing inside a wooden coffin, which in turn was placed in a stone sarcophagus. When this entire process was completed, the sarcophagus was placed inside the burial chamber of the pyramid. But despite all the precautions taken by the ancient Egyptians, most pyramids were plundered and only a few have been discovered intact.

Egyptian tombs, like temples and palaces, also contained royal statues, most of which were carved from rectangular blocks of stone. An impressive example is the Old Kingdom slate statue of Menkaure and his principal queen, Khamerenebty (**figure 15.16**). The king is an image of timeless power expressed through his frontal pose, monumental form, and stone medium. He assertively extends his left leg and his fists are clenched. He wears the royal wig (the *nemes* headdress), which is also worn by the Giza Sphinx, and a ceremonial beard. His tunic is flat and the stylized kneecaps are square. The spaces between the arms and body, and between the legs, have not been carved out, leaving the figure permanently embedded in stone.

Menkaure's queen is shorter than he, more natural, and slightly less assertive, which shows her lesser importance in the hierarchy of ancient Egypt. In contrast to the pharaoh, the queen's dress reveals her rounded form, which is a characteristic of the

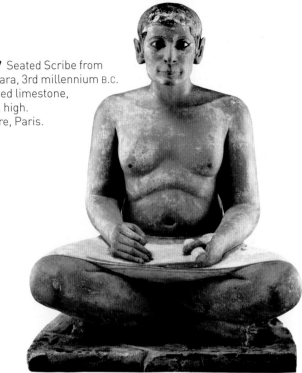

15.17 Seated Scribe from Saqqara, 3rd millennium B.C. Painted limestone, 21 in. high. Louvre, Paris.

portrayal of women in ancient Egyptian sculpture. She embraces the king, showing both her support for him and her unity with his power.

Another type of Old Kingdom sculpture shows figures whose pose identifies their profession. **Figure 15.17** is an example of an Old Kingdom scribe, a highly regarded profession in ancient Egypt. Scribes were important to the court because they kept records and composed diplomatic documents, including the pharaoh's correspondence with foreign leaders. Among the most educated members of society, scribes studied law and mathematics as well as writing. The high status enjoyed by scribes in ancient Egypt is reflected in poetry:

> Good fortune grows for the scribe even from childhood, and people shall respect him;
> They shall commission him to handle their affairs—nor will he go about dressed merely in a loin cloth.[10]

In Egyptian art, the scribe is conventionally shown sitting cross-legged, prepared to write on a papyrus scroll extended across his lap. (Papyrus is an ancestor of paper and was the main writing surface in ancient Egypt.) Compared with Menkaure, the scribe's torso is somewhat flabby and the open spaces create an impression of potential for movement. In contrast to the slate medium of the Menkaure, the scribe's limestone surface holds the original paint, making his features seem more individualized than those of the timeless pharaoh.

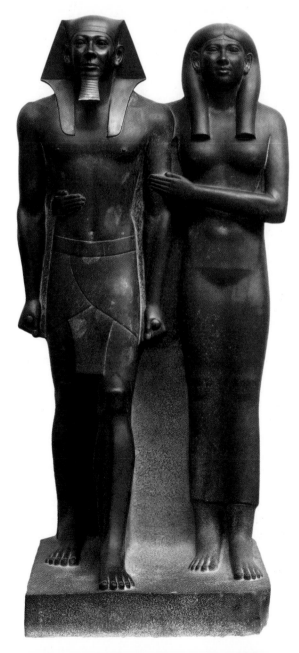

15.16 Menkaure and Khamerenebty, from Giza, 3rd millennium B.C. Slate, 4 ft. 6 1/2 in. high. Museum of Fine Arts, Boston. Harvard University–Boston Museum of Fine Arts Expedition.

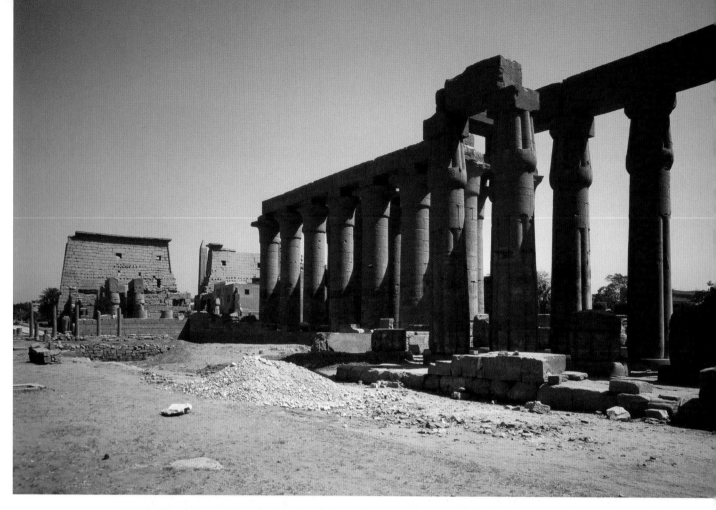

15.18 View of the colonnade of the Amon-Mut-Khonsu Temple, Luxor, Egypt, 14th century B.C. Columns 30 ft. high. The Getty Research Institute, Los Angeles.

COMPARE

Temple at Luxor.
figure 6.12, page 117

The Egyptians also built colossal temples with pylon entrances approached through rows of sphinxes (see figure 6.12). The interiors contained several courtyards and hallways leading to an inner sanctuary. Huge columns in the shape of plants symbolized the fertility of Egypt under the reigning pharaoh. In the view of the New Kingdom temple in **figure 15.18**, two column types are visible, one shaped as the papyrus plant and the other as the lotus flower. They represented Lower and Upper Egypt, respectively, and alluded to the pharaoh's control over a prosperous land.

Despite the stability of ancient Egypt, one New Kingdom pharaoh with radically different religious beliefs changed the conventions of royal art. He came to power around 1349 B.C. and took the name Akhenaton ("servant of the Aton") because he worshiped the sun-disk (Aton) rather than the many traditional Egyptian gods. He is thus the first known **monotheist** (one who believes in a single god) in history. Akhenaton moved his capital to Amarna, where the sun rises over a mountain, which is also the Egyptian hieroglyph for the rising sun. At Amarna, Akhenaton built a new complex of temples to reflect his devotion to the sun.

Note the emphasis on the horizon in Akhenaton's hymn, which describes the Aton as the source of all life and the one and only god:

When you sink to rest below the western
horizon earth lies in darkness like death,
... [stanza II]

Earth-dawning mount the horizon, glows in the
sun-disk as day;
You drive away darkness, offer your arrows of
shining, and the Two Lands are lively with
morning song.
... [stanza III][11]

Figure 15.19 shows a sunken relief (see Chapter 13) depicting Akhenaton, his principal wife, Nefretiti, and one of their three daughters worshiping the Aton. The rays of the sun-disk shine protectively down on the royal family and some end in the Egyptian hieroglyph for life: the Ankh.

Although the artist has retained the hierarchical convention equating size with importance, the proportions differ from those of Menkaure and his queen. Akhenaton and his family are elongated and

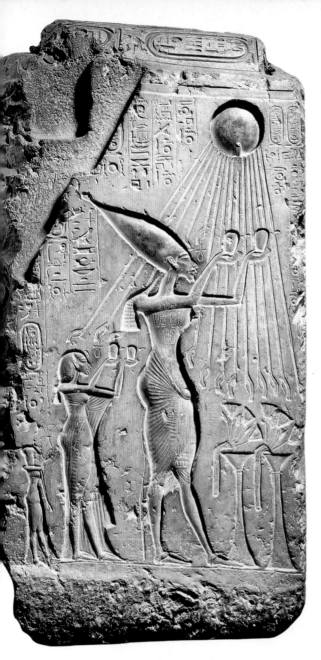

15.19 Akhenaton and Nefretiti Worshiping the Aton, from El-Amarna, New Kingdom, 1365–1349 B.C. Limestone, 40 ⅛ x 20 in. Egyptian Museum, Cairo.

(**figure 15.20**). Nefretiti is shown wearing a unique blue crown and an elaborate necklace that is typical of the Egyptian taste for jewelry made from precious stones. The style of the bust is unusual in its combination of elegant sophistication, open space, and organic form. A new naturalism, not previously seen in images of the Egyptian royal family, creates the impression of a living, breathing figure.

At the end of Akhenaton's reign, the old priesthood regained control of Egypt and returned to polytheism. Styles in art also reverted to tradition as Egypt attempted to eradicate all traces of Akhenaton's influence. Although his tomb has been discovered, his mummy has disappeared and much of the art he produced was destroyed after his death.

The art of the New Kingdom after the reign of Akhenaton illustrates the shift back to polytheism and more traditional artistic conventions. One type of painting is found on sheets of papyrus that are called by modern scholars the *Book of the Dead*. Because the Egyptians were so preoccupied with

curvilinear. The pharaoh's tall crown, as well as his thin waist and neck, creates open space and conveys a sense of natural movement.

The plants in front of Akhenaton signify the prosperity of Egypt during his reign. Surrounding the scene are hieroglyphs, among which several **cartouches** are visible. These are the curved rectangles that frame the name of the king; one cartouche appears above the sun-disk and another is behind Nefretiti. They reflect the belief that repeating the king's name, like his numerous images in sculpture and painting, was both a protective device and a way of ensuring his immortality.

The remarkably well-preserved painted limestone bust of Nefretiti dates to Akhenaton's reign

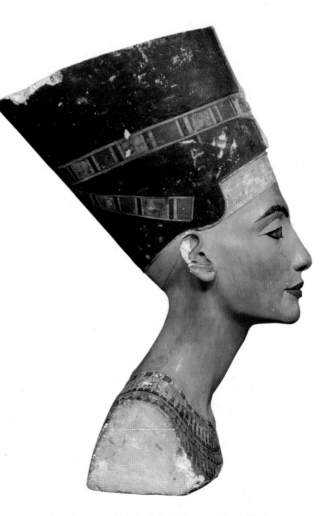

15.20 Bust of Nefretiti, 1330s B.C., from El-Amarna. Painted limestone, c. 19 in. high. Ägyptisches Museum, Staatliche Museen, Berlin.

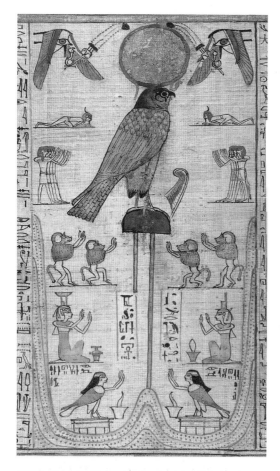

15.21 Vignette from the *Book of the Dead*, c. 1100 B.C. Papyrus of the Chief of the Concubines of Osiris, Chief of the Concubines of Nebru and Khnum, Chantress of Amun, Ahnai. British Museum, London.

death and the afterlife, they created numerous magic spells to evoke the protection of the gods. The spells were generally written on sheets of papyrus, illustrated with symbolic images (called **vignettes**), and placed in tombs to accompany the deceased.

The vignette in **figure 15.21** was found in a concubine's tomb, inside the hollow base of a statue of Osiris, god of the Underworld. The large green falcon is the sun-god with a sun-disk on his head. Protecting him on either side of the disk are eyes with fans made of ostrich feathers. Two rows of lesser deities worship the sun-god and four baboons dance just below him. The kneeling women below the baboons are two goddesses; one is Isis, the sister-spouse of Osiris. Two human-headed souls of the deceased are depicted as birds. They stand on platforms nestled in the mountains of the East. The text of the spell is written in hieroglyphics. In the following excerpt from a spell, the speaker addresses Osiris:

Hail to you who made the gods, the vindicated king of Upper and Lower Egypt Osiris, who founded the lands [Upper and Lower Egypt] with his potent deeds: you are Lord of the Two Banks [of the Nile].[12]

We conclude our survey of ancient Egypt with the spectacular gold mask of the New Kingdom pharaoh Tutankhamon (ruled 1336–1327 B.C.), who died at the age of nineteen. Despite his youth, his tomb was filled with thousands of valuable objects, including furniture, chariots, vessels, and jewelry. In 1922, when his burial chamber was discovered intact, the vast wealth of the pharaonic tombs was revealed.

The gold mask in **figure 15.22** differs from the Amarna style in its return to traditional conventions of representation. Instead of the naturalistic curved contours and open spaces created under Akhenaton, the mask is closed and stylized. The trapezoidal *nemes* headdress has reappeared and two ancient protection devices—the cobra goddess, Wedjet, and the vulture goddess, Nekhbet—guard the pharaoh's head. Their frontality and direct gazes echo Tutankhamon's. These figures recall the timeless representations of Old Kingdom pharaohs rather than the oddly proportioned but more natural figures created during the Amarna Period.

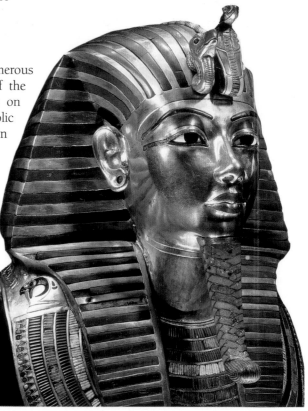

15.22 Funerary Mask of Tutankhamon, c. 1333–1323 B.C. Gold, enamel, and semiprecious stones, 21 ¼ x 15 ½ in. Egyptian Museum, Cairo.

MEANING

I.M. Pei on the Pyramids of Giza

The old Arab proverb, "Man fears time, yet time fears the pyramids," may explain why a trademark of I.M. Pei's architecture is the glass pyramid. He believes that geometry is the key to all architecture. Taking a simple geometric shape as his starting point, Pei forms his designs "like a piece of sculpture."

One of Pei's most famous buildings is the entrance to the Louvre Museum in Paris—one of the greatest art collections in the world. Once the official residence of the French kings, the Louvre dates back to the twelfth century, although the majority of its architecture belongs to the sixteenth and seventeenth centuries. In the 1980s, I.M Pei was commissioned to build a new entrance to the museum.

Pei proposed the idea of a glass pyramid for the museum entrance because he wanted a form that would combine contemporary architecture with history (**figure 15.23**).

He looked for inspiration to the Great Pyramid of the pharaoh Khufu at Giza because the pyramid is "the geometric shape that encloses the greatest area within the smallest possible volume, so it would stand as unobtrusively as possible." He called this "the natural solution." Furthermore, the pyramid has been translated from limestone into a "high-tech material" that results in a structure both "much older, and much newer than the Louvre."

Khufu's pyramid is the largest of the three Old Kingdom pyramids at Giza (**figure 15.24**). When first built around 2650-2575 B.C., it was 481 feet high. For more than 43 centuries, it was the tallest structure on earth, only being superseded by the Eiffel Tower in the nineteenth century. Each side of the pyramid is oriented to a point of the compass.

The Giza pyramids were built by the ancient Egyptians as royal tombs—the places from which the pharaoh would begin his journey to the afterlife. Perhaps it is no surprise that the judges of the competition for the entrance to the Louvre decided on a shape with such regal associations. The final, somewhat controversial, result is a bold juxtaposition of the old and the new.

15.23 I.M. Pei, Entrance to the Louvre, Paris, 1983–1989.

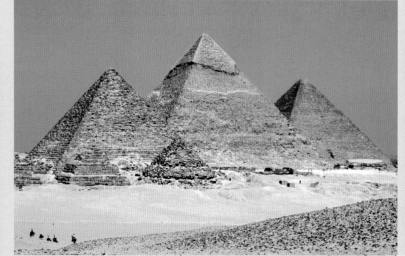

15.24 Pyramids at Giza, c. 2650–2575 B.C.

The Aegean Civilizations

While Mesopotamia and Egypt were flourishing, three distinct civilizations developed around the Aegean Sea (see map on p. 294), which lies between modern Greece and Turkey. The earliest preliterate, bronze-age culture of the Cycladic Islands lasted from around 3000 to the eleventh century B.C.

The major works of art found on the Cycladic Islands are marble sculptures, either of human figures or individual heads. In the absence of a written language, we do not know what the figures meant, but we assume that they had a religious significance related to an afterlife, because they were most often found in graves. The head in **figure 15.25** is striking, partly because of its simplified, geometric form. It is composed of a relatively flat, curved rectangle, the nose is pyramidal, and the neck is cylindrical. There are no other features (aside from flattened ears not visible in this view), but we recognize that the sculpture represents a human head. The artist has thus conveyed an abstract "essence" of a face by minimizing detail.

South of the Cyclades, on the island of Crete, the Minoan civilization emerged around 2000 B.C. It is named for its legendary king, Minos, a son of the Greek sky god Zeus, who disguised himself as a beautiful white bull and abducted the mortal girl Europa. According to Greek myth, Minos offended the sea god Poseidon, who took revenge by causing the king's wife to fall in love with a bull. The offspring of that union was the monstrous Minotaur, a creature that was part human and part bull. He ruled Crete as a tyrant until his daughter, Ariadne, helped the Greek hero Theseus defeat him.

The Minoan civilization on Crete did not need fortified architecture, because being an island offered sufficient protection from invaders for most of its history. Minoans were seafarers, whose economy was enriched by international trade, and they established a thalassocracy (rule by the sea) in the region.

Little is known about Minoan religion, although images exist of women dominating snakes, which suggests the worship of a powerful Nature Goddess. This is consistent with evidence of tree worship and rituals celebrating the arrival of spring. Instead of freestanding temples, Minoans worshiped on outdoor, mountain shrines or inside the palaces. The prevalence of bull imagery in Minoan art, including sacrificial scenes, reflects the importance of the bull in the founding myth of Crete.

The Minoans used a script known as Linear B, which modern scholars can read, for records and inventories. But the literary script, Linear A, has not been deciphered, which limits our knowledge of Minoan culture. Examples of both scripts have been found in Minoan palaces. The main Minoan palace was located at Knossos. Its plan covered an area of about four acres and was a meandering complex of mazelike corridors, stairways, columned rooms, and storage facilities. **Figure 15.26** shows an exterior porch at Knossos with reconstructed, painted wooden columns. These are much smaller in scale than Egyptian columns and are geared to human rather than to royal or divine stature. The Minoan columns are unusual in that they taper toward the base (as humans do) and have round, cushionlike capitals.

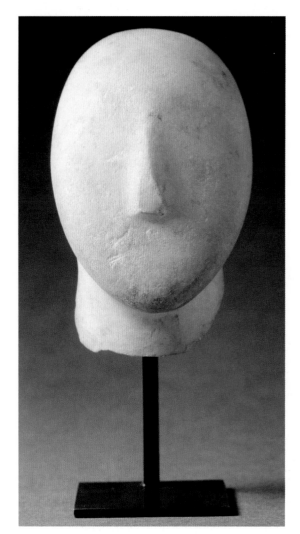

15.25 Cycladic head from Amorgos, c. 2700–2300 B.C. Marble, 10 ⅝ in. high. Louvre, Paris.

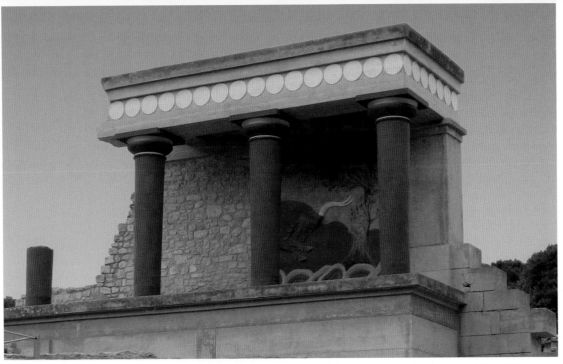

15.26 North east entrance to the Palace at Knossos, Crete, with reconstructed columns, 1600–1400 B.C.

Inside the palace, which was decorated with frescoes, archaeologists discovered fragments of a large painting that had fallen from the wall (**figure 15.27**). The dark areas are original, the rest is reconstructed. The scene represents a ritual performance most likely related to the Minoan bull cult. Two young girls (conventionally depicted with light skin) and one young man (with dark skin) somersault over the horns of a charging bull. In contrast to the static rectangularity of Egyptian style, Minoan artists preferred open spaces, curved forms, and a sense of lively movement.

Around 1200 B.C., Minoan culture was destroyed by invasions from the Greek mainland. The invaders were Mycenaeans, whose city, Mycenae, was the central site of a tribal warrior culture. Mycenae was famous in later Greek tradition as the home of King Agamemnon, who led the Greek army in the Trojan War. These legends were memorialized in the *Iliad* and *Odyssey* of Homer and later in Greek plays.

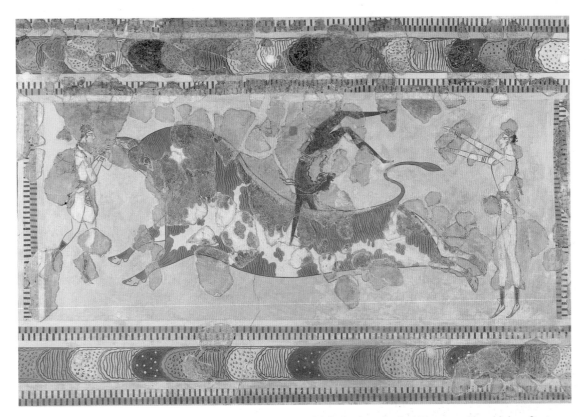

15.27 Toreador Fresco, from Knossos, c. 1500 B.C. 32 in. high. Archaeological Museum, Herakleion, Crete.

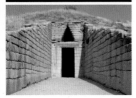

COMPARE

The Treasury of Atreus.
figure 14.23, page 276

The Mycenaean palace and administrative buildings were built on a hilltop citadel for protection. Enormous tholos tombs reserved for royal burial, which we discussed in Chapter 14, were also part of the Mycenaean complex.

The citadel was surrounded by huge walls made of **Cyclopaean masonry**, named for the mythical race of giant Cyclopes. They were children of the pre-Olympian gods, the Titans; their mother was Rhea, the Earth, and their father was Uranos, or Heaven. The eighth-century-B.C. Greek poet Hesiod tells us that:

> They were like gods but one eye only was set in the midst of their foreheads. And they were surnamed Cyclopes (Orb-eyed) because one orbed eye was set in their foreheads. Strength and might and craft were in their works.[13]

The blocks of Cyclopaean stone were so big that the later Greeks believed the walls must have been built by giant masons. The entrance to the citadel, visible in **figure 15.28**, is surmounted by the corbel arch framing a triangle made of different stone. The relief sculpture shows two lions guarding the Nature Goddess, represented here in the form of a Minoan column.

The opening of the gate is intentionally small to protect the citadel from invading armies. In contrast, the tombs of the Mycenaean kings and queens were huge, a sign of their power in life and probably the wish that it continue in death. Nevertheless, by around 1150 B.C., Mycenaean civilization had disappeared. It was followed by a so-called "Dark Age,"

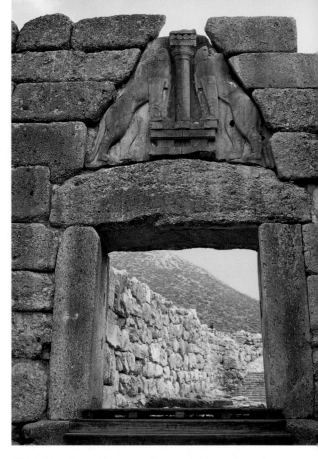

15.28 Lion Gate, Mycenae, Greece, 13th century B.C. Limestone, c. 9 ft. 6 in. high.

when writing was lost, large-scale works of art were no longer produced, and the economy declined. Literacy and monumental art revived again around 800 B.C., heralding historical Greece, which became a foundation of Western civilization.

Chapter 15 Glossary

cartouche—curved rectangle, usually containing an inscription such as (in ancient Egypt) a ruler's name

cromlech—prehistoric monument consisting of a circle of single large stones (monoliths)

cuneiform—script consisting of wedge-shaped characters used in ancient Mesopotamia

Cyclopaean masonry—stone construction using massive, irregular blocks without mortar

hieroglyphics—script used in ancient Egypt whose characters are pictorial representations of objects

Mesolithic—relating to the Middle Stone Age

monotheism—religious system based on belief in a single god

mummification—process of embalming a dead body in the manner of the ancient Egyptians

mummy—mummified body of a human or animal

Neolithic—relating to the New Stone Age

Paleolithic—relating to the Old Stone Age

pharaoh—ruler of ancient Egypt

polytheism—religious system based on belief in multiple gods

pyramid—(a) monumental burial place of ancient Egyptian pharaohs; (b) in geometry, a regular three-dimensional shape having four triangular sides and a square base

stele—upright stone pillar or slab, usually carved or inscribed for commemorative purposes

trilithon—a single post-and-lintel

vignette—decorative, symbolic image or design accompanying texts such as the ancient Egyptian *Book of the Dead*

ziggurat—stepped, trapezoidal structure representing a mountain, as in ancient Mesopotamia

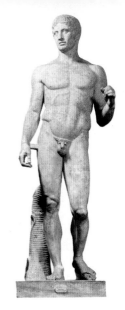

16

Ancient Greece, Etruria, and Rome

A round 800 B.C., after the period of decline following the Minoan and Mycenaean civilizations, historical Greece began to emerge. We call the period beginning in the eighth century B.C. "historical," because the Greeks developed writing that we can read. Before around 750 B.C., when the *Iliad* and *Odyssey* of Homer are thought to have been first written down, the literary tradition of Greece was oral. Traveling bards wandered from place to place, singing of the heroic warrior culture of Mycenae, and recounting tales of the Trojan War and the myths on which Greek religion was based.

Ancient Greece

Greek culture has had an enormous influence on Western tradition. Nearly every modern field, including literature, history, theater, science and medicine, philosophy, politics, and psychology, in addition to art and architecture, has a basis in ancient Greece. Greek religion, like all ancient religions, was polytheistic. But the Greek gods (called "Olympians" because, in myth, most of them lived on Mount Olympos) differed from others of the Mediterranean world in being anthropomorphic (having a human shape). They also had human

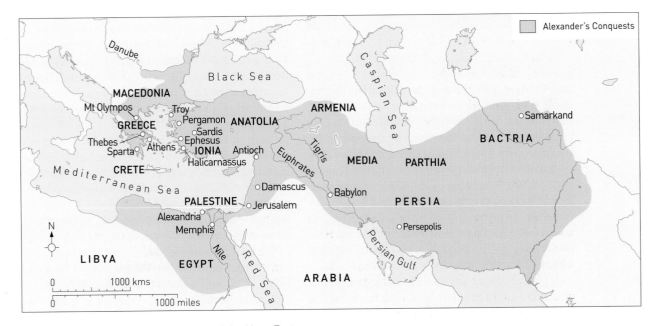

Ancient Greece, the Mediterranean, and the Near East.

HISTORICAL EVENTS	ART HISTORY
1,000 B.C.	
● Emergence of Etruscan civilization c. 1000 B.C.	
● Emergence of historical Greece c. 800 B.C.	● Pottery with geometric designs made on Greek mainland c. 8th century B.C.
750 B.C.	
● Homer's *Iliad* and *Odyssey* written down c. 750 B.C.	● Black-figure and red-figure vase painting from c. 600 B.C.
● Golden Age of Etruscan culture 7th to 5th centuries B.C.	● Etruscan sarcophagus from Cerveteri c. 520 B.C.
500 B.C.	
● Beginning of the Roman Republic 509 B.C.	
● The Athenian general Perikles (c. 500–429 B.C.) elected head of the *polis*	● Parthenon, Athens 447–438 B.C.
● Greece defeats the Persians after decades of invasion 479 B.C.	● *Doryphoros* (*Spearbearer*) c. 420 B.C.
● Alexander the Great of Macedon (356–323 B.C.) conquered most parts of the known world	● Emergence of the Hellenistic style begins 323 B.C.
● Beginning of the Roman Empire 23 B.C.	
A.D. 1	
● Golden Age of the Roman Empire A.D. 96–192	● *Augustus of Prima Porta*, early 1st century A.D.
● End of the Pax Romana (began 27 B.C) and beginning of the decline of the Roman Empire A.D 180	● Colosseum, Rome A.D. 72–80
	● Pantheon, Rome A.D. 112–125
● Beginning of successive waves of Barbarian invasions 3rd century A.D.	
● Fall of the Roman Empire A.D. 476	● Arch of Constantine, Rome, c. A.D. 313

personalities and, as in the founding myth of Crete (see Chapter 15), the gods socialized and reproduced with mortals.

In politics, too, ancient Greece was revolutionary in its own time. Greeks hated tyranny and evolved the idea of the city-state (the *polis*), requiring every male citizen to participate in governance. The most important *polis* was Athens (see map), which was ruled by an assembly of citizens and an elected leader. The Athenian government during the Classical period (c. 450–400 B.C.) was the ancestor of later Western democracies and an inspiration for Thomas Jefferson when he framed the American Constitution.

Beginning late in the seventh century B.C., there was a revival of monumental sculpture and architecture in Greece. But nearly all examples of monumental Greek painting have disappeared, and so

we have to study pictorial development from the thousands of vases that have survived. These were shaped according to their function, made of terracotta (baked clay), and painted. Many are also signed—by the potter as well as by the painter—so, for the first time in Western history, we can regularly identify the style of a specific artist.

The interest in the individual, reflected in the fact that artists signed their works, recurs in Greek art styles. In this chapter, we focus on the three main Greek styles: Archaic (c. 600–490/480 B.C.); Classical (subdivided into Early Classical: c. 490–450 B.C.; High Classical: 450–400 B.C.; and Late Classical: fourth century B.C.); and Hellenistic (323–1st century B.C.). As we can see from these dates, the high point of Greek civilization—High Classical—lasted for a mere fifty years. In comparison to stylistic and cultural developments in Egypt, Greece evolved much more rapidly.

Throughout Greek history, the visual arts reflect a trend toward increasing naturalism, first in representations of the heroic male nude and later (in the fourth century B.C.) of the female nude. This departure from the arts of other Mediterranean cultures is consistent with the Greek view that the measure (and scale) of all things was not gods or rulers, but man.

> Man is the measure of all things.
>
> Protagoras (5th century B.C.)

Archaic Period

During the Archaic Period (c. 600–490/480 B.C.), two vase painting techniques evolved. The earlier is known as **black-figure**, because the figures were painted in black on a reddish-brown terracotta surface. To add details, the artist incised the figures with a sharp instrument, exposing the red ground beneath the black. In the slightly later **red-figure** technique, the artist painted the figures in red and added details in black with a brush. The use of the brush allowed the artist more freedom of movement than incising. As a result, red-figure painting tends to show more natural three-dimensional form than black-figure.

If we compare the scene on the black-figure amphora that we discussed in Chapter 12 with the red-figure **kalyx-krater** (bowl for mixing water with wine) in **figure 16.1**, we can see the beginning of the Greek evolution toward naturalism in painting.

The black-figure scene, *The Judgment of Paris* (see figure 12.3), was a favorite in antiquity, because it illustrates the mythological origin of the Trojan War. At the center of the scene, we see Hermes (the messenger god) wearing his **attribute** (identifying

characteristic)—winged sandals. He grasps the hand of Paris, the Trojan prince who was chosen by Zeus, the ruler of the Olympians, to judge a beauty contest between three powerful Greek goddesses. The winner would be awarded the prize of a golden apple, which each wanted for herself. Athena (goddess of war, wisdom, and weaving) offered Paris fame in battle; Hera (goddess of marriage, wife of Zeus and queen of the gods) promised him greatness; and Aphrodite (the Greek Venus, goddess of love and beauty) promised him the most beautiful woman in the world. Paris chose Aphrodite. The world's most beautiful woman turned out to be Helen, the wife of Agamemnon's brother, King Menelaus of Sparta. Paris abducted her with the help of Aphrodite and brought her to Troy. Agamemnon was pledged to defend his brother's honor and so he assembled a Greek army, sailed for Troy, and began the ten-year-long Trojan War.

In the vase painting, Paris seems aware of his no-win predicament, for his effort to steal away from Hermes shows his ambivalence. Behind Hermes, the three goddesses eagerly lean forward, each assuming that the prize is hers. The lively, stylized character of the poses and the patterning are characteristic of black-figure painting. They are also consistent with the personalities of the goddesses.

The red-figure vase by Euphronios (figure 16.1) illustrates another scene from the Trojan War in which Hermes plays a central role. In this case, the god observes two winged warriors, the twin gods Sleep and Death, carrying off the fallen Trojan hero Sarpedon to prepare his body for funeral rites. The scene is framed at either end by a standing warrior; one turns so that his shield appears to occupy the foreground.

Compared with the black-figure scene, this shows greater attention to human form. Sarpedon extends horizontally, blood gushes from his wounds, and his anatomy is delineated. His left leg is slightly foreshortened (rendered in perspective), and there is less emphasis on stylized patterning than in black-figure. Another important distinction is the more naturalistic depiction of the male nude by the red-figure artist.

COMPARE

The Judgment of Paris.
figure 12.3, page 234

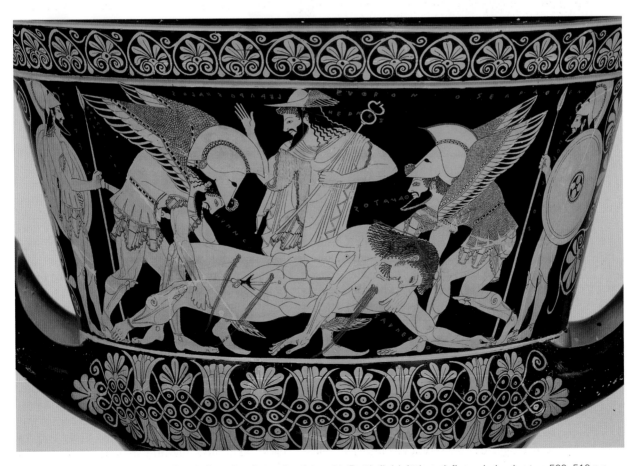

16.1 Euphronios, *Sleep and Death Carrying Sarpedon from the Battlefield*, Attic red-figure kalyx-krater, 520–510 B.C. Metropolitan Museum of Art, New York. Purchase. Bequest of Joseph H. Durkee, Gift of Darius Ogden Mills, and Gift of C. Ruxton Love by exchange. 1972. no. 72. 11. 10.

COMPARE

Menkaure and Khameremebty.
figure 15.16, page 307

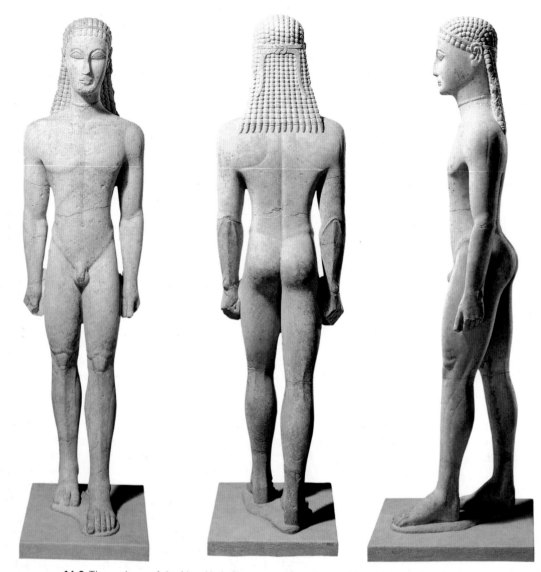

16.2 Three views of the New York *Kouros*, c. 900–580 B.C. Marble, 6 ft. 4 ⅝ in. high.
Metropolitan Museum of Art, New York. Fletcher Fund, 1932. no. 32.11.1.

Transition to the Classical Period

In sculpture, as in painting, we can see the transition to naturalism by comparing Archaic and Classical large-scale nude male figures. During the Archaic Period, Greek artists traveled to Egypt to learn monumental stone-carving. As a result, the early Archaic Greek sculptures share certain qualities with Egyptian royal art. The marble *Kouros* (Greek for "young man") in **figure 16.2** exemplifies a type of heroic male nude that probably commemorated a brave warrior or a victorious athlete. It retains the rectangular blocklike form of the Old Kingdom Menkaure and is in the same pose.

But the *Kouros* is nude, reflecting the Greek interest in human form. The proportions are slimmer, the contours are more rounded (compare the knee caps), and there is open space between the arms and torso and between the legs. Although the

original rectangular block of marble is still felt in the appearance of the *Kouros*, the figure is freer than the Menkaure. The Greek youth is not a timeless, powerful king forever embedded in stone; he is a young man whose memory is preserved to honor his heroism.

The High Classical sculpture of the *Doryphoros* (*Spearbearer*) (**figure 16.3**) by Polykleitos shows the change in Greek style that occurred over the next 200 years. The figure is no longer rigidly frontal and the anatomy seems more accurate, with muscles and bones shown as underlying structure. The *Doryphoros* almost certainly represents a warrior, since he carried a spear in his left hand. It was originally cast in bronze, but, like many ancient Greek sculptures, survives only in Roman marble copies. Nevertheless, we recognize that this figure has lost all sense of the rectangular block. He appears able to move freely in space. His pose is

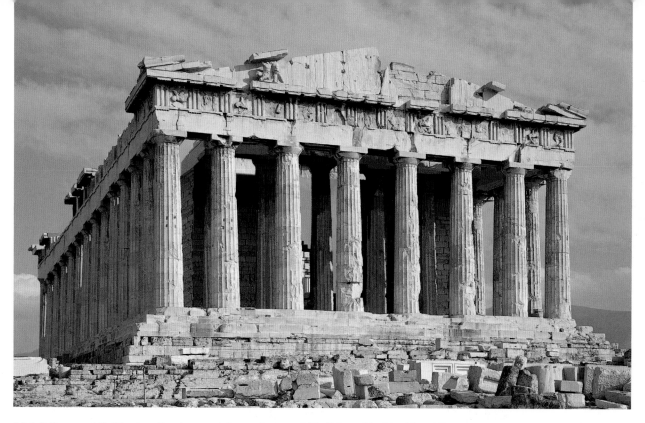

16.4 Iktinos and Kallikrates, Parthenon, Athens, Greece, 447–438 B.C. Marble, 111 x 237 ft.

relaxed, with one leg bearing his weight. In contrast to the Egyptian king and the Archaic *Kouros*, the body of the *Doryphoros* responds naturally as a harmonious, lifelike whole. As the knee bends, the leg is lowered, and there is a natural shift at the waist (**contrapposto**).

The *Doryphoros*, like Myron's *Discus Thrower* that we saw in Chapter 6 (see figure 6.6), is idealized. That is, he does not actually resemble a real person. He has no expression or personality. He is youthful, his head is a perfect dome shape, and he has no blemishes

or defects. Since no one is as physically perfect as these youths, such figures appeal to our narcissism, and have made the Classical style a force to be reckoned with by subsequent Western artists. The Roman historian Pliny the Elder (A.D. 23–79) expressed the Classical combination of idealized youth with a sense of adult self-assurance when he described the sculpture of the *Doryphoros* as "a boy, but manly-looking."[1]

Classical Architecture: The Parthenon

Classical Greek architects also strove for, and achieved, a new sense of harmonious balance. The most famous Classical building is the Parthenon (**figure 16.4**), the Doric temple that crowns the Acropolis of Athens (**figure 16.5**). The Parthenon was dedicated to Athena, the patron of Athens, in her aspect as a virgin goddess (*parthenos* in Greek means "virgin"). Although now in a state of ruin after centuries of neglect and abuse and undergoing restoration, the Parthenon remains a major monument of Western architecture. It was built almost entirely of marble quarried from nearby mountains and constructed without the use of mortar.

In 479 B.C., after decades of invasions by the Persians (see Chapter 15), Greece finally destroyed the Persian fleet at the naval Battle

16.3 Polykleitos, *Doryphoros* (*Spearbearer*), Roman copy of a Greek bronze, c. 420 B.C. 6 ft. 11 ½ in. high. National Archaeological Museum, Naples.

COMPARE

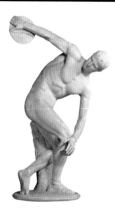

Myron, *Discus Thrower.*
figure 6.6, page 112

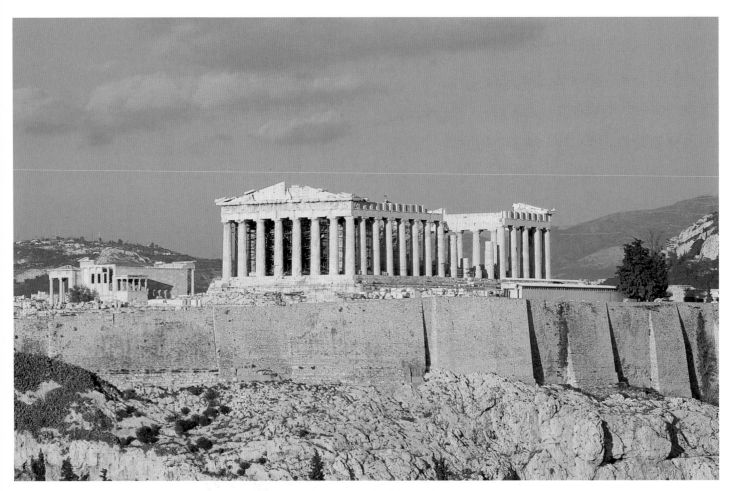

16.5 View of the Acropolis, Athens, Greece.

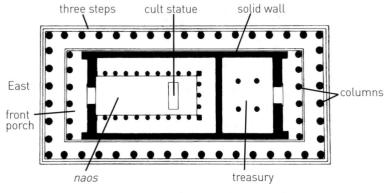

16.6 Plan of the Parthenon.

of Salamis. The Persians had previously sacked Athens and destroyed temples, precincts, and sculptures on the Acropolis. Some thirty years later, the great general Perikles (c. 500–429 B.C.) was elected head of the Athenian *polis*. He launched a vast program of rebuilding on the Acropolis.

Approached by a Sacred Way and the destination of several important religious festivals, the Acropolis was entered through an elaborate Doric gateway, the Propylaia. Immediately visible from the Propylaia was the majestic Parthenon, a simple rectangular building divided into two rooms (indicated by the thick black lines on the plan in **figure 16.6**).

The larger room (the *naos*) housed a colossal gold-and-ivory cult statue of Athena created by the Classical sculptor Phidias. The original statue has long since disappeared, but it has been reconstructed based on coins and ancient descriptions. **Figure 16.7** shows a reconstruction photographed from the point of view of a person standing in front of the statue. The goddess is armed for battle, but also wears a flowing garment and open sandals. She holds a small statue of Nike, the Greek goddess of victory, in her right hand, and her left hand rests on a huge shield.

The smaller room of the Parthenon served as the Athenian Treasury. Surrounding both rooms—the *naos* and the treasury—were four walls of columns (the black circles on the plan), forming a colonnade (**peristyle**) (see figure 16.5). The columns rise from three steps, indicated by the triple outer lines on the plan. Each porch had six columns, creating a symmetry between the front and back, as well as along the sides of the temple.

If we look closely at the view of the façade (front) in figure 16.4, we can see several refinements devised by the architects to improve the aesthetic appearance of the Parthenon. The top step, for example, curves very slightly upward toward the center. This corrects the natural tendency of the eye to perceive long horizontals as dipping in the middle and makes the steps appear straight.

The outer columns, which are Doric, are closer together at the corners than in the center. This creates the impression of a frame and increases the sense of stability. In contrast to Minoan columns (see Chapter 15), these taper upward, creating more visual and structural support at the bottom. The element of entasis (the slight bulge in the shaft) produces a sense of organic tension. This quality,

together with the alignment of sturdy verticals, is consistent with the Greek association of the Doric Order with masculine strength and with the orderliness of the military phalanx (see Chapter 14). The more graceful Ionic Order was associated with female quality and thus most often used in interiors. Respectable Athenian women spent most of their time indoors, going outside only when accompanied by a chaperone. In the Parthenon, there were four Ionic columns inside the treasury.

In addition to its architectural harmony, the Parthenon was decorated with freestanding and relief sculpture, all of which was the work of Phidias. The iconography of the Parthenon sculptures was designed to project the image of an advanced, civilized culture that had triumphed over its Eastern enemies.

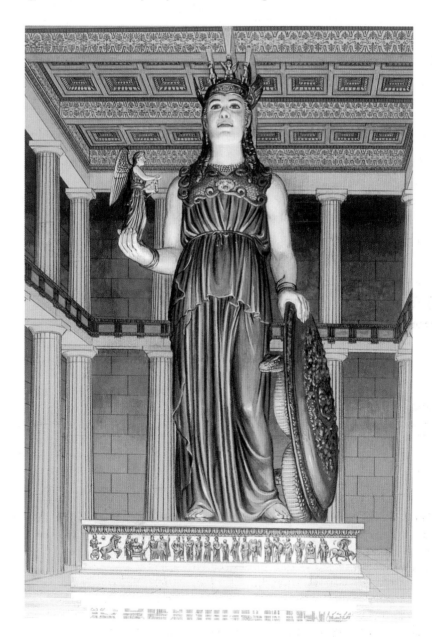

16.7 Reconstruction of the Athena Parthenos, by Phidias, 447 B.C., inside the Parthenon. Watercolor by Peter Connolly.

The Cultural Significance of the Parthenon Sculptures

The colossal cult statue of Athena in the *naos* was a statement of her divine power and, by extension, that of Athens itself. There were three additional areas of the Parthenon that contained sculptures—most of these are lost or damaged, and most of those that do survive are now in the British Museum in London. All the sculptures, like the building itself, were carved from gleaming white marble. Originally, however, all the sculptures were colorfully painted, but the paint has since worn away.

The east and west ends of the Parthenon are crowned by triangular pediments. For the base of each pediment, Phidias carved freestanding marble sculptures-in-the-round illustrating two myths of Athena. On the west pediment, she competed with Poseidon for patronage of the city. As god of the sea, Poseidon offered Athens a freshwater spring, but Athena defeated him with the olive tree, which is a staple of the Greek economy. The central part of the east pediment originally illustrated the mythological birth of the goddess, but those sculptures are lost. They showed Athena's birth on Mount Olympos, where she was born at dawn, fully grown and armed, springing, like an idea, from the head of Zeus. The place of her birth (in the east where the sun rises) is thus unified with the orientation of the Parthenon, the main entrance of which is at the eastern end.

Phidias also carved two sets of relief sculptures for the Parthenon. The Doric metopes (the square sections of the exterior frieze) illustrated four mythic battles, one on each side of the building: Greek gods against primitive pre-Greek gods (the Titans), Greeks against Trojans, who were easterners, Greeks against Amazons (eastern warrior women), and Greek Lapiths (a local tribe) against Centaurs. This last battle is the best preserved.

According to the myth, the Lapiths invited the Centaurs to a wedding. The Centaurs, a mythical race of creatures who were part man and part horse, became drunk and tried to rape the Lapith boys and girls. **Figure 16.8** shows a Lapith fighting a rearing Centaur; both are carved in relatively high relief. Each seems locked in the other's grip, their struggle reinforced by diagonals and signs of physical tension. The Greeks eventually defeated the Centaurs, as indeed they also defeated the enemies against whom they fought on all the metopes.

Taken together, these four battles demonstrated the superiority of Western culture over the eastern Trojans and Amazons. They also reflected the triumph of Greek rationality over primitive impulses and animal instincts, and the ideals of both Greek religion and the Olympian gods.

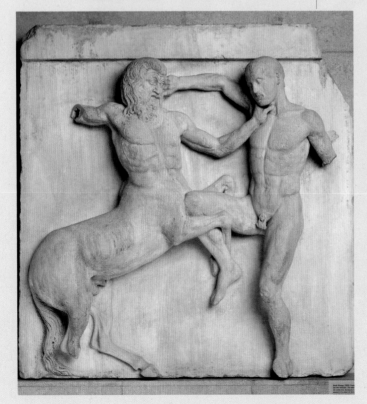

16.8 Metope showing the Battle of Lapiths and Centaurs, 447–438 B.C. Marble, c. 4 ft. square. British Museum, London.

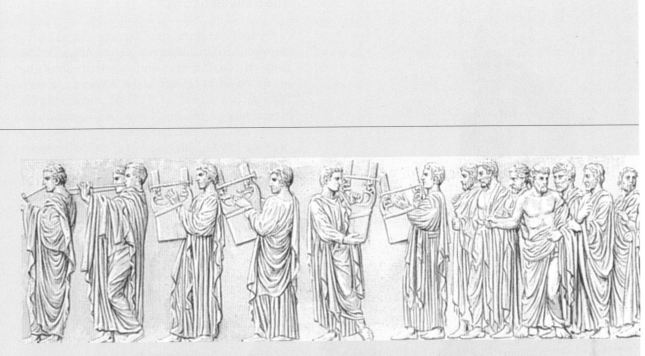

16.9 Reconstruction of a section of the Ionic frieze: old men and musicians. Watercolor by Peter Connolly.

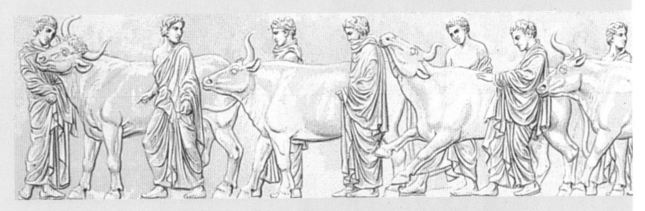

16.10 Reconstruction of a section of the Ionic frieze: bulls led to sacrifice. Watercolor by Peter Connolly.

The Ionic frieze is not visible in figure 16.4. It extended around the outside of the four inner walls, the two solid side walls, and over the porch columns. In contrast to the Doric frieze, the Ionic frieze is continuous; it is not divided into alternating vertical triglyphs and square metopes. The subject of the Ionic frieze was the city-wide procession (the **Panathenaia**) that took place every four years at the festival in honor of Athena's birthday.

The frieze showed various sections of the procession, ending on Mount Olympos, where a sacred dress is presented to the goddess. The detail in **figure 16.9** represents a group of elderly men and musicians playing lyres and double flutes. Note that some of the participants pause and turn to speak with those behind them. By this technique, Phidias adds variety to the procession and also depicts the figures moving freely in three-dimensional space, even though the degree of relief is lower than that of the metopes. In **figure 16.10**, we see youths leading bulls to be sacrificed to the goddess. The animals, like the human figures, are carved naturalistically as organic, living forms.

Read as a whole, the message of the Parthenon sculptures, conceived by Perikles and executed by Phidias, was the superiority of Greece, especially Athens, over the rest of the Mediterranean world. Perikles wanted to emphasize that Greece had triumphed over its Eastern enemies, that Greek religion, with its emphasis on humanity, was an advance over other belief systems, and that Greek culture was based on order and reason.

The Hellenistic Style

In the fourth century B.C., Greece produced one of the world's most brilliant conquerors, Alexander the Great of Macedon. His armies overran all of the known world as far east as the Punjab in modern Pakistan (see map on p. 315). He Hellenized the Mediterranean, bringing Greek language and culture to his conquered territories. After Alexander's death in 323 B.C., his empire was divided between four of his generals. In art, the Hellenistic style emerged and lasted for more than 300 years.

In the early third century B.C., the Greek colony at Pergamon, on the west coast of modern Turkey, was threatened by Gauls from the North (roughly modern France). They invaded continually from 279 B.C. and were finally defeated in 238 B.C. by the Greek king Attalos I. Commemorating his victory was a series of statue groups in the Hellenistic style. The centerpiece of one group shows a heroic Gaul killing himself and his wife rather than suffering the consequences of defeat (**figure 16.11**).

In Hellenistic style, as compared with Classical style, artists expanded open space, varied the viewpoints, thickened the proportions, and introduced extremes of emotion. This is evident in figure 16.11, which shows an over-lifesize Gaul lowering his dead wife to the ground. The Gaul, on the other hand, remains upright as he bravely plunges a sword into his own neck. We, the viewers, see blood flowing from the wound as he turns from the sight of his murdered wife and his own suicide.

Compared with the New York *Kouros* and the *Spearbearer*, which represent a single heroic male nude, the Hellenistic group engages us in a narrative progression. We see an implied sequence of events—the Gaul kills his wife, she falls, he prepares to commit suicide, and we know that he, too, will fall. In addition to more complex figural arrangements, and more realism in form and expression than in the Archaic and Classical styles, the Hellenistic sculptor introduced the dimension of time.

A more expansive and energetic example of Hellenistic style can be seen in the *Laocöon Group* (**figure 16.12**). Although the boy on the right was added to the group by the Romans when they copied the Greek statue in the first century A.D., the story calls for two boys. The scene depicts a well-known event described in Virgil's *Aeneid* that took place at the end of the Trojan War. Laocöon (the old man) was a priest of Apollo who warned the Trojans not to open the gates of Troy when the Greeks offered the city a large wooden horse as a peace offering and

16.11 *Ludovisi Gaul Killing Himself and his Wife*, Roman copy, c. 220 B.C. Marble, 7 ft. high. Terme Museum, Rome. Both arms of the Gaul and the left arm of his wife are modern restorations.

pretended to depart for home. Laocöon, who was a seer, cried out in a frenzy:

> Oh, wretched citizens,… Do ye believe the foe has sailed away? Or think ye any gifts of the Greeks are free from treachery?… Trust not the horse, ye Trojans. Whatever it be, I fear the Greeks, even when bringing gifts.[2]

Unfortunately for Laocöon and Troy, Athena favored the Greeks. She dispatched two huge serpents to devour the priest and his sons, which made the Trojans distrust Laocöon's advice. In the sculpture, the artist conveys the dying moments of Laocöon and his children as they struggle against the serpents. Violent diagonals, winding curves, muscular tension, and strong emotional expression define the work and are characteristic of Hellenistic style. The forms of the sculpture echo Virgil's description:

> … first each serpent enfolds in its embrace the youthful bodies of his two sons and with its fangs feeds upon the hapless limbs. Then himself too,… they seize and bind him in mighty folds;… The while he lifts to heaven hideous cries, like the bellowings of a wounded bull that has fled from the altar.[3]

The fate of Laocöon prefigured the fate of Troy itself, for the Trojans opened the gates and dragged the wooden horse into the city. The horse was crammed with Greek soldiers, who sacked the city, thus fulfilling Laocöon's warning to beware of Greeks, even bearing gifts.

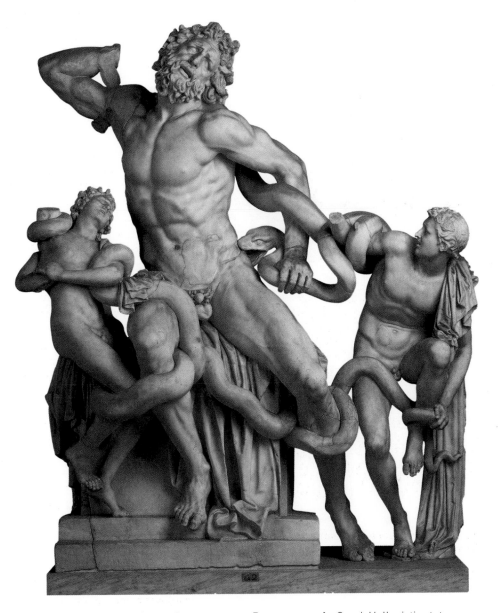

16.12 *Laocöon Group*, 1st century A.D. Roman copy of a Greek Hellenistic statue. Marble, 7 ft. high. Vatican Museums, Rome.

Grayson Perry on Classical Style

Grayson Perry is best known for his ceramic works, particularly his pots and vases shaped as in ancient Greece. They shimmer from the high-gloss, metallic glazes he uses and the combination of finely drawn figures, photographs, text, and colorful patterns. They invite close inspection of the surface and challenge us to see if we can work out "what's actually going on." What we encounter is a combination of lurid news headlines, often disturbing and perverse imagery, and kitsch ornament.

Perry's content has aroused controversy and discussion. Yet for all his flamboyance, which is seemingly rooted in the present, his work is inspired by an ancient art. Perry's pots are formed using the "coil method," an age-old technique that consists of rolling the clay into a long, snake-like form, then coiling and gradually smoothing it into the shape of a vase or urn. Perry says that for a work to inspire him, "It has to have something of quality about it, either the craftsmanship or rigorous ideas or strong feelings. The history of the handmade is littered with some very profound objects, and what is beautiful about them is that this profundity is not as self-conscious as a lot of contemporary art. When people ask me (what) inspires me... I say it is ...ancient antique ceramics. Great craft objects once seemed

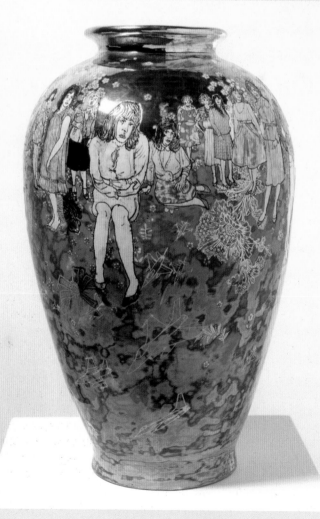

16.13 Grayson Perry, *Precious Boys*, 2004. Glazed ceramic, 21 ⅝ x 13 in. Collection Victoria and Warren Miro. © The Artist.

MEANING

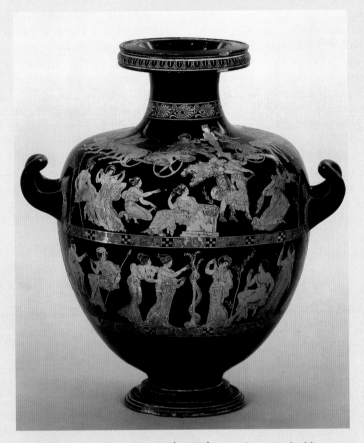

16.14 The Meidias Painter (attrib.), vase decorated with mythological scenes, c. 410-400 B.C. Attic red-figure ware, 20 1/2 in. high. British Museum, London.

to have sprung out of the culture spontaneously, to have been refined by tradition."

Perry creates a variety of vases, nearly all of which "purposely conform to the shape that we have come to expect from an urn." Perry's *Precious Boys*, 2004 (**figure 16.13**) is shaped like a Greek urn and its surface decoration can be seen as a continuation of Greek tradition. Greek vase-painters often decorated their pots with scenes taken from mythology and everyday life. Attic vase-paintings of the sixth and fifth centuries B.C., for example, though varied in style and technique, provide us with a sense of the artist's feeling for line, contour, and composition. They are invaluable to the art historian, for they offer better-preserved

examples of Greek pictorial art than the surviving fragments of monumental paintings and mosaics.

The vase in **figure 16.14**, for example, shows a scene of women in a garden. Although the narratives to which the images relate are mythological (the hero Herakles among the Hesperides—the daughters of Evening—and the rape of the daughters of Leukippos), the luxuriously painted figures show how women dressed in Greece in the fifth century B.C. Similarly, Perry's vase is decorated with boys dressed as girls and overlaid with the white outlines of fighter planes. These images reflect the artist's transvestism and his habit of dressing in women's clothing.

Quotations from *The Guardian*, 5 March 2005.

Etruscan mirror.
figure12.12a, page 239

The Etruscans

The Greeks established colonies on the southern part of the Italian peninsula (see map on p. 315), in the area of *Magna Graecia* ("Greater Greece"). At the same time, the development of native Italic civilizations overlapped with Greek history. Beginning around 1000 B.C., the Etruscan civilization emerged in Etruria—the region around modern Tuscany. Many theories about the origins of the Etruscans have been proposed, but today they are believed to have been native to Italy. Their culture was high-level, inventive, and technologically advanced. Women in Etruria had more freedom, were more fashion-conscious, and better educated than Greek women, a fact indicated by the bronze mirrors, used only by women, with inscriptions on them (see figure 12.13).

The period of greatest Etruscan influence and economic prosperity lasted from the seventh to the fifth centuries B.C., when its naval fleet controlled the western Mediterranean. We cannot read their language, but we know that Etruscans borrowed the Greek gods and were influenced by Greek art styles. Nevertheless, Etruscan art is distinctive and reflects a belief in a material afterlife.

One of the best-known Etruscan works of art is the sixth-century B.C. ash-urn in **figure 16.15**. This large-scale funerary monument in the shape of a banqueting couch is that of a wealthy couple. They are shown reclining in the manner of dining borrowed from Greece (where it was restricted to men) and later transmitted to Rome. The Etruscan couple are husband and wife, as is indicated by their shared covering from the waist down. That they appear together reflects the importance of the family and the relatively high status of women in ancient Etruria. The representation of this couple also illustrates a unique aspect of Etruscan funerary art—namely, that the deceased on the lid of the urn appear alive. Their animated gestures and cheerful smiles are reminiscent of the liveliness of black-figure vase paintings and the stylizations resemble those of Greek Archaic sculpture. Etruscan civilization is also important for creating a link between Greek and Roman civilization.

16.15 Sarcophagus from Cerveteri, c. 520 B.C. Painted terracotta, 6 ft. 7 in. long. National Museum of the Villa Giulia, Rome.

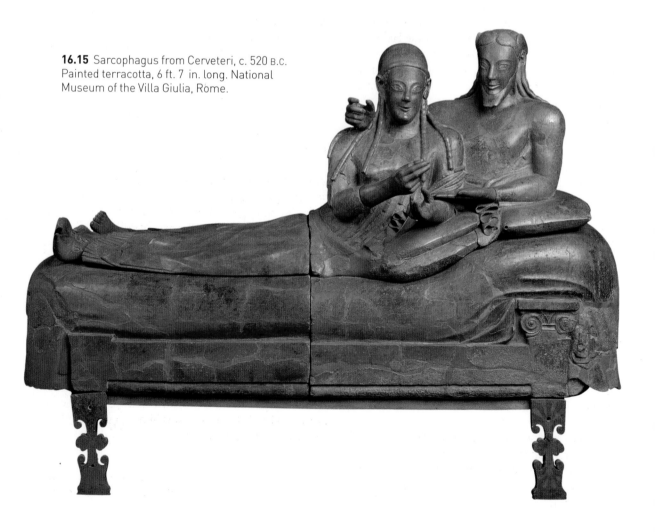

Extent of the Roman Empire in A.D. 284
Etruscan influence

Ancient Rome

According to tradition, the city of Rome was founded in 753 B.C. and some of its early kings were Etruscan. In 509 B.C. the last Etruscan king was expelled, marking the beginning of the Roman Republic, which lasted until 31 B.C. With its rise to power, Rome launched a new series of conquests in the Mediterranean, overrunning most of the Hellenistic world, including Egypt. Latin became the language of the western empire, whereas most of the Hellenistic world spoke Greek. The Romans admired the Greeks and, like the Etruscans, borrowed their gods and gave them new names. Rome also continued the Hellenistic taste for naturalism in painting and sculpture.

In the first century B.C., Julius Caesar (ruled Rome 46–44 B.C.) conquered Gaul, leading his troops as far north as Scotland. In 27 B.C., Caesar's adopted son Octavian became the leader of Rome. Four years later, Octavian took the name Augustus and declared himself emperor, launching more than 300 years of imperial rule.

Augustus was a genius at creating art for political purposes. He succeeded in projecting a positive, even democratic image of himself, despite having assumed autocratic power. Augustus ruled Rome until A.D. 14, when he died at the age of 76. During that time, he commissioned many works of art and architecture designed to show the benefits of his reign. According to Suetonius (A.D. 75–c. 140), author of Lives of the Caesars:

> Since the city was not adorned as the dignity of the empire demanded,… he [Augustus] so beautified it that he could justly boast that he had found it built of [sun-dried] brick and left it in marble.[4]

One example of Augustan imagery is the famous marble Augustus of Prima Porta (**figure 16.16**). We can see the influence of the Doryphoros in the relaxed stance and youthful, idealized form of the emperor. He is armed and raises his right hand as he speaks to his troops. Reliefs on his armor depict the surrender of enemy armies and the gods protecting Augustus. The fact that Augustus is barefoot (like Narmer, in figure 15.14) indicates that the statue was originally placed in a sacred setting.

The little winged boy by the emperor's leg is Cupid, the Roman god of love. Cupid was the son of Venus, and thus a link to the gods. Romans traced their lineage to the Trojan hero Aeneas, who escaped from Troy at the end of the Trojan War and carried the household gods (spirits who protected homes and forums) to Rome. His epic journey is the subject of Virgil's Aeneid, which was composed under Augustus to celebrate Roman history. In Greek myth, Aeneas was the son of Venus and in Roman tradition his descendants were Romulus and Remus, the founders of Rome. By placing Cupid next to the powerful figure of the emperor, the artist implies that Augustus was himself descended from the gods.

16.16 Augustus of Prima Porta, early 1st century A.D. Marble, 6 ft. 8 in. high. Vatican Museums, Rome.

As Roman emperors went, Augustus was relatively benevolent. This was not, however, always the case. Nero (ruled 54–68), for example, was insanely grandiose. And, according to Suetonius:

> There was nothing … in which he was more ruinously prodigal than in building.[5]

Nero built a vast house known as the Golden House, after the abundance of its gold decoration. It had a mile-long porch and a circular banquet hall that rained down perfumed flowers on the guests and revolved continuously in imitation of the planets. In the entrance hall, Nero erected a huge statue of himself that was known as the Colossus. The resentment aroused by Nero's abusive grandiosity led his successor, Vespasian (ruled 69–79), to decapitate the statue. Vespasian tore down the Golden House and began the construction of a public amphitheater, aptly named the Colosseum (**figure 16.17**).

The Roman Colosseum exemplifies the Roman genius for large-scale buildings designed to accommodate the ever-expanding population of the empire. It was used for violent public spectacles, including gladiatorial contests and battles between men and wild animals. The floor of the Colosseum, under which was an elaborate drainage system for disposing of the blood, could be filled with water for mock naval battles. In case of inclement weather, sailors drew a canvas covering over the structure.

Originally the Colosseum, which has a concrete core, was faced with marble and was a gleaming white building. The arch construction system (see Chapter 14) that was extensively used by Roman architects is the basis of the first three stories of the Colosseum. Following the visual and structural logic of the Greek Orders, the first story has a Roman version of Doric columns (Tuscan Doric), the second has Ionic columns, and the third has the more decorative Corinthian columns.

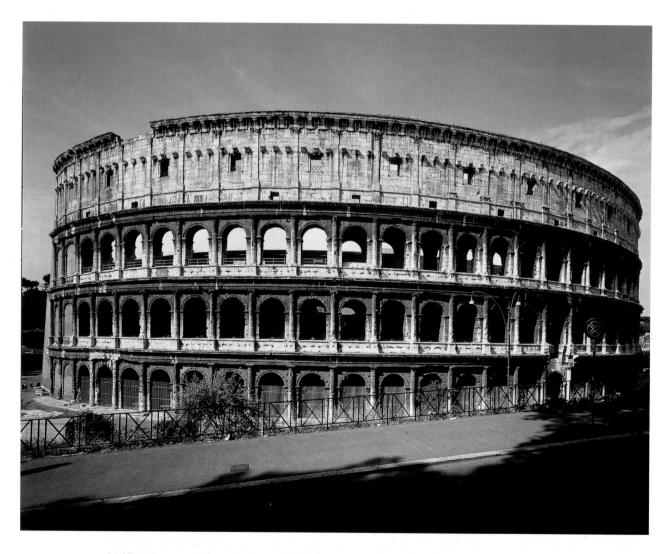

16.17 Colosseum, Rome, Italy, A.D. 72–80. Concrete, tufa, brick, and marble, c. 615 x 510 ft.

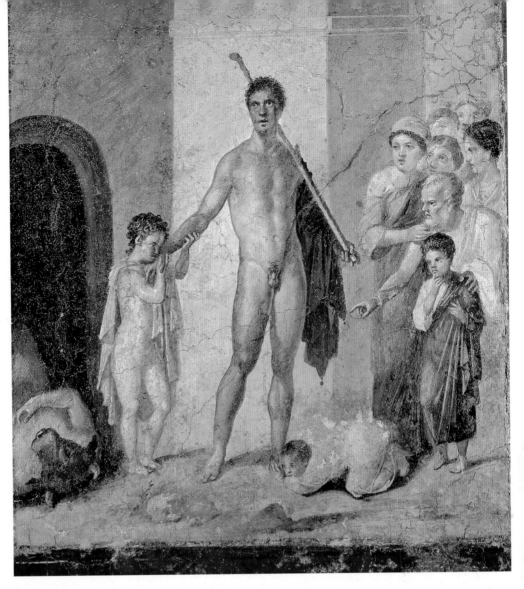

16.18 *Theseus after Killing the Minotaur*, from the House of Gaius Rufus in Pompeii, 1st century A.D. Fresco, 38 x 35 in. Now in the National Archaeological Museum, Naples.

In A.D. 79, the last year of Vespasian's reign and the year before the dedication of the Colosseum, Mount Vesuvius, a volcano near Naples (south of Rome) erupted. The speed and violence of the eruption buried the entire towns of Pompeii and Herculaneum under volcanic ash. This preserved the towns intact, like time capsules, until they were rediscovered in the eighteenth century. Excavations of the sites have revealed a great deal about daily life during the Roman Empire.

Many of the paintings that decorated the walls of upper-class houses in Pompeii and Herculaneum, which we discussed in Chapter 4, have been preserved. These reflect the continuing Hellenistic taste for naturalism and the influence of Greek style and Greek subject matter. A scene from the myth of the Minotaur (see Chapter 15) is shown in **figure 16.18.**

The Greek hero Theseus dominates the center of the scene. His pose was probably inspired by the *Doryphoros*, although his face is more individualized and his thicker proportions are more Hellenistic. A crowd of astonished Minoans gestures excitedly and gazes at the dead Minotaur to the far left. A small boy caresses Theseus's arm and echoes the hero's relaxed pose. Another figure embraces Theseus's foot. In contrast to the ideal human form of the heroic liberator, the monstrous ruler is depicted with a bull's head.

Greek influence is evident in the attention to shading, which creates a sense of volume. The artist shows the anatomical structure of the nudes and the drapery folds of the crowd define their forms. In the absence of monumental Greek painting, scholars assume that Roman works such as the *Theseus* were inspired by (or even copied from) lost Greek frescoes.

According to Pliny the Elder, art was held in high esteem in imperial Rome. He also discusses the formal elements that made Roman painting naturalistic:

> … art … discovered light and shade, contrast of colors heightening their effect reciprocally. Then came the final adjunct of shine, quite a different thing from light. The opposition between shine and light on the one hand and shade on the other was called contrast, while the juxtaposition of colors and their passage into one another was termed attunement [in Greek the term meant 'adjustment of parts.'].[6]

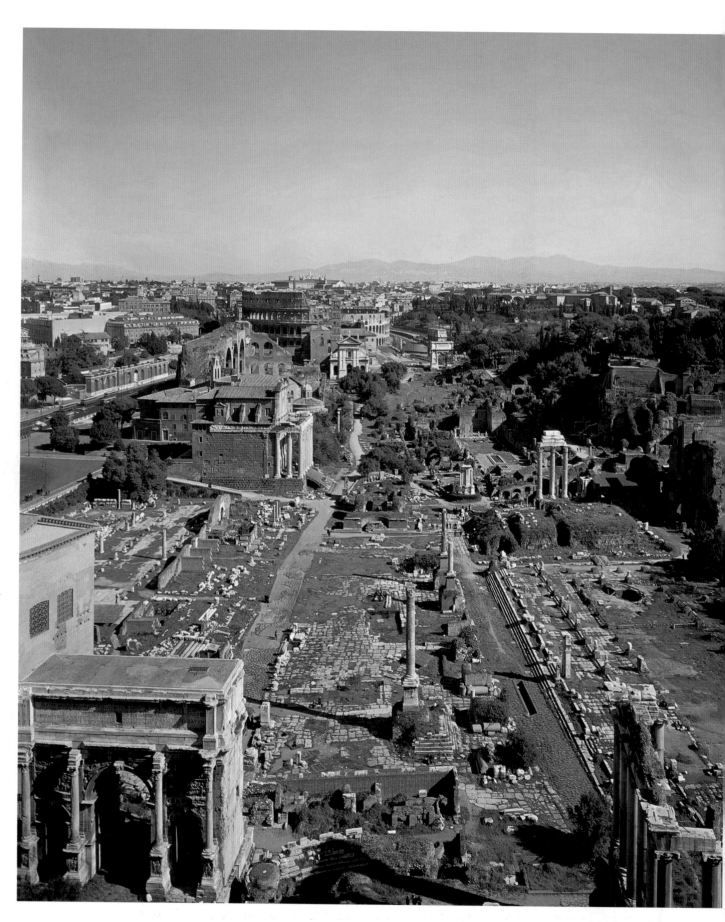

16.19 View of the Roman Forum, c. A.D. 46–117.

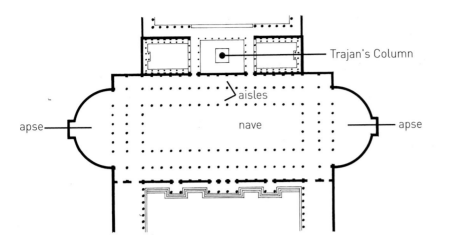

16.20 Plan of Trajan's Basilica, Forum of Trajan, Rome, A.D. 98–117.

Trajan's Column

aisles

apse

nave

apse

COMPARE

Trajan's Column.
figure 3.3, page 38

16.21 Reconstruction of Trajan's Basilica.

Rome called itself *caput mundi* ("head of the world"), reflecting the city's central importance in the minds of its rulers and citizens. One expression of this view was the **forum**, originally a marketplace that expanded into a large area filled with temples and other buildings (**figure 16.19**). It was also in the forum that the Council and the Assembly met, and where public announcements were made to the citizens. The first Roman forum was laid out by Julius Caesar and completed by Augustus. Subsequent emperors added to it or built their own forums.

One of the most important buildings in any forum was the **basilica**. Basilicas were used for commerce, as public meeting places, and for law courts. Most are now destroyed or in ruins, but **figure 16.20** shows the plan of Trajan's Basilica, which is reconstructed in **figure 16.21**. It was a huge structure, with a curved **apse** at either end. One apse contained a large statue of the emperor and a law court, implying that the emperor ruled over a fair and just legal system. Columns (the black circles on the plan) divided the main space into a central **aisle** (nave) and side aisles, which facilitated the circulation of crowds. Second-story (**clerestory**) windows provided interior light. Eventually the basilica plan would provide a basic model for Western church plans (see Chapter 17).

Another characteristic Roman structure found in Trajan's forum is the freestanding colossal column we discussed in Chapter 3, visible in figure 16.21.

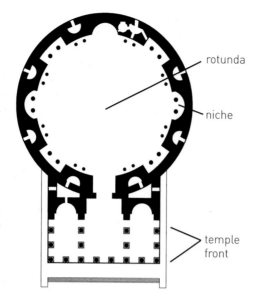

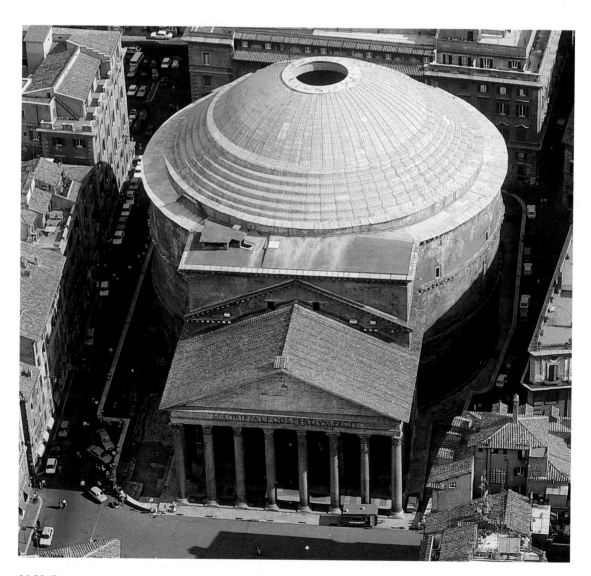

The Romans also built rectangular temples influenced by Greek and Etruscan temples. But the largest surviving Roman temple is the second-century-A.D. Pantheon (**figures 16.22** and **16.23**), which, as we saw in Chapter 14, was the inspiration for Thomas Jefferson's library at the University of Virginia. The Pantheon was constructed during the reign of Hadrian as a dome on a drum. A Greek temple front (**portico**) in the Corinthian Order (see p. 269) was superimposed over the entrance to improve its appearance. It is a massive building, dominating the open urban space before it and echoing the emperor's domination of Rome. The temple was dedicated to the gods named for the five planets known at the time, plus the sun and the moon.

16.22 Plan of the Pantheon.

16.23 Exterior view of the Pantheon, Rome, A.D. 112–125. Marble, brick, and concrete.

The interior of the Pantheon, illustrated in an eighteenth-century oil painting (**figure 16.24**), shows the enormous scale of the Pantheon in relation to its visitors. Nevertheless, the regular proportions and symmetrical wall arrangement of round and square columns alternating with pedimented niches, as well as the floor design, create an elegant, inviting impression. The weight of the dome was decreased by the decorative coffers (indentations) in the ceiling. Their original blue color, which has worn away, was a reminder that the dome symbolized the dome of heaven. The central **oculus** (round opening) in the dome was the Pantheon's only source of outdoor light and this, too, was symbolic—it alluded to both the sun god and the all-seeing divine eye of Jupiter (the Roman Zeus).

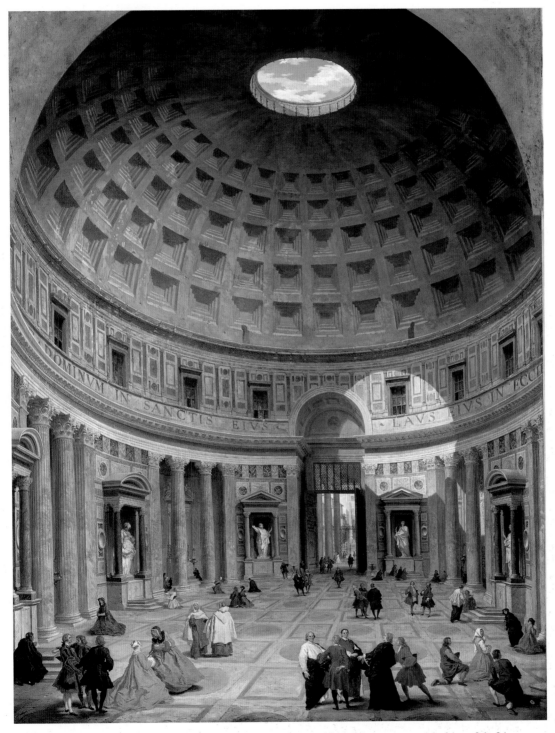

16.24 Giovanni Paolo Panini, *Interior of the Pantheon*, c. 1740. Oil on canvas, 4 ft. 2 in. x 3 ft. 3 in. National Gallery of Art, Washington, D.C.

In the second half of the second century, the philosopher-emperor Marcus Aurelius (ruled A.D. 161–180) was commemorated with an **equestrian monument** (showing a ruler or general on horseback) (**figure 16.25**). Marcus Aurelius admired Greek culture and, in contrast to the smooth-shaven Augustus of Prima Porta, he wears a Greek-style beard. He rides a warhorse, which originally trampled the figure of a defeated enemy underfoot. His extended hand is a gesture both of leadership and oratory, for, like Augustus, Marcus Aurelius is shown addressing his troops.

After the death of Marcus Aurelius, Rome lapsed into a period of decline. New emperors restored stability for a time, but increasing political unrest made it difficult to control so vast an empire. One of the greatest threats to Rome was the development of a new religion that had been developing in the Mediterranean world since the first century—namely, Christianity.

As the teachings of Jesus began to gain adherents who refused to worship the Roman emperor as a god, Rome had him crucified and persecuted his Christian followers. Finally, in the fourth century, the emperor Constantine the Great (ruled A.D. 306–337) came to power after defeating his rival emperor, Maxentius, for control of Rome. Constantine attributed his victory to a vision instructing him to carry the sign of the Cross before him into battle. When he won without a fight, Constantine issued the Edict of Milan in A.D. 313, which mandated tolerance of all religions, and especially of Christianity.

16.25 Marcus Aurelius, A.D. 164–166. Bronze, 11 ft. 6 in. high (after restoration). Now in the Capitoline Museum, Rome.

This legislation, in Constantine's view, would strengthen the solidarity of Rome as well as his own power. It is not documented whether or not Constantine himself became a Christian, but the imperial family soon did so.

In 313, Constantine commissioned a triumphal arch commemorating his victory over Maxentius (**figure 16.26**). This characteristic Roman structure was typically erected on a major roadway leading into a city. Victorious emperors and generals marched through such arches, marking their triumphal return from war. Each opening of Constantine's arch is framed by a Corinthian column resting on a podium, the surfaces are decorated with relief sculptures, and the center of the **attic** (the rectangular block at the top) contains an inscription. As a traditional Roman structure commemorating a victory fought under the sign of the Cross, Constantine's great arch can be seen as bridging two major periods of Western history—the Roman Empire and the Early Christian era, which is the subject of the next chapter.

In 395 the emperor Theodosius I banned pagan worship altogether and turned Rome into a Christian city. In 476, Rome was overrun by Germanic tribes and its empire was at an end.

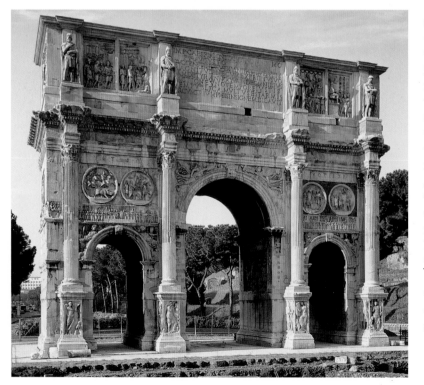

16.26 Arch of Constantine, Rome, C. A.D. 313. Marble, 70 ft. high.

Chapter 16 Glossary

aisle—passageway flanking a central area (such as the nave of a basilica or church)

apse—projecting part of a building (especially a church), usually semicircular in shape and surmounted by a half-dome

attic—in Roman architecture, a low story above the entablature, which is part of an Order above the capital of a column

attribute—object closely identified with, or belonging to, a specific individual, especially a god, saint, or hero

basilica—(a) in ancient Roman architecture, a rectangular building used for tribunals and other public functions; (b) in early Christian architecture, a church building with similar features

black-figure—technique of ancient Greek pottery in which the decoration is black on a red background

clerestory—upper part of the main outer wall of a building (for example, a basilica or church), admitting light through a row of windows

contrapposto (or **counterpoise**)—stance of the human body in which the weight is placed on one leg, while the other is relaxed, and there is a shift at the waist

equestrian monument—sculpture of a figure mounted on a horse

forum—civic center of an ancient Roman city, typically containing a marketplace, official buildings, and temples

kalyx-krater—wide-mouthed bowl for mixing wine and water in ancient Greece

oculus—round opening in a wall or at the top of a dome

Panathenaia—festival (which included a great procession) held every four years in ancient Athens in honor of the goddess Athena's birthday

peristyle—colonnade surrounding a building

portico—(a) colonnade; (b) projecting porch with its roof supported by columns, often forming the entrance to a building

red-figure—technique of ancient Greek pottery in which the decoration is red on a black background

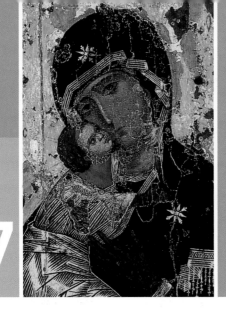

17

KEY TOPICS
Early Christian art and architecture
Art of the Byzantine Empire
The rise of Islam
Medieval art and architecture
Romanesque and Gothic style

Early Christianity and the Medieval World

This chapter covers the culturally diverse period of Western European history that began with Constantine's legalization of Christianity in A.D. 313, when he issued the Edict of Milan. By the end of the fourth century, Christianity was the official religion of Rome and it ushered in new artistic styles. The next several centuries formed a complex period, with influences coming from the Middle East as well as from different areas of Europe. As Rome declined, Constantine tried to strengthen the empire by establishing a second capital at Byzantium, on the Bosporus Sea, in modern Turkey. He renamed the city Constantinople after himself. But in the sixth century Byzantium became the capital of a new empire—the Byzantine Empire. In the seventh century, the birth of Islam in Saudi Arabia and the Muslim conquest of Spain brought Islamic art forms to the West. The medieval period (the Middle Ages) overlapped with the early Byzantine Empire and lasted from the fifth century to the fifteenth century, depending on the region.

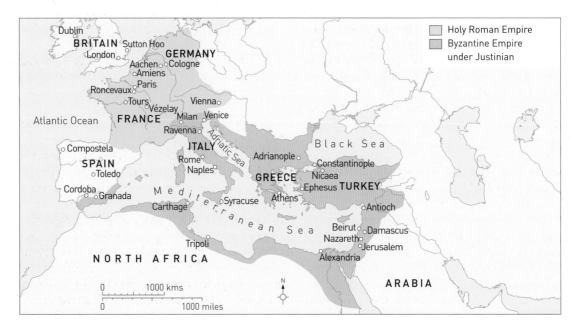

Byzantine Empire under Justinian and the Holy Roman Empire.

The Middle Ages are divided into several periods, beginning with migrations of nomadic tribes from the fifth to the eighth century. In 771, the Frankish ruler Charlemagne came to power in what is modern Germany and revived aspects of Roman and Greek culture. He introduced some measure of political and economic stability; in A.D. 800 the pope crowned Charlemagne Holy Roman Emperor in Rome. But a new wave of invasions, carried out by pagan Vikings from Scandinavia, launched a period of warfare and religious conflict. Most of Europe at the time was agrarian and was dominated by a feudal system based on mutual loyalty between lords and vassals. Farms were worked mainly by serfs, who were bound to a lord and tied to land they did not own.

It was not until around A.D. 1000 that towns began to grow up and there was a surge in building activity, especially of churches and monasteries. This marked the beginning of the Romanesque period, which, in the twelfth century, evolved into the Gothic Age of Cathedrals.

The Rise of Christianity

We now turn to the rise of Christianity, the religion that challenged the Roman Empire. Christianity began with the teachings of Jesus, a Jew born in the Middle East during the reign of Augustus. Today Jesus's birth, in Bethlehem, in modern Israel, is celebrated by Christians on December 25 and Christianity is an established world religion. But, when Augustus ruled the vast Roman Empire, Jesus and his followers comprised just one of many religious groups in the diverse mix of Mediterranean civilizations. As long as such beliefs did not interfere with the power of the emperor, they were tolerated by Rome. The Egyptian cult of Isis, for example, the sister-spouse of Osiris (see Chapter 15), was quite popular even in Rome itself. Other religious influences came from Persia and Asia Minor, and from Greek mystery cults.

Christianity followed Judaism in being monotheistic. Like Jews, Christians believed in one god. But, in contrast to the Jews, who believed that a Messiah (Savior) would one day come, the Christians believed that Jesus *was* the Messiah. (The term "Christ" comes from the Greek word *Christos*, meaning "he who is anointed by God.") In the course of his short life—he died around the age of thirty-three—Jesus called a group of twelve men (the **apostles**) to follow him and spread his teachings.

The life and teachings of Jesus were compiled beginning around A.D. 70 in the four **Gospels**, the books written by Matthew, Mark, Luke, and John (called the **Evangelists**—"bearers of good news" in Greek) at the beginning of the Christian Bible, also

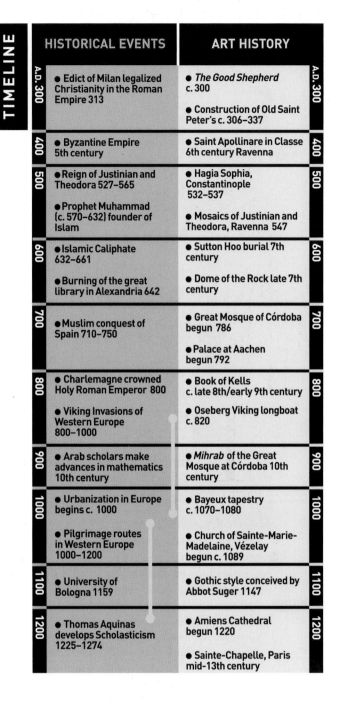

TIMELINE	HISTORICAL EVENTS	ART HISTORY
A.D. 300	● Edict of Milan legalized Christianity in the Roman Empire 313	● *The Good Shepherd* c. 300 ● Construction of Old Saint Peter's c. 306–337
400	● Byzantine Empire 5th century	● Saint Apollinare in Classe 6th century Ravenna
500	● Reign of Justinian and Theodora 527–565 ● Prophet Muhammad (c. 570–632) founder of Islam	● Hagia Sophia, Constantinople 532–537 ● Mosaics of Justinian and Theodora, Ravenna 547
600	● Islamic Caliphate 632–661 ● Burning of the great library in Alexandria 642	● Sutton Hoo burial 7th century ● Dome of the Rock late 7th century
700	● Muslim conquest of Spain 710–750	● Great Mosque of Córdoba begun 786 ● Palace at Aachen begun 792
800	● Charlemagne crowned Holy Roman Emperor 800 ● Viking Invasions of Western Europe 800–1000	● Book of Kells c. late 8th/early 9th century ● Oseberg Viking longboat c. 820
900	● Arab scholars make advances in mathematics 10th century	● *Mihrab* of the Great Mosque at Córdoba 10th century
1000	● Urbanization in Europe begins c. 1000 ● Pilgrimage routes in Western Europe 1000–1200	● Bayeux tapestry c. 1070–1080 ● Church of Sainte-Marie-Madelaine, Vézelay begun c. 1089
1100	● University of Bologna 1159	● Gothic style conceived by Abbot Suger 1147
1200	● Thomas Aquinas develops Scholasticism 1225–1274	● Amiens Cathedral begun 1220 ● Sainte-Chapelle, Paris mid-13th century

known as the New Testament. Christians believe that the New Testament rests on the foundation of the Old Testament (the Hebrew Bible) and that Jesus was the Messiah foretold by the Hebrew prophets.

The new religion came into conflict with Roman authority because Jesus and his followers refused to worship the emperor. Jesus also challenged the entrenched Jewish religious establishment. The Romans had him arrested and crucified (being nailed to a wooden cross and left to die) on the hill of Golgotha outside Jerusalem. According to Christianity, when Jesus died, he took on the sins of humanity and saved the faithful from the Original Sin committed by Adam and Eve in the Garden of

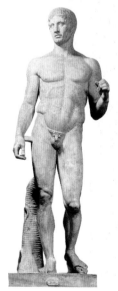

17.1 *The Good Shepherd*, c. A.D. 300. Marble, 3 ft. high. Vatican Museum, Rome.

COMPARE

Polykleitos, *Spearbearer*.
figure 16.3, page 319

Eden. In addition, he promised salvation and eternal life to the faithful. Jesus's own rebirth (Resurrection) three days after his death is celebrated on Easter Sunday.

The events of Jesus's life became subjects of Christian art in later centuries. But as long as Rome outlawed Christianity, works of Christian art were illegal. As a result, until the fourth century, there was no monumental Christian architecture. Paintings and sculptures were small and generally hidden in **catacombs**. These were underground burial passages on the outskirts of the city, where Christians could find refuge because the Romans did not desecrate cemeteries.

There were important differences between the Christian rituals and those of the pagan world. Christians celebrated Jesus's Last Supper in the rite of the **Eucharist** (the Mass), where the bread and the wine were believed to be miraculously transformed into his body and blood. Christian rites did not involve animal blood sacrifices as those of the pagans did.

As word of Jesus's teachings spread to Rome, they first appealed to the lower classes and to slaves, who could hope for a better life after death. Gradually the wealthy and intellectual classes were drawn to the new religion, which was adopted by the imperial family in the fourth century. By that time, after more than 200 years of sporadic persecution, the legalization of Christianity led to the development of monumental public art and architecture. The surviving, small-scale works that predate the Edict of Milan (A.D. 313) reflect the process of assimilation known as **syncretism**, in which elements of an earlier religion and its works of art are absorbed by a new one.

Early Christian Art

Although Christianity incorporated aspects of several Mediterranean cults, Early Christian art was stylistically most influenced by the art of Greece and Rome as well as by Jewish art current in the Middle East. We can see Classical influence in the image of a shepherd carrying a sheep, which had also been popular in Greek and Roman art (**figure 17.1**).

The Early Christians transformed the Greco-Roman image into a metaphor for Jesus as a shepherd protecting his flock. In this statue, the influence of Classical style is evident in the relaxed pose, the *contrapposto* shift at the waist, and the garments that reveal the natural form of the body. But the proportions are no longer Classical and the meaning has changed. As a sacrificial animal, the lamb alludes in Christian art to Jesus's sacrifice through his death on the Cross.

With Constantine's support of Christianity, large-scale religious architecture became possible. During his reign, many churches were built to accommodate the faithful, reflecting the congregational character of Christian worship. In contrast to Greek and Roman temples, which were built to house a cult statue, Christian churches had to be large enough for the crowds who worshiped inside the building. Greeks and Romans, on the other hand, held religious ceremonies on altars outside the temple, reserving the interior mainly for priests and priestesses who tended the cult statue.

The most important Early Christian church was Old Saint Peter's in Rome. It was built on the traditional burial place of Jesus's apostle Peter. The church no longer exists, because it was torn down to make way for the New Saint Peter's. But the reconstruction drawing of the elevation and plan give some idea of its original appearance (**figures 17.2** and **17.3**).

The plan of Old Saint Peter's evolved from the Roman basilica. As a result, the Early Christian church is often referred to architecturally as a basilican church. Like the Roman basilica, Old Saint Peter's had a long central nave flanked by side aisles, but there was an apse at only one end. Between the apse and the nave, the church added a transverse section (the **transept**), creating a design that resembled a cross. This arrangement is referred to as the longitudinal **Latin-Cross** plan.

The entrance, at the end opposite the apse, consisted of a narrow **narthex** (porch or vestibule) and a large, rectangular **atrium** (courtyard), which was a standard feature of Roman houses. In the design of the church plan therefore, as with the motif of the Good Shepherd, Christian architects combined traditional Roman elements with new ones suited to their new message.

The nave of Old Saint Peter's, composed of more than one story (see figure 17.2), was taller than the aisles. The lower story, the nave **arcade**, was a colonnade supporting round arches. Above the nave arcade, as in the Roman basilica, a clerestory allowed exterior light to enter the church. The elevation drawing also shows that Old Saint Peter's **gable** (triangular roof) carried the interior space upward and expanded it. At the far end of the drawing, we can see the entrance to the apse in the form of a round arch. This is derived from the Roman triumphal arch (see Chapter 16), which here denotes the triumph of Jesus's teachings rather than military victory.

Although Old Saint Peter's no longer exists, a few later Early Christian churches do survive. One is shown in the eighteenth-century engraving in **figure 17.4.** It illustrates the huge scale of such buildings, which were designed for large numbers of worshipers.

COMPARE

Plan of Trajan's Basilica.
Figure 16.20, page 333

17.2 Elevation diagram of Old Saint Peter's, Rome.

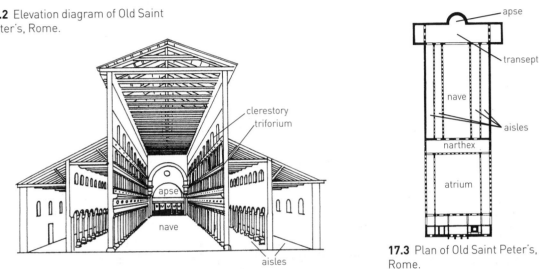

17.3 Plan of Old Saint Peter's, Rome.

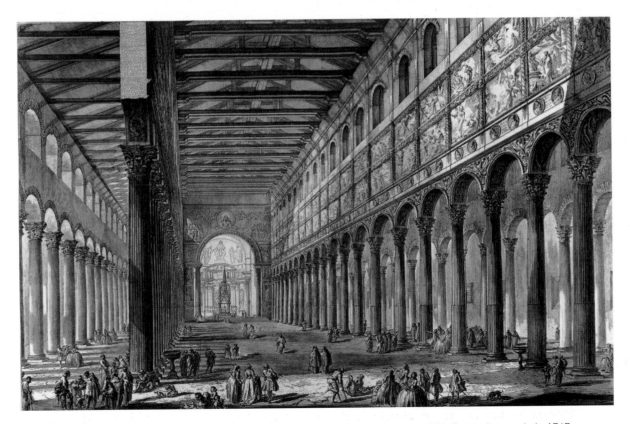

17.4 Giambattista Piranesi, *Saint Paul Outside the Walls*, Rome, begun c. 385. Engraving made in 1747. British Museum, London.

Despite Constantine's efforts to reinforce Roman power in the East, the Byzantine Empire diverged from Rome. It was ruled by an autocrat who claimed to have been appointed by God. New art forms developed and evolved into the Byzantine style. In the fifth century, after Rome was sacked by the Germanic Goths, Constantinople emerged as a second Rome and the two halves of the Christian world grew apart. This division was reinforced by language, with Latin remaining the official language of Rome and the West, and Greek the official language of the East.

Eventually, in 1054, the growing split between West and East led to a **schism** (division) within the Church. Byzantium had different traditions from those of Rome, even though it was still considered part of the Roman Empire. In Eastern Europe, the Church became known as the Eastern or Orthodox Church. In the Orthodox Church there are several patriarchs, with the most important in Constantinople, whereas the single head of the Roman Catholic Church is the pope.

Byzantine Art

With the ascension of the Byzantine emperor Justinian (ruled 527–565) and his empress, Theodora, the Golden Age of the Byzantine Empire began. As a testament to his piety and his power, Justinian commissioned many churches, but his most important and largest church was his personal imperial church—Hagia Sophia (Holy Wisdom) in Constantinople (**figure 17.5**). With the intention of rivaling the Temple of Solomon in Jerusalem, Justinian hired two Greeks to design the building: one, Isidorus of Miletus, was a physicist and the other, Anthemius of Tralles, was a mathematician. The view of the exterior, with its complex array of domes and formal variety, has the organic quality of constantly flowing motion. The four pointed towers (**minarets**) at each corner were not part of the original building; they were added later following the Muslim conquest of Constantinople in 1453 when Hagia Sophia was converted into a mosque (see below).

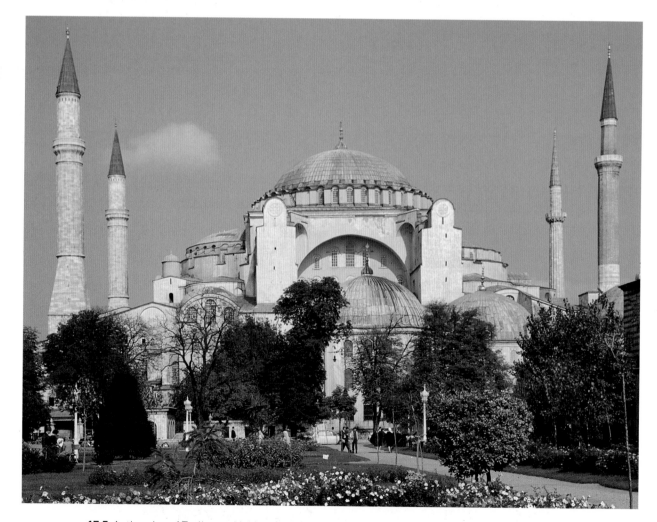

17.5 Anthemius of Tralles and Isidorus of Miletus, Hagia Sophia, modern Istanbul, Turkey, 532–537.

The plan of Hagia Sophia (**figure 17.6**) differs from the basilican plan of the Roman Church in being centralized. It is based on the **Greek Cross**, in which all four arms are of equal length. The nave is the large central space below the dome (the circle on the plan).

A view of the interior (**figure 17.7**) gives some idea of the original splendor of Hagia Sophia. The walls were covered with gold mosaics, which reflected light streaming in through the windows. Their dazzling effect inspired Justinian's court historian to declare the dome a heavenly sphere of gold. The impressive interior of Hagia Sophia inspired other commentators with its beauty and its symbolism. With Hagia Sophia in mind, Germanos, the eighth-century patriarch of Constantinople, described the symbolic meaning of the Church building:

> The Church is the temple of God, a holy place, a house of prayer, the assembly of the people, the body of Christ. It is called the bride of Christ. It is cleansed by the water of his baptism, sprinkled by his blood, clothed in bridal garments, and sealed with the ointment of the Holy Spirit....[1]

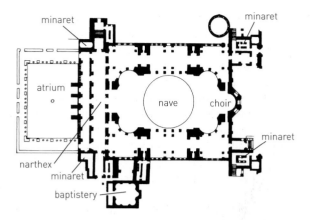

17.6 Plan of Hagia Sophia.

The nave of Hagia Sophia is three stories high. Above its nave arcade is a narrow colonnaded triforium, with the clerestory in the form of large lunettes (the half-moon sections of the upper wall). Between the curves of adjacent lunettes is the Byzantine pendentive, which seems suspended from the base of the dome. The curves of the pendentive create a harmonious transition from the cubed base of the building to its round dome.

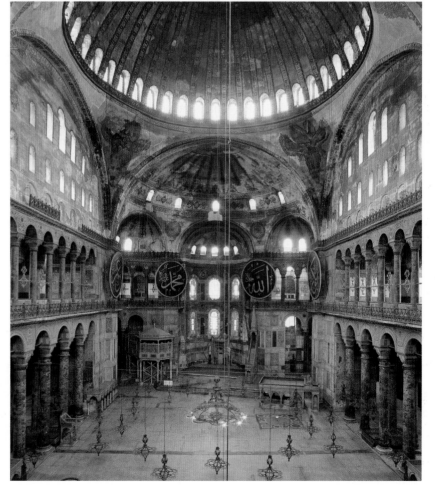

17.7 Interior of Hagia Sophia.

COMPARE

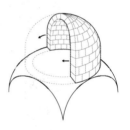

Dome on pendentive diagram.
figure 14.29, page 278

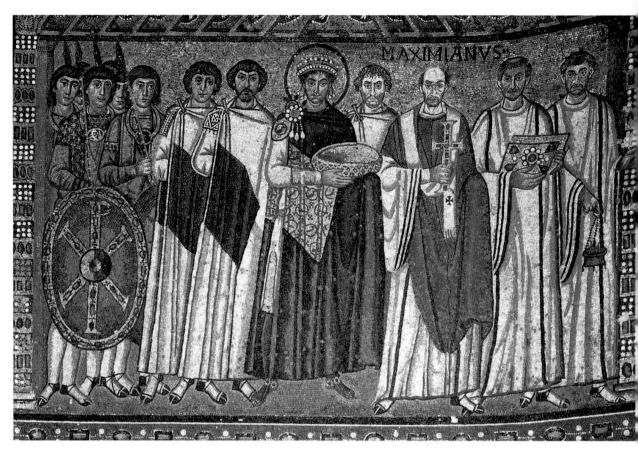

17.8 Court of Justinian, San Vitale, Ravenna, 547. Mosaic.

COMPARE

Apse mosaic,
San Vitale, Ravenna.
Figure 3.12, page 44

Under Justinian, the Byzantine Empire expanded west to the east coast of Italy and southeast as far as the Sinai peninsula. In the Italian city of Ravenna, the church of San Vitale contains impressive apse mosaics depicting Justinian and his empress, Theodora (**figures 17.8** and **17.9**). These mosaics face each other on the side walls of the apse, where they flank the mosaic of Christ on the curved wall that we discussed in Chapter 3 (see figure 3.12).

Justinian and Theodora are shown as co-rulers of enormous wealth and power, to which they were considered entitled by divine right. They are frontal, centered, and dressed in royal purple robes, all of which identify them as the most important figures in their respective mosaics. Justinian is surrounded by clergymen and soldiers displaying a shield with Constantine's emblem—the Chi-Rho (the first two letters of Christ's Greek name—*Christos*—XP in Greek). This iconography identifies Justinian as Constantine's successor, legitimized by the Church and defended by the army.

Theodora, despite low-class origins in theater and a reputation as a former courtesan, is elaborately jeweled, as are her ladies-in-waiting. She, too, is attended by clergymen. Signs of her divine right to rule and her Christian piety can be seen in her halo (Justinian is also

haloed), the three kings bearing gifts to the infant Jesus at the bottom of her robe, and the baptismal fountain at the left. In addition, the use of gold tesserae (mosaic tiles) in the background increases the gold light, which in Christian art symbolizes the presence of God.

In addition to large-scale mosaics on church walls, Byzantine artists created smaller portable images of holy figures on wood panels or ivory plaques. These are called **icons** by art historians, a term that derives from the Greek word meaning "image." Icons were used in the Eastern Orthodox Church as objects of private veneration and were also integrated into the liturgy.

In the eighth century, Byzantine icons became the subject of a violent debate in the Orthodox Church: the Iconoclastic Controversy. At issue was whether *any* image of a saint would cause people to revert to paganism and the worship of idols. The **iconoclasts** (those opposing icons) feared that imagery would corrupt the spiritual basis of Christianity. They took literally the Second Commandment in Exodus 20: 4–5: "Thou shalt not make unto thyself a graven image, nor the likeness of any thing that is in heaven above, or in the earth below nor of those things that are in the waters under the earth." In 726, Emperor Leo III (ruled 717–741) banned icons. His son and

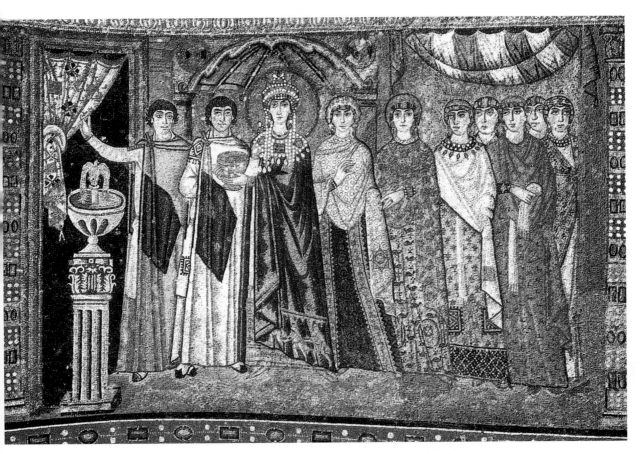

17.9 Court of Theodora, San Vitale, Ravenna, 547. Mosaic.

successor continued the policy, destroying icons and executing those who favored them.

The **iconophiles** (supporters of icons) argued that imagery could be used to convey the humanity of Jesus. They claimed that imagery served the spiritual purpose of assisting the worshiper in making the transition from the image to the holy person. Many people, including two empresses, revered icons privately and escaped persecution. But the official prohibition against icons was not lifted until 843.

Very few portable icons survived, because they were easily destroyed by the iconoclasts. A twelfth-century example is *The Virgin of Vladimir* (**figure 17.10**), which was made in Constantinople but was a gift to the Russian city of Kiev. The icon was taken north from Kiev to Vladimir, hence its name, but eventually ended up in Moscow. It shows the Byzantine taste for delicate, linear gold patterns, almond-shaped eyes, and the unnatural, adult proportions of Jesus. He looks adoringly up at his mother, the Virgin Mary, as she gazes mournfully out of the picture. Her downcast expression is a convention in Christian art that reveals her foreknowledge of Jesus's death on the Cross. This icon conveys the psychological power of the mother–child relationship while also achieving spiritual intensity.

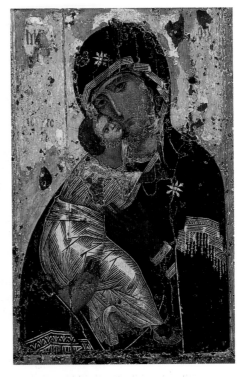

17.10 *The Virgin of Vladimir*, c. 1131. Wood panel, painted section 30 ¾ x 21 ½ in. Tretyakov Gallery, Moscow. 14.243.

The Byzantine style persisted in Italy through the thirteenth century, but the art and beliefs of Eastern orthodoxy migrated northward and continued as late as the sixteenth century in the East. The last great Italian Byzantine painter was Cimabue (active 1272–1302), who worked during the late thirteenth century. His large altarpiece in **figure 17.11** represents the Virgin and the infant Jesus seated on a towering golden throne flanked by angels. Below are four Hebrew prophets, identified as such by their scrolls. Their presence signifies that the prophecy of a Messiah is fulfilled in Jesus.

As in *The Virgin of Vladimir*, Cimabue's drapery folds are depicted with gold lines, the eyes are almond-shaped, and the proportions of Jesus are those of a miniature adult. Mary again gazes sadly at the viewer, but Jesus is no longer an adoring infant. He is now an infant king, seated regally on Mary's lap, blessing the world. This conflation, in which Jesus is both a king and an infant, became a convention of Christian art. It denoted the miraculous nature of Jesus—a human child with the wisdom of a great king and the divine power of a god.

Although in Italy styles began to change with the dawn of the fourteenth century, the Byzantine Empire lasted until 1453, when the Ottoman Turks overran Constantinople and converted the city to Islam. In the meantime, Europe entered the medieval period—the Middle Ages—when new art styles emerged.

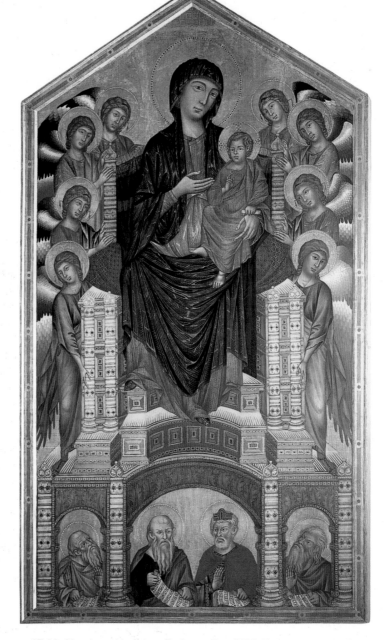

17.11 Cimabue, *Madonna Enthroned*, c. 1280. Tempera on wood, 12 ft. 7 in. x 7 ft. 4 in. Uffizi, Florence.

Reading Christian Symbolism

From its beginnings, Christian art was imbued with complex, often abstract symbolism. This is apparent in the iconography of the huge apse mosaic in the church of Saint Apollinare in Ravenna's port at Classe (**figure 17.12**). The image combines continuing Greco-Roman naturalism in landscape details with the newer, more static quality of Byzantine style.

Above the curve of the apse, a bearded Christ blesses the faithful. To Christ's left and right are four creatures described in the last book of the Bible (Revelation) by Saint John the Divine. In Christian art, these creatures came to symbolize the four Evangelists: Mark is depicted as a winged lion, John as an eagle, Matthew as an angel, and Luke as a winged bull. (The lion of Mark and the bull of Luke is sometimes shown without wings.) The twelve sheep that proceed from the jeweled gates of heaven represent the twelve apostles in symbolic form.

In the curve of the apse, a large jeweled Cross with a figure of Christ at its center appears in a star-studded sky. The emphasis on circular form is itself symbolic, for the circle stood for the universal, never-ending character of the Church. In this case, the Cross also stands for Christ's Transfiguration, when he ascended Mount Tabor and was transformed by light. Moses appears on our right and the prophet Elijah appears on our left. Above the Cross, emerging through the clouds, is the hand of God. He points to the Cross, which refers to his statement in the Bible that Jesus is his son, "in whom I am well pleased." The three sheep on either side of the Cross symbolize the three astonished apostles who accompanied Jesus to Mount Tabor and witnessed his Transfiguration. Palm trees framing the apse identify the Middle East as the region where these events occurred.

Directly below the Cross is the frontal figure of Saint Apollinare wearing the robes of a bishop. His pose is that of the Early Christian **orans** (one who is in an attitude of prayer) and he identifies with Christ through martyrdom. In the iconography of this apse, the artist has combined time in a way that is characteristic of Early Christian and Byzantine art. We are shown the past, present, and future simultaneously, which alludes to the notion that the Church is timeless and eternal.

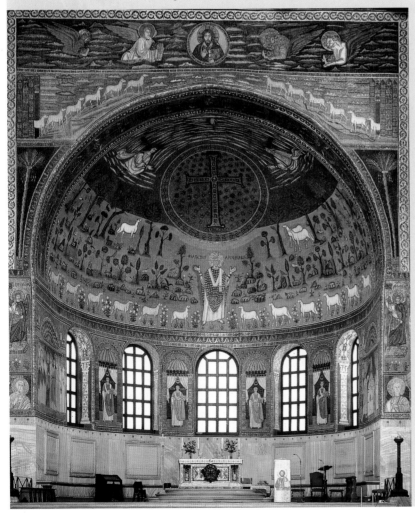

17.12 Apse mosaic, Saint Apollinare in Classe, 6th century, Ravenna, Italy.

The Rise of Islam

More than five centuries after the birth of Jesus, a new world religion was born in the Middle East—Islam. The term means "submission," in this case submission to Allah as the one true God. Islam originated in the city of Mecca, which is on the Arabian peninsula, with the teachings of the Prophet Muhammad (c. 570–632). He opposed paganism and proclaimed himself the prophet of Allah. Muhammad believed that he was God's messenger and the last of the great prophets, coming after Abraham, Moses, and Jesus. Those who follow the teachings of Muhammad are called Muslims.

Muhammad was an inspired and charismatic speaker. He was born in Mecca, in Saudi Arabia, which became the central city of Islam. The main object of veneration in Mecca then and today is the Ka'aba, a shrine which houses a huge black stone cube. Muslims believe that the angel Gabriel gave the stone to Abraham.

Islam has five basic precepts, known as the Five Pillars. These require submission to Allah, prayer five times a day while facing Mecca, giving to charity, fasting in the daylight hours during the holy month of Ramadan, and undertaking a pilgrimage (the *hajj*) to Mecca at least once in one's lifetime. A sixth pillar calls for converting and conquering non-Muslims, a tenet that led to new invasions across the Mediterranean, especially North Africa, and into parts of Europe during the seventh century. These armed incursions overlapped the rise of the Byzantine Empire and also brought Islam into conflict with Western Europe.

With conquest and conversion, Islamic art spread throughout the world. We saw in Chapter 3 that Muslims, like Christians, believe in the sacred character of God's Word and developed writing as an art in its own right. The most sacred book of the Muslims is the Koran (*Qur'an*), which contains the revelations received by Muhammad from Allah. In contrast to Christians, but as is true of Judaism, Muslim teachings discourage figurative imagery, especially sculpture, in religious art.

There is no Islamic priesthood, but Islam requires a building where people gather and pray—a mosque. The faithful are called to prayer from a tower (minaret) of the type erected outside Hagia Sophia (see figure 17.5). The oldest surviving mosque is the Dome of the Rock, in modern Jerusalem (**figure 17.13**), which was built in the seventh century, during the formative years of Islam.

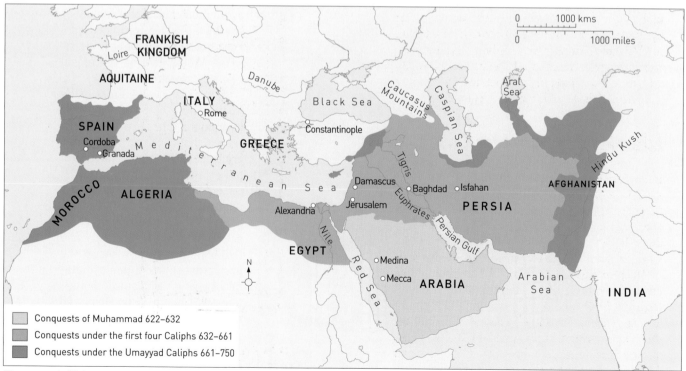

The spread of Islam.

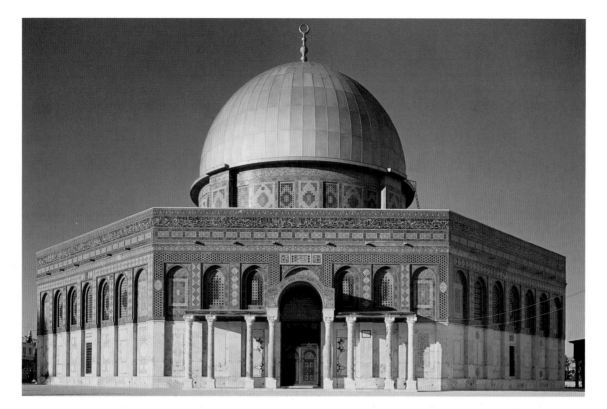

17.13 Dome of the Rock (Mosque of Omar), late 7th century, Jerusalem.

The site is holy to Muslims as the place from which the angel Gabriel guided Muhammad to heaven. It is also sacred to Jews as the Temple Mount, the location of Solomon's Temple and the place where Abraham agreed to sacrifice his son Isaac. The structure itself is octagonal, surmounted over the center by a gilded dome. The design patterns of mosaic and marble are characteristic of both Islamic and Byzantine style. The **caliph** (Islamic ruler) who commissioned the Dome of the Rock intended it as a statement of the Muslim conquest of Jerusalem.

Islamic Art in Western Europe

In Western Europe, the most impressive example of Islamic architecture is the Great Mosque at Córdoba, in southern Spain. It was begun in 786, after the Moors (Muslims from North Africa) conquered Spain. They remained in power until 1492, when the country was reclaimed by the Christians.

The plan (**figure 17.14**) is a large rectangle, divided into a courtyard (the **sahn**), a hall of columns (**figure 17.15**), and a *qibla* wall oriented toward Mecca. The vast interior space of the Córdoba mosque is enlivened by a system of double arches shaped like horseshoes. The voussoirs (see Chapter 14) of the lower arches are made of red brick and yellow stones. From these a second level of arches springs to the roof.

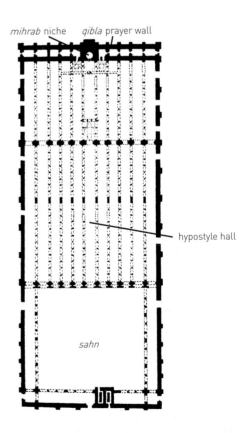

17.14 Plan of the Great Mosque, Córdoba, Spain.

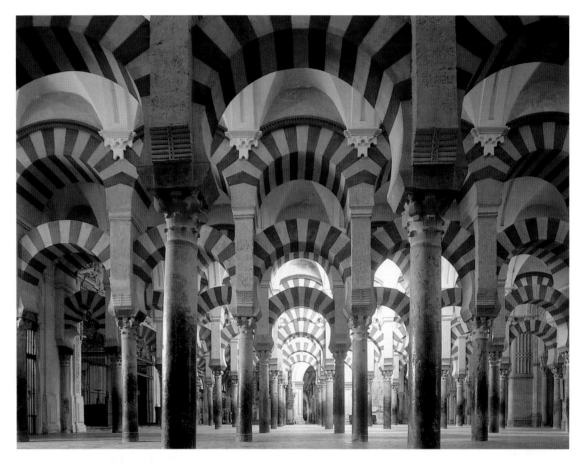

17.15 Arches of the Great Mosque, Córdoba, Spain, begun 786. Columns 9 ft. 9 in. high.

In the tenth century, another feature, the **mihrab** bay, was added (**figure 17.16**) to mosque design. The *mihrab* accentuates the *qibla* wall and reminds worshipers that it faces the holy city of Islam. It also celebrates the splendor of Islamic decoration, with its three levels of **lobed arches** creating waves of elegant, curvilinear patterns, and its gold surfaces covered with intricate calligraphy. After the Christians retook Spain in 1492, the Córdoba Mosque was converted to a church.

Spurred on by their success in Spain, the Muslims advanced to central France. But in 734, they were repelled by Charles Martel, ruler of the Franks (inhabitants of modern France), thus defeating the Muslim effort to conquer Europe. The period that begins with Martel's rule is called Carolingian; it continued until the tenth century, but reached its greatest artistic success under Martel's grandson, Charles the Great, known as Charlemagne.

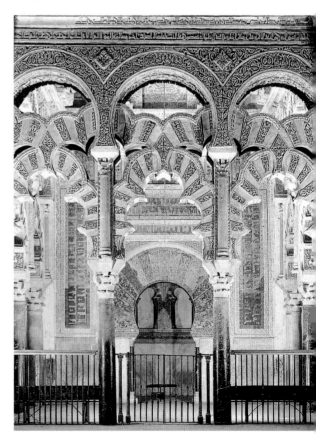

17.16 *Mihrab* bay of the Great Mosque, Córdoba, Spain, 10th century.

Early Medieval Art in Western Europe

Charlemagne was a shrewd ruler and military strategist, who gained control of large areas of Western Europe. His power challenged Rome, which the pope acknowledged in 800 when he crowned Charlemagne the first Holy Roman Emperor. Charlemagne's coronation led to a new political division in Europe—between the pope in Rome and the Holy Roman Emperor—that would continue for centuries.

An admirer of ancient Roman culture, Charlemagne presided over a Classical revival in the arts. Although unable to write himself, he promoted literacy by simplifying scripts and improving punctuation. He also encouraged the establishment of libraries, and hired scholars to produce a new educational curriculum.

The small statue of Charlemagne on horseback in **figure 17.17** was cast by the lost-wax method. Both the technique and iconography of Charlemagne's statuette reflect the Holy Roman Emperor's identification with the Classical tradition. Like Marcus Aurelius (see p.336) Charlemagne is represented as an image of imperial and military triumph.

The most famous work of architecture produced under Charlemagne was his Palace Chapel at Aachen (see map), where he and his court worshiped. Designed by his court architect, Odo of Metz, the plan is based on the centralized Greek Cross (**figure 17.18**). It has a square apse and an **ambulatory** surrounding the space under an octagonal dome. The view of the interior in **figure 17.19** reflects the influence of Roman round arches and thick walls, as well as the Byzantine taste for patterning.

According to Einhard, Charlemagne's biographer, the Holy Roman Emperor:

> constructed a church of stunning beauty at Aachen and adorned it with gold and silver, with lamps, grillwork, and doors made of solid bronze. When he could not obtain the columns and marble for this building from any place else, he took the trouble to have them brought from Rome and Ravenna.[2]

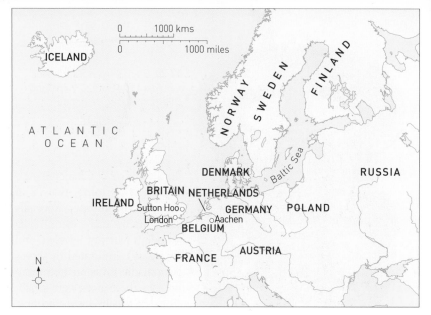

Medieval Northern Europe.

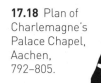

17.18 Plan of Charlemagne's Palace Chapel, Aachen, 792–805.

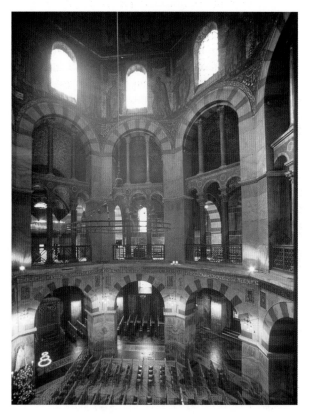

17.17 Equestrian statuette of Charlemagne, 9th century. Gilt bronze, 9 ½ in. high. Louvre, Paris.

17.19 Interior of Charlemagne's Palace Chapel, Aachen, 792–805.

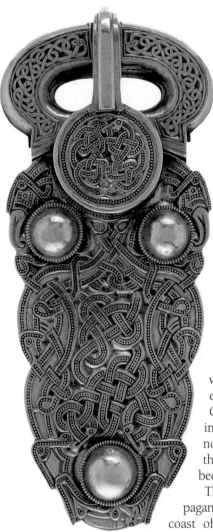

In the course of Charlemagne's reign, new art forms evolved in the north of Europe, especially in Britain and Scandinavia (modern Norway, Sweden, and Denmark). Infiltrated by waves of nomadic invasion from central Asia, these areas were inhabited by culturally diverse groups. Germanic Angles and Saxons, and non-Germanic Celts, settled in Britain; in Scandinavia, the Viking warrior culture flourished. These nomadic peoples were distinct from the Franks and evolved styles unrelated to the Classical tradition that had inspired Charlemagne. At first the nomads were pagans, but over time they converted to Christianity and became more settled.

The discovery of a seventh-century pagan ship burial at Sutton Hoo, on the coast of East Anglia north of London, reveals the high level of craft characteristic of Anglo-Saxon metalwork. One impressive object from the ship is a gold buckle decorated with complex interlace designs (**figure 17.20**). These typically form flat, dynamic patterns that resemble woven threads and contain echoes of Byzantine and Islamic decoration.

The picture stone from Gotland, in modern Sweden, is decorated with scenes in low, flat relief (**figure 17.21**), and bordered with interlace patterns. Two armed warriors do battle at the top of the stone, and a Viking longboat sails over stylized, triangular waves below. The ship, propelled by oars, a large sail, and a side rudder, is filled with soldiers.

Interlace design is also characteristic of the Hiberno-Saxon (relating to Celtic Ireland and English Saxon) art of Ireland. Isolated as it was from much of the turmoil pervading Europe, Ireland was, according to tradition, converted to Christianity by Saint Patrick (c. 387–463) in the fifth century. In Irish monasteries, monks and nuns kept literacy alive. They copied the Bible by hand and illuminated individual pages of text with painted images.

The most famous Irish manuscript is the *Book of Kells*, which contains the four Gospels in Latin. **Figure 17.22** shows a page of the manuscript with a frontal figure of Christ in the center. He holds a book that denotes the power of God's Word and his own teachings. The peacocks flanking his head symbolize immortality and the vines they stand on allude to the wine of the Eucharist. Matthew, Mark, Luke, and John, the authors of the Gospels, are framed in rectangles below the peacocks. The border designs are interlaced; the space (as in the Sutton Hoo buckle) is flat; and the figures are stylized.

A potent force in medieval Europe from 800 to 1000 came from the Viking invasions. The Vikings were fierce warriors and accomplished sailors. They designed sailboats up to 80 feet in length that were fast and efficient and could hold many warriors, together with their armor, weapons, and horses. Like the ancient Near Eastern rulers (see Chapter 15), Vikings erected large boundary stones to mark important events. These were inscribed with runic inscriptions (**rune stones**) or with pictures (**picture stones**).

17.21 Viking Smiss Stone from Gotland, Sweden. 4 ft. 1 ½ in. high. National Antiquities Museum, Stockholm.

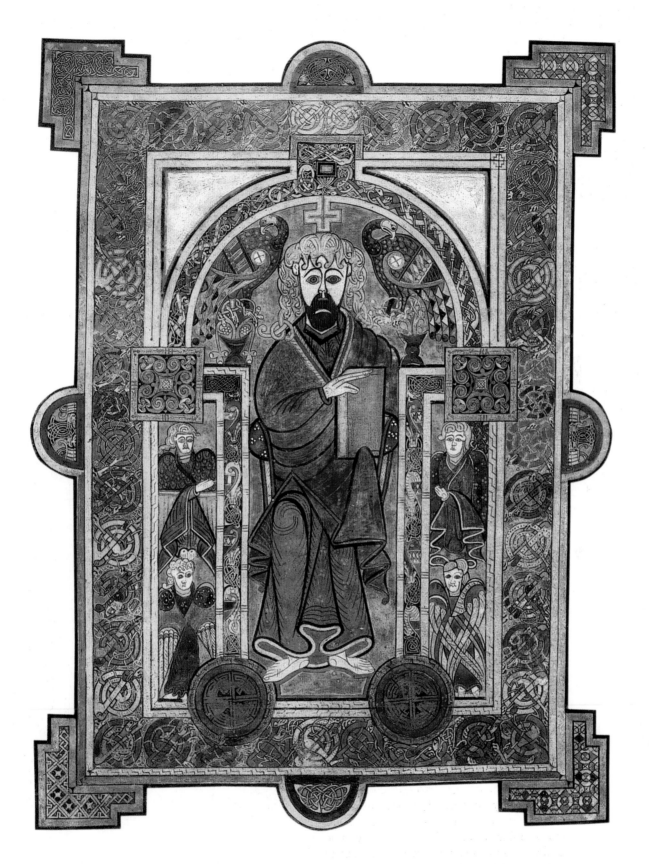

17.22 Christ with angels, peacocks, grapes, and animal interlace, from the *Book of Kells*, late 8th to early 9th centuries. Vellum, 13 x 9 ½ in. Trinity College Library, University of Dublin.

Romanesque Art

The period of the European Middle Ages from around 1000 to 1200 is called Romanesque, because aspects of its architecture were influenced by ancient Roman buildings. As the Viking invasions died down, prosperity increased, and a long process of urbanization began. Western Europe, now mainly Christian, witnessed a revival of monumental church architecture. This new building activity began in France and was fuelled by the popularity of pilgrimages to Christian holy sites, the two most important being Jerusalem and Rome. These pilgrimages were undertaken as a means of doing penance for one's sins. Pilgrims traveled to sacred sites to venerate relics of saints and martyrs, such as the reliquary sandal of Saint Andrew that we saw in Chapter 3 (see p. 47)

Relics were believed capable of producing miracles. Thus Bishop Gregory of Tours described the power of relics at Old Saint Peter's in Rome:

> If someone wishes to take away a blessed relic, he weighs a little piece of cloth on a pair of scales and lowers it into the tomb [of Saint Peter];… if the man's faith is strong, when the piece of cloth is raised from the tomb it will be so soaked with divine power that it will weigh much more than it weighed previously; and the man who raised the cloth then knows that … he has received what he requested.[3]

In addition to Rome and Jerusalem, pilgrimage destinations sprang up throughout France, Spain, Italy, and northern Europe. A network of roads, the so-called Pilgrimage Routes, provided lodgings for thousands of traveling pilgrims and encouraged commerce. Another development in the Romanesque period that caused large numbers of people to travel was the Crusades—armed conflicts that brought warriors from Christian Europe to free Jerusalem from Muslim domination.

To accommodate the influx of pilgrims, Romanesque church plans (**figure 17.23**) evolved from the Early Christian design. The side aisles of the basilican church were extended past the transept to form an ambulatory around the inside of the apse. This allowed for an uninterrupted flow of visitors, while the clergy worshiped in **radiating chapels** attached to the apse.

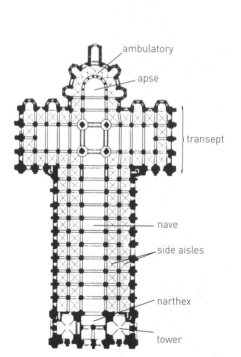

17.23. Generic Romanesque church plan.

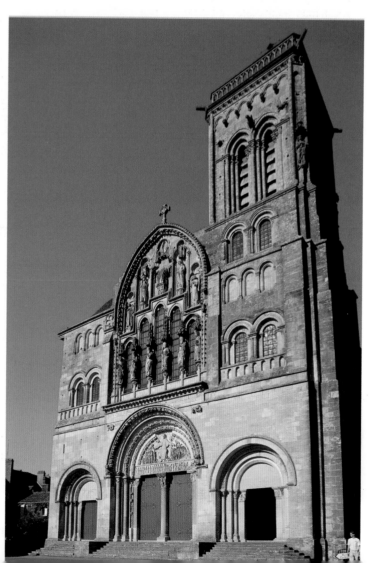

17.24 (Right) Church of Sainte-Marie-Madelaine, Vézelay, France, begun c. 1089.

One of the major pilgrimage churches in central France was located at Vézelay and dedicated to Saint Mary Magdalen, the biblical prostitute who repented her sins and followed Jesus. Vézelay was a popular pilgrim site and a Crusade church. The façade in **figure 17.24** has a sturdy, fortified appearance and a blocklike tower, with thick walls and round arches derived from ancient Rome. In addition to reviving monumental building, Romanesque architects decorated church entrances (**portals**) with sculptures. (Note the triple entrance arches based on the Roman triumphal arch.) **Figure 17.25** is a generic diagram showing the main architectural sections of a Romanesque portal. The most impressive portal sculptures on Romanesque churches were located above the door so that worshipers would experience the impact of their message as they entered the church (**figure 17.26**). Since the literacy rate in the Middle Ages was low, the scenes had a didactic purpose and provided a visual link between the Christian texts and the faithful.

The scene here shows a huge figure of Christ instructing his apostles to carry his message throughout the world. Marking the beginning of missionary activity, this event is referred to as the **Pentecost**, when the apostles were miraculously given the ability to speak many languages. The lintel depicts races that have not yet converted to Christianity.

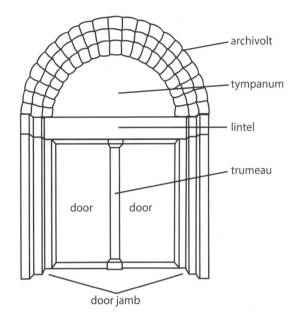

17.25 Diagram of a portal showing trumeau, lintel, door jambs, tympanum, and archivolts.

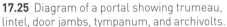

17.26 Tympanum of Sainte-Marie-Madelaine, Vézelay, France, 1120–1132.

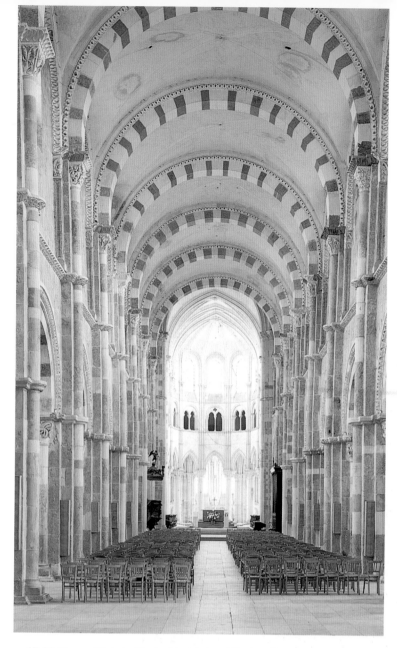

17.27 Nave of Sainte-Marie-Madelaine, Vézelay, France, 11th century.

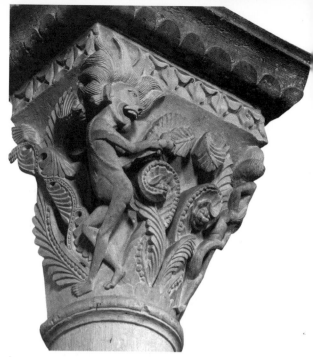

17.28 Capital illustrating the vice of Despair, from Sainte-Marie-Madelaine's south aisle, Vézelay, France, early 12th century. Stone.

COMPARE

Diagram of a round arch and barrel vault.
figures 14.10 and 14.12, page 272

In the interior, the round arches extend along the nave to form a barrel-vaulted ceiling as in ancient Rome (**figure 17.27**).

The clerestory windows are relatively small, contributing to the simpler, more massive appearance of Romanesque as compared with Byzantine interiors. The thick Romanesque walls produce a sense of imposing strength that conveys the power of the Church and the religion it embodies.

A new feature in Romanesque churches is the sculptural decoration carved on the capitals. The little monster in **figure 17.28** illustrates the vice of Despair. Entwined in leafy, Byzantinelike designs, Despair is a subhuman figure, with a large, grotesque head. The impossibility of the pose, with the upper and lower body facing in opposite directions, shows that despair itself is an "impossible," self-destructive, state of mind.

Gothic Art

The next major medieval period was first called Gothic by Renaissance artists who considered the style crude and barbaric; they coined the term after the Goths, who had sacked Rome. Gothic style was conceived in 1147 by the French cleric Suger, abbot of the royal abbey church of Saint Denis, just north of twelfth-century Paris. Suger's ambition was to create lavishly decorated churches that would inspire the faithful. A friend of two French kings (Louis VI and Louis VII), Suger was given financing and permitted to renovate Saint Denis. Suger believed that churches should be more open to light and color than Romanesque churches, with their dark interiors and massive walls. This, in his view, would celebrate God's divinity and his presence inside the church building. In addition, according to Suger, an abundance of gold decoration would reflect not only God's power, but also that of the Church and the king. In Suger's view, artistic beauty inspires faith. These ideas, gleaned from reading mystical Christian texts, led to the development of Gothic style.

Suger wrote an account of his renovations, in which he justified their cost as a route to salvation. A verse on the door in copper-gilt letters describes the uplifting, spiritual effect of light:

> … Marvel not at the gold and the expense but at the craftsmanship of the work. Bright is the noble work; but, being nobly bright, the work should brighten the minds, so that they may travel, through the true lights, to the True Light where Christ is the true door.[4]

Three changes in church design formed the basis of Gothic architecture: the use of the pointed arch to extend the height of the building; an exterior buttressing system to support the taller walls; and the development of large, stained-glass windows (see Chapter 9).

The Gothic period, which lasted in France well into the fifteenth century, is also called the Age of Cathedrals (a cathedral is the seat of a bishop). With urbanization by now well under way, towns competed with each other to build ever larger and taller cathedrals. The style spread throughout Europe, with the upsurge in architectural activity bringing many workers and their families to the cathedral towns. The workers themselves were organized into guilds, which regulated standards of workmanship and also protected workers and their families.

In Chapter 14, we discussed the Gothic cathedral at Reims as an example of the soaring effect made possible by using pointed arches (see p. 274). We now consider the cathedral at Amiens, which, like Reims, is north of Paris (**figure 17.29**). At Amiens, the elaborate façade is enlivened by sculpture and stone **tracery** (decorative, abstract designs). The recessed portals consist of door jambs, lintels, tympanums, and archivolts as at Vézelay. But in Gothic style, the windows are larger than in Romanesque. The huge round rose window at the center of the façade at Amiens represents the universal and never-ending nature of the Church. And finally, the verticality of the soaring towers was meant to lead the viewer's gaze and spirit toward heaven.

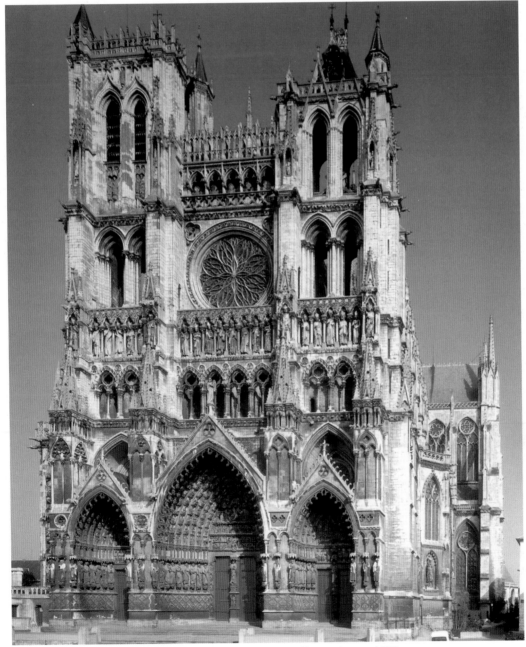

17.29 Amiens Cathedral, Amiens, France, begun 1220.

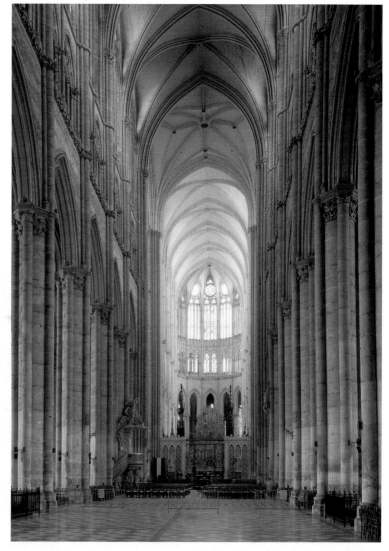

17.31 Nave of Amiens Cathedral, 1120–1236.

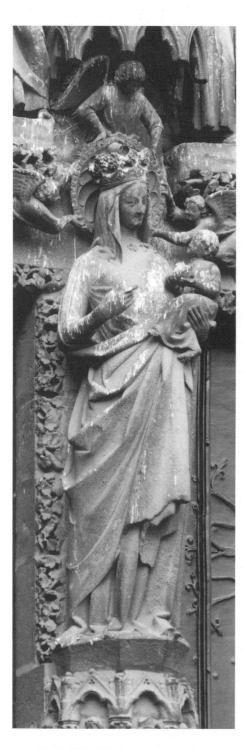

17.30 Gilded Virgin, south portal, Amiens Cathedral, France, c. 1250.

The exterior sculpture on the south portal **trumeau** representing the Virgin and Jesus (**figure 17.30**) reflects a new trend toward naturalism in the depiction of the human figure. Compared with the rigidly frontal Byzantine figures of Justinian and Theodora (see figures 17.8 and 17.9), for example, these are more naturally rounded and they interact as a normal mother and infant might. In contrast to the mournful gazes of *The Virgin of Vladimir* (figure 17.10) and the *Madonna Enthroned* of Cimabue (figure 17.11), a slight smile is discernible as the Virgin at Amiens admires her son.

If we compare the nave of Amiens (**figure 17.31**) with that of Vézelay, we can see the effect of the pointed arches inside the building. They create rib vaults, whose uplifting movement had spiritual meaning. The proportions are tall and thin, and light enters from large windows—the original stained-glass windows were shattered by German bombs during World War II.

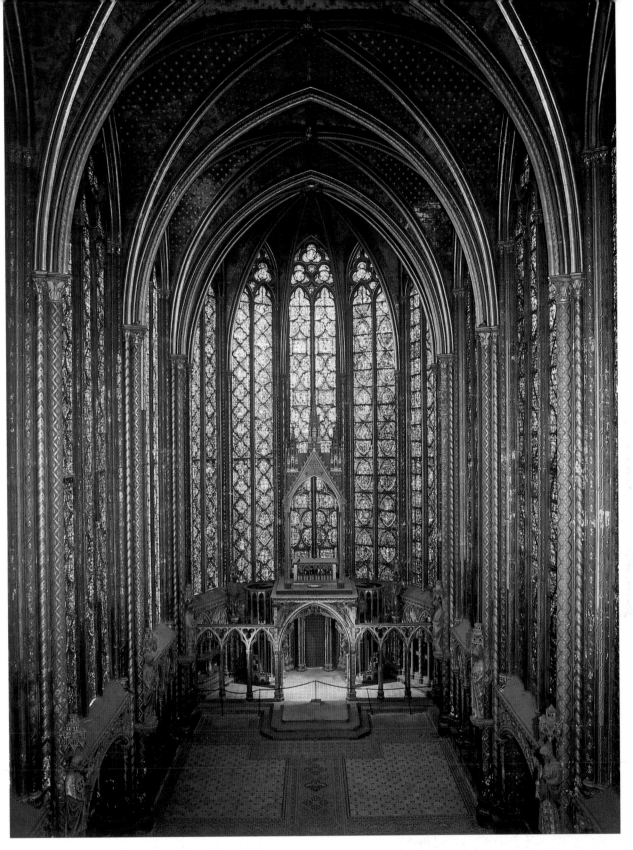

17.32 Nave of Sainte-Chapelle, Paris, France, mid-13th century.

For the effect of stained glass on a Gothic interior, we turn to the dazzling reliquary chapel of Sainte-Chapelle, in Paris (**figure 17.32**). This was the private chapel of King Louis XI, who launched a crusade and brought relics of the Crucifixion from Jerusalem to France. He commissioned the large gold reliquary over the central arch to house the relics, which included fragments of the Cross and Crown of Thorns. In this chapel, we can see the ideals of Suger achieved as the walls dissolve into light and color.

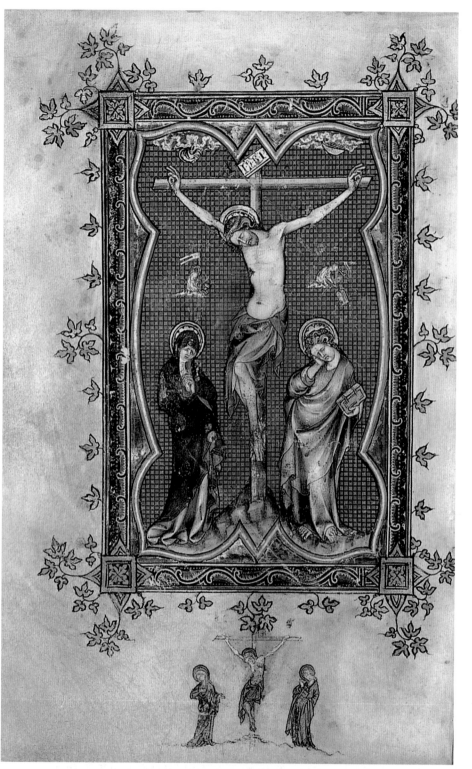

17.33 *The Crucifixion*, page from the *Missal for the Use of Paris*, early 14th century. Parchment, 11 ³/₄ x 8 ¹/₄ in. Bibliothèque Nationale, Paris.

Gothic artists continued the early Medieval tradition of illuminating manuscripts. The page in **figure 17.33**, compared with the Hiberno-Saxon page from the *Book of Kells*, is less static. The forms are more curvilinear, and the figures occupy graceful, S-shaped poses. The central figure of the crucified Christ dominates the scene. On either side of the Cross stand the mourning figures of his mother and his youngest apostle, John. Above, two little figures symbolize the Jewish Synagogue with the tablets of the Ten Commandments and the Christian Church holding the chalice that received Christ's blood. This shows once again that in Jesus the Hebrew prophecies of a Messiah are fulfilled. Outside the blue frame, the vines allude to Christ's blood through the wine of the Eucharist.

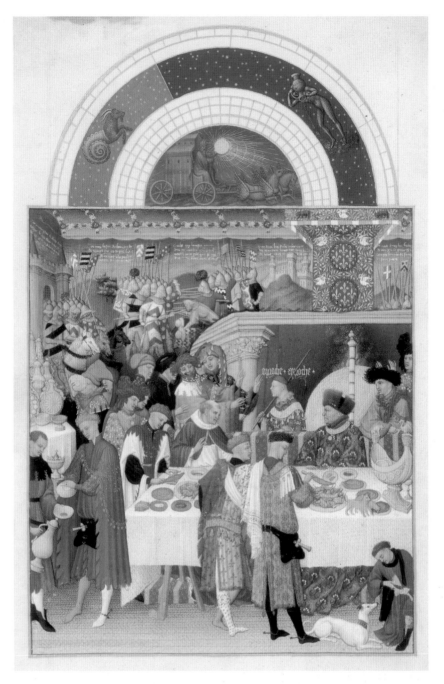

17.34 Limbourg Brothers, January page from *The Very Rich Hours of the Duke de Berry*, c. 1413. Manuscript illumination, 8 ¼ x 5 ⁵/₁₆ in. Musée Condé, Chantilly, France.

Gothic style, like Romanesque, began in France and spread throughout Europe. In the courts, a late form of Gothic—International Gothic—appealed to wealthy taste and lasted into the fifteenth century. The style is characterized by rich color and materials, exotic as well as local details, and intricate designs. One of the wealthiest patrons and most avid art collectors in France was Jean, Duke of Berry (1340–1416), the brother of the king. Jean commissioned a lavishly decorated **Book of Hours** (prayer book organized according to the calendar months), known as *The Very Rich Hours of the Duke of Berry*. The artists were the Limbourg Brothers (active, early fifteenth century), who came from northern Europe to work at the French court.

Figure 17.34 shows the page of January, in which the duke enjoys a winter feast. The scene is typical of the courtly splendor of International Gothic style. In the background, we can see an outdoor scene of chivalric battle, complete with knights, horses, banners, and castles. The foreground scene takes place inside the duke's castle, which is filled with details of court life. Servants attend the duke and his clerical guest. A lavish array of elaborate dishes is laid out on the table, with even the dogs joining in the feast.

In the north of Europe, the influence of Gothic style persisted longer than in Italy. There a new, revolutionary style, inspired by a widespread Classical revival, began to evolve at the dawn of the fourteenth century.

MEANING

Gilbert & George and Stained Glass

Gilbert & George (Gilbert Proesch and George Passmore have worked as a pair since meeting at St. Martin's College of Art & Design in London in the late 1960s. Initially performance artists, they went on to produce large-scale photomontages. These are suggestive of Gothic stained glass, being backlit, usually tinted in vivid colours, and overlaid with black grids. The vibrant but relatively limited palette of colors coupled with the "stained glass" effect of the black grid give their work a medieval feel.

Gothic stained-glass artists were restricted to a palette of basic colors such as red, green, blue, and yellow. They depended on light shining through the glass to bring their images to life. In the example shown here, the Virgin Mary holds the child Jesus in her lap (**figure 17.35**). Both are frontal and stare rigidly ahead. The angels flanking them are shown in profile and give the suggestion of movement, but they also are essentially stiff, iconic figures conveying the solemn splendor of the Queen of Heaven and her son.

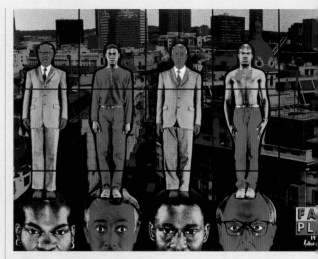

17.36 Gilbert & George, *Fair Play*, 1991. Photomontage, 8 ft. 3 ½ in. x 11 ft. 7 ⅝ in. Courtesy the artists.

In Gilbert & George's *Fair Play* (**figure 17.36**), stiffly posed images of the two artists—wearing their trademark suits—alternate with similarly posed images of two young men from immigrant backgrounds. Each figure stands on a large head: Gilbert & George each stand on the head of a youth, while the youths each stand on the head of one of the artists. All four are set against a panoramic view of the rooftops of central London, where the artists live. The entirety has been overlaid with a grid of black lines, and each figure is also outlined in heavy black. Both of these features suggest the lead tracery of stained-glass windows, just as their stiff frontality recalls early Gothic figures.

17.35 *Notre Dame de la Belle Verrière* ("Our Lady of the Beautiful Glass"), twelfth century. Stained glass. Chartres Cathedral.

Chapter 17 Glossary

ambulatory—vaulted passageway, usually surrounding the apse or choir of a church

apostles—in Christian terminology, one of the twelve followers, or disciples, chosen by Jesus to spread his Gospel

arcade—second-storey gallery formed by a series of arches with supporting columns or piers

atrium—(a) open courtyard leading to, or within, a house or other building, usually surrounded by a colonnade; (b) in modern architecture, a rectangular space off which other rooms open

Book of Hours—prayer book containing the devotions (acts of worship) for the hours of the Christian church (i.e. the times appointed for prayer)

caliph—Muslim ruler

catacombs—underground complex of passageways and vaults, such as those used in Rome by Jews and early Christians to bury their dead

Eucharist—(a) Christian sacrament of Holy Communion, commemorating the Last Supper; (b) consecrated bread and wine used at such a ceremony

Evangelists—literally "bearer of good news" in Greek; the author of one of the four Gospels; more generally, one who brings the first news of the Gospel message

gable—roof formed by the intersection of two planes sloping down from a central beam

Gospels—one of the first four books of the New Testament, which describe the life of Jesus

Greek Cross—cross with four arms of equal length

icon—sacred image portraying Jesus, the Virgin Mary, or a saint

iconoclast—one who destroys or opposes religious images

iconophile—one who favors religious images

Latin Cross—cross in which the vertical arm passes through the midpoint of a shorter horizontal arm

lobed arch—arch containing lobes (or rounded projections)

mihrab—a bay in a mosque that accentuates the *qibla*, which is oriented to Mecca

minaret—tall, slender tower attached to a mosque, from which a *muezzin* calls the Islamic faithful to prayer

narthex—porch or vestibule in early Christian churches

orans (or **orant**)—figure in a posture of prayer in ancient Greek or early Christian art; usually, but not always, a female

Pentecost—Christian festival on the seventh Sunday after Easter commemorating the descent of the Holy Ghost on the apostles

picture stone—in Viking art, an upright boulder with images incised on its surface

portal—doorway of a church and the architectural composition surrounding it

qibla—wall oriented to Mecca inside the prayer hall of a mosque

radiating chapel—one of a number of chapels placed around the ambulatory or transepts of a medieval church

rune stone—in Viking art, an upright stone with characters of the runic alphabet inscribed on it

sahn—the courtyard of a mosque

schism—division or breach of unity within the Church

syncretism—reconciliation of conflicting beliefs (especially religious) into an integrated system

tracery—decorative, interlaced design, as in the stonework of Gothic windows

transept—cross arm of a Christian church, placed perpendicular to the nave

triforium—in Gothic architecture, part of the nave wall above the arcade and below the clerestory

trumeau—in Romanesque and Gothic architecture, the central post supporting the lintel in a double doorway

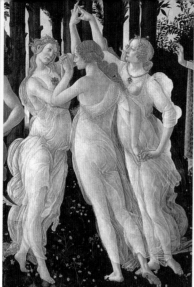

18

The Renaissance and Mannerism

	HISTORICAL EVENTS	ART HISTORY	
1300	● The Black Death (bubonic plague) kills one-third of Europe's population 1348 ● Humanist movement in Italy 14th century	● Giotto, Arena Chapel, Padua c. 1305	**1300**
1400	● Florence, artistic center of Italy 15th century ● 15th-century Perspective systems ● Medici family in Florence c. 1450 ● Columbus discovers America for Spain 1492 ● High Renaissance in Italy: 1480–1520	● Dome of Florence Cathedral 1410–1436 ● Northern European Renaissance begins 15th century ● Campin, *Annunciation Triptych* c. 1425 ● Donatello, *David* c. 1420–1440 ● Alberti, *On Painting* c. 1435	**1400**
1500	● Martin Luther, Protestant Reformation 1517 ● Mannerism 1520 ● Vasari, *Lives of the Artists* 1550 and 1568 ● Spanish Armada attacks England 1588	● Dürer, *Self-Portrait* 1500 ● Michelangelo, *David* 1501–1504 ● Leonardo, *Mona Lisa* 1503–1505 ● New Saint Peter's, Rome, begun 1506 ● Michelangelo, Sistine Chapel ceiling 1508–1512 ● Raphael, *School of Athens* 1509–1511 ● Titian, *Assumption of the Virgin* 1526–1528	**1500**

**TIMELINE**.

"Renaissance" means "rebirth." The term refers to a widespread cultural revival of Classical ideas and culture that began in fourteenth-century Italy (see map on p. 365), spread to northern continental Europe, and lasted into the sixteenth century. Perhaps the most important impetus for the development of the Renaissance was the humanist movement, which entailed collecting and translating ancient Greek and Latin texts, including all of Plato. This interest in reviving antiquity led to the study of Roman ruins on Italian soil. Humanist artists began looking to nature as a guide in depicting the world around them, and humanist philosophers strove to integrate the study of antiquity with the Christian world. They followed their Greek predecessors in placing man, rather than God, at the center of the universe. This humanist focus on man's place in nature is reflected in the style of Renaissance art, which revived representations of the nude, adopted Classical symmetry and clarity, depicted Classical myths as well as Christian subjects, and used **perspective** systems (see Chapter 5) to replicate the appearance of three-dimensional space.

There are several possible explanations for the development of the Renaissance in Italy as opposed to other European countries. One reason is that Italy was geographically and culturally tied to ancient Rome. By reviving its links to Rome, Italy felt that it was recapturing its own distinguished past. As more and more ancient texts were translated, Italy reinforced its identification with the Latin and Greek cultures and with works written in those languages.

The emerging mercantile economy of Italy also contributed to the Renaissance. It enabled a growing

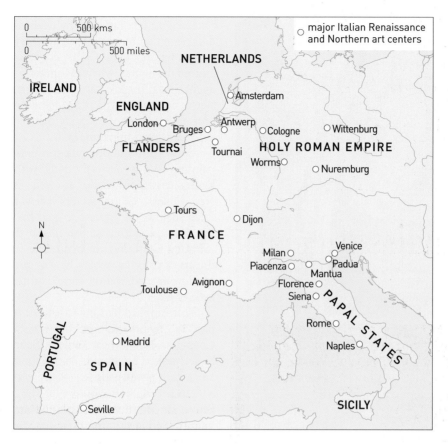

Major art centers of the Renaissance.

number of people to become wealthy and to finance and collect works of art. Italy at the time was not a single, unified nation, but rather a group of states. Some were ruled by courts, some by the pope, and some were republican states that identified with the Roman Republic and the Athenian democracy. The latter, especially Florence, encouraged individuals to take part in their own governance. In the courts, humanist rulers used links to Rome and Greece for political purposes. They commissioned artists to create works that adorned their cities and authors to write poetry and philosophical treatises glorifying their rule and comparing them to ancient Greeks and Romans.

From its beginnings in the fourteenth century, the Renaissance continued to develop in Italy through the High Renaissance (c. 1480–1520), which we consider a high point of Western artistic history and associate with the names of Leonardo da Vinci, Raphael, Michelangelo, Giorgione, and Titian. During the fifteenth century, Renaissance culture spread to northern Europe.

During the sixteenth century, Europe witnessed the religious upheaval known as the Protestant Reformation, which was followed by the Counter-Reformation within the Catholic Church. For the first time since Christianity became the official religion of Rome in the fourth century A.D., the Church lost a significant amount of its power. Some countries chose to remain Catholic, but others became Protestant, and these changes affected the styles, content, and patronage of art. Coinciding with the Protestant Reformation and the efforts of the Church to reassert its preeminence, Renaissance style evolved into Mannerism.

In the sixteenth century, the Mannerist artist Giorgio Vasari (1511–1574) wrote biographies of artists entitled *Lives of the Most Excellent Painters, Sculptors, and Architects* (first edition 1550). This ambitious undertaking recorded the lives and works of Renaissance artists in order to preserve them for posterity. The *Lives* begins with the biography of Cimabue and the second edition of 1568 ends with Vasari's autobiography. Not only does this work reflect the humanist revival of Classical interest in the individual and in history-writing, but it also provides a framework for the period, a wealth of source material, and many lively anecdotes about artists.

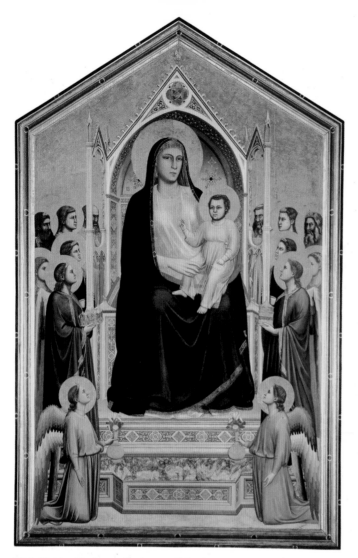

18.1 Giotto, *Madonna Enthroned* (*Ognissanti Madonna*), c. 1310. Tempera on wood, 10 ft. 8 in. x 6 ft. 8 in. Uffizi, Florence.

Fourteenth-Century Italian Painting

The fourteenth-century painter who first introduced natural space into his work was Giotto di Bondone (c. 1267–1337). If we compare his large altarpiece, the *Madonna Enthroned* (**figure 18.1**) with Cimabue's late Byzantine work of the same subject, we can see the revolutionary character of Giotto's style. Giotto's setting appears to be the same three-dimensional space that we inhabit. His throne stands solidly on a horizontal floor, with steps leading toward the Virgin and Jesus. We have the feeling that we would have to climb those steps to ascend Giotto's throne. Cimabue's throne, in contrast, occupies a different kind of space. It is elevated and tilts slightly forward, towering over the viewer. The angels flanking Cimabue's throne are elongated and seem suspended, as if independent of the laws of gravity. Giotto's angels kneel solidly at the base of the throne or stand firmly to either side of it.

COMPARE

Cimabue,
Madonna Enthroned.
figure 17.11, page 346

If we compare the way the two artists depict Mary and Jesus, we observe that Giotto's figures appear more solid than Cimabue's. They are rendered in *chiaroscuro*, defining form by changes in light and dark, as in nature, rather than by lines (which do not exist in nature). Giotto's drapery folds fall naturally around the figures, whereas Cimabue's are depicted as gold lines. The folds of Giotto's Virgin curve to the side at her waist, suggesting *contrapposto*, and Jesus himself has a more naturally babylike appearance than Cimabue's miniature man.

Giotto's innovations reflect a new approach to painting. We as viewers identify with the weighty figures psychologically as well as physically. Nevertheless, Giotto retains a few medieval features such as the Byzantine gold background and the pointed Gothic arches of the throne. In his own day, Giotto was recognized as having revived the art of painting, which he was said to have rescued from medieval darkness and restored to the light of day.

Giotto applied his new style to storytelling in the narrative fresco cycle on the walls of the Arena Chapel, in Padua (near Venice) (**figure 18.2**). The barrel-vaulted building is named for an old Roman arena on its site; it is also called the Scrovegni Chapel after its patron, Enrico Scrovegni, the richest man in Padua. He commissioned the building and its decoration in part to atone for his father's sin of usury, for which the poet Dante had consigned him to hell in his *Purgatory*, the second part of his epic poem *The Divine Comedy*. Dante compares Giotto's reputation with that of Cimabue, noting both the transitory quality of fame and the fact that Giotto's fame had overshadowed that of Cimabue:

> O empty glory of human powers! How short the time its green endures at its peak, if it be not overtaken by crude ages! Cimabue thought to hold the field in painting, and now Giotto has the cry, so that the fame of the former is obscured.[1]

The barrel vault and round arch leading to the chancel of the Arena Chapel reflect the revival of Roman architectural forms. The scenes on the walls illustrate three sets of lives: Anna and Joachim (Mary's parents); Mary herself; and Jesus. Separating the scenes are bands that reinforce the impression that the events take place on the other side of the wall. Both the individual scenes and the ceiling vault have a natural blue sky, rather than the more spiritual gold characteristic of Byzantine style.

> **Giotto was born in order to give light to painting.**
>
> Giorgio Vasari, artist and biographer (1511–1574)

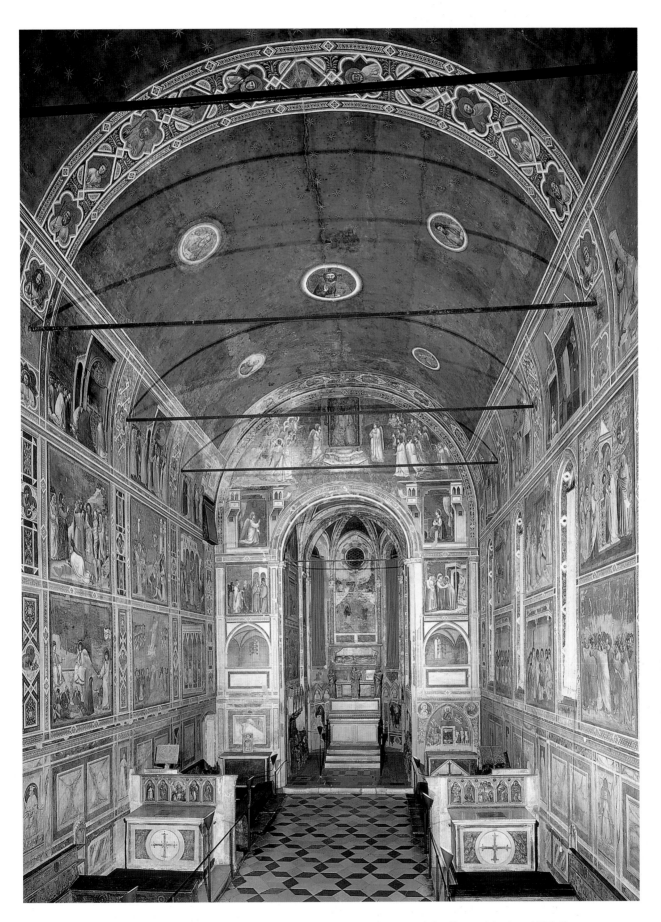

18.2 Giotto, View of the Interior of the Arena Chapel, Padua, Italy, toward the Chancel Arch, c. 1305. Fresco.

The *Meeting at the Golden Gate* (**figure 18.3**) illustrates a climax in the story of Anna and Joachim and reflects Giotto's genius for conveying drama. The elderly, barren couple has just received the news that their prayers for a child have been answered. Anna conceives the Virgin miraculously and rushes to tell Joachim her news. Meanwhile, Joachim, a shepherd tending his flock, dreams that Anna is pregnant and hurries to join her in Jerusalem. Their embrace arrests the narrative flow from two directions: a young shepherd accompanying Joachim follows from the left while a group of townswomen, like the chorus in a Greek play, eagerly join Anna as she leaves the city.

The curved bridge with its round arches is reminiscent of a Roman triumphal arch (see p. 336). Both the bridge and the crenellated city gate are convincingly solid forms, although they have the quality of a stage set. They are small in relation to the scale of the figures, which they reinforce formally—the gate frames the women and the curves of the bridge echo the curved contours of the heads of Anna and Joachim. They themselves merge into a single unit, combining psychology with form.

The only discordant element in the painting is the figure wearing a dark robe. She draws a hood over half her face, as if wanting to see and not see at the same time. On the one hand, she is a witness to the good news reflected in the embrace and, on the other, she is an omen of Jesus's death on the Cross. She thus signifies both the present and the future, informing viewers that the narrative continues past the present scene. In the Arena Chapel, the final scene is a huge Last Judgment, visible on the entrance wall and the last image confronting viewers as they turn to leave the chapel.

The city of Padua was the site of an old and distinguished university. It was a center of humanist learning and had witnessed a revival of Classical Roman theater. Padua was thus a logical setting for Giotto's dramatic narrative, in which he merges elements of Greco-Roman naturalism and Classical dramatic technique with Christian content. Such combinations of form, content, and cultural ideas characterized the interdisciplinary genius of Renaissance humanism.

In 1348, Europe was devastated by an outbreak of bubonic plague. Contemporaries called the plague the Black Death, and the disease killed a third of Europe's population. Italy was also hit by bank closings and a series of poor harvests in the fourteenth century, from which it took several generations to recover. It was not until the dawn of the fifteenth century that Italy was ready to embrace the ideals of humanism on a broad, cultural scale.

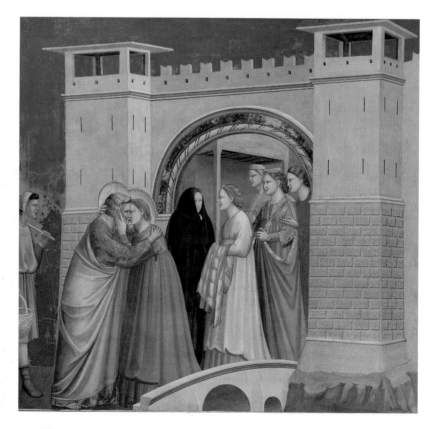

18.3 Giotto, *Meeting at the Golden Gate*, c. 1305. Fresco. Arena Chapel, Padua, Italy.

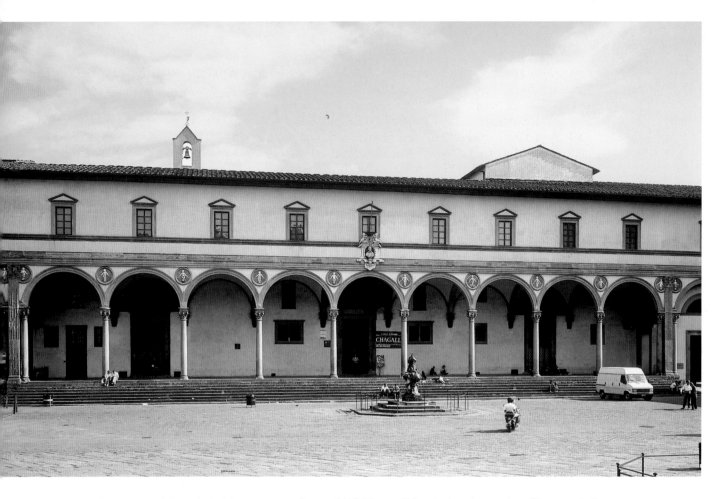

18.4 Filippo Brunelleschi, Hospital of the Innocents, begun 1419. Piazza di Santissima Annunziata, Florence, Italy.

Italian Art in the Fifteenth Century

The first generation of major Renaissance artists lived and worked mainly in Florence. Inspired by the republic of ancient Rome, Florence was ruled by an oligarchy (rule by a few) composed of members of influential families, especially the Medici banking family. But because Florence was a commercial center, the guilds also participated in the city government, which was an important source of art patronage.

Patrons in Florence espoused the view that wealthy people, as well as the government, should spend money decorating the city. Financing paintings to be displayed in churches, outdoor sculptures, and works of architecture was considered an expression of civic virtue. Although Florence was the leading artistic city in the early fifteenth century, its artists traveled and worked elsewhere. As the humanist movement spread and the new style caught on, major art centers outside Florence were soon influenced by the revival of ancient Greek and Latin culture.

Florence: The First Generation

The leading architect in early fifteenth-century Florence was Filippo Brunelleschi (1377–1446). His first major commission after visiting Rome and studying ancient ruins was the Hospital of the Innocents (**figure 18.4**). This was an orphanage for foundlings, commissioned by the silk guild and financed mainly with funds provided by the Medici. Instead of the soaring verticals of Gothic style, the Hospital is horizontal; its lowered height is related to human scale.

A long colonnade of small Corinthian columns reflects the Renaissance revival of the Greek Orders of architecture (see p. 269). Brunelleschi, however, used smooth, rather than fluted, shafts in his columns. The second-story windows have Greek pediments, the round arches and the narrow barrel vaults connecting the colonnade to the solid wall are derived from ancient Roman architecture, and the Classical taste for harmony and symmetry has been adopted. The blue circles (or roundels) between the arches contain reliefs of swaddled infants, which were added later in the fifteenth century.

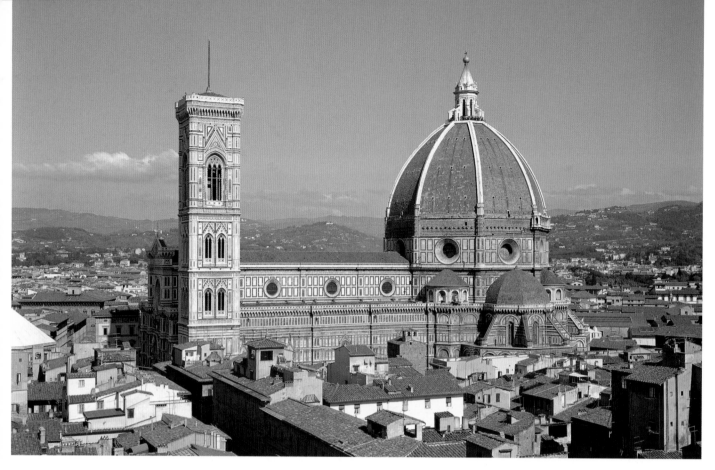

18.5 View of Florence cathedral.

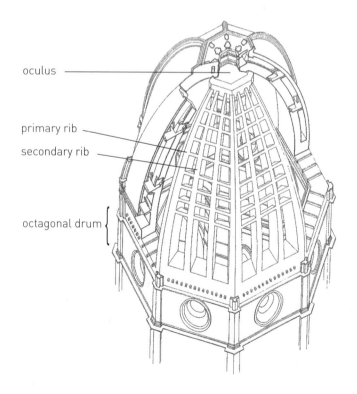

oculus

primary rib

secondary rib

octagonal drum

18.6 Diagram of Brunelleschi's dome.

Perhaps Brunelleschi's most important architectural feat in Florence was designing and constructing a dome for the city's huge Gothic cathedral (**figure 18.5**). Officially called Santa Maria dei Fiori (Saint Mary of the Flowers, named after Florence—"city of the flowers"), the cathedral is more generally known as the Duomo (the dome). The view illustrated here shows the cathedral and its dome, and the single square bell-tower (**campanile**) designed by Giotto.

From around 1410 to 1436, Brunelleschi worked on the dome, which measures about 100 feet in height. He had visited Rome, where he studied the Pantheon (see Chapter 16) and the problem of placing a huge dome on a large drum. Brunelleschi's dome rests on an octagonal rather than a round drum, for which he used a system of twenty-four curved vertical ribs as an armature (**figure 18.6**).

Larger ribs rise from the eight corners of the octagon, forming a sharper angle than the Pantheon dome, and they frame pairs of smaller ribs. An inner and outer shell on either side of the ribs were connected with horizontal ties. Because Brunelleschi made the shells thin and used a more pointed form than the Romans had, he was able to lighten the weight of the dome and lessen its thrust compared with the Pantheon dome. The opening at the top of Brunelleschi's dome, in contrast to the open oculus of the Pantheon, is covered by a new Renaissance feature—the **lantern**.

As a work of public art, the dome was a landmark in architectural design and also a source of great pride to the Florentines. Another important commission that could be enjoyed by the entire city was begun five years after Brunelleschi's Hospital of the Innocents. This was a new set of doors for the Florence Baptistery (**figure 18.7**), just opposite the cathedral. The artist, Lorenzo Ghiberti (c. 1382–1455), was a goldsmith and sculptor who worked on the project for nearly twenty-five years. Because the space between a cathedral and its baptistery is called a *paradiso* in Italian, the doors are known as the *Gates of Paradise*. They are composed of ten Old Testament scenes, with figures and heads used as framing devices. The latter include portraits of the artist and his two sons, which reflect the Renaissance interest in the identity and fame of the artist. This was another aspect of Greek culture revived by Renaissance humanists.

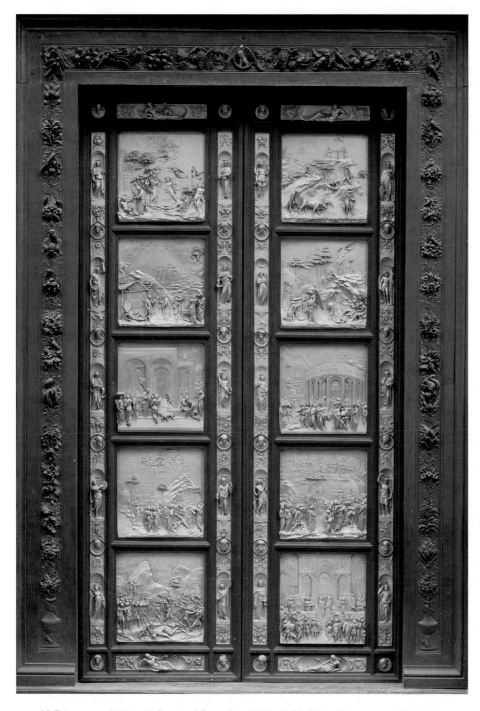

18.7 Lorenzo Ghiberti, *Gates of Paradise*, 1424–1452. Gilded bronze, c. 17 ft. high. East door of the Florence Baptistery.

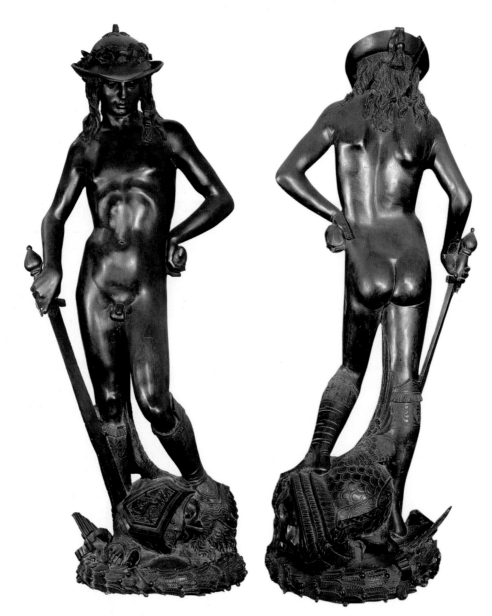

18.8 Donatello, *David*, c. 1420–1440. Bronze, 5 ft. 2 ½ in. high. Bargello Museum, Florence.

Ghiberti's contemporary, the sculptor Donatello (1386–1466), was familiar with Greek philosophy and he studied Greek art. Donatello produced the single most innovative sculpture of his generation—the sensuous bronze *David* cast sometime between 1420 and 1440 (**figure 18.8**). In that work, he revived the relaxed, Classical nude. But Donatello's *David* has a distinctive form and personality, rather than the abstract idealization of Classical style, and there are several layers of meaning in the figure's unique iconography.

David is shown as a self-satisfied adolescent who has defeated and beheaded the giant Goliath. He wears a shepherd's hat, stands on Goliath's severed head, and leans on the giant's sword. Having defeated so formidable an enemy with only a slingshot for a weapon, David became a symbol of Florence and its success in fending off its political enemies. Politically, therefore, the defeat of Goliath came to symbolize the defeat of tyranny. From a Christian point of view, David's victory represented Christ's victory over Satan. Donatello's *David* was almost certainly commissioned by Cosimo, the Medici patriarch and a committed humanist. It stood in the courtyard of Cosimo's palace in Florence, where it signified the Medici claim to support republican government. On yet another level, the *David* has Platonic meaning, for Cosimo commissioned translations of all of Plato's *Dialogues* and the artist was acquainted with the Classical revival. The *David* celebrates Plato's admiration for male youth and the beauty of young male bodies.

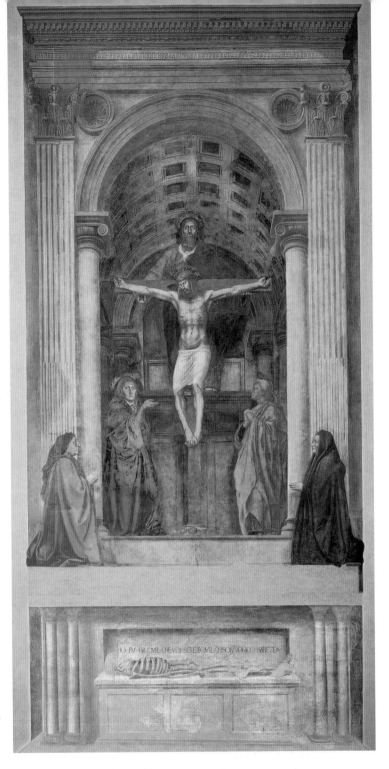

18.9 Masaccio, *Holy Trinity*, c. 1425. Fresco, 21 ft. 9 in. x 9 ft. 4 in. Santa Maria Novella, Florence.

The leading painter in early fifteenth-century Florence was Tomasso di Ser Giovanni (nicknamed "Masaccio," meaning "Sloppy Tom") (c. 1400–1428). In about 1425, at the age of twenty-four or twenty-five, he painted the work that immediately established his reputation.

Masaccio's *Holy Trinity* (**figure 18.9**) is located on the nave wall of Santa Maria Novella. In that painting, the artist continued Giotto's depiction of weighty figures, his use of shading, and of three-dimensional space to convey form as it appears in nature. Masaccio also adopted an architectural setting and a perspective system based on Brunelleschi's ideas.

Subsequent generations of fifteenth-century artists continued and elaborated the innovations of the first generation. In architecture, the most important contributions were those of Leon Battista Alberti (1404–1472), the author of the first Renaissance book on art theory—*On Painting*. As a humanist who advocated formal and narrative naturalism, Alberti modeled his ideas and his forms on Classical culture. He believed that nature was the inspiration for art and therefore that artists, especially painters, should strive to replicate nature in their works. In addition, he saw painting as a means to preserve a person's image in the cultural memory.

Masaccio's *Trinity*: A Renaissance Synthesis of Form and Meaning

Masaccio's *Holy Trinity* exemplifies the Renaissance synthesis of form and iconography with the humanist revival of Classical antiquity. It also reflects the new role of civic patronage in the arts. The artist used perspective, geometry, color, and light, as well as written text, to convey the meaning of the image.

Renaissance art theorists conceived the idea that a painting is like a window, through which we see space and figures as in nature. In the *Trinity*, the wall of the church appears to open onto a Crucifixion scene. Mary and Saint John stand on either side of the Cross, the Holy Spirit (the white dove) hovers above Christ's head, and God the Father stands on a ledge illusionistically projecting from the back wall.

The ceiling of the painted room is a barrel vault with square coffers. The round arch in the foreground frames the scene like a triumphal arch, alluding to Christ's victory over death. Adam's skull at the base of the Cross, refers to the Christian belief that Jesus's death redeemed Adam's Original Sin and that Jesus was crucified on the site of Adam's burial. The Brunelleschian smooth-shafted columns have capitals with Ionic volutes and a Doric abacus. On the outside, fluted pilasters have foliate Corinthian capitals and support a Classical entablature with a lintel, a patterned frieze, and a projecting cornice.

Kneeling on the outer step in the viewers' space are members of the politically important Lenzi family who commissioned the work. Below the step, an altarlike platform covers a skeleton lying on a sarcophagus. Above the skeleton, an inscription reminds viewers that death is inevitable: "I was what you are, and what I am you will be."

The triple form of Masaccio's *Trinity* is based on an implied pyramid. God's head is the apex and the donors form the angles at the base. A series of smaller, spatial triangles can be drawn from God's head to Christ's hands, and from Christ's hands to the base of the Cross.

The diagram shown in **figure 18.10** illustrates Brunelleschi's perspective system in which a viewer stands at street level looking upward at a building. Similarly, the *Trinity* was constructed for a viewer standing on the floor of the church. The vanishing point (where the orthogonals converge) is at the center of the lower step, which is also at the eye-level of the average viewer (**figure 18.11**).

Masaccio's tightly controlled color and light reinforce the meaning of the *Trinity*. He limited the colors to red and blue, which alternate in the coffers and the draperies. Light is used not only to define form but also symbolically. Christ is the figure most bathed in light, which brings his form forward. His outstretched arms reach toward the white columns and contribute to the sense of architectural structure.

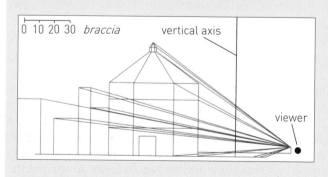

18.10 Diagram of Brunelleschi's perspective system, showing a viewer before a building.

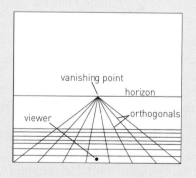

18.11 Diagram of Brunelleschi's perspective system, showing a viewer in relation to orthogonals converging at a vanishing point.

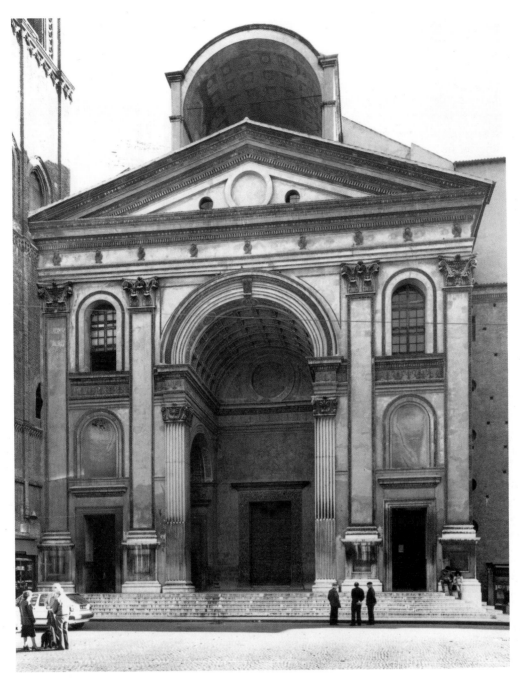

18.12 Leon Battista Alberti, Sant'Andrea, Mantua, 1470–1493.

The Later Fifteenth Century in Italy

One of Alberti's most important architectural achievements was the imposing church façade of Sant' Andrea (**figure 18.12**) in Mantua (see map on p. 365). The façade is symmetrical, and the main entrance is framed by a huge round arch inspired by the Roman triumphal arch. Echoing this arch are the windows and an imposing barrel vault at the top. Giant Corinthian **pilasters** resting on rectangular podia rise three stories in height to the entablature. This, in turn, is surmounted by a broad pediment, creating an ensemble that replicates the appearance of a Greek temple front. The two large barrel vaults are coffered, which reflects the influence of the Pantheon on Alberti's architecture.

The symmetrical plan of Sant' Andrea (**figure 18.13**) is based on the longitudinal Latin-Cross. Compared with Gothic church plans, Sant' Andrea's is simpler. It has a dome over the crossing and side chapels separated by massive walls along the nave. In the design, Alberti departed from the traditional arrangement of medieval churches and cathedrals, in which the side aisles continued uninterrupted on either side of the nave from the entrance to the ambulatory. The enormous, expansive interior (**figure 18.14**) like the exterior barrel vaults, was inspired by Roman buildings with vaulted coffered ceilings and ample spaces (see figure 16.24).

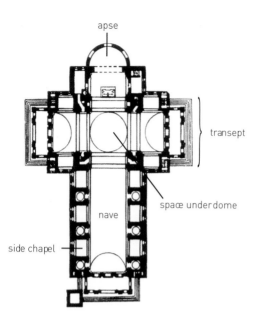

18.13 Plan of Sant'Andrea, Mantua.

COMPARE

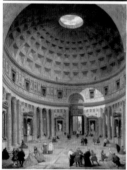

The Pantheon.
figure 16.24, page 335

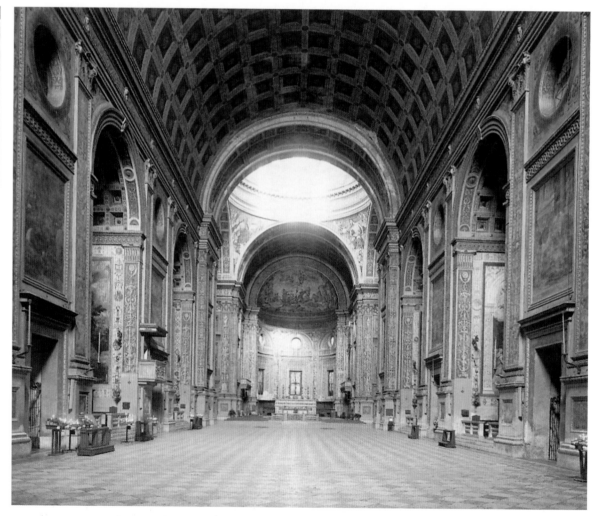

18.14 Nave of Sant'Andrea, Mantua.

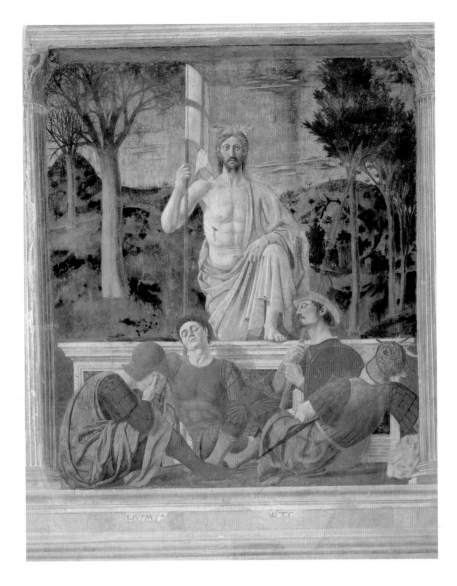

18.15 Piero della Francesca, *Resurrection*, c. 1452. Fresco and tempera. 7 ft. 4 ⅝ in. x 6 ft. 6 ¾ in. Museo Civico, Borgo San Sepolcro.

The most important painter in the mid-fifteenth century from central Italy was Piero della Francesca (c. 1420–1492). He executed a fresco of the *Resurrection* (**figure 18.15**) for the town hall of his native village of Borgo San Sepolcro. Framed by illusionistic Corinthian columns, the Resurrection appears to be taking place in the landscape on the other side of the wall. The dead tree at the left and the living tree at the right are symbolic. They stand for the death and rebirth of Christ through resurrection. By combining the idea of painting-as-a-window with the Resurrection, Piero merges the Holy Land and Christ's sepulcher with Borgo San Sepolcro—village of the Holy Sepulcher.

Piero's emphasis on symmetry in the fictive architectural frame and the geometric quality of his figures reflects his interest in ordered form and space. He described this in his treatise *On the Perspective of Painting*. According to Piero, painting consists of three main elements—drawing, measurement, and coloring:

By drawing we mean profiles and outlines which contain the objects. By measurement we mean the profiles and outlines placed proportionately in their places. By coloring we mean how colors show themselves on the objects: light or dark, changing according to the light.[2]

In Piero's monumental fresco, Christ is placed at the center; the sculpturesque form and color are consistent with the artist's theory. Christ steps firmly from his tomb, carrying a banner denoting Christian triumph. The Roman soldiers who carried out the Crucifixion are sleeping—an allusion to death through sin and ignorance. The soldier facing the viewer has been identified as the artist's self-portrait, for he is aligned with the staff of the banner. Another allusion to Piero can be seen in the motif of the prominent rock at the lower right corner. It is a self-image that echoes Piero's name, meaning "rock," as well as Christ's declaration to Peter, his first apostle: "On this rock I build my Church." (*Petros* is Greek for "rock.")

Graham Nickson and Piero della Francesca

Interview with Laurie Adams, January 25, 2006.

Graham Nickson was born in 1946 in Lancashire in the northwest of England. He studied at the Royal College of Art in London, spent two years in Italy on a Prix de Rome, and came to the United States on a Harkness Fellowship. Today he lives and works in New York, where he is Dean of the Studio School. He also travels around the world teaching marathon courses in drawing.

LA: Your work is clearly influenced by the most monumental Italian Renaissance painters. Can you discuss that influence in relation to the philosophy of your teaching and of your own approach to painting?

Graham Nickson: As in the Renaissance, I see drawing as a progressive fact. The philosophy of the Studio School is the focus on ambition for the work rather than for the career. I teach that all art is abstract, and imagery is the bonus. The entire process of creating art is abstract, but the finished work is a metaphor for the artist's experience and direct observation of nature. The work of creation entails solving the problem of translating that experience and observation by making marks on a surface.

I spent two years in Italy, during which time I traveled extensively, painting the dawn and sunset every day. Piero della Francesca is a favorite artist because of his genius for combining powerful abstraction and understatement with moving human imagery. His color is highly original and it steers your eye around the work—look at the rose color in the *Resurrection*. That image incorporates biblical allegory; its color is haunting; and at the same time it is intensely personal, as we see from the self-references.

Now look at my *Georgica Bathers* (**figure 18.16**). I also focus on mysterious color, but my colors are always inspired by nature, especially by the Italian sunsets. Even though the figures are set on a Long Island beach, they have a mythic quality achieved by

their forms and by their physical relationship to the expansive, extended horizontal of the space. They are simultaneously static and in motion. Similar qualities characterize Piero's work. In *Georgica Bathers*, there is the manifest content apparent in the foreground figures, while something mysterious is happening in the background with the fallen lifeguard chair—the scene is based on a real event that I witnessed. Connecting foreground and background is the figure climbing out of the water onto the sand, which is an echo of Piero's Christ in the *Resurrection*.

The theme of bathers has preoccupied me for more than twenty years. Figures putting on and taking off their shirts create a sense of something hidden and the cloth itself becomes a geometric form. This, like the juxtaposition of an obvious event in the foreground with a mystery in the background, can be seen in Piero's *Baptism of Christ* (**figure 18.17**), which I studied at the National Gallery in London. That entire picture is composed of geometric form, whether in the depiction of nature or of human figures. Jesus, John the Baptist, and the angels are parallel to the tree-trunk, the dove of the Holy Spirit parallels the clouds, and the spiral of the River Jordan is repeated in the distant landscape. The tree is a static vertical, but its foliage expands across the top of the picture. Similarly, John stands still, but moves his left leg as if walking. His graceful gestures seem to have a hidden significance, but they also perform the identifiable ritual of baptism.

Something mysterious is happening in the background of the *Baptism*, which has tantalized viewers for generations. The man pulling his shirt over his head is formally abstract and personally anonymous—the very quality I admire in Piero's imagery. As with my figures dragging the lifeguard chair, Piero has placed unknown figures behind the scene of Baptism. They are both distanced from the main event and intimately related to it. In the *Baptism*, the intense whites carry meaning and thus reinforce the content.

I am also interested in Piero's architectonic form. That quality appears in *Georgica Bathers*, which is

MEANING

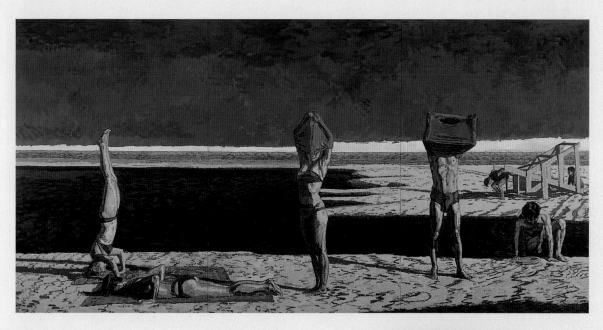

18.16 Graham Nickson, *Georgica Bathers*, 1984–1996. Lascaux acrylic on canvas, 8 x 16 ft. Private Collection. Courtesy of the artist.

divided into four sections by the three vertical figures. Each section can be seen both as an individual image and as an integral part of the entire painting. That kind of unified image, in which parts reinforce the whole, is a basic principle of Renaissance style inspired by the revival of classicism.

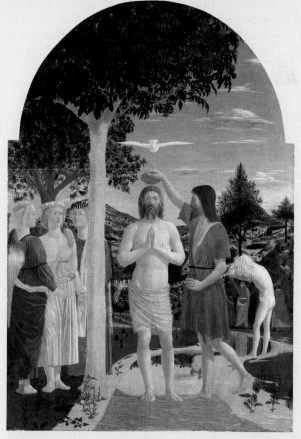

18.17 Piero della Francesca, *Baptism of Christ*, c. 1445. Egg tempera on wood panel, 5 ft. 5 ³/₄ in. x 3 ft. 11 ³/₄ in. National Gallery, London.

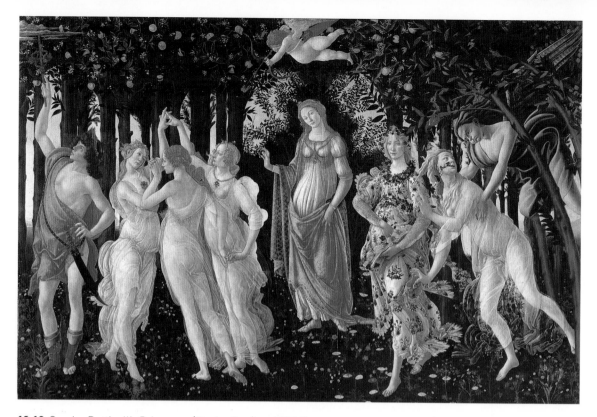

18.18 Sandro Botticelli, *Primavera* (*Springtime*), c. 1480. Tempera on wood, 6 ft. 8 in. x 10 ft. 4 in. Uffizi, Florence.

In addition to Classical form and space, Renaissance artists, especially the humanists, revived mythological subject matter. Sandro Botticelli's (1445-1510) allegorical *Primavera* (*Springtime*) (**figure 18.18**), commissioned by a member of the Medici family, is populated with figures from Greek myth. Although the exact meaning of the picture has remained elusive, its individual elements can be identified. The setting is a lush forest filled with fruit and flowers. At the center stands Venus, goddess of love and beauty, with her son, the love-god Cupid, shooting an arrow above her. At the right, Flora, a personification of spring, wears a floral dress and tiptoes through the grass. Another woman in a transparent dress is being pushed by a wind god. To the left of Venus, the three Graces of Greek myth dance in a circle and the messenger god, Mercury, reaches upward toward a fruit-filled tree.

Whatever the message of Botticelli's painting, it appears to be about love and springtime. The graceful figures, elongated from the waist down, and the flowing draperies are characteristic of the artist's style. Like the first-generation Italian artists of the fifteenth century, Botticelli revives Classical nude form, but endows it with a distinctive character.

Renaissance artists revived ancient types as well as aspects of Classical style and content. One such type that combined the Renaissance interest in individual achievement with the humanist preference for republican government was the equestrian monument. Around 1480, the Florentine sculptor Andrea del Verrocchio (1435–1488) was commissioned to cast a large equestrian monument depicting the *condottiere* (mercenary soldier) Bartolommeo Colleoni, who had defended the republic of Venice against its enemies (**figure 18.19**). Inspired by the Roman statue of Marcus Aurelius (see p.336), the *Colleoni* is much more dynamic than the small, tentative, relatively static figure of Charlemagne (see figure 17.17).

The *Colleoni* is an image of military authority, with his chest thrust forward, his rugged physiognomy, and his weapon at the ready. He turns to the side as if toward his troops, as his warhorse seems eager to advance into battle. The forcefulness of Colleoni and his individualized character, as well as his political meaning, was characteristic of the Renaissance *condottiere*. As an artistic type, the equestrian monument reflects the Renaissance revival of Classicism and the humanist interest in earthly fame.

Verrocchio was convinced of his own fame and was confident in his talent. Vasari's life of the artist reports that the Signoria (ruling committee) of Venice decided that Verrocchio would cast only the horse and another sculptor would make the figure. In response, Verrocchio broke the legs and head of his model and returned to Florence in a huff. When the Signoria informed him that they would have him beheaded if he ever returned to Venice, he replied that a man's head cannot be replaced but that he could replace the horse's bronze head with a more beautiful one. With this response, Verrocchio was rehired and his salary was doubled.

Painting in Venice

In the port city of Venice, there had been ongoing trade with the Byzantine Empire for centuries. Built on a network of canals, Venice has a different character from the inland cities of Italy. Venetian painters were influenced by the reflective gold light of the Byzantine style and the textured, shifting lights of the city. They used oil paint earlier than painters in other Italian cities, and this enriched the colors and extended the drying time as compared with fresco and tempera. As a republic that had lasted some 800 years, Venice identified with the revival of Roman and Greek culture.

The greatest of the late fifteenth-century painters native to Venice was Giovanni Bellini (c. 1432–1516), a member of a prominent artistic family. His late work, the *Madonna of the Meadow* (**figure 18.20**), shows the attention to landscape and the filtered yellow light that appealed to Venetian artists. Mary is in a pastoral setting with distant shepherds tending their animals. Her placement on the ground as she prays contemplatively over her sleeping infant signifies her humility. Here the traditional twinship of sleep and death is a reminder of Jesus's future death—as is the crow in the barren tree. Note that Bellini's Jesus is a babylike nude, perfectly relaxed in sleep. He is no longer the infant-king we saw in the enthroned Madonnas of Cimabue and Giotto.

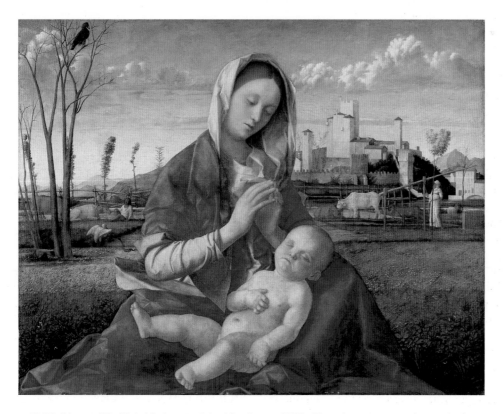

18.19 Andrea del Verrocchio, *Bartolomeo Colleoni*, c. 1481–1496. Bronze, 13 ft. high. Campo Santi Giovanni e Paolo, Venice.

18.20 Giovanni Bellini, *Madonna of the Meadow*, c. 1500. Oil and egg tempera on synthetic panel transferred from wood. 26 ½ x 38 ⅛ in. National Gallery, London.

Northern European Art in the Fifteenth Century

Contemporary with the new style in Italy, northern Europe also witnessed a Renaissance, more so in painting than in sculpture and architecture. The major northern artists in the fifteenth century came from the Netherlands (modern-day Holland and Belgium) and Germany. In the Netherlands, artists used oil paint more than in Italy and built up layers of glaze to intensify color and modulate the light and shade. Reflecting the bourgeois mercantile economies of the North, religious scenes often take place inside a house.

The *Annunciation Triptych* (**figure 18.21**) by Robert Campin (c. 1375–1444), a master painter in Tournai (in modern Belgium), is a **triptych**. As in Italy, the space is three-dimensional, but the orthogonals do not converge at a single vanishing point as in Masaccio's *Trinity*. Instead, Campin's perspective structure shifts from panel to panel.

The center depicts the Annunciation in the interior of a private home. The Virgin reads an open book, showing her receptivity to God's Word as Gabriel delivers God's message. The flowing draperies with angular folds are characteristic of northern taste. The persistence of International Gothic style is evident in the attention to minute details, many of which are endowed with symbolic meaning. The towel, washbasin, and lilies, for example, signify the purity of the Virgin. Above Gabriel's wing, a ghostly miniature Jesus slides down a shaft of light, carrying the Cross. This image was a medieval metaphor for the Virgin conception, which was compared to light passing through a window and leaving the glass intact.

At the right, Mary's earthly husband, Joseph the carpenter, bores a hole into a slab of wood. He is making mousetraps to trap the devil (often symbolized as a mouse) and to keep him from interfering with the Annunciation. In the background, visible through the open window, Campin painted the view of a local street. The left panel shows the donors kneeling to witness the Annunciation.

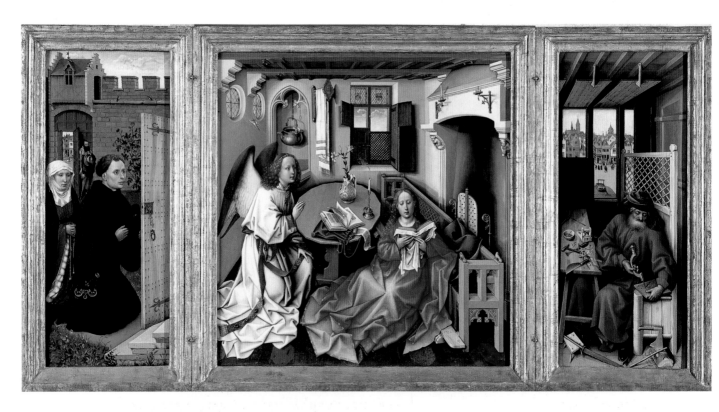

18.21 Robert Campin (Master of Flémalle), *Annunciation Triptych*, c. 1425. Oil on wood, all three panels 25 ³/₈ x 46 ⅜ in. Metropolitan Museum of Art, New York. Cloisters Collection. 1956, no. 56.70.

18.22 Jan van Eyck, *Man in a Red Turban*, 1433. Tempera and oil on wood, 13 1/8 x 10 1/8 in. National Gallery, London.

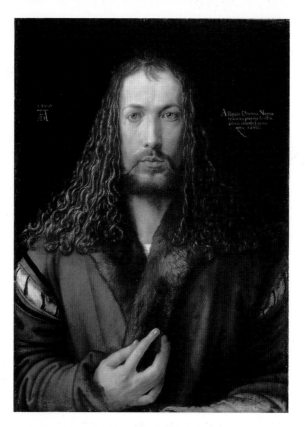

18.23 Albrecht Dürer, *Self-Portrait Age 28*, 1500. Oil on wood, 26 5/16 x 19 5/16 in. Alte Pinakothek, Munich.

> The art of painting is made for the eyes, for the sight is the noblest sense of man.
>
> Albrecht Dürer, artist (1471–1528)

> ... the face of a man who is already dead certainly lives a long time through painting.
>
> Leon Battista Alberti, artist, architect, and author (1404–1472)

Robert Campin's contemporary, Jan van Eyck (c. 1390–1441), was the leading artist at the court of Philip the Good in Bruges (in modern Belgium). Van Eyck's *Man in a Red Turban* (**figure 18.22**) of 1433 is generally considered to be his self-portrait. As is typical of the Renaissance interest in the individual, van Eyck asserts the man's presence with conviction. The figure is in three-quarter view, turning to face the observer. Van Eyck used Renaissance shading to define the face and his attention to precise detail, facilitated by the oil medium, is characteristic of Northern painting. The folds of the red "turban," which is actually not a turban but a fashionable contemporary headcovering, accentuate the face and are also a design in their own right. Van Eyck distinguishes between the furry texture of the collar, the craggy flesh of the face, and the heavy coat. The frame contains the statement "Als Ich Kan" ("All I can"), indicating that he did the best he could in painting the portrait, but that he would have done better had he been able to.

The most important turn-of-the-century painter in Germany, Albrecht Dürer (1471–1528), was trained by his father as a goldsmith in Nuremberg, in southern Germany. His expertise in woodcut and engraving is reflected in the linear quality of his style. He traveled to Italy, where he studied Renaissance style and in 1515 became court painter to Emperor Maximilian I, the Holy Roman Emperor. We remember from Chapter 10 that Dürer engraved the triumphal chariot in celebration of the emperor's wedding (see p. 182).

In 1500, at the age of twenty-eight, Dürer painted a frontal self-portrait (**figure 18.23**), which, like van Eyck's, emphasizes the artist's presence. Dürer's direct, intense gaze is arresting. His face, framed by a mass of wavy hair highlighted in gold, emerges from a dark background. On either side of his head is an inscription; the one on the left records the date above his signature monogram (see p. 42). His fingers lightly play over the fur of his coat, emphasizing the painter's hand and its role in the execution of the self-portrait.

Dürer's attention to convincing textures is consistent with his view that the eye is the means by which the experience of painting is conveyed to the viewer.

The High Renaissance in Italy

In Italy, the High Renaissance (c. 1480–1520) begins in the late fifteenth century with the work of Leonardo (1452-1519), who was born in the small town of Vinci, near Florence. Beginning around the age of eleven, Leonardo trained as an apprentice in the Florentine workshop of Verrocchio. Although he lived mainly in Florence, Leonardo also worked in Milan, Rome, and France. He, more than any other artist, came to embody the notion of the Renaissance Man—one who is skilled in many disciplines. Leonardo was a painter, sculptor, architect, scientist, engineer, and inventor, who wrote on every known field. His illustrated notebooks discuss art, music, poetry, and architecture in addition to physics, chemistry, botany, geology, astrology, and the weather. He also made the first topographical maps at a time when European navigators were beginning to sail around the world.

In addition to exploring the external world, Leonardo studied animal and human anatomy. His anatomical drawings are among the most accurate ever made and they reflect careful study of the human body (**figure 18.24**). Although dissection had been strictly forbidden by the Church in the Middle Ages and human cadavers were difficult to come by even during the Renaissance, some artists obtained the bodies of executed criminals. Gradually, in the course of the fifteenth and early sixteenth centuries, they began to study anatomy as a means of achieving accurate depictions of human form.

As a painter, Leonardo was a master of subtle *chiaroscuro* and the technique of creating *sfumato* (the smoky effect of hazy, filtered light). Leonardo's *sfumato* contributes to the mysterious effect of the *Mona Lisa*. Mona Lisa's flesh is bathed in subtle gradations of light and shade and she is surrounded by a misty, blue-green background. She is shown in three-quarter view, seen head on, whereas the imaginary landscape behind her is seen from above. In this painting, the woman and the landscape are symbolically and formally united according to Leonardo's metaphor comparing the earth with human form. He wrote that the earth is flesh, rocks are bones, and waterways are blood. This image, like the investigative impulse to study human form, embodies the Renaissance revival of the Greek notion that man is the center of the universe.

The *Mona Lisa* was, according to Vasari, commissioned by a Florentine nobleman. But Leonardo constantly revised the picture over a period of several years and never delivered it to the patron. He took it with him when he went to France to work at the court of Francis I. Leonardo died there, and the painting entered the French national collection—now in the Louvre, in Paris.

COMPARE

Leonardo, *Mona Lisa*.
figure 5.5, page 78

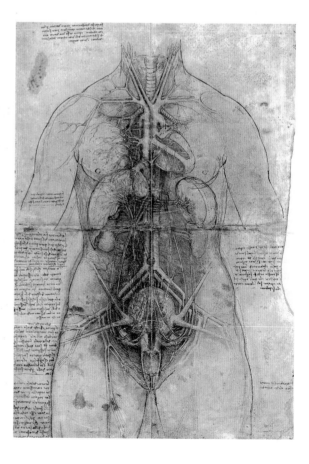

18.24 Leonardo da Vinci, *Drawing of Female Anatomy*. c. 1510. The Royal Collection.
© 2006 Her Majesty Queen Elizabeth II.

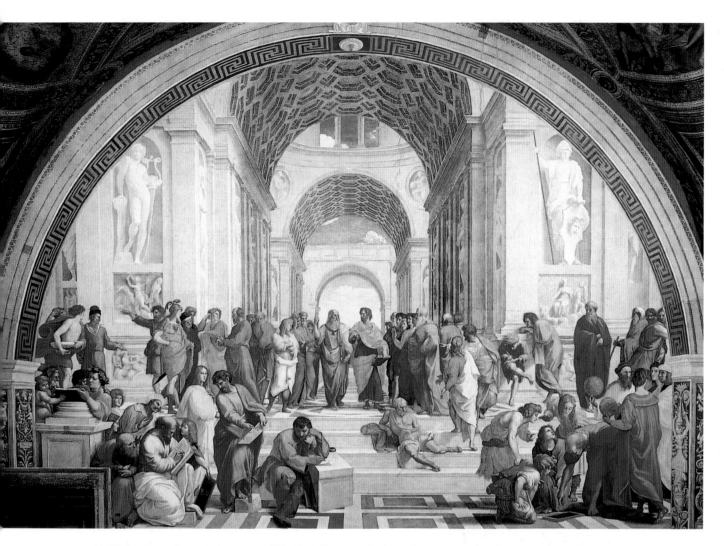

18.25 Raphael, *School of Athens*, 1509–1511. Fresco, 19 x 27 ft. Stanza della Segnatura, Vatican, Rome.

With the dawn of the sixteenth century, the center of patronage shifted to Rome, where humanist popes and wealthy bankers admired and financed the arts. The pope most engaged in hiring High Renaissance artists and collecting Classical as well as Christian texts was Julius II (1443–1513). He was also an accomplished warrior and a skilled politician who fought for the Papal States.

The enormously prolific Raphael Sanzio (1483–1520), who died at the age of thirty-seven, exemplified the Classical ideals of calm, order, symmetry, and harmony. From 1509 to 1511, Raphael decorated the Stanza della Segnatura, a room used for signing documents and the pope's library in the Vatican. He painted four large lunette frescoes filled with lifesize figures; the fresco that is considered a summation of Renaissance classicism is the *School of Athens* (**figure 18.25**). In this fresco, Raphael has assembled the greatest Greek philosophers in a single space. The setting is a symmetrical, domed interior, with three receding coffered barrel vaults at the center and a floor design with orthogonals leading to a vanishing point. The wall niches contain statues of Greek gods and goddesses—the two facing us are Apollo to our left and Athena (Minerva) to our right. The vanishing point is located at the mathematical center of the picture, between the heads of Plato (our left) and Aristotle (our right), who occupy the center of the top step. Not all of the philosophers have been identified, but we know that several are portraits of Raphael's Renaissance contemporaries: Plato is a portrait of Leonardo; the brooding figure in the foreground is Michelangelo; and the young man in the black hat at the far right is Raphael himself. This merging of Greek philosophers with early-sixteenth-century portraits reflects the Renaissance interest in fame, and also emphasizes the intellect of Renaissance artists. The Classical spirit appears in the fluid poses, the naturalistic forms, and the prevalence of texts, as well as in the formal order and symmetry.

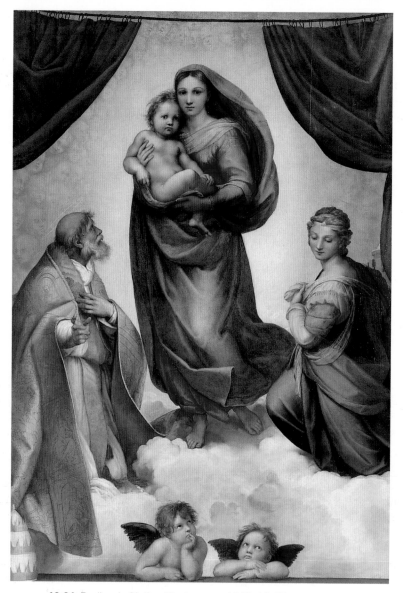

18.26 Raphael, *Sistine Madonna*, c. 1513–14. Oil on canvas, 8 ft. 6 in. x 6 ft. 7 ⅛ in. Gemäldegalerie, Dresden. Staatliche Kunstsammlungen, Dresden.

Around 1513, Raphael painted his famous *Sistine Madonna* (**figure 18.26**), which Julius II commissioned for the high altar of a church dedicated to the third-century saint, Pope Sixtus II, in Piacenza (see map on p. 365).

The painting is a complex synthesis of the spiritual and material worlds, of the viewer's space and heavenly space, and of present time and past time. It is designed to show the timelessness of the Christian universe and the important role of Julius II and his papal forebears in that universe. At the center of the picture, the curtains part to reveal the Virgin stepping forward on a cloud. She holds a nude, babylike Jesus, as if offering him to the viewer as the priest offers the wafer (Christ's body) during Mass.

At the left, Pope Sixtus II (actually a portrait of Julius II) kneels and points toward the congregation.

His papal tiara sits on a ledge with two cherubs gazing wistfully upward. On the right-hand side is Saint Barbara, identified by the tower (one of her attributes); as the patron saint of warriors, she alludes to Julius II's role as commander of the papal army.

The calm repose of the *Sistine Madonna*, the Virgin's grace, her serene expression, and the naturalism of the infant Jesus are characteristic of Raphael's classicizing style. A soft light plays over the figures and defines their draperies. Directly framing the Virgin is the more intense, heavenly white light of the clouds that expands downward, around the cherubs. The introspective, somewhat aloof quality of the figures removes them from the material world and presents the viewer with a glimpse of heaven.

Michelangelo (1475–1564), who was revered by Vasari as *il divino* (the divine one), outlived Raphael by forty-four years, which gave him more time to develop his style.

By the end of his life, Michelangelo's style was evolving in new directions, away from the Classical tradition. Like Leonardo, Michelangelo was born near Florence, and was apprenticed to a master artist in Florence as an adolescent. While in Florence, he studied the paintings of Masaccio and was drawn to his monumental forms. But, although Michelangelo worked as an architect and a painter and wrote sonnets, he thought of himself as primarily a sculptor. His preferred material was marble.

When Michelangelo was twenty-six, he was commissioned to carve a monumental marble statue of *David* (**figure 18.27**). Originally intended for the exterior of the cathedral, the *David* was transferred to the Signoria, the government seat in the Palazzo Vecchio. There, like Donatello's *David*, the statue stood for the city itself. Ever-watchful, the biblical hero guards Florence against its enemies. In contrast to Donatello's *David*, Michelangelo's hero has not yet killed Goliath. His *David* carries the sling in his left hand and the stone in his right and seems to be sighting the giant from a distance. The figure is a forceful nude in the tradition of Hellenistic expressiveness (see Chapter 16). The muscles are tensed, but *David* occupies the relaxed pose of the *Spearbearer* (see figure 16.3). With the added tree-trunk support that the *Spearbearer* also has, the *David* is reminiscent of Roman marble copies of Greek statues.

Vasari's life of Michelangelo contains an amusing anecdote about the *David*, which was nicknamed the Giant after the huge block of marble from which it was carved. The story shows both the

> ... from the art of [Michelangelo's] brain and of his hand there would be seen to issue forth works marvelous and stupendous.
>
> Giorgio Vasari (1511–1574)

COMPARE

Polykleitos, *Doryphoros (Spearbearer)*
figure 16.3, page 319

relationship between art and illusion and the artist's sense of his own superiority as an artist. According to Vasari, the mayor of Florence found David's nose too big and asked Michelangelo to reduce it. Whereupon Michelangelo climbed a ladder, taking with him a chisel and a handful of marble dust:

> "... and then, beginning to strike lightly with the chisel, let fall the dust little by little, nor changed the nose a whit from what it was before."[3]

The mayor, believing that the artist had made a change, asserted that the statue now had more life. "And so," concludes Vasari:

> "Michelangelo came down, laughing to himself at having satisfied that lord, for he had compassion on those who, in order to appear full of knowledge, talk about things of which they know nothing."[4]

18.27 Michelangelo, *David*, 1501–1504. Marble, 14 ft. high. Accademia, Florence.

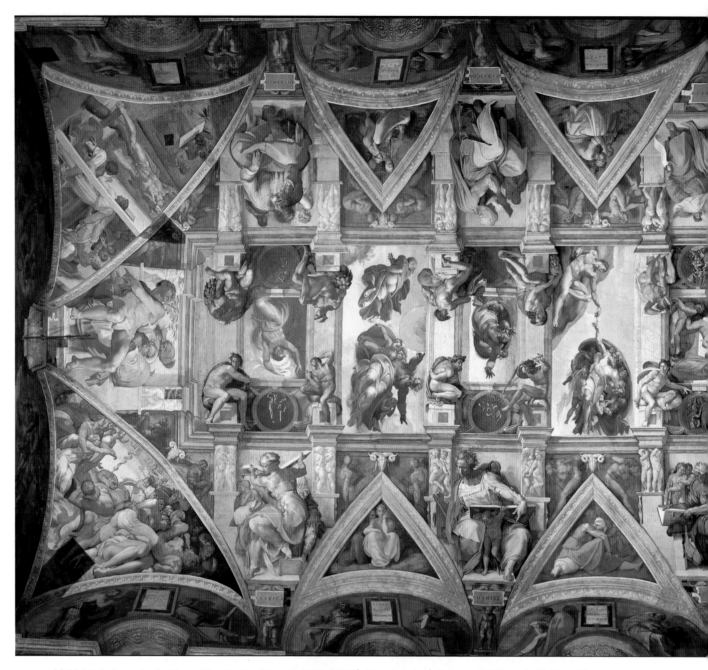

18.28 Michelangelo, Ceiling of the Sistine Chapel, 1508–1512 (after cleaning). Fresco, 5,800 sq. ft. Vatican, Rome.

A few years after carving the *David*, Michelangelo was summoned to Rome by Julius II. Among other papal commissions, Michelangelo was given the task of decorating the ceiling of the Sistine Chapel (**figure 18.28**). This was the pope's personal chapel. It was built in the 1470s by Julius's uncle, Pope Sixtus IV, to match the dimensions of the Temple of Solomon in Jerusalem. At the time, the barrel-vault ceiling was painted as a star-studded sky, but Julius had a more monumental vision in mind.

Michelangelo constructed a scaffold and began work in 1508. The ceiling was unveiled four years later. Along the center of the vault Michelangelo

painted nine scenes from Genesis, beginning with *God Separating Light and Dark* and ending with the *Drunkenness of Noah* after the Flood. The first three scenes illustrate the Creation of the universe; the second three show the creation of Adam and Eve and their Fall; and the last three are from the life of Noah. All are populated with powerful, muscular figures moving dynamically through space. The energy of God's creative force mirrors that of the artist.

Each of the small narrative scenes is framed by four heroic nudes in sharp *contrapposto*, reflecting the artist's interest in human power. Surrounding the narrative scenes are alternating Old Testament

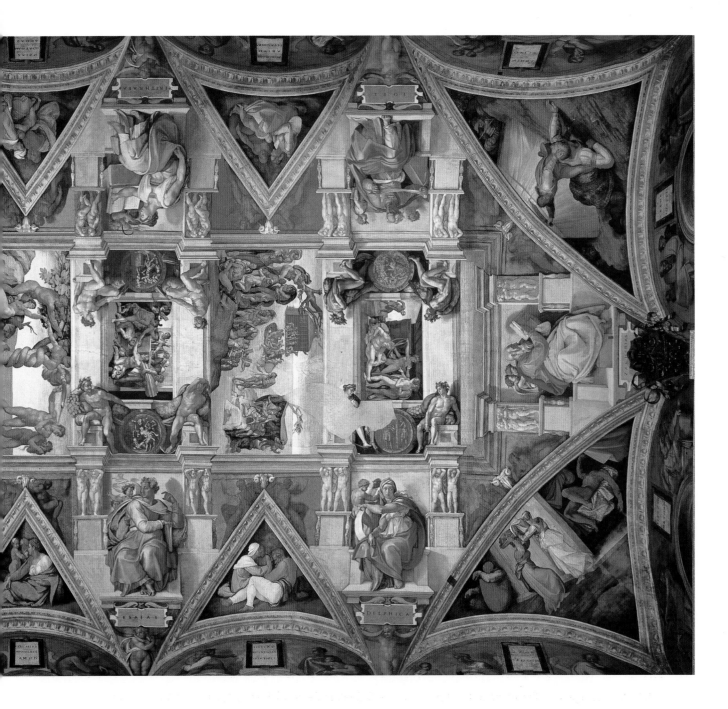

prophets and pagan sibyls (women who foretold the future in antiquity). The **spandrels** (curved triangles) over the windows depict ancestors of Jesus as enumerated at the beginning of the Gospel of Matthew. The four corner spandrels depict Old Testament events that in Christian iconography were traditionally paired with events of Jesus's life. Thus, although Jesus appears nowhere in the ceiling, the emphasis is on events that led up to, or prefigured, his coming—and the prophets and sibyls who foretold it.

The fame of the Sistine Ceiling frescoes notwithstanding, Michelangelo was not pleased with the discomfort he suffered in executing them. In one of his best-known sonnets, the artist conveys this in no uncertain terms:

> I've already grown a goiter at this drudgery—
> as the water gives the cats in Lombardy,
> or else it may be in some other country—
> which sticks my stomach by force beneath my
> chin.
>
> ...
>
> In front of me my hide is stretching out
> and, to wrinkle up behind, it forms a knot,
> and I am bent like a Syrian bow.[5]

Another project that occupied Julius II was the huge new church of Saint Peter's built on the site of Old Saint Peter's (see figures 17.2 and 17.3). Several artists, including Raphael, produced plans for the new structure and building began in 1506 when the foundation stone was laid. New Saint Peter's began as a centralized Greek-Cross plan, which was the preferred humanist design. But as the Church evolved and the popes changed their view of how the new building should look, it underwent several alterations.

Michelangelo received the commission in 1546 when he was seventy-one. By the time he died, in 1564, the church was nearly complete. In the plan (**figure 18.29**) we can see that he kept the centralized Greek-Cross plan and added a Greek temple portico at the entrance. The exterior view in **figure 18.30** shows the enormous Corinthian pilasters supporting an entablature that wraps around the building between the second and third stories. The huge dome, built according to Michelangelo's specifications, rises upward slightly rather than being a perfect hemisphere, reducing the thrust and carrying the viewer's gaze upward, and is crowned by a lantern.

As in the fifteenth century, Venice in the High Renaissance produced several major painters, whose style was affected by the atmosphere of the city. Like the Northern painters, Venetians used oil and glazes to enrich color and texture earlier than artists in Rome and Florence.

Giorgione (c. 1477–1510), who died young of plague, painted the *Sleeping Venus* (**figure 18.31**) in a

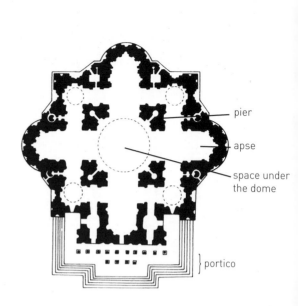

18.29 Michelangelo's plan for the New Saint Peter's, Vatican, Rome, c. 1546.

landscape filtered with soft yellow lighting reminiscent of Giovanni Bellini. As with the *Mona Lisa*, Giorgione's landscape formally echoes the contours of the woman, who, as Venus, may be an allusion to Venice itself. The sensuous, sleeping nude may be dreaming. She is related to Hellenistic sculptures of Venus, but here is transformed into flesh softened by many layers of glaze.

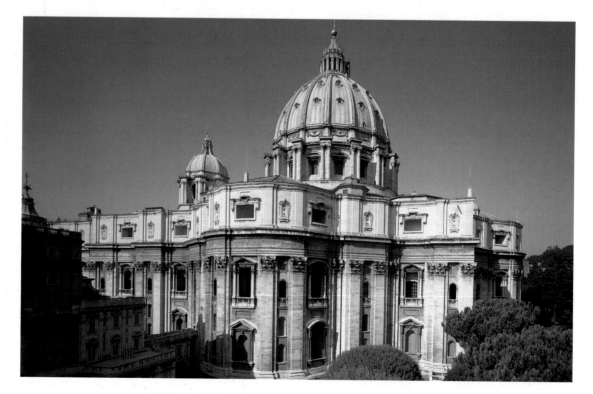

18.30 View of New Saint Peter's, Vatican, Rome, 1505–1615.

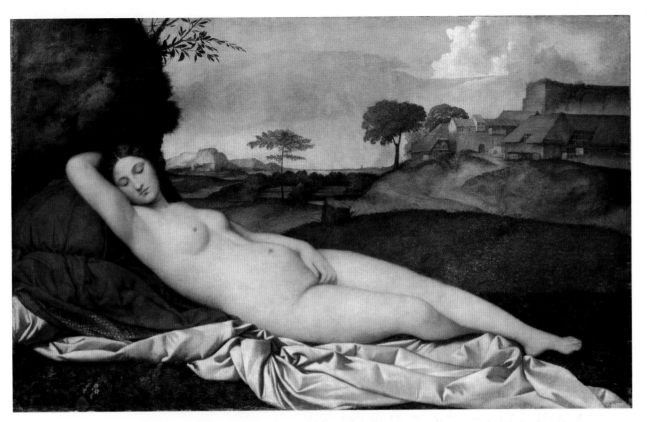

18.31 Giorgione, *Sleeping Venus*, c. 1509. Oil on canvas, 3 ft. 6 ¼ in. x 5 ft. 9 in. Gemäldegalerie, Dresden. Staatliche Kunstsammlungen, Dresden.

After Giorgione's death, Tiziano Vecelli (c. 1485–1576)—Titian, in English—became the greatest Venetian painter working in the sixteenth century. He continued the older artist's use of sensuous texture and rich color. Like Michelangelo, Titian lived a long and productive life. In Titian's mythological *Venus at Her Toilet with Two Cupids* (**figure 18.32**), as in Giorgione's *Sleeping Venus*, the goddess is depicted as a nude with soft, voluptuous flesh. Accentuating her sensuality is the emphasis on rich textures such as fur, velvet, and gold embroidery. The self-absorbed goddess contemplates her own beauty in a mirror supported by a Cupid. Another Cupid crowns her with a floral wreath. Venus turns her torso toward the viewer and her head toward the mirror, with the result that her reflection seems to be looking at us. By shifting viewpoints and multiplying the goddess, Titian compared the mirror to a painting. Both are surfaces containing images; the former reflects an aspect of reality, whereas the latter is an artist's fiction.

The mirror itself is a traditional motif in Western art. It refers to the transience of beauty and warns of future decay through old age and death. But the goddess is timeless, so that her beauty, like the painted picture, outlasts real time.

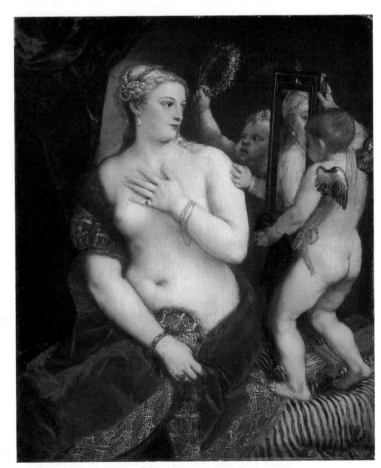

18.32 Titian, *Venus at Her Toilet with Two Cupids*, c. 1555. Oil on canvas, 4 ft. 1 in. x 3 ft. 5 ½ in. National Gallery of Art, Washington, D.C. Mellon Collection.

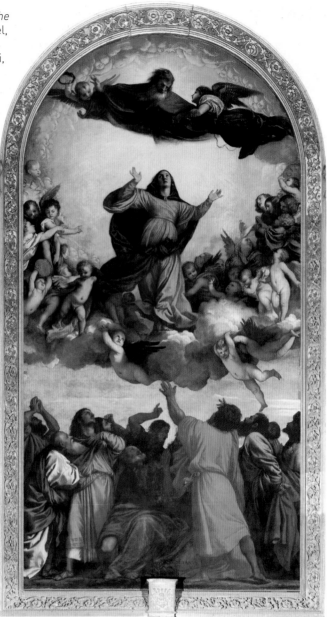

18.33 Titian, *Assumption of the Virgin*, 1516–1518. Oil on panel, 22 ft. 7 ½ in. × 11 ft. 9 ¾ in. Santa Maria Gloriosa dei Frari, Venice.

Earlier in Titian's career, in 1518, the enormous *Assumption of the Virgin* (**figure 18.33**) was unveiled in the church of Santa Maria Gloriosa dei Frari. Titian then became famous and was in great demand as an artist.

He shows the Virgin rising toward heaven surrounded by a host of angels and an intense yellow light. The deep red of her dress, Titian's signature color, is repeated throughout the painting, most strikingly in the foreground apostle. God descends to receive Mary, literally "with open arms," as she gazes ecstatically toward him. Below, in the symbolic darkness of earth, separated from heaven by a horizontal of gray, the apostles watch in amazement. Their animated gestures and expressions of astonishment reveal the wonder of the miracle of the Assumption. Titian's reputation as a great colorist,

which is confirmed in the *Assumption*, is reflected in Vasari's assertion that:

> … he used to set himself before living and natural objects and counterfeit them as well as he was able with colors, and paint them broadly with tints crude or soft according as the life demanded, without doing any drawing, holding it as certain that to paint with colors only, without the study of drawing on paper, was the true and best method of working, and the true design.[6]

In this account, Vasari alludes to the Renaissance view that since there are no lines in nature, the artists whose works are most true to life define form with shading and color rather than with line.

The Sixteenth Century in the North

As in Italy, painters in northern Europe continued to work in the Renaissance style during the sixteenth century. In Germany, the Augustinian monk Martin Luther objected to the corrupt manner in which Julius II raised money for the New Saint Peter's. German pardoners (clergymen designated by the Church to pardon sins for money) sold indulgences (letters promising a reduction of time in Purgatory) throughout Europe. In 1517, according to tradition, Luther nailed 95 theses (arguments) detailing his objections to indulgences and other evidence of clerical corruption to a castle door in Wittenburg, in Germany. His protests struck a chord and launched the Protestant Reformation. Several northern countries split from the Catholic Church and became Protestant—that is, they joined the Protestors' Church. The Netherlands split into Catholic Flanders (modern Belgium) and Protestant Holland. Most of Germany, England, and Scandinavia became Protestant, whereas Italy, Spain, Austria, and France remained Catholic. These political and religious developments influenced the style, content, and patronage of the arts. In Catholic countries, Church patronage remained central, whereas in the Protestant countries art patronage became increasingly secular.

One of the most complex Netherlandish artists, whose imagery is still not entirely understood, is Hieronymus Bosch (c. 1450–1516). The central panel of the large triptych entitled *Garden of Earthly Delights* (**figure 18.34**) is populated with nude figures in a garden. They are engaged in erotic pursuits among enlarged fruits and birds, and fanciful castles and plants on the edge of a pool. A procession of frenzied figures mounted on animals circles the pool. The globes refer to the northern proverb that glass, like earthly delights, is fragile and easily broken. They are also reminiscent of alchemical vessels and suggest that, just as men pursue the illusion that gold can be made from base metal, so they pursue physical pleasures that do not last. The unnatural variations in scale reflect the perverse activities of Bosch's figures.

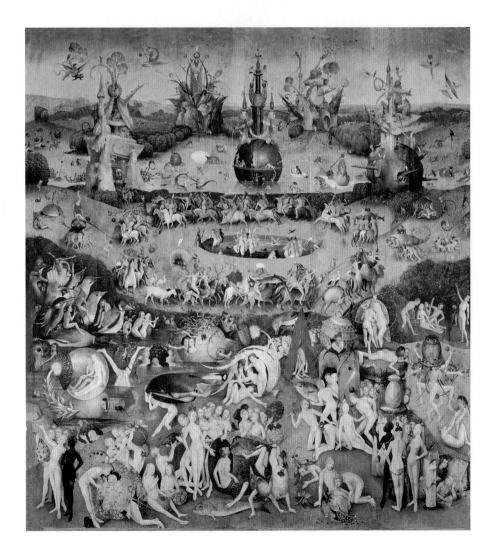

18.34 Hieronymus Bosch, *Garden of Earthly Delights*, c. 1510–1515. Center panel, 7 ft. 2 in. x 6 ft. 4 in. Prado, Madrid.

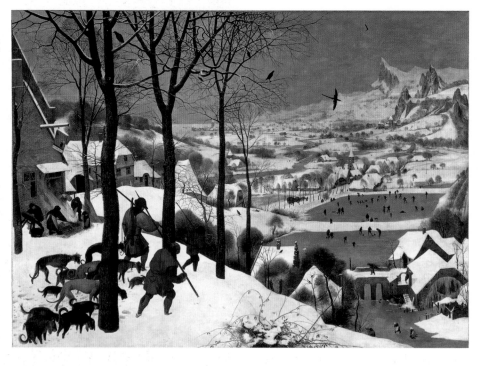

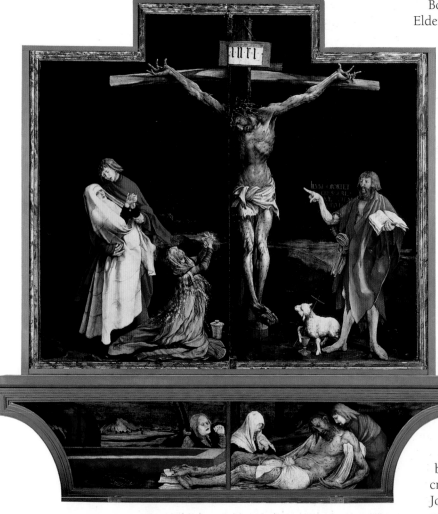

18.36 Matthias Grünewald, *Isenheim Altarpiece* (closed), c. 1510–1515. Oil on panel, center panel 9 ft. 9 ½ in. x 10 ft. 9 in. Unterlinden Museum, Colmar, France.

Bosch's humanist follower, Pieter Bruegel the Elder (c. 1525–1569), worked mainly in Antwerp (in modern Belgium). During a trip to Italy, he became inspired by landscape. In one series of paintings showing man's relation to nature, Bruegel depicts peasant activities according to the season. *Hunters in the Snow* (**figure 18.35**) is a winter scene. The landscape is drained of color by the gray sky and white hills. At the right a group of hunters and dogs trudge through the snow, past barren trees, carrying their prey. From the elevated vantage point of the hunters, we observe the village below, with its crows, snow-covered rooftops, and ice-skaters on a frozen lake. The only warmth is provided by a glowing red fire at the far left.

In Germany, Matthias Grünewald (d. 1528) painted a distinctive altarpiece for the hospital attached to Saint Anthony's monastery in Isenheim, in Colmar (today part of France) (**figure 18.36**). In this view, the altarpiece is closed. It shows the Crucifixion in the center and the Lamentation over Jesus's body on the base. The black sky refers to death and the tradition that the sky blackened and nature died when Jesus was crucified. To the left of the Cross, the apostle John supports the Virgin, and Mary Magdalen prays at the foot of the Cross. At the right, John the Baptist carries an open book and points toward Jesus. The blood-red inscription spoken by John reads: "He must increase and I must

decrease," referring to the expansion of the Christian message throughout the world. The little lamb next to the Baptist symbolizes Christ; he carries a cross and his blood drips into a chalice.

Very little is known of Grünewald's life. A seventeenth-century biography of him describes a small *Crucifixion* that emphasized the realism of Jesus on the Cross:

> … the strange figure of Christ on the cross … conveys the most powerful sensation of hanging since the weight of his body is borne entirely by the feet … this Crucifixion is so extraordinarily close to real life that it appears true and natural beyond all others if one contemplates it for some time with patience and understanding.[7]

In the Isenheim *Crucifixion*, Grünewald also emphasized the reality of Christ's suffering. He showed contorted limbs, a tortured expression, and discolored flesh. This particular rendition of the Crucifixion was related to the function of the altarpiece. Patients suffering from skin diseases, especially ergotism (called Saint Anthony's Fire, because it causes a burning sensation), prayed before the altar. Saint Anthony himself is shown in the right panel, and Sebastian, a plague saint associated with skin ailments (because he was martyred when Romans shot him full of arrows), occupies the left panel. On feast days, the altar was opened to reveal the resurrected Christ in a blaze of light and glory, thus giving hope for salvation to dying patients.

The other leading German artist of the sixteenth century, Hans Holbein the Younger (c. 1497–1543), became court painter to the English king, Henry VIII (see p.47). England, like Germany, broke with the pope. Henry was angered when the Medici pope Clement X refused to annul his marriage to Katharine of Aragon, which he requested because she had failed to give him a son. The king retaliated by proclaiming himself and all future English monarchs head of the Protestant Church of England. Henry went on to marry five more wives. His third wife, Jane Seymour, gave him a son, but died soon afterward. In her portrait (**figure 18.37**), she appears flat and prim, conveying her quiet demeanor. At the same time, Holbein emphasizes the regal textures of her velvet dress and brocade sleeves edged with lace. She wears an elaborate necklace that matches her delicate jeweled collar and the trim of her headdress. Her facial features are depicted in a detailed, linear fashion characteristic of Northern painting.

18.37 Hans Holbein the Younger, *Jane Seymour*, 1536. Oil on panel, 25 ³/₄ x 18 ³/₄ in. Kunsthistorisches Museum, Vienna.

Mannerism

Mannerism is the style that emerged around the time of Raphael's death in 1520 and overlapped with the late styles of Michelangelo and Titian. It coincided with efforts by the Church to combat Martin Luther and the Reformation. This counter-reform movement, called both the Counter-Reformation and the Catholic Reformation, swept Europe in the sixteenth century. It involved not only reform within the Catholic Church, but also reform in the arts. The Church established new rules, which required artists to emphasize mysticism and spiritual ecstasy and to evoke identification with the suffering of saints and martyrs. In art commissioned by the courts, on the other hand, there was a new, overt eroticism in both subject matter and style. In portraiture, artists focused on surface elegance, which in the best work also reveals character.

The Mannerist style disrupted the calm, orderly classicism of the Renaissance. Elongated figures are represented in twisted poses, spaces are more animated and open, colors are often jarring, and the use of light is designed to express a sense of divine spirituality.

A good example of a Mannerist sculpture imbued with political meaning is Benvenuto Cellini's (1500–1571) *Perseus* (**figure 18.38**). Perseus was the Greek hero who slew the monstrous Gorgon Medusa, cut off her head and gave it to the goddess Athena. The statue was a public commission from Cosimo I de' Medici, the ruler of Florence in the mid-sixteenth century and later the Grand Duke of Tuscany. As a heroic nude male, the *Perseus* follows in the tradition of the *Davids* of Donatello and Michelangelo.

The *Perseus*, like the *Davids*, was thought of as an image of Florentine triumph over its enemies. In this case, however, the image is not a generalized republican one, but is intended to show specifically that Cosimo I is a stern but heroic leader. If we take a purely formal approach and compare the *Perseus* with the *Davids*, we can see that Cellini has opened up the spaces and animated the pose and surface anatomy of the hero.

Cellini also created an unsettling impression, which is characteristic of Mannerism. His Perseus steps on Medusa's torso and displays her severed head for all to see. The waves of blood flowing from the head and the neck produce an odd, rather grotesque impact on the viewer.

Portrait of the Artist's Sisters and Brother (**figure 18.39**) by Sofonisba Anguissola (c. 1533–1625) is Mannerist in the affectation of the poses and expressions, as well as in the fussiness of the dog and the girls' dresses. Note the lace cuffs, headbands, textural variety of the materials, and the little tassels on the boy's collar. Each figure turns abruptly, creating a sense of rapid movement even though the children are sitting still for their portraits.

18.38 (Above) Benvenuto Cellini, *Perseus*, 1545–1554. Bronze, 10 ft. 6 in. high. Loggia dei Lanzi, Florence.

18.39 (Right) Sofonisba Anguissola, *Portrait of the Artist's Sisters and Brother*, c. 1555. Oil on panel. Methuen Collection, Corsham Court, Wiltshire, England.

Anguissola was unusual in being a successful woman artist at a time when women were denied formal artistic training, including access to nude models. Nevertheless, she came from an educated, humanist family that encouraged its five artist daughters. She herself had a long and successful career.

The artist who followed most intensely the precepts of Catholic reform was El Greco (1541–1614). He was born on the Greek island of Crete, studied in Venice, and went to Spain, where he worked mainly in Toledo, outside Madrid. His *Holy Trinity* (**figure 18.40**), part of an altarpiece for Toledo's Church of Santo Domingo el Antiguo, is strikingly different from Masaccio's fifteenth-century painting of the same subject (see figure 18.9).

El Greco eliminated the architectural setting, the Classical proportions, the contemporary donors, and linear perspective. His scene takes place entirely in a celestial setting, where a powerful, protective God receives his resurrected son. Cherubs emerge from the clouds and appear at Christ's feet. He is surrounded by agitated, elongated angels, whose colorful robes contrast with his gray, deathly pallor. His contorted pose reveals the rich red stigmata that denote his suffering on the Cross. At the very top of the picture, the dove of the Holy Spirit descends in a blaze of mystical light, reminding viewers that salvation comes through suffering and martyrdom.

——◆——

The exaggerated, theatrical qualities of Mannerist form and content signalled the end of Renaissance style. Beginning around 1620 in Rome, artists absorbed Mannerist developments in modified form and evolved from them a new style—the Baroque—that would dominate nearly the entire seventeenth century.

18.40 El Greco, *The Holy Trinity*, 1577. Oil on canvas, 9 ft. 10 1/8 in. x 5 ft. 10 1/2 in. Prado, Madrid.

Chapter 18 Glossary

campanile—Italian for "bell tower," usually a freestanding building near or attached to a church or cathedral

lantern—structure crowning a dome or tower and often admitting light to the interior

perspective—system for creating the illusion of depth in a two-dimensional work of art or a relief sculpture

pilaster—architectural feature resembling a flattened, rectangular version of a column, sometimes load-bearing but often purely decorative

spandrel—triangular space between (a) the curve of an arch and the right angle enclosing it; (b) two arches

triptych altarpiece or painting consisting of one central panel and two wings

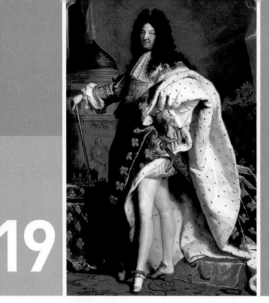

19

The Seventeenth and Eighteenth Centuries

TIMELINE

	HISTORICAL EVENTS	ART HISTORY	
1600	● Counter-Reformation ● Colonization by major European powers expands	● Caravaggio, *The Conversion of Saint Paul* 1601 ● Bernini, *Saint Longinus* 1635–1638 ● Borromini, Sant'Ivo della Sapienza, 1642–60	**1600**
1650	● Reign of Philip IV of Spain 1605–1665 ● Urban VIII, pope 1623–1644 ● Reign of Louis XIV of France 1643–1715 ● Execution of Charles I of England 1649 ● Alexander VII, pope 1655–1680 ● Restoration of the monarchy in England under Charles II 1660	● Rubens, *Rape of the Daughters of Leucippus* c. 1618 ● Velázquez, *Las Meninas* 1656 ● Rembrandt, *Self-portrait*, 1658 ● Vermeer, *Girl with a Pearl Earring* 1665 ● Saint Paul's Cathedral, London, begun 1675 ● Palace of Versailles, 1682	**1650**
1700	● Age of Enlightenment, 18th century ● Catherine the Great rules Russia 1762–1796	● Rococo style after 1715 ● Watteau, *The Return from Cythera* 1717 ● Neumann, Vierzehnheiligen, 1742–1772	**1700**
1750	● American Revolution 1776 ● French Revolution 1789	● Jefferson, State Capitol, Richmond, 1785–1789 ● David, *The Oath of the Tennis Court* 1791	**1750**

The seventeenth century in Western Europe was an age of absolute monarchs—especially the rulers in Spain, France, and England—who attempted to rule with complete power. They used the arts to promote their power and hired the most talented artists to work at their courts. These monarchs were discerning collectors and their vast art collections later formed the core of several of today's national museums. In Rome, patronage came mainly from the Church, which continued to apply the rules of the Counter-Reformation (see Chapter 18), requiring artists to represent miracles and the suffering of saints and martyrs. Protestant countries, such as Holland, tended to have more secular and less Church patronage, as a result of which art was increasingly commissioned by private individuals and civic groups in those regions.

Ever since Columbus discovered the Americas at the end of the fifteenth century, geographic exploration expanded. And with religious persecutions in Europe, more and more people fled to the so-called New World. Thus the seventeenth century was an age of colonization, which also led to new developments in the arts.

During the eighteenth century, European and American intellectuals questioned the age-old divine right of kings and the notion of citizens' rights began to emerge. This new way of thinking culminated in two violent revolutions, first in the American colonies in 1776 and then in France in 1789. These challenges to tradition were partly the result of the eighteenth-century movement known as the Enlightenment (also called the Age of Reason).

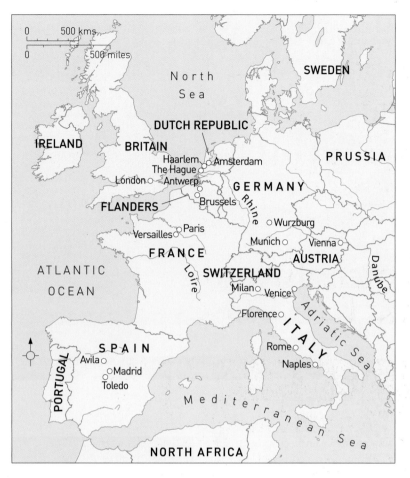

Europe in the seventeenth century.

The Baroque style that swept Europe, beginning around 1620 and prevailing throughout the rest of the seventeenth century, is characterized by dramatic emotion, expansive forms, and sometimes by violent narratives. Baroque style differs from Renaissance style in its use of dynamic diagonals and animated S-curves. There is also more variety in the spaces and shapes in Baroque, which avoids symmetry and linear perspective. Baroque light and color are used as highlights rather than being evenly distributed, as in the Renaissance. Despite formal similarities uniting the style, however, Baroque could vary according to individual national tastes. The style had a more Classical flavor in Rome; at the European courts, it was extravagant; and it appealed more to the middle class and to civic groups in mercantile Holland.

In addition to stylistic developments, new subjects, such as landscape, still life, and genre (scenes of everyday life), appear in the seventeenth century. By the eighteenth century, Baroque had evolved into the more ornate Rococo style, which was especially popular in Germany, as the Age of Absolutism evolved into the Enlightenment. With

revolution inspired by the Roman republic and Greek democracy on the horizon, France revived classicism and created the Neoclassical style. In the newly formed United States, the Neoclassical style was espoused by Thomas Jefferson and developed the Federal style.

The Baroque Style in Italy

One of the most impressive architectural achievements of the Baroque era was the completion in Rome of the New Saint Peter's (**figure 19.1**), which we described in Chapter 6 from a formal point of view (see p. 122).

In 1626, Carlo Maderno (1556–1629) extended Michelangelo's Greek temple façade by adding two pilasters at each end to frame and emphasize the center. He also lengthened the nave, making the plan more of a Latin Cross, as the Counter-Reformation required (see Chapter 18).

Pope Alexander VII (papacy 1655–1680) commissioned the large public square (the **piazza**) in front of Saint Peter's. He entrusted the work to

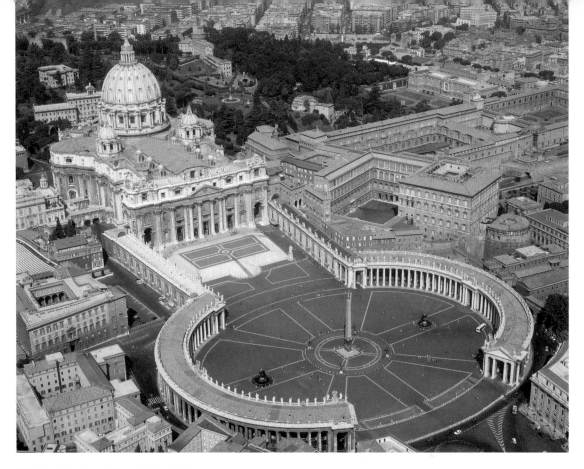

19.1 Aerial view of Saint Peter's, Rome.

Bernini, the leading architect and sculptor in seventeenth-century Rome. In contrast to the Renaissance preference for simple shapes such as circles, squares, and rectangles, Bernini designed a trapezoidal space narrowing from the steps and then expanding into a wide oval. At the short ends of the oval, a curved colonnaded passageway allows people to move easily in and out of the square even when it is filled with large crowds. Completed in 1663, the colonnade consists of 284 huge columns supporting an entablature. Over the entablature, 96 statues of saints energize the space. At the center of the oval, an Egyptian obelisk (tall pointed pillar) is flanked by two fountains. Both the curved walls and the animation of urban space through the presence of fountains became characteristics of Baroque style.

Bernini was also in charge of renovating the interior of Saint Peter's, including its sculptural decoration. During the 1630s, he carved the dramatic marble statue of Saint Longinus, the Roman soldier who pierced the side of Jesus on the Cross, converted to Christianity, and died a martyr (**figure 19.2**). The statue is located in a niche below the dome, where it is illuminated from the outdoors, making the figure appear to be gazing toward heavenly light. In keeping with the requirements of the Counter-Reformation, Bernini represented Longinus's moment of conversion. The transition from paganism to Christianity is shown

COMPARE

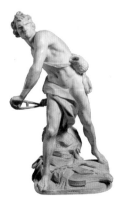

Bernini, *David*.
figure 7.9, page 136

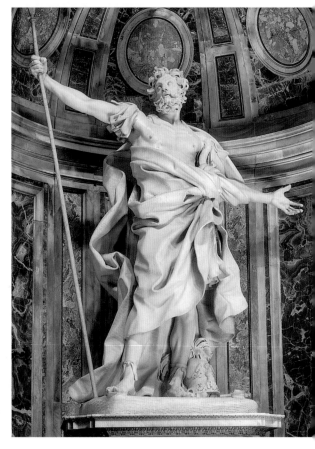

19.2 Gianlorenzo Bernini, *Saint Longinus*, 1635–1638. Marble 14 1/2 ft. high. Saint Peter's, Rome.

by the helmet lying on the ground that Longinus has renounced, and by the Roman armor visible under his robe. Bernini displaces the intensity of Longinus's spiritual transformation onto the agitated drapery and flowing beard. The broad diagonal formed by the saint's outstretched arms creates irregular, open space somewhat stabilized by the lance.

Bernini's highly placed ecclesiastical connections and his innate genius insured him a successful career in Rome. His marble *David* of 1623 for Cardinal Borghese, which we discussed in Chapter 7, exemplifies the Baroque taste for dramatic narrative action, broad diagonals, and open spaces. In the 1640s, Bernini decorated a private chapel belonging to the wealthy Cornaro family in Rome's church of Santa Maria della Vittoria. He designed the architectural setting as well as the lifesize marble group entitled *The Ecstasy of Saint Teresa* (**figure 19.3**). Born in Avila in Spain, Teresa (1515–1582) wrote about her mystical experiences, one of which Bernini illustrates here. According to Teresa,

an angel descended from heaven and pierced her heart with an arrow. So ecstatic was her response that she levitated (rose from the ground):

> … this angel was very beautiful, his face so aflame that he appeared to be one of the highest types of angel who seem to be all afire … In his hands I saw a long golden spear and at the end of the iron tip I seemed to see a point of fire….[1]

Bernini shows the youthful angel preparing to pierce the saint as he gently lifts her robe. Teresa leans backward, her body a series of diagonals, closing her eyes and slightly parting her lips. Her outward calm is contradicted by the formal agitation of her drapery folds, which reveal her inner excitement. The gold diagonals behind the figures represent rays of light sent from heaven. In this scene, Bernini combines the humanist interest in character and personality with the mystical aura of a spiritual event in a way that would have satisfied the rules of the Catholic reform movement.

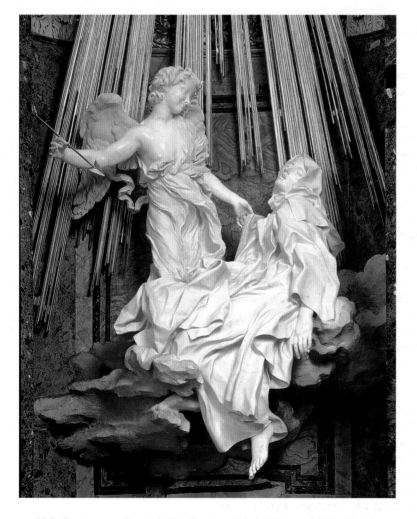

19.3 Gianlorenzo Bernini, *The Ecstasy of Saint Teresa*, 1640s. Marble, 11 ft. 6 in. high. Cornaro Chapel, Santa Maria della Vittoria, Rome.

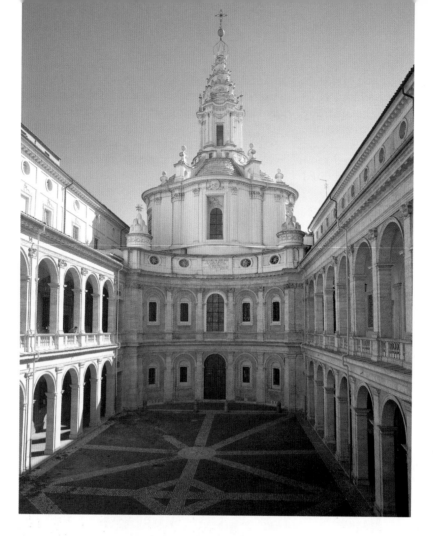

19.4 Francesco Borromini, Collegiate Church of Sant'Ivo della Sapienza, Rome, 1642–1660.

Bernini's sometime rival, Francesco Borromini (1599–1667), produced highly innovative architecture in Rome, though for less important and less wealthy patrons. His Collegiate Church of Sant'Ivo della Sapienza (Wisdom) (**figure 19.4**) has even more spatial variety than Bernini's architecture.

Under Urban VIII (papacy 1623–1644), Borromini was appointed the official architect of Rome University. Sant'Ivo had to fit into the existing space of the university, so that the façade would be visible at the end of an open area framed by two-story arcades (rows of arches). Borromini harmonized the church with the arcades by repeating the round arches in the door and windows of the concave façade. As a result, the façade of Sant'Ivo flows naturally from one arcade to another and connects them visually. In addition, the geometric design of the square seems to direct visitors toward the church entrance.

The complex plan (**figure 19.5**) echoes the radiating pattern of the open square. It is designed as a six-pointed star with each point at the center of an apse. The walls of the dome pulsate, as if pushing against the restraining effect of the Corinthian pilasters. An elaborate lantern, with alternating concave and convex walls, supports a spiral that rises toward the crowning laurel wreath.

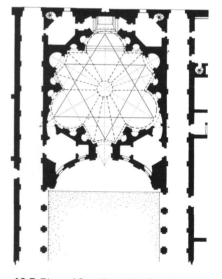

19.5 Plan of Sant'Ivo della Sapienza.

The leading early-seventeenth-century Baroque painter in Rome was Michelangelo Merisi, known as Caravaggio (1571–1610). In 1601, he was commissioned by a papal treasurer to paint *The Conversion of Saint Paul* (**figure 19.6**) in the Church of Santa Maria del Popolo. Although radically different from

Bernini's *Longinus*, Caravaggio's image of spiritual conversion is no less dramatic. Saint Paul was born Saul of Tarsus in the first century A.D.; he was a Jew and a Roman citizen who persecuted Christians on behalf of Rome. While traveling to Damascus (in modern Syria), Saul saw a sudden flash of light and heard the voice of Jesus asking why Saul persecuted him. Saul fell from his horse and was blinded. Three days later, a disciple of Jesus restored Saul's vision.

In Caravaggio's conversion scene, Saul seems to fall nearly out of the picture plane toward the viewer. His foreshortened, diagonal form compresses the space, and his outstretched arms, like those of Longinus, echo the pose of the crucified Christ. The Baroque highlight of light signifies spiritual enlightenment and enriches the reds and greens of Saul's armor. The groom, not understanding the significance of the event, is shown in darkness.

Caravaggio was famous in Rome for having introduced a new realism into painting. It is evident here in the variety of surface textures—the horse's coat and mane, the metal bridle, Saul's sword, his leather uniform, and rough flesh. Caravaggio also invented the technique of **tenebrism**—large areas of dark from which highlighted forms suddenly emerge. His biographer, Giovanni Pietro Bellori, compared the effect of his tenebrism to:

> … the dark brown atmosphere of a closed room [with] a highlight that descends vertically over the principal parts of the body while leaving the remainder in shadow.[2]

A less favorably inclined art writer of the seventeenth century, Vincenzio Carducho, was offended by Caravaggio's "modernism" and called him an "evil genius." Carducho feared that Caravaggio would adversely influence other artists and objected to his practice of painting directly on the canvas without prior preparation. "In our times," according to Carducho:

> Michelangelo da Caravaggio arose in Rome with a new dish, prepared with such a rich, succulent sauce that it has made gluttons of some painters, who I fear will suffer apoplexy. . . . They don't even stop stuffing themselves long enough to see that the fire of his talent is so powerful . . . that they may not be able to digest the impetuous, unheard-of, and outrageous technique of painting without any preparation.[3]

As Carducho feared, Caravaggio's style influenced artists throughout Western Europe and his followers were known as the *Caravaggisti*.

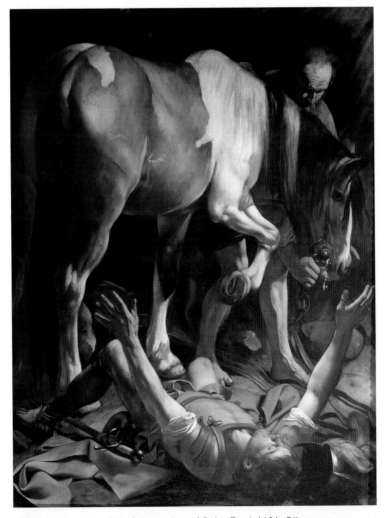

19.6 Caravaggio, *The Conversion of Saint Paul*, 1601. Oil on canvas, 7 ft. 6 ⅝ in. x 5 ft. 8 ⅞ in. Cerasi Chapel, Santa Maria del Popolo, Rome.

The most famous of the *Caravaggisti*, Artemisia Gentileschi (1593–c. 1653), had a successful career despite continuing restrictions faced by women artists. Her patrons included the Grand Duke of Tuscany and King Charles I of England. Artemisia's *Lucretia* (**figure 19.7**), like Caravaggio's *Conversion of Saint Paul*, illuminates the figure's flesh against a dark background. Artemisia also shared Caravaggio's taste for violent scenes, and typically portrayed women as victims or avengers. Her attraction to such themes has been attributed to the fact that she was raped by her painting teacher and then tortured in court to test the accuracy of her allegations.

Lucretia, like the artist herself, was sexually abused by a man in a position of authority. She lived during the tyrannical reign of Tarquin the Proud, the last Etruscan king. Her husband boasted of her beauty and her loyalty to Tarquin, who tried to seduce her and threatened to kill her if she rejected his advances. Lucretia committed suicide rather than suffer dishonor. She is shown by Artemisia as a monumental heroine, her face contorted and her massive body composed of diagonals, as she prepares her left breast for the dagger's thrust. The rich red velvet drapery and gold trim reflect Caravaggio's influence in the creation of illusions of texture.

An entirely different type of Baroque painting in Rome was commissioned to decorate large church ceilings. These were intended to fulfill the Counter-Reformation aim of glorifying Christ and the Church. In 1676, Giovanni Battista Gaulli (1639–1709) began work on his *Triumph of the Name of Jesus* (**figure 19.8**) for the church of Il Gesù, the mother church of the Jesuit Order in Rome. Gaulli's use of sharp Baroque contrasts of light and dark and his chromatic variety increases the dramatic tension of the ceiling.

Framed by an oval in the barrel vault, the *Triumph* glorifies Jesus's name—here illustrated as his monogram: *IHS*. It is surrounded by a mystical blaze of white and yellow light filled with angels. The *IHS*, like the saved souls, seems to rise upward through the ceiling toward an immaterial light and space. As figures descend, on the other hand, they are covered in shadow and tumble illusionistically from the oval frame; these are the damned, which is conveyed by both their fall and their darkness.

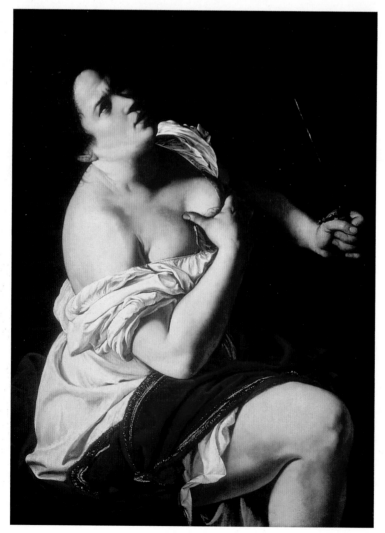

19.7 Artemisia Gentileschi, *Lucretia*, c. 1621. Oil on canvas, 3 ft. 3 in. x 2 ft. 6 in. Etro Collection.

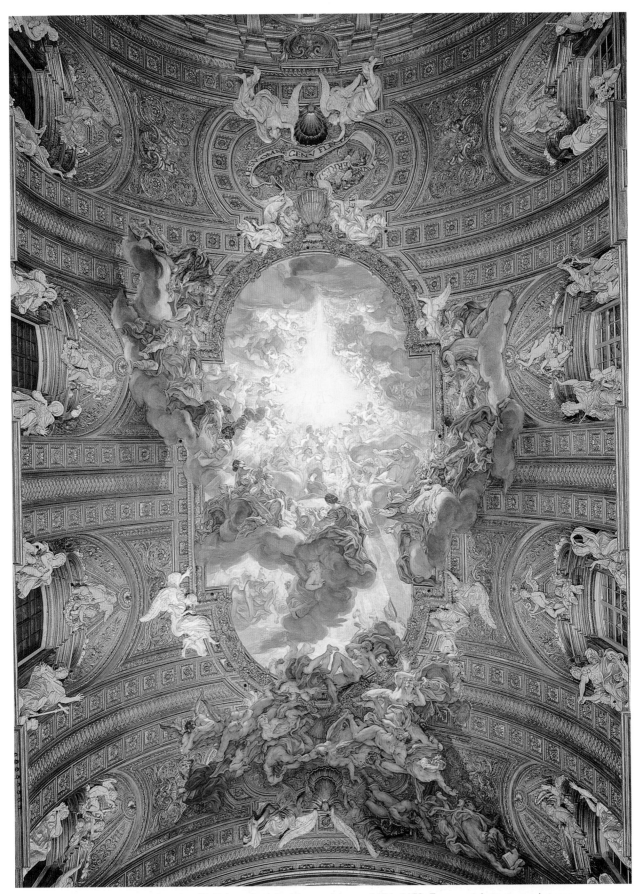

19.8 Giovanni Battista Gaulli, *Triumph of the Name of Jesus*, 1676–1679. Fresco and stucco sculptures. Church of Il Gesù, Rome.

Spanish Baroque: Velázquez

The leading Baroque artist in Spain was Diego Velázquez (1599–1660), who became court painter to Philip IV (ruled 1605–1665). Called the Planet King after the sun, which was fourth in the planet hierarchy, Philip commissioned many portraits of the royal family, its courtiers, dwarfs, and dogs, as well as political paintings. Like his grandfather, Philip II, Philip IV was a great art collector and especially admired the work of Titian.

The strict protocols of Philip's court were relieved by dwarfs, jesters, and other popular entertainers painted by Velázquez. His portrait of the jester Don John of Austria (**figure 19.9**) is a remarkable study of character. Nicknamed for a Spanish military hero, Don John is shown with armor scattered on the floor and a naval battle taking place outside the window. Velázquez pokes fun at the jester by contrasting the fallen, dismantled armor with an ostentatious outfit and the incongruity of the lance. Don John, in turn, mocks the world by "looking down his nose" at the viewer and implicitly at courtly society.

Velázquez's biographer, Antonio Palomino, said that the artist "was called a second Caravaggio because he always had his eye on nature and imitated it so skillfully."[4]

The artist's genius for conveying character won him many portrait commissions. For example, the elusiveness of the jester, who made fun of the court but had to avoid offending it, is shown in the blurring of his face. The shifting diagonals of the floor and the tilted perspective create a Baroque space, while the attention to rich silks, feathers, gold, and velvet reflects the extravagance of Philip's court.

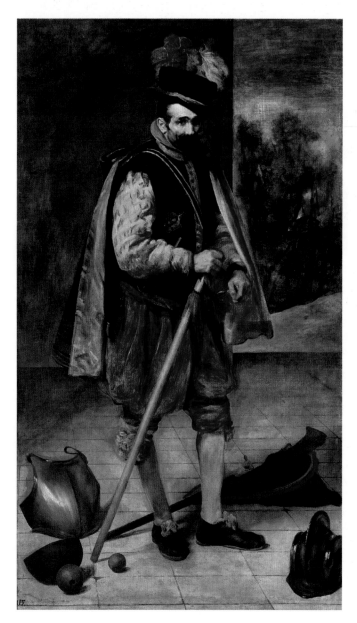

> He is the painter of painters.
>
> Édouard Manet, artist (1832–1883), on Velázquez

19.9 Diego Velázquez, *The Jester Don John of Austria*, c. 1633. Oil on canvas, 6 ft. 10 ¾ in. x 4 ft. ½ in. Prado, Madrid.

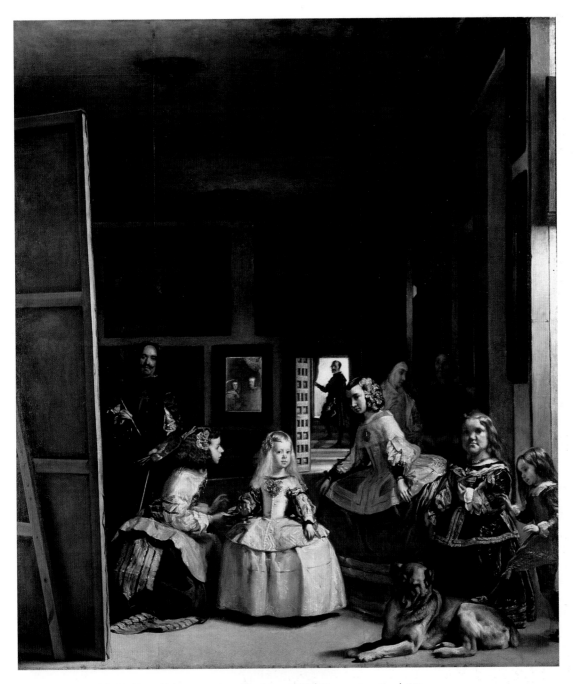

19.10 Diego Velázquez, *Las Meninas*, 1656 (after restoration). Oil on canvas, 10 ft. 7 in. x 9 ft. ½ in. Prado, Madrid.

Velázquez's best-known picture, which Palomino called his "most illustrious work," is the monumental *Las Meninas* (*The Maids*) (**figure 19.10**). It is set inside the palace, in a room filled with paintings, and depicts the artist at work on a huge canvas, surrounded by members of the court. The central figure is the infanta, the five-year-old Margherita, daughter of the king and his Austrian queen. Attending her are two young maids (*meninas*) and an elderly couple by the wall. A dwarf, a dog, and a midget occupy the lower right; the tapestry master is silhouetted in the doorway; and the king and queen are visible in the mirror on the back wall.

A characteristic of the Baroque in Velázquez's use of space is its unclassical asymmetry. Here the right wall is visible but the left is obscured by the large canvas. Highlights of reds on the costumes, sharp contrasts of light and dark, and the diagonal poses of the figures are typical Baroque features. They are depicted by Velázquez with a fluid brushstroke that emphasizes texture. The spatial complexity includes the ambiguous position of the king and queen, and the iconography has an autobiographical subtext.

Consider

Las Meninas: Autobiography as Iconography

In Spain, a court artist had to be a courtier as well as an artist, and competition for court commissions was fierce. By including his self-portrait in *Las Meninas*, Velázquez asserts the importance of his position at court and his role as court painter.

Two competing themes reinforce the autobiographical meaning of Las Meninas: the artist's social and professional ambition on the one hand, and his warning against the dangers of unrealistic ambition on the other. The former is evident in Velázquez's presence among the highest levels of the Spanish court. He holds up a palette (**figure 19.11**) containing the same colors used in the painting, which identifies him as its creator. He is also the tallest figure, rising above even the reflected king and queen.

Because they worked with their hands, Spanish painters were considered artisans rather than artists in the modern sense of the term. Velázquez wanted painting elevated to the status of a Liberal Art and believed that, as in Italy, artists should rank with intellectuals and gentlemen rather than with craftsmen. As for his personal status, Velázquez aspired to membership of the noble Order of Santiago, an honor he received only in 1659. Since he completed *Las Meninas* in 1656, but is shown wearing the Order's red cross on his tunic, he must have added it later.

In the darkened, barely visible, paintings on the back wall, Velázquez alludes to the dangers of ambition by depicting Greek myths in which mortals challenge the gods and suffer dire consequences. One of these represents the Fable of Arachne, the story of the mortal girl Arachne, who challenged Athena to a weaving contest. As a goddess of weaving and wisdom, Athena advised Arachne to reconsider, but the girl refused. Seeing that Arachne's skill rivaled her own, Athena took revenge by turning Arachne into a spider— *arachne* is the Greek word for "spider" (cf. the English word "arachnid"). As a spider, Arachne was destined to spin webs, but lost her human ability to create works of art.

The other picture on the back wall represents the Flaying of Marsyas, in which a flute-playing satyr (part-man, part-goat) challenges the sun god, Apollo, to a musical contest. Apollo plays the lyre and wins the contest, whereupon he punishes Marsyas by having him flayed upside down. In that myth, the punishment symbolizes the unnatural, "upside-down" situation in which a lesser, subhuman creature believes himself capable of defeating a superior one (in this case, a powerful god).

19.11 Detail of Velázquez's palette in 19.10.

French Baroque

In seventeenth-century France, both the arts and the state were dominated by the person of the king. Louis XIV (ruled 1643–1715), called the Sun King (*Le Roi Soleil*), is shown in all his solar splendor in Hyacinthe Rigaud's (1659–1743) portrait of 1701 (**figure 19.12**). The curtains part to reveal the king, wrapped in a royal blue robe decorated with gold *fleurs-de-lys* (symbols of French royalty) and highlighted by the white ermine and silk stockings. Louis stands on a platform and wears the elevated shoes that he himself designed to increase his height. His image as the embodiment of the state, reflected in his famous declaration "*L'état, c'est moi*" ("I am the state"), is shown by the huge column, an architectural metaphor of the king as the supporting element of France. Rigaud's portrait well conveys Louis's assertion: "I was king and Born to Be One."[5]

The enormous scale of Louis XIV's palace at Versailles, southwest of Paris, cannot be grasped in a single photograph. But the view in **figure 19.13** gives some idea of the vast gardens lined with statues, the neatly manicured lawns, and the grandeur of the architecture. The gilded fountain visible in the foreground is the Apollo Fountain, in which Apollo seems to rise from the water with his horse-drawn chariot to begin his daily journey across the sky. This is but one example of Louis XIV's identification with the Greek sun god, reflected in his epithet—Sun King.

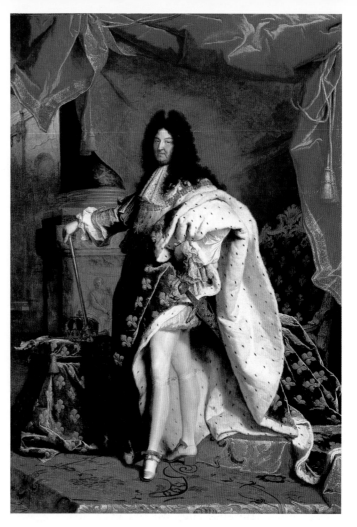

19.12 Hyacinthe Rigaud, *Portrait of Louis XIV*, 1701. Oil on canvas, 9 ft. 1 in. x 6 ft. 4 1/8 in. Louvre, Paris.

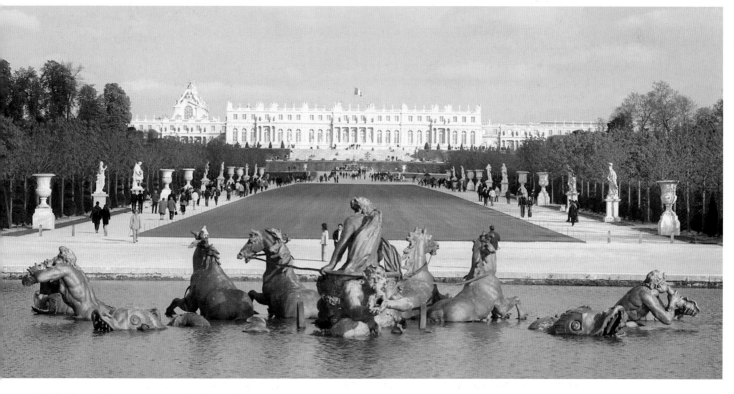

19.13 View of Versailles from the Grand Canal with the Apollo Fountain.

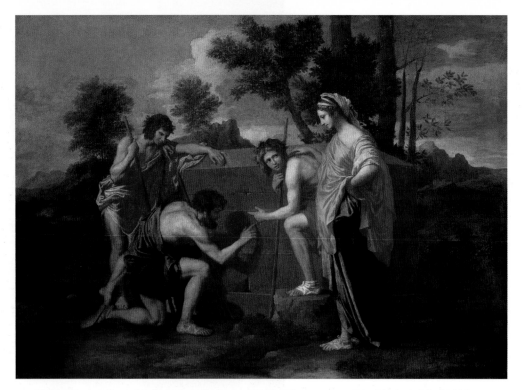

19.14 Nicolas Poussin, *Et in Arcadia Ego*, c. 1640. Oil on canvas, 2 ft. 9 ½ in. x 3 ft. 11 ½ in. Louvre, Paris.

> Painting is the imitation of human actions [and] the Queen of the arts. ... Colors in a painting are a snare to persuade the eye, like the charm of the verse in poetry.
>
> Nicolas Poussin, artist (1594–1665)

A more Classical form of French Baroque characterizes the style of Nicolas Poussin (1594–1665), who declined to work at Versailles because he did not like its political intrigues. He lived in Rome and many of his paintings were inspired by Greek and Roman myth and history. *The Arcadian Shepherds*, also called *Et in Arcadia Ego* (**figure 19.14**) is set in the idyllic pastoral setting of Arcadia, where life is peaceful and rural.

Three shepherds, hitherto unaware that death exists, come upon a tombstone inscribed with the words *Et in Arcadia Ego* ("I, too, lived in Arcadia"). This, like the inscription above Masaccio's skeleton in the *Trinity* (see p. 373), is a warning that death is inevitable. In Poussin's painting, the reality of death comes as a surprise to the shepherds, who react with astonishment. One traces the text with his hand as his shadow falls ominously over the tomb. The statuesque woman at the right is probably Clio, the Greek muse of history; she stands for the relentless march of time. Time, Poussin seems to be saying, is the only sure thing; human life is fleeting. Despite the Classical quality of the figures and their costume, the textured lights and darks in the sky, the somber mood, and the animated gestures are typical of Baroque drama.

Poussin defined painting as the imitation of nature, and, like Leonardo (see Chapter 5), compared painting with poetry.

Baroque in Northern Europe

In Catholic Flanders, which had political ties to Spain, the most important and most prolific painter was Peter Paul Rubens (1577–1640). He spoke several languages, traveled in Italy, and worked for the Spanish court, the French court, the Church, and private patrons. A draughtsman of great skill, Rubens was famous for his drawings and paintings of animals, portraits, and fleshy figures. In *The Rape of the Daughters of Leucippus* (**figure 19.15**), Rubens depicts a moment of typical Baroque-style violence. The foreground is filled with two men abducting two women, a pair of powerful horses, and two Cupids engaged in a fierce struggle. Rubens' taste for voluptuous women with rippling, dimpled flesh and for rich textures is abundantly clear in this painting. Enhancing the violence are the repeated diagonals and S-curves, and the close-up view of the struggling figures.

Iconographically, Rubens combined myth with politics. The men are Castor and Pollux (called the Dioscuri), twin sons of Zeus who abducted the daughters of King Leucippus. Politically, the picture has been interpreted as a metaphor for the marriages of Louis XIII of France (engaged to the sister of Philip IV of Spain) and Philip (who was engaged to Louis' sister). Two powerful European kings were thus engaged to royal sisters, which made the kings future brothers-in-law. Implicitly, therefore, Louis and Philip were related by Rubens to the Greek gods, making the painting a justification for absolute monarchy and endowing the kings with sexual entitlement as well as with divine right.

Rubens had great respect for the Classical tradition and he believed that artists should study both the form and content of ancient art. On the imitation of Greek and Roman statues, he wrote:

… in order to attain the highest perfection in painting, it is necessary to understand the antiques, nay, to be so thoroughly possessed of this knowledge, that it may diffuse itself everywhere.[6]

In Protestant Holland, the Baroque style appealed to the prosperous middle-class bourgeoisie. Church patronage was rare, and most patrons were private individuals or professional groups. Rembrandt van Rijn (1606–1669) was born in Leiden, but spent most of his career in Amsterdam. His *Anatomy Lesson of Dr. Tulp* (**figure 19.16**), especially the background, is composed of dark colors, which suggests the influence of Caravaggio's tenebrism. Characteristic of Rembrandt is the thickly applied paint, the focus on the face and hands, the areas of shine on metal surfaces, and the Baroque diagonals.

This work is a group portrait that reflects the expansion of empirical science in the seventeenth century. Seven physicians are observing the dissection of an arm. The cadaver is dramatically highlighted in a Baroque diagonal of light and the blood vessels of the arm are rendered in a pattern of rich reds and yellows. The space occupied by

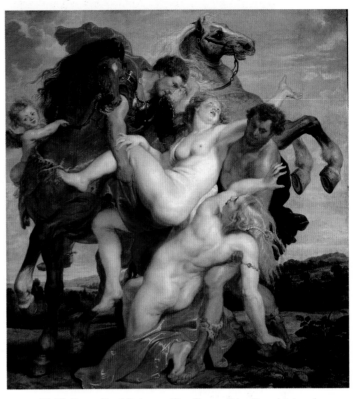

19.15 Peter Paul Rubens, *The Rape of the Daughters of Leucippus*, c. 1618. Oil on canvas, 7 ft. 3 in. x 6 ft. 10 in. Alte Pinakothek, Munich.

the doctors is ambiguous, as is the object of their gazes; some appear to be staring off into space rather than listening to the lecture or observing the demonstration.

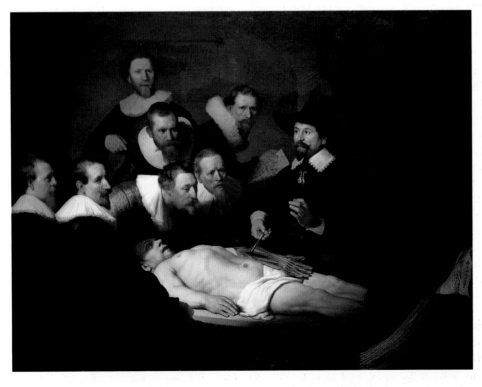

19.16 Rembrandt van Rijn, *Anatomy Lesson of Dr. Tulp*, 1632. Oil on canvas, 5 ft. 3 ³/₄ in. x 7 ft. ¹/₄ in. Royal Cabinet of Paintings, Mauritshaus, The Hague.

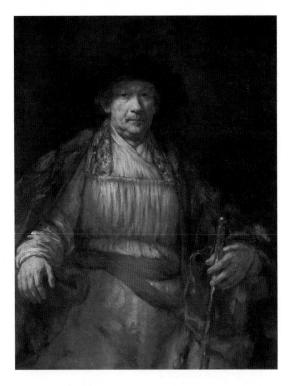

19.17 Rembrandt van Rijn, *Self-portrait*, 1658. Oil on canvas, 4 ft. 4 ³/₄ in. x 3 ft. 4 ³/₈ in. The Frick Collection, New York.

Rembrandt, like Velázquez, was a genius at rendering character, which made him the most sought-after portrait painter in Amsterdam. In addition to portraits of others, he produced a life-long series of self-portraits, documenting his passage from youth to old age. In these he records the effects of time and of his own changing fortunes. At the age of fifty-two, he painted the self-portrait

in **figure 19.17**, which shows him as an imposing, pyramidal figure painted in thick impasto golds and oranges with a red sash and a heavy, dark cloak. But the deep, black, introspective eyes avoid the viewer's gaze and the wistful expression seems to hint at the financial and emotional setbacks of Rembrandt's later years. He accentuates his age in the shaded areas of the face—especially the furrowed brow, sagging cheeks and chin, and creases around the eyes.

Another subject that became popular in seventeenth-century Dutch painting was landscape. Land was (and still is) very much part of Dutch consciousness, since Holland is below sea-level and owes its survival to an ingenious system of dikes. Dutch painters reflected the national interest in land by turning their attention to landscape. In *The Windmill at Wijk bij Duurstede* (**figure 19.18**), Jacob van Ruisdael (c. 1628–1682) monumentalizes the windmill, which towers over the flat Dutch landscape and was important to the Dutch economy. The diagonal pier juts into the sea, and the atmospheric clouds, darkening at the top of the picture, allude to the constant threat to Holland from the elements. There is also a suggestion of wind, which is necessary to turn the blades of the mill and to propel the sailboats, in the slim whitecaps approaching the shore. Nearly lost in the landscape are three small women formally echoing the vertical pilings and also acting as a reminder of the Dutch ability to control their land.

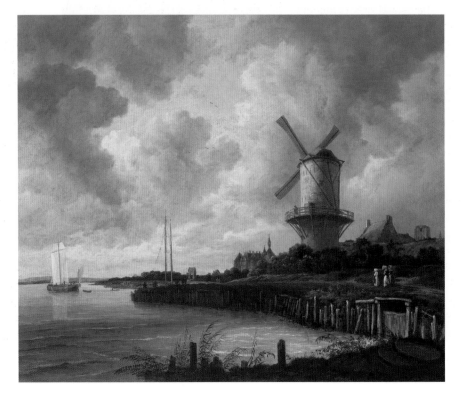

19.18 Jacob van Ruisdael, *The Windmill at Wijk bij Duurstede* c.1670. Oil on canvas, 2 ft. 8 ³/₄ in. x 3 ft. 3 ³/₄ in. Rijksmuseum, Amsterdam.

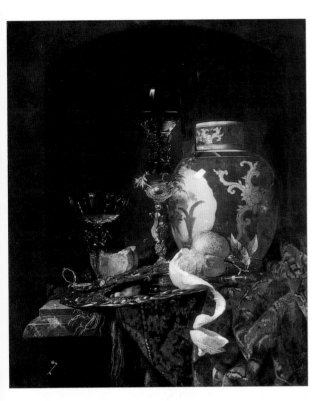

19.19 Willem Kalf, *Still Life with Chinese Porcelain*, 1669. Oil on canvas, 30 x 25 ¾ in. Indianapolis Museum of Art. Gift of Mrs. W. James Fesler in memory of Daniel W. and Elizabeth C. Marmon.

In addition to exploring the planet Earth, seventeenth-century scientists studied the stars. Made more empirical by the development of lenses, especially in Holland, astronomy began to supplant astrology. Johannes Vermeer (1632–1675) lived and worked in the small Dutch town of Delft. He painted mainly interior scenes, though the presence of the outside world is usually implicit in the iconography. In *The Astronomer* (**figure 19.20**), Vermeer shows the scientist focused on a celestial globe and an open book highlighted by intense white light. The window, as well as the globe, makes the outside world present in the enclosed room. In addition, the artist uses the device of a picture-within-the-picture to convey the past. The painting on the wall represents the pharaoh's daughter finding Moses in the bulrushes. This is a biblical allusion evoking the vast time span of human history, just as the globe is a reminder of the vastness of the universe.

Vermeer's signature pinpoints of light create a jewellike sparkle on different textures. This unique feature of his style intensifies the quiet calm of the room. The asymmetry and the diagonals—the chair, table, wall, and the figure—draw us into the space and invite us to identify with the astronomer's gaze.

The genre of still life also became popular in seventeenth-century Holland. Willem Kalf's (1619–1693) *Still Life with Chinese Porcelain* (**figure 19.19**) shows a wealth of objects popular with bourgeois patrons. They stand out, highlighted in light against a dark background reflecting the continuing influence of Caravaggio. Note how the Baroque tilt of the platter and the spiraling curves of the lemon peel impart a sense of spatial instability to the objects. The Baroque interest in textural variety is evident in the glass, silver, marble, and other materials. Kalf has also assembled a number of imported objects that allude to the international character of Dutch commerce. Lemons and peaches were grown in warm Mediterranean climates, while the carpet came from Turkey. The blue and white Chinese Ming vase was imported from Asia, where Holland had established the Dutch East India company early in the century.

The watch, a traditional symbol of time and the transience of life, was adopted from religious iconography prevalent in the Middle Ages and Renaissance. Its message, like the inscriptions in *The Arcadian Shepherds* and Masaccio's *Trinity*, is that life is fleeting and death inevitable. Reinforcing this theme are the peeled lemon and wrinkled peach, indicating that fruit, like life, should be enjoyed before it begins to decay.

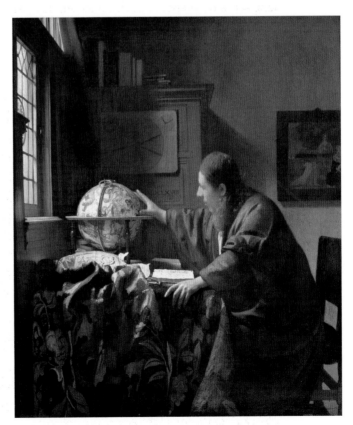

19.20 Johannes Vermeer, *The Astronomer*, c. 1668. Oil on canvas, 20 x 18 ¼ in. Louvre, Paris.

Tracy Chevalier and Vermeer

Tracy Chevalier is an author of historical novels. She was inspired to write *Girl with a Pearl Earring* by Vermeer's painting of the same title (**figure 19.21**). For years she had a poster of the painting on her wall, and over time became increasingly absorbed by it: "At first I thought it was simply a beautiful painting that uses color and light very well. But after a while I began to focus more on her expression. I was struck by the different moods she portrays, and the contradiction in her face. Is she happy or sad? I was never sure. I'm still not sure! I think it's remarkable that Vermeer managed to capture a combination of different emotions in one pose."

Chevalier's idea for the novel crystallized once she began to think about the nature of the relationship between painter and subject: "It was the story behind her look that caught my imagination. I wondered why she is looking at him in that way and what it was that Vermeer did to her to get her to have that mixed-up expression. So the painting became for me not a portrait of a person but of the relationship between the painter and the model. Then I discovered that nothing is known about the model—who she was, what her relationship to Vermeer was—and I felt free to make up her story.

I decided immediately that she would be a maid in his house. There is an intimacy in her look that made me feel she knows him well. Art historians have suggested she is his eldest daughter, but I feel her look is too sexualized to be how a father would portray his daughter. (In Dutch painting, an open mouth was meant to suggest sexual availability.) So if she is a maid, what is she doing wearing a pearl she couldn't possibly own? Whose could it be? Well, we know that Vermeer's wife's clothing features in many of his paintings, worn by different women, so clearly her things were lent to models; perhaps the pearls are here. And how would a harassed, perpetually pregnant housewife (Vermeer had 11 children) feel about this beautiful girl spending hours alone with her husband, and wearing her jewels? There's your drama, all interpolated from this one simple painting."

Further adding to the image's mystery was its dark background, different from most of Vermeer's other paintings of single figures, which usually inhabit a domestic setting. "Many 17th-century Dutch paintings go heavy on conventional symbolism, so that if a woman is reading a letter with a painting of a ship behind her, we know she's reading a love letter and her lover is far away. However, this painting is entirely pared down of all accoutrements."

Vermeer did employ such symbolism in his work, but only comparatively lightly, and as Chevalier points out, "X-rays of some of his paintings have revealed symbolic objects he's painted over to make the paintings less prescriptive and more open to interpretation. *Girl with a Pearl Earring* takes this to an extreme, stripping away all context that might help with meaning so that we have to focus, as Vermeer did, on her gaze."

For Chevalier, the most difficult part about translating Vermeer's artistic process into writing was learning, from Vermeer, that: "Less Is More. He tightened his focus to the corner of one room, and stripped away the unnecessary. I tried to do that with my writing, making it plain and narrowly focussed, trying not to interpret for the reader. Vermeer leaves a lot of room in his work for viewers to ponder; I tried too to leave gaps for the reader to fill in. It is always tempting to explain things, tie up loose ends; I had to resist that impulse."

Considering how confidently Chevalier describes Vermeer's materials, it was surprising to learn that she knew nothing about painting techniques before she began researching the book. She describes how she felt at the onset: "Starting at the bottom of a very long hill...I took a beginning painting class, and was awful at it, but at least I came to understand just how hard it is to do!"

As far as Chevalier is concerned, a key difference between Vermeer's work and that of his contemporaries is: "... his probable use of a *camera obscura*. The *camera obscura* concentrates colour and light and creates a tight focus, making the image more intense. In effect he cuts his subjects off from their

MEANING

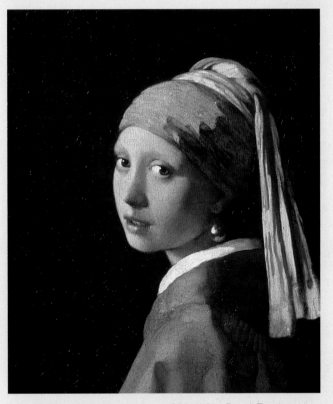

19.21 Johannes Vermeer, *Girl with a Pearl Earring*, c. 1665. Oil on canvas. 17 ¾ x 15 ¾ in. Royal Cabinet of Paintings, Mauritshuis, The Hague.

social context and creates the impression of great importance in the subject. I was interested at a recent exhibition of his work to see the shift from his early work, which uses conventional subjects for paintings such as mythological or biblical stories, to the middle to later work which is less cluttered and treats daily life with great reverence. There is a theory that he started using the *camera obscura* about the time of this change."

In Chevalier's novel, Griet, the fictional character created from the subject of Vermeer's painting, has a heightened awareness of color and form, combined with an "eye" for painting. To Chevalier: "The model certainly looks as though she has some knowledge and awareness. Vermeer painted very slowly and it probably took two to three months to complete this painting, so the model would have been exposed to Vermeer and his painting techniques in the studio for some time. In that time she could

have learnt quite a lot about painting and the process of creating art."

While *Girl with a Pearl Earring* is the principal source of inspiration for Chevalier's novel, she also drew from other works by the artist in order to write her story: "The general feel of the house and rooms are inspired by his paintings, and some of the characters in the novel are loosely based on people in his other work." Chevalier also looked to other contemporaneous Dutch works in her research, in order to "get a feel for daily life. Dutch paintings of that time are a great social resource, where a painting really is worth a thousand words. If I wanted to describe a church interior, or a fish market, for instance, I would look at a bunch of paintings of church interiors or fish markets and describe what I saw. It was just as accurate, and a lot more fun, than reading dusty old tomes!"

Tracy Chevalier in conversation February 22, 2006.

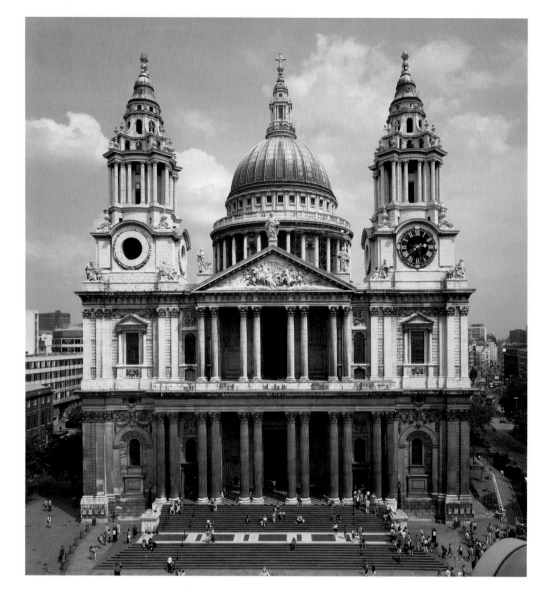

England: Saint Paul's Cathedral

The adaptability of Baroque style made it accessible to new forms. In England, innovative formal combinations characterize the architecture of Christopher Wren (1632–1725), an astronomer and mathematician. After the Great Fire that struck London in 1666 and burned for ten days, destroying a large area of the city, Wren was appointed Surveyor-General of the King's Works. He was commissioned to rebuild London's churches, hundreds of which had burned down. His major work was England's first Protestant cathedral, Saint Paul's (**figure 19.22**).

This monumental expression of English Baroque combines the longitudinal Latin-Cross plan with features of Gothic, Renaissance, Roman, and Greek architecture. The façade consists of a two-story Greek temple front with Corinthian columns and a crowning pediment. Round arched windows occupy the ground floor and frame its long horizontal. On the second story, pilasters at either side of a pedimented window can be read horizontally as framing the upper temple front and vertically as supporting the clock towers. These rise upward as in Gothic cathedrals, although the impression of their vertical thrust is reduced by the broader central space.

The concave and convex columned walls supporting the lanterns are reminiscent of Borromini's Sant'Ivo (see figure 19.4), but the lanterns themselves are topped with distinctive gilded pineapples. The central dome, inspired by Roman and Renaissance buildings, rests on a round drum with an outer wall of columns, and a **balustrade** over the entablature. Wren's juxtaposition of different styles in Saint Paul's, as well as his use of the curved wall and new details (such as the pineapple), is characteristic of the increasing variety of Baroque style.

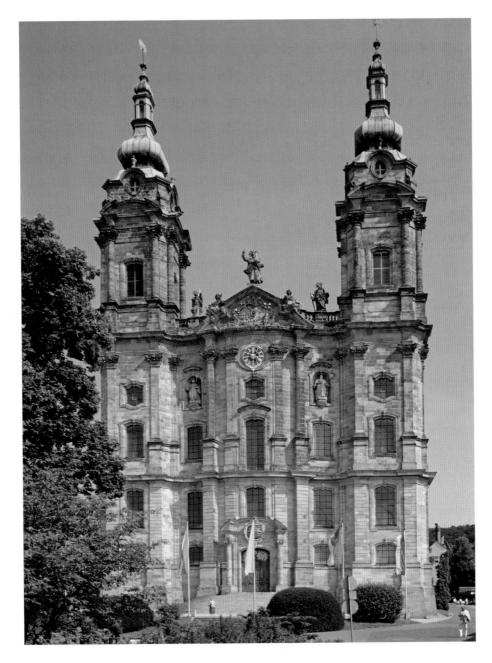

19.23 Johann Balthasar Neumann, Vierzehnheiligen Pilgrimage Church, Franconia, Germany, 1742–1772.

The Rococo Style

In the eighteenth century, after the death of Louis XIV in 1715, the center of art patronage in France shifted from Versailles to Paris. There, upper-class, well-educated women presided over *salons* in private houses, where intellectuals gathered for evenings of social and intellectual conversation. The style that evolved in this setting is Rococo, which was a more ornate version of Baroque. The term itself is thought to be a conflation of two French words, *rocaille* (pebble) and *coquille* (seashell), conveying the Rococo taste for delicate, twirling, organic forms. Rococo painters were drawn to frivolous, aristocratic subject matter, pastel colors, and silks and laces. In Rococo architecture, there is an abundance of fussy detail and gilt and stucco trim. Although the style began in France, it became most popular in Germany.

If we compare the Vierzehnheiligen Pilgrimage Church (**figure 19.23**) by Johann Balthasar Neumann (1687–1753), in Franconia (Germany), with Saint Paul's Cathedral, we see how ornate Rococo style is compared with Baroque. Neumann has eliminated the Classical elements of the English cathedral, narrowed the central space, and extended the vertical thrust of the towers. The surface of the Vierzehnheiligen is animated by a medley of architectural detail and its outline by projecting elements, fussy towers, and rooftop statues. The center of the façade is convex, and seems to be advancing, as if able to move independently away from the wall. Built on a hill, like many Gothic cathedrals, the Vierzehnheiligen is a commanding presence.

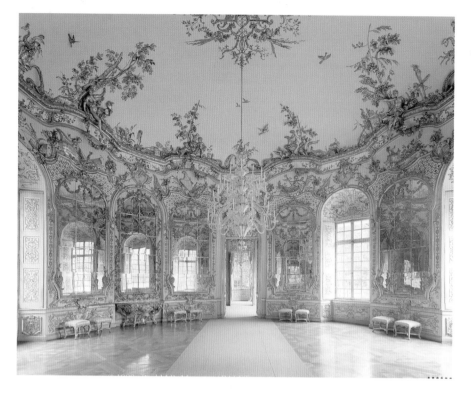

The quintessential Rococo interior in Germany is the hunting lodge known as the Amalienburg (**figure 19.24**). It was built near Munich for Amelia, wife of the Elector of Bavaria, and named after her. Compared to grand, expansive Baroque royal palaces such as Versailles, with their political iconography, the Amalienburg is small in scale and intimate. In the Mirrors Rooms, the walls seem to dissolve into swirls of silver filigree and stucco foliage. Branches, flowers, and birds extend the elaborate design upward to the ceiling, and the huge chandelier, like the windows and mirrors, multiplies the reflections of light.

The best of the Rococo painters, Antoine Watteau (1684–1721), was born in Flanders and worked mainly in France. He was influenced by the rich colors of Rubens, but the proportions of his figures are slim and delicate. Although Watteau shared the Rococo taste for aristocratic frivolity, there is often a serious theme underlying the surface levity of his paintings.

Watteau's acknowledged masterpiece, the *Return from Cythera* (**figure 19.25**), depicts the island of Cythera (another name for Venus), where lovers wearing pastel-colored silks dally in an idyllic setting. Powder-pink Cupids flit over the sea and encourage romance among the mortals. At the left, couples board a boat to return to everyday life from their island of pleasure. The statue of Venus draped in flowers at the right exemplifies a recurring theme in Watteau's paintings—statues signify what lasts, whereas human pleasures are transitory.

Watteau's eighteenth-century biographer, the Comte de Caylus, had some reservations about the artist. He found his style "infinitely mannered." But the count did admire Watteau's "taste and effect," and described his color as:

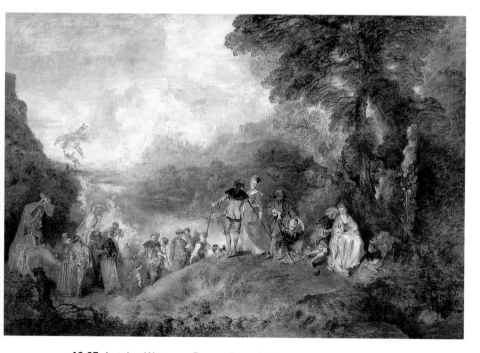

19.25 Antoine Watteau, *Return from Cythera*, 1717. Oil on canvas, 4 ft. 2 3/4 in. x 6 ft. 4 3/8 in. Louvre, Paris.

19.26 Élisabeth Vigée-Lebrun, *Marie Antoinette à la Rose*, 1783. Oil on canvas, 3 ft. 8 ½ in. x 2 ft. 10 ¼ in. Châteaux de Versailles et de Trianon.

… very exact in the rendering of stuffs … he [Watteau] hardly ever painted other stuffs than silk, which falls always in small folds…. His choice of color was good and was never out of harmony with his tonality. Finally, his delicate touch infused a life and piquancy into everything he painted.[7]

Élisabeth Vigée-Lebrun (1755–1842), another Rococo painter, specialized in aristocratic and royal portraiture. From the time of her father's death, when she was only fifteen, Vigée's popularity as a painter made it possible for her to support her family. She produced a number of portraits of Marie Antoinette (1755–1793), the unpopular Austrian queen of Louis XVI of France (ruled 1774–1792). *Marie Antoinette à la Rose* exemplifies Vigée's style (**figure 19.26**). Decked out in a powdered wig, feathered hat, pearl necklace, and lace-trimmed blue dress that matches her eyes, the queen displays a pink rose and runs her fingers over its silk ribbon. The queen's self-absorption

and concern for her own person is consistent with her notorious lack of attention to the needs of her subjects.

In her memoirs, Vigée describes her impression of Marie Antoinette's splendid complexion, which she captures in her portrait:

I have never seen one so brilliant, and brilliant is the word, for her skin was so transparent that it bore no umber in the painting. Neither could I render the real effect of it as I wished. I had no colors to paint such freshness, such delicate tints, which were hers alone, and which I had never seen in any other woman.[8]

When the French Revolution erupted in 1789, Vigée was exiled from France. She took the opportunity to travel throughout Europe, including a six-year stay in Russia. There she was welcomed by Catherine II (Catherine the Great; ruled 1762–1796) and commissioned to paint her portrait, but the tsarina died before Vigée could begin work.

The Neoclassical Style

The abuses of the French king and other absolute monarchs angered their subjects. Inspired by the republics of Athens and Rome, some political thinkers conceived the notion that rulers ruled only with the consent of the governed and not by divine right. This idea was not fulfilled without a deadly struggle. In France, the revolution officially began in 1789 when mobs attacked the Bastille (a prison in Paris), an event celebrated annually on July 14, which is known as Bastille Day.

French revolutionary sympathizers who were active in the arts looked to the Classical style as one that matched their ideology. The leading painter associated with the revolution in France, Jacques-Louis David (1748–1825), worked in the Neoclassical style. He revived the relative clarity of form and space, clear edges, Greek and Roman costume, and subject matter from antiquity. His *Lictors Returning to Brutus the Bodies of his Sons* (figure 19.27) depicts an event from Roman history. It embodies the steadfast, stoic commitment to liberty of Junius Brutus, who lived in the early sixth century B.C. He joined the Romans in their rebellion against kings, overthrowing Tarquin the Proud, the last of the Etruscan kings and the man who raped Lucretia (see figure 19.7).

Choosing political principle over family loyalty, Brutus ordered the execution of his own sons for treason when they sided with the monarchists. In this painting, they are carried home on a stretcher for burial. At the lower left, Brutus sits in darkness, literally turning his back on his family. Echoing his stoic resolve are the sturdy Doric columns behind the more emotional women. They are shown with Classical profiles and wear colorful Roman dress, but their histrionic gestures are more Baroque than Classical. A knitting basket prominently displayed on the bright red tablecloth alludes to their role in the household, in contrast to the political stance taken by Brutus.

19.27 Jacques-Louis David, *The Lictors Returning to Brutus the Bodies of his Sons*, 1789. Oil on canvas, 10 ft. 7 ⅛ in. x 13 ft. 10 ⅛ in. Louvre, Paris.

In 1791, David exhibited a large preparatory drawing filled with lifesize figures for a painting he would never complete—*The Oath of the Tennis Court* (**figure 19.28**). Commissioned by a revolutionary faction, David's study records a meeting of June 20, 1789, when deputies of the newly formed National Assembly met at an indoor tennis court in Versailles. They resolved not to leave until they had agreed on the provisions of a new constitution.

The revolutionary fervor of the crowd, united in their commitment to liberty, is shown by the repeated gestures. All walks of life are represented to show the ideal of every citizen participating in governance. The Assembly's president stands on an elevated platform in the center of the tennis court; he raises his right arm like the *Augustus of Prima Porta* addressing his troops (see figure 16.16). Below the president, three clergymen embrace to show that the Church supports the cause of liberty. The light streams in through the windows, symbolic of the notion that intellect, rather than divine right, is the source of the light in Enlightenment.

In 1793, two years after the Oath of the Tennis Court was taken, a reign of terror swept France. Thousands of aristocrats and suspected royal sympathizers were beheaded by the guillotine. That same year, Marie Antoinette and Louis XVI were captured trying to escape from France. They were imprisoned and publicly guillotined in the Place de la Concorde, in Paris.

Augustus of Prima Porta.
figure 16.16, page 329

> Each one of us is accountable to our country for the talents that we have receiv'd from nature;... The true patriot must eagerly seize every opportunity to enlighten his fellow citizens, and ceaselessly proffer the sublime features of heroism and virtue to their eyes.
>
> Jacques-Louis David, artist (1748–1825)

19.28 Jacques-Louis David, *Drawing for The Oath of the Tennis Court*, 1791. Graphite, ink, sepia, with white on paper, 2 ft. 1 ½ in. x 3 ft. 5 ⅓ in. Château de Versailles, Versailles, France.

European Colonization of North and Central America in the seventeenth century.

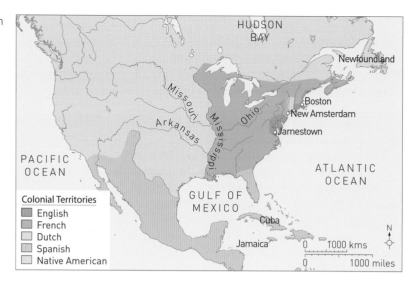

The Federal Style

In 1776, with the Declaration of Independence, the American colonies rebelled against the English king George III. Led by General George Washington, the colonists defeated the British and drew up a new constitution, which was signed in 1787. Washington became the first United States president in 1789, the same year that the French stormed the Bastille.

19.29 Thomas Jefferson, State Capitol, Richmond, Virginia, 1785–1789.

The third president of the United States was an architect, statesman, author, and inventor. Thomas Jefferson (1743–1826) sought to create a style of architecture that would embody the ideals of American democracy. While ambassador to France, he had studied Roman ruins and he also became acquainted with Neoclassicism and collected Neoclassical sculpture. In Neoclassicism, Jefferson found what he was seeking and on it he based the American Federal Style.

For his home state of Virginia, Jefferson designed the capitol building (**figure 19.29**) inspired by ancient Greek and Roman temples. He added an Ionic temple front of six columns to the rectangular building, but left the pediment without sculptural decoration. Its Classical clarity and symmetry contribute to the sense of security, while its location at the top of a hill overlooking Richmond imbues the building with authority.

The Federal style was widely adopted for official buildings, including the U.S. Capitol in Washington, and countless courthouses and banks. People like to feel that their money, like their government, is secure and will remain so. In 1795, a Philadelphia merchant, Samuel Blodget, Jr. (1757–1814), designed the First Bank of the United States (**figure 19.30**). Like Jefferson, Blodget used Classical elements to achieve a sense of tradition combined with a restrained but imposing stability. In addition to strict symmetry, the bank has a projecting Corinthian porch with fluted columns supporting an entablature. The pediment is decorated with relief sculpture, not of the Greek gods, but of the American bald eagle carrying a cornucopia and an olive branch. The message of the pediment sculpture is clear—the United States is a stable democracy, blessed with prosperity and peace.

19.30 Samuel Blodget, Jr., First Bank of the United States, Philadelphia, Pennsylvania, 1795–1797. Engraving by Russell Birch, 1799.

The French and American Revolutions changed the course of Western history and laid the foundation for radical social and economic changes during the nineteenth century. The next major revolution in the West, the Industrial Revolution, increased the power of manufacturers and led to new class conflicts. The arts of the nineteenth century developed along with the changing times. Neoclassicism continued for a while, but soon evolved into a series of new styles, which we consider in Chapter 24.

— ◆ —

At this point, we interrupt our history of Western art and take a detour beyond the West to explore a few examples of non-Western art. Non-Western art styles became more and more familiar to the West with the expansion of travel and colonization. By the end of the nineteenth century, non-Western art had become a source of inspiration for the most innovative Western artists.

Chapter 19 Glossary

balustrade—series of balusters (upright pillars) supporting a railing

piazza—open public square in an urban space

tenebrism—use of dark in a painting as a background to highlighted forms; a style of painting practiced by Caravaggio and his followers

Art Beyond the West

At this point in our historical survey, we take a brief detour from the West to consider the arts of the Far East, Africa, and the Americas. East–West contacts were not new, for the Silk Roads—along which silk and other goods were brought from China to India, the Middle East, and Europe—had been traversed for centuries. The Silk Roads were also used by missionaries traveling in both directions, bringing Eastern religious ideas to the West and vice versa. Since antiquity, explorers had visited different parts of the world, bringing back tales of exotic lands and their customs. Centuries of invasions and migrations also carried artistic styles and iconographic themes across continents.

At the end of the fifteenth century, Christopher Columbus's discovery of the Americas unleashed waves of geographical etxploration. The Spanish conquered Mexico and Peru in the sixteenth century, and colonization of North America by the English, Dutch, and French—as well as the Spanish—began. From the seventeenth century, Africans were brought to Europe and the Americas to work as slaves. As we saw in the previous chapter, with the rise of a mercantile economy in Europe, trade between the Far East and Europe expanded. This led to colonization as well as to increasing cross-cultural influence in the arts.

The areas of the world covered in the next four chapters are geographically vast and culturally rich, and their history spans long periods of time. In our limited space, therefore, we can only skim the surface of their enormous contributions to world art. At this point in the Western narrative, however, we can see an increasing awareness of other cultures in the art of both East and West.

TIMELINE		HISTORICAL EVENTS	ART HISTORY	
	3000 BC	• Indus Valley Urbanization 3rd millennium B.C. • Aryan invaders from the Caucasus overran Indus Valley c. 1500 B.C. • Birth of the Buddha 563 B.C.	• Dancer from Harappa, c. 2300–1750 B.C. • *Bearded Man* Mohenjo-Daro c. 2300–1750 B.C. • Great Stupa at Sanchi begun 3rd century B.C.	3000 BC
	AD 0	• Hinduism and Buddhism spread to Southeast Asia c. 1st century • Greek Hellenistic influence in Gandhara 3rd-4th century • Khmer kingdom 9th century	• Golden Age of Buddhist art in India 320–640 • Ajanta cave paintings 462–500 • Mahabbarata sculptural reliefs, Mamallapuram 7th century • Temple of Borobudor, Java late 8th century	AD 0
	AD 1000	• Muslim invasions of northern India 10–13th century • Buddhism dies out in India c. 10th century • Islamic states in northern India and Hindu states in central and southern India from 1000	• Kandariya temple, Khajuraho, India c.1000 • Temple of Angkor Wat, Cambodia 12th century • Siva Nataraja 11–12th century	AD 1000
	AD 1500	• Mughal Dynasty unifies northern and central India late 16th and 17th centuries	• Shah Jahan, Taj Mahal 1631 • Miniature painting under Mughal imperial patronage	AD 1500

KEY TOPICS

The Indus Valley civilization
The art and architecture of Hinduism and Buddhism
Art in Southeast Asia: Indonesia and Cambodia
Mughal art in India

20

The Art of India and Southeast Asia

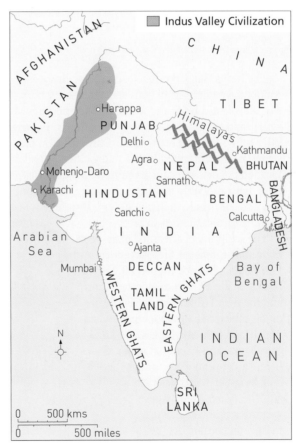

The Indian subcontinent.

India, located in South Asia, is large enough to be called a subcontinent (see map, right). It is bordered on the east by the Bay of Bengal, on the west by the Arabian Sea, and on the south by the Indian Ocean. Evidence of urbanization has been found as early as the third millennium B.C. in the Indus Valley, now part of Pakistan, which parallels the chronology of Mesopotamia (see Chapter 15). Hinduism and Buddhism, the two main religions of India, had a strong impact on its art and culture. The spread of Buddhism to Southeast Asia is also reflected in the arts of that region. In some areas, the persistence of Hinduism led to works of art that combine features of both religions.

Certain periods of Indian art were influenced by the expansion of Islam. The Muslim Mughal Dynasty, which flourished in the late sixteenth and seventeenth centuries, produced a lavish court style that attracted Hindu and Persian artists. Their work differed from traditional Islamic art in being figurative and narrative. The Mughal rulers also welcomed visitors from Western Europe and their artists absorbed elements of Baroque style and iconography.

Indus Valley Civilization

We begin our survey of India with the Indus Valley civilization, which flourished from around 2300 B.C. It had a writing system, which is preserved in inscriptions on square stamp seals, but has not yet been deciphered. Artisans worked the potter's wheel to make vessels, which were painted. Excavations in the Indus Valley indicate active commerce and trade; in addition to gold and silver, people wore jewelry made of lapis lazuli from Afghanistan, jade from China, and turquoise from Iran. Monumental jars were used for storage and there is evidence of metal tools.

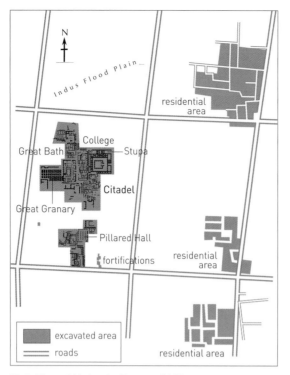

20.1 Plan of Mohenjo-Daro, c. 2300 B.C. Modern Pakistan.

The Indus Valley produced an urban culture with residential complexes of two- and three-story houses made of mud-brick and wood, public buildings of stone, and streets laid out in grid patterns. **Figure 20.1** shows the plan of Mohenjo-Daro, the best preserved of the excavated Indus Valley cities. It had a fortified citadel, indicating the need for defense; a huge bath probably for ritual cleansing; irrigation; and a sophisticated drainage system. But there is no evidence of temples or a palace.

The sculpture of a bearded man, possibly a priest, reflects Mesopotamian and East Asian influence (**figure 20.2**). The beard, made of vertical incised lines, and the trefoil (three-leaf clover) design on his robe recall Mesopotamian stylization. In addition, as in the *Gudea of Lagash* (see figure 15.9), one shoulder is bare—a convention for priests and kings in Mesopotamian art. The *Bearded Man* is also wearing a headband, which in later Indian art denotes high status. Like the *Gudea*, the figure from Mohenjo-Daro is compact, having

COMPARE

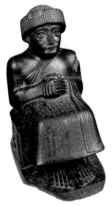

Gudea of Lagash.
figure 15.9, page 301

little open space, a large head and a short, thick neck. This creates a sense of monumentality despite its small size. What distinguishes the bearded figure from Mesopotamian styles, however, are the block-like proportions, large flat lips, slit eyes, and narrow forehead.

The larger, but less well-preserved, Indus Valley city of Harappa was laid out like Mohenjo-Daro; it had similar buildings and a thriving artistic tradition. The *Dancer* from Harappa (**figure 20.3**) indicates the presence of a contemporary style very different from that of the *Bearded Man*. Although in a fragmentary state, the *Dancer* reflects an interest in the nude that was unusual in the ancient world and its rhythmic pose is more lifelike than the stiff Mohenjo-Daro figure. The dancer's waist shifts slightly as the shoulders turn in one direction and the bent leg in another. Her pose replicates the later Indian **tribhanga** (three-bends) pose associated with sensuous movement. Assuming that the head was inserted into the hole in the neck, it could have turned in an additional direction. The slow, graceful motion of the body conveys the lifelike quality that the Indians call **prana** and that we see in Indian sculpture of a later period. This is the sense that the figure can expand and contract as if breathing and is therefore alive.

The Indus Valley seems to have been a stable culture for a relatively long period. By around 1500, Aryan invaders from the Caucasus (north of the Black Sea in modern Russia) overran the Indus Valley. They brought with them new methods of warfare, a hierarchical social organization that formed the basis of the Hindu caste system, and Sanskrit, the literary language of India.

20.3 *Dancer*, c. 2300–1750 B.C., from Harappa. Limestone, 3 7/8 in. high. National Museum of India, New Delhi.

20.2 *Bearded Man*, c. 2300–1750 B.C., from Mohenjo-Daro. Limestone, 7 in. high. National Museum of India, New Delhi.

Hinduism and Buddhism

India was home to two of the world's great religions: Hinduism and Buddhism. Today, these are the two predominant Far Eastern religions. Buddhism evolved from Hinduism, which is much older, but both conceived of the mythical world mountain, Meru, as the center of the universe.

Hinduism is a complex religion with many gods and numerous sects. Hindu deities can assume many forms and are believed to be present everywhere in nature. The main gods are Brahma the Creator; Vishnu, who dreamed the universe into existence (see p. 18); and Shiva, the dancer who both creates and destroys the world. The main goddess is Devi, a female warrior who embodies virtue and defends civilization.

Hinduism produced a rich literature, beginning with the early Aryan *Vedas*, which are hymns and instructions to priests on the conduct of rituals. The original *Vedas* are believed to have been told by Brahma to the sages, who in turn transmitted their message to others. The latest *Vedas* are the *Upanishads*, which were written down in the first millennium B.C. More philosophical than the earlier *Vedas*, the *Upanishads* explain the Hindu cycle of birth and rebirth in which all living creatures are imprisoned.

The life cycle formed the basis of the caste system that strictly maintains the Hindu social structure. According to the Hindu notion of *karma*, one's present life is determined by the way one's past life was lived. By the process of *samsara* (the transmigration of souls), one's soul moves from one life to another. People who lead a good life move up in the social hierarchy, at the top of which are the Brahmins (priests), who comprise the highest caste. One is finally freed from the life cycle on attaining *Nirvana* (a state of enlightenment in which bodily weaknesses are transcended and eternal harmony attained)—becoming one with *Brahmin*, the cosmic soul.

Buddhism developed in the sixth century B.C. It was based on the teachings of the prince of the Shakyamuni clan who came from Nepal. Born Siddhartha Gautama (563–483 B.C.), the young prince decided to leave his comfortable home and family and seek solutions to the world's suffering. At first he led an ascetic life, but, while meditating under a *bodhi* tree, Siddhartha found Enlightenment, and became the Buddha (the Enlightened One). This gave him the answer to his quest—namely, to live life according to a Middle Way. The Buddha's message comprised a cultural code of behavior—the Eightfold Path: right opinions, right aspirations, right speech, right conduct, right profession, right effort, right mindfulness, and right contemplation. Like Jesus, the Buddha challenged entrenched religious and social views (especially the caste system) and offered new hope of salvation for the masses. As a result, Buddhism, like Christianity, had widespread appeal.

The teachings of Buddhism are compiled in the *sutras*, which contain the Buddha's sermons and instructions to monks and nuns. Over time, several sects evolved, some strictly monastic and others dedicated to helping everyone attain *Nirvana*. An important figure in Buddhism is the *bodhisattva*—one who is enlightened, but who delays buddhahood in order to help others achieve it. In art, *bodhisattvas* are portrayed wearing royal garments (**figure 20.4**), as had the Buddha when he was Prince Siddhartha, although the Buddha himself is usually portrayed in monastic robes. The *bodhisattva* shown here wears flowing sashes, a necklace, and earrings. Scenes from the Buddha's life are depicted on the base of the statue.

20.4. Standing *bodhisattva*, 2nd century. Stone, 3 ft. 7 in. high. Museum of Fine Arts, Boston. Helen and Alice Colburn Fund.

Emperor Ashoka: From Hinduism to Buddhism

Ashoka (ruled 273–232 B.C.), the first Indian emperor to embrace Buddhism, was a member of the Maurya Dynasty founded in 321 B.C. He was drawn to the peaceful message of Buddhism and, like rulers in the West, he used monumental works for political and religious purposes. In India, Ashoka commissioned art to spread the Buddha's teachings throughout the subcontinent and also advocated Buddhism as a way of unifying the country under a single ruler.

Ashoka erected tall pillars, representing the World Axis, which were the architectural descendants of Vedic tree worship. On these pillars Ashoka inscribed messages to his people; he advocated nonviolence and moral persuasion rather than conquest, and he wanted missionaries to spread Buddhist ideas. Surmounting Ashoka's pillars were capitals carved in the form of symbolic animals. **Figure 20.5** illustrates a lion capital, a symbol of the Buddha, who was called the Lion of the Shakyamuni clan. Four lions, attached to each other behind the forelegs, face the four points of the compass, signifying that the Buddha's teachings extend to the four corners of the earth.

The lions are at once stylized (the manes and whiskers) and endowed with a sense of lifelike energy. Four animals—a horse, a bull (visible in this view), a lion, and an elephant (not visible)—move around the circular abacus. Below the front paws of each lion is a wheel—the Buddha's Wheel of the

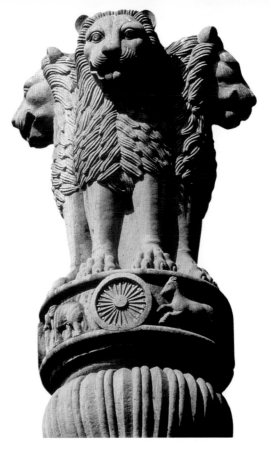

20.5 Replica of lion capital from an Ashoka pillar, 3rd century B.C., from Sarnath, Uttar Pradesh. Polished chunar sandstone, 7 ft. high. Museum of Archaeology, Sarnath, India.

Law (*Dharmachakra*). According to tradition, the Buddha set the Wheel of the Law in motion when he preached his first sermon in the Deer Park at Sarnath.

In addition to the pillars, Ashoka developed the **stupa** (burial mound) into a characteristic, monumental Indian structure. The best-known example is the Great Stupa at Sanchi, begun under Ashoka and later enlarged (**figures 20.6** and **20.7**). Stupas are symbolic structures, with cosmological meaning. They celebrate the last miracle of the Buddha's life—when he was cremated, his ashes sparkled like pearls.

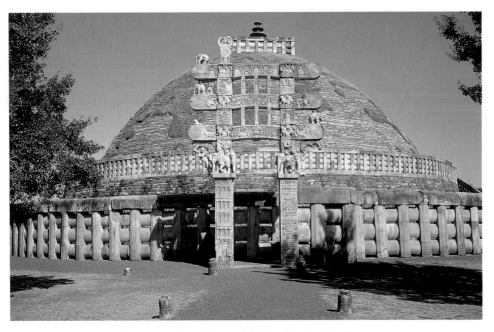

20.6 Great Sanchi Stupa, Madhya Pradesh, India, begun 3rd century B.C. Diameter c. 120 ft. .

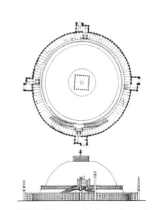

20.7 Plan and elevation of the Great Stupa at Sanchi.

The Stupa as a Cosmic Symbol

Buddhist texts refer to the miraculous radiance of the Buddha's ashes as the *Mahaparinirvana*. According to Buddhist tradition, the ashes were divided and buried in eight earth mounds (stupas). After Ashoka's conversion to Buddhism, he redivided the ashes into 64,000 additional stupas. We can see from the plan (figure 20.7) that the base of the stupa is a circle, and from the elevation that the building (**anda**) is a hemisphere. These forms conflate three ideas: the cosmic egg, the dome of heaven, and the mythical Mount Meru.

At the top of the stupa's dome, a small circular fence (**vedika**) surrounds a square railing (**harmika**). At the central point of the square stands a pillar (**yasti**). This, like Ashoka's pillars, represented the World Axis and was derived from pre-Buddhist nature worship when trees and burial mounds were surrounded by a wooden fence. The *yasti* supports a triple **chattra**, a pole with three parasol-shaped elements that symbolize the Buddha's royal status. Parasols, which were a royal prerogative in Asia, were placed directly over the Buddha's ashes as a way of symbolically protecting them from the sun.

Unlike Western buildings of worship, the stupa has no interior. Instead, railings circling the hemisphere guide the worshiper, who circumambulates (walks around) in a clockwise direction following the path of the sun. When worshipers proceed around the stupa, they make a symbolic spiritual journey that replicates Siddhartha's quest for enlightenment. The stone *vedika* at ground level, like the one on top of the dome, resembles earlier wooden fences.

At each of four points in the outer *vedika* there is a gate (**torana**) oriented to a cardinal point of the compass. The *toranas* consist of square pillars with elephant capitals supporting three architraves that terminate in scroll-shapes (**figure 20.8**). On either side of the elephants, swinging outward from a branch, is a **yakshi** (tree goddess). Her sensuous nudity is a sign of life and fertility, reflected in the abundant fruit of the mango tree.

She occupies the characteristic Indian *tribhanga* pose that we saw in the *Dancer* from Harappa (see p. 426).

The elaborate carvings on the gates depict events of the Buddha's previous lives (**jatakas**). But instead of showing him in human form, they show him in symbolic form. A horse, for example, might represent Siddhartha's departure from the palace, whereas his footprints protected by a parasol show that he has dismounted and walks through the world. The Buddha's life story is thus told by the traces he left behind, indicating his presence even in his absence. The eventual proliferation of Buddhas of the past, present, and future signifies that he is eternally present.

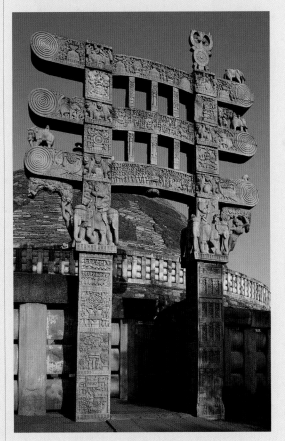

20.8 East *Torana*, Sanchi Stupa, 1st century B.C. 35 ft. high.

Buddhist Sculpture in India

Although not represented in anthropomorphic form at Sanchi, there is a vast amount of Indian sculpture showing the Buddha as a man. **Figure 20.9** illustrates the Buddha of the Future, holding his attribute—a water vessel—in his left hand. He raises his right hand in the gesture of reassurance that means "have no fear" and his slight smile denotes inner peace. He wears jewelry and a flowing

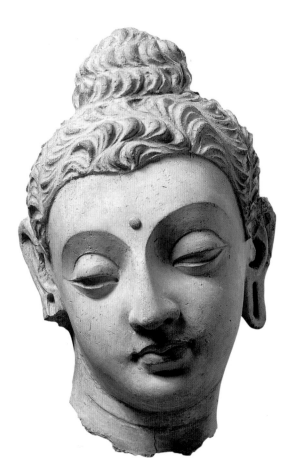

20.10 Head of Buddha, 3rd century A.D., from Gandhara. Lime composition, 16 ¹/₁₀ in. high. Victoria and Albert Museum, London.

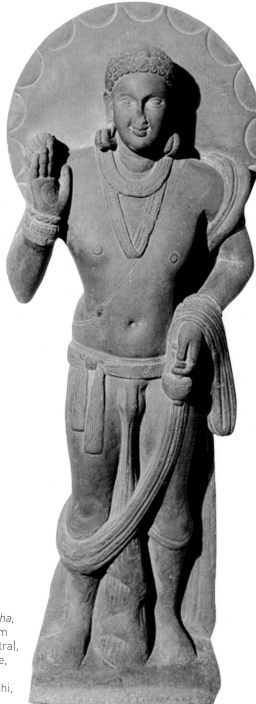

20.9 *Maitreya Buddha*, 2nd century A.D., from Ramnagar (Ahicchatra), India. Red sandstone, 26 in. high. National Museum of New Delhi, India.

scarf and a large halo frames his head and shoulders, relating heavenly light to enlightenment. The rounded face and fleshy surface of the body exude an air of *prana*, so that he seems to be alive and breathing.

Another, more Westernized type of Buddha image, influenced by Greek art, was produced in Gandhara, in the northwest. The exquisite head in **figure 20.10** shows the impact of Hellenistic style (see Chapter 16) following the conquests of Alexander the Great. Its proportions are slimmer than those of the Buddha of the Future; the sense of relaxation and the symmetry is closer to Greek Classical style. At the same time, the iconography is Buddhist, as is the sense of inner peace. There is a caste mark on the forehead, the elongated ear lobes denote the jewelry worn by Prince Siddhartha before he became the Buddha, and the conventional top-knot—*ushnisha*—crowns the head. The hair patterns, however, are clearly influenced by Greek styles.

Buddhist Painting in India: The Ajanta Caves

The Buddhist focus on meditation was part of its rich monastic tradition. Beginning in the late fourth century under the Gupta rulers (A.D. 320–640), there was a surge in artistic activity. Although the Gupta were Hindu, they patronized Buddhist art. Among the greatest legacies of this period are the rock-cut monastery caves at Ajanta, in western India.

Indian ascetics had occupied caves from the third century B.C. and from around 100 B.C. Buddhists cut monasteries into existing caves. The Ajanta caves were begun in A.D. 462 and completed soon after 500. Artists decorated the interiors of these caves with sculptures and paintings. They covered the lime surface of the walls and ceilings with murals.

Pigments ground from local stone included red and yellow ochers, greens, and blacks, and blue was made from lapis lazuli.

The detail in **figure 20.11** is from the *jatakas* (stories of the Buddha's previous lives). It depicts a group of graceful, lifelike figures seated in *tribhanga* poses. Their fleshy proportions and full faces and necks create the characteristic impression of *prana*. Beneath the seats, we can see a clear area of ground that locates the figures in natural, three-dimensional space. The sense of depth is increased by the foreshortened, overlapping forms, and the subtle shading of the flesh and the clothing.

Caves became increasingly popular in India and were used from A.D. 500 by Hindus as well as Buddhists. By the tenth century, Buddhism had all but disappeared from India but had infiltrated other areas of the Far East.

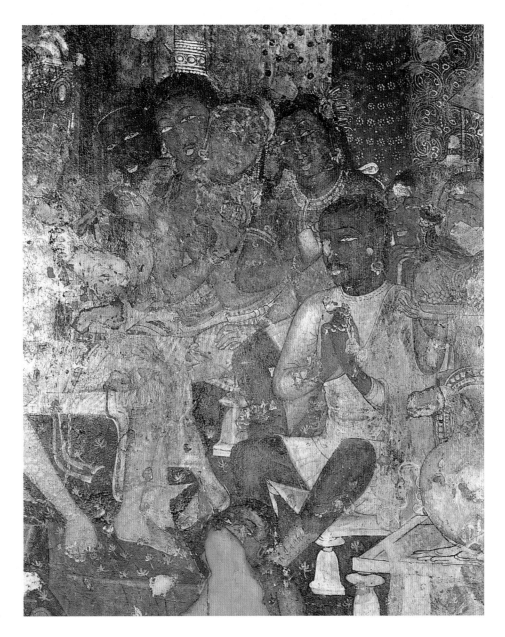

20.11 Detail from Cave 16 showing a scene from a past life of the Buddha, A.D. 462–500. Ajanta, India.

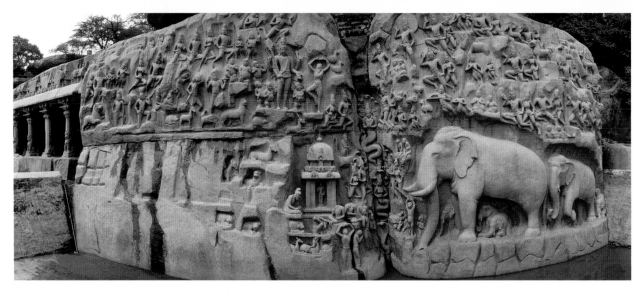

20.12 *Descent of the Ganges* (or *Penance of Arjuna*), 7th century. Mamallapuram, India.

Hindu Art in India

In India, Hinduism persisted alongside Buddhism and emerged as the main religion after the decline of Buddhism. Today the country remains primarily Hindu. Like Buddhism, Hinduism produced a rich and long-lasting artistic tradition.

In southern India, during the rule of the Pallava Dynasty (c. 500–750), artists carved reliefs on existing rock. One example is the impressive group of sculptures from the seventh century illustrating the Hindu war epic *Mahabbarata* (**figure 20.12**). This view shows the hero, Arjuna, sitting by a shrine dedicated to Shiva at the left of the opening. Water spirits in the shape of cobras mark the place where

water flows and identify the presence of Ganga, the river goddess. Various other naturalistic human figures and gods in dynamic poses and an array of animals, including large elephants, approach the water. They are crowded together on the rock surface, conveying the impression that all of creation is gathering by the sacred River Ganges.

One of the main expressions of Hinduism is the freestanding temple, of which there are many throughout the Indian subcontinent. Hindu temples, like those in Western antiquity, were thought of as the dwelling place of the god or goddess to whom the building was dedicated. Before constructing a temple, Hindu architects carefully chose a fertile site, cleansed it of spirits, and set sacred cows to

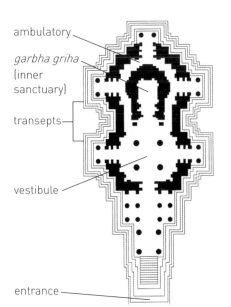

ambulatory
garbha griha (inner sanctuary)
transepts
vestibule
entrance

20.13 Plan of the Kandariya Temple.

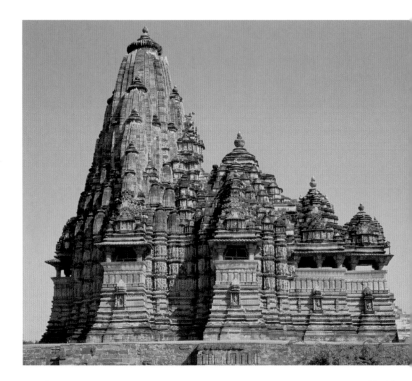

20.14 Kandariya Temple, Khajuraho, Madhya Pradesh, India, c. 1000. 98 ft.

graze on it. The temple plan was thought of as an image of the cosmos—the **mandala**. Rituals performed at the site included the repeated chanting of sacred syllables (*mantras*), dancing, and sacrifices.

One classic example of a northern Indian temple is the Kandariya Temple of c. 1000, which was dedicated to Shiva. Its plan (**figure 20.13**) is longitudinal, with a double transept, and a single entrance at the eastern end. The interior consists of an entrance porch, an assembly hall, and a vestibule that precedes the inner sanctuary—the **garbha griha** ("womb-chamber"). This is surrounded by a curved space resembling an ambulatory that expands toward the westernmost transept. Rather than accommodate a large congregation as the Christian church does, the function of the Hindu temple was to house the god's statue. A *brahmin* (priest) stood at the entrance to the *garbha griha*, which contained the statue of Shiva, and received offerings of food and incense from individual worshipers. He then placed these before the statue, which was believed to be inhabited by the god.

The exterior view shows the solid terrace platform supporting the Kandariya Temple (**figure 20.14**) and symbolically elevating it above the material earthly world. As visitors climb the steps, they replicate the ideal ascent through the life cycle to *Nirvana*. Each interior room is marked on the exterior by a tower with an elaborately carved pyramidal roof. The largest tower (**shikhara**) rising over the *garbha griha* is a metaphor for the cosmic mountain.

Hindu temple interiors were typically dark and unadorned. The main focus is the statue of the god in the innermost sanctuary. In the recesses of the outer wall, however, there is a burst of erotic sculptures of gods and goddesses (**figure 20.15**).

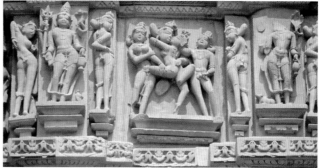

20.15 Detail of exterior sculpture from the Kandariya Temple.

The embracing, animated figures, many of whom are nude, seem to sway seductively despite the confined space of the reliefs.

Southeast Asia: Indonesia and Cambodia

Hinduism and Buddhism spread to Indonesia in the eighth century. The elaborate rectangular temple of Borobodur, on the island of Java in Indonesia, was begun as a Hindu structure but evolved into a Buddhist stupa (**figure 20.16**). As with the Sanchi Stupa, there is no interior at Borobodur. The temple has nine terraces culminating at the top in an enclosure for a statue of the Buddha. Situated on a hill, the temple is further elevated on a base, with stairways oriented to east, west, north, and south, indicating its cosmic meaning as the sacred Mount Meru.

More than ten miles of sculpture decorates the walls. The images on the lower five tiers illustrate the life cycle of reincarnation. The next four tiers contain scenes from the Buddhist *jatakas* and *sutras*. At the very top are seventy-two small stupas, each containing a statue of the seated, meditating Buddha. This uppermost level represents the sphere of heaven.

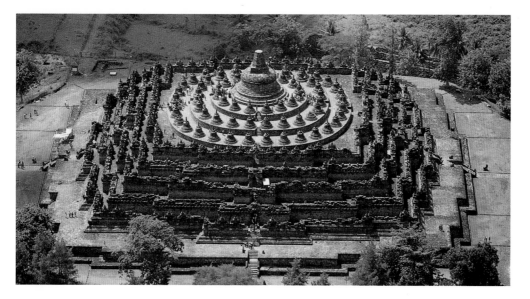

20.16 Aerial view of the Borobodur Stupa, Java, late 8th century. 408 ft. wide by 105 ft. high.

As at Sanchi and in the Hindu temples, the passage of the worshiper through the architectural space of Borobodur has a symbolic, ritual meaning. In this case, as worshipers ascend the levels, they identify with cosmic time. As they pass through past, present, and future lives, they replicate the continuous cycle of reincarnation that ultimately leads to *Nirvana*.

Another type of Hindu temple can be seen at Angkor Wat, the capital of the Khmer Kingdom (ninth to fifteenth century) in Cambodia. The Khmer ruler, the Devaraja, was, like the Egyptian pharaoh (see Chapter 15), a god on earth. During the twelfth century, a large temple complex of limestone was dedicated to the Hindu god Vishnu at Angkor. The main area formed a large rectangle laid out like a *mandala*, and was oriented from east to west (**figure 20.17**). As with Hindu temples in India, the one at Angkor Wat was based on cosmic design.

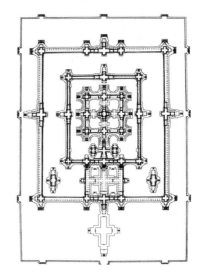

20.17 Plan of the main complex at Angkor Wat, Cambodia, 12th century.

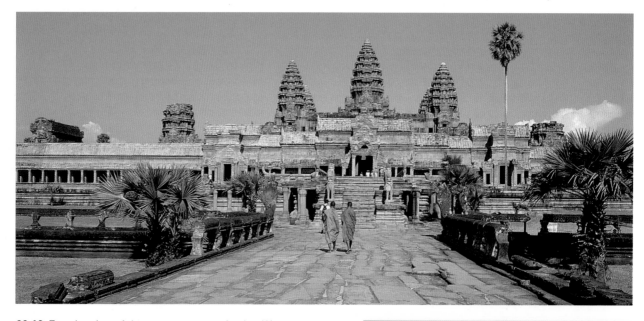

20.18 Exterior view of the entranceway to Angkor Wat.

The central structure (**figure 20.18**) consists of five shrines surmounted by elaborately carved towers, the tallest of which is about 200 feet high and signifies Mount Meru. In the view shown here, we can see the roadway approaching the entrance and the balustrades (railings) on either side that are shaped like water snakes—symbols of fertility.

In the thirteenth century, Angkor Thom became the Cambodian capital of Jayavarman VII (ruled 1181–1218). A conqueror and a Buddhist, Jayavarman was the last Khmer ruler. He constructed the Bayon Temple in the capital and conceived of it as a metaphor of the universe (**figure 20.19**). The walls were symbolic mountains, the moat stood for the oceans and rivers, and the Bayon itself was considered Mount Meru.

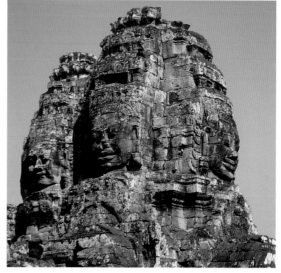

20.19 Bayon Temple, Angkor Thom, Cambodia, c. 1200.

Merging architecture with sculpture, Jayavarman had colossal images of his own features carved into the structure. His face, in relatively high relief, projects clearly from the rock, while his headdress, in lower relief, blends into the rock. He gazes in four directions, indicating his rule over the entire world. In so doing he becomes one with the cosmic mountain and king of Mount Meru.

Despite Jayavarman's power and its expression in monumental architecture, the Khmer Kingdom did not survive long after his death. It was overrun and destroyed in the thirteenth century by invading Mongols.

Mughal Art in India

The third major religion that infiltrated the Indian subcontinent was Islam. Beginning in the eleventh century, Muslim sultans ruled in the north and by the sixteenth century another Muslim group, the Mughals, ruled an empire from Delhi. Under the sultans, the arts adhered to orthodox Islamic rules prohibiting figurative and narrative images. But the Mughals spent a period of exile in Persia, where the courts had developed miniature painting into a richly decorative style.

In the sixteenth century, the Mughals returned to India. The Mughal ruler Akbar (1542–1605) established an empire and became a lavish patron of the arts. Inspired by the Persian court style, Akbar commissioned figurative miniatures depicting historical events. He also encouraged Western diplomats to visit the Mughal court, where his artists were influenced by European style and content.

Figure 20.20 shows a page from Akbar's official biography illustrated by the Persian painter Basavan (active 1590–1605). It depicts Akbar, mounted on the unruly steed, Havai, bravely pursuing a runaway elephant charging across a pontoon bridge. The rich colors are typical of Persian miniatures, while the three-dimensional space

and shading reflect Western influence. Movement is created formally by the broad diagonal of the bridge, which is repeated in the animated poses and gestures of figures in the turbulent water. For Akbar, the very act of creating such naturalistic scenes brought the painter closer to God. The emperor's conviction that art is next to godliness led him to defend figurative painting against the orthodoxy of Muslim clerics.

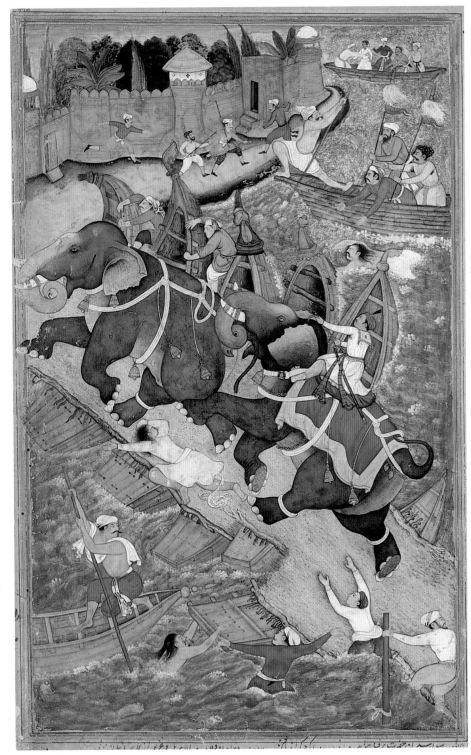

20.20 Basavan, *Akbar Restrains Havai*, c. 1590, from the Akbarnama. Watercolor on paper, 13 ⁷/₈ x 8 ³/₄ in. Victoria and Albert Museum, London.

Akbar's grandson, Shah Jahan (1592–1666), patronized the arts, loved jewels, and, as shown in **figure 20.21**, sat on a peacock throne. Two peacocks are perched on the roof of the throne, which is surmounted by a pink canopy. Shah Jahan's elaborate turban is bound with strings of pearls, and he wears several jeweled necklaces, armbands, and bracelets in addition to a jeweled belt. His contemplation of the flower in his right hand indicates that he is a man of cultivation and aesthetic refinement. This is further shown by the rich green background, delicate foliage, and the frame decorated with floral patterns and Islamic calligraphy. This particular portrait was, in fact, made in the late eighteenth century when the Mughal empire was in decline. Produced by a workshop in one of the Mughal courts scattered across northern India, this posthumous portrait was created as testimony to an illustrious ancestor and a more glorious age.

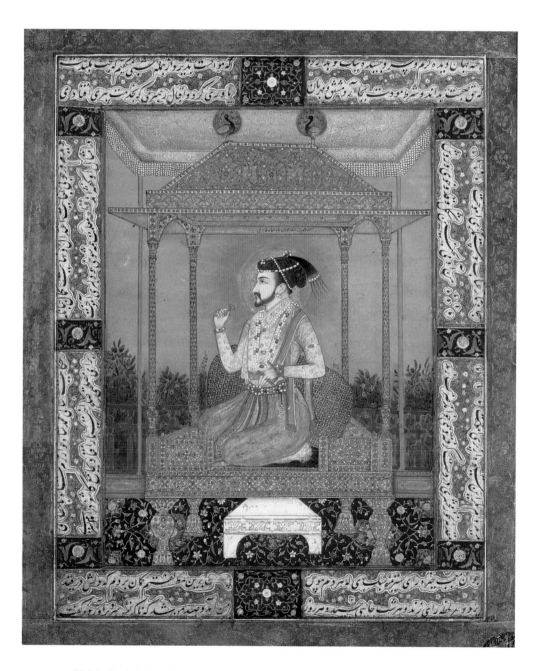

20.21 *Shah Jahan Enthroned*, c. 1800 after a 17th-century orginal. Opaque watercolor on paper, 15 x 10 ½ in. Victoria and Albert Museum, London.

Shah Jahan's taste for jewels is also evident in the architectural masterpiece of his reign (**figure 20.22**). The Taj Mahal, located in Agra, is made of white marble inlaid with colored gems. It is a harmonious, symmetrical mausoleum, which was built to house the tomb of the emperor's favorite wife—Mumtaz Mahal, who died in 1631. The gleaming white surface, symmetry, and graceful Indian arches and onion domes create a dazzling image of majestic repose. Situated at one end of a garden, the Taj Mahal symbolizes God's throne in Paradise.

The Taj Mahal has enchanted and intrigued visitors ever since it was built. The British author Rudyard Kipling called it:

the Ivory Gate through which all dreams come true.[1]

The Indian author Rabindranath Tagore declared:

Only let this one teardrop, this Taj Mahal, glisten spotlessly bright on the cheek of time, forever and ever.[2]

And Shah Jahan concluded the poem he wrote praising his wife's mausoleum as follows:

The sight of this mansion creates sorrowing sighs
And makes sun and moon shed tears from their eyes.
In this world this edifice has been made
To display thereby the Creator's glory.[3]

After the death of Shah Jahan, orthodox Islam reasserted itself and figurative art disappeared from Muslim India. Buddhism declined in India, but spread to China in the first century. By the sixth century, Buddhism had infiltrated Japan, where, as in China, it eventually became the dominant religion. The arts of China and Japan are the subject of the next chapter.

20.22 The Taj Mahal, Agra, India, 1631–1643.

MEANING

Howard Hodgkin and Indian Miniature Painting

The British painter Howard Hodgkin has long collected Indian miniature paintings of the sixteenth to nineteenth centuries. Their vivid, jeweled color and flat, tapestry-like backgrounds are assimilated into Hodgkin's own, small-scale works. In his own words "The picture *is* instead of what happened. We don't need to know the story; generally the story's trivial anyway. The more people want to know the story, the less they'll look at the picture." And so it is that Hodgkin's work is imbued with the mystery of new experience and inspiration free from narrative.

Before the 1970s, Hodgkin's work can be described as demonstrating a consistent geometric flatness. By the mid 1970s, this gave way to less rigid, more rhythmic patterning. Hodgkin also began to experiment with framing devices, exuberant color, and decorative motifs incorporated into his work. This period of joyful experimentation and the resulting mixture of styles can be traced to his annual trips to India.

Although Hodgkin is influenced by Indian miniatures, he translates them into modernist visual language. The miniature painters were concerned with fine line, delicate detail, and rich color. But Hodgkin applies his own formal system, replacing clear edges and pin-point precision with solid shapes: the sphere, cube, and cylinder. In contrast to Indian miniatures, however, his blurred outlines pulsate with energy thanks to the intensity of his pigments. The crispness of edge and line have been replaced by a fuzzy, affable kind of formal system.

This kind of relationship is demonstrated by Hodgkin's *Small Indian Sky* (**figure 20.23**), the orange and greens of which evoke the rich palette of colors commonly used by the artists working within the courts of the Punjab hill states in the seventeeth and eighteenth centuries (**figure 20.24**).

Quotation from *Nothing if Not Critical: Selected Essays on Art and Artists*, 1992.

20.23 Howard Hodgkin, *Small Indian Sky*, 1990. Oil on wood, 10 ¾ x 13 ⅛ in. Courtesy of Howard Hodgkin and Gagosian Gallery, London.

20.24 *Crowned Ganesha*, Punjab Hills, Basohli style, c. 1720. Watercolor on paper, 4 ¾ x 8 in. British Museum, London.

Chapter 20 Glossary

anda—dome of a Buddhist stupa

chattra—pole with three parasol-shaped features symbolizing the Buddha's royal status

garbha griha—literally "womb-chamber," the inner sanctuary of a Hindu temple

harmika—square railing on the dome of a stupa

jatakas—events in the Buddha's previous lives

mandala—Hindu image of the cosmos

prana—in Indian and Southeast Asian art, the quality of appearing to have breath

shikhara—tower in a Hindu temple

stupa—in Buddhist architecture, a mound or dome-shaped structure having cosmological meaning

torana—gate one of the four corners of a *vedika*

tribhanga—in Indian art, a characteristic sensuous pose, also called the "three-bends" pose

ushnisha—conventional topknot of hair on images of the Shakyamuni Buddha, symbolizing his wisdom

vedika—round fence surrounding a stupa or on its dome

yakshi—Hindu tree goddess

yasti—in Hinduism, a pillar representing the World Axis

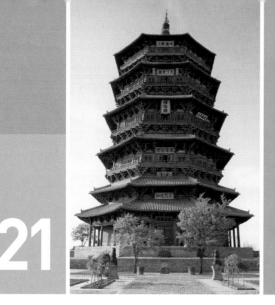

21

KEY TOPICS

The art of China:
Bronze Age, Daoism, Confucianism, Qin Dynasty,
Tang Dynasty, Song Dynasty, Ming Dynasty

The art of Japan:
Kofun Period, Heian Period, Kamakura Period,
Momoyama Period, Edo Period

The Art of China and Japan

COMPARE

Great Wall of China.
figure 14.1, page 267

China (see map) is larger than India, its history is as ancient and complex, and its vast landscape is spectacular. The two countries are separated by the world's tallest mountains, the Himalayas. The variety of China's border countries contributes to its complexity, for it is bounded on the east by the Yellow Sea, and on the south by Cambodia and the South China Sea. At its western border, China abuts Kazakstan, Kyrgyzstan, Tajikistan, and Pakistan. The northern border with Mongolia is open, leaving China vulnerable to invasions (against which Emperor Qin built the Great Wall we discussed in Chapter 14, see figure 14.1). In addition, China was accessible to cross-cultural influences through the Silk Roads, connecting the country with India, Iran, and the Mediterranean world. Other influences came from nomads entering the country from Mongolia, the Black Sea, and Siberia.

Japan (see map on p. 449) was more isolated than China and is a much smaller country. It consists of a group of islands cut off from the mainland by the Sea of Japan and somewhat buffered by Korea. Although later influenced by Chinese culture, as well as by the West, Japan remained a more insular country longer than its huge neighbor. Both countries were ruled for thousands of years by emperors—China until the Emperor was deposed in 1911–1912 and Japan until the end of World War II in 1945.

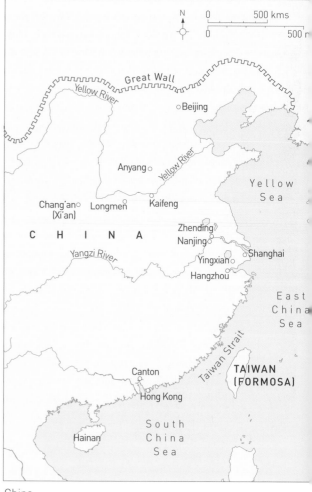

China.

Art in China

Neolithic China

The Neolithic era in China lasted about 3,000 years—c. 5000–2000 B.C. Beginning around 5000 B.C., Neolithic settlements grew up along the banks of the Yellow River in northeastern China and along the lower Yangzi River to the south. These village economies were mainly agricultural; animals were domesticated, and people used stone tools shaped according to their function. Hunting is indicated by finds of spears and stone arrowheads. Formal burials containing grave goods such as woven baskets, pottery, and decorative ornaments suggest a belief in an afterlife. From early on in its history, Chinese artists have shown great skill in shaping and carving hard stone, especially jade (nephrite). The little elephant figure we discussed in Chapter 13 is a good example of the Chinese art of jade carving (see figure 13.11).

Long identified as the quintessential stone of China, jade was actually imported in large quantities from Siberia and Central Asia. One type of jade sculpture frequently found in Neolithic graves is the *cong* tube (**figure 21.1**), a hollow rectangle of varying lengths. The interiors are cylindrical and the exteriors are decorated with raised bands that wrap around the corners. Delicate patterns, of either pure interlace or recognizable forms, are incised into the bands. Some resemble faces and are thought to represent masks. It is not certain what the meaning of these objects

21.1 *Cong*, Liangzhu Culture, 3rd millennium B.C. Hardstone, 11 ½ in. high. Sidun, Wujin, Jiangsu. Nanjing Museum, China.

TIMELINE	HISTORICAL EVENTS	ART HISTORY	
5000 B.C.	• Neolithic settlements established along Yellow River c. 5000 B.C. • Shang Dynasty 1700–c. 1050 B.C. • Zhou Dynasty c. 1050–480 B.C. • Confucius c. 551–479 B.C. • First Emperor of Qin united China 221 B.C.	• Jade *Cong*, 3rd millennium B.C. • Yu ceremonial wine vessel 1st millennium B.C. • Great Wall of China begun 3rd century B.C. • Terracotta army c. 210 B.C.	5000 B.C.
A.D. 0	• Han Dynasty 206 B.C.–A.D. 220 • Tang Dynasty 618–907 • Song Dynasty 960–1279 • Buddhism becomes Japan's official religion 5th–6th centuries	• *Haniwa* warriors 300–600 • *Great Buddha*, Longmen, Hanan Province 675 • Horyuji monastery, Nara, Japan 7th century	A.D. 0
A.D. 1000	• Genghis Khan 1162–1227 • Lady Murasaki, *Tale of Genji*, 12th century • Mongol rule of China 1259–1368 • Ming Dynasty 1368–1644	• Moni (Pearl) Hall, Zhending, China c. 1052 • Fogongai Pagoda, Yingxian, China c. 1058 • Golden Age of porcelain Ming Dynasty 1368–1644	A.D. 1000
A.D. 1500	• Qing Dynasty 1644–1912 • Edo Period 1615–1868	• Hall of Supreme Harmony, Forbidden City, Beijing, 17th century • Audience Hall, Nishi Hongan-ji, Kyoto, Japan c. 1630 • *Ukiyo-e* School, Japan 1615–1868	A.D. 1500
A.D. 1900	• Emperor deposed China becomes a Republic 1911–1912 Chairman Mao Zedong, People's Repbulic of China 1949–1976		A.D. 1900

was, but the emphasis on the four corners of the tube invites comparison with ancient structures oriented to the cardinal points of the compass. It is possible that the *cong* tubes were endowed with cosmic significance and were symbols of the Earth.

COMPARE

Elephant from Henan Province.
figure 13.11, page 254

Bronze Age China

Bronze Age China dates from around 2000 B.C. and continued until the reign of Emperor Qin, which began in 221 B.C. The beginning of the period is traditionally marked by the arrival of the Xia rulers, an early dynasty mentioned in ancient legends. The Xia were expelled by the Shang, a warrior culture ruled by kings from around 1700 to 1050 B.C. Shang culture coincided with the rise of urbanization and monumental stone architecture in China. It also produced an early script found on oracle bones, which were used to read the future. This script is the ancestor of modern Chinese characters and the art of calligraphy.

Late Shang burials at the capital city of Anyang indicate that the afterlife was conceived of as the continuation of the present life and there is evidence of ancestor worship. Royal tombs contained chariots, weapons, shells (which were used as currency), jewelry made of gold, silver, ivory, and turquoise, lacquered and jade objects, and bronze vessels.

Bronze vessels in the Shang Period were symbolic as well as practical. They were filled with food and drink for the gods and the ancestors, and were also signs of status, measured by the number and size of the bronzes one owned. Before the West invented the lost-wax method of bronze casting (see p. 252), China had developed the **piece-mold** process (**figure 21.2**).

Piece-mold casting begins with a clay model of a vessel. When the model dries, a negative mold is made by pressing sections of soft clay over it. When the sections are dry, they are removed and fired. Each section is reconnected to the original mold (from which a thin layer has been removed) by bronze pegs (**spacers**), which keep the mold and the sections in place. Molten bronze is poured into the space between the sections and the original mold through a pouring duct. When the bronze cools, the outer sections are removed, leaving the bronze in the shape of the mold. At this point, the surface of the hardened bronze can be refined and polished. **Figure 21.3** illustrates a *Yu*, a particularly complex ritual bronze vessel. The surface is covered with intricate, incised designs, many of which can be identified on close inspection. For example, the head of a man in the open jaws of the animal is clearly visible. Although the vessel is covered with stylized patterns, the man's head is relatively naturalistic, creating a sharp juxtaposition of abstraction and organic form. We can identify with the man's sense of danger as he gazes helplessly from under the animal's bared teeth, but the rest of him seems to disappear into the movement of surface patterning.

The incised motifs fit the shape of the vessel, creating a tight formal unity between the vessel's contour and the animated images on its surface. Aside from the area between the feet and around the handle, which ends in a bear's head, there is little open space. The forms are thus crowded into the sturdy, compact bronze, which gives it a sense of inherent tension and power.

With the decline of the Shang Dynasty, the Zhou came to power c. 1050 B.C. This lasted until around 480 B.C., when the Zhou succumbed to waves of nomadic invasions. By this time, the two main belief systems of China were in place: the older philosophy of Daoism and that of Confucius, who lived during the late Zhou Period.

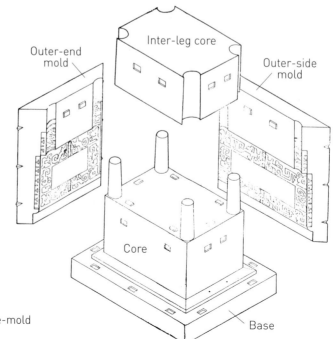

21.2 Diagram of piece-mold bronze casting.

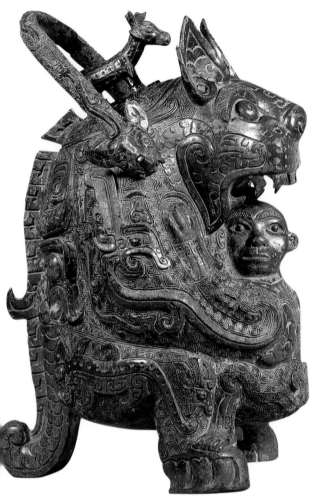

21.3 *Yu* (ceremonial wine vessel) in the shape of a bear or tiger swallowing a man, Shang Dynasty. Bronze, 12 7/8 in. high. Sen-Oku Hakuko Kan, Kyoto.

Daoism and Confucianism

From the dawn of Chinese history, there is evidence of a belief in many gods, in spirits that had to be appeased, in ancestor worship, and in the continuation of life after death. Daoism, named after the Chinese word *dao*, meaning "the way," is the oldest known Chinese religious system. It taught the importance of wisdom and emotional tranquillity. Although based on ancient traditions, Daoism is attributed to the thought of Laozi, a mystic philosopher believed to have written the *Daode jing* some time in the fourth century B.C. Daoism stressed the importance of withdrawal from the illusory world of social hierarchy, religious ritual, and even language

and writing. Until the seventh century, Daoist imagery was minimal and its emphasis was more spiritual than material.

The philosophy of Confucius (c. 551–479 B.C.), in contrast to Daoism, was socially oriented. It taught the value of attaining the status of the "good man"—defined by right conduct, respect for ancestors, dedication to family, and the performance of appropriate rituals honoring not only one's own family and ancestors, but also those of the ruler. Eventually the state became an object of ritual worship, and the wellbeing of society was seen as dependent on the serenity of the universe. As a result, rituals involved appeasing nature with a view to maintaining social harmony.

Emperor Qin

The Zhou Period was followed by the turbulent Warring States Period (480–221 B.C.). Unrest was caused by a lack of centralized power and fighting among warlords. Then, in 221 B.C. China was reunited under a strong ruler.

Shihuangdi (ruled 221–206 B.C), known as the First Emperor of Qin (for which China is named), killed the warlords who opposed him and established a centralized court. He undertook a number of measures calculated to unify China, including strengthening the army and constructing roads, standardizing weights, the currency, and the writing system, and commissioning large-scale architectural projects. Using more than 700,000 workers, he built a large part of the Great Wall to defend China from northern invaders.

Today, Emperor Qin is best known for the huge burial mound accidentally discovered by peasants in 1974. Located near Xi'an, in Shaanxi Province, Qin's tomb is a colossal expression of the Chinese belief that life after death is a continuation of life in the here and now (**figure 21.4**). On a scale unprecedented in the history of China, Qin planned to maintain his power in the next life.

After the death of Emperor Qin, the Han Dynasty (206 B.C–A.D. 220) came to power and overlapped with the period of the Roman Empire. The Han extended Qin's empire, opened the Silk Roads, and established sea routes to India. They also improved the Chinese writing system and revitalized Daoism and Confucianism. Under the Han, Buddhism entered China by way of missionaries from India. But the new religion was not widely accepted until the late fourth century under the Northern Wei rulers (A.D. 386–535).

Life Goes On:
Emperor Qin's Bodyguard

When excavations began on the tomb of Emperor Qin, a colossal bodyguard of more than 8,000 lifesize terracotta soldiers (archers, infantrymen, cavalry, and horses) was revealed to an astonished world. The soldiers, who wear the uniforms and hairstyles of their respective rank, are positioned as they would have been in actual military formation.

Smaller tombs nearby were built for Qin's princes, concubines, officials, and horses. They too are filled with remarkable objects, including gilded bronze chariots. But these do not compare with the emperor's plans for his personal protection by an enormous armed bodyguard in the next life. Like the Egyptian pharaohs (see Chapter 15), Qin ordered his tomb built as soon as he ascended the throne. Hundreds of thousands of workers were required for the project. They had to prepare the site, amass the clay, gather firewood to operate the kilns where the clay was fired, and then produce the figures. Enormous administrative planning was necessary, as each stage of the process had to be financed and supervised.

Qin's figures were made in sections from molds and then assembled. The main sections were the torso, limbs, head, and a small platform on which each figure stands. There is some variety in the depiction of the figures to give the impression that the army, as in reality, is composed of individuals organized into a unified whole. Traces of paint on the figures add to their lifelike appearance. Although Qin's terracotta bodyguard was never intended to be seen, their naturalism was believed to ensure their effectiveness in the emperor's next life.

The tomb of Qin is not only the replica of an army, it is also a mirror of the emperor's grandiose character and experience of political reality. Recognizing that he had to defeat competing warlords in order to gain the throne, Qin made certain that he would be provided with a huge army after death. And just as he expanded the Great Wall to defend China against invaders, so he protected his tomb from discovery for nearly 2,000 years. The burial chamber, which has not yet been excavated because of fears that it was booby-trapped, is located beneath a stream and is sealed with a layer of bronze.

Today the terracotta army has become a vast archaeological site and museum. The site has been roofed in, but is open to visitors who can watch as the excavations proceed. Not only do thousands of tourists visit the site every year, but replicas of the warriors and their horses are sold in all sizes throughout the world.

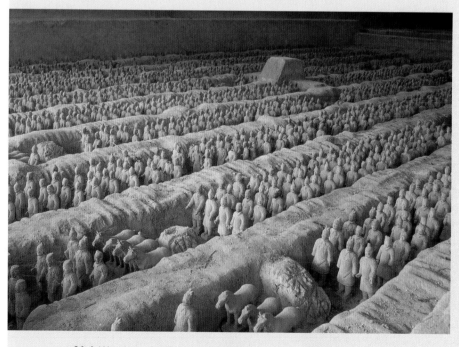

21.4 Warriors, Qin Dynasty, c. 210 B.C. Terracotta. Trench 1, Lishan, Lintong, Shaanxi.

The Tang Dynasty

By the Tang Period (618–907), Buddhism had become the prevailing Chinese religion and Buddhist art flourished. The Tang unified China, and expanded their empire. They stimulated all the arts, and encouraged international trade. Tang emperors were aristocratic and cosmopolitan, and their imperial capital at Chang'an (formerly Xi'an) was a cultural and intellectual center.

One of the greatest sculptural projects undertaken by the Tang were the colossal statues of Buddha in the caves at Longmen, in Henan Province (see map on p. 440). *The Great Vairocana Buddha* (**figure 21.5**) represents him as the resplendent, universal Buddha of Wisdom seated on an octagonal throne. The figures on either side are attendant *bodhisattvas*. Carved into the rock behind the Buddha are a large halo and **mandorla** (oval of light around the entire body), each decorated with lively, fiery patterns.

This sculpture emphasizes the Buddha's spiritual aspect. It is based on the *Flower Garland Sutra*, a Buddhist text in which he is described as transcending time and space. The fleshy surface of the body and flowing, flattened curves of the drapery set him apart from everyday reality. The elongated earlobes are unadorned, indicating that he has renounced his princely jewels for a life of quiet meditation. As was typical of the Tang Dynasty, this is a cosmic Buddha, impassive, serene, detached from the world, and gazing into the eternal future. The power of the Tang emperors at the Chang'an court is shown in the detail of a Tang emperor scroll in **figure 21.6**. The artist, Yan Liben (d. 673), was an architect, court official, and prime minister, as well as a painter. In this work, he accentuated the emperor's bulk by the massive robes, use of shading, and placement next to his smaller attendants. The emperor's dignity and grandeur are conveyed by his rooflike headdress and extended arms, which create a wide three-dimensional space. The solemnity of the occasion—the red of the upturned shoes seems to announce his arrival—is conveyed by his slight scowl and creased forehead.

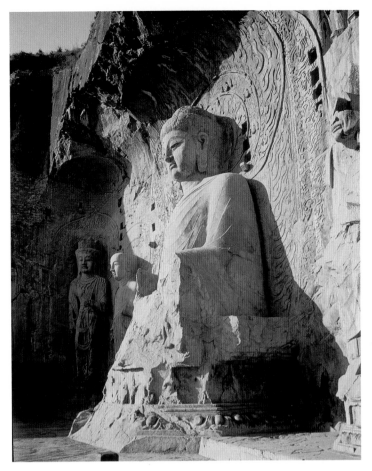

21.5 (Above) *The Great Vairocana Buddha*, Tang Dynasty, c. 675 A.D. Limestone, 55 ft. 9 in. high. Fengxian Temple, Longmen, China.

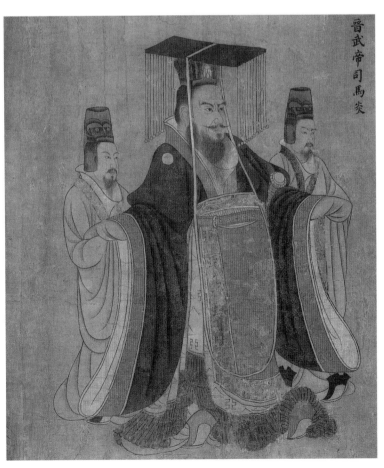

21.6 Attributed to Yan Liben, *Emperor Wu Di*, Tang Dynasty, 11th-century copy of a 7th-century handscroll. Pigment, ink, and gold on silk, 20 3/16 in. high. Museum of Fine Arts, Boston.
Denman Waldo Ross Collection.

With the rise of internal rebellion and unrest caused by competing regional rulers, the Tang Dynasty declined. But China again revived under the Song. The Northern Song (960–1127) established their capital at Kaifeng, which was overrun by Manchurian tribes in 1126. Remnants of the Song Dynasty then moved south and established the Southern Song Dynasty (1127–1279) in the picturesque city of Hangzhou, southwest of modern Shanghai.

The Song Dynasty

The Song Period (960–1279) produced new opportunities for commerce and wealth as urbanization expanded. Its rulers were hereditary aristocrats who valued education and scholarship. The position of women improved, especially in the arts. A great deal of porcelain was exported, woodblock printing was developed, and moveable type was invented, making it possible to disseminate information through printed books more rapidly than before.

In architecture, the Song continued and elaborated earlier building types. The Moni (Pearl) Hall of the Northern Song Longxing (Dragon Flourishing) Temple (**figure 21.7**) is a complex, rhythmic arrangement of pitched, **hip-roof c**onstruction ending in curved gables. The roof sections are outlined with ridges, and decorative finials enliven the upturned corners. Supporting the projecting eaves are brackets

21.8 Diagram of the Chinese beam-frame system.

that extend from interior columns of various heights, on which support horizontal lintels rest. This system of construction, called **beam-frame**, is diagrammed in **figure 21.8**.

The most characteristic Chinese religious architectural type is the **pagoda**. Derived from the Indian stupa and military watchtowers in China, the pagoda is a tower of a varying number of stories erected over Buddhist relics. As with the stupa, worshipers circumambulate the pagoda in a clockwise direction, replicating the Buddha's spiritual journey. But, in contrast to the stupa, the pagoda has an interior.

The Song pagoda in **figure 21.9** is nine stories high. Its eaves, like those in the Northern Song temple (see figure 21.7), curve upward and the tiled roof of each story is edged with ridges. The vertical projection at the top symbolizes the World Axis.

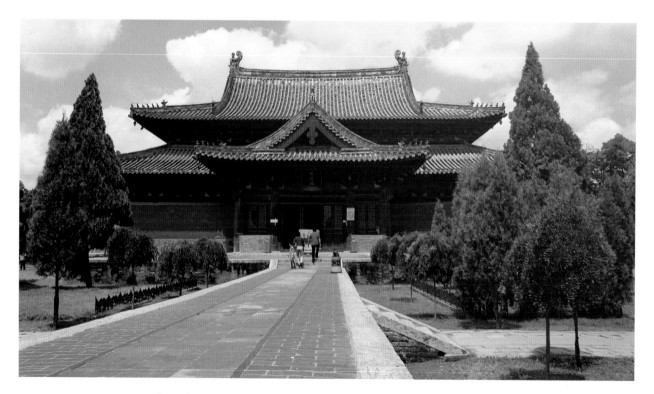

21.7 Moni (Pearl) Hall, Longxing (Dragon Flourishing) Temple, Zhending, Hebei, China, Northern Song Dynasty, c. 1052.

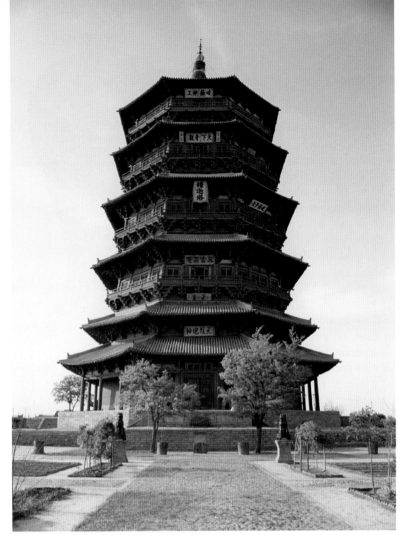

21.9 Fogongai Pagoda, Yingxian, Shanxi, China, 1058. Tower 216 ft. high.

The main Southern Song contribution to painting was the development of landscape. Ma Yuan (active c. 1190–after 1225), the leading painter at the Hangzhou court, produced particularly lyrical landscapes. The example in **figure 21.10** contains a couplet in which flowers and birds allude to the emperor's romantic power over women who reside at court. It is painted on silk, which was characteristic of the Song court and reflects the royal taste for varieties of texture. The thickly painted tree trunk, for example, contrasts with the slim branches that curve above the solitary figure. He gazes into the barely visible distant horizon, fading into a sky whose calm is disturbed only by a single bird flying toward the poem. Its calligraphic design echoes the shifting, varied lines of the landscape forms.

The Mongol invasions of China begun by Genghis Khan (1162–1227) culminated in the domination of the country by his grandson, Khublai Khan, who ruled until 1294. Khans maintained control until expelled by the Ming in 1368. At first the Ming ruled from Nanjing, but then moved to Peking (modern Beijing). Still wary of the Mongols, the Ming extended the Great Wall to protect their northern border.

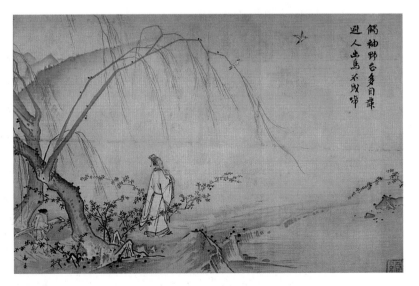

21.10 Ma Yuan, *On a Mountain Path in Spring*, inscribed couplet by Emperor Ningzong, Song Dynasty, early 13th century. Ink and color on silk, each leaf 10 ¾ in. x 17 in. National Palace Museum, Taipei.

The Ming Dynasty

The Ming (ruled 1368–1644) were autocratic rulers of what was the world's largest and most populous empire. Following the Mongol occupation, they revived education, built up the army, enlarged the bureaucracy, and elevated the emperor to new heights—he was now called Son of Heaven.

Ming porcelain has become synonymous with high quality and elegant artistry. From the fourteenth century it has been one of China's major exports (see figure 12.4). Under the Ming emperors, the ceramic industry began using the highest-grade porcelain enriched with glazes.

The typical Ming vase has a blue design (made from blue cobalt) on a white background, as in **figure 21.11**. In this example, two blue dragons propel themselves around the surfaces. Their graceful, curvilinear forms create a sense of harmony with the contours of the vases. Their fierce energy, bared claws

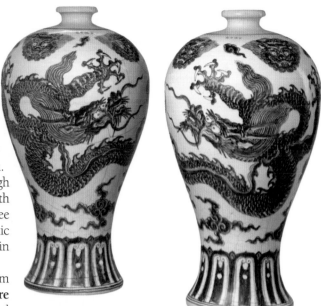

21.11 Pair of porcelain vases, Ming Dynasty, 15th century. Underglaze of cobalt blue, 21 ¾ in. high. Nelson-Atkins Museum of Art, Kansas City. Purchase: Nelson Trust.

and fangs, and intense, bulging eyes reappear in the emperor portrait in **figure 21.12**.

The formality of this imperial image conveys the autocratic character of the Ming emperor. He sits on an elaborate green and blue throne framed by a dragon screen. His frontal pose has a ritual quality and his intense gaze echoes the bulging eyes of the dragon. The voluminous orange robe is richly decorated with carefully coordinated reds, blues, and greens as well as with royal emblems. By repeating the traditional dragon motif, the artist reinforces the sense of inherent, imperial might and potential danger. The swirling clouds on the screens are a reminder that the emperor is himself the Son of Heaven.

Chinese artists valued what appeared ancient and thus appealed to the authority of the past and the persistence of formality. One early Yuan painter wrote:

> The spirit of antiquity is what is of value in painting. If there is no spirit of antiquity, then, though there may be skill, it is to no avail….[1]

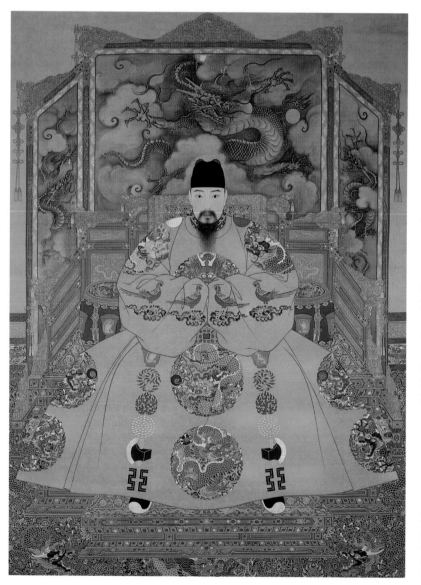

21.12 Anonymous, *Portrait of the Ming Hongzhai Emperor*, 15th century. Hanging scroll, ink and colors on silk, 6 ft. 8 in. x 5 ft. ¾ in. National Palace Museum, Taipei.

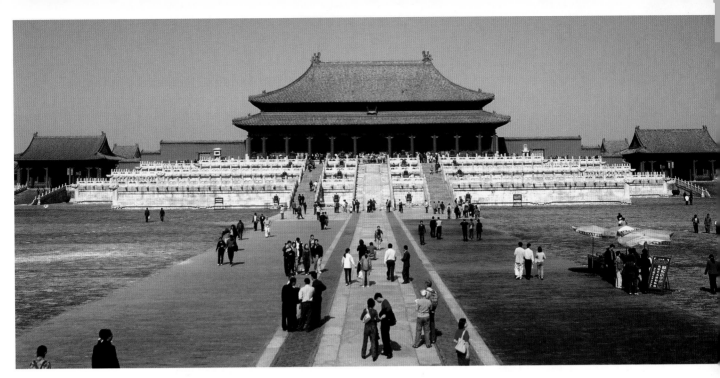

21.13 Forbidden City, Hall of Supreme Harmony, Beijing, China, begun 17th century.

In the seventeenth century, the Ming began building the Forbidden City in Beijing (**figure 21.13**). This vast walled-in area contained temples, administrative offices, palaces, gardens, lakes, theaters, museums, and a library. The emperor's throne was located here, in the Hall of Supreme Harmony. It crowned a platform of white marble, accessible by stairways cut into long, horizontal tiers decorated with balustrades. The curved roof typical of Chinese architecture is covered with yellow tiles—the imperial color.

This view conveys something of the impressive, expansive, intentionally "forbidding" spaces of the Forbidden City. Under the Ming and subsequent emperors, the Forbidden City was the seat of China's power and remained so until the Communist Revolution. Today an enormous banner of the revolutionary leader and dictatorial president of China for decades, Mao Zedong (1893–1976), hangs over the Tiananmen Square entrance to the Forbidden City. Ironically, the Forbidden City is now one of the world's most visited tourist attractions.

Art in Japan

The native religion of Japan is Shinto—"The Way of the Gods." This was a polytheistic belief system, involving the worship of many nature gods (called *kami*) and of ancestors. The primary deity was the great sun goddess, Amaterasu, from whom the imperial family was said to descend. The Japanese emphasis on nature is consistent with the respect accorded to natural materials, their use as art media, and the meanings with which they are endowed. In Shinto art there was no conventional iconography and no texts are known to exist.

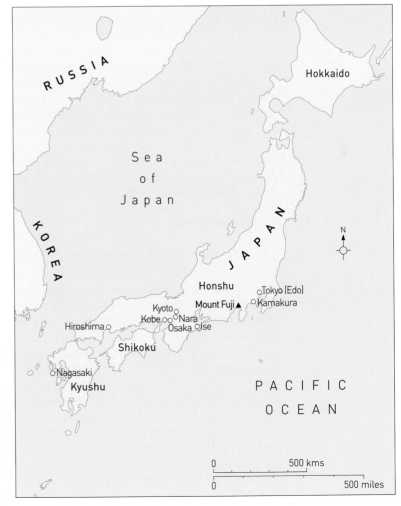

Japan.

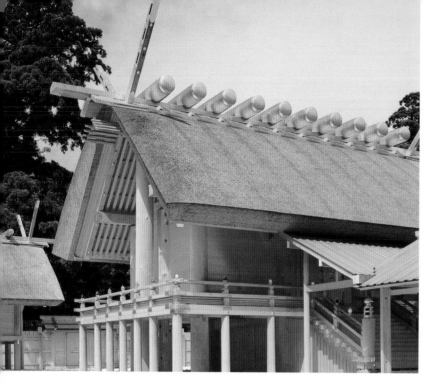

21.14 Reconstructed shrine, A.D. 690, originally 3rd century, Ise, Japan. Wood.

The Buddhist Monastery in Japan

From the fifth to the sixth century, under Prince Shotoku Taishi (574–622), Buddhism became Japan's official religion. Shotoku is credited with having commissioned the oldest Buddhist structure in Japan—the Horyuji Monastery in Nara (**figure 21.16**). The monastery complex consists of several buildings, including a pagoda, temple, cloister, rooms for the monks, and a *kondo* (golden hall). Inside the *kondo*, monks circumambulate statues oriented, like the *toranas* around the Sanchi Stupa (see Chapter 20), to the four cardinal points. The ceramic tile roofs with curved eaves reflect the dominance of Chinese Buddhist forms and materials over the more natural wood structures with thatched roofs prevalent in Shinto tradition.

The Heian Period

The Heian Period (794–1185) produced the Japanese literary classic *The Tale of Genji*, written by Lady Murasaki, a lady-in-waiting at the early-eleventh-century court in Kyoto. This was a period of leisurely aristocratic lifestyle and literary and artistic expansion, which is reflected in the tale. It is the story of Prince Genji, who wants power but spends his time enjoying sensual pleasures. Episodes unfold in leisurely fashion accompanied by lengthy descriptions of lavish textiles, social rituals, garden settings, and palace intrigues.

Prior to the arrival of Buddhism in Japan, people worshiped the *kami* in wooden shrines. After their construction, these shrines were ritually rebuilt every twenty years. The Grand Shrine at Ise was first erected in the third century in the form of a granary—reflecting the early association of agriculture with the nature gods (**figure 21.14**). The Ise Shrine is made from unpainted wood and has a thatched, sloping roof. The shrine is raised on a platform and accessible by a stairway; originally, only the imperial family and priests were allowed to enter it. The smooth, clean lines and simple wood surfaces are characteristic of Japanese taste.

The Kofun Period

During the Kofun Period (300–710), named after burial mounds known as *kofun*, Japanese warrior culture flourished. Large tomb mounds were prepared by the emperors and protected by moats. They were surrounded by freestanding sculptures of warriors called *haniwa* (literally "clay circle"), possibly substitutes for those who had once been ritually killed during an emperor's funeral. Like Qin's terracotta army, the *haniwa* warriors served a protective function, reflected in their sturdy, determined character. They were often arranged in a circle separating the tomb from the space of the living. The warrior in **figure 21.15** stands on a cylindrical base, supported by stocky cylindrical legs that expand at the knees to meet the short tunic. The forms are simple, somewhat geometric and compact, and the natural appearance of the terracotta medium is retained.

21.15 *Haniwa* warrior figure, 300–600. Terracotta, 4 ft. 1 in. high. Aikawa Archaeological Museum.

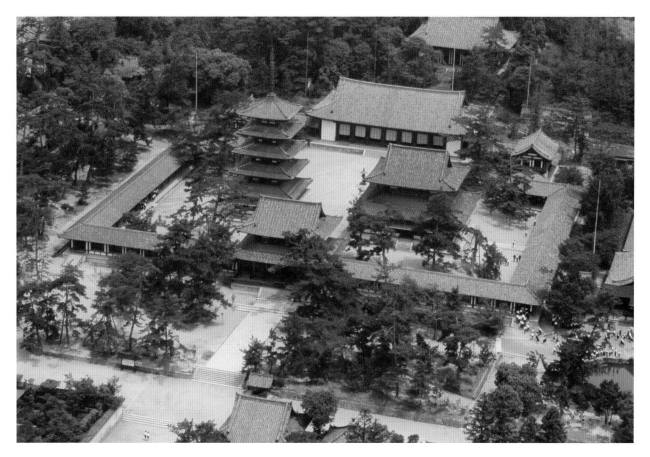

21.16 Horyuji Monastery Complex, Nara, Japan, 7th century.

The popularity of the tale of *Genji* inspired many illustrations by Japanese artists. One twelfth-century handscroll, now in a damaged state, contains individual scenes accompanied by text (**figure 21.17**). In this segment, we view the interior of an aristocratic residence from above. The floor is seen from an angle creaing a sense of unposed figures, who do not know they are being watched. Dressed in voluminous robes and adorned with aristocratic hairstyles, one plays a flute, and two seem to be engaged in conversation. All are in a state of calm repose. The rich patterning visible on the floormats and hanging material is described in vivid detail by Lady Murasaki.

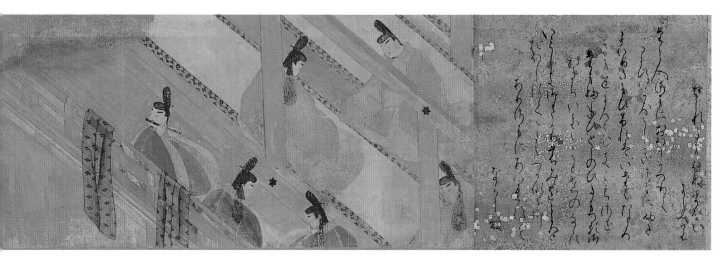

21.17 Attributed to Takayoshi, *Second Illustration to a Chapter from The Tale of Genji*, 12th century. Handscroll, ink and color on paper, 8 ¹⁄₂ in. high. Gotoh Museum, Tokyo, Japan.

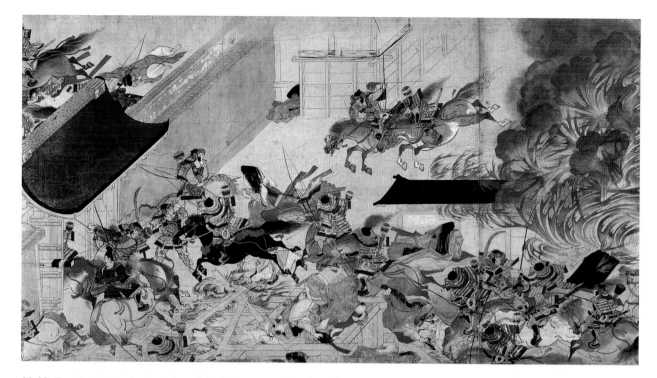

21.18 *Burning of the Sanjo Palace*, late 13th century. Handscroll section, ink and color on paper, 16 ¾ in. x 22 ft. 11 in. Museum of Fine Arts, Boston. Fenellosa-Weld Collection.

The Kamakura Period

The Kamakura Period (1185–1333) saw a warrior culture that preferred order and efficiency to the leisurely, aristocratic style of the Heian rulers. A cadre of warriors that included *samurai* (swordsmen) loyal to their lords sustained the *shoguns* (military rulers).

The bellicose character of the shogunate is shown in a late-thirteenth-century handscroll illustrating an attack on the Sanjo Palace (**figure 21.18**).

As with the *Tale of Genji* handscroll, we observe the scene from above. But in this case, the space is filled with violence, showing armed and mounted *samurai* penetrating the palace and setting it on fire. At the right, patterns of swirling reds and yellows appear amid billowing curves of smoke that engulf the building. Tension builds from the relatively open space and green highlights at the upper left and center to the fierce fighting in the lower half of the scroll. Soldiers and horses clash in a medley of curves and sweeping diagonals accentuated by reds that echo the approaching flames.

By the late twelfth century, the Kamakura warriors came under the influence of a meditative form of Buddhism (*Chan*) imported from China. Called *Zen* in Japan, this philosophy emphasized an ascetic simplicity that was in tune with Japanese Shinto tradition. This can be seen in the colossal *Amida Buddha* (the Buddha of Infinite Light) presently in Kamakura (**figure 21.19**). In this aspect, the Buddha displays his compassionate nature; he vowed to alleviate the suffering of the world and to provide an avenue for spiritual rebirth ending with *Nirvana*.

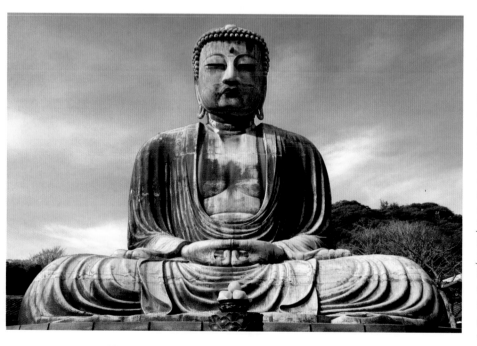

21.19 *Great Amida Buddha*, 13th–14th century. Bronze, 37 ft. 4 in. high. Kotoku-in, Kamakura, Japan.

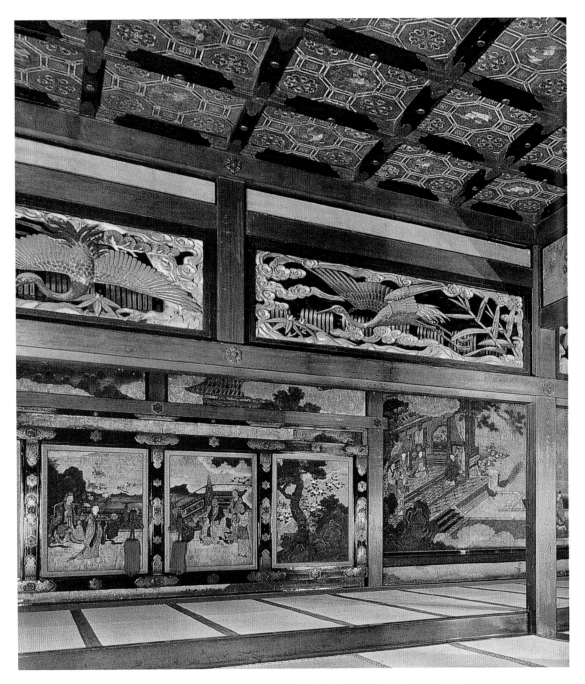

21.20 Interior of an audience hall, Nishi Hongan-ji, Kyoto, c. 1630.

The Momoyama Period

The Momoyama Period (1573–1615) was fraught with warfare and internal unrest, but was also a time of rich artistic patronage. Rulers used the arts to enhance their political image with public festivals, highly decorated pageantry, and lavish buildings embellished with gold.

Figure 21.20 shows the interior of a Momoyama Period audience hall in Kyoto. It is devoid of furnishings and the rooms are divided by painted screens. The colors are subdued, but accented with blacks and highlighted in gold. Brown wooden pillars and beams blend with the screens and ceiling patterns, creating an interior environment filled with an interplay of simple spaces and complex imagery.

The Edo Period

Hokusai, *The Great Wave of Kanagawa*.
figure 2.11, page 24

The Edo (Tokugawa) Period (1615–1868), named for the capital city that is now Tokyo, is best known in the West for the woodblock prints that influenced nineteenth-century painting in Europe. Edo became a commercial and artistic center in the seventeenth century. Increasing demand for images led to the publication of colorful prints, notably those produced by the *Ukiyo-e* ("Floating World") School. The *Ukiyo-e* artists depicted scenes of everyday life, of fleeting pleasures, of leisure and entertainment (see figure 7.1) and of landscape.

The leading landscape artist was Katsushika Hokusai (1760–1849), who produced series of prints showing different views of specific locations. His most famous series is *Thirty-six Views of Mount Fuji*; this series depicted the volcanic Mount Fuji, which is about a hundred miles from Edo. It was regarded as a sacred mountain that was endowed with religious meaning related to ancient traditions of nature worship (see figure 2.11).

In *Mount Fuji in Clear Weather* (**figure 21.21**), Hokusai shows the mountain as a red triangle rising from a dark green forest plain and piercing the clear blue sky. Cold white clouds punctuate the blue and echo the rivers of snow flowing from the top of the mountain. The imposing, static character of Mount Fuji in this print conveys its power as an icon of the Japanese landscape.

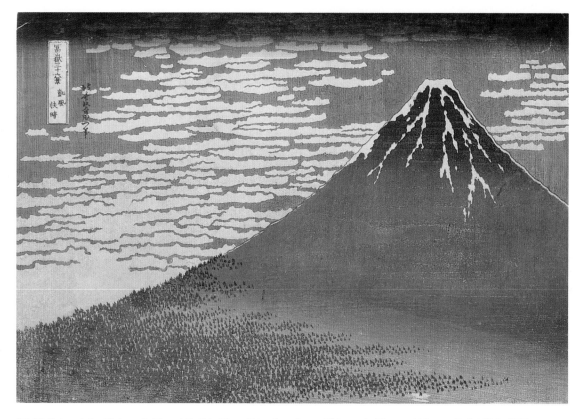

21.21 Katsushika Hokusai, *Mount Fuji in Clear Weather*, from *Thirty-six Views of Mount Fuji*, 1830–1832. Oban woodblock print, 10 ¼ x 15 in. Indianapolis Museum of Art.

Chapter 21 Glossary

beam-frame—type of construction in which projecting beams are supported by brackets extending from interior columns
hip-roof—gabled roof
kondo—main hall of a Japanese Buddhist temple or monastery
mandorla—oval of light surrounding the body of a holy person

pagoda—multistoried Buddhist reliquary tower
piece-mold—process method of bronze-casting used in ancient China
spacer—attachment used in piece-mold bronze-casting to separate sections of the mold from the core

22

KEY TOPICS

Northwest Africa: Nok, Mali, Dogon, Yoruba
Central-West Africa: Cameroon, Gabon, Kongo
South Africa: San rock art, The Great Zimbabwe

Art in Africa

A frica, like Asia, is a huge continent, composed of many different cultures with disparate geographies and diverse climates (see map). Not only is its art varied, but it has an ancient history. We saw in Chapter 15 that the civilization of ancient Egypt in Northeast Africa lasted 3,000 years and had cross-cultural interchanges with the Near East to the north and east, and Nubia to the south. Much of North Africa, which gives onto the Mediterranean Sea, was Hellenized by the armies of Alexander the Great in the late fourth century B.C. and conquered by Rome in the first century B.C. Throughout antiquity, Africa was a rich source of trade with the Mediterranean world, especially Greece and Rome. In the seventh and eighth centuries, Muslim Arabs overran North Africa and converted most of the area, which remains largely Muslim today.

The area south of the Sahara—sub-Saharan Africa—has produced works of art from about 1,000 cultures over the past 30,000 years. Some regions were traveled by explorers and merchants, colonized by Europe, and infiltrated by Christian missionaries, and thus show evidence of Western influence. The slave trade, plied by Europeans as well as by Americans, provided another source of contact with Africa. Some areas of the continent, however, remained relatively isolated throughout the nineteenth century.

It is impossible to characterize African art as a cohesive totality. Nevertheless, there are a few features of African culture that are relatively constant.

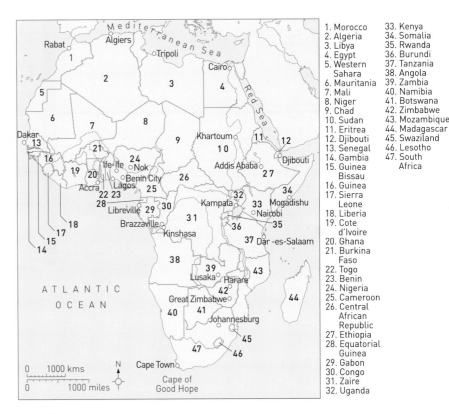

Africa.

These include polytheistic belief systems, ancestor worship, the notion that images and certain artifacts make possible communication between the human and spiritual worlds, and the oral transmission of history. African sculpture is generally produced by hereditary blacksmiths. Believed to have secret knowledge (which is associated in many cultures with artists who seem to have magic creative power), African blacksmiths are simultaneously admired and feared.

1. Morocco
2. Algeria
3. Libya
4. Egypt
5. Western Sahara
6. Mauritania
7. Mali
8. Niger
9. Chad
10. Sudan
11. Eritrea
12. Djibouti
13. Senegal
14. Gambia
15. Guinea Bissau
16. Guinea
17. Sierra Leone
18. Liberia
19. Cote d'Ivoire
20. Ghana
21. Burkina Faso
22. Togo
23. Benin
24. Nigeria
25. Cameroon
26. Central African Republic
27. Ethiopia
28. Equatorial Guinea
29. Gabon
30. Congo
31. Zaire
32. Uganda
33. Kenya
34. Somalia
35. Rwanda
36. Burundi
37. Tanzania
38. Angola
39. Zambia
40. Namibia
41. Botswana
42. Zimbabwe
43. Mozambique
44. Madagascar
45. Swaziland
46. Lesotho
47. South Africa

TIMELINE	HISTORICAL EVENTS	ART HISTORY	
28000 B.C.	● Paleolithic and Neolithic Stone Age cultures in Africa 28,000–800 B.C. ● Nok culture , Nigeria 800 B.C.–A.D. 600	● Tools and ornaments of stone, bone and shell from 28,000 B.C. ● Cave paintings, Natal. Drakensberg Mountains, Namibia c. 2nd millennium B.C. ● Nok-style head, Nigeria c. 800 B.C.–A.D. 200	**28000 B.C.**
A.D. 1000	● Yoruba culture , Nigeria and Benin 1000–1400 ● Kingdom of Mali 13th–14th century ● European colonization of Africa begins 15th century ● Kong kingdom 15th century ● Dogon culture western Sudan 15th century	● Yoruba royal head, Nigeria 11th–15th century ● The Great Enclosure, Great Zimbabwe c. 1350–1450 ● Great Mosque, Djenne, Mali 14th century ● *Nkisi nkondi* (medicine hunter figures) Democratic Republic of Congo 15th–17th century ● Benin sculptures 15th–19th century	**A.D. 1000**
A.D. 1500	● Bamum kingdom Cameroon early 19th century ● Collapse of Benin Kingdom and destruction of its captial 1897	● Yoruba-style beaded crown 19th century ● Seated Dogon couple, Mali 19th century ● Bamum Throne of King Nsa'ngu, Cameroon late 19th century	**A.D. 1500**

In the absence of writing systems, we do not know the names of the major African artists before the modern period and cannot always assign dates to African works. A great deal of art was made of perishable materials such as wood, beads, and shells, and has disappeared. Some of it is ceremonial and intentionally transitory.

Because of the vast diversity of African art, which usually has a ritual purpose, it cannot be understood outside its cultural context. This chapter thus considers a few representative examples of African art accompanied by a brief discussion of their cultural meaning. In light of uncertain dating, however, there is no attempt to present works chronologically. We begin with the Nok culture of central Nigeria, in Northwest Africa.

Northwest Africa

Among the areas of Northwest Africa that created major works of art are those found in modern-day Nigeria and Mali. Some cultures, such as the Nok, in northern Nigeria, were mainly agricultural. The Yoruba and Benin were more urbanized and produced a rich legacy of royal art. In Islamic Mali, Muslim monuments co-exist with the indigenous art of the Bamana and the Dogon.

Nok Culture

The agrarian Nok culture, named for the town of Nok, flourished from around 800 B.C. to A.D. 600. It had a long tradition of hollow terracotta sculptures fired in hot furnaces that were ventilated with bellows (**figure 22.1**). Most represent human figures with handmade, lifesize heads attached to short, stocky bodies, but some surviving Nok animal figures depict snakes, rams, elephants, and monkeys. The human heads are smooth, with hollowed-out, round pupils and an open mouth that create an expression of astonishment. The upper lip reaches to the wide, flattened nose and the ears are lower than in reality. There is stylization in the beaded eyebrows and incised parallel lines of the hair.

Little is known about the function of Nok figures and interpretations are limited by the fact that very few have been found in their original context. Even the well-documented sites have been disrupted by plundering and floods. The figures may have been used as grave goods or placed on altars and, since they have been found scattered over a large area, it is possible that they were traded. But scholars do not know why the Nok style disappeared or whether it was absorbed into subsequent Nigerian cultures.

22.1 Nok-style head, c. 800 B.C.–A.D. 200. Terracotta, 8 1/2 in. high. National Museum, Lagos.

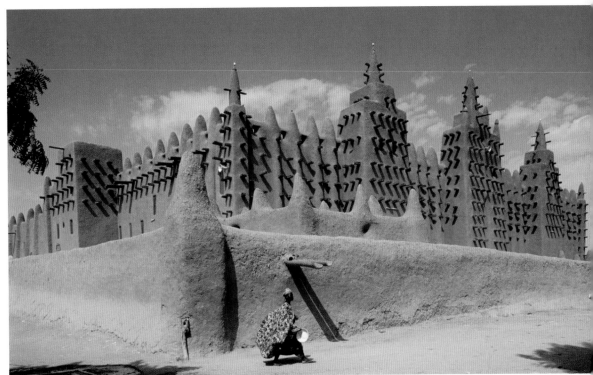

22.2 The Great Mosque, Djenne, Mali, 14th century. Adobe.

Mali

In Mali, the thirteenth-century Great Friday Mosque at Djenne was among the largest Muslim structures built in North Africa (**figure 22.2**). It was constructed of **adobe** (sun-dried brick) on the site of the palace after the Djenne king converted to Islam. The mosque is an example of load-bearing architecture (see Chapter 14), with thick walls and small windows. The outer surface is faced with mud plaster and recoated annually.

The walls slant inward as they rise to increase the stability of the structure. The *qibla* wall borders the city's marketplace and the *mihrab* is located inside the central tower. Ostrich eggs placed on the square towers of the *qibla* wall were believed to have associations with the cosmos and fertility. Formally, the horizontal wooden projections (*toron*) counteract the groupings of five vertical pillars attached to the outer wall and energize the mosque's exterior. The interior, in contrast, is dark and undecorated. Functionally, the protruding poles serve as footholds for workers who replaster the mosque each spring.

Despite the Islamic domination of Mali, other indigenous artistic traditions reflect the persistence of native style and custom. This can be seen, for example, in the sculptures of mothers and infants from Bamana (**figure 22.3**), the function of which was to assist women in childbirth and child-rearing. They were carved by blacksmiths for *Gwan* organizations, which were dedicated to insuring successful births. Such images were personifications of female procreation and are believed to have originated at the beginning of time. They are sometimes displayed with a male consort representing the first blacksmith, a notion relating the primal blacksmith–artist with creation and procreation.

The figure of the mother combines geometric forms—the cylindrical neck—and symmetry with a sense of organic volume. Her pendulous, triangular breasts denote her role as the provider of nourishment. She wears a conical cap worn by male hunters or shamans. The infant is shown in back view, clinging to its mother.

Mali was also the home of the Dogon culture, which arrived in the western Sudan some time during the fifteenth century. Their origins are in dispute, but it is known that they were hunters before being colonized by the French. Today the Dogon economy is based mainly on agriculture.

22.3 *Gwandusu* (mother-and-child-figure) from Bamana, Bougani or Dioila region, Mali, 15th–20th century. Wood, 4 ft. 8 ⁵/₈ in. high. The Metropolitan Museum of Art, New York. The Michael Rockefeller Memorial Collection. Bequest of Nelson A. Rockefeller, 1979. no. 79.206. 121.

The Dogon Seated Couple

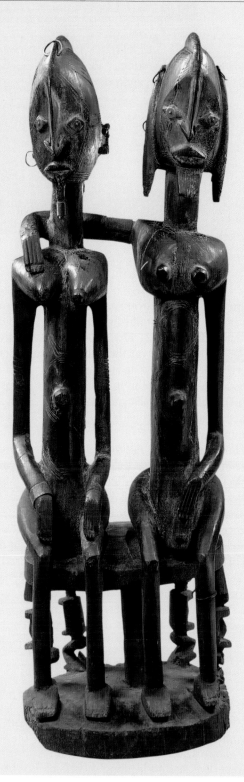

Like Bamana sculptures, those carved by the Dogon in Mali were the work of wood- and metal-working hereditary blacksmiths. The figures are themselves altars, which were made for shrines; it is not certain whom they represent. A prominent theme of Dogon sculpture is the human couple, possibly embodying the ideal of the family unit (**figure 22.4**).

One way in which the Dogon sculptors conveyed the idealized sense of unity was by minimizing gender differences between male and female. At the same time, however, there are conventional signs of different social roles. The man is slightly taller than the woman and he places his arm around her shoulder in a protective gesture. He gestures toward his phallus, emphasizing his function as a procreative force. The woman supports an infant on her back (not visible in this view), denoting her role as nurturer of the young, whereas the man carries a quiver, identifying him as a hunter and warrior. The man's nipples are flatter and rounder than those of the female, whose breasts, though small, are fuller than his. The couple sits side by side on a shared stool, underneath which are four small crouching figures. These may be ancestors whose function in supporting the stool could be a metaphor for the support they offer their living descendants.

Also minimizing gender difference is the geometric abstraction of the figures—note the long, thin cylindrical torsos, necks, arms, and legs. Facial features, such as the pointed noses, are stylized and, as with the Nok head in figure 22.1, the round pupils and oval mouths accentuate the intensity of their gazes. Here, however, the animated spaces that alternate with the solid forms are very much a part of the work's aesthetic impact.

22.4 Dogon seated couple, probably 16–19th century. Wood and metal, 28 ¾ in. high. Metropolitan Museum of Art, New York. Gift of Lester Wunderman, 1977. no. 77.394.15.

The Yoruba

In contrast to the Bamana and Dogon figures we have discussed, some African art is naturalistic and indicates a tradition of portraiture. Such works are found among the Yoruba of Nigeria and Benin Republic (formerly Dahomey), the most urbanized of the African cultures. The sacred capital, Ile-Ife, was considered the site of the world's inception and the place first ruled by Yoruba kings. According to Yoruba myth, the original ruler (the *oni*) was the creator god Oduduwa, who instituted centralized kingship. The palace thus became the political and spiritual focus of the city. It was also the artistic center, and the most impressive Yoruba works, dating from between A.D. 1000 and 1400, reflect royal patronage.

The importance accorded to artists in Yoruba culture can be seen in a so-called citation poem—a poem of praise—composed in the voice of the wife of the artist Olowe:

> . . . One who carves the hard wood of the *iroko*
> tree as though it were as soft as a Calabash.
> One who achieves fame with the Proceeds of his carving. . . .
> I shall always adore you, Olowe.
> Olowe, who carves the *iroko* wood.
> The master carver
> He went to the palace of Ogoga
> And spent four years there.
> He was carving there. . . .[1]

The naturalistic head in **figure 22.5** was cast by the lost-wax method and probably represents the *oni*. It is modeled organically, with a sense of muscle and bone structure underlying the surface. The incised lines on the face and neck could be either conventional scarification patterns or pure decoration. The holes at the edge of the scalp were probably for holding a crown or headdress in place.

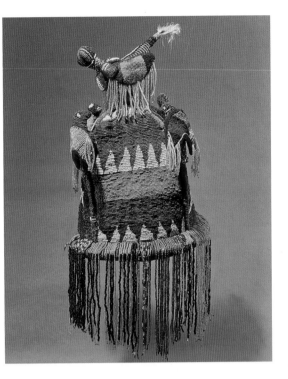

22.6 Yoruba-style beaded crown, 19th century. Beads and mixed media, 17 ³/₄ in. high. Musée de l'Homme, Paris.

The Yoruba believed that the head was the locus of character, knowledge, and good judgment, which are qualities they attributed to rulers. This head was one of many such sculptures found at the rear of the palace. They are thought to have been used during ceremonies and were possibly dressed for ancestor rites and other sacred performances.

Dressing the king for ceremonial purposes, as we saw in the beaded costume of the *oba* in Chapter 4 (see figure 4.4.), was an important part of Yoruba culture. It was meant to project an image of strength, wealth, and physical beauty.

One of the most lavish and significant aspects of Yoruba royal costuming was beading. Families of royal beaders worked under the patronage of the beading-god, Obalufon. The beaded crown in **figure 22.6**, made in the Yoruba style of the Benin Republic, is composed of diamond and triangle patterns. The bright colors have symbolic meaning that increases the authority inherent in the crown, and the bird motif at the top signifies the power of flight. Beaded veils separated the king from his subjects, which protected them from the danger of being in the royal presence. Medicinal plants, placed inside the top of the crown, reinforced the power of both the king and his headdress.

COMPARE

Airowayoye1.
figure 4.4, page 58

22.5 Yoruba royal head, Ife, 11th–15th century, from Nigeria. Zinc and brass, 12 ¹/₄ in. high. Museum of Ife Antiquities, Ife.

A surge of Western influence, mainly through colonization, infiltrated Nigeria at the end of the nineteenth century. From then on, the authority of the Yoruba kings declined. As if to compensate for this loss of power, the Yoruba expanded production of beaded crowns and other features of royal costuming.

Benin city in southwest Nigeria was colonized by Portugal in the fifteenth century. At that time, Benin was a flourishing urban center with a central palace and a royal enclave consisting of shrines, altars, and workshops, all of which were protected by a moat. By the seventeenth century, Benin was trading with the Dutch. Then, in 1897, a group of British officials was killed during an ancestor festival. The British retaliated by sending in a "punitive expedition," which destroyed the city and looted its valuables.

As at Ile-Ife, Benin had a rich tradition of royal art, producing sculptures of bronze, ivory, and terracotta. The central palace of Benin faced west, the direction of the thunder god, Ogiwu. Its *oba* ruled from the palace, but his closest advisor was the queen mother. She was not allowed to see her son once he became king and she lived outside the city wall in a separate palace. Other royal advisors were considered descendants of the *Ogiso*, divine rulers of the sky.

Benin's foremost royal animal was the leopard. The king wore leopard skins during ceremonies and processions, and live leopards participated in rituals. Leopard teeth and skins were highly prized objects awarded to chieftains and warriors as signs of achievement. Benin kings were called "leopards of the house," a metaphor attributing the leopard's speed, physical beauty, and danger to the king.

According to Benin tradition, the fifteenth-century king, Ewuare, enlarged the capital and its political administration, expanded religious rites, and was a generous patron of art and costuming. In one cultural myth, the blood of a leopard dripped on Ewuare as he slept under a tree. When he awoke, he killed the leopard and decreed that one leopard would be sacrificed each year.

Leopards are a frequent subject of royal Benin art. The brass water vessel in **figure 22.7** is clearly the product of a royal workshop. It shows a powerful, alert leopard, baring its teeth and fangs, ready to strike at any moment. The entire surface of the body is patterned with circles, which are stylizations of the leopard's spots. There are also incised patterns in the ears and whiskers, and a tail that resembles a serpent.

This was a type of vessel used during court rituals. Benin tradition has it that King Ewuare first received such a vessel from Olokun, the god of the sea and of wealth. Its form suggests contacts with the West and the origin of the myth of the sea god has been explained by the fact that water vessels such as this were first brought to Benin by European sailors.

Central-West Africa

The central regions of West Africa are considerably diverse. In Cameroon, traveled by merchants and penetrated by waves of migration, the terrain consists of grasslands and mountains. The art of Cameroon reflects the influx of different cultural and religious groups. In Gabon, which has a number of rainforests, the Fang culture was less urbanized than that of Cameroon. Fang social cohesion depended on small settlements and individual male groups, rather than on large centralized political centers. The Kongo Kingdom, to the east of Gabon, was founded early in the fifteenth century. It overlapped the areas occupied by modern Angola and Zaire.

22.7 Benin water vessel in the shape of a leopard, late 16th century. Brass, 12 in. high. British Museum, London.

Cameroon

Located to the south of Nigeria, Cameroon absorbed both Christianity and Islam. It was composed of many different kingdoms that have created widely divergent styles of art. The Bamum culture in the eastern part of the country was home to one of the most interesting late-nineteenth-century rulers. King Njoya ascended the throne in the 1890s while still an adolescent. He was an accomplished diplomat and politician, able to maintain good relations with both the Christians and the Muslims. With a view to recording Bamum history, Njoya invented a writing system based on a combination of Arabic and Western characters. He established a school to improve the general educational level of his subjects, built palaces, and patronized the arts. The architecture and textiles he commissioned show influences from German colonizers and Islam.

Njoya's close relations with Germany were established when the German emperor ordered the rescue of the head of Njoya's father, Nsa'ngu, from enemy hands. The head of the former king was then placed with other ancestral skulls in a designated room next to the reigning king's bedroom. In return for the assistance of the German emperor, in 1908 Njoya presented him with one of his father's thrones (**figure 22.8**).

Royal Bamum thrones were called "wealth of beads," which is reflected in the abundant beading on Nsa'ngu's throne. Such thrones were typically kept inside the palace and carried outdoors for ceremonies and state visits.

This example has a complex iconography, which is divided into three sections. At the back are two figures, male and female twins who guarded the royal cemetery and oversaw the king's coronation. The male twin at the right has a blue face and carries a phallic drinking horn; the red-faced female holds an offering bowl associated with a fertile womb. Echoing the twins' role as symbols of fertility are the frog designs on the headdresses. The small size of the twins, in relation to the king occupying the throne, was designed to enhance the viewer's impression of the king.

The middle section is cylindrical and contains an openwork pattern of intertwined, double-headed snakes, which denoted the warrior ancestry of the king. The surface of the seat and border designs are made of cowrie shells, which were used as currency and permitted as decoration only on royal thrones.

22.8 Bamum Throne of King Nsa'ngu from Cameroon, late 19th century. Wood, glass beads, and cowrie shells, 5 ft. 8 ½ in. high. Ethnologisches Museum, Berlin.

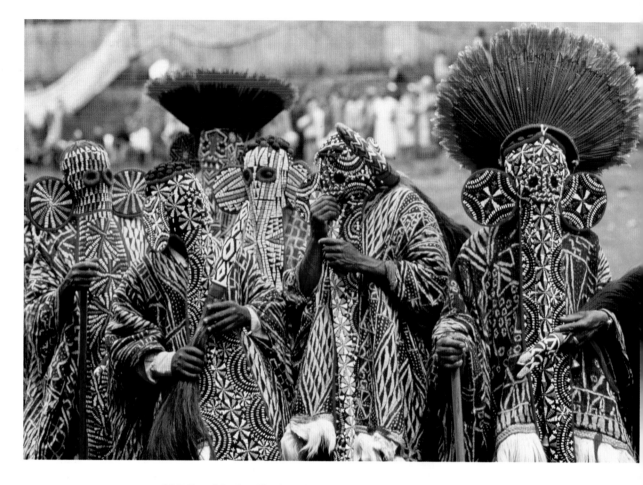

22.9 Kuosi Society Elephant Mask Performance, 1985. Cameroon.

The base of the throne is the king's footrest and its surface is covered with cowries. Two warriors, one at each end, carry rifles to defend the king. Carved spiders at the ends of the base signify sacred knowledge and good judgment. Since spiders were used for divination and their configurations were read as omens of the future, they stood for the king's ability to solve problems.

Njoya ruled until 1931, when the French placed him under house arrest and exiled him to the colonial capital of Yaounde, where he died in 1933.

Cameroon kings sometimes participated in masked festivals, for which elaborate ceremonial costumes had to be created. Such festivals are related to the palace, which is typically decorated with textiles for the occasion. The Kuosi Society of the Bamileke culture, located in the Cameroon grasslands, is known for lavish, dramatic masquerades, which are held every two years. Originally a hereditary warrior society, the contemporary Kuosi members are wealthy, influential men.

Figure 22.9 illustrates men participating in the Elephant Mask Performance in 1985. Their beaded costumes are made from dyed blue cloth and leop-ard skins. Long flaps hanging from their chins represent trunks that identify them as elephants, which are symbols of kingship. The elaborate headdresses fan out and culminate in wide circles of red feathers. In addition to the elephant, the colors have symbolic meaning: black denotes links between the living and the dead; white (the color of bones) alludes to the ancestors and is believed to have healing power; red (because it is the color of blood) stands for life, women, kingship, and fertility.

African ancestor worship is particularly pronounced among the Fang, who live along the south coast of Cameroon and in areas of Gabon. They kept relics of bones and skulls until the practice was banned by the French colonial government in the early twentieth century. Each family had its own ancestor reliquaries, to which their young men were introduced during initiation ceremonies. Because the Fang were, until recently, a nomadic culture, they did not build palaces or other permanent structures. They carved individual heads and complete figures to protect their reliquaries, which they carried from place to place. A large number of skulls reflected the importance of a family's ancestry.

MEANING

Sokari Douglas Camp and Traditional African Masks

Sokari Douglas Camp, a Kalabari woman who grew up in the delta region, recounts that, at the age of eight or nine, she was taken to the Museum of Mankind (part of the British Museum) in London and experienced a profound sense of discomfort. She saw a display of masks which she found disturbing because they were removed from their native Nigerian context. She recalls: "I discovered masks I knew looking dead, decapitated on poles and these items were described as being **masquerades**. The look of the display seemed out of context to a child. It would be like the crown jewels being described as the Queen. Yes, the crown jewels have something to do with the Queen but she would not be expected to sit with her regalia every day. So the masks at the British Museum

were not properly dressed, they did not have people wearing them with costumes and there was no music. In my practice I have worked figuratively to get masks at the right height visually and my work has touched on sound and kinetic movement because these are what one would find at a masquerade performance. I love the elements of theater or a happening for a gallery exhibition because I have such fun memories of these components during masquerade showings in my home town."

Douglas Camp's work has been influenced by Kalabrian tradition and masquerades. She began her work "observing how masks are put on to masqueraders, how the human form is changed, how men become gods when they perform . . . The way I remember seeing masks and masqueraders when they performed for my town is the masquerades are alive and frightening and beautiful when they move. Fear in masquerading is an important element for the observer. It adds to the play of the spirits. This element does not come across in a museum, because the mask is not moving and is usually in a glass box."

Douglas Camp evokes the animated quality of the masquerade in motion in her sculptures. She made two versions of the *Otobo* (*Hippo*) masquerade (**figure 22.10**), as she explains:" I made the first for my Museum of Mankind exhibition in 1994: *Play and Display.* I felt it was important to show the mask of Otobo facing the viewer. In reality the face/mask of the *Otobo* is hardly seen by the viewers because the mask is made to face the sky. It is worn as a hat on top of the performer's head—only when the dancer looks at the ground is the full face of the masquerade seen. The masquerade also has a garland of fresh palm leaves around the mask which makes you think that the face of this creature is wading through water or reeds. Over the years carvers have worked on this structure, combining the face of a man and the face of a hippo. The current mask features are startling and fierce. I kept as close to this format as the other artists except that my mask is made of steel. For my Museum of Mankind show I liked the idea that the visitor to the exhibition could view the masquerade like God, with face-to-face contact."

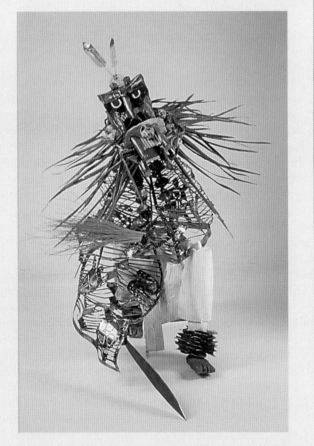

22.10 Sokari Douglas Camp. *Otobo* (*Hippo*) *Masquerade*, 1993. Wood, steel, and palm-stem brooms, 6 ft. high. British Museum, London.

Quotations from email exchange with Sokari Douglas Camp.

In northern Gabon, Fang reliquary guardians (***bieri***) were full-length standing figures (**figure 22.11**). This one was carved by the Mabea, who predated the Fang but have been absorbed into Fang culture. The figure's surface is smooth and lightly polished. A tight-fitting helmet is placed on the relatively small head. The nose is also small, but the eyes are large and almond-shaped, the jaw juts forward aggressively, and the teeth are bared. The cylindrical neck seems too large for the head, as does the body, which is a curious combination of organic and geometric form. Aside from the ankle rings, the helmet, and the flat armbands, the figure is nude. This and other Fang reliquary sculptures have baby-faces, which have been interpreted as an allusion to the idea that newborns are closer to the ancestor world, which they link with that of the adult living world.

Another major culture of Central Africa was the Kongo Kingdom located in the Congo Basin. At its height in the late fifteenth century, the Kongo Kingdom was a large, centrally governed state. It maintained a flourishing trade with cultures along the coast and in the interior of the continent. In the course of the next 200 years, the Kongo developed diplomatic relations with Brazil and parts of Europe.

One of the most characteristic Kongo sculpture types, the ***nkisi*** (medicine) ***nkondi*** (hunter) figure (**figure 22.12**), was associated with rulers. These were used in a ceremonial context, accompanied by singing, dancing, and drum-beating. They have a medicinal function, because they contain objects such as vessels, shells, and gourds that are themselves containers for materials endowed with healing power. These are usually placed inside the head or torso.

The *nkondi* (meaning "hunter") is a category of *nkisi* and is so called because it was used

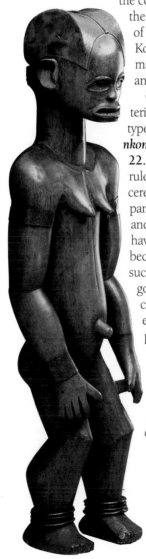

22.11 Fang *Bieri* figure, undated. Wood. Barbier-Mueller Museum, Geneva.

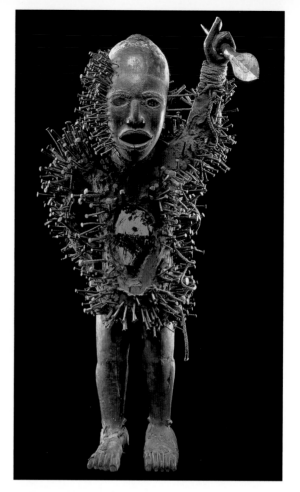

22.12 *Nkisi nkondi* (medicine hunter figure) from the Democratic Republic of Congo, Kongo, collected 1905. Wood, metal, glass, mixed media, 3 ft. 2 in. high. Barbier-Mueller Museum, Geneva.

by priests to solve problems and seek out lawbreakers. Once the figure was carved it was presented to the priest (the *nganga*), who then placed medicines and fetishes in the containers. Often the opening was sealed with a mirror, which priests used for divination. The figure shown here can be identified as a *nkisi nkondi* by the upraised hand wielding a weapon. The aggressive character of the work is accentuated by the frontal pose, intense gaze, and open mouth. By carving an open mouth, the artist reminds viewers of the belief that speech and saliva are transmitters of power.

Nails are driven into the *nkisi nkondi* when a person seeks to activate the statue's power by angering it. Many nails mean that the statue has been consulted many times and is thus a powerful healer and problem-solver. The pain caused by the nails is believed to be transferred to the offender being sought. The offender, in turn, might consult another *nkisi nkondi* to counteract the effects of the first statue and cure his pain. Such statues performed a dual role: they protected the king and the laws, while also embodying the king's power to protect his state and its subjects.

Although colonial officials banned the use of hunter figures as of 1920, some are still in use today.

South Africa

The oldest surviving works of African art have been discovered in the south. They were produced by the San (formerly called Bushmen) of South Africa in the form of impressive rock paintings at thousands of mountain sites. In the late nineteenth century, the Afrikaaners tried to wipe out San culture, which led to its decline. In Zimbabwe, the Shona culture was at its height between around 1350 and 1450; its most powerful city was the Great Zimbabwe. The San were Africa's oldest known cultural group, and their art sheds light on their religious practices—especially shamanism. A number of rock paintings illustrate the shamanistic beliefs of the San, suggesting that the imagery was itself part of their rituals.

The animal most often associated with San rock art is the slow-moving eland, a large antelope hunted for food (**figure 22.13**). In this example, the elands are depicted naturalistically, indicating that the artists studied their appearance and wanted them to appear realistic. The elands are shown in different poses, from various angles, and their shaded bodies convey an impression of three-dimensional massiveness. One eland has been speared and is dying. The hunters identify with their prey and suffer along with it; they tremble, their noses bleed, and they salivate. Like the shaman, the hunters enter into a trancelike state, dance in a circle around the dying animal, and absorb its power.

In contrast to the San, who did not build monumental architecture, the people of Great Zimbabwe smelted metals and imported luxury goods from the East. They also built impressive structures, the most famous of which is the Great Enclosure (**figures 22.14** and **22.15**). The monumental size and craftsmanship of the wall, its conical tower, and granite blocks precisely cut without the use of mortar attest the power of Great Zimbabwe in its heyday.

Originally the term **zimbabwe** referred to a court or palace. Today it denotes the ruins of a great city. The oval plan (figure 22.15) of the Great Enclosure

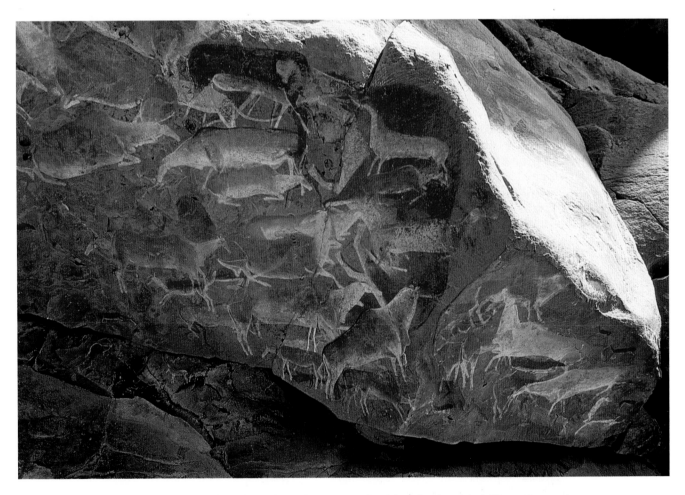

22.13 *Men assuming eland features as they approach a dying eland*, undated. Pigment on rock. Game Pass shelter, Kamberg, Natal Drakensberg Mountains, southern Namibia.

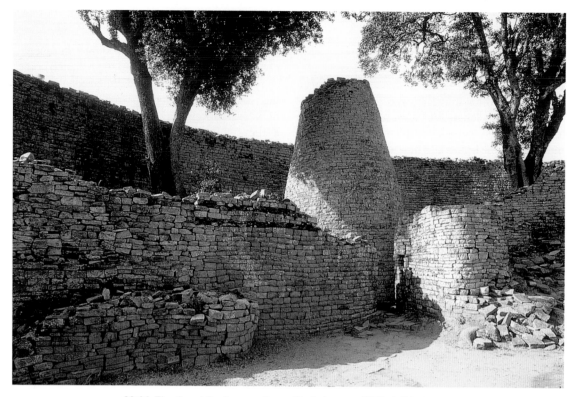

22.14 The Great Enclosure, Great Zimbabwe, c. 1350–1450. Stone.

shows the outer stone wall (292 feet in diameter), its three entrances, and tower. The wall itself is 20 feet thick and rises as high as 30 feet in certain places; at the top, it is decorated with stone courses forming chevron bands. These stand for the king in his dual aspect as an eagle and as a flash of lightning. As such, they signify his power to connect earth with sky and control the elements of nature.

In Great Zimbabwe, there was no more monumental architecture on the scale of the Great Enclosure after the arrival of the European colonizers. As we have seen, when European officials banned certain customs, the art through which the customs were expressed often declined. In other instances such as in Mali, however, indigenous African arts and traditional practices co-existed with superimposed customs and imported styles.

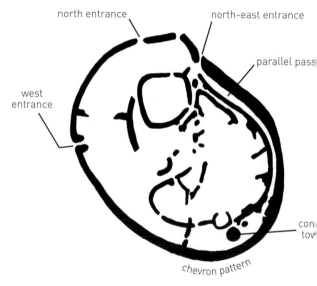

22.15 Plan of the Great Enclosure, Great Zimbabwe.

Chapter 22 Glossary

adobe—sundried brick made of earth and straw
bieri—Fang reliquary guardians
masquerade—(a) gathering of people wearing masks; (b) costume worn at such a gathering

nkisi nkondi—literally "medicine hunter," a type of royal Kongo sculpture
zimbabwe—originally a court or palace; today refers to the ruins of a great city

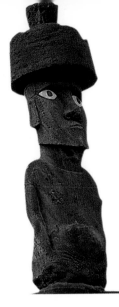

Art of the Pacific and the Americas

The arts covered in this chapter span three continents (Australia, and North and South America linked by Mesoamerica) and thousands of islands thousands of miles apart. The Americas are separated from the Pacific Islands by the huge expanse of the Pacific Ocean. Before the end of the last Ice Age, about 10,000 years ago, Asia and Alaska were connected by a land bridge, over which people migrated from parts of the Far East to the North American continent. But with the flooding of the bridge, migrations ended and groups from these regions lost contact with each other.

By the early sixteenth century, European explorers had begun circumnavigating the globe. Much of our information about the Pacific comes from accounts and drawings compiled by these Europeans—the best known being the eighteenth-century Englishman Captain James Cook (1728–1779). Soon thereafter, colonization of the Pacific cultures began.

The origins of the people who inhabited the American continents is still debated by scholars. It is generally assumed that they too migrated over the land bridge from East Asia to Alaska and then moved south to South America and across North America. By around 13,000 B.C., both North and South America had indigenous populations. And although the extent of communication between them is not known, there is some evidence of Mesoamerican influence on Native American groups.

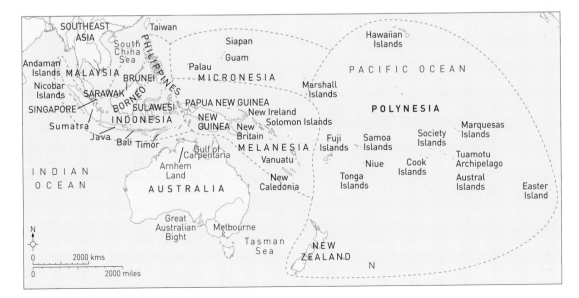

Australia and the Pacific Islands.

HISTORICAL EVENTS	ART HISTORY
50,000 B.C. ● Aboriginal population in Australia c. 50,000 B.C. ● Oceanic islands settled c. 40,000 B.C. ● First settlement of the Melanesian islands c. 25,000 B.C.	● Stone carvings Papua New Guinea c. 18,000 B.C.
A.D. 1000 ● New Zealand settled c. A.D. 9000 ● Easter Island culture 1100–1500	● Easter Island statues (*moai*) A.D. 1000 and 1500
A.D. 1500 ● Easter Island discovered by the Dutch 1722 ● Hawaii united under Kamehamaha I (r. c. 1758–1819) ● Three voyages of Captain James Cook charting the Pacific Islands 1768–1779	● Men's House (*bai*), Belau Islands c. 1700 ● Feathered god from Hawaii collected by Captain Cook c. 1776–1780 ● Meeting House, New Zealand 1840s ● Modern Aboriginal painting, Australia 1920s

around A.D. 900, seafarers had settled most of the islands and formed into distinct groups, each with its own rich cultural and artistic tradition. Some of these declined with European colonization, but today most are independent and have reasserted their cultural and artistic identities.

Although the cultures of the Pacific are widely disparate, certain common themes are found throughout the region. All cultures are polytheistic, and most trace their ancestors to the gods. There is a prevailing belief that people can contact the spiritual world of the ancestors (called the Dreaming by Australian Aborigines—see p. 31) through images, sacred spaces, and ceremonial buildings. Works of art are considered a means of communication that can transcend time and space. This led to the idea that sacred art and architecture are imbued with a spiritual essence called **mana**.

Mana is a complex notion. It is believed to originate with the gods and to increase with time, as objects, sacred sites, or generations of families exist for longer and longer periods. In figurative art, *mana* tends to be concentrated in the head or spine, both of which are associated with the ancestors and genealogy. Another way in which humans can enhance their *mana* is through ceremonies, costuming and masking, and decorating their bodies with tattoos and scarification. Sacred sites and ceremonial meeting houses used for initiation and other cultural rituals are also important sources of *mana*.

The force that protects *mana*, but is also potentially dangerous, is **tapu**, which is related to the concept of taboo. A person or object that is taboo must generally be avoided, and a taboo building or space cannot be entered except under certain prescribed circumstances. The taboo figure is sacred and profane, benevolent and dangerous, and believed to be able to shift from past to present, from human to animal, and from one world to another. In many Pacific cultures, as elsewhere, these powers are embodied in the shaman.

Australia

The large island continent of Australia has an Aboriginal population of hunters and gatherers descended from Southeast Asians who migrated there more than 50,000 years ago. For thousands of years, the Aborigines painted on rocks and cave walls located in sacred areas. The *Wandjina* (cloud spirits) we considered in Chapter 2 (see figure 2.20) embodied the Aboriginal notion of the Dreaming, through which it was believed possible to contact the spirit world of ancestors. The Aborigines also had a tradition of painting on bark; subjects included mythological figures and the indigenous animals that they hunted for food.

Wandjina rock painting.
figure 2.20, page 32

Whereas Western Europe had had contacts with Asia and Africa since antiquity, the discovery of the Americas and the Pacific opened new, hitherto unknown cultures to the Western world. The term "pre-European contact" denotes periods before Western Europeans infiltrated and colonized Pacific regions and before settlers arrived in North America; "pre-Columbian" denotes the art and culture of South America before the arrival of Christopher Columbus and the Spanish conquest in the late fifteenth and early sixteenth centuries.

Arts of the Pacific

The Pacific includes the Oceanic Islands and Australia, the latter settled by Southeast Asians about 40,000 B.C. (see map on p. 467). The islands of Oceania are grouped into three large regions: Melanesia ("Black Islands"), Micronesia ("Small Islands"), and Polynesia ("Many Islands"). By

figure composed of sharp diagonals and open spaces that convey rapid movement. The pronounced phallus is typical of images of *mimi* hunters and is probably a sign of male fertility and power.

The bark paintings of Australia have a didactic as well as a magical purpose. They are meant to teach hunting methods to young boys and to transmit mythological traditions. Furthermore, the very act of painting the figure was believed to assist the hunter by fixing the image of his prey on a surface. In addition to such hunting magic, bark paintings were used to illustrate proper social behavior and to call on spirits for aid in fertility and in curing disease.

Melanesia

Moving north and northeast of Australia, we come to Melanesia, which includes New Guinea, New Ireland, New Britain, and the western Solomon Islands. Parts of Melanesia were settled more than 27,000 years ago by people who spoke a Papuan language. Some 21,000 years later, a new, Austronesian group arrived by canoe and populated the islands. The antiquity of their art is reflected in a number of small figures carved from stone that have been found in the region of Papua, New Guinea and are believed to be around 18,000 years old. The curious animal, possibly an anteater, in **figure 23.2** has a long, phallic snout and a body with human characteristics. It is seated like a human, with its elbows resting on its knees. The eye is stylized and the surface rough but elegantly shaped. We do not know the meaning of such figures, although the merging of human with animal qualities suggests the transformations of the shaman.

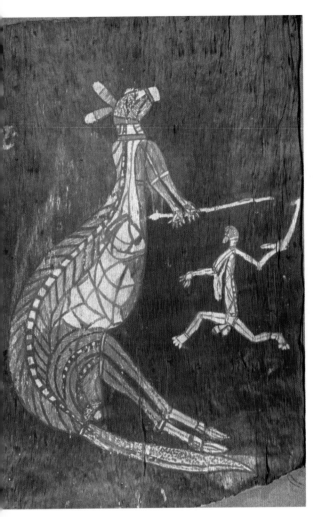

23.1 *Hunter and Kangaroo*, c. 1912, from Oenpelli, Arnhem Land, Australia. Paint on board, 4 ft. 3 in. x 2 ft. 8 in. Museum Victoria, Melbourne, Australia.

Modern Aboriginal painting dates from the 1920s and we depend on reports by anthropologists to explain its iconography. A favorite subject, the kangaroo hunt, is shown in the bark painting in **figure 23.1**. This depicts a spirit hunter (*mimi*) spearing a rare black kangaroo on a dark red-brown background. *Mimis* are elongated figures in Aboriginal myth; they have power over humans and teach them how to hunt and how to behave.

In this example, the *mimi* is a stick figure carrying a sack (a dilly bag) filled with hunting aids on his shoulder. Both the *mimi* and the kangaroo are clearly delineated in the ancient "X-Ray" style of Arnhem Land, in north Australia, which shows a schematic view of the internal organs. The artist has depicted the kangaroo in the process of dying. Its spine and bulky lower body begin to collapse in a gradual curve, whereas the upper body is more animated and the extended hands seem to be trying to ward off the spear. The *mimi*, in contrast, is an aggressive

23.2 The Ambum Stone, from the Ambum Valley, Western Highlands Province, Papua, New Guinea. Prehistoric igneous rock, 7 1/4 in. high. National Gallery of Australia, Canberra.

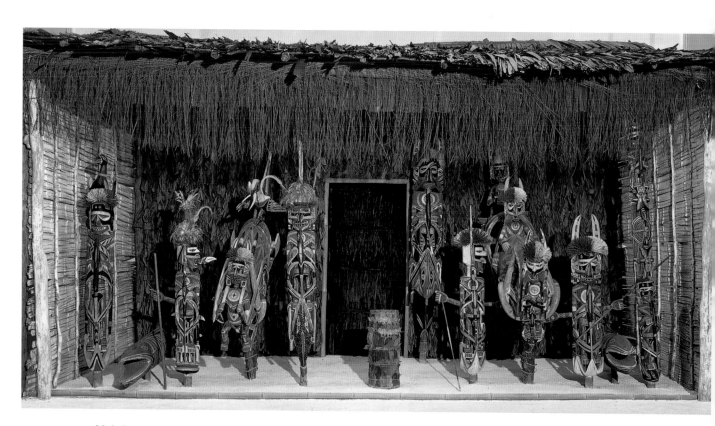

23.3 Recreation of a *malanggan* tableau from New Ireland. Bamboo, palm, croton leaves, and painted wood, 8 ft. 6 in. x 16 ft. 6 in. x 10 ft. Museum der Kulturen, Basel, Switzerland.

More recent works from New Ireland include the elaborate, colorful carvings used in *malanggan* funerary rites (**figure 23.3**). Masking ceremonies, in which dance and music were performed, took place in enclosed structures faced with green foliage. Openwork carved poles were exhibited in front of the façade and the bones of the deceased were wrapped and placed beside them. The imagery on these poles represents palm leaves, feathers, birds, fish, snakes, and animal combinations, all of which represent clan ancestors (totems). Accompanying rituals were designed to speed the spirits of the dead on their way to join the ancestors.

Traditionally, a new set of totem poles was created for each funeral. Relatives of the deceased gathered to attend the performances, participate in the feasting, and trade ornaments. The final event was the display of the poles and other works of art. At the conclusion of the ceremony, the sculptures were burned or exposed to the elements and left to disintegrate. This custom was believed to prevent other clans from using the images and taking their power.

Polynesia

To the east and northeast of Australia lie the Polynesian islands, which were isolated from the West until the voyages of Captain Cook. Polynesia forms a large triangular area with Hawaii to the north, New Zealand to the southwest, and Easter Island to the southeast. In between are the Marquesas, Samoa, Tahiti and the Society Islands, Fiji, and Samoa. The Marquesas and New Zealand were ruled by chiefs; Tahiti and Hawaii had more centralized kingship systems. All of Polynesia remained isolated until the colonization in the nineteenth century of Fiji and New Zealand by the British, Samoa by the United States and Germany, and the Marquesas and Tahiti by the French.

Hawaii

Beginning around A.D. 300, Marquesans sailed to Hawaii and 600 years later the Tahitians followed. Hawaii was annexed to the United States in 1898 and

became a state in 1959. The first ruler to unite Hawaii under a single king, Kamehameha I (c. 1758–1819), enjoyed an unusual degree of prosperity and commissioned a great deal of art.

Kamehameha's patron deity was the war god Kukailimoku. The king housed statues of Kukailimoku next to his own dwelling and erected temples (**heiau**) dedicated to him. Like other Polynesian gods, Kukailimoku was conceived of as covered in features denoting the power of flight (**figure 23.4**). Feathers signified high status, and feathered busts such as this were placed on poletops, carried in processions, and celebrated with singing and dancing.

The god's face is made of red feathers, with a yellow feathered crest adding *mana* to the image. Such crests were also worn on helmets, where they symbolically protected the head of the warrior. They were thought of as an abbreviated spine that conferred genealogical power on the head. When effigies of his feathered head were carried aloft on a pole, Kukailimoku seemed to be glaring angrily down on the human race. His slanted eyes, bushy black brows, bared dog's teeth, and fearsome, grimacing countenance appear disapproving and dangerous. The combination of the bust type with nonhuman features and a feathered surface creates a surreal, uncanny effect.

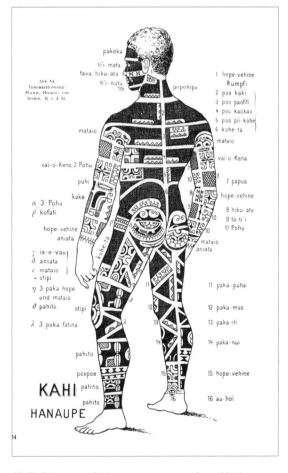

23.4 Feathered god from Hawaii, collected by Captain Cook in 1776–1780. Fiber, feathers, dog teeth, and shell on wickerwork, 18 ³/₄ in. high. Institut und Sammlung der Kulturen, Göttingen, Germany.

Marquesan Tattooing

Throughout Polynesia, decoration was an important expression of rank. Ornaments conferring status on the wearer were made of ivory, shell, whale teeth, and porpoise teeth. In the Marquesas Islands, the human body was a popular surface for tattooed designs that signified status and gender, and provided protection through the presence of *mana*.

Many drawings of Marquesan tattoos were made in the late nineteenth century by European visitors (**figure 23.5**). In this diagram, the entire surface of the subject's body is covered with geometric patterns. The vertical of the spine is clearly marked, as are the legs, and schematic curvilinear designs conform to the contours of the body.

Marquesan women were also tattooed, but with different and fewer patterns. A man's entire body was covered, but the woman's torso, shoulders, and neck were not. The man's tattoos provided protection in war and power to kill the enemy, whereas female tattoos enhanced fertility and the nourishment of the young.

23.5 Diagram of Marquesan tattoos from Karl von den Steinen, "Die Marquesaner und ihre Kunst," 1925.

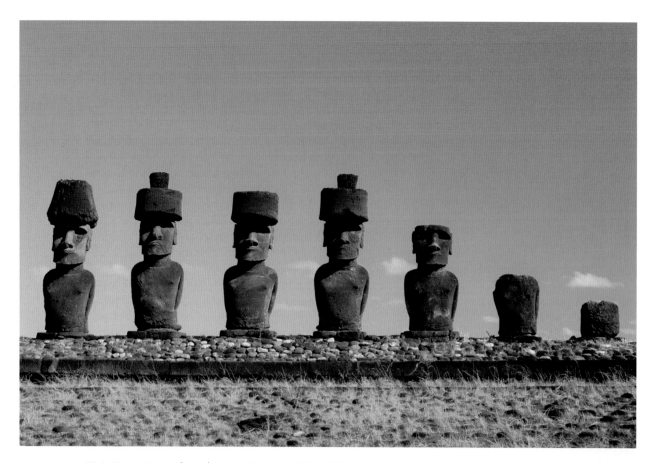

23.6 Stone figures (*moai*) on Ahu Naunau, 1000–1500. 24 ft. high. Anakena, Easter Island (Rapanui).

Easter Island

In southeast Polynesia, the remote island known to its inhabitants as Rapanui and to Westerners as Easter Island produced some of the world's most imposing and mysterious works of art (**figure 23.6**). At 24 feet high, these monumental sculptures are the largest carved stone statues in Polynesia. They date to some time between A.D. 1000 and 1500. Called *moai*, they are placed on outdoor platforms (*ahu*) in ceremonial centers with ramps, courtyards, and underground burials. Quarried from volcanic rock and then dragged to the site, these figures are assumed to represent divine ancestors, possibly deified chieftains. They consist of a solid torso and a head, usually with a large round crown and red **tufa** (porous volcanic stone) topknots. Their poses are frontal and their expressions are impassive. Most had large, inlaid coral eyes with dark stone pupils, pursed lips, and large ears and noses. They appear to be gazing out to sea, as if eternally protecting the island.

The meaning of these remarkable statues is uncertain. The cultures that produced the *moai* had disappeared, probably as a result of warfare, by the seventeenth century. Over the course of the next 200 years, the statues were neglected and eventually fell into ruin.

New Zealand

New Zealand, to the southeast of Australia, was settled around A.D. 900 by the Maori, a people of uncertain origin. The first European contacts with the island occurred in the eighteenth century and, by the nineteenth, Maori carvers were using Western tools to create distinctive works of sculpture and architecture. Early Western travelers were impressed by the Maori's use of agricultural terraces, their houses surrounded by wooden fences, and their rich oral literary tradition. Warfare was a fact of Maori life and their elaborately carved canoes could carry more than forty warriors.

For the Maori, gods were the primal artists, making living human artists links to the gods. Maori artists were protected by Tane, the crafts god of creativity and of the forests (the source of the wood from which sculptures were carved). The very process of making art followed ritual rules designed to endow works with a high degree of *mana*.

The most characteristic architectural structure of the Maori was the meeting house, where leaders met to discuss social and political issues. In the nineteenth century, the warrior-chieftain and priest Raharuhi Rukupo (c. 1800–1873) built the meeting

house in **figure 23.7** to honor his dead brother, the previous chief. Rukupo hired eighteen carvers skilled in the use of metal tools imported from the West.

The statues are carved with the swirling, curvilinear surface patterns typical of Maori style. The symbolism of the house is highly complex: the house stands for the cosmos, while poles and ceiling rafters form the spine and ribs of the sky god and represent the chief's divine descent. Carved wooden figures along the walls embody protective ancestors (**tiki**), whose *mana* resides in their oversized heads. Their wide, watchful eyes and fearsome expressions reflect their **apotropaic** purpose—to ward off the "evil eye" and defend the interior from danger. Alternating with the *tiki* are rectangular weavings, the patterns of which have symbolic meaning. They were made by elite women, who had to work from the exterior because they were barred from entering the house except on special occasions.

Taken as a whole, the Maori meeting house is a cosmic metaphor. It gives concrete form to the belief that ancestors, appeased by rituals, support divine tradition and royal lineage. This particular meeting house has been preserved as a national monument and is open to the public. Historically, however, the meeting houses, like the *malanggan* tableaux of New Ireland, were allowed to fall into ruin and disintegrate.

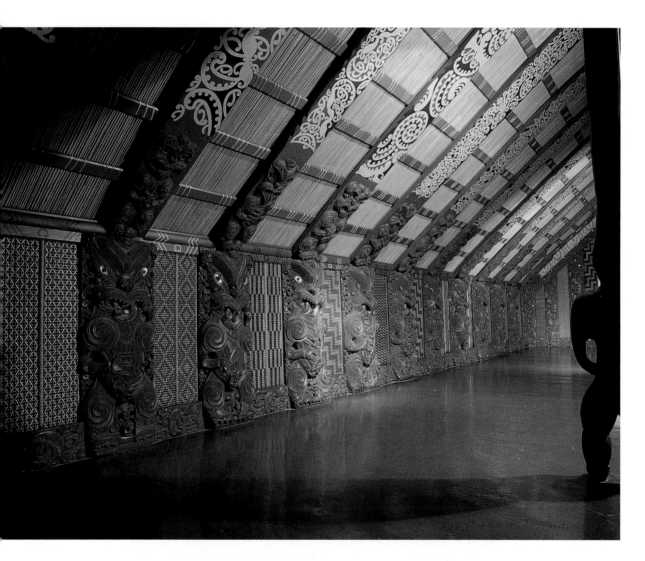

23.7 Interior of *Te Maori Hau-ki-Turanga* (Spirit of Turanga) Meeting House, Poverty Bay, New Zealand, 1840s, restored 1935. Wood, shell, grass, flax, and pigment. Auckland Museum, New Zealand.

Micronesia

Proceeding west from Polynesia and northwest from Melanesia, we come to the large western Pacific area of Micronesia. Composed of numerous islands, its largest groups are the Caroline and Mariana Islands. Those that are inhabited are mainly coral atolls with limited vegetation and fewer animals than in Melanesia and Polynesia.

Like the Maori, the Micronesians built ritual houses for meetings, receptions, and ceremonies. The men's house (**bai**) in Belau on the Caroline Islands (**figure 23.8**) is located in the village of a local chieftain. It has six doors that are taboo; they cannot be touched and only elite males are allowed to enter through them. The image of a bat at each entrance is a warning to visitors to obey convention and not violate the taboo. The interior contains seats arranged according to rank, with the four leaders placed at each corner. This symbolizes their role as the foundation and support of the community.

The men occupying the corners were elected by the senior women (*ourot*) of the clan, who could also recall them from their position of privilege. Although statues of two *ourot* were placed on the door jambs of the west façade, the women themselves were barred from the house except during certain periods. Generally women had their own communal houses, which were smaller than those used by men.

The designs on the façade illustrate episodes of village history. Each of the ten horizontal strips (called **story boards**) on this house depicts a particular event in symbolic form. Animals, especially fish, reflect the economy of the region; plants and phalluses encourage fertility; the sun signifies divine protection; and the heads show success in war and the practice of head-hunting. Heads of defeated enemies were typically displayed on stakes outside the house or placed under the entrances.

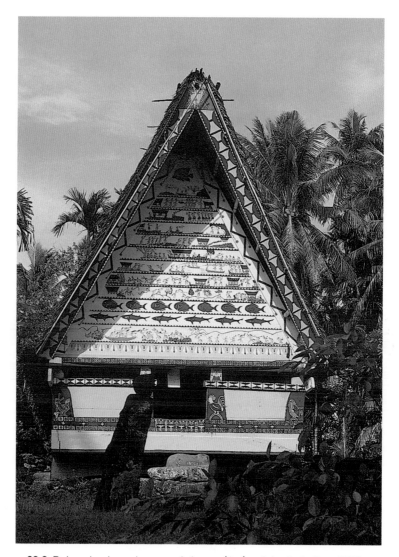

23.8 Bai-ra-Irrai, modern men's house (*bai*), originally built c. 1700 and later restored. Irrai, Belau, Caroline Islands.

Arts of the Americas

We now turn our attention to the arts of the Americas. If we were to sail hundreds of miles eastward from Easter Island, we would eventually reach the west coast of South America (see map, right). If we then traveled north to western Bolivia and modern Peru, we would be in the region of the Andes Mountains. These were the site of ancient cultures that produced monumental architecture, distinctive pottery and sculptural types, and remarkable textiles imbued with profound cultural meaning.

Paracas Culture

Located on the Paracas Peninsula on the southern Pacific coast of Peru, Paracas culture is known for its fine, intricate textile manufacture, which flourished

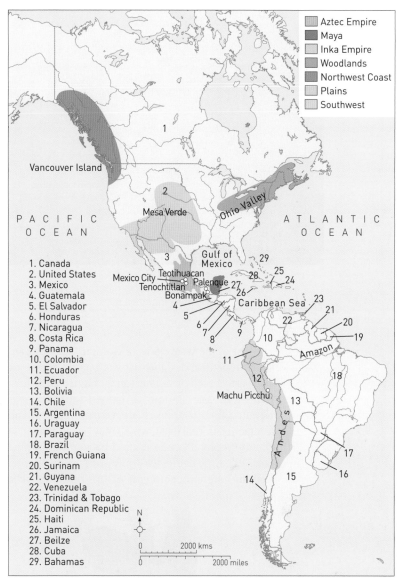

The Americas.

HISTORICAL EVENTS	ART HISTORY
13,000 B.C.	
● Indigenous populations in North and South America c. 13,000 B.C.	
● Mesoamerica Preclassic period 1200 B.C.–A.D. 250	● Olmec head, Mexico c. 1000 B.C.
● Paracas culture, Peru c. 700 B.C.–A.D. 200	
● Woodlands culture North America 500 B.C.–A.D. 600	● Adena human effigy pipe, Woodlands culture, Ohio 500 B.C.–A.D. 1
● Moche culture, Peru c. 200 B.C.–A.D. 600	● Embroidered mantle, Paracas Necropolis, Peru 200 B.C.–A.D. 200
A.D. 0	
● Mesoamerica Classic period 250–900	● Pyramid of the Moon, Teotihuacan, Mexico 250
	● Deer-headed warrior, Moche culture, Peru 450–550
● Mesoamerica Postclassic period 900–c. 1520	● Maya Palace, Palenque, Mexico 7th century
1000	
● Aztec Empire 1300–1500	● Anasazi cliff dwellings, Mesa Verde, Colorado c. 1100–1200
● Inka Empire 1450–1532	● Inka city of Machu Picchu, Peru 1450–1530
1500	
● Spanish Conquistadors destroy Aztec and Inka empires 1521–1532	● Aztec Calendar Stone, Tenochtitlán, Mexico 1502–1520
● Louisiana Purchase 1803	● Sioux *tipi*, probably South Dakota c. 1885
	● Kwakiutl Transformation Mask, Vancouver Island late 19th century

from around 700 B.C. to A.D. 200. Many are today in good condition, well preserved by the dry climate. The main materials used by Paracas textile workers were cotton and wool—particularly that of the indigenous alpaca, llama, and vicuna. Most of the cloth was woven or embroidered for everyday clothing, but some was intended for the deceased, who were wrapped in layers of cloth and buried in a fetal position. The dead were accompanied by lavish grave goods and decorated with jewelry. Modern scholars assume that Paracas burials were intended to provide the dead with what they would need in the afterlife.

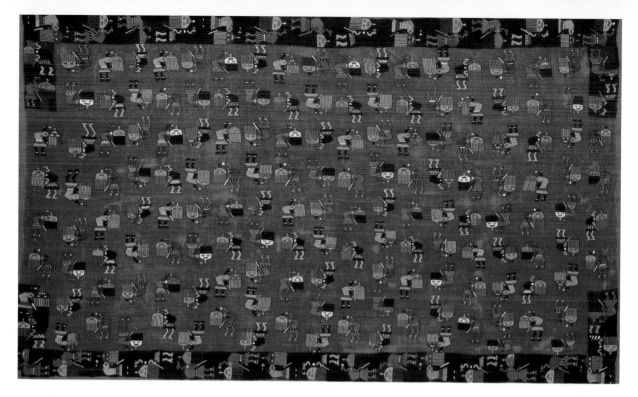

23.9 Embroidered mantle, from Paracas Necropolis, south coast of Peru, late Paracas, c. A.D. 200. Camelid fiber, entire mantle 4 ft. 7 ⅞ in. x 7 ft. 10 ⅞ in. Museum of Fine Arts, Boston. William A. Paine Fund.

Most of the weavers were women. They created small, repetitive designs that were partly geometric and partly based on animal forms. **Figure 23.9** illustrates the basic figure of an armed warrior that is repeated about 200 times. He has a profile body and a detached frontal head, which may be his own or an enemy trophy. Placed on a red background with a black edge, the figures vary only in color and orientation and are either upright or upside down. The frontality of the heads, with their staring eyes, toothy grins, and erect hair, probably served the protective function of keeping evil away from the deceased wrapped in the textile.

Moche Culture

To the north of Paracas on Peru's coast, the Moche civilization flourished from about 200 B.C. to A.D. 600. The Moche, like the Paracas culture, produced works of art to accompany the dead. They performed elaborate burial rituals, built large architectural complexes, and established a centralized government ruled by a king.

Among the major surviving artistic productions of the Moche are terracotta ceramics with a stirrup-shaped handle by which they could be attached to a belt. Many are in the form of naturalistic human heads, possibly of rulers, and some are intentionally humorous. The deer-headed ceramic in **figure 23.10** shows an alert, compact creature that merges a deer's head, antlers, hoofs, and spotted skin with an otherwise human body seated in a human pose. Clearly this represents a supernatural being, although its exact meaning is unknown. Since the deer has a rope around its neck, it probably represents a mythological captive warrior. Stylistically, the figure combines naturalism in the organic carving and some stylization, notably the eye outlines.

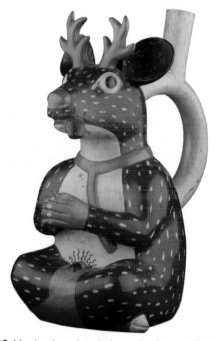

23.10 Moche deer-headed warrior figure, 450–550, from Peru. Terracotta, 9 ¾ x 8 in. Museo Arqueológico Rafael Larco Herrera, Lima.

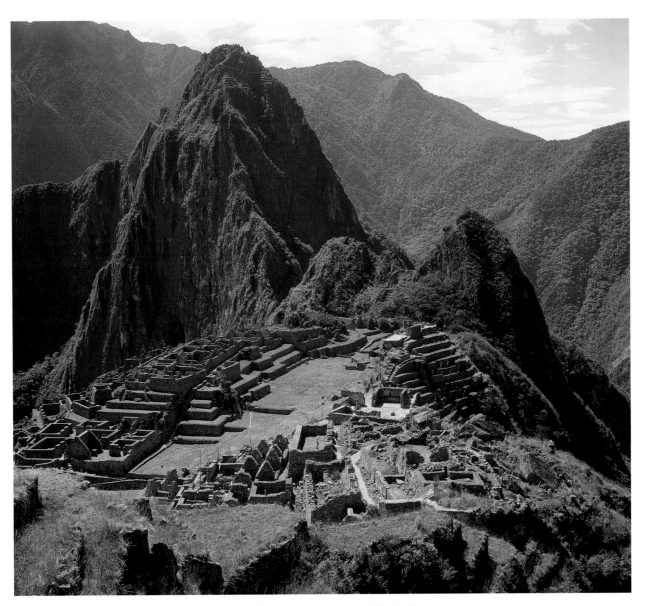

23.11 Machu Picchu, Peru, 1450–1530.

Inka Civilization: Machu Picchu

The Inka were a powerful civilization located in southern Peru and Bolivia. They emerged around 1300 and by 1450 began to form a huge empire. Linked by a paved road system of 20,000 miles, the Inka conquered an extensive area stretching along the Pacific coast from Chile to Ecuador. In the early sixteenth century, the Inka were defeated by the Spanish under their commander, Francisco Pizarro.

The largest surviving Inka site is at Machu Picchu (**figure 23.11**), some 200 miles inland from the Peruvian coast. Crowning a leveled mountaintop overlooking a bend in the River Urubamba (a tributary of the Amazon), Machu Picchu is believed to have belonged to King Pachakuti (ruled 1438 –1473). The site consists of rows of buildings made from local rock clustered around an open plaza. In addition to the palace, structures include terraces for agriculture, a sun-temple, residences for priests and workers, baths, barracks, and storehouses.

The elevation of the site and the presence of a temple of the sun indicate the importance of the sun (*Inti*) in Inka religion. In addition, the so-called Intihuatana Stone (literally "the place where the sun is harnessed") appears to have functioned, like Stonehenge (see p. 297), as a kind of sundial. It is thought to have been used in seasonal rituals such as the midwinter solstice, which in South America occurs in June.

Machu Picchu escaped Spanish destruction because of its remote location. It remained largely unknown until 1911, when it was rediscovered by a Yale University expedition. Today it is one of the world's most visited sites.

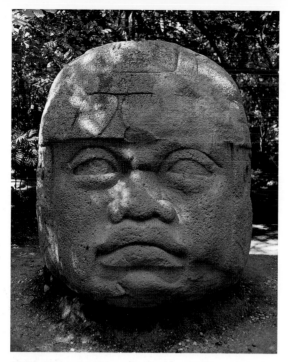

23.12 Olmec head from La Venta, c. 1000 B.C. Basalt, 9 ft. 4 in. high. Museo-Parque La Venta, Mexico.

Mesoamerica

Continuing north, we arrive at the area that links South America with North America. Known as Mesoamerica (literally "Middle America"), this was the site of several prominent civilizations spanning more than 3,000 years. Mesoamerica consists of modern southern Mexico, Guatemala, Belize, the western region of Honduras, and western El Salvador. The period of high Mesoamerican culture is divided by modern scholars into Preclassic (1200 B.C.–A.D. 250), Classic (250–900), and Postclassic (900–c. 1520).

The Olmec

The Olmec were members of a village culture on Mexico's Gulf Coast. They produced the earliest known monumental art of Mesoamerica. Among the most impressive are the Preclassic colossal heads (**figure 23.12**) that were placed in sacred sites and are thought to represent rulers. The stone was quarried some fifty miles away, brought to the site, and carved in a naturalistic style. All have wide flat noses, and a sense of organic structure. They are monumental in form as well as in size; the large features and rounded heads are compressed by a tight-fitting cap or helmet. The slight downturn of the mouth and the furrow over the nose create a stern expression. To date, seventeen such heads have been discovered.

Teotihuacan

Thirty miles north of modern Mexico City, a thriving culture dating from around 200 to 650 grew into the largest city-state in Classic Mesoamerica. With a population of about 200,000, the city of Teotihuacan had extensive monumental architecture arranged along avenues juxtaposed with landscape vistas.

Early in its history, Teotihuacan had been a ceremonial site, where agricultural rituals were performed on a seasonal basis. The site was imbued with a rich mythological tradition, reflected in its huge, stepped trapezoidal pyramids of the Sun and the Moon. The Sun's pyramid is the largest and oldest; it stands over a cave and is aligned with the setting sun on June 21 (the summer solstice).

Later the site was enlarged with the addition of the Pyramid of the Moon (**figure 23.13**). It is connected to the Pyramid of the Sun and to a temple of Quetzlcoatl (the Aztec feathered serpent, god of inclement weather) by the Avenue of the Dead. This stretch of road is about a mile and a half long and 130 feet wide. It runs from north to south, bisecting the city, and is lined with sacred structures.

When the Spanish conquerors arrived in Mexico, Teotihuacan was under Aztec control (see p. 481). The Aztecs recognized the religious importance of the buildings and their layout and absorbed the site into their own culture. As a result, the names associated with Teotihuacan today are Aztec.

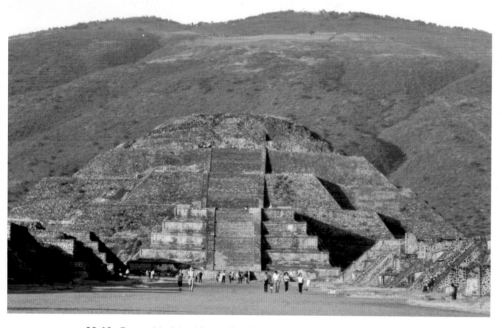

23.13 Pyramid of the Moon, Teotihuacan, Mexico, A.D. 1–750.

The Maya

The Maya, to the south of Teotihuacan, also flourished during the Classic Period. They flourished around 1100 B.C. to A.D. 1500, developing a stratified hierarchy, a hieroglyphic writing system, a calendar, and a complex mythology based on a view of the universe as inherently dualistic. This dualism was embodied by twin heroes who journeyed to *Xibalba* (the Underworld) and deceived the gods. The Maya believed that the gods had created humans from their blood, which had to be restored to them through various blood-letting rituals. The major themes of Mayan narrative art are thus warfare, blood-sacrifice, and the power of the ruler.

In the *Popul Vuh*, the Mayan creation epic, the first people on earth are described as sculptures that were "made and modeled." In one passage, they thank the "Maker Modeler":

Truly now,
Double thanks, triple thanks
that we've been formed, we've been given
our mouths, our faces,
we speak, we listen,
we wonder, we move,

....

Thanks to you we've been formed,
we've come to be made and modeled,
our Grandmother and our Grandfather.[1]

In Late Classic palace art (**figure 23.14**), the Maya used structural techniques such as interior corbelled vaulting (see p. 271). The sophistication and imposing appearance of the palace would have projected the king's might. At Palenque, a series of platforms, accessible by stairways, support the central building. Three open courtyards placed on three stories are surrounded by buildings with square pillars and massive walls and ceilings. The interior has many large rooms, which were probably used for administration. The tower might have been used for reading the sun, moon, and stars. As we can see from this short account, there is a lot that remains unknown about the complex art and civilization of the Maya.

Mayan frescoed murals have been discovered at Bonampak, in the Chiapas region of Mexico, that illustrate rituals performed by kings and priests (**figure 23.15**). This detail of a much larger scene shows prisoners being tortured or killed. The ruler's power is indicated by his jaguar pelt, jade ornaments,

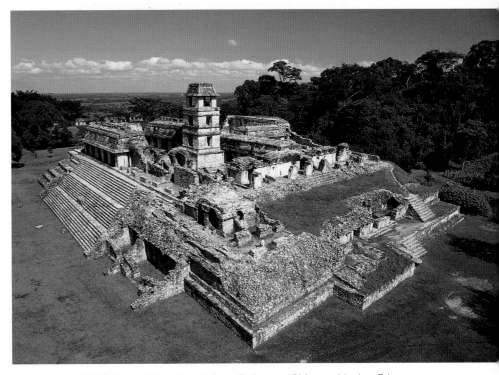

23.14 View of the Maya Palace, Palenque, Chiapas, Mexico, 7th century.

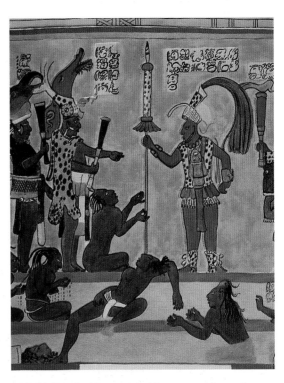

23.15 Detail of a copy of a Maya mural from above door in Room 2, Structure 1, c. A.D. 790. Entire wall fresco 17 x 15 ft. Bonampak, Chiapas, Mexico.

and large, sweeping headdress. Two aristocrats at the left wear elaborate animal masks on their heads and animal pelts. The prisoners are naked, indicating their lowly status, and some plead for mercy. At the left, one seems to be in shock as he stares at the blood flowing from his hands. At the very bottom of the detail, we can see a severed head lying on a step.

The Maya Ball Game

One of the most intriguing themes in Mayan art is the ball game. It is described in myth as having originated with the story of the hero twins and is memorialized in the *Popul Vuh*. When the gods of *Xibalba* heard the twins playing the Mayan ball game, they invited them to play in the Underworld, where they tricked them and then killed them. But later a second set of twins, born with heroic magic powers, defeated the gods and were transformed into celestial bodies.

The object of the game as actually played by the Mayans was to hit or kick a heavy rubber ball through a ring set high into a stone wall. The fact that players could use only their hips, elbows, or knees made the game extremely difficult. Losers could be ritually killed and their blood offered to the gods. Often enemy captives were forced to play and then sacrificed.

Figure 23.16 shows a stone monument carved in the flat style typical of Mayan relief sculpture. A ballplayer with callused knees offers a human heart to the fiery god at the top of the monument. His frontal head is the area of highest relief, his hands are clawed, and he wears a large necklace. A smaller, skeletal figure in front of the ballplayer, possibly a dead player, also makes an offering. Both figures wear a thick yoke decorated with a serpent's head that was part of the standard gear used in the ball game.

The frontality of the God, in contrast to the player and the small skeleton, emphasizes his greater power, for he confronts the viewer directly. His placement above the other figures at the very top of the monument reinforces his divine status.

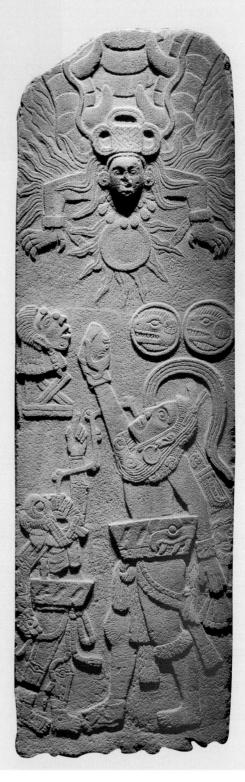

23.16 Ballplayer on Monument 3, from Bilbao, Guatamala, c. 600. Stone, 9 ft. 6 in. high. Ethnologisches Museum, Berlin.

23.17 The Calendar Stone from Tenochtitlán, Mexico, 1502–1520. Stone, diameter 11 ft. 10 in. Museo Nacional de Antropologia, Mexico City.

The Aztecs

The Aztecs, a literate warrior society that called itself the Mexica, inhabited the Valley of Mexico beginning around 1300. By the fifteenth century, the Aztecs had taken over the site of Teotihuacan and grown into a huge empire. When the Spanish conquerors, led by Hernán Cortés, arrived in the early sixteenth century, they coveted Aztec gold and were appalled by the practice of human sacrifice. The Aztecs explained these rituals in light of the belief that the end of the world by earthquake was approaching. They divided world history into five periods; the one they were living in was the fourth. In order to fend off their final destruction, the Aztecs made blood sacrifices to the gods.

A well-known Aztec object that has been interpreted as a reflection of these beliefs is the Calendar Stone from Tenochtitlán (**figure 23.17**). Scholars read the relief carved on the stone as a chart of the Aztec cosmos. At the center, a frontal face of the sun god stares out at the viewer. The five ages, four of which have already elapsed, surround the face, which

is ringed by another circle of the twenty-day signs of the calendar. Two sky serpents, signifying time and space, are represented on the outermost ring.

The imagery on the Calendar Stone, like Aztec religion, portrays a destructive, dangerous view of what the gods had in store for the human race. Mirroring this view were Aztec rituals designed to appease the gods with blood sacrifice. Aztec ferocity and the custom of killing captives led their neighbors to join forces with Cortés. He defeated the Aztecs in 1521 and claimed their empire for Spain.

The Aztecs admired their artists, especially painters who made and illustrated books. One Aztec song calls painters "creators with color" and, as in many other cultures, expresses the notion that artists are divinely inspired:

> The good painter . . . creates with red and
> black ink,
> The good painter is wise, God is in his heart,
> He puts divinity into things;
> he converses with his own heart.[2]

North America

Before the period of European contact, North America was inhabited by numerous native cultures. Some were nomadic, living by hunting, fishing, gathering, trading, and warfare. Others were more settled and built permanent architecture. In this section, we consider works of art from four main regions of the North American continent: the Woodlands (stretching from the Ohio Valley eastward); the Northwest Coast (the Pacific coastal area from southern Alaska through the state of Washington); the Plains (from southern Canada west to the Rocky Mountains); and the Southwest (including Arizona, New Mexico, and Colorado).

Woodlands

The Woodlands are the earliest Native American culture so far known. It dates from around 500 B.C. to A.D. 600. Among the Adena, located in the Ohio Valley, the dead were buried in large, round earth mounds filled with grave goods. Skilled in stone carving, the Adena produced the little object in **figure 23.18**. The head is emphasized by its relatively large size, the elaborate headdress, and round ear spools. The open mouth might be

an indication that the figure is singing, in which case the bent knees might be a dance pose. In any case, the style is reminiscent of Mesoamerican carving, suggesting cross-cultural influence between the two regions.

Northwest Coast: The Kwakiutl

Cultures along the Northwest Coast are known to have made works of art from at least 1500 B.C. They built houses close to the coastline, used boats for fishing, wove elaborate blankets, and carved objects, such as the Kwakiutl totem pole which we discussed in Chapter 3 (see figure 3.11), from wood furnished by the abundant forests. Captain Cook was one of the first European explorers to visit the region.

The Kwakiutl flourished on Vancouver Island, trading and warring with each other and their neighbors. They produced the most lavish masks of the Northwest Coast, which were used in shaman ceremonies. Like the shaman, the so-called Transformation Mask can be changed to produce different images (**figure 23.19**). Sections of the mask are attached by strings, which can be pulled to create the image of an altered state. In this instance, the closed mask represents the setting sun; when the strings are pulled and the mask opens, it becomes a frowning human face. The multiple smaller faces incorporated into the design, as well as the bright colors and flat, stylized forms, are typical of such masks and of Northwest Coast style in general.

COMPARE

Kwakiutl, Totem Pole.
figure 3.11, page 43

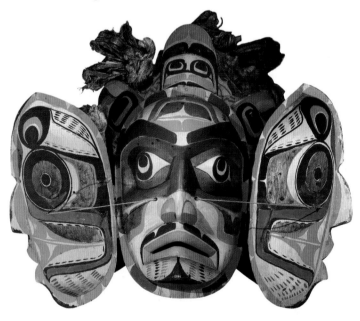

23.18 Adena artist, human effigy pipe, Woodland Period, 500 B.C.– A.D 1. Stone, 8 in. high. Ohio Historical Society, Columbus.

23.19 Kwakiutl Transformation Mask, late 19th century. Carved and painted wood with plant fibers, 19 ⅜ in. high. Field Museum of Natural History, Chicago.

The Plains

The Native Americans who inhabited the Plains included some groups that were nomadic and others that lived in permanent settlements. They created remarkable works of art that were both practical and aesthetic. Many Plains people used animal hides for painted surfaces, as we saw in the Crow war shield in Chapter 4 (see p. 59).

The *tipi* (a conical tent) in figure **23.20** is covered with images of over 30 horses, some with riders and some without. Horizontal ranks of warriors circle the *tipi* on horseback. This produces an impression of the disarray that occurs in the chaos of battle.

With the destruction of Native American culture by the advance of European settlers and the subsequent policies of the United States government, a cult known as the Ghost Dance developed for a brief period in the late nineteenth century. This was inspired by the visions of a holy man who claimed that if Native Americans danced the Ghost Dance and sang certain songs, they would be transported to an ideal, pre-European-contact world filled with buffalo herds. The messianic quality of the Ghost Dance, partly resulting from contact with Christianity, contributed to the imagery on costumes made for the ceremonies (**figure 23.21**). This picture shows an Arapaho Ghost Dancer's shirt. The stars set against a blue background symbolize the coming of a new age for the Indians, while the ascending birds represent the belief that the dancer would be flown to safety at the start of a new day when the white man would disappear and the buffalo herds would return to Native American lands. (Many ghost dancers also believed the shirt would protect them from the white man's bullets.)

Southwest: The Cliff Dwelling

Among the cultures of the American Southwest, there is evidence of pre-European contact with Mesoamerica. Some groups used irrigation techniques and in some areas the ritual ball game was played. The Anasazi, whose culture dates from around 1100 to 1450, lived in the area where the borders of Colorado, New Mexico, Utah, and Arizona meet. They built monumental stone architecture into the existing rocks of cliffs. Protected by their elevated location and the overhang of the cliff, such buildings served defensive as well as domestic and ceremonial purposes.

23.20 Sioux *tipi* cover with painted decoration, c. 1885, probably South Dakota. Muslin, 9 ft. 5 ¼ in. high. National Museum of the American Indian, Smithsonian Institution.

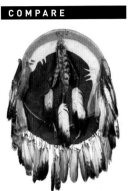

COMPARE

Crow war shield.
figure 4.5, page 59

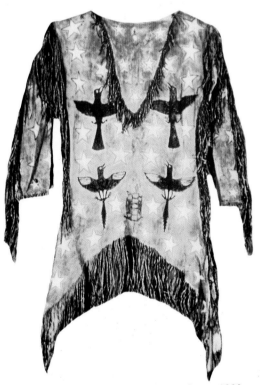

23.21 Arapaho artist, Ghost Dance dress, 1890s. Deerskin and pigment. Private Collection.

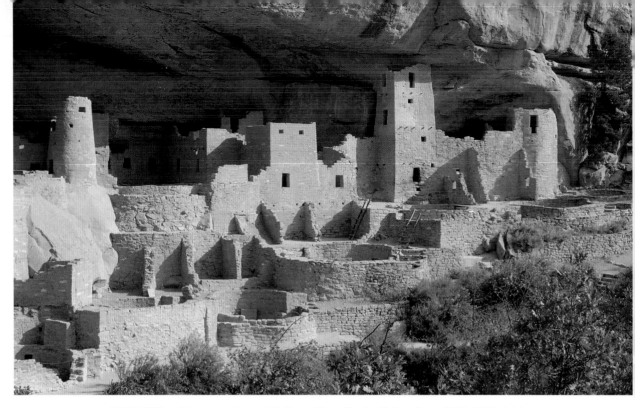

23.22 Cliff architecture, Anasazi Culture, Mesa Verde, Colorado, c. 1100–1200. Adobe.

At Mesa Verde, in Colorado, the Anasazi built an architectural complex resembling apartment blocks. The upper level, under the cliff overhang, consists of living quarters several stories high, storage areas, and towers (**figure 23.22**). Below the cliff, usually underground, were large round covered rooms (**kivas**), where ceremonies were held. The *kivas* contained altars and some were decorated with wall-paintings symbolizing agricultural and fertility rituals. Mesa Verde's original inhabitants deserted the area in the fourteenth century, but today it is a popular tourist site.

——◆——

Now that we have completed our brief detour into non-Western art, we return to our narrative of Western art history. We move to the nineteenth century, which witnessed the opening of trade with Japan. Goods imported from Asia, the South Pacific, and Africa were shown in a number of international exhibitions held in the major European capitals. By the turn of the twentieth century, avant-garde Western artists sought alternatives to the Classical tradition. They looked to non-Western art for inspiration and found in its unfamiliar forms a new sense of awe and reverence. Although Westerners did not necessarily understand either the cultural context or the iconographic meaning of non-Western art, they were intrigued by it and borrowed its forms. Today, the visual arts continue to participate in the increasing globalization of the contemporary world.

Chapter 23 Glossary

ahu—platforms on which *moai* are placed

apotropaic—designed to protect against the "evil eye" (noun: apotropaion)

bai—men's house in Micronesia

heiau—Hawaiian temple

kiva—large round covered room for ceremonies in Anasazi culture

mana—supernatural force that may be concentrated in an object or a person

mimi—Aboriginal spirit hunters

moai—carved stone statues on outdoor platforms on Easter Island

story boards—horizontal strips containing symbolic narratives of village history on men's houses in Micronesia

tapu—related to taboo, meaning ritually unclean and sacred

tiki—protective ancestors

tipi—conical tent characteristic of the Plains Indians

tufa—porous volcanic stone often used as a building material

The Nineteenth Century

In Europe and the United States, the nineteenth century was heir to the Enlightenment and to the upheavals caused by the French and American Revolutions at the end of the eighteenth century. Paris remained the center of the art world, but it became a very different place than it had been a few decades earlier. The development of industry attracted more people to the cities and led to new conflicts between workers and factory owners. With the decline of the monarchy, art galleries and private collectors replaced the courts as the main sources of patronage and the great museums of Europe evolved from royal collections. The first of these was the Louvre, in Paris, which was established in 1793, the year that the French king and queen were executed (see Chapter 19). Works of art that had been accessible only to monarchs and aristocrats could now be seen by the general public.

In the aftermath of the American Revolution, new American art styles developed and most serious artists studied for a time in Paris. After the Civil War (1861–1865), America developed a new sense of itself as an independent nation and this was reflected in its art.

Nineteenth-century improvements in travel and technology led to more rapid communication than Europe or America had ever known. Newspapers were widely distributed, caricatures published in the popular press were vehicles for social and political satire, and posters advertised public events. With the development of photography, a new medium of imagery was born. At first, photography was used mainly for portraiture and documentation—including scientific classification, war reporting, and social observation. Eventually, however, it became accepted as an art form in its own right.

TIMELINE

HISTORICAL EVENTS	ART HISTORY
1800 ● Napoleon declares himself emperor of France 1804 ● Napoleon defeated at Waterloo 1815 ● Gas street lighting installed in most major European cities 1823	**1800** ● Romantic movement c. 1800–1840 ● Goya, *Executions of the Third of May, 1808*, 1814 ● Géricault, *The Raft of the Medusa*, 1818–1819 ● Friedrich, *Woman in Front of the Setting Sun*, c. 1818–1820
1825 ● First railroad in Britain 1826 ● Marx and Engels, *The Communist Manifesto* 1848	**1825** ● Photography invented c. 1826 ● Turner, *The Slave Ship*, 1840 ● Realism c. 1840–1889 ● Courbet, *Burial at Ornans*, 1849–1850
1850 ● American Civil War 1861–1865 ● France loses Franco-Prussian War, Third Republic 1870	**1850** ● Impressionism 1860s ● First Salon des Réfusés, Paris 1863 ● Manet, *Olympia*, 1865 ● Post-Impressionism 1870s
1875 ● Edison invents the cylinder phonograph (1878) and the electric light bulb (1879) ● Lumière invents the first motion picture camera 1895 ● Freud, *Interpretation of Dreams* 1899	**1875** ● Monet, *Impression, Sunrise*, 1872 ● Cézanne, *Plate of Apples*, c. 1877 ● Rodin, *Gates of Hell*, 1880–1890 ● Van Gogh, *The Night Café*, 1889 ● Eiffel Tower, Paris 1889

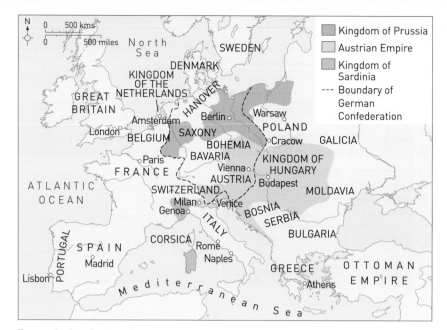

Europe in the nineteenth century.

The idea of modernity evolved in the nineteenth century, reflecting a widespread awareness of change. This came from several sources, including a program of urban renewal in Paris designed both to improve the city's appearance and to eliminate slums that nurtured seeds of rebellion. Increasing contacts with the non-Western cultures we surveyed in the last four chapters brought about changes in taste and style. And the development of modern psychology, culminating in the publication of Sigmund Freud's *Interpretation of Dreams* in 1899, made people more aware of the nature of the human mind.

There was also more rapid change from one style to another than in previous centuries; in fact, several styles overlapped with each other. Whereas the seventeenth century had been dominated by the Baroque style and the eighteenth first by Rococo and then by Neoclassical, the nineteenth century witnessed a parade of styles. Neoclassicism continued into the early part of the century, but soon became academic and superficial and was rejected by the most modernist artists. After Neoclassicism, the four major nineteenth-century styles were Romanticism (which began at the end of the previous century), Realism, Impressionism, and Post-Impressionism.

Romanticism

The term "Romantic" comes from literary works written in the Romance languages, especially medieval tales of chivalry. Romantic poets and novelists felt an intense nostalgia for past eras and exotic, non-Western locales. As with the early phase of Neoclassicism, the Romantic movement was associated with political freedom and the rights of the individual. Both styles reflected the Enlightenment's admiration for the ancient Greek and Roman republics. In addition, Romantic philosophers advocated a return to nature and believed that childhood was a time of blissful innocence. They were inspired by imagination, passion, and mystery.

Spain: Goya

Francisco de Goya y Lucientes (see p. 36) was trained in the Rococo style. He spent nearly all his life in Spain, where the effects of the Inquisition were still felt. Nevertheless, Goya himself was an enlightened thinker, committed to political freedom, outraged by Church corruption, and psychologically insightful. From 1792, he was completely deaf, which drew him further into the world of the imagination.

In 1799, Goya published *Los Caprichos* (*The Caprices*), a series of satirical etchings and aquatints (combining the linear medium of etching with the fluid effect of watercolor). In *Little Hobgoblins* (**figure 24.1**) he satirizes the corrupt clergy. Hobgoblins were believed to have joined with Lucifer when he was expelled from Heaven, but instead of going to Hell they inhabit the human world. They are tricksters who frighten people and steal from them. In Spain, the term "*Duendecitos*" was applied to friars as well as to hobgoblins.

Goya's image shows three grotesque, deformed figures, two friars and one priest, in a monastic cell. Their stunted appearance is a metaphor for their moral shortcomings. The friar at the left sucks on a piece of bread dipped in wine—an allusion to the Eucharist, but also a reflection of the friar's greed. The monk at the right hides a wine glass under his cloak. The priest in the center is a subhuman monster with bared fangs and an enlarged hand. He too holds a glass of wine. All three secret drinkers, in Goya's view, stand for a voracious clergy cannibalizing Spain at a time when the Church was the richest institution in the country.

24.1 (Above) Francisco de Goya, *Little Hobgoblins* (*Duendecitos*), from *Los Caprichos*, plate 49, first edition 1799. Etching and burnished aquatint, 12 1/2 x 8 3/4 in. Metropolitan Museum of Art, New York. Gift of M. Knoedler, 18.64 (49).

Writing about *Los Caprichos*, Goya asserted that he:

chose as subjects . . . from the multitude of follies and blunders common in every civil society, as well as from the vulgar prejudices and lies authorized by custom, ignorance, or interest. . . .[1]

Goya expressed his intense dislike for political injustice in his famous indictment of the French occupation of Spain (**figure 24.2**). On May 2, 1808, a group of *Madrileños* (citizens of Madrid) rebelled against the French forces. The following day, the French army executed without a trial all citizens suspected of joining the uprising.

Goya's allusions to Christian iconography encourage the viewer to sympathize with the Spanish victims. At the right, we see the anonymous firing squad from the back and follow the line of sight of the French guns. They are aimed at the man in white, whose pose resembles that of Jesus on the Cross and whose wide-eyed gaze conveys his terror of being executed. Echoing his pose is the man lying on the ground as his blood mingles with the Spanish soil—for which he has died. The remainder of the condemned either cover their eyes in fear or shake their fists in anger. In the black sky and distant church, Goya alludes to the tradition that the sky went dark at the Crucifixion.

> The censure of human errors and vices ... may ... be the object of Painting.
>
> Francisco de Goya, artist (1746–1828)

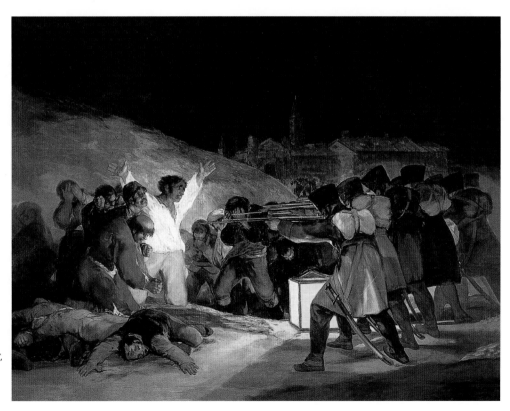

24.2 Francisco de Goya, *Executions of the Third of May, 1808*, 1814. Oil on canvas, 8 ft. 9 in. x 11 ft. 4 in. Prado, Madrid.

France

Nineteenth-century France was marked by continual political upheaval. From 1804, when Napoleon Bonaparte crowned himself emperor of France, until 1870, when France lost the Franco-Prussian War, the country oscillated between being a monarchy and being a republic. It was not until 1870 and the founding of the Third Republic that France became a modern democracy.

French Romantic painting in the nineteenth century mirrored these political shifts. In Antoine-Jean Gros's (1771–1835) *Napoleon Visiting the Plague Hospital at Jaffa* (**figure 24.3**), which was painted in the year Napoleon became emperor, the artist "romanticizes" the French leader. Five years earlier, while fighting in the Holy Land, Napoleon had ordered the execution of prisoners in order to avoid wasting resources. When plague broke out among the French soldiers and the Arabs, a makeshift hospital was hurriedly set up in the courtyard of a mosque at Jaffa. Napoleon visited the hospital on March 11, 1799. Gros shows him in dress uniform,

fearlessly reaching out to touch the plague sore of a victim. This gesture refers to the ritual "king's touch," traditionally believed, like that of Jesus, to have healing power. Highlighting Napoleon's bravery is the realistic detail of the soldier holding a cloth to his nose to avoid the smell of disease and death. In addition, the concentration of light on the crowd around Napoleon reinforces his image as a miracle worker.

The dead and dying in the foreground lead the viewer deeper into the picture space. A series of reds culminates in the large feather on Napoleon's helmet and echoes the red of the distant tricolor (the French flag). Although surrounded by gunsmoke, the flag signals Napoleon's victory. The scene is filled with picturesque local color and Islamic architectural patterns that reflect the Romantic taste for the exotic East.

In 1818 to 1819, when Théodore Géricault (1791–1824) painted his epic masterpiece, *The Raft of the Medusa*, he was protesting a recent scandal that had shaken French society and had exposed the corruption of the monarchy (**figure 24.4**). On July 2, 1816, the French frigate *Medusa* heading for

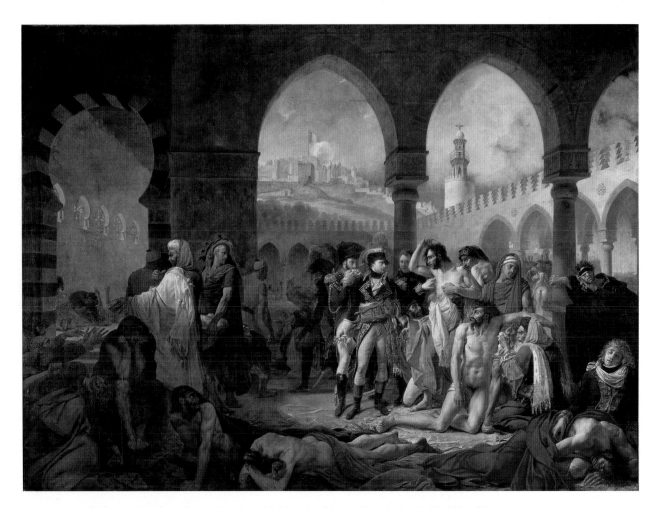

24.3 Antoine-Jean Gros, *Napoleon Visiting the Plague Hospital at Jaffa*, 1804. Oil on canvas, 17 ft. 5 ¹/₂ in. x 23 ft. 6 ¹/₂ in. Louvre, Paris.

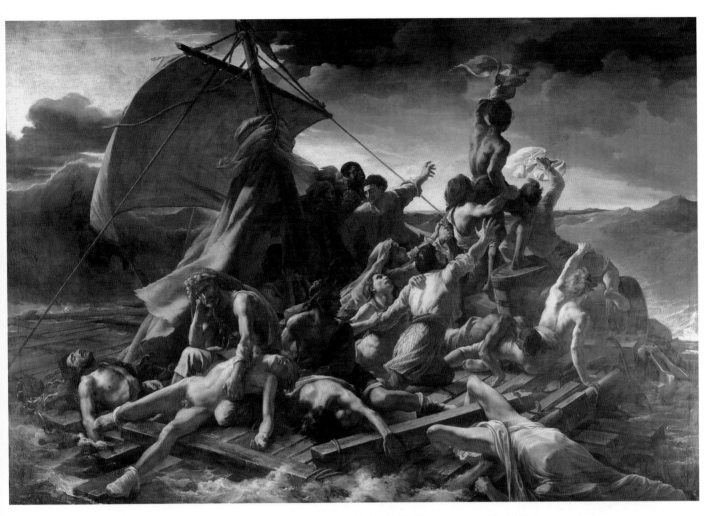

24.4 Théodore Géricault, *The Raft of the Medusa*, 1818–1819. Oil on canvas, 16 x 24 ft. Louvre, Paris.

the African colony of Senegal hit a reef and sank. 250 passengers and crew, including the captain, boarded six lifeboats. The remaining 150 passengers were forced onto a makeshift raft, which the captain promised to tow alongside the lifeboats. Instead, he cut the cables and cast the raft adrift. By the time the raft was rescued, only fifteen people were alive. The French government covered up the story, but two of the survivors exposed the truth. This caused a national scandal, because the captain owed his commission to political connections rather than merit.

In Géricault's painting, we see the first sighting of a rescue ship. The space tilts upward, with four cadavers at the bottom of the picture drawing us into the crowded raft. We follow the hopeful gestures of the survivors who are signaling to the distant ship. The struggle of man against nature, which is shown in the painting by the turbulent sea and gathering clouds, is a characteristic Romantic theme. In addition, Géricault creates a sense of psychological tension between the dead and the dying, and between hope and despair.

Of this painting the British art historian Kenneth Clark (1903–1983) wrote as follows:

… the total effect of this great picture is moving and authentic. We feel, as Géricault intended we should, that all humanity is a raft of desperate men, surrounded by the dead and dying, but suddenly united by hope. This is a true theme of revolutionary art, a theme for Beethoven; the unity of movement and the way in which the composition rushes toward its climax is worthy of a Beethoven symphony;…[2]

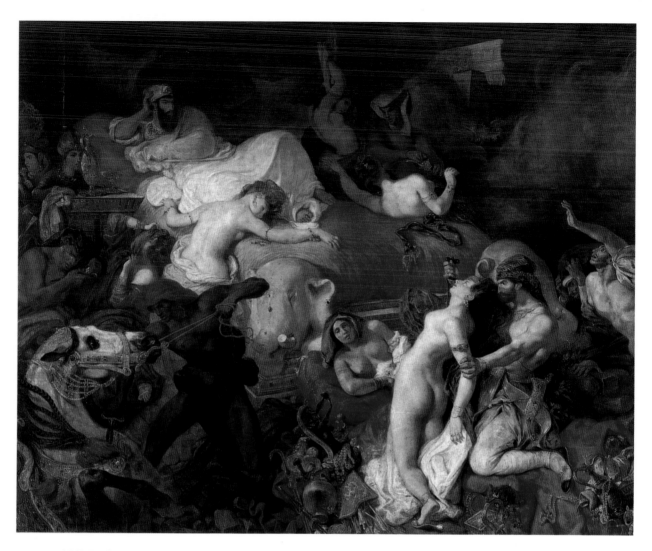

24.5 Eugène Delacroix, *Death of Sardanapalus*, 1827–1828. Oil on canvas, 13 ft. x 16 ft. 3 in. Louvre, Paris.

Eugène Delacroix (1798–1863) shared Géricault's passion for social justice and political freedom. With the use of energetic brushwork and vivid color, Delacroix created dynamic images of great power. In 1827–1828, he exhibited the monumental *Death of Sardanapalus* (**figure 24.5**). It was inspired by a play in verse by the English poet Lord Byron (1788–1824) about a tyrannical Assyrian king who destroyed his palace rather than allow his enemies to take it. Delacroix's Sardanapalus reclines in bed as his men seize or destroy his possessions—including his women, his jewels, and his horses. The painting is a scene of passionate struggle, filled with intense reds, rich golds, struggling nudes, and, as in Gros's plague hospital, allusions to the exotic East.

The exuberance of the *Death of Sardanapalus* mirrors that of Delacroix himself, when he wrote in his journal in 1822, describing the advantages of imagery over the written word:

> When I have painted a fine picture I have not given expression to a thought! That is what they say. What fools people are! . . . A writer has to say almost everything in order to make himself understood, but in painting it is as if some mysterious bridge were set up between the spirit of the person in the picture and the beholder.[3]

> In painting, as in external nature, proper justice is done to what is finite and to what is infinite, in other words, to what the soul finds inwardly moving in objects that are known through the senses alone.

> Eugène Delacroix, artist (1798–1863)

24.6 Jean-Auguste-Dominique Ingres, *Louis-François Bertin*, 1832. Oil on canvas, 3 ft. 10 in. x 3 ft. 1 ½ in. Louvre, Paris.

In sharp contrast to the dynamic exuberance of Delacroix, the paintings of Jean-Auguste-Dominique Ingres (1780–1867) are restrained, the brushstrokes are not visible, and the contours are precisely delineated. Ingres was a student of David (see p. 420), and his style contains Romantic as well as Neoclassical features. His view that color was a mere handmaiden to painting and his famous statement—"Drawing is the probity of art"—are reflected in the portrait of Louis-François Bertin (**figure 24.6**). A self-made journalist who supported the French monarchy, Bertin (1766–1841) is shown as a powerful, assertive businessman.

The formal clarity of the picture is associated with Classicism and the dark brown meander pattern on the back wall recalls designs on ancient Greek vases. At the same time, however, a "Romantic" subtext emerges in the accounts of Ingres' struggle to arrive at Bertin's pose. There are two versions of how this happened: in one, Ingres caught sight of Bertin at a

> **Art is not merely a profession, it is also an apostleship.**
>
> Jean-Auguste-Dominique Ingres, artist (1780–1867)

dinner party and his pose struck the artist as true. In the other, Ingres witnessed a disagreement between Bertin and his sons. Rather than dismiss his sons' point of view, Bertin listened to what they had to say. In so doing, he differed from Ingres' recollections of his own father, who tried to force him to become a musician instead of a painter. Bertin took on the mythic status of a new, more reasonable father than Ingres' actual father. In revising the character of his own father through his impression of Bertin, Ingres expressed the Romantic nostalgia for a childhood past. His new sense of equality between father and son is shown in the parallel texts painted at the top of the back wall: his own signature *INGRES PINXIT* and the date at the left and *L-F BERTIN* directly opposite at the right.

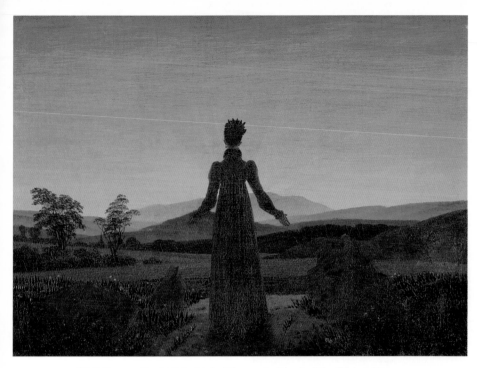

24.7 Caspar David Friedrich, *Woman in Front of the Rising Sun*, c. 1818–1820. Oil on canvas, 8 $^{11}/_{16}$ in. x 11 $^{1}/_{16}$ in. Museum Folkwang, Essen, Germany.

Germany: Friedrich

In Germany, the Romantic landscapes of Caspar David Friedrich (1774–1840) embody the notion that nature is eternal whereas human life is finite. In his *Woman in Front of the Rising Sun* (**figure 24.7**), Friedrich romanticizes the landscape, freeing it of contemporary industrial pollution, urban slums, and social and economic conflict. In the fusion of beauty and terror, shown in the woman riveted by the sight of nature's vastness, Friedrich achieves a sense of the sublime, which was characteristic of the Romantic Movement, particularly in Germany. Silhouetted against the orange sunset, the woman is anonymous and mysterious, and yet we as viewers identify with her human form and awestruck response to nature's grandeur. Friedrich expressed the passion that he felt for art when he wrote in 1909 that: "Art can never be at home with those whose hearts and soul are cold."[4]

England: Constable and Turner

The calm Romantic landscapes of John Constable (1776–1837) are endowed with a pastoral atmosphere that, like the landscapes of Friedrich, seems untouched by modern industry. Their "romance" lies in their nostalgia for the artist's childhood. Born in the Stour River Valley, in Suffolk, which he rarely left, Constable was the son of a wealthy mill owner. Rather than enter the family business, however, he painted the land from which goods were manufactured and depicted its changing moods.

In spring of 1800, echoing his nostalgic attachment to the countryside, Constable wrote to a friend describing his reaction to the weather:

> This fine weather almost makes me melancholy … I … love every stile and stump, and every lane in this village, so deep rooted are early impressions. …[5]

Constable's best-known picture, *The Haywain* (**figure 24.8**) is a Romantic vision of his remembered childhood, merging the reality of landscape with psychological truth. The scene takes place at harvest time, in late summer, as seen from the banks of the Stour. A wagon (the haywain) leisurely crosses the river as a few small figures go about their business in the foreground. In the distance, tiny farmers in white shirts tend to the harvest. Constable shows nature and humanity at peace; both are structured and closely observed. Deep browns and greens predominate, with only a few highlights of intense red. The sky is heavy with clouds, but it lightens as the threat of a storm recedes. In contrast to the dense painting of the landscape, Constable's sky is changeable; it has the potential to open up space, relieving the weight and solidity of the land.

Constable was not only trying to preserve his lost youth in *The Haywain*; he was also responding to the encroachment of industry onto nature by painting as if nothing had changed. Constable's landscape is thus an image of his personal past and of a vanishing, rural way of life in England.

For Constable's contemporary, Joseph Mallord William Turner (1775–1851), nature is a force in constant motion. From the age of fourteen, Turner took long walks in the country and sketched the landscape. His paintings are energized by intense color and enriched by layers of glaze. In Turner's paintings of the sea, the prominent brushstrokes dissolve form into paint texture.

Turner's aversion to social injustice is the theme of *The Slave Ship* of 1840 (**figure 24.9**). Although the slave trade had been outlawed in England in 1807, it was still being practiced by the British in 1840. Turner depicted an actual event from the 1780s, when slaves who were ill were thrown overboard so that the traders could claim insurance on their loss. In Turner's painting the drowning slaves, pulled down by their chains, are vainly fighting off a school of fish at the lower right. Two very large fish, their jaws wide open, approach from above. At the center, only the raised hands of the slaves are visible above the water's surface.

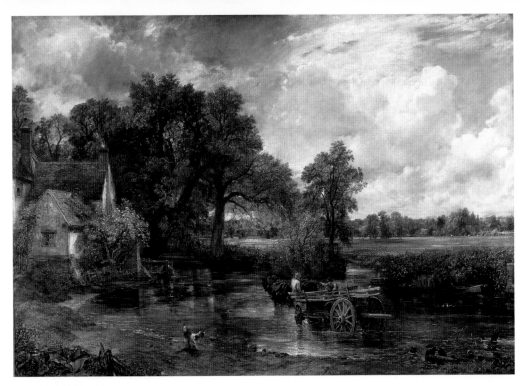

24.8 John Constable, *The Haywain*, 1821. Oil on canvas, 4 ft. 3 ¼ in. x 6 ft. 1 in. National Gallery, London.

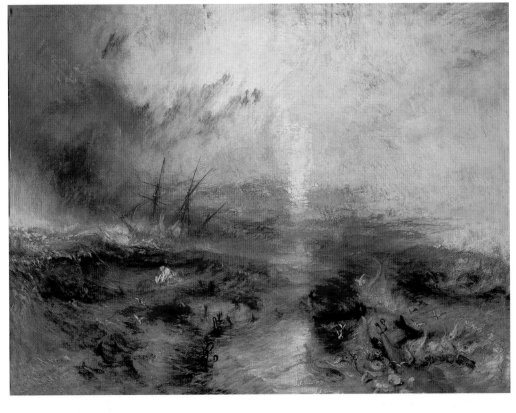

24.9 Joseph Mallord William Turner, *The Slave Ship (Slavers Throwing Overboard the Dead and Dying)*, 1840. Oil on canvas, 2 ft. 11 ¾ in. x 4 ft. ¼ in. Museum of Fine Arts, Boston. Henry Lillie Pierce Fund.

In the distance, the silhouetted ship sails off toward a fiery orange horizon. A streak of white shoots through the middle of the sky as if to divide the waters, giving the episode a biblical cast reminiscent of Moses parting the Red Sea. Echoing the panic of the slaves are the seagulls overhead, and the turbulence of the swirling sea and sky.

The Slave Ship impressed the reigning English art critic, John Ruskin (1819–1900), whose famous description emphasizes the violence of both the content and the paint. His style of art writing has been called "word painting," that is, creating the equivalent of a picture with words:

> … the torn and streaming rain-clouds are moving in scarlet lines to lose themselves in the hollow of the night … the tossing waves by which the swell of the sea is restlessly divided, lift themselves in dark, indefinite, fantastic forms, each casting a faint and ghastly shadow behind it along the illumined foam …[6]

Romantic Landscape in the United States

In the United States, Romantic landscape painting was associated with specific parts of the country and thus had a nationalistic flavor. Thomas Cole (1801–1848) laid the foundation of the genre in New England, concentrating on the Catskill and the Adirondack Mountains of New York State and the White Mountains of New Hampshire. His landscapes, like his poetry, portray humanity's place in nature. Critical of Turner for painting rocks that resemble spun-sugar, Cole preferred a more straightforward recording of landscape.

Whereas we cannot identify the season in Turner's *The Slave Ship*, the colors of Cole's landscape in **figure 24.10** are clearly those of fall. Cole conveys the unpredictable character of nature, with its continually shifting weather conditions. A storm cloud at the upper left changes to more benign white clouds as the sky moves to the right. At the center of the landscape a yellow light illuminates the cabin and the lone rider galloping towards it. The smallness of the human figure in the vast landscape bounded by a looming distant mountain is a reminder that people are engulfed by nature and cannot control it. The last stanza of Cole's untitled poem on nature's contrasting moods describes his feeling for landscape in the aftermath of a storm:

> ... So storms of ill when pass'd away
> Leave in our souls serene delight;
> The blackness of the stormy day,
> Doth make the welcome calm more bright.[7]

Realism

Realism flourished in France beginning in the 1840s. The social abuses caused by the Industrial Revolution inspired the publication in 1848 of *The Communist Manifesto* by Karl Marx and Friedrich Engels. Realism continued until around 1880, rejecting Neoclassicism and Romanticism on the grounds that they neglected the social and economic reality of modern life. Like Realist novelists such as Balzac, Zola, and Dickens, the Realist painters wanted to represent the broad panorama of society and the life led by the average citizen. In architecture, Realism is related to the manufacture of steel, which led to buildings that could accommodate more people at a lower cost. Photography also contributed to the Realist interest in social documentation.

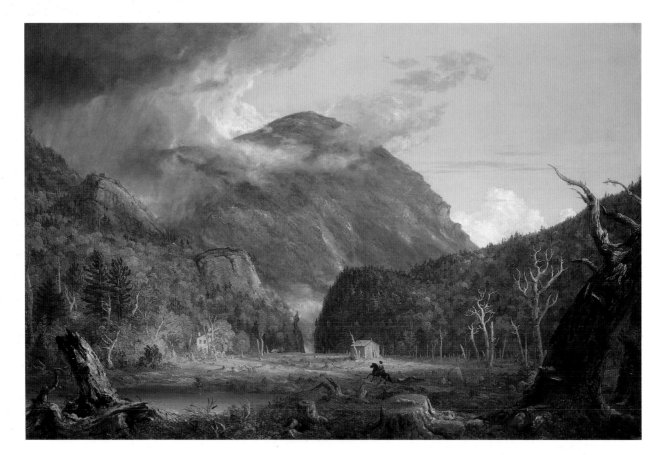

24.10 Thomas Cole, *A View of the Mountain Pass Called the Notch of the White Mountains (Crawford Notch)*, 1839. Oil on canvas, 3 ft. 4 ³⁄₁₆ in. x 5 ft. 1 ⁵⁄₁₆ in. National Gallery of Art, Washington, D.C. Andrew W. Mellon Fund.

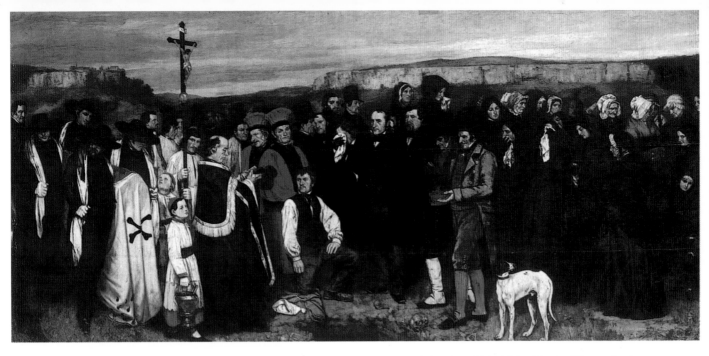

24.11 Gustave Courbet, *Burial at Ornans*, 1849–1850. Oil on canvas, 10 ft. 4 in. x 21 ft. 11 in. Musée d'Orsay, Paris.

Gustave Courbet (1819–1877) exemplified the principles of Realism when he wrote that:

> To go backward … is to waste effort. I deny the possibility of historical art applied to the past. Historical art is by nature contemporary. Every age must have its artists, who give expression to it and reproduce it for the future.[8]

In his huge *Burial at Ornans* (**figure 24.11**), Courbet produced a frieze of middle-class people attending a funeral in the French provinces. They are conservative, staid, and staunchly Catholic. The picture is divided into broad horizontals: the grim sky pierced by a crucifix; somber mourners whose black clothes are relieved only by the red costumes of the beadles (local administrators) and the blue stockings worn by the man in the foreground. The dog turns abruptly and directs our attention to the block of women at the right, while the kneeling grave-digger focuses us on the imminent reality of death and burial. The sameness of the figures, for which Courbet was criticized, can also be seen in a Marxist context as alluding to the new political power of the middle class.

One of the greatest artistic scandals of the nineteenth century occurred in 1865, when Édouard Manet exhibited *Olympia* (**figure 24.12**). We saw in Chapter 1 that Manet's *Déjeuner sur l'Herbe* also created controversy because of its depiction of two clothed men lunching with a nude woman, but the *Olympia* offended propriety for other reasons. Although derived from the Classical tradition of the reclining nude, Manet's *Olympia* is transformed into an image of lower-class modern life.

Olympia's pose and gesture, the rumpled sheets and shawl, the flowers (from a client), and the alert black cat (compare "cat house") all identify her as a prostitute—the shoes worn in bed can denote "street-walking." Adding insult to injury in the eyes of French viewers and critics were the unidealized proportions of the nude and her specific physiognomy that made her seem more real than mythological. Olympia is pushed forward, right up against the picture plane and thus confronts the viewer "up close." Her position in space and her pose were reminders of the reality of prostitution and the dangers of venereal (from "Venus") disease in nineteenth-century Paris.

COMPARE

Manet, *Le Déjeuner sur l'Herbe*.
figure 1.10, page 11

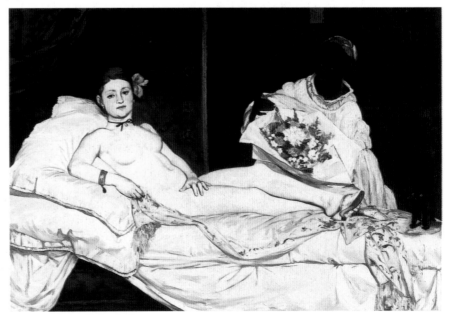

24.12 Édouard Manet, *Olympia*, 1865. Oil on canvas, 4 ft. 3 in. x 6 ft. 2 in. Louvre, Paris.

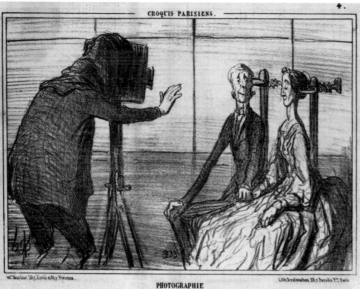

24.14 (Above) Nadar (Félix Tournachon), *Portrait of Édouard Manet*, c. 1865. Caisse Nationale des Monuments Historiques, Archives Photographiques, Paris.

Photography as Medium and Subject

The nineteenth-century Realist interest in documenting all classes of society also appealed to photographers. Although the technique of capturing an image with light had been known since the Renaissance, it was not until the eighteenth century that light-sensitive surfaces made with silver were produced. Until the nineteenth century, such images were fleeting. But even when an image could be fixed, the exposure time might last as long as eight hours. Louis Daguerre, whose *Shells and Fossils* we saw in Chapter 11 (see p. 201), discovered a way to shorten the exposure time, but his daguerreotypes, unlike modern photographs, were single images and could not be reproduced.

Honoré Daumier (see Chapters 5 and 7), who published satirical lithographs and caricatures in the popular press, made fun of the new enthusiasm for photography. In **figure 24.13**, he illustrates a couple posing for their portrait. The photographer's head has disappeared under his cloth and he extends his hand as if to steady his sitters. The sitters are held in place by head clamps, which were used at the time to keep people's heads still for long exposure times. Daumier conveys the humor of the situation through the sitters' stiff poses, thin proportions, and exaggerated expressions.

Portraiture was one of the main uses of early photography. It was less expensive than painting and thus accessible to more people. The leading portrait photographer in Paris was Gaspard-Félix Tournachon, called Nadar, whose *Pierrot* we discussed in Chapter 11. Nadar's portrait of Manet (**figure 24.14**) shows the artist's vitality and discerning eye. Manet's pose, with his fist placed on his leg, conveys the insistence on challenging tradition that we saw in the *Olympia*.

The American Realist painter Thomas Eakins (1844–1916) also experimented with photography. His motion studies (**figure 24.15**) record the human

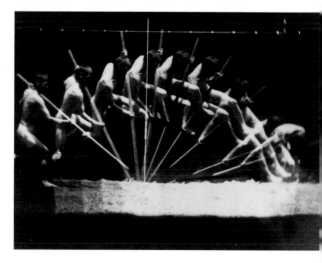

24.15 Thomas Eakins, *Motion Study: George Reynolds, Pole-Vaulting*, 1884. Print from gelatin dry-plate negative, 5 1/16 x 6 3/4 in. Philadelphia Museum of Art, Pennsylvania. Gift of Charles Bregler.

body, especially male nudes, in action. This photograph was made by taking a series of exposures in rapid succession. The result is a graceful, metaphorical image in which the repeated poles resemble the spokes of a wheel and the vaulter's movement creates the wheel's curve.

In the early days of photography, the American poet and short-story writer Edgar Allan Poe (1809–1849) recognized the potential of the new medium as a:

> . . . positively perfect mirror . . . infinitely more accurate in representation than any painting by human hands.[9]

American Realist Painters: Homer and Tanner

Realism in America, as in France, depicted scenes of everyday life. Winslow Homer (1836–1910) worked as an illustrator for *Harper's Weekly*, drawing and painting scenes of the Civil War. In 1866–1867 he went to France and came into contact with the notion of modernity. His style has elements of Romanticism as well as Realism, as can be seen in *Snap the Whip* of 1872 (**figure 24.16**). This represents typical American boys playing outdoors in the Adirondacks. Homer shows us their red school house, implying that this is a period of recreation. It is a clear day, with cast shadows visible on the grass. There is a Romantic aspect in the nostalgia for the innocent pleasures and natural energy of youth, but the attention to observed detail and everyday life has a Realist quality.

The paintings of Henry Ossawa Tanner (1859–1937) convey the reality of African-American life in the late nineteenth century. Born in Philadelphia, Tanner studied with Eakins at the Art Academy, but in 1891 moved to Paris, where black artists were more readily accepted than in the United States. In *The Banjo Lesson* (**figure 24.17**), an elderly man teaches a small boy to play the banjo. They are seated together on an old wooden chair, surrounded by everyday household objects.

The loose brushwork conveys the texture of the floorboards, the cracked leather shoes, and the heavy cotton clothing. The light on the back wall partially silhouettes the figures and creates a halo effect, which accentuates their blackness and ennobles them. It also binds them formally and emotionally in their concentration on the banjo. Their intimate relationship is reinforced by the banjo's diagonal, which echoes the frying pan lying on the floor behind them.

Tanner's subtle use of color and texture, which are enhanced by glazing, was described as follows by a critic in the April 14, 1913 issue of the *New York American*:

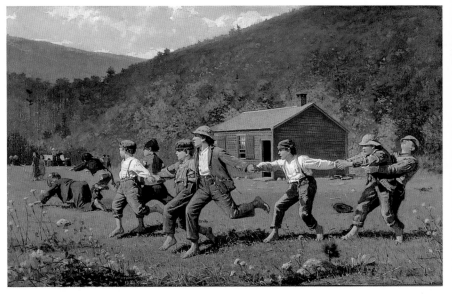

24.16 Winslow Homer, *Snap the Whip*, 1872. Oil on canvas, 22 ¼ x 36 ½ in. The Butler Institute of American Art, Youngstown, Ohio.

If you examine his canvases closely, you will find that the blue is threaded through the strokes of purple, gray and pinkish mauve, and more sparingly with pale, creamy yellow.... Tanner [has] introduced chromatic relations into the dark and light colors of his canvas and so draws them into a unity of vibrating and resonant harmony.[10]

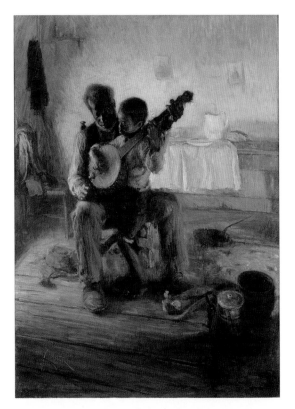

24.17 Henry Ossawa Tanner, *The First Lesson* (*The Banjo Lesson*), c. 1893. Oil on canvas, 4 ft. x 2 ft. 11 in. Hampton University Museum, Hampton, Virginia.

Realism and Architecture

The utilitarian possibilities of iron and steel are associated with Realism in architecture. As a result of the Industrial Revolution, architects could take advantage of the tensile strength of steel frames, make suspension bridges using steel cables, and construct temporary, prefabricated structures. Once these techniques had been mastered and with the invention of the electric elevator, the way was open for the development of the skyscraper.

In 1889, the Universal Exposition opened in Paris. As we saw in Chapter 14, one of its chief attractions was the cast-iron Eiffel Tower, which was designed as a temporary structure by Alexandre-Gustave Eiffel. Using metal truss construction on a base of reinforced concrete, Eiffel created a graceful, wrought-iron, open lattice-work tower supported by steel girders. Taller than the Giza pyramids (see p. 306), the Eiffel Tower offered visitors an unprecedented, panoramic view of Paris. The four corner supports framing a round arch on each side converge into a single vertical with gradually sloping sides. Projecting from the top is a radio antenna.

Elisha Otis (1811–1861), the American who invented the elevator, installed an elevator that could rise in a curved trajectory to conform to the outlines of the tower. In 1856, Otis built the first elevator for a New York City department store and in 1861 he patented the steam-powered elevator.

Elevators were (and still are) an essential feature of the skyscraper, a type of building developed in the American Middle West. Louis Henry Sullivan, who designed the Wainwright Building in Saint Louis (see p. 283), used steel-frame construction in the Guaranty Building in Buffalo, New York (**figure 24.18**). His famous assertion that "form follows function" has a Realist quality in its appeal to practicality and recognition of the economic factors facing architects.

In the case of both the Guaranty Building and the Wainwright Building, Sullivan's forms follow their function, but they are also aesthetically harmonious. In the Guaranty Building, he used horizontal elements and wider areas of stone in the lower stories than in the upper ones. This creates a visual as well as a structural base. It is "finished" with a projecting cornice, from which ten stories rise to a second, crowning cornice at the top. Tall vertical elements frame the windows on all ten stories, which culminate in narrow round arches surmounted by a pattern of circular windows. A large pier wraps around each of the four corners, creating a smooth transition and the sense of a frame on all sides.

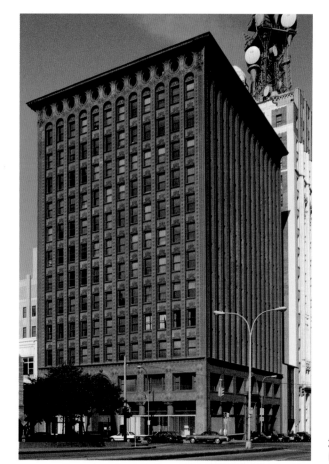

Eiffel Tower.
figure 14. 40, page 282

24.18 Louis Henry Sullivan, Guaranty Building, Buffalo, New York, 1894–1895.

Impressionism

The Realist concern for representing the broad panorama of society in a "realistic" manner was supplanted by the concerns of Impressionism. At the outset, the Impressionist style, like Realism, was a French style. It first developed in Paris from the 1860s, but also appealed to a number of artists from other countries, and lasted through the 1920s. Although social themes appealed to Impressionist painters, they were more interested in the reality of vision and in how we see the world around us. To this end, they studied light and color, they explored the nature of shadows and reflections, and they depicted the effects of light, dark, and color on moving and still surfaces. Because the Impressionists often painted outdoors, they were called *plein-air* ("open-air") painters. They tended to apply paint directly to a canvas, often creating the impression of spontaneity. Visible brushstrokes gave their work more surface texture than in Realist or Neoclassical painting. As Impressionism evolved, brushstrokes became increasingly prominent, creating a dissolution of form and making the paint itself a subject of the work.

We have seen that the American Impressionist James Abbot McNeill Whistler (1834–1903) used musical titles to convey the abstract character and linear and chromatic rhythms of his paintings. Born in Lowell, Massachusetts, Whistler spent several years as a child in Russia, studied art in France, and finally settled in London, where he earned a living as a portrait painter. As a follower of the Aesthetic Movement popular in France, which considered works of art in terms of their form rather than their iconography, Whistler believed in the philosophy of "Art for Art's Sake."

In 1867, Whistler exhibited his first painting with a musical title (**figure 24.19**). The languid poses of the girls conform to the lack of vitality in the whites and the slow-paced rhythms of the curved contours. In this picture, the subject is as much color as it is form. The predominant shades of white are varied by the fan and the areas of patterning, both of which reflect the influence of Japanese woodblock prints (see p. 183). Whistler antagonized the London critics with his musical titles. In 1867, when an art critic objected to the title of one of his *Symphonies in White* because it contained several colors, Whistler retorted with his typical sharp wit:

> Bon Dieu! Did this wise person expect white hair and chalked faces? And does he then … believe that a symphony in F shall be a continued repetition of F, F, F,? … Fool![11]

As was the case with Whistler in London, so the Impressionists working in Paris did not appeal to prevailing taste. French critics and the public were disturbed by the dissolution of form and the blurring of Impressionist paintings. After being excluded from the official jury-selected art exhibitions—the Salon—the Impressionists formed a Private Company in 1873 to exhibit their work independently.

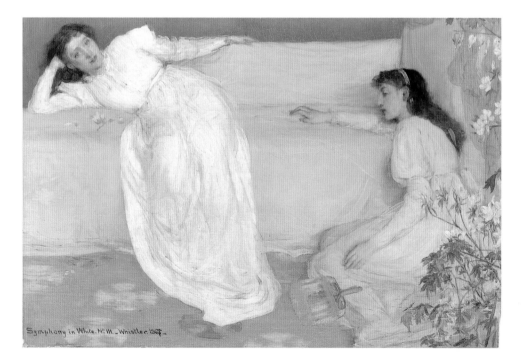

24.19 James Abbot McNeill Whistler, *Symphony in White, No. 3*, 1867. Oil on canvas, 20 x 30 ⅛ in. Barber Institute of Art, University of Birmingham.

COMPARE

Whistler, *Symphony in Blue and Pink*.
figure 6.25, page 124

COMPARE

Whistler, *The White Symphony*.
figure 6.26, page 124

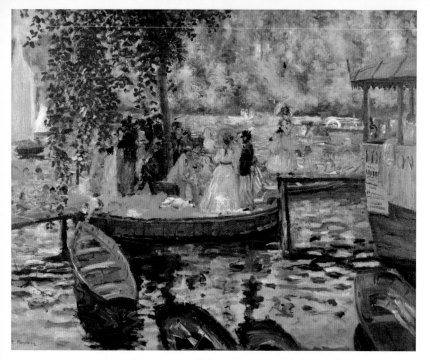

24.20 Pierre-Auguste Renoir, *La Grenouillère*, 1869.
Oil on canvas, 26 x 31 ⁷/₈ in.
National Museum of Fine Arts, Stockholm.

One of the favorite Impressionist subjects was scenes of leisure. Pierre-Auguste Renoir's (1841–1919) *La Grenouillère* of 1869 (**figure 24.20**) shows a crowd of people enjoying an afternoon on the outskirts of Paris. Among the typical Impressionist features of the painting are the sharp diagonals (the boats), the thickly applied paint, and the broken color (the water separated into individual strokes of different colors rather than being depicted as a uniform color). Renoir's water is composed of horizontal strokes, creating the impression that it is flowing slowly and reflecting the surrounding area. We see only a section of a scene that, like a photograph, has been cropped. This focuses us in on a slice of contemporary life as if we are observing the scene through a zoom lens.

Despite their close study of formal elements, Impressionist artists did not ignore the social realities of everyday life. Here, for example, Renoir has chosen an area along the Seine where people swam in their leisure time, but that was also frequented by prostitutes. Thus, although form, light, and color are predominant features of Impressionism, there are often subtexts beneath the surface of the imagery.

In Claude Monet's (1840–1926) *Impression, Sunrise* (**figure 24.21**), we are first struck by the fog and the blurred forms. We try to focus on objects such as the silhouetted boats and we are struck by the bright orange sun. We notice that the sun's reflection in the water is composed of the components of orange—red and yellow—arranged horizontally. This tells us that the water is moving slowly, whereas the sun is still. Looking past the water, we notice that there are allusions to industry. Rising from the shore are cranes and large, black smoke stacks, declaring the presence of factories and emitting the pollution that darkened the skies of nineteenth-century commercial cities. Monet's painting is credited with being the origin of the term "Impressionism," which was coined by a hostile critic. He objected to the visible brushstrokes, the broken color, the lack of a sense of drawing, and the blurred forms.

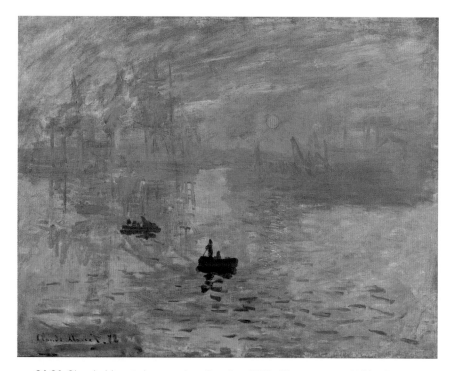

24.21 Claude Monet, *Impression, Sunrise*, 1872. Oil on canvas, 18 ⁷/₈ x 24 in.
Musée Marmottan, Paris.

Photography was also a major influence on the paintings of Edgar Degas (1834–1917), who was himself a photographer. In *End of the Arabesque* (**figure 24.22**), the viewpoint is from above. The view of the stage floor is tilted and the composition is asymmetrical, as it might be in a candid camera shot. Interested in forms moving through space, as we saw in Chapter 10 (see p. 193), Degas did many paintings of horse races and studied ballerinas and other performers on stage. Here the dancer is illuminated artificially from the footlights, which light up the white patches on her cheeks and forehead, giving her face the quality of a mask. The light filters through the diaphanous tutu, the texture of which is conveyed by individual strokes of yellow. At the back, a group of ballerinas relaxes after the performance.

Mary Cassatt (1844–1926), Degas' good friend from Philadelphia, lived in Paris from 1874. She exhibited with the Impressionists, focusing on themes of women and children, who are often depicted in interior spaces.

Her *Little Girl in a Blue Armchair* (**figure 24.23**), which is painted with the same bright color and rich paint texture as her *Woman in Green* (see figure 9.7), shows a girl before the age of sexual awareness. Her casual, slouched pose, with one arm behind her head, has a defiant quality, although she appears not to realize her erotic potential. On the one hand, she wears the plaid socks of a child and, on the other, her skirt is pulled up to reveal her underwear. The little dog, demurely curled up on the chair opposite, highlights by contrast the girl's provocative character.

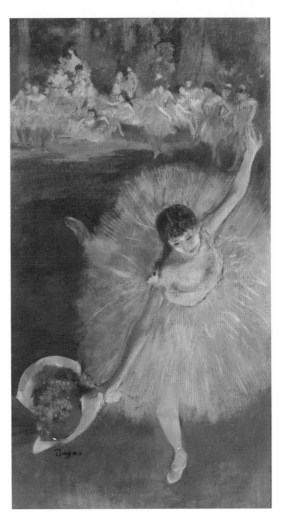

24.22 Edgar Degas, *End of the Arabesque* (*Fin d'arabesque*), 1876–1877. Essence and pastel on paper, 25 ⅝ x 14 ⅛ in. Musée d'Orsay, Paris.

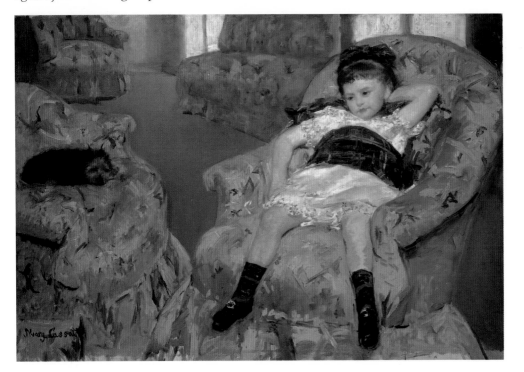

COMPARE

Cassatt, *Young Woman in Green.*
figure 9.7, page 164

24.23 Mary Cassatt, *Little Girl in a Blue Armchair*, 1878. Oil on canvas, 2 ft. 11 in. x 4 ft. 3 ⅛ in. National Gallery of Art, Washington, D.C. Collection of Mr. and Mrs. Paul Mellon.

Who's Looking at Whom? The Erotic Gaze

The influence of Impressionist color can be seen in the way in which Manet changed his palette in the 1870s. A comparison of the *Nana* (**figure 24.24**) of 1877 with the *Olympia* of 1865 shows that he has gone from dark to bright color and has increased the visible texture of the brushstrokes. At the right, the cropping of the male client is a photographic technique, while the Japanese screen reflects the growing popularity of non-Western art in late nineteenth-century France.

The intensity of the gaze, which Nadar captured in his photograph of Manet (see figure 24.14), is translated into iconographic meaning in Manet's *Nana*. The artist engages the viewer's eye and sense of texture formally by the silky materials of Nana's slip and corset. But he also makes the gaze an important part of the painting's iconography. The cropped man is a client, waiting to possess the woman sexually. He stares directly at her as she turns from her mirror to gaze at the viewer. Her prominent powder puff and the dress lying on a chair indicate that she is in the process of preparing herself for the enounter. As with *Olympia*, money and sex are part of the painting's message, although here it is conveyed in a more Impressionist style.

COMPARE

Manet, *Olympia.*
figure 24.12, page 495

We do not see Nana's reflection in the blurred glass of the tilted mirror. Instead, we see her psychological double in the flamingo on the cropped Japanese screen. The elegant bird, with its white feathers and long neck, echoes Nana's white silk slip and turned neck. Both are preening for the viewer, who is invited into the picture, along with the client, as the potential consumer of a commodified woman.

Manet accentuates the difference between Nana and the man by a number of formal choices that reinforce the meaning of the work. The man is fully clothed

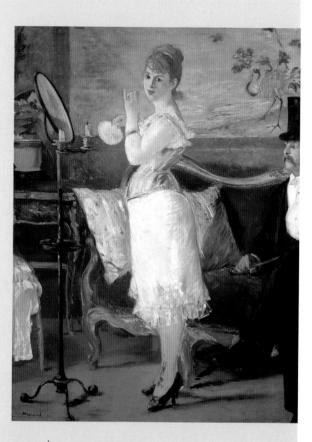

24.24 Édouard Manet, *Nana*, 1877. Oil on canvas, 5 ft. ¾ in. x 3 ft. 11 ¼ in. Kunsthalle, Hamburg.

in formal attire with a top hat and cane. Nana, in contrast, is only partly dressed. She stands in a neutral plane that echoes the mirror-stand in such a way that her head, the powder puff, and the glass create a variety of circular shapes. Both the powder puff and the reflection in the mirror convey an impression of the fleeting and insubstantial as opposed to the sturdy self confidence of the waiting client. His attention focused on her and the sense that he is waiting to possess her is further suggested by the diagonal of his foot.

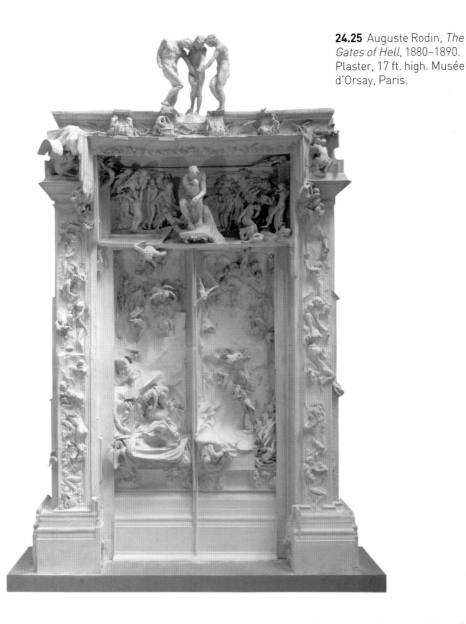

Sculpture: Rodin

Impressionism is more often associated with painting, drawing, and photography than with sculpture. Nevertheless, the work of the greatest nineteenth-century French sculptor, Auguste Rodin (1840–1917), shares certain qualities with Impressionist paintings. The surfaces of Rodin's sculptures are typically textured so that the medium, like Impressionist brushstrokes, contributes to the aesthetic appearance of the work. Rodin makes the viewer aware of his process, often creating partial figures that leave an unfinished impression.

In 1880, Rodin was commissioned to sculpt the portal for a planned Museum of Decorative Arts. He worked on the project for ten years, completing only the plaster version (**figure 24.25**) before the project was cancelled. The work was not cast in bronze until after his death. Rodin took as his point of departure the idea of an entryway, carving two doors framed by pilasters and crowned by a lintel. For the real door, he may have had in mind Ghiberti's *Gates of Paradise* (see p. 371), but he chose for his content Dante's *Inferno*, transforming his doors into *Gates of Hell*.

Three shades are intertwined at the very top and the brooding figure of Dante in the center of the lintel below became the inspiration for Rodin's famous *Thinker*. In the *Gates*, therefore, Dante meditates on his poetic journey through the circles of Hell, immortalized in the *Inferno*. Writhing figures populate the surface of the work; they are reminiscent of Michelangelo's powerful nudes in the Sistine Chapel (see p. 388). Rodin's figures tumble downward, hide their eyes in horror at their eternal fate, and struggle in agony. The theme of a portal leading to Hell is part of an ancient metaphor: the door of death. Formally, the animation of the figures exemplifies Rodin's ability to capture fugitive movement, which seems to glide over the surfaces of his sculpture.

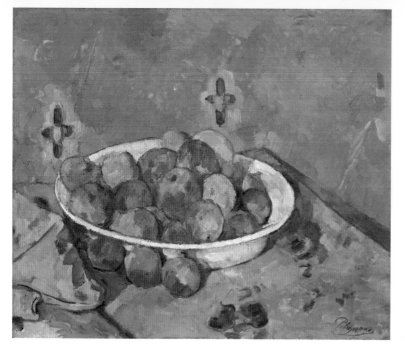

24.26 Paul Cézanne, *Plate of Apples*, c. 1877. Oil on canvas, 18 ⅛ x 21 ¹¹/₁₆ in. Art Institute of Chicago. Gift of Kate L. Brewster.

Seurat, *Circus Sideshow*.
figure 5.50, page 103

Post-Impressionism

Post-Impressionism (literally, "after Impressionism") refers to the late-nineteenth-century style that followed Impressionism. The Post-Impressionists can be distinguished from the Impressionists by their clear edges and the fact that their forms do not dissolve despite the thickness of the paint. Post-Impressionism thus appears more structured than Impressionism. However, the Post-Impressionists were drawn to the same subject matter as the Impressionists—leisure, everyday scenes, and portraits—and continued their interest in the properties of light and color.

Perhaps the most "structural" of the Post-Impressionists was Paul Cézanne (1839–1906), who exhibited in Paris but preferred to live in his native town of Aix-en-Provence, in the South of France. His early themes were violent and his early colors were dark—mainly black. But under the influence of the Impressionists, his color brightened and its range increased. His later themes were still life, landscape, and portraiture.

Cézanne revolutionized Western painting with a radical new approach to space. The still life in **figure 24.26**, for example, shows a tilted table against a vertical wall. In reality, the plate of apples would slide onto the floor. At the left, the tablecloth is structured as a pyramid, with straight edges. Although the apples are, in fact, spheres, they are composed of rectangular, crystalline brushstrokes and their contours are shown through changes in color rather than shading.

In 1907, the German lyric poet Rainer Maria Rilke (1875–1926) wrote as follows of fruits painted by Cézanne:

> [They] don't seem to care whether they are beautifully eaten or not. In Cézanne they cease to be edible altogether, that's how think-like and real they become, how simply indestructible in their stubborn thereness.[12]

In an allusion to the Judgment of Paris that was the mythological cause of the Trojan War (see p. 317), Cézanne wanted "to astonish Paris with an apple." By that he meant that he wanted to forge a new style, whose impact on the history of painting would elevate him to the same heroic stature as the Trojan prince. In this he succeeded, for Cézanne is considered perhaps the most important influence on the development of twentieth-century painting.

The Post-Impressionist style of Georges Seurat has been called both Pointillism and Divisionism. These terms refer to his application of paint in tiny dots of color, which we discussed in Chapter 5 (see figure 5.50). In his early *Bathers at Asnières* (**figure 24.27**), Seurat first used the Impressionist technique of broken color, especially in the landscape. But he reworked the picture later, adding his signature points of paint. The composition is orderly, and the figures

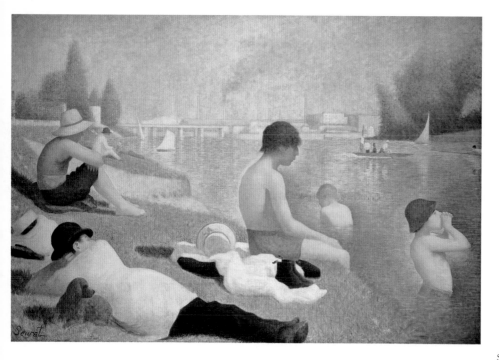

24.27 Georges Seurat, *Bathers at Asnières*, 1880s. Oil on canvas, 6 ft. 7 in. x 9 ft. 10 in. National Gallery, London.

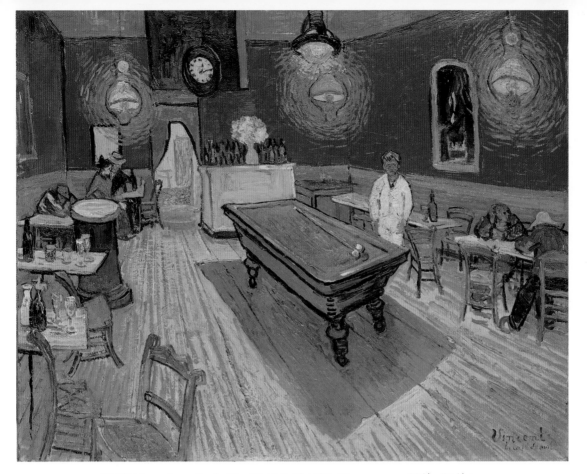

24.28 Vincent van Gogh, *The Night Café*, 1888. Oil on canvas, 28 ¹/₂ x 36 ¹/₄ in. Yale University Art Gallery. Bequest of Stephen C. Clark, 1903.

have a static quality. As they enjoy a period of leisure, lying on the grass, swimming, or boating, the background factories are reminders of modern urban life.

Vincent van Gogh's (see Chapter 5) distinctive brushstrokes and vibrant color animate his surfaces and endow his pictures with unique emotional intensity. In *The Night Café* (**figure 24.28**), van Gogh painted his vision of a sinister setting, eerily illuminated and decorated in jarring color contrasts. The green ceiling is reflected in the tabletops, the felt of the pool table, and the bartender's hair. Spatially as well as chromatically, the scene has an unreal quality. The floor slants upward, the pool table seems to be missing a leg, and the bartender does not seem to be standing on the floor.

Van Gogh wrote to his brother that *The Night Café* was one of his ugliest paintings and that only such ugly paintings can have deep meaning. Indeed, van Gogh has conveyed the isolation of the night café, with single men who do not communicate juxtaposed with the couple in the far corner. The lamps glow with eerie haloes, and the clock over the door seems to have stopped. Anxiety and tension pervade the painting—consistent with the intensity of van Gogh's assertion that:

... the café is a place where one can ruin oneself, go mad or commit a crime. So I have tried to express, as it were, the power of darkness in a low public house, by soft Louis XV green and malachite contrasting with yellow-green and harsh blue-greens, and all this in an atmosphere like a devil's furnace of pale sulfur.[13]

Paul Gauguin, a sometime friend and rival of van Gogh's, gave up his career as a stockbroker and left his family to become a painter. At the Universal Exposition of 1889, where non-Western artifacts were exhibited, Gauguin was drawn to Polynesia. In 1891, he moved to Tahiti in search of a Romantic ideal of "primitive" innocence, free from European tradition and the corruption of modern life. In fact, however, Gauguin took his problems, including alcoholism, with him, and contracted venereal disease. Nevertheless, he tried to assimilate into Tahitian culture, taking several young mistresses from the island. His attraction to the landscape of Tahiti is clear from the colorful *Tahitian Landscape* (see figure 5.7) and his effort to merge Oceanic civilization with the West is evident in the *Self-Portrait with Yellow Christ* (see figure 7.10).

COMPARE

Gauguin, *Tahitian Landscape*. **figure 5.7, page 79**

COMPARE

Gauguin, *Self-Portrait with Yellow Christ*. **figure 7.10, page 137**

24.29 Paul Gauguin, *Where do we come from? What are we? Where are we going?* 1897. Oil on canvas, 4 ft. 6 ¾ in. x 12 ft. 3 ½ in. Museum of Fine Arts, Boston. Tomkins Collection – Arthur Gordon Tompkins Fund.

Gauguin's large, late painting, *Where do we come from? What are we? Where are we going?* (**figure 24.29**) is an allegory of civilization that combines Christian tradition with Tahitian mythology. The soft, velvety brushstrokes are characteristic of Gauguin, as are the juxtapositions of bright and dark color. The flat patterns, which are found on Polynesian printed textiles, are also the result of Japanese influence. *Where do we come from?…* is a kind of frieze of life, with the central figure reaching for an apple reminiscent of Adam in the Garden of Eden. An infant at the far right is placed opposite the old, seated figure at the far left. In between these metaphors of infancy and old age are men, women, a child, and animals, which represent the individual life span and the march of human history. The blue statue with extended arms represents a native god, but its pose recalls traditional images of Jesus on the Cross.

Gauguin's attraction to Christianity is as evident in his writings as in his art. In 1884–1885, he wrote on the relationship between painting, music, and literature:

> To judge a book, you must be intelligent and well educated. To judge painting and music, you need … special feelings…. In a word you must be a born artist; and though many are called few are chosen.[14]

Lithograph posters became a popular form for advertising public events in late nineteenth-century Paris. The posters of the Post-Impressionist painter Henri de Toulouse-Lautrec (see p. 54) were most often announcements for the cabarets of Montmartre (**figure 24.30**). They tend to be brightly colored, with little or no shading.

Crippled and stunted from two riding accidents, Toulouse-Lautrec admired singers and dancers who could move gracefully through space. In this example, the famous redheaded entertainer Jane Avril and a male companion are attending a performance by the fashionable singer Yvette Guilbert, whose head is cropped by the top of the poster. Jane Avril wears a black dress and hat and carries a black fan, which echo the blacks of the top hat and Guilbert's gloves. Also visible are the arms of the conductor and the necks of the double basses. The tilted viewpoint, cropping, and clear edges, as well as the subject matter, are characteristic of Post-Impressionism.

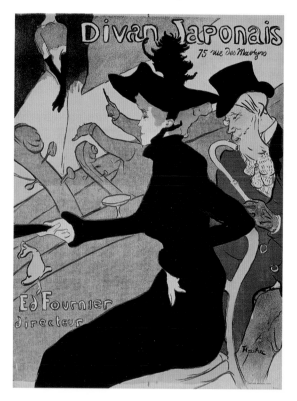

24.30 Henri de Toulouse-Lautrec, *Le Divan Japonais* (*The Japanese Love Seat*), 1892–1893. Lithograph poster, 31 x 23 ⅝ in. Bibliothèque Nationale, Paris.

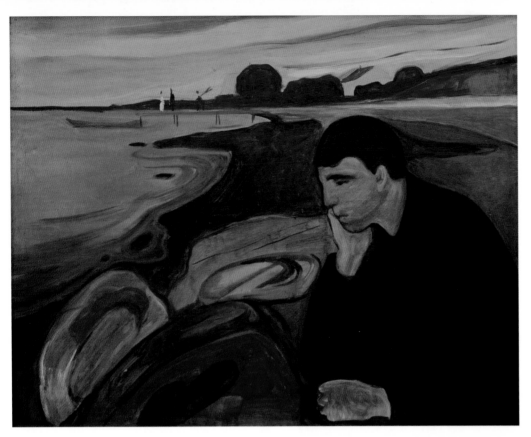

Munch, *The Scream*.
figure 6.29, page 126

24.31 Edvard Munch, *Melancholy*, 1894–1895. Oil on canvas, 32 x 39 in. Rasmus Meyer Collection, Bergen Kunstmuseum, Norway.

> ... all art, literature, and music must be born in your heart's blood.
>
> Edvard Munch, artist (1863–1944)

The top of the poster gives the name of the club (*The Japanese Love Seat*) and its address. The director's name is placed at the lower left. And Toulouse-Lautrec's signature monogram, a superimposed *HTL* followed by *autrec*, is behind the chair at the right.

At the end of the nineteenth century, new stylistic trends began to emerge. The paintings of the Norwegian Edvard Munch (1863–1944) show the influence of Post-Impressionist dynamic line and color, but there is a new depth in conveying states of mind. Affected by a series of personal tragedies, Munch's art has an overtly autobiographical flavor.

In Munch's *The Scream* (see figure 6.29), we saw an expression of the artist's panic when he felt that nature (and he himself) was in danger of disintegrating. In his *Melancholy* of 1894–1895 (**figure 24.31**), Munch depicts a brooding, immobilized, meditative figure, whose mood is echoed by the landscape colors. He occupies the foreground, leaning his chin on his hand and is rendered mainly in blacks. The swirling dark blues and greens in the background are brightened only by the distant couple on the pier, whose togetherness contrasts with the isolation of the main figure. Munch's combination of prominent paint texture with the images of emotional states has a Symbolist quality—Symbolism being a movement that developed in art and literature in the late nineteenth century.

—◆—

The two main trends in art at the turn of the twentieth century are embodied in the late work of Cézanne and Munch. Cézanne's faceted brushstrokes led to new spatial developments, the most influential of which was Cubism. The exuberant brushstrokes of Munch and his interest in conveying mood inspired the twentieth-century Expressionists. Both trends were strongly affected by the visibility of paint in Impressionism and Post-Impressionism and the fact that the medium was now a conscious part of a work's meaning. Another influence came from the Realist emphasis on modern society, especially the effects of industry, which led to a new urban iconography. From the exposure of Western artists to non-Western forms through travel and international exhibitions, the early-twentieth-century artists would find new ways to subvert the Classical tradition.

25

1900 to 1945

KEY TOPICS

Expressionism
Fauvism
Cubism
Futurism
Suprematism
The Blue Rider
The Bridge

Dada and Surrealism
American Realism and
 Abstraction
The Harlem Renaissance
Constructivism
De Stijl
The Bauhaus
The Prairie Style

HISTORICAL EVENTS	ART HISTORY
1900	**1900**
	● Fauve exhibition, *Salon d'Automne*, Paris 1906
	● Matisse, *The Joy of Life* 1906
● First Model T, Ford Motor Company 1908	● Picasso, *Les Demoiselles d'Avignon*, 1907
● First motion picture studio in Hollywood 1909	● Marinetti, Futurism in Italy 1909
1910	**1910**
● Freud, *Jokes and Their Relation to the Unconscious* 1911	● Analytic Cubism exhibitions in Paris 1911
	● The Blue Rider, Munich 1911
	● Dada in Zürich 1914
● World War I 1914–1918	● *De Stijl* in Holland 1917
● Russian Revolution 1917	● Walter Gropius founds the Bauhaus in Germany 1919
1920	**1920**
● First commercial radio station in the United States 1920	● Harlem Renaissance, New York 1920s–early 1930s
	● André Breton , *First Surrealist Manifesto* 1924
● Five Year Plans being in the Soviet Union 1928	● Le Corbusier, Villa Savoye, Poissy-sur-Seine, France 1928–1930
● Great Depression 1929	
1930	**1930**
● Adolf Hitler Chancellor of Germany 1933	● Man Ray, *Glass Tears* 1930–1933
● Spanish Civil War 1936–1939	● Frank Lloyd Wright, "Fallingwater", Bear Run, Pennsylvania 1936–1939
● World War II 1939–1945	● Alexander Calder, *Hanging Spider* c. 1940

In the early twentieth century, the notion of modernity that arose in the nineteenth evolved into an ideal of newness for its own sake—the avant-garde. Avant-garde artists searched for new ways to construct space, to represent the figure, and to expand the expressiveness of color. They rejected the Classical tradition and strove to free themselves from the domination of the Old Masters. In so doing, they were inspired by the exuberant colors and prominent brushstrokes of Impressionism and Post-Impressionism, and by Cézanne's revolutionary approach to structured, faceted space (see Chapter 24). In the course of the nineteenth century, trade with the Far East increased, colonization expanded, and international exhibitions were held in Europe. As a result, the Western avant-garde became more and more interested in non-Western art (see Chapters 20–23).

Inspired by the abstract qualities of certain non-Western art, especially sculpture, many avant-garde artists collected works from Asia, Africa, and the Americas. Most Westerners did not understand much about the cultural context of non-Western art. Nevertheless, the avant-garde was intrigued by unfamiliar non-Western forms and saw in them a sense of mystery that seemed lacking in their own culture.

The first half of the twentieth century was devastated by World War I (1914–1918), called "the war to end all wars." Artists reacted to the war in a number of ways. One was the anti-art, anti-war, and anti-bourgeois Dada Movement, which included writers and performers as well as painters and sculptors.

The attraction to mystery and the imagination that had also evolved in the nineteenth century was

partly derived from discoveries in psychology. Freud's work in psychoanalysis continued through the first three decades of the twentieth century and influenced all of the arts. Beginning in the 1930s, artists working in the Surrealist style depicted the world of fantasy, of the unconscious, and of dreams.

In 1903 the center of the Western art world was Paris, where artists established the *Salon d'Automne* to exhibit the most avant-garde work of the day.

Expressionism and Cubism in France

During the first decade of the twentieth century, the two artists who best embodied the interest in color and form were Matisse and Picasso, respectively. Color was the primary focus of Expressionism, a general term that characterizes the use of exuberant color in several early twentieth-century styles. The first and most influential of these was Fauvism, the object of which was to free color from observed reality.

In 1906, the *Salon d'Automne* exhibited a group of brightly colored paintings that reminded one critic

of the jungle. When he caught sight of a traditional sculpture in their midst, he reportedly exclaimed: "*Donatello parmi les fauves!*" ("Donatello among the wild beasts!"). The French word for "wild beast"—*fauve*—has remained the term used to describe paintings such as Matisse's *The Roofs of Collioure*, which we discussed in Chapter 5 (see figure 5.36).

In *The Joy of Life* (**figure 25.1**) of 1906, Matisse depicts an idyllic, dreamlike scene populated by nude figures relaxing, dancing, playing music, and embracing. They occupy a radiant landscape, juxtaposing oranges, pinks, purples, yellows, and greens. Although such combinations are not literally "realistic," they convey the luxuriant warmth of the content—the joy of life. Note also the dynamic energy of Matisse's curved contours, the *arabesques* he named after Islamic patterns he admired. He associated arabesques with dance and music, both of which are themes in *The Joy of Life*. For Matisse, it was his work, rather than what he or anyone said about it, that was most important. In *Notes of a Painter*, he wrote: "A painter's best spokesman is his work."[1]

COMPARE

Matisse, *The Roofs of Collioure.*
figure 5.36, page 97

25.1 Henri Matisse, *The Joy of Life*, 1906. Oil on canvas, 5 ft. 8 ¾ in. x 7 ft. 10 in. The Barnes Foundation, Merion, Pennsylvania.

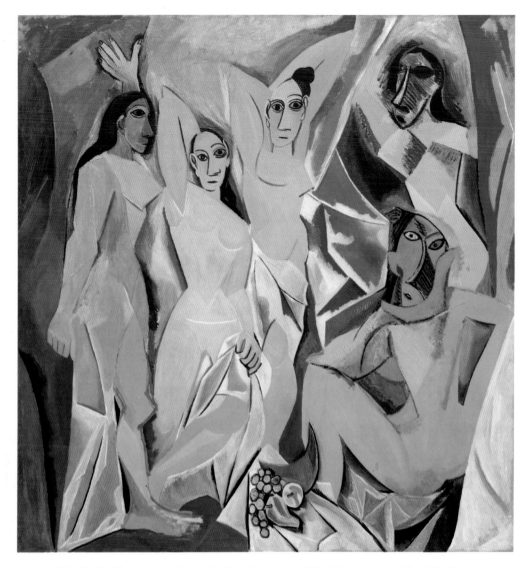

25.2 Pablo Picasso, *Les Demoiselles d'Avignon*, 1907. Oil on canvas, 8 ft. x 7 ft. 8 in. The Museum of Modern Art, New York. Acquired through the Lillie P. Bliss Bequest.

Picasso's monumental and highly original *Les Demoiselles d'Avignon* (*The Women of Avignon*) (**figure 25.2**) was in part a response to *The Joy of Life*. Whereas Matisse had disrupted traditional color theory, Picasso was inspired by Cézanne's new concept of space. Both the figures and background in the *Demoiselles* are geometrically constructed and do not conform to the reality of space we inhabit in nature. The color, in contrast to Matisse's, is low-key and has limited range.

"*Avignon*" refers to the *carrer Avinyo*, a street in the red-light district of Barcelona. The women in the picture are prostitutes gathered around a still life of fruit.

Picasso made many studies of this work, rethinking its iconography several times. In one study, he depicted a medical student carrying a skull, who entered the brothel from the left. In another, it is a sailor who enters. In the end, however, Picasso eliminated the male figures, forcing the viewer to enter the space and confront the women directly.

The women themselves contain features of Egyptian, Greek, and non-Western sculpture. The elongated, geometric faces of the two at the right are clearly derived from African art. In the so-called squatter at the lower right, Picasso abandoned the single viewpoint for a simultaneous one; he shows us the front of the woman's face and the back of her torso at the same time. The angular forms make the women appear aggressive and dangerous. By disrupting the natural configuration of the faces, Picasso shocked viewers and invented a new approach to the human figure.

> I would like to know if anyone has ever seen a natural work of art.
> Nature and art, being two different things, cannot be the same thing.
> Through art we express our conceptions of what nature is not.
>
> Pablo Picasso (1881–1973)

The *Women of Avignon* can be seen as a transition to a major twentieth-century style, namely Analytic Cubism, which culminated in two exhibitions held in Paris in 1911. Picasso and his French contemporary Georges Braque (1882–1963) developed the style together by limiting and subduing color and creating a radically new kind of space. Braque's *The Portuguese* (**figure 25.3**) of 1911 exemplifies pure Analytic Cubism. It depicts the artist's recollection of a Portuguese guitarist he saw performing in a French bar, in the southern port of Marseilles. The colors are muted yellow-browns and grays and the space resembles a jumble of cubic and cylindrical blocks. The figure, which we can just make out, is fragmented and merges with the guitar and the surrounding space through shared geometric shapes. The visible brushstrokes, like Cézanne's, are short, distinct, and rectangular.

There are also a number of stenciled letters disconnected from words and words disconnected from sentences. This echoes the fragmentation of the figure and the space. At the top right, Braque painted the word BAL (Dance). The use of letters and words increased in the course of twentieth-century painting and led to the development of collage.

After the exhibitions of 1911, when artists and the public saw the entire range of Analytic Cubism, the style sparked an enormous amount of excitement. Recognizing the new potential for rendering space, artists evolved new, related styles inspired by Cubism. One of these was Futurism, which associated the mechanical appearance of the solid geometric shapes with modern industry and automation.

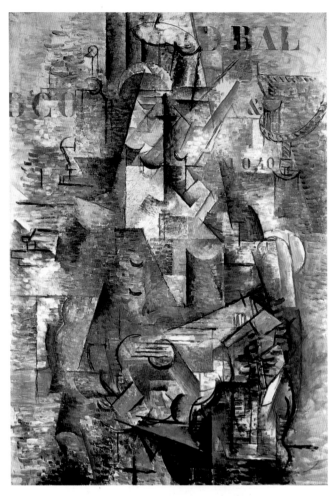

25.3 Georges Braque, *The Portuguese*, 1911. Oil on canvas, 3 ft. 10 1/8 in. x 2 ft. 8 in. Offentliche Kunstsammlung Basel, Kunstmuseum, Basel. Gift of Raoul La Roche, 1952.

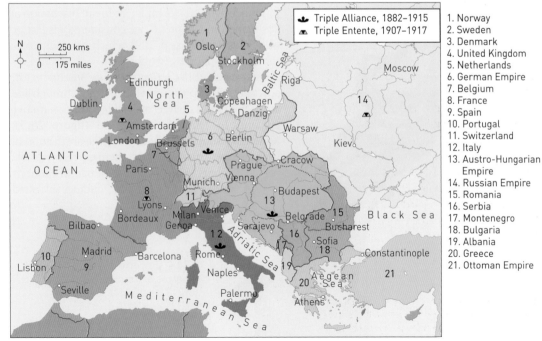

Europe on the eve of World War I.

Futurism in Italy: Boccioni

The Futurist movement began in Italy in 1909, when Filippo Marinetti, the editor of a literary magazine in Milan, published a manifesto attacking the past as outmoded, weak, and feminine. He advocated a more "masculine" art based on speed, energy, and the machine, all of which he considered to be the way of the future. Futurism favored warfare as a means of eradicating the past, including works of art by the Old Masters, traditional literature, libraries, and even history itself.

The work that best exemplifies Futurism is Umberto Boccioni's (1882–1916) dynamic bronze sculpture *Unique Forms of Continuity in Space* (**figure 25.4**). This image of a dehumanized, powerful male,

> **All forms of imitation must be despised, all forms of originality glorified.**
>
> Umberto Boccioni, artist (1882–1916)

25.4 Umberto Boccioni, *Unique Forms of Continuity in Space*, 1913 (cast 1931). Bronze, 43 ⁷/₈ in. x 34 ⁷/₈ in. x 15 ³/₄ in. The Museum of Modern Art, New York. Acquired through the Lillie P. Bliss Bequest.

striding determinedly through space seems to be made of armor plates. The figure is composed of strong diagonals and open spaces that create an impression of mechanized speed. This work corresponds to Boccioni's ideal of rendering movement as repeated images perceived by the eye as a single action. In this sculpture, therefore, forward motion is a metaphor for the future.

Expressionism and Suprematism in Russia and Germany

In Moscow and Germany (especially Munich and Dresden), the avant-garde flourished in the early twentieth century. As in France, Russian and German artists were influenced by Expressionist color, although they were not immune to the effects of Cubism. In fact, one of the main sources of patronage for Picasso and Matisse, who had not yet achieved fame in France, were Russian art dealers. They recognized the genius of these two artists and acquired many of their early works for Russian collections.

The Russian painter Kandinsky gave up his career as a law professor in Moscow and moved to Munich. There, as we saw in Chapter 10, he organized an Expressionist group called The Blue Rider (*Der blaue Reiter*). The name combines the interest in color (blue) with the emblem of Moscow (the Rider), showing Saint George killing the dragon (see figure 10.4).

Kandinsky is credited with being the first artist to renounce figuration completely. In our discussion of abstraction in Chapter 6, we considered his *Picture with White Border* (see p. 109), which is thought to be the first non-figurative work.

His treatise of 1912, *Concerning the Spiritual in Art*, advocates the expression of inner feeling through line and color rather than recognizable form or narrative content. In *Improvisation No. 30* (**figure 25.5**), Kandinsky's musical title conveys the abstraction of the image. This being said, there are recognizable elements in the painting—a pair of cannons at the lower right and outlines of tilted

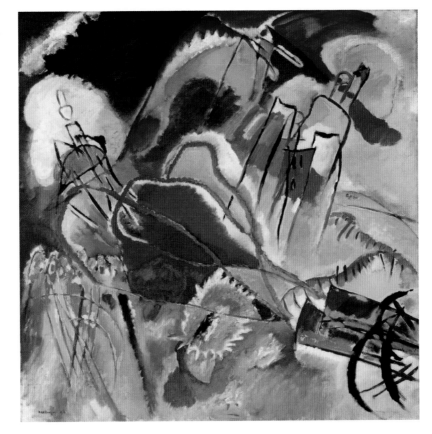

25.5 Wassily Kandinsky, *Improvisation No. 30*, 1913. Oil on canvas, 3 ft. 7 ¼ in. x 3 ft. 7 ¾ in. Art Institute of Chicago. Arthur Jerome Eddy Memorial Collection.

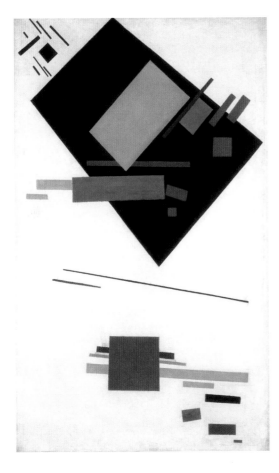

buildings above them. When asked about these forms, Kandinsky said that they had not been made intentionally, implying that they emerged spontaneously from his unconscious. In *Concerning the Spiritual in Art*, he wrote that: "Every work of art is the child of its time, often it is the mother of our emotions."[2]

Another Russian artist who believed in the spirituality of art was Kasimir Malevich (1878–1935). He called his style Suprematism, by which he meant that simple forms and deep emotion had supremacy over materialism and narrative. His Suprematist works are composed of pure geometric forms, in either black, white, or color, without shading or a sense of volume. In Malevich's *Suprematist Composition* in **figure 25.6**, a black trapezoid is juxtaposed with red, orange, green, blue, and black rectangles. They are carefully balanced by contrasting diagonals that shift direction and float in a flat, white space. White, for Malevich, represented the ultimate absence of materiality and thus the height of spirituality.

25.6 Kasimir Malevich, *Suprematist Composition, Black Trapezium and Red Square*, after 1915. Oil on Canvas, 39 ¾ in. x 24 ⅜ in. Stedelijk Museum, Amsterdam.

Malevich's *Black Square*

We have seen that there are many instances in the history of art in which new and unexpected imagery causes controversy. We saw this when Manet exhibited his *Déjeuner* and his *Olympia* in the 1860s, when Brancusi's *Bird in Space* was imported into the United States in the early twentieth century, and when the Cincinnati Museum mounted the Mapplethorpe show in 1989—to cite only a few examples.

In 1915, while Brancusi was working in Paris, Malevich first exhibited his now famous *Black Square* (**figure 25.7**) in St. Petersburg. At the time, czarist Russia, like Paris, Dresden, and Munich, was a center of the avant-garde in Europe. Malevich was born in Kiev, in the Ukraine, and had not been exposed to art in his youth. But he later recalled a fascination with the changing shapes of nature and of being inspired to paint by watching a house painter at work. Malevich decided to study art and, in 1904, enrolled in the Moscow School of Painting, Sculpture, and Architecture.

In Moscow, Malevich came into contact with contemporary art and met artists who studied and collected non-Western works in their search for new visual ideas. Malevich himself had painted in a number of styles before turning to geometric abstraction. His first Suprematist work was *Black Square*, which he exhibited in St. Petersburg along with thirty-nine other purely geometric paintings.

If we want to explore the meaning of such a work and begin to understand what Malevich meant by Suprematism, we have to know something about the time and place in which the artist lived. Even today, nearly a century after *Black Square* was first exhibited, many people wonder just what the artistic value of the work might be. Malevich addressed these issues in his book, *The Non-Objective World*, where he described his efforts to achieve mystical experience and clarity of vision through simple forms. For Malevich, the simplicity of these forms conveyed "supremacy" of feeling and thus could be universally understood.

Black Square, in the artist's view, expressed the essence of pure, cosmic feeling, whereas the white edge represented a void that was beyond feeling. For Malevich, it was only through the absence of worldly objects and their associations that spirituality and direct sensation could be conveyed. To this end, he abandoned recognizable form, especially, he said, the human face, because it is the most universally recognized configuration. (Picasso, in contrast, never abandoned the face, although he distorted it in unprecedented ways.)

> Color and texture ... are the essence of painting, but this essence has always been destroyed by the subject.
>
> Kasimir Malevich, artist (1878–1935)

In 1917 the Russian Revolution erupted, causing radical cultural and political changes in Russian society. The reigning czar, Nicholas II, and his family were executed, political power was seized by the communists, and the Soviet Union was established. Under Soviet rule, cultural institutions became more and more repressive. For political reasons, the government promoted the Soviet Realist style, designed to illustrate the achievements of the working class in the newly formed Soviet Union.

Malevich was named Commissar for the Preservation of Monuments and Antiquities in 1917. In the 1920s, he tried to visit Germany and Poland, both of which were centers of the avant-garde at the time. The bureaucratic complications that delayed his trip until 1927 made him realize that modernism would no longer be tolerated by the Soviets and he arranged to leave a number of his paintings in Germany.

When Malevich returned to St. Petersburg (its name changed to Leningrad), he was criticized for not conforming to the needs of communism. Beginning in 1928, the policies and Five-Year Plans of the Communist leader Joseph Stalin (1879–1953) were instituted and two years later Malevich was arrested for

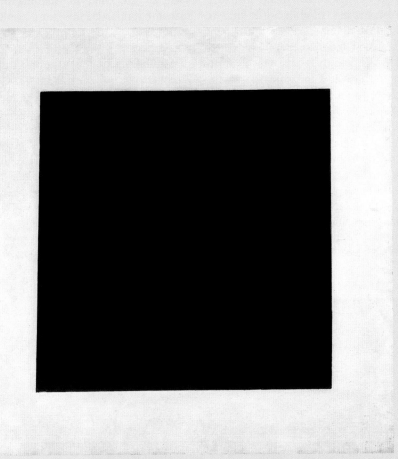

25.7 Kazimir Malevich, *Black Square*, first exhibited 1915, this version 1923. Oil on canvas, 41 ¼ x 41 ¼ in. Russian State Museum, St. Petersburg.

artistic "deviation." In the 1930s, when the National Socialists (Nazis) came to power in Germany, Malevich's paintings, left there to escape the communists, were hidden to save them from the Nazis.

In 1935, when Malevich died, a black square and a black circle were placed at either end of his coffin. The following year, Malevich's works were included in an exhibition at the Museum of Modern Art in New York, whereas in Leningrad his work was impounded by the state. It was not exhibited again in Russia until 1977.

The most important lesson of the history of the *Black Square* is that art cannot be reasonably judged by the standards of politics.

Imagine the reverse: it would be absurd to judge politicians by the standards of art. Art has its own history, its own conflicts, and its own characteristics. One can, of course, disapprove of a particular artistic message, as well as of the appearance of a work. One can also simply not like it—just as one can dislike a particular politician. But the attempt of the Soviet Union and the Nazis to suppress modern art boomeranged. The result of these shortsighted policies was the loss of a great deal of important (and valuable) works (and artists) that left Communist Russia and Nazi Germany for safer, more congenial, and more profitable pastures.

In Germany, the most avant-garde Expressionist group in the early twentieth century was The Bridge (*Die Brücke*), which was dedicated to bridging past and present and to creating links between nations. Like The Blue Rider, the philosophy of The Bridge was to invest art with spiritual significance and to emphasize spontaneity over academic tradition. The leading artist of The Bridge, Ernst Ludwig Kirchner (1880–1938), was influenced by Cubist structure as well as by Expressionist color. In *Self-Portrait as a Soldier* (**figure 25.8**), Kirchner reflects the anxiety of the age—the tension and devastation unleashed by World War I, which was then in its first year. He combines geometric form and unnatural space with visible paint texture and arresting color. He shows himself as a uniformed soldier in front of, and apparently disconnected from, a nude woman. The jarring effect of color and space, together with the distorted shapes—note that the soldier's right hand is a red and green stump—reflects the alienation of modern society as well as the onset of war.

> As youth, we carry the future and want to create for ourselves freedom of life and of movement against the long-established older forces.
>
> Ernst Ludwig Kirchner, artist (1880–1938)

World War I and the Dada Movement

With the declaration of World War I, the optimism of the avant-garde and the notion of progress were dealt a devastating blow. Advances in science and technology hailed for their potential to improve society were used to manufacture poison gas, machine guns, bombs, and tanks. In art, the response took the form of the Dada Movement, which began with a group of artists, writers, and performers who gathered at the Cabaret Voltaire, in Zurich, in neutral Switzerland.

Dada was not so much a formal style as a set of ideas. Dadaists advocated negation, a philosophy of nihilism ("nothingness") that challenged the social institutions they believed had contributed to the war. The origin of the term "dada" has been widely debated—ranging from a child's first words and reflecting a wish to begin over again, to the more optimistic Russian *da da* ("yes, yes"), to the French word for "hobby-horse," to having no meaning at all. Dada was about destruction and construction, about the chance results of unfettered imagination, and about creative play.

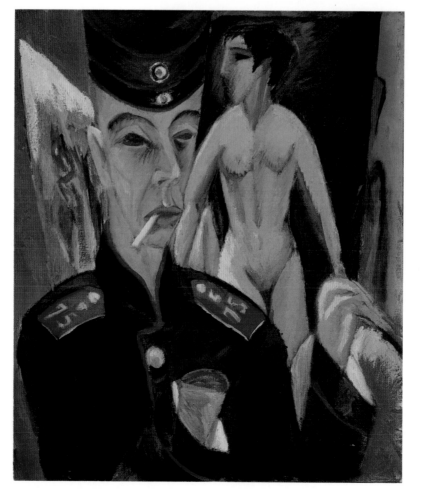

25.8 Ernst Ludwig Kirchner, *Self-Portrait as a Soldier*, 1915. Oil on canvas, 27 1/4 x 24 in. Allen Memorial Art Museum, Oberlin College, Ohio. Charles F. Olney Fund, 1950.

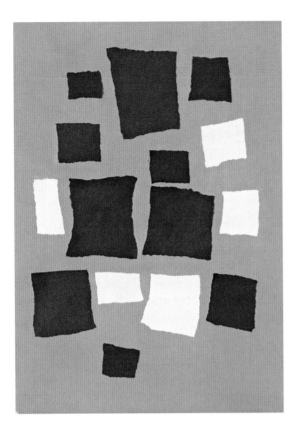

25.9 Jean (Hans) Arp, *Arrangement According to the Laws of Chance*, 1916–1917. Torn-and-pasted papers on paper, 19 ⅛ x 13 ⅝ in. Museum of Modern Art, New York. Purchase.

> ... art is reality, and the reality we share
> must assert itself beyond all particularity.
>
> Jean Arp, artist (1887–1966)

These ideas are embodied in the pictures and poems of one of the founding members of Dada, the German Hans Arp (1887–1966). He made the collage in **figure 25.9** by tearing up pieces of paper into approximate squares, dropping them, and then pasting them where they fell. Each has an irregular edge and is slightly tilted, as if trying to find its place on the surface of the paper. Arp's process was an experiment in randomness and play, in which he allowed the laws of chance to dictate the image. At the same time, however, the artist intervened and decided on the final appearance of the work.

Dada spread to the United States mainly through Marcel Duchamp, the French artist whose *L.H.O.O.Q.* and *In Advance of a Broken Arm* we have already discussed (see pp. 15 and 256). Duchamp's most scandalous ready-made was the *Fountain* of 1917 (**figure 25.10**), when he took a porcelain urinal, turned it on its side, signed it *R. Mutt, 1917*, and gave it a title. The punning quality of *Fountain* is characteristic of Dada play and reflects Duchamp's view that art should engage the mind rather than the senses of the viewer. In the very conception of this work, the artist challenges the notion of what art is and in its execution he redefines the boundary between art and non-art. Duchamp submitted the *Fountain* to an exhibition at the American Society of Independent Artists in New York, but it was rejected. The original has since disappeared.

In May, 1917, Duchamp protested the rejection of "R. Mutt's" *Urinal*. Responding to allegations that

the ready-made was immoral, vulgar, and an act of plagiarism, because merely a "plain piece of plumbing," he wrote:

> Whether Mr. Mutt ... made the fountain or not has no importance. He CHOSE it. He took an ordinary article of life, placed it so that its useful significance disappeared ... created a new thought for that object.[3]

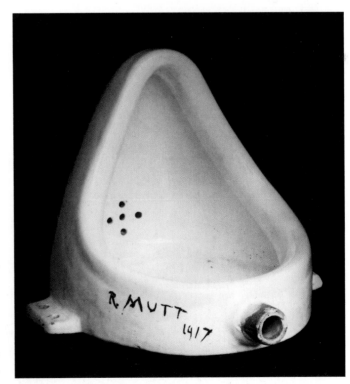

25.10 Marcel Duchamp, *Fountain*, 1917. Ready-made, 24 ⅝ in. high. Courtesy Sidney Janis Gallery.

MEANING

Barbara Kruger and the Challenge of Tradition

The American artist Barbara Kruger is known for her arresting, large-scale works that use images and text from mass media: "I try to address notions of power and how they make us look and feel: how they dictate our futures and our past. How power is threaded through culture impacts on both men and women. We all live in a world constructed through the dense machinations of trade and expenditure, of pleasure and desire, of labor and wages. I think that pictures and words have the power to make us rich or poor. I try to engage that power using methods that are both seductive and critical."

In works such as *Untitled (Your Gaze Hits the Side of My Face)* (**figure 25.11**), Kruger confronts the way men can violate women merely with a lewd look. This particular work projects a profile of a woman's face which is actually a bust executed in the stylized and idealized style associated with the sculptural forms favored by Hitler's Nazi regime. "Your gaze hits the side of my face" is superimposed to the left as if each word has been cut out from a newspaper or magazine and pasted on the image. The work recalls the work of such politically-active collage artists of the 1920s and 1930s as Hannah Höch, whom we discussed in Chapter 24. As Höch confronted the social injustices of Germany between the wars, Kruger addresses issues relevant to her generation. Similarly, like Arp and The Bridge, Kruger challenges traditional artistic forms and techniques.

Kruger's work forces us to rethink what we accept as "given." They prompt us to question our culture, politics, concepts of identity, and subjectivity by fragmenting our notion of reality and then reassembling the fragments. This process is refuted in her assertion: "I want to blur the firm boundaries."

Quotations from Kruger's interview with Amnesty International UK, 20 April 2005

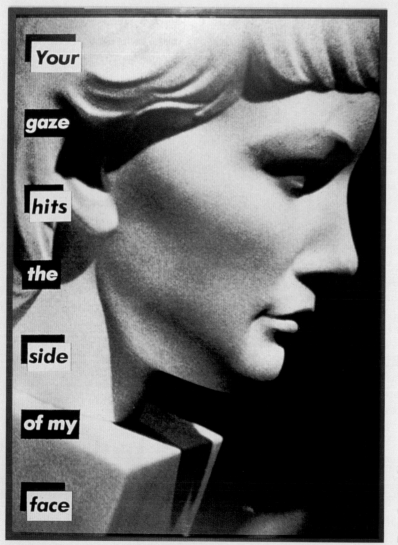

25.11 Barbara Kruger, *Untitled (Your Gaze Hits the Side of My Face)*, 1981. Photograph, 4 ft. 7 in. x 3 ft. 5 in. Courtesy of Mary Boone Gallery, New York. Collection Vijak Mahdavi and Barnado Nadal-Ginard.

Realism and Abstraction in the United States

In the United States, from the early twentieth century through World War I, most artists worked in traditional, relatively realistic, often regional styles. A few, however, began to reflect the avant-garde interest in abstraction. An example of the former can be seen in the New York Ash Can School, so-called because it represented the "reality" of everyday life, especially urban life in New York City (**figure 25.12**).

John Sloan (1871–1951) first worked as a newspaper illustrator in his native Philadelphia. When he moved to New York, he painted everyday scenes, capturing moments in time as the Impressionists had done. In *McSorley's Bar*, the paint textures are thick and the brushstrokes are visible. The dark interior of the bar is frequented by men who are unaware of the viewer; the dark tones of the muted colors contrast sharply with the whites of the uniforms and the light bulbs. Sloan captures a slice of New York life, just as van Gogh's *Night Café* (see figure 24.28) shows us a café late at night in the South of France. But Sloan used subdued color to convey the "reality" of the dark interior, whereas van Gogh used intense, bright, often "unreal" colors to convey the intensity of his own feelings.

Van Gogh, *The Night Café*.
figure 24.28, page 505

> ... the artists of the Ash Can School ... rejected ... the rather effete and derivative work of the academy ...
>
> Milton Brown, art historian and critic (1911–1998), on the emergence of modern art in the United States

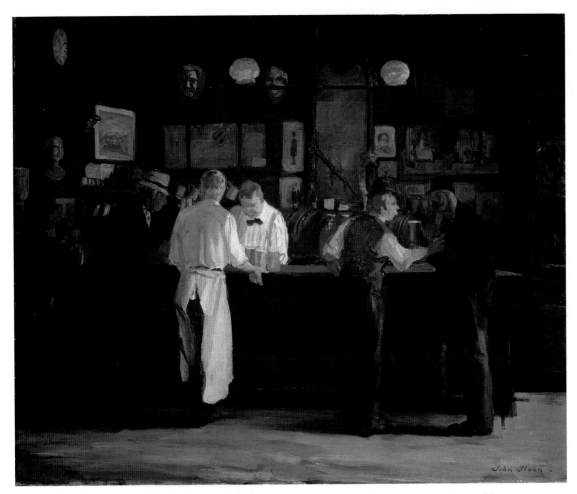

25.12 John Sloan, *McSorley's Bar*, 1912. Oil on canvas, 26 x 32 in. Detroit Institute of Arts. Founders Society Purchase, General Membership Fund.

25.13 Georgia O'Keeffe, *Blue and Green Music*, 1919. Oil on canvas, 23 x 19 in. The Art Institute of Chicago. Alfred Stieglitz Collection. Gift of Georgia O'Keeffe.

A different trend in American painting can be seen in the work of the early abstractionist Georgia O'Keeffe (1887–1986). She formed part of a group of avant-garde artists in New York and eventually moved to New Mexico, where she painted scenes inspired by the desert. Although many of O'Keeffe's works are figurative, their effect is often abstract by virtue of the viewpoint. But in *Blue and Green Music* of 1919 (**figure 25.13**), the image is abstract, as is indicated by its musical title. The absence of recognizable objects forces us to concentrate on the colors and rhythms, variations of tone and line, and carefully orchestrated harmony. There is no narrative as there is in *McSorley's Bar*.

Another early-twentieth-century development in the United States was the emerging artistic culture among American blacks. The signature sculpture of the African-American artist Meta Warrick Fuller (1877–1968) is *Ethiopia Awakening* (**figure 25.14**). This work reflects the struggle of American blacks in a predominantly white society, but it uses forms based on the ancient Egyptian mummy and is influenced by artistic and political developments in Europe and Africa. In 1896, Ethiopia defeated Italy's attempt to conquer and colonize the country. This victory led to an anticolonial movement known as Ethiopianism, which Fuller celebrates in *Ethiopia Awakening*. She

shows Ethiopia (symbolizing American blacks and black Africans, and associated with the Queen of Sheba) awakening from slavery as a woman might emerge from a mummy case. In this instance, the lower half of the body is still trapped in its age-old prison, but the top half is coming to life, gazing proudly into a future of freedom. Fuller thus alludes to the enslaved, "mummified" past of blacks in America and heralds the black intellectual movement—the Harlem Renaissance—that flourished in New York shortly after World War I.

25.14 Meta Warrick Fuller, *Ethiopia Awakening*, 1914. Plaster, 5 ft. 7 in. x 16 in. x Art and Artifacts Division, The Schomburg Center for Research in Black Culture, The New York Public Library, Astor, Lenox and Tilden Foundat

The Harlem Renaissance

During the 1920s, as we saw in Chapter 6, Jacob Lawrence produced the *Migration Series* (see p. 123), depicting scenes of blacks moving North in search of a better life. Photographers such as James Van Der Zee (see p. 41) documented black life in Harlem, in New York City. Philosophers encouraged blacks to draw on their African heritage, as many Harlem Renaissance authors did. Among the painters who did so, one of the most powerful was Aaron Douglas (1899–1979). His series for the book entitled *God's Trombones*, a collection of seven spirituals, is an expression of a new black aesthetic combined with flat planes of blue and geometric shapes derived from Cubism. The study for *God's Trombones* in **figure 25.15** shows a monumental black man striding energetically upward and forward as if to recall the resurrected Christ (see figure 18.15). At the same time, however, he looks back and blows a trumpet, reminiscent of angels sounding the Last Trump on Judgment Day. Angel wings rise up behind his shoulders and the key in his left hand alludes to Saint Peter's key to Heaven's Gate. Four figures in the background combine characteristics of gospel singers with a sense of being reborn and saved.

Piero, *Resurrection*.
figure 18.15, page 377

25.15 Aaron Douglas, Study for *God's Trombones, The Judgment Day*, 1927. Gouache on paper, 11 ³/₄ x 9 in. The Walter O. Evans Collection of African American Art/ Savannah College of Art and Design, Georgia.

Trends in Europe after World War I

As World War I drew to a close, and in its immediate aftermath, Europe, like the United States, turned toward recovery. Both wanted to build better societies, although the United States withdrew into isolationism. In the arts, the European avant-garde sought ways to promote international understanding.

During the last year of the war, Russia experienced the enormous upheaval of the revolution led by Lenin in 1917. The Russian avant-garde espoused Constructivism, which, in contrast to pre-war Expressionism and Suprematism, was a style unconcerned with emotion and spirituality. Constructivist artists produced works made of manufactured materials that were devoid of subject matter and narrative.

Tatlin's Constructivism

Vladimir Tatlin's (1895–1956) *Project for the Monument to the Third International* (**figure 25.16**) was designed to support the Russian Congress building. Although never realized and eventually destroyed, the project reflects the Constructivist rejection of aesthetics in favor of practicality. The project would have consisted of a double openwork spiral one-third-mile high. Tatlin shared the Constructivist conviction that all social products, including the arts, should be determined by utilitarian reality rather than by the creative imagination or a desire for beauty. This approach to the arts was part of an effort in Europe to produce work that was useful and could be understood. In keeping with this idea, Tatlin asserted in 1932 that: ". . . the most aesthetic forms are the most economic."[4]

The avant-garde in Russia was allowed to continue after the Revolution until it was banned in 1932 under the repressive regime of Joseph Stalin.

De Stijl in Holland: Rietveld and Mondrian

The post-war ideal of improving the lifestyle of the average person, especially of the middle and working classes, led to the International Style in art and architecture. The movement was founded in 1917 in Holland, where it was called *De Stijl* ("the Style"). *De Stijl* architects wanted to design simple, functional houses at affordable

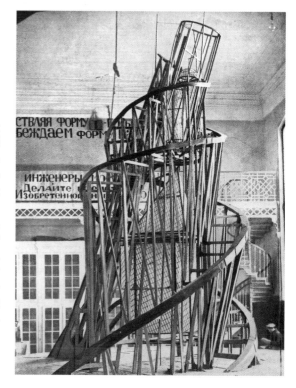

25.16 Vladimir Tatlin, *Project for the Monument to the Third International*, 1919–1920. Wood, iron, and glass. Destroyed.

cost. In Gerrit Rietveld's (1888–1964) Schröder House, in Utrecht, the influence of Cubism is evident in the central cubic core, the repeated rectangular shapes of the windows, and cantilevered balconies. In addition, Rietveld created crisp, white, unadorned walls and a flat roof (**figure 25.17**). But here the geometry is not purely formal as in Cubism; it is functional and built around a skeletal core. The main living rooms occupy the second floor and the private rooms the first. The floors and walls are painted in primary colors and are otherwise without decoration. Sliding partitions permit occupants to move the walls and rearrange the interior space to suit their needs.

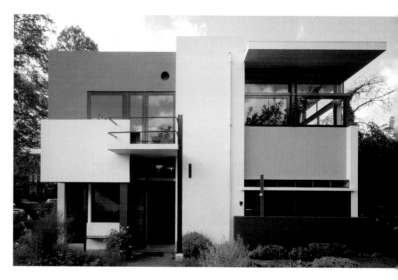

25.17 Gerrit Rietveld, Schröder House, Utrecht, The Netherlands, 1924.

Geometric purity also characterizes the *De Stijl* paintings of Piet Mondrian, whom we discussed in Chapter 5. Influenced by the 1911 Analytic Cubism exhibitions in Paris, Mondrian turned to abstraction (although he continued to produce more marketable flower paintings throughout his life). Mondrian believed in the spirituality of simple shapes, primary colors, and vertical and horizontal lines. *Tableau 2* asymmetrically balances rectangles of red, yellow, and blue, bordered by strong black, intersecting lines, on a white background. Arrangements such as these exemplify Mondrian's ideal of an orderly, peaceful world, where harmony is achieved through intellectual control, visual calm, and spiritual well-being. In an interview published in 1919, Mondrian declared that: "The straight line tells the truth."[5]

The Bauhaus in Germany

In 1919, two years after *De Stijl* was established in Holland, the innovative and enormously influential German architect Walter Gropius (1883–1969) founded the Bauhaus. This was a school aimed at transcending traditional design categories with a view to creating functional houses and furnishing them with useful objects. In addition, Gropius encouraged creative teamwork—architects working together on projects, as well as with interior and industrial designers. He described the credo of the Bauhaus as the coordination of:

> … all creative effort, to achieve, in a new architecture, the unification of all training in art and design. The ultimate, if distant, goal of the

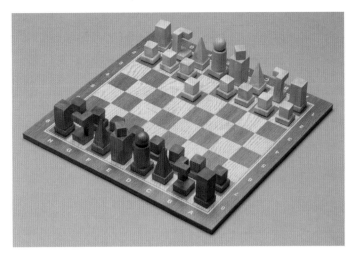

25.19 Josef Hartwig, handmade preliminary stage for the Bauhaus Chess Set, 1922. Stained lime wood, tallest figure 2 ¾ in. high. Stiftung Bauhaus Dessau Foundation.

Bauhaus is the collective work of art—the Building—in which no barriers exist between the structural and the decorative arts.[6]

Figure 25.18 shows the clean lines, basic rectangular shapes, and functionality of Gropius's own house in Dessau, which he built in 1925. **Figure 25.19** illustrates a chess set designed for the Bauhaus in 1922. The block-like, sturdy, practical forms are typical of the Bauhaus aesthetic.

When Hitler came to power, the Bauhaus was closed and many of its artists, architects, and designers left Germany for the United States. Gropius became a professor at Harvard, where he designed dormitories and a graduate center.

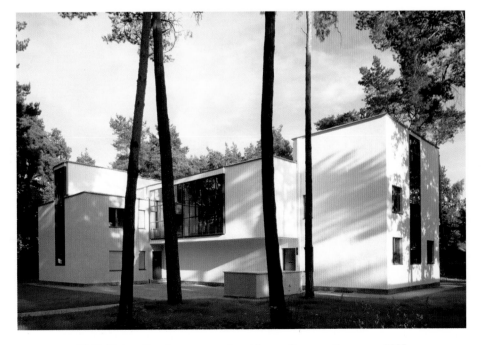

25.18 Walter Gropius, personal residence, Dessau, Germany, 1925.

Opposing Trends in Architecture: Le Corbusier and Wright

COMPARE

Le Corbusier, *Diagram of domino construction.*
figure 14.43, page 284

The Swiss International-Style architect Charles-Edouard Jeanneret (1887–1965), known as Le Corbusier, was influenced by the ideas of Gropius and believed that houses should be "machines for living in." We described his use of domino construction in Chapter 14 (see figure 14.43) as a way of making practical, "liveable" architecture available to a broad segment of society. Le Corbusier designed a number of single-family houses, of which his best known is the Villa Savoye, about twenty miles northwest of Paris (**figure 25.20**). Like the Schröder House and Gropius's residence, the Villa Savoye is based on the cube. But the ground-floor interior, which can function as a garage, is opened, and load-bearing walls are replaced by reinforced concrete stilts. The living area is on the second floor, accessible by a ramp and a stairway. In this house, Le Corbusier reversed the conventional (and Classical) practice of making the supports visually heavy and lightening the upper floors. With identical windows and exterior walls, he also eliminated the traditional sense of front and back so that there is no readily identifiable façade.

In America, the Prairie Style of Frank Lloyd Wright (1869–1959), in contrast to the International Style and the principles of the Bauhaus, was designed to blend with the landscape—as we saw in the Robie House (see p. 285). Wright was trained by Louis Sullivan in Chicago (see p. 283), and then turned from skyscrapers to domestic architecture.

> **The regulating line is a guarantee against willfullness. It brings satisfaction and understanding ...**
>
> Le Corbusier (1887–1965), on regulating lines

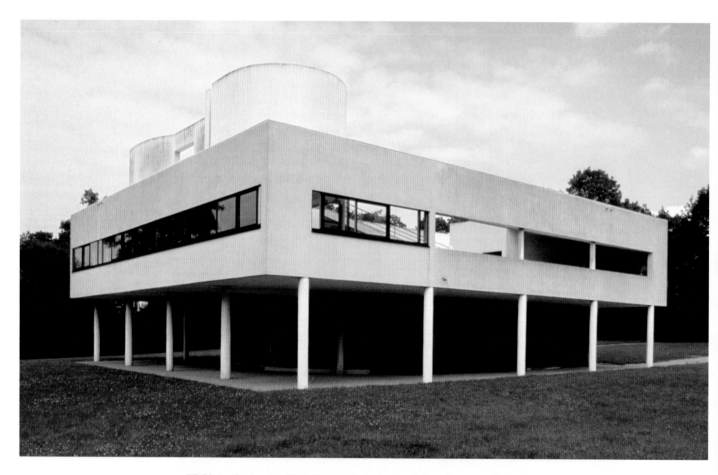

25.20 Le Corbusier, Villa Savoye, Poissy-sur-Seine, France, 1928–1930.

Rather than being conceived as "machines for living," Wright's homes appear organic and, as far as possible, are made of natural materials. They seem to "grow" from the surrounding landscape. He described his view of architecture in 1939:

All things are in process of flowing in some continuous state of becoming.[7]

Wright associated the notion of a building as a box with Fascism. He believed that an American

architecture of freedom and democracy needed something basically better than the box. So I started to destroy the box as a building. … The light now came in where it had never come in before and vision went out. … The walls vanished as walls, the box vanished as a box.[8]

In 1936, giving concrete form to this idea, Wright began work on the Kaufmann House, nicknamed "Fallingwater," for the Kaufmann family in Bear Run, Pennsylvania (**figure 25.21**). The vertical chimney core is made of local stone and the projecting cantilevered horizontals are of reinforced concrete. The long horizontal windows echo both the cantilevers and the plane of the natural rock below. A waterfall emerges from the base of the house and the vertical flow of the waterfall echoes the verticals of the chimney and the surrounding trees. Wright thus coordinated the planes and materials of the house with those in nature. In addition, the large amount of window space in the house makes nature visible from the interior, for which Wright designed furniture to match his architecture.

Wright conceived of his houses not only in terms of landscape, but also in terms of humanity. In 1954, he wrote that architecture, like life, needs "integrity." As in human beings, he said: "integrity is the deepest quality in a building."[9]

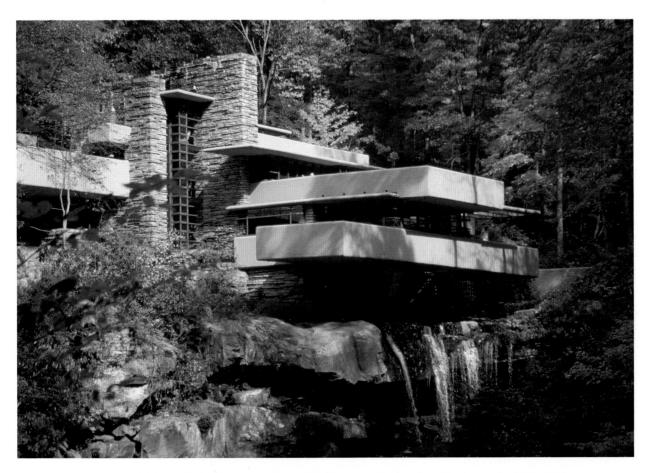

25.21 Frank Lloyd Wright, Kaufmann House ("Fallingwater"), Bear Run, Pennsylvania, 1936–1939.

Surrealism

Concurrent with American developments in early-twentieth-century art and architecture, in Europe the Surrealist style evolved from the Dada Movement. After World War I, Surrealism, like Dada, became international in scope. Its aims were set out in the 1924 *First Surrealist Manifesto* of the French physician and author André Breton (1896–1966). Influenced by the discoveries of Freud, Breton advocated an art concerned with the imagination, play, spontaneity, and the world of the unconscious—particularly dreams. These areas of human experience, in Breton's view, were the most "real"—hence the term "surrealism," meaning a more profound, higher reality than everyday reality. Surrealist artists, therefore, consciously depicted aspects of the unconscious mind.

Precursors of Surrealism can be seen earlier in the twentieth century, for example, in Brancusi's work—notably the *Bird in Space*, which we discussed in Chapter 1. When Brancusi declared that he was representing the "essence" of a bird rather than the physical form of a bird, he was referring to feelings, sensations, and the imagination, as well as to the conscious visual perception of a bird in space. In Picasso's *Guernica* (see p. 51), elements of Surrealism and Cubism are merged in a political protest against the rise of Fascism in the 1930s.

The flamboyant Spanish artist Salvador Dalí (1904–1989) produced a series of pictures he called "hand-painted dream photographs." As in dreams, Dalí's pictures superimpose images that do not ordinarily go together. Nor do they depict natural color or follow the logical time sequence of conscious life. The color can be jarring and space and time represented according to the illogic of dreams, in which sequential time and natural space do not exist. Dalí's images must be individually analyzed and then rearranged in conscious time and space to be understood. But, as is true of dreams, definitive interpretations are not always possible (**figure 25.22**). In this work, a horse merges oddly into a reclining nude woman. Two unexplained blue spheres are placed on either side of the rectangular platform supporting the horse. Illogically small figures stand at the base of the giant columns behind the horse and a mechanical figure strolls off to the left.

In the *Le Viol* (*The Rape*) (**figure 25.23**), the Belgian artist René Magritte (1898–1967) created a visual pun, in which the upper and lower parts of a female body are superimposed. The breasts are the eyes, the navel is the nose, and the pubic hair is the mouth. The large neck appears to grow like a tree-trunk from a stark landscape. Although we recognize that such an image would not appear in everyday reality, we can appreciate the intended pun. In this startling painting, Magritte disrupts conscious expectations of the human figure by

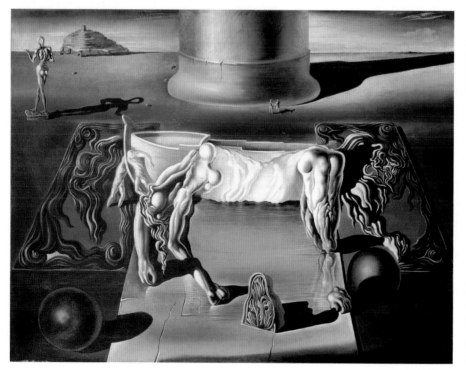

> The greatest of joys is mine: that of bei[ng]
> Salvador Dalí.
>
> Salvador Dalí, artist (1904–1989), on him[self]

25.22 Salvador Dalí, *The Invisible Sleeping Woman, Horse, Lion, etc.*, 1930. Oil on canvas, 19 ³/₄ x 25 ⁵/₈ in. Musée National d'Art Moderne, Centre Georges Pompidou, Paris.

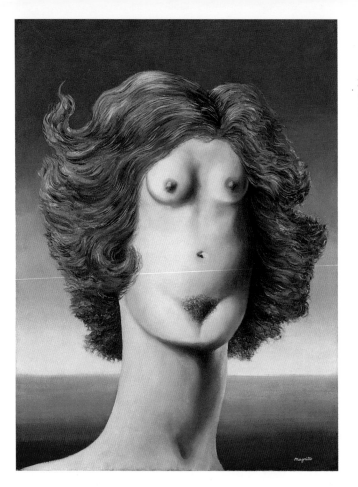

25.23 René Magritte, *Le Viol* (*The Rape*), 1934.
Oil on canvas, 28 ⅞ x 21 ½ in.
Menil Collection, Houston.

> **The mind loves the unknown.**
>
> René Magritte, artist (1898–1967)

rearranging natural space and form. He also conveys the association between jokes and unconscious images described by Freud in his 1911 study *Jokes and their Relation to the Unconscious.*

The American sculptor Alexander Calder combined Surrealism and abstraction with a unique brand of humor, which we saw in his *Chock* in Chapter 1 (see p. 7). In Chapter 5, we discussed Calder's mobiles (see p. 93), which are imbued with a sense of fantasy and play. In *Hanging Spider* (**figure 25.24**) of around 1940, the thin wires simultaneously resemble the legs of the spider and the threads of its web. Curvilinear patterns suggest spidery motion and the flat black metal shapes have organic quality. As with Brancusi's *Bird*, this is not a literal representation of a spider but rather one that evokes visual and mental associations with our experience of spiders and their webs.

In around 1958, reflecting his delight in formal play, Calder said: "… my triangles are spheres, but they are spheres of a different shape."[10]

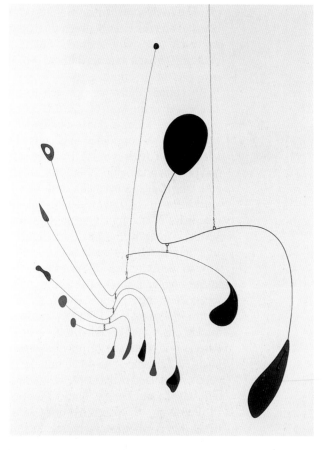

25.24 Alexander Calder, *Hanging Spider*, c. 1940. Painted sheet metal, wire, 49 ½ x 35 ½ in. Whitney Museum of American Art, New York. Mrs. John B. Putnam Bequest.

Photography

In Chapter 24, we discussed the early development of photography, which came into its own in the nineteenth century. In the twentieth century, photographers, like painters and sculptors, continued to explore new visual ideas. One of the most significant early-twentieth-century photographers in America was Alfred Stieglitz, whose *From the Shelton* we saw in Chapter 11 (see p. 205).

Like the Impressionist painters, Stieglitz aimed to capture a moment and make a visual record of what he had seen and the way in which he had seen it. However, his photographs are aesthetic as well as documentary, for he saw and recorded the world around him in such a way that existing, everyday forms evoke intense emotion. His famous photograph of New York City's Flatiron Building (**figure 25.25**) at the intersection of Fifth Avenue and Broadway shows the triangular skyscraper on a cloudy, snow-covered day.

We see the building in the background, behind a silhouetted tree. The extended diagonal branch creates a triangular space that echoes the building and clips its upper corner so that it, too, is seen as a triangle. The fresh snow is neatly arranged on the park benches and the trees between them and the building itself are softly textured. By recording the building so that it appears diffused, Stieglitz isolates it from its urban setting.

An entirely different approach to photography can be seen in the work of Man Ray, whose technical innovation—the rayogram—and experiments with solarization we considered in Chapter 11. Man Ray left the United States in 1921 and became a fashion and portrait photographer in Paris. He was involved with the Dada movement and then turned to Surrealism. In contrast to Stieglitz, Man Ray devised new ways of manipulating photographs to create Surrealist imagery. In *Glass Tears* (**figure 25.26**), he superimposed beads made of glass on the face of a woman. As is typical of Surrealism, the resulting image is an engaging visual pun that captures our imagination and is reminiscent of dreams.

In 1929, the United States witnessed the Stock Market crash that heralded the Great Depression. Resulting in a decade of unemployment, extreme financial hardship, and total ruin for millions of people, the effects of the Depression spread throughout America and Europe. Under President Franklin D. Roosevelt, the Farm Security Administration (FSA) hired photographers to document social conditions, thus creating a historical record and providing work for artists. One example we considered in Chapter 11 was Dorothea Lange's *Migrant Mother* (see p. 209).

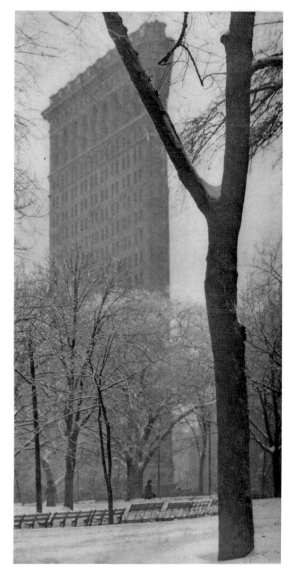

25.25 Alfred Stieglitz, *The Flatiron Building*, 1903. Gravure on vellum 12 ⅞ x 6 ⅝ in. from *Camera Work*, iv (October 1903). Museum of Modern Art, New York.

> **Why ... should not a photographic print look like a photographic print?**
>
> Alfred Stieglitz, photographer (1864–1946)

Walker Evans (1903–1975) worked for the FSA and produced many images of poverty caused by the Depression. His image of the worker in Havana, Cuba, in **figure 25.27** uses the close-up to show the surface of the blackened face and to evoke our identification with the subject's hard work and his poverty. The face is a map of wrinkles, and the slight smile suggests well-being and a willing acceptance of hard labor. This is more than a portrait of an individual; it is an image that implies hope in the face of economic adversity.

Evans did some work in color, but he found black and white photographs to have greater aesthetic

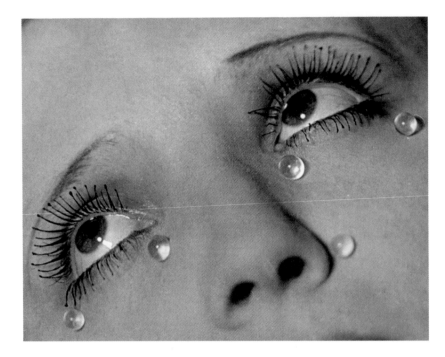

25.26 Man Ray, *Glass Tears* (*Larmes*), 1930—1933. Gelatin silver print, 9 x 11 in. The J. Paul Getty Museum, Los Angeles.

potential. In the 1960s he declared that:

> … there are four simple words which must be whispered: color photography is vulgar.[11]

Describing his relationship to photography Evans declared:

> I go to the street for the education of my eye and for the sustenance that the eye needs—the hungry eye, and my eye is hungry.[12]

Despite international efforts to bring about world peace, in fewer than twenty years after the end of World War I, the rise of National Socialism in Germany, Fascism in Italy and Spain, and militarism in Japan led to a second war that involved more countries and deadlier weapons than ever before. World War II and the development of atomic energy made people aware that they could cause the total annihilation of the planet we inhabit. This realization created enormous anxiety that persists to the present day.

Before and during World War II, persecutions of Jews and other minorities, especially in Germany, France, Italy, and Eastern Europe, led many artists, intellectuals, and scientists to emigrate to America. The German chancellor, Adolf Hitler, was a failed painter, who detested modern art and the avant-garde. The suppression of artists and intellectuals in Hitler's Germany and Stalin's Russia effectively destroyed any remaining vestiges of modern art. As a result of large-scale immigration to the United States, and with its new infusion of intellectual life, the center of the Western art world shifted from Paris to New York. The most exciting new art styles after World War II were, for the first time, originating in America, especially New York City.

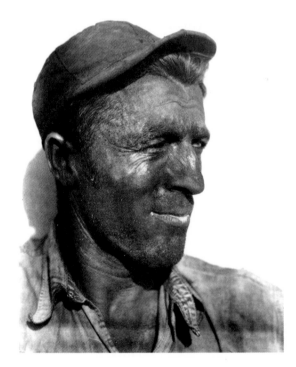

25.27 Walker Evans, *Dock Worker*, Havana, 1933. Gelatin silver print, 8 x 6 ³⁄₆ in. Museum of Modern Art, New York. David H. McAlpin Fund © Walker Evans Archive, The Metropolitan Museum of Art, New York.

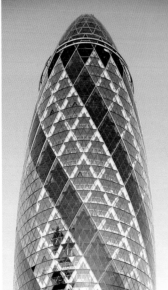

26

KEY TOPICS

Abstract Expressionism
and Color Field

Self-taught artists

Pop Art

Minimalism

Feminist Art

Environmental Art

Photorealism
and Super Realism

Graffiti Art

Performance, Video,
and New Media

Architecture

1945 to the Present

TIMELINE	HISTORICAL EVENTS	ART HISTORY
1940	• End of World War II 1945 • Cold War between the West and the Soviet bloc 1946–1989 • Korean War 1950–1953 • Civil Rights Movement in the United States 1955–1965	• The International Style 1940s–1950s • Abstract Expressionism 1945 • Jackson Pollock, *Number 27*, 1950 • Mark Rothko, *Black over Reds [Black on Red]*, 1957 • Jasper Johns, *Three Flags*, 1958
1960	• The Berlin Wall built 1961 • John F. Kennedy assassinated 1963 • Vietnam War 1965–1975 • Martin Luther King assassinated 1968 • First man on the moon 1969	• Pop Art movement 1962 • Roy Lichtenstein, *Blam*, 1962 • Minimalism 1962 • Claes Oldenburg, *Giant Hamburger*, 1962 • Feminist and Environmental Art 1970s
1980	• Berlin Wall demolished 1989 • Collapse of the Soviet Union 1989–1991	• Jean-Michel Basquiat, *Hollywood Africans*, 1983 • I.M. Pei, Louvre Pyramid, Paris, 1988
2000	• Bombing of World Trade Center 2001 • Iraq War 2003	• Christo and Jeanne-Claude, *The Gates Project for Central Park*, New York, 2003 • Norman Foster, Swiss Re Building, London, 2004

The year 1945 marked the end of World War II. Europe was once again devastated, and together with America had lost millions of lives. By 1945, with the influx of European artists, scientists, and intellectuals into the United States, the way was open for a new creative synergy. In New York City, artists gathered from different parts of America and Europe and met informally. They became known as the New York School, which produced the radical new style of Abstract Expressionism.

For the first time in its history, American art became international and influenced artists abroad. This remains the case today, although now there is a new globalization in the visual arts. As people regularly travel, watch television, and send messages and images via the internet, the world seems closer and closer to home. This is reflected in some of the most recent cross-cultural trends in the visual arts.

There is also an ongoing inventiveness in the use of new media, in performance, in video and digital art, as well as in the more traditional media. New formal categories and themes such as protest art, feminist art, graffiti art, environmental art, self-taught, and others, have emerged. And many more traditional boundaries between genres have been called into question. Influenced in large part by Dada (see Chapter 25), artists have merged media, form, and content in new ways. As with the first half of the twentieth century, art styles continue to evolve more quickly than they had before 1900.

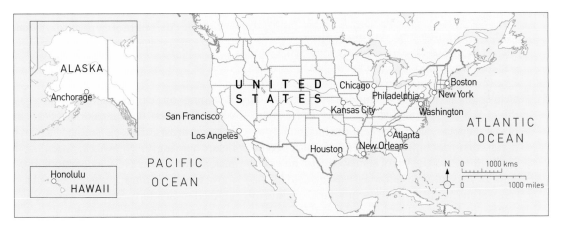

United States after World War II.

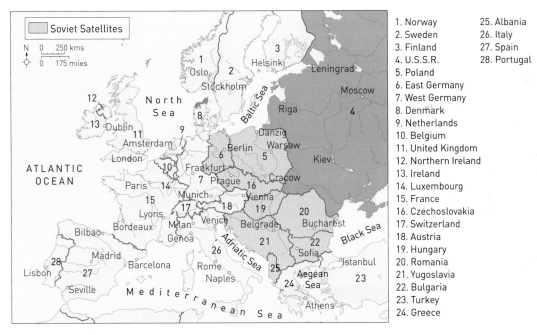

1. Norway	25. Albania
2. Sweden	26. Italy
3. Finland	27. Spain
4. U.S.S.R.	28. Portugal
5. Poland	
6. East Germany	
7. West Germany	
8. Denmark	
9. Netherlands	
10. Belgium	
11. United Kingdom	
12. Northern Ireland	
13. Ireland	
14. Luxembourg	
15. France	
16. Czechoslovakia	
17. Switzerland	
18. Austria	
19. Hungary	
20. Romania	
21. Yugoslavia	
22. Bulgaria	
23. Turkey	
24. Greece	

Europe after World War II.

Abstract Expressionism

The Abstract Expressionist style developed in New York City, and probably owed its existence to emigrés from Europe coming into contact with American-born artists. It was a style influenced by the Surrealist interest in spontaneous, uncontrolled access to the mind, by the spatial fragmentation of Cubism, and by an American sense of rugged individualism.

Arshile Gorky (1904–1948), one of the seminal figures in the New York School, arrived at Ellis Island in 1920. He was sixteen years old and had barely escaped the genocidal campaign launched by Muslims to annihilate the Armenian population of

Turkey. As a result of this experience, Gorky decided to reinvent himself. He was born Vosdanik Adoian, but changed his first name to Arshile (after Achilles, the heroic warrior of Homer's *Iliad*) and his last name to Gorky (after the famous Russian author). He thus created himself as well as his paintings. At the age of forty-four, after a series of tragedies, Gorky committed suicide.

His early work was influenced first by Impressionist color and texture, then by Cézanne and Picasso, and finally by Surrealism. His radical artistic ideas and original imagery created a bridge between the European avant-garde and America. To a large extent, Gorky embodied the transition from Surrealism to Abstract Expressionism.

In *The Liver is the Cock's Comb* of 1944 (**figure 26.1**), Gorky depicted the **biomorphic** (lifelike) shapes he had used since the early 1940s that suggest the liquid motion of amoeba-like creatures. Embedded in the biomorphs and submerged by the vivid colors are a number of hidden images, such as the cock's comb attached to a torso at the right. Below the torso, we can discern the image of a dog that seems to be contentedly asleep on a mat. Several phallic forms, to the left of center, suggest an erotic subtext. According to Gorky, he was inspired by the sense of an ancient Armenian spirit impelling him to create a lush image of his lost childhood landscape. He thus reclaimed his past by painting impressions from his memory and his dreams.

Gorky's biomorphic abstraction is characterized by continually evolving figures metamorphosing into new shapes. He depicts lively movement and mainly primary colors bordered by thin black lines. As in Cubism, the space shifts and pushes form to the surface of the canvas. As in Surrealism, there is a sense of mystery and unexplained enigma. There is also a new, gestural means of applying paint, which increases the sense of the artist's presence in the creative process. This emphasis on the artist's gesture became characteristic of the so-called action painters of the New York School.

Perhaps the purest of the action painters was Jackson Pollock (1912–1956). He was born in Cody,

Wyoming, one of five children from a poor family, whose mother encouraged all her children to become artists. Pollock studied art in California before moving to New York, where he became a major figure in the New York School. Eventually he moved to the Springs, in eastern Long Island, where he died at age forty-four in a car crash. Today his house and studio are a museum.

Pollock was attracted to the Surrealist notion, based on psychoanalysis, that unedited spontaneity provides creative access to the unconscious. During his Surrealist phase, he painted totemic images and unintelligible signs. From 1948 to 1952, he produced nonfigurative works with numbered titles (**figure 26.2**). Pollock avoided the specificity of figures, narrative, and foreground and background in order to arrive at universal imagery. *Number 27* exemplifies his all-over drip paintings, in which his gestures created the curvilinear motion of the paint.

Instead of using an easel, Pollock placed the canvas on the floor and moved around it—and sometimes on it—as he dripped housepainter's paint from a stick or brush. He compared this process to Navajo sand painting (see p. 46), which, although very different in style, shares a sense that the act of painting has spiritual and curative qualities.

Pollock said that he was not consciously aware when "in" his painting and that the act of painting is an organic thing, with "a life of its own." Nevertheless, he admitted that the artist has to control the rhythmic harmony of the work as it evolves. He liked large pictures, he said, because he could be inside the work and feel more intimately connected with it. In smaller works, according to Pollock, the artist has more perspective and is more on the outside.

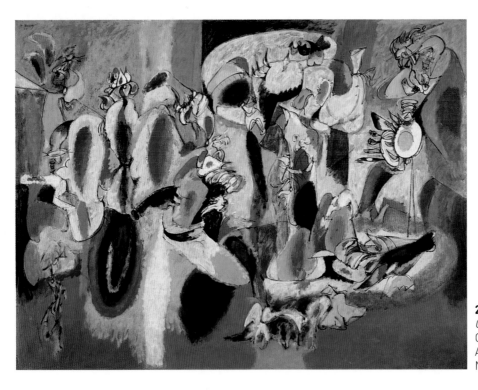

26.1 Arshile Gorky, *The Liver is the Cock's Comb*, 1944.
Oil on canvas, 6 ft. 1 1/4 in. x 8 ft. 2 in. Albright-Knox Gallery, Buffalo, New York. Gift of Seymour H. Knox.

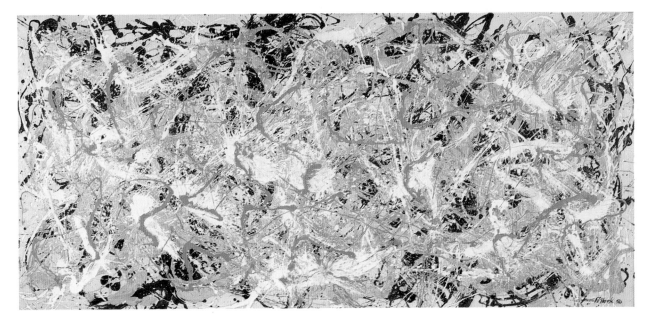

26.2 Jackson Pollock, *Number 27*, 1950. Oil on canvas, 4 ft. 1 in. x 8 ft. 10 in. Whitney Museum of American Art, New York. Purchase.

Color Field

A trend that formed part of Abstract Expressionism is called Color Field because artists created large areas (fields) of flat color. The leading Abstract Expressionist Color Field painter, Mark Rothko (1903–1970), left his native Lithuania at the age of ten and traveled with his family to Oregon. After a year at Yale, he moved to New York and joined the New York School. His early work is Surrealist—inspired by Greek mythology and the unconscious. But he gave up figuration around 1950, saying that he "wished to reassert the picture plane."

In contrast to Pollock's dynamic, linear energy, Rothko's Color Field paintings are imbued with an imposing silence. His signature shape is the horizontal rectangle that seems to move forward in a field of color (**figure 26.3**). In this work, three rectangles occupy a red space. They vary in color and intensity; the top rectangle is black, the middle one is a bright red illuminated by an inner glow, and the lower one is a thin strip of a slightly pinker red. All three have softened edges, a shimmering luminosity, and seem released from the natural pull of gravity as they hover in space. The contemplative mood of Rothko's pictures reflects his aspiration to convey a sense of spirituality and led to a commission in 1964 to paint large canvases for a chapel in Houston, Texas.

From 1969 to 1970, Rothko painted mainly black paintings, signaling the depression that ended in his suicide.

> I insist upon the equal existence of the world engendered in the mind and world engendered by God outside of it....
>
> Mark Rothko, artist (1903–1970)

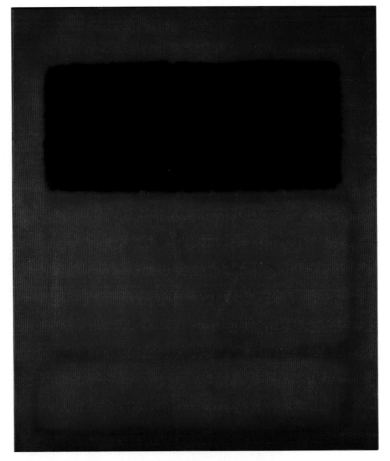

26.3 Mark Rothko, *Black over Reds* [*Black on Red*], 1957. Oil on canvas, 7 ft. 11 in. x 6 ft. 9 in. The Baltimore Museum of Art, Maryland. Gift of Phoebe Rhea Berman, Lutherville, Maryland, in memory of her husband, Dr. Edgar F. Berman.

Self-Taught: Horace Pippin and Grandma Moses

Although there have always been artists who taught themselves, few of these have entered the mainstream canon of art history. A major exception is van Gogh, who spent only a brief period in an art school and otherwise learned art by reading and looking on his own. Another self-taught artist, Henri Rousseau, whose *Dream* of 1910 we considered in Chapter 2 (see p. 30), is also considered mainstream.

In the course of the twentieth century, however, the category known as "self-taught" came into its own and some of these artists are now highly acclaimed. They do not, however, tend to participate in a prevailing cultural style and often retain a naive appearance reminiscent of folk art. One such artist is Horace Pippin (1888–1946), who painted *Man on a Bench* (**figure 26.4**) in the last year of his life.

Pippin was born in Pennsylvania, and when he was three his family moved to Goshen, New York. There he showed an early interest in drawing horses he saw at the Goshen racetrack. During World War I, Pippin enlisted in the army but was shot in the right shoulder and discharged. For a time he decorated cigar boxes in charcoal to exercise his arm, but he soon turned to oil painting. He exhibited in local shops and eventually attracted the attention of a wider public.

Pippin's style has a refreshing, naive quality. Much of his imagery is autobiographical, depicting everyday life and dealing with childhood themes. In *Man on a Bench*, he represents an isolated figure—himself—whose oneness with nature is shown through the arrangement of color. The blacks and browns of the trees echo Pippin's clothing and skin tones, and the white dog in the background repeats the white of his shirt. At the same time, a slight unease is suggested by the awkward pose and downcast expression. The bright red bench contrasts sharply with the green (its opposite on the color wheel) and frames the figure. Although concerned with depicting memories of his childhood, Pippin was also a painter of black life in America and an advocate of world peace.

The work of the American self-taught artist Anna Mary Robertson (Grandma Moses) (1860–1961), like Pippin's, is both figurative and narrative. The

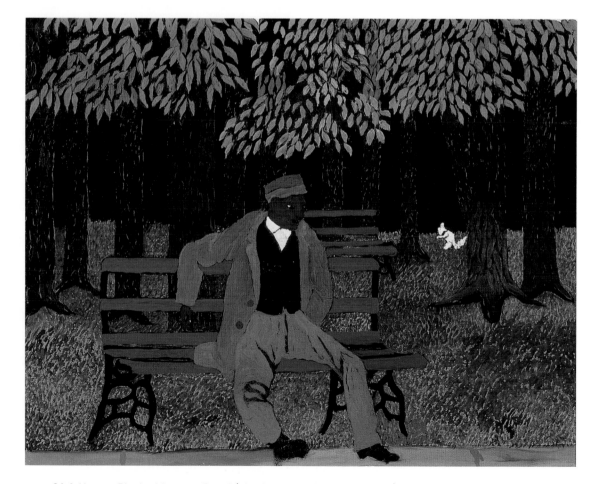

26.4 Horace Pippin, *Man on a Bench* (also known as *The Park Bench*), 1946. Oil on fabric, 13 x 18 in. Courtesy Fleisher Ollman Gallery, Philadelphia. Collection Mr. Daniel W. Dietrich II.

subject matter is distinctly American and does not reflect the contemporary interest in abstraction. Anna Mary Robertson was raised on a farm in upstate New York; she was one of ten children and the mother of ten children, five of whom did not survive infancy.

In her seventies, Grandma Moses (as Anna Mary came to be called) finally found time to paint. In 1938, a New York City collector noticed her pictures in a local drugstore and bought nine of them. He promoted her work and arranged an exhibition for her in a gallery on 57th Street, in New York. She received some critical attention, sold three pictures, and soon became an icon of American folk art.

In *Barn Roofing* of 1951 (**figure 26.5**) she depicts a panoramic view of a farm, showing identifiable local workers and creating a clear sense of foreground and background and of naturalistic, three-dimensional space. The abstraction of Grandma Moses's work is in the patterning (probably inspired by embroidery designs)—the black and white dress of the roofers, the wooden beams of the barn, and the green foliage visible through the open gable slats.

Barn Roofing is at once a local scene, with no allusion to the world outside—no reference to the end of World War II only six years earlier—and an image of hard work, building, and cultivating that has universal appeal. But the universality of this picture is in its narrative theme and its folk quality, whereas the Abstract Expressionists sought universality through pure form. Grandma Moses has been quoted as saying that "memory is a painter,"[1] because memories are history and they are stored in our minds. In that statement, as in Gorky's Armenian spirit, she shares with the avant-garde of her time the view that memory is a storehouse of creative energy and that the artist can access the past (and therefore the unconscious) through the creative process.

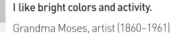

I like bright colors and activity.

Grandma Moses, artist (1860–1961)

26.5 Anna Mary Robertson (Grandma Moses), *Barn Roofing*, 1951. Oil on pressed wood, 18 x 24 in. Galerie St. Etienne, New York.

Pop Art

In the 1950s, a group of artists reacted against Abstract Expressionism and returned to the object. The new style—Pop Art—was launched in 1962 with the exhibition of "New Realists" at the Sidney Janis Galley in New York. Pop Art celebrated the popular, everyday imagery of American commercial culture. In contrast to nonfigurative abstraction, the Pop (for "popular") artists painted recognizable images, drawing their iconography from the media, consumerism, and specifically American themes. Two artists associated with the Pop movement—Robert Rauschenberg (b. 1925) and Jasper Johns (b. 1930)—formed a transition between the painterly, textural, self-related, and gestural qualities of Abstract Expressionism and the more objective and object-driven character of Pop Art.

Robert Rauschenberg grew up in Port Arthur, on the Gulf Coast of Texas. He studied art in Kansas City and at the Black Mountain art school in North Carolina before moving to New York. He had an experimental mind, but no interest in self-revelation or the unconscious. For Rauschenberg, as with Duchamp, a work of art is a fact, an objective rather than a subjective fact. From that fact, he claimed, feeling and meaning would "take care of itself." Nor does he want his personality revealed in his work. Rauschenberg's media are found objects from the environment that he comes upon in the course of his daily activities.

Beginning in the early 1950s, Rauschenberg developed works he called **combines**, which "combine" techniques of collage and assemblage. In his famous combine entitled *Bed* (**figure 26.6**), he used a quilt and a pillow, toothpaste and fingernail polish, as well as paint, mounted on wooden supports. Although inspired by Duchamp's ready-mades, Rauschenberg hoped to evoke universal associations to the object rather than to create Dada puns and Surrealist symbolism. He retained the painterly quality and drips of Abstract Expressionism, but his *Bed* marks a return to the object.

In the self-consciously American imagery of Jasper Johns, whose *Three Flags* we have discussed previously (see p. 161), paint texture is combined with popular objects.

COMPARE

Jasper Johns, *Three Flags.*
figure 9.2, page 161

> A pair of socks is no less suitable to make a painting than wood, nails, turpentine, oil and fabric.
>
> Robert Rauschenberg, artist (b. 1925)

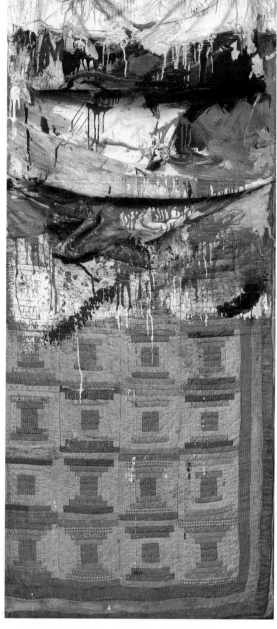

26.6 Robert Rauschenberg, *Bed*, 1955. Combine painting, oil and pencil on pillow, quilt, and sheet on wood supports, 75 x 31 ½ x 8 in. Museum of Modern Art, New York.
Gift of Leo Castelli in honor of Alfred H. Barr, Jr.

His *Map* of 1961 (**figure 26.7**) portrays the map of the United States in primary colors and dynamic, visible brushstrokes. The names of the forty-eight states (in 1961) are stenciled, indicating the influence of Cubism and early collage. As in Abstract Expressionism, the paint is allowed to drip, taking on a life of its own. But the state borders are marked, creating lively, colorful movement

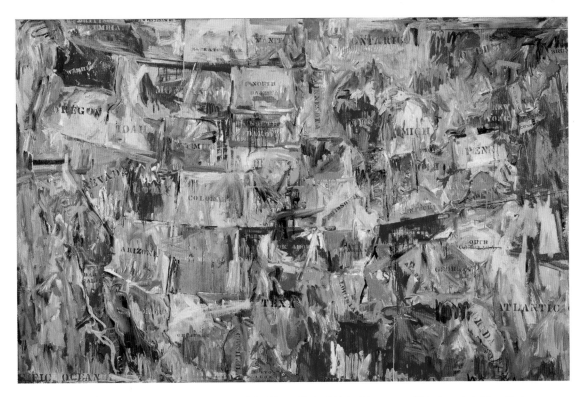

26.7 Jasper Johns, *Map*, 1961. Oil on canvas, 6 ft. 6 in. x 10 ft. 3 ⅛ in. Museum of Modern Art, New York. Gift of Mr. and Mrs. Robert C. Scull.

> Sometimes I see it and then I paint it. Other times I paint it and then see it.
>
> Jasper Johns (b. 1930)

within a framework. In this case the framework structures the vast American landscape, signified by the painterly topography of its map.

Two purely Pop Art painters who abandoned texture altogether in favor of the object are Andy Warhol and Roy Lichtenstein (1923–1997). Warhol, whose *Cow Wallpaper* (see p. 192) and *U.S. Dollar Signs* (see p. 131) we have already discussed, was the most notorious and versatile of the Pop artists. His imagery ranged from American icons such as Marilyn Monroe, Elvis Presley, Jackie Kennedy, Superman, and Mickey Mouse to Heinz boxes and Campbell soup cans, to political subjects such as electric chairs. Warhol also made underground movies and became the center of a cult movement.

Warhol's family came from Eastern Europe (their name was originally Warhola) and belonged to a Rutherian (similar to Russian Orthodox) community in Pittsburgh. He did not learn English until he started school. Nevertheless, his art has come to exemplify American consumer culture. Warhol's interest in consumer packaging can be seen in *Green Coca-Cola Bottles* of 1962 (**figure 26.8**). It shows the mechanical, repetitious quality associated with advertising and depicts 112 Coke bottles, 16 across by 7 down, in slightly varied shades of green. Their sameness is broken only by the red logo at the bottom, its sharp contrast to the bottles enhanced by the fact that red

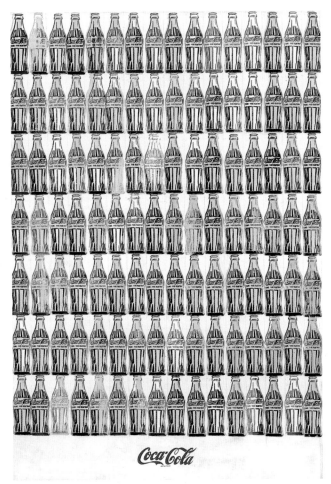

26.8 Andy Warhol, *Green Coca-Cola Bottles*, 1962. Oil on canvas, 6 ft. 10 ½ in. x 5 ft. 7 in. Whitney Museum of American Art, New York. Purchase with funds from the friends of the Whitney Museum of Art.

and green are opposites on the color wheel (see p. 101). Images such as this reflect Warhol's famous assertion that he wanted to be a machine.

For Warhol, both the imagery and meaning of his work was explicit, readily accessible, and all on the "surface." He made this clear when he said:

> If you want to know all about Andy Warhol, just look at the surface of my paintings and films and me, there I am. There's nothing behind it.[2]

Lichtenstein's signature style replicates the Ben Day dots used in newsprint to create the impression of popular media. Born and raised in New York City, he was thoroughly familiar with American mass culture. Among his best-known paintings are the monumental enlargements of comic book imagery—Walt Disney characters, 1950s' romances, and scenes of war.

In *Blam* (**figure 26.9**), a fighter plane has been hit and turned upside down. At the right, the silhouetted pilot tumbles from the cockpit. Lichtenstein monumentalizes the image by the strong diagonal planes of the red and yellow explosion and the foreshortened body of the plane that compresses the space. This picture, unlike Warhol's repetitious imagery, has narrative content, which we comprehend through our familiarity with comic strips. We know that this is but one frame in a story, and that there is a preceding and a following frame.

The sculptor Claes Oldenburg, whose installation of soft sculptures we saw in Chapter 5 (see p. 90), is associated with Pop Art, because of his iconography of American objects. His *Giant Hamburger* of 1962 (**figure 26.10**) differs from traditional sculpture in its soft material and unexpected scale. There is, of course, an element of humor in such works, for we can imagine pushing and pulling the sculpture like a pillow. At the same time, we associate hamburgers with eating, and it would be very difficult to get our teeth into Oldenburg's hamburger.

> ...it *is* an involvement with what I think to be the most brazen and threatening characteristics of our culture, things we hate but which are also powerful in their impingement on us.
>
> Roy Lichtenstein (1923–1997)

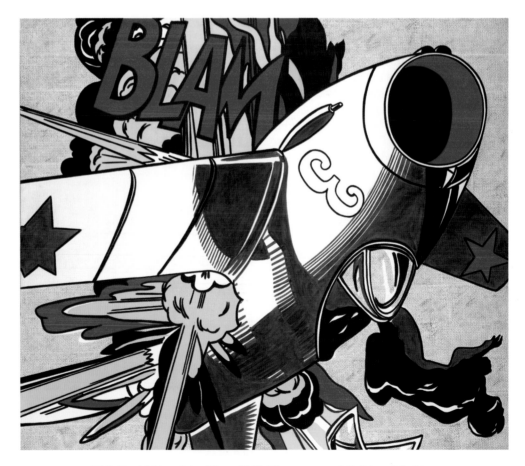

26.9 Roy Lichtenstein, *Blam*, 1962. Oil on canvas, 5 ft. 8 in. x 6 ft. 8 in. Yale University Art Gallery. Gift of Richard Brown Baker, B.A., 1935.

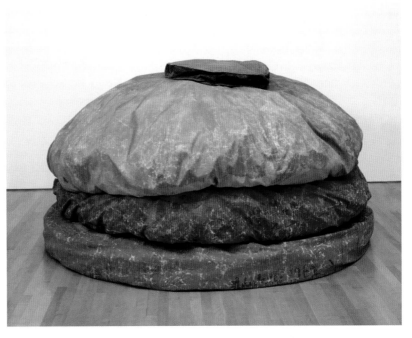

26.10 Claes Oldenburg, *Giant Hamburger*, 1962. Painted sailcloth canvas stuffed with foam, rubber and cardboard boxes, painted with acrylic paint, 4 ft. 4 in. x 6 ft. 11 ⁷/₈ in. Art Gallery of Ontario, Toronto. Purchase 1967.

> **Gravity is my favorite form creator.**
>
> Claes Oldenburg (b. 1929)

Minimalism

Another artistic movement of the 1960s began partly as a reaction against the "objectness" of Pop Art and the gestures of Abstract Expressionism. Minimalism, as the new style was called, rejected the figure and other representational images, as well as narrative content. Some Minimalists tried to remove connotations and associations from their imagery and to assert its objectlessness. Nevertheless, even the most "objectless" objects are still objects and can evoke emotional and intellectual responses in a viewer. For their media, Minimal artists preferred manufactured, industrial materials, and reductive, geometric forms.

The chosen medium of Dan Flavin (1933–1996) was fluorescent light, arranged in a given interior space that could be illuminated by switching on the electricity. He decorated church interiors with neon lights that recall the colors of stained glass, homes with lights arranged in corners and along the walls, and public spaces. In *Monument for V. Tatlin* (**figure 26.11**), Flavin pays homage to Vladimir Tatlin's Constructivist *Monument to the Third International* (see p. 522).

Flavin and Tatlin shared a utilitarian view of media and a geometric aesthetic. But Flavin incorporated color and light into his sculptures, so that despite the manufactured materials, his work softens the space it occupies.

> **Regard the light and you are fascinated.**
>
> Dan Flavin, artist (1933–1996)

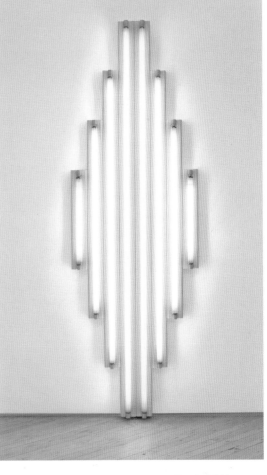

26.11 Dan Flavin, *Monument for V. Tatlin*, 1968. Cool white fluorescent light, 8 ft. high. Collection Dia Art Foundation.

COMPARE

Tatlin, *Monument to the Third International*. **figure 25.16, page 522**

Eva Hesse (1936–1970) is considered a Post-Minimalist, because, although her forms are non-figurative and non-representational, there is an identifiable autobiographical subtext in her work. She was born in Germany, escaped from the Nazi persecutions of Jews to Holland, and then went to New York, where she spent a short time in an orphanage. Hesse's life was marked by a series of abandonments—including her mother's suicide, desertion by her husband, and departure from her homeland. She studied art at Yale, and then returned to Germany, where she had her first one-woman show in 1965. Five years later, at the age of thirty-four, she died of a brain tumor.

Among Hesse's favorite media were rope and string, which had also been used by Duchamp, Arp, and other Dadaists. In *Untitled (Rope Piece)* (**figure 26.12**), string and rope are extended across a corner connecting two walls of a room. The lively, curved variations recall Pollock's drips, and seem to take on a life of their own as if dancing through space. For Hesse, however, the rope and string are more than Dada puns and pure formal movement; they reflect her wish to establish links—to repair the broken connections of her life.

... I wanted to get to non-art, non-connotative, non-anthropomorphic, non-geometric, non-nothing....

Eva Hesse, sculptor (1936–1970)

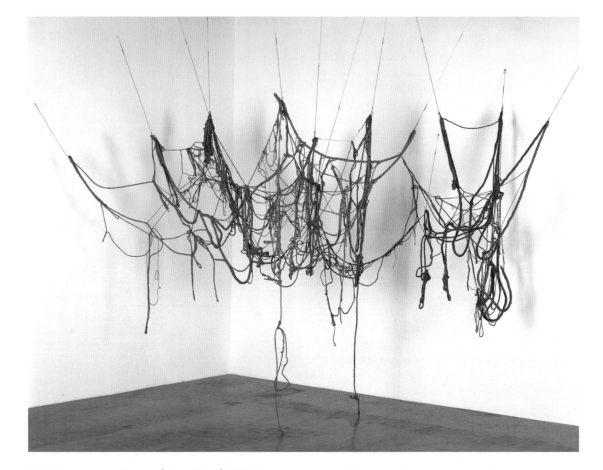

26.12 Eva Hesse, *Untitled (Rope Piece)*, 1970. Latex over rope, string, and wire, two strands, dimensions variable. Whitney Museum of American Art. Purchase, with funds from Eli and Edythe L. Broad, the Percy Uris Purchase Fund, and the Painting and Sculpture Committee.

Feminist Art: Judy Chicago

In the 1970s, Feminist Art began to establish itself as a specific genre and women artists became politically and artistically assertive. Feminism, which we discussed as a methodology of artistic analysis in Chapter 7, was not new to the twentieth century. Women had fought for ownership and marriage rights, for suffrage, and for the right to study and work equally with men for centuries. But in the 1970s feminism became a well-defined category of art, which included content involving women and their experience and also used and imitated craft techniques traditionally practiced by women. Decoration and patterning, for example, which were associated with quilting, embroidery, and weaving, are themes in some feminist art. Later, in the 1980s and 1990s, the female body was explored in ways that occasionally offended conventional taste.

A seminal feminist work is Judy Chicago's (born Judy Cohen in 1939) *Dinner Party* (**figure 26.13**), a large installation in the shape of an equilateral triangle representing a dinner table. Each side of the triangle is set with thirteen places. Each plate, dedicated to a famous woman, is painted with female imagery and rests on top of an embroidered placemat runner. At the base are the painted names of 999 additional women, such as Queen Hatshepshut of Egypt, the American painter Georgia O'Keeffe, and the British author Virginia Woolf, all of whom Judy Chicago has symbolically invited to dinner.

The artist imbues the work with the traditional role of the woman as a homemaker, household cook, and social secretary. Triangles are often female signs, but they can also refer to the Trinity in Christian art. This, too, is an embedded aspect of the *Dinner Party*, for thirteen is the number of Christ plus his apostles at the Last Supper, and also the number of witches believed to comprise a coven. Chicago intentionally alluded to the iconography of the Last Supper but said: "In my 'Last Supper,'… the women would be the honored guests."[3] She thus challenged traditional superstitions that denigrate and endanger women and also elevated them to high status.

26.13 Judy Chicago, *The Dinner Party*, 1974–1979. Painted porcelain and needlework, each side 48 ft. long, 36 in. wide. Collection of the artist.
© 1979 Judy Chicago. Now in the Brooklyn Museum, New York.

Earth and Environmental Art: Smithson and the Christos

We have seen that landscape has been part of American iconography since the nineteenth century (see Chapter 24). But in the 1970s, land became a site and earth became a medium. The huge earthworks of Robert Smithson (1938–1973) were chosen for their location and terrain. His earlier Minimalist "**nonsites**" consisted of aerial photos or maps of sites that were placed on the wall or floor of a gallery and then decorated with rocks and earth taken from the site.

Smithson's *Spiral Jetty* (**figure 26.14**), made in 1970 with a bulldozer, consists of over 6,500 tons of gravel, rock, and earth moved into a 15-foot-wide, 1,500-foot-long spiral projecting into the Great Salt Lake of Utah. The formation of algae turned the interior of the spiral red and the salt crystals around the edge give the spiral a reflective framework. For Smithson, *Spiral Jetty* transcended the notion of art as an object and integrated it with nature. As a result, he broke the boundary between indoors and outdoors and between architectural space and the natural environment.

In Smithson's view, art should reflect nature as the ongoing process that it is. "Nature," he wrote, "is never finished. It is both sunny and stormy..."[4] He wanted to disengage art from narrative and figurative imagery and integrate it with nature. "I am for an art that takes into account the direct effect of the elements as they exist from day to day apart from representation."[5] Smithson died in a plane crash in 1973, while filming a potential earthwork site in Texas.

Christo (born Christo Javacheff) and Jeanne-Claude Christo were born in 1935. Christo escaped from Communist Bulgaria after World War II and survived as a portrait painter in Paris. There he met Jeanne-Claude, the daughter of a French army officer, and together they have made art an international project. They alter rural and urban environments using fabric and hundreds of workers. Their work involves a concept, but is not Conceptual, and sometimes packaging, but is not Pop Art; its execution is a performance, but they are not performance artists.

Christo and Jeanne-Claude have run a white fabric fence through 24½ miles of Sonoma and Marin Counties in California and surrounded eleven islands in Miami's Biscayne Bay with pink fabric. They have wrapped trees in Switzerland, part of the Australian coastline, and the Reichstag in Berlin. In 1991, they realized a cross-continental project between Japan and the United States, installing 1,760 yellow umbrellas in California and 1,340 blue umbrellas in Japan. Each umbrella was over 19 feet high and weighed about 450 pounds. They were opened simultaneously at dawn on October 9, 1991.

26.14 Robert Smithson, *Spiral Jetty*, 1970. Rock, crystal salts, earth and water with algae, 1500 ft. long by approx. 15 ft. wide. Great Salt Lake, Utah. Image courtesy of James Cohan Gallery, New York. Collection Dia Center for the Arts, New York, photo Gianfranco Gorgoni.

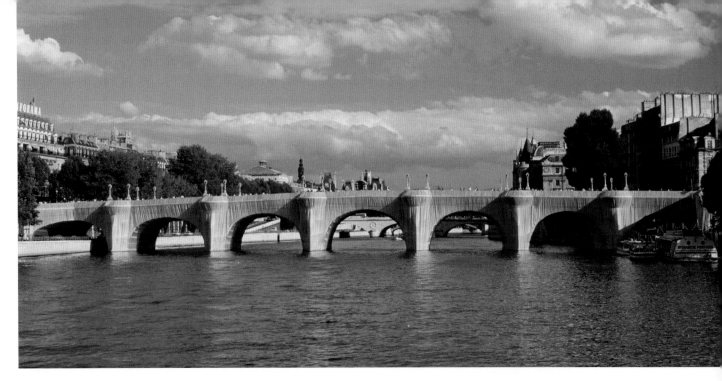

26.15 Christo and Jeanne-Claude, *The Pont Neuf Wrapped*, Paris, 1975–1985. Polyamide fabric and rope.

In September 1985, Christo and Jeanne-Claude wrapped the Pont Neuf, a bridge in Paris constructed under King Henry IV (1553–1610), who wanted to connect the Ile de la Cité with the Left and Right Banks of the Seine River (**figures 26.15** and **26.16**). After ten years of negotiation with the Paris authorities, permission for the project was granted. Three hundred workers implemented the artists' vision using slightly under 441,3000 square feet of woven polyamide fabric. 1,217,000 feet of rope and over twelve tons of steel chains secured the fabric to the bridge and its lampposts.

The two views illustrated here show the silky golden color of the fabric as it catches the light at different times of day and "dresses up" the old bridge. The bridge itself, which has a practical function, is here transformed into a monumental, shimmering urban sculpture. In the distant view, we can see how the fabric has accentuated the graceful form of the bridge and its reflection in the slowly flowing river. Inspired by a formal idea about changing (and improving) a view of Paris, Christo and Jeanne-Claude had to have imagined how the bridge would look under different conditions. By wrapping the Pont Neuf, they gave new life to an ancient structure, outfitting it with bright fabric and making it stand out, while also accentuating its intimate relationship to the overall design of Paris.

In February 2005, Christo and Jeanne-Claude realized *The Gates Project for Central Park*, Central Park, New York City (see figure 26.17). 7,503 gates were placed on the walkways of Central Park, with saffron-colored panels of fabric suspended between vinyl poles. The fabric blew with the wind, and changed color with weather conditions. To prepare

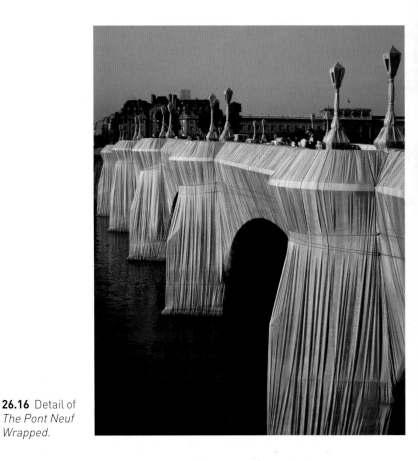

26.16 Detail of *The Pont Neuf Wrapped.*

for the project, Christo made hundreds of drawings, models, and collages, including maps of the site. In contrast to Smithson's *Spiral Jetty*, which still exists, Christo and Jeanne-Claude's projects are temporary. Their materials are recycled, the sites are returned to their original condition, and the projects are recorded on film and in books.

Christo and Jeanne-Claude

In an interview with Laurie Adams, July 21, 2005.

LA: You have done many large environmental projects throughout the world. How did you conceive the idea for the Central Park Gates?

Jeanne-Claude: Every one of our projects comes from our hearts and our minds. They are linked to a place, to our personal feelings about a place, to our memories of a place, and to our impression of the aesthetic possibilities related to a place. We have lived in New York City since coming to America in 1964. We arrived on the SS France at 5 am and passed under the then unfinished Verrazzano Bridge. We stood at the prow of the ship and what we saw before us was a postcard view of downtown Manhattan. It was a cold, misty day in February and we were in each other's arms. Christo asked me, "Do you like it?" And I said, "I love it!" To which Christo replied, "I give it to you."

Christo: We fell in love with downtown Manhattan; we had never seen such tall buildings. In 1964, we asked the owners of 2 Broadway and 20 Exchange Place if we could wrap their buildings. They said "No. A building cannot be wrapped."

Ever since 1964 we have worked around the world on different projects, but we always came back to New York and we always wanted to do a project here. Our interest in New York lay in the dynamic of its people. It is the most walked city in the world.

In 1979 we got the idea for a project in Central Park. It is the city's most visible park. At the same time, it is a defined, geometric space enclosed by a stone wall. But the wall is low enough to permit a view of the buildings around it. So people in the park are inside the city and secluded from it simultaneously.

Jeanne-Claude: Central Park was designed by Frederick Law Olmstead, who wanted to close the openings in the wall at night with iron gates. But he did not like any of the proposed designs, so he left the original openings—which are called gates. Several of the gates have a name—the Gate of the Mariners, the Gate of the Soldiers, the Gate of the Engineers, the Gate of the Artists, the Gate of All-Saints, and so forth.

Christo: We wanted a project for walking, and we decided to incorporate the original idea of gates with the interior of the park—its walkways, its undulating terrain, and its trees. We observed that the space between the ground and the branches of the trees is generally ignored. So we built a module to organize that space in such a way as to reflect the rectangular geometry of the city blocks. We contrasted this with the flowing fabric to express and harmonize our module with the organic quality of the park. The serpentine walkways are echoed in the motion of the fabric, which is created by the wind. The posts, on the other hand, are static and form a commanding presence. We didn't really invent anything, but we did create a synthesis of nature and geometry that mirrors New York City as embodied in Central Park.

The process we use is different in every project and it involves lengthy efforts to obtain permission from local authorities. There is thus no set precedent for the process as there is, for example, in the templates of buildings. The process is crucial, but it is not the aim.

Jeanne-Claude: I would compare the process to a nine-month pregnancy, although obtaining permission for our projects has often taken many years. The process is essential, but the aim is giving birth to the baby and seeing and experiencing him or her. The work of art is the baby.

Christo: The materials we used in *The Gates* were inseparable from the idea. All the fabric (as in all of our projects) is of manmade fiber, because natural fiber such as wool and cotton is not sufficiently sturdy. The poles were made of vinyl—there were 60 miles of poles placed end to end. The bases of the poles were made of steel—5,000 tons of steel, two-thirds the amount of steel in the Eiffel Tower.

We decided on a saffron color. But before selecting the exact hue of the saffron, we made 18 full-size gates in 2002 to test our choice. We also tried different rectangular shapes and thicknesses for the steel bases. The test fabrics varied in the way they were sewn, in the size of the hems, and in the depth and extent of the folds. All in all, the test lasted seven months, because we wanted to see how *The Gates* would look in

MEANING

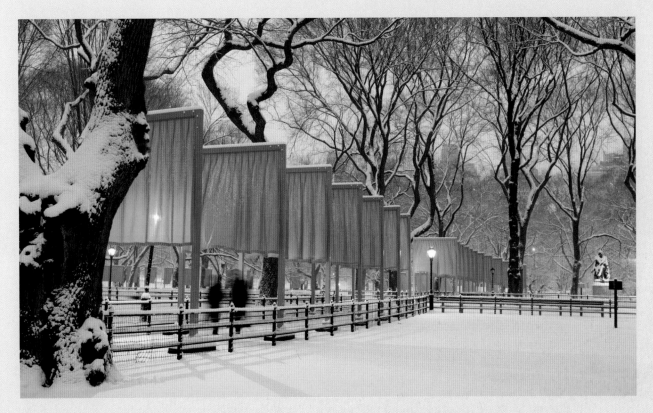

26.17 Christo and Jeanne-Claude, *The Gates Project for Central Park*, New York City, 2003.

all weather conditions. We wet them to see how they would look in the rain and we photographed them in color and in black and white, as we do for every project.

Jeanne-Claude: *The Gates* were a winter project—February—by coincidence the very month of our arrival in New York. We chose winter because the trees are leafless and the trunks and branches are a silvery color. The saffron made a striking contrast with the silver, but it also harmonized with it. We prayed that it would snow, and it did.

Above all, we conceived of *The Gates* in relation to the people of New York. *The Gates* were at once intimate and expansive. They were a private experience between visitors and their feet, their minds and their souls, and their relation to the space of the park and to the view of the surrounding buildings. The poles served as an attraction and presence, especially at the entrances (Olmstead's original gates), for they were like a funnel, drawing crowds into the space of the walkways. The poles added to the ceremonial quality of the work, ceremonial but also joyous, as saffron is a joyous color. Unlike *The Pont Neuf* and other projects that were public events, *The Gates* had a private quality. It was porous, because people were inside *The Gates* but also outdoors and in the City of New York surrounded by visible buildings. We think of New York as "Our Town"—it is where we have lived for over 40 years, the longest we have lived anywhere.

LA: How do you see the important influences on your work in the continuum of art history?

Jeanne-Claude: The artist who has most influenced me is Christo.

Christo: I was most influenced by my parents. I grew

Christo and Jeanne-Claude

up in communist Bulgaria, where the study of art was officially restricted to Socialist Realism. But my parents were artistic and liberal. My mother was Secretary of the Fine Arts Academy in Sofia, Bulgaria. She arranged for me to have private art lessons three times a week from the age of six. My grandmother was a pianist, my brother is an actor, and my father was a chemist who made dye for textiles.

I studied art in a conservative school in the tradition of the nineteenth-century Academy. The first four years were devoted to all the arts—painting, sculpture, architecture, design—and to anatomy. In the fourth year, at the age of twenty-one, I escaped. I traveled to several Eastern European cities and arrived in Paris in 1958. After communism, I wanted to be free of all influences. For me, the most important thing was to be in the West and to experience what was new and to become aware of all the artistic possibilities.

I saw the Le Corbusier chapel at Ronchamp and admired his architecture (see Chapter 14). I met Giacometti (see Chapter 5) in Paris and was impressed by his spare stage design for Beckett's *Waiting for Godot*. I met the publisher of Picasso's prints, but as I was in my twenties, I declared that I did not want to meet Picasso. He was too towering a monument.

In 1958 I went to the Brussels World's Fair. The exhibition of art from the Belgian Congo was incredible. I also saw a traveling exhibition of the American Abstract Expressionists; the enormous sizes of the paintings were new for me. I realized that anything is possible. That was the main influence on my art—the realization that anything is possible.

So, while I can't say that I am aware of any specific influence of a single artist on my art, Jeanne-Claude and I nevertheless work within a long artistic tradition that revolves around fabric.

Jeanne-Claude: Throughout the history of art, fabric is a crucial aspect of creating form, movement, energy, and even of defining space. We make regular pilgrimages to Giotto's Arena Chapel in Padua (see p. 367). His command of fabric is astonishing. He shows figures that are defined entirely by their drapery. They turn in space and are shown from all viewpoints, including from the back. It is the fabric that creates the figures.

Think of the Greek statues, the Egyptian statues, and their relationship to fabric. Think of Rodin's statue of Balzac—the robe creates its monumental presence, its dynamic pose, and its power.

Christo: But our work is not a static sculpture, building, or painting. Our projects are living works and they are in motion. They respond to the flow of nature and to the human forces around them. They are tactile, spatial, solid, and temporary all at the same time. As artists we are like nomads and our art has a nomadic character. The nomads arrive and unfold their fabric tents. Then, when they depart, they fold up their tents and all is gone. Every one of our projects is light, airy, and "passing through." We always restore the site to its original state and recyle our materials.

LA: Who is your favorite artist?

Christo and Jeanne-Claude: Giotto.

Christo: And our favorite contemporary artist is Nam June Paik (see p. 551). He is a master of organizing and animating space in original ways. Some of his works are permanent, but he, too, packed up his temporary installations and moved on.

Photography: Self as Subject

Photography, as is clear from the films made to record projects such as those by Smithson and Christo and Jeanne-Claude, continues its documentary function. But it is also used to record artistic performances. As an art form in its own right, photography has become a major contemporary medium of expression.

The photographs of Cindy Sherman (see pp. 134 and 215) have been associated with feminism because of their focus on female imagery and experience. Her brand of feminism is variously humorous and polemical, as we saw in her satirical version of Raphael's *Fornarina*. She challenges traditional notions of the woman's role by photographing herself as others or as famous images of others. In the 1980s, she made imitation black-and-white film stills of herself based on Hollywood *films noirs* of the 1940s and 1950s.

Untitled Film Still in **figure 26.18** shows the artist as a girl alone, at night, in a hostile city. She is a platinum blonde, conventionally dressed, and engulfed by darkness. She pulls up her coat collar and seems slightly apprehensive, recalling the figure of Munch on the bridge in Oslo in his painting *The Scream* (see figure 6.29). Both works are autobiographical, but Sherman is very much "pulled together," whereas Munch is in the process of mental disintegration. Her anxiety is realistic; his is paranoid.

Sherman is always present in her work, but usually in the guise of someone else. She is an actress and model in her own photos, revealing herself through a series of roles, simultaneously distanced from the image and part of it. In her work, therefore, there is a new approach, merging the artist as author with the artist as consciously disguised subject.

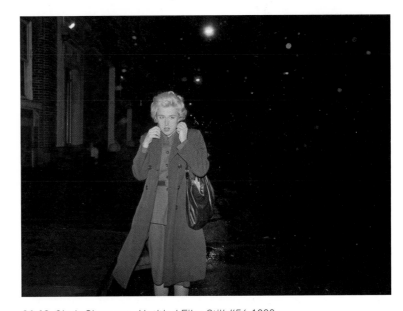

26.18 Cindy Sherman, *Untitled Film Still #54*, 1980. Black and white photograph, 8 x 10 in. Collection of the artist. Courtesy Metro Pictures, New York.

The photographic self-images of the Japanese artist Yasumasa Morimura (b. 1951) deal with cross-cultural, gender, and interracial identity. All three are themes in his *Self-Portrait (Actress)/White Marilyn* of 1996 (**figure 26.19**), where he has dressed and photographed himself as Marilyn Monroe three times. He places himself-as-her on a cylindrical platform, alluding to the unreal idealization of women by "putting them on a pedestal." By showing his/her skirt flaring up and revealing various amounts of leg, Morimura conveys Marilyn Monroe's status as an icon of American 1950s Hollywood-style sexuality. He also reflects the contemporary globalization of the arts by subverting the distinction between East and West, Caucasian and Asian, and male and female.

COMPARE

Munch, *The Scream*.
figure 6.29, page 126

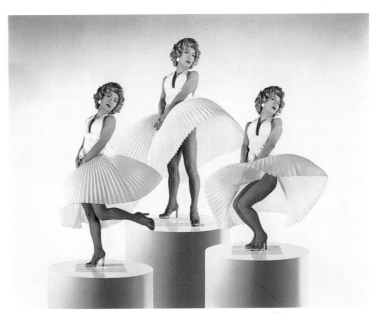

26.19 Yasumasa Morimura, *Self-Portrait (Actress)/White Marilyn*, 1996. Ilfrochrome/acrylic sheet, 3 ft. 1 1/4 in. x 3 ft. 11 1/4 in. Courtesy Luhring Augustine, New York.

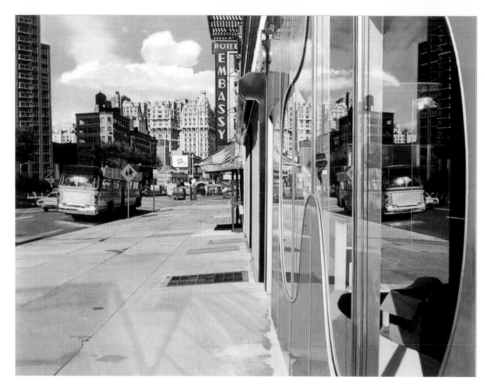

26.20 Richard Estes, *Bus Reflections* (*Ansonia*), 1972. Oil on canvas, 3 ft. 4 in. x 4 ft. 4 in. Private Collection. Courtesy Marlborough Gallery, New York.

Photorealism and Super Realism: Estes and Hanson

In the 1970s Photorealist style, artists create the impression that a painting is a color photograph of a real person or place. The Photorealist paintings of Richard Estes (b. 1936) typically represent the urban landscape. In *Bus Reflections* (*Ansonia*) of 1972 (**figure 26.20**), he shows a city street devoid of people. Each surface is detailed with equal clarity, whether it is in the foreground or the background. Colorful shapes and patterns animate the reflections and multiple superimposed images are mirrored in the glass and chrome. Signs of city life can be seen throughout—hotel and store windows, sidewalk squares, cars, clouds, a bus, and street signs. The crisp, clear edges and the sharp thrust into space recall Renaissance linear perspective (see Chapter 5). As in a photograph, we have the impression of a captured moment in time—the bus and the yellow car seem to be approaching the cross-street.

> I don't believe photography is the last word in realism.
>
> Richard Estes, artist (b. 1936)

Super Realist sculptures are often mistaken for the real thing. The style followed logically from the success of Pop Art's literalism. Unlike Pop Art, however, Super Realists, like Photorealists, generally create **trompe l'oeil** illusionism. The polyvinyl and polyester resin sculptures of Duane Hanson (see p. 256) represent typically American middle- and working-class types. His humorous *Woman with Dog* (**figure 26.21**) depicts a relaxed, elderly woman reading a letter. She is seated at a table, now in the restaurant area of the Whitney Museum of American Art in New York. Viewers who see her for the first time generally

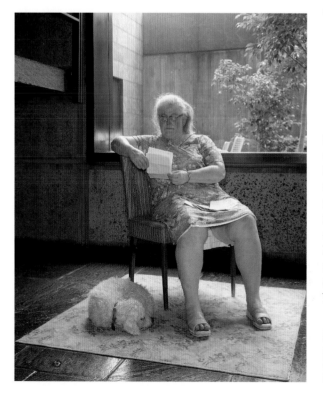

26.21 Duane Hanson, *Woman with Dog*, 1977. Cast polyvinyl, polychromed in acrylic with cloth and hair, lifesize. Whitney Museum of American Art, New York. Purchase, with funds from Frances and Sidney Lewis.

assume she is real and might wonder how a dog has been admitted to the museum. She is casually dressed, wearing open-toed sandals, and seems unaware of being observed.

During the 1950s, when Abstract Expressionism was the reigning New York style, Hanson struggled against his attraction to figurative naturalism. At the time, he said:

> I would try to do abstract art, but I always put an arm or a nose in it. I never could do just nonfigurative work.[6]

Graffiti and the Urban Street

The underclass of the urban scene is celebrated in the graffiti paintings of Jean-Michel Basquiat (1960–1988), the son of a Haitian father and a black Puerto Rican mother from Brooklyn. At seventeen, Basquiat ran away from home and spent two years on the street. In 1979 and 1980, he had a band—a "noise band"—that performed in downtown clubs in Manhattan. His first work was actual graffiti painted in the subway designed to challenge middle-class culture and address African-American issues. Despite controversy over the issue of graffiti itself (see p. 70), Basquiat joined a gallery in 1980 and achieved remarkable success with graffiti-inspired images. At the age of twenty-eight, however, he died of a drug overdose, a victim of the street that had inspired his style.

In *Hollywood Africans* (**figure 26.22**), Basquiat used painterly brushwork and a gestural process that allows the paint to drip. Painted words allude to African themes (*IDI AMIN*), American consumerism (*TOBACCO*), the criminal underworld (*GANGSTER-ISM*), African slaves in the Caribbean (*SUGAR CANE*), and the Far East (*200 YEN*). Although Basquiat's juxtaposition of unlikely combinations is reminiscent of Surrealism, his process is gestural and his textures have a Neo-Expressionist flavor. All are merged to project political, social, and racial messages.

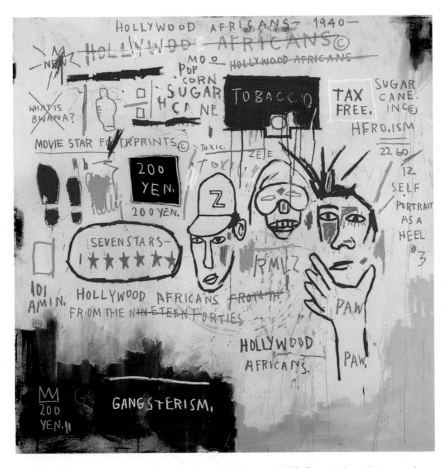

26.22 Jean-Michel Basquiat, *Hollywood Africans*, 1983. Synthetic polymer and mixed media on canvas, 7 ft. x 7 ft. Whitney Museum of American Art, New York. Gift of Douglas S. Kramer.

Performance, Video, and New Media

Modern performance art is derived from Dada performances at the Cabaret Voltaire in Zurich during World War I (see Chapter 25) and **Happenings** of the 1960s, many of which protested the Vietnam War. Such events have a political as well as an artistic aspect. In West Germany, in the early 1960s, the Fluxus group, an art movement influenced by Duchamp, engaged avant-garde writers, artists, musicians, and dancers in exploring new art forms.

The American installation artist, dramatist, and opera director Robert Wilson (b. 1941) was a member of Fluxus. He called rock concerts "the great opera of our time," reflecting the creative interplay of genres in the contemporary aesthetic. Wilson is interested mainly in fantasy, surreal effects, and access to the unconscious, all of which characterize his stage sets. In 1976, he produced the innovative *Einstein on the Beach* (**figure 26.23**), a five-hour opera by Philip Glass (b. 1937) that toured Europe and was performed at the Metropolitan Opera in New York. Wilson worked with avant-garde, atonal composers and modern dancers, and wrote grammatically incorrect dialogue to replicate the illogic of unconscious thinking. He wanted to show the effect of Einstein's theory of relativity on modern life.

Another member of Fluxus, Joseph Beuys (1921–1986), was the first major German artist after World War II to explore his national identity. Inspired by a mystical strain of nationalism characteristic of German philosophy and literature, Beuys experienced intense guilt at German brutality during the war. He flew for Hitler's airforce, and claimed to have been shot down in a snowstorm in the Crimea and rescued by Tartars. They wrapped him in animal fat to keep him from freezing and saved his life. Although the truth of this story cannot be verified, it became part of the Beuys myth and influenced his art. He made many sculptures using animal fat.

In an obsessive attempt to remake his life and redeem his self-respect, Beuys created "art actions" during the 1960s and 1970s. He emulated a professor, lecturing and traveling with a view to bringing about world peace. He saw himself as a shaman with transformative power over animals, and he performed in a ritualistic way. **Figure 26.24** shows a photograph of Beuys lecturing in 1974. He speaks into a microphone, emphasizing his points on the blackboard. He filled the space with diagrams, an amoebalike oval above his hat, and the word *ART* to the left. Writing with chalk, he made his message erasable and therefore transitory and he made himself a combination actor, professor, political emissary, and performer.

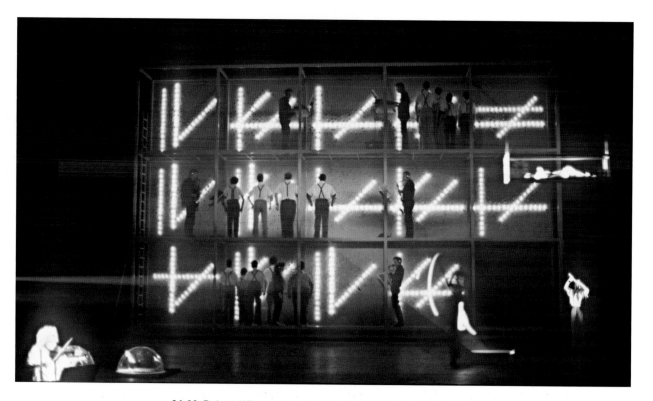

26.23 Robert Wilson, setting for *Einstein on the Beach*, 1976.

The Korean-born Nam June Paik (see p. 225) participated in Fluxus and for a time worked with Beuys. He studied Western music in Japan and Munich, and later became an American citizen. A remarkably inventive pioneer of electronic art, Paik used television sets as a medium of sculpture and created imaginative installations using music, video, laser projections, and other media to fill large interior spaces.

Paik's *Electronic Superhighway* (**figure 26.25**) represents the map of the United States, which, like Jasper Johns' *Map* (see p. 537), is composed of bright color and imbued with dynamic energy. But instead of paint, Paik used 313 television monitors working on 47 closed-circuit channels, with outlines made of neon lights. And instead of a painted surface, Paik's space is virtual. The notion of electronic media as a superhighway, connecting continents electronically instead of physically, reflects the global nature of Paik's own career.

26.24 Joseph Beuys lecturing in New York, 1974.
Photograph © the Estate of Peter Moore.

26.25 Nam June Paik, *Electronic Superhighway: Continental U.S.*, 1995. Forty-seven-channel and closed-circuit video installation with 313 monitors, neon, and steel structure; color, sound; approx. 15 x 32 x 4 ft. Smithsonian American Art Museum.

26.26 Asymptote (Hani Rashid and Lise Anne Couture), *Fluxspace 3.0*, M-Scape City, 2002. Installation at Documenta XI in Kassel.

Creating virtual space is the aim of recent digital installations such as *Fluxspace 3.0* (**figure 26.26**) by the New York architectural firm, Asymptote. In this view, the dark plane of an urban shape hovers over the center of a room. The walls are covered with mirrors, multiplying the shape and surrounding the viewer on three sides. In such works, artists explore the interplay, or spatial fluctuations (fluxspace), between real space and virtual space, and real and virtual architecture.

Architecture

Architecture in the second half of the twentieth century comprises a wide variety of forms that reflect the innovative global thinking found in other forms of visual art. The surge in architectural creativity that followed World War II, as in painting and sculpture, was enriched by the influx of emigrés from Europe. By the turn of the twenty-first century, architecture had become global, with architects working in foreign countries and exploring cross-cultural ways of thinking about architectural space.

One of the main architectural influences to enter the United States from Europe was the International Style (see Chapter 25). This can be seen in the Lever House (**figure 26.27**), created in 1951–1952 by the New York firm of Skidmore, Owings, and Merrill, under the supervision of one of its architects, Gordon Bunshaft. At the time it was built, the Lever House was a startling addition to the New York skyline. Supported below on freestanding steel columns, the building is opened on the ground level. The base is a horizontal rectangle inspired by Bauhaus design that extends the length of an entire Park Avenue block.

26.27 Gordon Bunshaft of Skidmore, Owings, and Merrill, Lever House, New York, 1951–1952.

Rising from the horizontal is a tall vertical on the north (uptown side) with a green glass skin. The surface of the skin mirrors the shifting clouds, with their soft edges, juxtaposed with the sharp outlines of static buildings. The thin **mullions**—vertical bars separating the glass panes of the windows—create a grid pattern that orders the surface and echoes the arrangement of the surrounding streets.

Ludwig Mies van der Rohe (1886–1969), who also worked in the International Style and was influenced by the Bauhaus, came to the United States in 1938 to escape Hitler and was appointed department chairman at the Illinois Institute of Technology. Twenty years later, he collaborated with the American architect Philip Johnson (1906–2005), whom he had met in Germany in 1930. Consistent with the philosophy of the International Style, Mies believed that in architecture "less is more."

This aesthetic is exemplified in the Seagram Building, which is an example of the steel-frame,

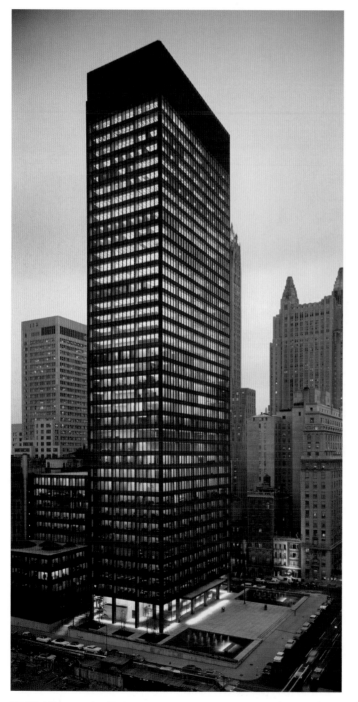

26.28 Mies van der Rohe and Philip Johnson, Seagram Building, New York, 1958. photo © Ezra Stoller/ESTO.

domino construction devised by Le Corbusier (see Chapter 14) (**figure 26.28**). Located on Park Avenue, in New York, diagonally across from Lever House, the Seagram Building is a simple, single rectangle, with a bronze-coated steel frame and amber-colored glass windows. Set back from the street on its own plaza, the Seagram Building is separated from the surrounding buildings. As with Le Corbusier's Villa Savoye (see p. 524) and Lever House, the ground floor is open, so the space flows through it and lightens the base. The harmonious proportions and avoidance of historical and natural references are related to Minimalism.

The most controversial late-twentieth-century style of architecture—Postmodernism—is considered ahistorical. That is, it juxtaposes elements from different styles, cultures, and periods of history, in ways that do not conform to traditional categories. Postmodernism is also eclectic. It detaches elements from their original cultural and stylistic contexts, producing what some critics consider a meaningless rejection of traditional architectural logic. In addition, the various responses to the style reflect the persistence of controversy as artists continue to push the envelope and move beyond what is expected.

The Louvre Pyramid (**figure 26.29**) is Postmodern in its combination of cultural ideas and juxtaposition of vastly diverse periods of history. The architect I.M. Pei was born in 1917 in Canton, China, enrolled in MIT (Massachusetts Institute of Technology) in 1938, and then attended Harvard. His first works of architecture were government buildings, private homes, and small museums.

In 1988 Pei completed the glass pyramid commissioned by the French government for the courtyard of the Louvre. Formerly the royal palace and today the French national art museum, the Louvre is a vast Baroque building. The pyramid, which was controversial when first opened to the public, leads to an underground museum entrance. It is composed of glass diamonds and triangles through which the stately façade of the Louvre is visible. Pei not only juxtaposed works from different periods (ancient Egypt and *ancien régime* France) and made of different materials (stone and glass), but also works having entirely different functions (a palace-turned-museum and a pharaoh's tomb). A few years later, Pei designed the Bank of China building that we discussed in Chapter 14 (see p. 284).

The Team Disney Building (**figure 26.30**), completed in 1991, is a good example of Postmodernism. It was designed by the Japanese Arata Isozaki (b. 1931), who was inspired by his study of Western architecture, especially Roman, medieval, and late Renaissance. The building rises from its foundation like a giant, three-dimensional cartoon, composed of flat greens, pinks, purples, browns, and blacks,

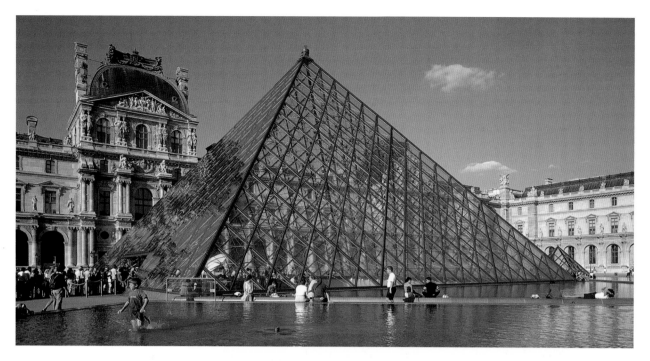

26.29 I.M. Pei, Louvre Pyramid, Paris, 1988. 65 ft. high at apex, 108 ft. wide.

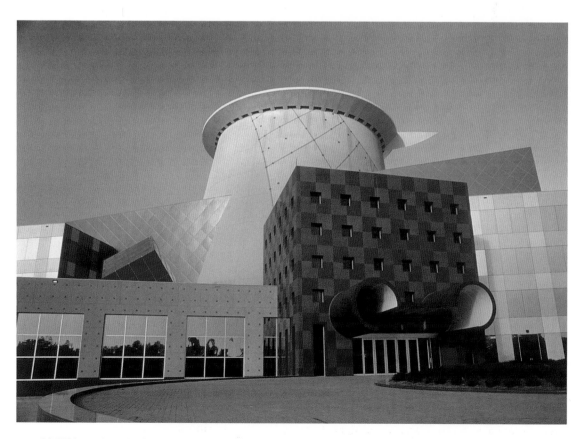

26.30 Arata Isozaki & Associates, Team Disney Building, Orlando, Florida, 1991. © Disney Enterprises, Inc.

with exterior wall surfaces enlivened by decorative patterns. Over the entrance, two large cylinders ending in circles resemble the large ears of Mickey Mouse. The building projects the image of playful, childlike creativity that one would expect from the Disney team.

In London, the building at 30 St. Mary Axe (**figure 26.31**), built in 2004 and known as the Swiss Re Building, is a controversial addition to the London skyline. At 30 stories in height, it is not especially tall by modern standards, but its unique, elegant, zeppelin shape distinguishes it from its surroundings. It rises skyward, like a missile awaiting take-off, bulging outward and tapering toward the top. The outer glass surface is composed of triangular windows framed by an overlay of diamond shapes. Spirals of dark glass create the sense of ribbons flowing over the surface. As is true of many skyscrapers, it is primarily an office building, though

it also contains a bar, a restaurant, and private apartments on the upper floors. In London, it is colloquially referred to as the Gherkin.

We have seen that the impulse to create a taller building than one's neighbors has existed for centuries. The colossal pyramids of Egypt were numbered among the Seven Wonders of the World for their huge size, imposing, monumental appearance, and technological skill. In Gothic Europe, towns vied with each other to erect the tallest cathedral. Today, modern skyscrapers participate in the same competitive spirit. A recent example of this impulse can be seen in the project design for the 94-story World Financial Center in Shanghai (**figure 26.32**). Compared with this building, the Seagram Building and Lever House seem modest in both height and form. The reflective exterior of the Shanghai building is made of glass and steel and contrasts sharply with the sky. Its outline curves

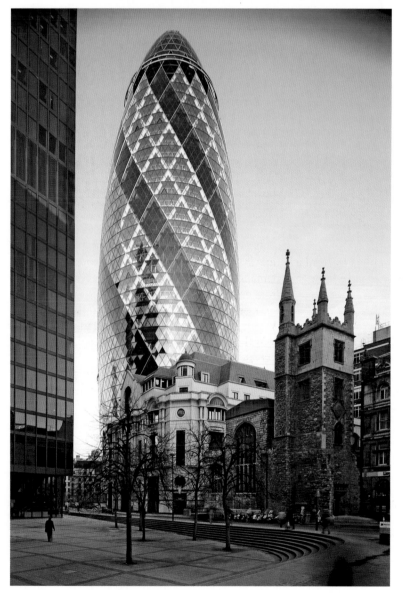

26.31 Norman Foster, Swiss Re Buildir London, 2004.

26.32 Kohn Pederson Fox, Rendition of Project Design for the Shanghai World Financial Center, Shanghai, China, 2001. 94 stories, 1,509 ft. high. Rendering by Crystal.

gracefully toward the top, metamorphosing from a rectangle to a trapezoid and a triangle, and ending in a narrow strip at the top.

— ◆ —

Having reviewed the span of Western art, with brief forays into non-Western art, we must conclude that human cultures are endlessly varied. But they also have similar concerns that are expressed in the visual arts. Art is inspired by an interplay between imagination, intellect, and emotion and the demands of external reality. This has been the case from earliest history and it continues to be the case because we share the human condition with our distant ancestors. In the most recent art that we have considered, certain traditional boundaries have been traversed and the arts have been enriched for it. As we open our minds to new artistic possibilities, we increase our potential for learning and improving our lives.

Chapter 26 Glossary

biomorphic—representing organic forms rather than abstract shapes

combine—work of art combining the techniques of collage and assemblage

Happening—event in which artists give an unrehearsed performance

mullion—vertical bar or pier (usually nonstructural) separating the lights of doors or windows

nonsite—form of environmental art in which a picture or photograph of a site is decorated with objects (e.g. earth, rocks) taken from that site

trompe l'oeil—literally "fooling the eye," referring to illusionistic imagery

Further Reading

Adams, Laurie Schneider, *The Methodologies of Art: An Introduction*, New York: Harper Collins, 1996.

— *Looking at Art*, Englewood Cliffs, NJ: Prentice Hall, 2002.

— *Art across Time*, New York: McGraw-Hill, 3rd edition, 2007.

— *Italian Renaissance Art*, Boulder, CO: Westview Press, 2004.

Arnason, H.H., *History of Modern Art: Painting, Sculpture, Architecture, Photography*, revised by Peter Kalb, Upper Saddle River, NJ: Prentice Hall, 5th edition, 2004.

Bahn, Paul G., *The Cambridge Illustrated History of Prehistoric Art*, Cambridge and New York: Cambridge University Press, 1998.

Blier, Suzanne Preston, *The Royal Arts of Africa: The Majesty of Form*, New York: Abrams, 1998.

Bonfante, Larissa (ed.), *Etruscan Life and Afterlife: A Handbook of Etruscan Studies*, Detroit: Wayne State University Press, 1986.

Canby, Sheila R., *Persian Painting*, New York: Thames and Hudson, 1993.

Chu, Petra ten-Doesschate, *Nineteenth-Century European Art*, New York: Abrams, 2nd edition, 2003.

Corbin, George A., *Native Arts of North America, Africa and the South Pacific: An Introduction*, New York: Harper and Row, 1988.

Cormack, Robin, *Byzantine Art*, New York: Oxford University Press, 2000.

Craven, Wayne, *American Art: History and Culture*, New York: McGraw-Hill, 2nd edition, 2003.

Diebold, William J., *Word and Image: An Introduction to Early Medieval Art*, Boulder, CO: Westview Press, 2000.

Flynn, Tom, *The Body in Three Dimensions*, New York: Abrams, 1998.

Frankfort, Henri, *The Art and Architecture of the Ancient Orient* (Pelican History of Art), New Haven, CT: Yale University Press , 5th edition, 1996.

Gage, John, *Color and Culture: Practice and Meaning from Antiquity to Abstraction*, Boston: Little Brown, 1993.

Harris, Ann Sutherland, *Seventeenth-Century Art and Architecture*, Upper Saddle River, NJ: Prentice Hall, 2005.

Hirsch, Robert, *Seizing the Light: A History of Photography*, Boston: McGraw-Hill, 2000.

Honour, Hugh, *Neo-Classicism*, New York: Penguin Books, 1977; reprinted, 1991.

Kostof, Spiro, *A History of Architecture: Settings and Rituals*, revised by Greg Castillo, New York: Oxford University Press, 1995.

Lee, Sherman E., *A History of Far Eastern Art*, New York: Abrams, 5th edition, 1994.

Levey, Michael, *Rococo to Revolution: Major Trends in Eighteenth-Century Painting*, New York: Thames and Hudson, 1985.

Nelson, Robert S. and Shiff, Richard (eds), *Critical Terms for Art History*, Chicago: University of Chicago Press, 2nd edition, 2003.

Nochlin, Linda, *Realism*, New York: Penguin Books, 1971; reprinted, 1990.

Pedley, John Griffiths, *Greek Art and Archaeology*, Upper Saddle River, NJ: Prentice Hall,

4th edition, 2007.

Pipes, Alan, *Production for Graphic Designers*, Upper Saddle River, NJ: Prentice Hall, 4th edition, 2005.

Scully, Vincent, *The Earth, The Temple, and The Gods: Greek Sacred Architecture*, New Haven, CT: Yale University Press, 1962; revised edition, 1979.

Shearman, John K.G., *Mannerism*, Harmondsworth: Penguin, 1977; reprinted New York: Viking Press, 1990.

Smith, William Stevenson and Simpson, William Kelly, *The Art and Architecture of Ancient Egypt*, New Haven, CT: Yale University Press, revised edition, 1988.

Snyder, James, *Northern Renaissance Art: Painting, Sculpture, the Graphic Arts from 1350 to 1575*, revised by Larry Silver and Henry Luttikhuizen, Upper Saddle River, NJ: Prentice Hall, 2nd edition, 2005.

Stokstad, Marilyn, *Medieval Art*, Boulder, CO: Westview Press, 2nd edition, 2004.

Taylor, Joshua C., *Learning to Look: A Handbook for the Visual Arts*, Chicago: University of Chicago Press, 2nd edition, 1981.

Trachtenberg, Marvin and Hyman, Isabelle, *Architecture from Prehistory to Postmodernity*, New York: Abrams, 2nd edition, 2002.

Walford, E. John, *Great Themes in Art*, Upper Saddle River, NJ: Prentice Hall, 2002.

Zanker, Paul, *The Power of Images in the Age of Augustus*, translated by Alan Shapiro, Ann Arbor: University of Michigan Press, 1988.

Notes

Part I

Quote:

p. 1 [Baudelaire]. *The Painter of Modern Life*, cited in Rose, Barbara, *Oldenburg for the Museum of Modern Art*, Greenwich, CT: Museum of Modern Art, 1970, p. 19.

Chapter 1

Quotes:

p. 2 [Brancusi]. Jiménez, Carmen and Gale, Matthew (eds), *Constantine Brancusi, The Essence of Things*, Guggenheim Museum and Tate Modern, London, 2004.

p. 5 [Leonardo]. Richter, J. P., *The Notebooks of Leonardo da Vinci*, New York: Dover Publications, 1970, p. 278.

p. 6 [Brancusi]. Ashton, Dore (ed.), *Twentieth-Century Artists on Art*, New York: Pantheon Books, 1985, p. 52.

p.7 [Calder]. Ashton, *op. cit.*, p. 96.

Text notes:

1. Adams, Steven, *The Impressionists*, Philadelphia: Running Press, 1990, p. 496.

2. Rosenblum, Robert and Janson, H. W., *Nineteenth-Century Art*, Upper Saddle River, NJ: Prentice Hall, rev. and updated ed. 2005, p. 282.

3. *Newsweek*, April 16, 1990, p. 27.

Chapter 2

Quotes:

p. 17 [Buckminster Fuller]. *New York Times*, July 3, 1983.

p. 18 [Brancusi]. Ashton, *op. cit.*, p. 53.

p. 19 [Whistler]. Whistler, James McNeill, *The Ten o'Clock Lecture*, 1885, in Robin Spencer (ed.), *Whistler: A Retrospective*, New York: Macmillan Publishing, 1989, p. 221.

p. 20 [Leonardo]. Richter, *op. cit.*, p. 253.

p. 22 [Quintilian]. *The Major Declamations Ascribed to Quintilian*, translated by Lewis A. Sussman, New York: Verlag P. Lang, 1987, X, ii, 7.

p. 25 [Diebenkorn]. Ashton, *op. cit.*, p. 200.

p. 26 [Goldsworthy]. Goldsworthy, Andy, *A Collaboration with Nature*, New York: Abrams, 1990.

p. 28 [Leger]. Ashton, *op. cit.*, p. 13.

Text note:

1. Chipp, Herschel B., *Theories of Modern Art*, Berkeley: University of California Press, 1968, p. 129.

Part II

Quote:

p. 35 [Mondrian]. Chipp, *op. cit.*, p. 352.

Chapter 3

Quotes:

p. 37 [Leonardo]. Kemp, Martin (ed.), *Leonardo on Painting*, New Haven: Yale University Press, 1989, p. 147.

p. 40 [Bearden]. Ashton, *op. cit.*, p. 191.

p. 51 [Picasso]. Chipp, *op. cit.*, p. 487.

p. 52 [Ringgold]. Farrington, Lisa, *Art on Fire*, New York: Millennium Fine Arts Publishing, 1999, p. 52.

p. 54 [Toulouse-Lautrec]. Desloge, Nora. *Toulouse-Lautrec: The Baldwin M. Baldwin Collection*, San Diego: San Diego Museum of Art, 1988.

p. 55 [Glaser]. Glaser, Milton, *Art is Work*, London: Thames and Hudson, 2000, pp.18–19.

Chapter 4

Quotes:

p. 60 [Picasso]. Chipp, *op. cit.*, p. 487.

p. 62 [Picasso]. Chipp, *op. cit.*, p. 264.

p. 69 [Moore]. Ashton, *op. cit.*, p. 73.

p. 71 [Ford]. Wren, Linnea H. (ed.), *Perspectives on Western Art: Source Documents and Readings from the Renaissance to the 1970s* (vol. 2), New York: HarperCollins Publishers, 1994, p. 304.

Text note:

1. Morgan, Ann Lee (ed.), *Contemporary Designers*, London: Macmillan, 1984, p. 10.

Part III

Quote:

p. 75 [Leonardo]. Kemp, *op. cit.*, p. 23.

Chapter 5

Quotes:

p. 76 [Oldenburg]. Rose, *op. cit.*, p. 154.

p. 78 [Matisse]. Chipp, *op. cit.*, p. 131.

p. 78 [Leonardo]. Kemp, *op. cit.*, p. 15.

p. 79 [Gauguin]. Chipp, *op. cit.*, p. 59.

p. 80 [Leonardo]. Kemp, *op. cit.*, p. 144.

p. 81 [Leonardo]. Kemp *op. cit.*, p. 57.

p. 85 [Leonardo]. Kemp, *op. cit.*, p. 165.

p. 88 [Giacometti]. Ashton, *op. cit.*, p. 57.

p. 89 [Picasso]. Chipp, *op. cit.*, p. 273.

p. 90 [Oldenburg]. Chipp, *op. cit.*, p. 586.

p. 93 [Calder]. Chipp, *op. cit.*, p. 562.

p. 96 [Leonardo]. *op. cit.*, Kemp, p. 72.

p. 97 [Matisse]. Chipp, *op. cit.*, p. 134.

p. 100 [Kelly]. *op. cit.*, Ashton, p. 222.

p. 105 [Van Gogh]. Chipp, *op. cit.*, p. 33.

Text note:

1. Chipp, *op. cit.*, p. 393.

Chapter 6

Quotes:

p. 109 [Kandinsky]. Chipp, *op. cit.*, p. 157.

p. 110 [Picasso]. Chipp, *op. cit.*, p. 270.

p. 111 [Hofmann]. Ashton, *op. cit.*, pp. 216–217.

p. 112 [Protagoras]. *Protagoras/Plato*, translated by C.C.W. Taylor, New York: Oxford University Press, 1996.

p. 113 [Lichtenstein]. Ashton, *op. cit.*, p. 260.

p. 115 [Demuth]. Ashton, *op. cit.*, p. 101.

p. 118 [Oldenburg]. Rose, *op. cit.*, p. 192.

p. 120 [Leonardo]. Richter, *op. cit.*, p. 182.

p. 121 [Calder]. Lipman, Jean with Aspinwall, Margaret, *Alexander Calder and His Magical Mobiles*, New York: Hudson Hills Press and Whitney Museum of Art, 1981, p. 36.

p. 125 [Mondrian]. Chipp, *op. cit.*, p. 364.

Text notes:

1. Ashton, *op. cit.*, p. 47.

2. Meuris, Jacques, *Magritte*, Köln: Taschen, 2004, p. 62.

3. Kandinsky, Wassily, *Du spirituel dans l'art, et dans la peinture en particulier*, Paris: Denoël Gonthier, 1989, p. 69.

4. Flam, Jack, *Matisse on Art*, New York: Phaidon 1973, p. 117.

5. Chipp, *op. cit.*, p. 365.

6. "Statement by Hans Hofmann," *It is*, winter–spring, 1959, pp. 149–50.

7. Ashton, *op. cit.*, p. 191.

8. Weintraub, Stanley, *Whistler: A Biography*, New York: Weybright and Talley, 1974, p. 124.

9. Chipp, *op. cit.*, p. 114.

Chapter 7

Text note:

1. de Vecchi, Pierluigi, *Raphael*, New York: Abbeville Press, 2002.

Part IV

Text note:

1. Cennini, Cennino d'Andrea, *The Craftsman's Handbook*, translated by Daniel V. Thompson, Jr. New York: Dover Publications, 1960, p. 5.

Chapter 8

Quotes:

p. 146 [Leonardo]. Kemp, *op. cit.*, p. 225.

p. 147 [Picasso]. Chipp, *op. cit.*, p. 273.

p. 150 [Cennini]. Cennini, *op. cit.*, p. 5.

p. 151 [Van Gogh]. Chipp, *op. cit.*, p. 31.

p. 151 [Kelly]. Ashton, *op. cit.*, p. 222

Chapter 9

Quotes:

p. 161 [Johns]. Interview with David Sylvester, in Harrison, Charles and Wood, Paul (eds), *Art in Theory, 1900–2000*, Malden, MA: Blackwell Publishing, 2003, p. 740.

p. 165 [de Kooning]. Tuchman, Maurice, *The New York School, Abstract Expressionism in the 40s and 50s*, London: Thames and Hudson, 1971, p. 50.

p. 170 [Höch]. Chipp, *op. cit.*, p. 396.

p. 170 [Duchamp]. Chipp, *op. cit.*, p. 394.

p. 171 [Matisse]. Chipp, *op. cit.*, p. 143.

p. 161 [Murray]. Storr, Robert, *Elizabeth Murray*, New York: Museum of Modern Art, 2005, p. 195.

p. 177 [Cennini]. Cennini, *op. cit.*, p. 115.

Text notes:

1. *Anacreonta*, translated by David A. Campbell, *Greek Lyric II*, Cambridge, MA: Loeb Library Edition, 1988, pp. 183–185.

2. Chipp, *op. cit.*, p. 143

Chapter 10

Quotes:

p. 183 [Kandinsky]. Chipp, *op. cit.*, p. 170.

p. 184 [Picasso]. Harrison and Wood, 2003, *op. cit.*, p. 216.

p. 192 [Warhol]. Harrison and Wood, 2003, *op. cit.*, p. 747.

Text note:

1. Harrison and Wood, 2003, *op. cit.*, p. 522.

Chapter 11

Quotes:

p. 202 [Richter]. Harrison and Wood, 2003, *op. cit.*, p. 757.

p. 208 [Bourke-White]. Bourke-White, Margaret, *Portrait of Myself*, New York: Simon and Schuster, 1963, p. 308.

p. 210 [Serrano]. Interview with Marcia Tucker, May 1986.

p. 225 [Paik]. Rush, Michael, *New Media in Late 20th-Century Art*, London: Thames and Hudson, 1999, p. 42.

Text notes:

1. Barthes, Roland, *Camera Lucida*, translated by Richard Howard, New York: Hill and Wang, 1981, p. 3.

2. Szarkowski, John, *Photography Until Now*, New York: Museum of Modern Art, 1989, p. 12.

3. Stieglitz, Alfred, *Camera Notes*, edited by Christian A. Peterson, New York: Minneapolis Institute of Arts and W.W. Norton, 1993, p. 10.

4. Adams, Ansel, *Photographs of the Southwest*, Boston: New York Graphic Society, 1976, p. vii.

5. Meredith, Roy, *Mr. Lincoln's Camera Man*, New York: Dover Publications, 1974, p. 1.

6. Lange, Dorothea, "The Assignment I'll Never Forget," in *Photography, Essays and Images: Illustrated Readings in the History of Photography*, edited by Beaumont Newhall, New York: Museum of Modern Art, 1980, pp. 263–266.

7. Preface to *Henri Cartier-Bresson Photographer*, International Center of Photography, New York, November/December 1979.

8. Eisenstein, Sergei M., *The Film Sense*, translated by Jay Leyder, New York: Harcourt Brace and Co., 1970, p. 78.

9. Hanhardt, John G., *Worlds of Nam June Paik*, New York: Guggenheim Museum, 2000, New York, p. 14.

10 Rush, *op. cit.*, p. 42.

11 Rush, *op. cit.*, p. 145.

Part V

Quote:

p. 231 [Saint Exupery]. de Saint Exupery, Antoine, *The Little Prince*, translated by Richard Howard, San Diego: Harcourt, 2000, chapter 14.

Chapter 12

Quote:

p. 233 [Morris]. Stansky, Peter, *Redesigning the World*, Princeton: Princeton University Press, 1985, p. 230.

Text note:

1. Noble, Joseph Veach, *The Techniques of Painted Attic Pottery*, New York: Watson-Guptill Publications and the Metropolitan Museum of Art, 1965, p. 103. Poem translated by Marjorie J. Milne.

Chapter 13

Quotes:

p. 248 [Geist]. Geist, Sidney, *Brancusi: A Study of the Sculpture*, New York: Grossman, 1968, p. 158.

p. 251 [Leonardo]. Kemp, *op. cit.*, p. 45.

p. 255 [Segal]. Ashton, *op. cit.*, p. 249.

p. 260 [Holzer]. Waldman, Diane, *Jenny Holzer*, New York: Solomon R. Guggenheim Museum and Abrams, 1997, p. 31.

Text notes:

1. Kemp, *op. cit.*, pp. 38–39.

2. Kemp, *op. cit.*, p. 40.

3. Ashton, *op. cit.*, p. 52.

4. Ashton, *op. cit.*, p. 21.

5. Ashton, *op. cit.*, p. 67.

6. Wittkower, Rudolf, *Sculpture, Processes and Principles*, New York: Harper & Row, 1977, p. 276.

7. Goldsworthy, Andy, *A Collaboration with Nature*, New York: Abrams, 1990.

8. Fabozzi, Paul F., *Artists, Critics, Context*, Upper Saddle River, NJ: Prentice Hall, 2002, p. 257.

Chapter 14

Quotes:

p. 266 [Le Corbusier]. Le Corbusier, *Towards a New Architecture*, translated by Federick Etchells, New York: Dover Publications, 1986, p. 2.

p. 281 [Buckminster Fuller]. Fuller, Buckminster, "Conceptuality of Fundamental Structures," in Gyorgy Kepes, *Structure in Art and in Science*, New York: George Braziller, 1965, p. 68.

p. 283 [Sullivan]. Roth, Leland M., *A Concise History of American Architecture*, Boulder, CO: Westview Press, 1980, p. 181.

Text notes:

1. Le Corbusier, *op. cit.*, p. 25.

2. Wright, Frank Lloyd, *A Testament*, New York: Horizon Press, 1957, p. 64.

Part VI

Chapter 15

Text notes:

1. Eliade, Mircea, *A History of Religious Ideas*, vol. 1, translated by Willard R. Trask, Chicago: University of Chicago Press, 1978, p. 123.

2. *The Epic of Gilgamesh*, translated by John Gardner and John Maier, New York: Alfred A. Knopf, 1984, lines 9–12, tablet 1, col. 1, p. 57.

3. Pritchard, James B. (ed.), *Ancient Near Eastern Texts*, Volume 1, Princeton: Princeton University Press, 1973, pp. 85–86.

4. *Ibid.*, translated by Theophile J. Meek, p. 139.

5. *Ibid.*, p. 155.

6. *Ancient Egyptian Literature*, translated John L. Foster, Austin: University of Texas Press, 2001, Pyramid Text 261, p. 74.

7. *Ibid.*, p. 69.

8. *Ibid.*, p. 72.

9. *Ibid.*, p. 95.

10. *The Satire on the Trades*, in *Ibid.*, stanza iii, p. 34.

11. *Ibid.*, pp. 2-3.

12. Faulkner, R.O., *The Ancient Egyptian Book of the Dead*, London: The Trustees of the British Museum, 1996, p. 41.

13. Hesiod, *Theogony*, in *ibid.*, p. 89.

Chapter 16

Quote:

p. 316 [Protagoras]. Protagoras/Plato, *op. cit.*

Text notes:

1. Pliny, *Natural History IX*, xxxiv, xix, 57. translated H. Rackham, Cambridge, MA: Loeb Classical Library, Harvard University Press, 1984, p. 169.

2. Virgil, *Aeneid II*, 42–49 passim. in *Eclogues, Georgics, Aeneid, 1–6*, translated by H. R. Fairclough, Cambridge, MA: Loeb Classical Library, Harvard University Press, 1986, p. 297.

3. *Ibid.* 215–225 passim., p. 309.

4. Suetonius, *Lives of the Caesars II*, xxviii, iii, in *Suetonius I*, translated by J. C. Rolfe, Cambridge, MA: Loeb Classical Library, Harvard University Press, 1989, p. 167.

5. *Ibid. II, Nero*, xxxi, i. 1992, p. 135.

6. *Ibid.*, xxxv, xi, p. 283.

Chapter 17

Text notes:

1. Cormack, Robin, *Byzantine Art*, New York: Oxford

University Press, 2000, p. 37.

2. Diebold, William, *Word and Image*, Boulder, CO: Westview Press, 2000, p. 64.

3. *Ibid.*, p. 62.

4. Panofsky, Erwin (ed.), *Abbot Suger on the Abbey Church of St. Denis and its Art Treasures*, Princeton: Princeton University Press, 1979, pp. 47–49.

Chapter 18
Quotes:
p. 366 [Vasari]. Vasari, Giorgio, *The Lives of the Artists*, vol. 1, translated by Julia Conaway Bondarella and Peter Bondarella, New York: Oxford University Press, 1998, p. 110.

p. 373 [Vasari]. *Ibid.* vol. 1, p. 382.

p. 383 [Dürer]. Holt, Elizabeth Gilmore (ed.), *A Documentary History of Art*, vol. 1, *The Middle Ages and the Renaissance*, Princeton: Princeton University Press, 1981, p. 313.

p. 383 [Alberti]. Alberti, Leon Battista, *On Painting*, translated by John R. Spencer, New Haven: Yale University Press, 1966, p. 63.

p. 387 [Vasari]. Vasari, *op.cit.*, vol. 3, p. 1833.

Text notes:
1. Dante, *Purgatory*, bk. II, lines 91–95, translated and cited by Millard Meiss, *Painting in Florence and Siena after the Black Death*, Princeton: Princeton University Press, 1951, p. 5, n. 6.

2. Holt, *op.cit.*, pp. 256–257

3. Vasari, *op.cit.*, vol. 3, p. 1845.

4. Vasari, *op.cit.*, vol. 3, p. 1846.

5. *The Poetry of Michelangelo*, translated by James M. Saslow, New Haven: Yale University Press, 1991, p. 70.

6. Vasari, *op.cit.*, vol. 3, p. 1968.

7 Holt, *op.cit.*, p. 356.

Chapter 19
Quotes:
p. 406 [Manet]. Brown, Jonathan, *Velazquez*, New Haven: Yale University Press, 1986, p. 269.

p. 410 [Poussin]. Harrison, Charles, Wood, Paul, and Geiger, Jason (eds), *Art in Theory 1648–1815*, Oxford and Boston: Blackwell, 2000, p. 75.

p. 421 [David]. Harrison, Wood, and Geiger, *op.cit.*, p. 719.

Text notes:
1. Wren, *op.cit.*, p. 126.

2. *Ibid.*, p. 77.

3. *Ibid.*, p. 173.

4. *Ibid.*, p. 183.

5. *Ibid.*, p. 135.

6. *Ibid.*, pp. 133–145.

7. *Ibid.*, p. 361.

8. *Memoirs of Madame Vigée-Lebrun*, translated by Lionel Strachey, New York: George Braziller, Inc., 1989, p. 26.

Chapter 20
Text notes:
1. Saran, Shalimi, *Taj Mahal*, New Delhi: Lustre Press, QVT Ltd., 1996, p. 70.

2. *Ibid.*, p. 71.

3. *Ibid.*, p. 71.

Chapter 21
Text note:
1. Thorp, Robert L. and Vinograd, Richard Ellis, *Chinese Art and Culture*, New York: Prentice Hall and Abrams, 2001, p. 302.

Chapter 22
Text note:
1. Visonà, Monica Blackmun *et al.*, *A History of Art in Africa*, New York: Prentice Hall and Abrams, 2001, pp. 11–12.

Chapter 23
Text note:
1. *Popul Vuh*, translated by Dennis Tedlock, New York: Touchstone Books, 1996, p. 146.

2. Day, Jane S., *Aztec*, Niwot, CO: Denver Museum of Natural History and Roberts Rinehart Publishers, 1992, p. vii.

Chapter 24
Quotes:
p. 487 [Goya]. Harrison, Wood, and Geiger, *op.cit.*, p. 975.

p. 490 [Delacroix]. *The Journal of Eugène Delacroix*, edited by Hubert Wellington, translated by Lucy Norton, Ithaca, NY: Cornell University Press, 1980.

p. 491 [Ingres]. Harrison, Wood, and Geiger, *op.cit.*, p. 1171.

p. 507 [Munch]. McShine, Kynaston (ed.), *Edvard Munch: The Modern Life of the Soul*, New York: Museum of Modern Art, 2006, p. 65.

Text notes:
1. Harrison, Wood, and Geiger, *op.cit.*, p. 975

2. Clark, Kenneth, *The Romantic Rebellion*, New York: Harper Row, 1973, pp. 185–186.

3. *The Journal of Eugène Delacroix*, *op.cit.*, 1980, p. 7.

4. Harrison, Wood, and Geiger, *op.cit.*, p. 1026.

5. Harrison, Wood, and Geiger, *op.cit.*, p. 1060.

6. Ruskin, John *Modern Painters* I, III, cited by Quentin Bell, *Ruskin*, New York: George Braziller Inc., 1978, pp. 29–30.

7. Truettner, William H. and Wallach, Alan (eds), *Thomas Cole. Landscape into History*, New Haven: Yale University Press, National Museum of American Art, Smithsonian Institution, Washington, D.C., 1994, p. 64.

8. Chu, Petra Ten-Doesschate, *Nineteenth-Century European Art*, New York: Abrams, 2003, p. 252.

9. Marien, Mary Warner, *Photography, A Cultural History*, London: Laurence King Publishing, 2002, p. 28.

10. Bearden, Romare and Henderson, Harry, *A History of African-American Artists from 1792 to the Present*, New York: Pantheon Books, 1993, p. 101 and n. 92.

11. From *The Gentle Art of Making Enemies*, cited in Laurie Adams, *Art on Trial*, New York: Walker and Co., 1976, p. 11.

12. Rilke, Rainer Maria, *Letters on Cézanne*, edited by Clara Rilke, translated Joel Agee, New York: Fromm International Publishing Corp., 1985, pp. 32–33.

13. Collins, Bradley, *Van Gogh and Gauguin*, Boulder, CO: Westview Press, 2001, p. 124.

14. Gauguin, Paul, *The Writings of a Savage*, edited by Daniel Guérin, translated by Eleanor Levieux, New York: Paragon House, 1990, p. 9.

Chapter 25
Quotes:
p. 510 [Picasso]. Charles Harrison and Paul Wood, eds., *Art in Theory 1900–1990*, New York and Oxford: Blackwell Publishing, 1993, p. 215.

p. 512 [Boccioni]. *Ibid.*, p. 152.

p. 514 [Malevich]. *Ibid.*, p. 175.

p. 516 [Kirchner]. Harrison and Wood, 2003, *op. cit.*, p. 65.

p. 517 [Arp]. Harrison and Wood, 2003, *op. cit.*, p. 276.

p. 519 [Brown]. Chipp, *op. cit.*, p. 502.

p. 524 [Le Corbusier]. Le Corbusier, *op. cit.*, p. 67.

p. 526 [Dalí]. Néret, Gilles, *Dalí*, Köln: Taschen, 2000, p. 7.

p. 527 [Magritte]. Ashton, *op. cit.*, p. 47.

p. 528 [Stieglitz]. Marien, *op. cit.*, p. 181.

Text notes:
1. [Matissse]. Flam, *op. cit.*, p. 35.

2. Harrison and Wood, 1993, *op. cit.*, p. 83.

3. Harrison and Wood, 1993, *op. cit.*, p. 252.

4. Ashton, *op. cit.*, p. 94.

5. Harrison and Wood, 2003, *op. cit.*, p. 287.

6. Harrison and Wood, 2003, *op. cit.*, p. 311.

7. Hoffman, Donald, *Frank Lloyd Wright's Fallingwater: The House and Its History*, revised edition, New York: Dover Publications, 1993.

8. Waggoner, Lynda S., *Fallingwater*, Fallingwater: Western Pennsylvania Conservancy in association with Universe Publishing, 1996, p. 61.

9. Wright, Frank Lloyd, *The Natural House*, New York: Horizon Press, 1954, p. 129.

10. Ashton, *op.cit.*, p. 97.

11. Ashton, *op.cit.*, p. 361.

12. Ashton, *op.cit.*, p. 361.

Chapter 26
Quotes:
p. 532 [Gorky]. Ashton, *op.cit.*, p. 208.

p. 532 [Pollock]. Harrison and Wood, 2003, *op.cit.*, p. 571.

p. 533 [Rothko]. Ashton, *op.cit.*, p. 248.

p. 535 [Moses]. Cleary, Margot, *Grandma Moses*, New York: Crescent Books, 1991, p. 15

p. 536 [Rauschenberg]. Ashton, *op.cit.*, p. 243.

p. 537 [Johns]. Ashton, *op.cit.*, p. 219.

p. 538 [Lichtenstein]. Ashton, *op.cit.*, p. 22.

p. 539 [Oldenburg]. Ashton, *op.cit.*, p. 241.

p. 539 [Flavin]. Ashton, *op.cit.*, p. 204.

p. 540 [Hesse]. Ashton, *op.cit.*, p. 216.

p. 548 [Estes]. Stremmel, Kerstin, *Realism*, Köln: Taschen, 2004, p. 46.

p. 551 [Beuys]. Ashton, *op.cit.*, p. 134.

p. 553 [Paik]. Hanhard, John G., *The Worlds of Nam June Paik*, New York: Solomon R. Guggenheim Museum, February 11–April 26 2000, p. 113.

p. 554 [Johnson] *Oxford Dictionary of Quotations*, Oxford: Oxford University Press, 1999, p. 488.

Text notes:
1. Margot, *op.cit.*, p. 6.

2. Honnef, Klaus, *Warhol*, Köln: Taschen, 2000, p.45.

3. Fabozzi, Paul F., *Artists, Critics, Context*, Upper Saddle River, NJ: Prentice Hall, 2002, p. 321.

4. *Ibid.*, p. 249.

5. *Ibid.*, p. 249.

6. Pamer, Laurence, *Duane Hanson*, Fort Lauderdale, Fl: Museum of Art, January 17–August 2 1998, p. 8.

Glossary

abrading—rubbing away or filing down by friction, usually with a rough-edged tool

abstract—having a generalized form with only a symbolic resemblance to real objects

acrylic—fast-drying synthetic paint medium

action painting (or **gesture painting**)—technique of twentieth-century painting characterized by the artist's dynamic gestures in applying the paint

A.D.—*anno domini* (in the year of our Lord), designating time after the birth of Jesus

additive process—sculptural process in which pliable material (e.g. clay) is molded by hand

adobe—sundried brick made of earth and straw

aesthetic—having an artistic quality

afterimage—visual sensation that persists after the external stimulus that first caused it has ceased

ahu—platforms on which *moai* are placed

aisle—passageway flanking a central area (such as the nave of a basilica or church)

ambulatory—vaulted passageway, usually surrounding the apse or choir of a church

amphora—ancient Greek two-handled ceramic vessel for storing grain, oil, etc

analogous hues—hues containing a common color, though in different proportions

anda—dome of a Buddhist stupa

anthropomorphic—having a human shape

aperture—the opening in a photographic lens that admits light

apostles—in Christian terminology, one of the twelve followers, or disciples, chosen by Jesus to spread his Gospel

apotropaic—designed to protect against the "evil eye" (noun: apotropaion)

apse—projecting part of a building (especially a church), usually semicircular in shape and surmounted by a half-dome

aquatint—print taken from a metal plate on which certain areas have been "stopped out" to prevent the action of the acid

arcade—second-storey gallery formed by a series of arches with supporting columns or piers

arch—curved architectural member used to span an opening

architrave—lowest long horizontal part of the entablature, resting directly on the capital of a column

assemblage—group of three-dimensional objects brought together to form a work of art

atmospheric perspective (also known as **aerial perspective**)—technique for creating the illusion of distance by the use of less distinct contours and a reduction in color intensity

atrium—(a) open courtyard leading to, or within, a house or other building, usually surrounded by a colonnade; (b) in modern architecture, a rectangular space off which other rooms open

attic—in Roman architecture, a low story above the entablature, which is part of an Order above the capital of a column

attribute—object closely identified with, or belonging to, a specific individual, especially a god, saint, or hero

asymmetrical balance—lack of precise symmetry in a balanced work

asymmetry—sense of balance achieved by placing dissimilar objects or forms on either side of a central axis

Autobiography—related to the biographical method, this method works from the basis that the artwork is an expression of the artist's life

avant-garde—literally "the advance guard"; the innovators or nontraditionalists in a particular field

bai—men's house in Micronesia

balance—aesthetically pleasing equilibrium in the arrangement or combination of elements

balloon frame—frame for a building consisting of small members (as opposed to large beams) nailed together

balustrade—series of balusters (upright pillars) supporting a railing

base—lowest part of a wall or column considered as a separate architectural feature

basilica—(a) in ancient Roman architecture, a rectangular building used for tribunals and other public functions; (b) in early Christian architecture, a church building with similar features

B.C.—before Christ, designating time before the birth of Jesus

beam-frame—type of construction in which projecting beams are supported by brackets extending from interior columns

bieri—Fang reliquary guardians

binder—liquid substance used in paint and other media to bind particles of pigment together and make them adhere to the support

Biography—related to the autobiographical method, this method works from the basis that an artist's life and personality give meaning to the art he or she produces

biomorphic—representing organic forms rather than abstract shapes

black-figure—technique of ancient Greek pottery in which the decoration is black on a red background

Book of Hours—prayer book containing the devotions (acts of worship) for the hours of the Christian church (i.e. the times appointed for prayer)

broken color—color whose pure hue has been "broken" through the addition of another, often complementary, color

burin—metal instrument with a sharp point used to incise designs on pottery or metal plates

burr—in etching, a rough ridge left projecting above the surface of an engraved plate on which a design has been incised

buttress—exterior architectural support that counteracts the lateral thrust of an arch or a wall

c.—*circa* (latin for "around" or "about"), denoting an approximate date

campanile—Italian for "bell tower," usually a freestanding building near or attached to a church or cathedral

cancellation print—print made after the plate has been destroyed or defaced by the artist

caliph—Muslim ruler

calligraphy—handwriting designed to be beautiful

cantilever—projecting beam or girder supported at only one end

canvas—closely woven cloth, usually of linen, hemp, or cotton, frequently used as a support for a painting

capital—decorated top of a column

cartoon—(a) full-scale preparatory drawing for a painting; (b) comical or satirical drawing

cartouche—curved rectangle, usually containing an inscription such as (in ancient Egypt) a ruler's name

carving—subtractive sculptural technique in which a figure or design is cut out of hard material such as wood or stone

casting—process in which molten material (usually metal) is poured into a mold; the mold is then removed when the material has solidified, producing a cast object

cast-iron construction—construction system relying heavily on the use of cast iron

catacombs—underground complex of passageways and vaults, such as those used in Rome by Jews and early Christians to bury their dead

catenary—curve assumed by a flexible cord suspended between two points (as in a cable used in a suspension bridge)

cel—one of the transparent celluloid sheets on which the figures and objects in animated cartoons are drawn

ceramicist (or **ceramist**)—one who engages in ceramic arts

ceramics—general term for pottery made by firing (heating) clay

charcoal—piece or pencil of black carbon used as a drawing instrument

chattra—pole with three parasol-shaped features symbolizing the Buddha's royal status

chiaroscuro—"light–dark" in Italian; the subtle gradation of light and shadow to create the effect of three-dimensionality

Cibachrome—a photographic process, developed in the 1960's, for making high-quality color prints

clerestory—upper part of the main outer wall of a building (for example, a basilica or church), admitting light through a row of windows

close-up—(a) a photograph taken at close range; (b) a scene in a movie in which action is focused on the facial expression of characters

coffer—recessed geometrical panel in a ceiling, often used as a decorative element and forming a continuous pattern; also used to reduce the weight of a ceiling

collage—work of art formed by pasting together fragments of printed matter, cloth, and other light-weight materials on a surface

colonnade—row of columns set at regular intervals

column—cylindrical support, usually with three parts—base, shaft, and capital

color wheel—circular, two-dimensional model illustrating the relationships of the various hues

combine—work of art combining the techniques of collage and assemblage

complementary colors—hues that are directly opposite each other on the color wheel

conté crayon—improved brand of crayon invented in 1795 using less graphite than previously

content—themes or ideas in a work of art, as distinct from its form

contour line—line representing the outline of a figure or form

contrapposto (or **counterpoise**)—stance of the human body in which the weight is placed on one leg, while the other is relaxed, and there is a shift at the waist

corbel arch—an arch formed by brick and masonry courses, each projecting beyond and supported by the one below

corbel dome—a dome formed by brick and masonry courses, each projecting beyond and supported by the one below

Corinthian Order—see **Orders of architecture**

cornice—topmost horizontal part of a Classical entablature

course—layer of stone

craquelure (also known as **cracking** or **crazing**)—fine cracks (of paint, varnish, enamel) on the surface of a work of art

crayon—stick of white or colored chalk (or clay and graphite) used for drawing

crenellation—series of indentations, as in a battlement

cromlech—prehistoric monument consisting of a circle of single large stones (monoliths)

cross-hatching—pattern of superimposed parallel lines (hatching) on a two-dimensional surface to depict shading and shadow

Cubism—artistic style developed in the early twentieth century by Braque and Picasso, in which the artist changed the traditional notion of space by fragmenting planes into solid geometric shapes

cuneiform—script consisting of wedge-shaped characters used in ancient Mesopotamia

curvilinear—composed of curved lines

cut-out—image or design cut out of paper, wood, or other material

cyanotype—a photographic print in white on a blue ground, often used for copying maps, architects' plans, etc. (also called a blueprint)

Cyclopaean masonry—stone construction using massive, irregular blocks without mortar

daguerreotypes—an early photograph produced on a light-sensitive metal plate

Deconstruction—branch of the semiotic method that opens up structural methods (structuralism and

post-structuralism) and questions traditional assumptions about what we see, or think we see

depth of field—the range of distances of an object from a camera which produces an acceptable degree of sharpness

design (or composition)—arrangements of visual elements in a work of art

divisionism—painting technique in which color is built up through the use of dots of color (also known as **pointillism**)

dome—hemispherical roof or ceiling made by rotating a round arch

domino construction—system of construction using vertical steel supports and horizontal slabs of reinforced concrete

Doric Order—see **Orders of architecture**

drum—circular support of a dome

dry masonry—stone construction in which no mortar is used to attach the stones

drypoint—engraving in which the image is incised directly onto the surface of a metal plate with a pointed instrument

earthenware—type of porous pottery that has been air-dried or fired at a relatively low temperature

echinus (Greek for "hedgehog")—part of the Doric Order above the abacus

edition—batch of prints, usually limited in number, made from a single plate

effigy—sculptured likeness

encaustic—painting medium or technique in which pigment is mixed with a binder of hot wax and fixed by heat after application

engraving—(a) process of incising an image on to a hard surface such as wood, stone, or a copper plate; (b) print made by such a process

entablature—portion of a column above the capital, including the architrave, frieze, and cornice

entasis (Greek for "stretching")—bulge in the shaft of a Doric column

equestrian monument—sculpture of a figure mounted on a horse

equestrian portrait—portrait of a person on horseback

etching—(a) printmaking process in which an impression is taken from a metal plate on which an image has been etched (or eaten away by acid); (b) print produced by such a process

Eucharist—(a) Christian sacrament of Holy Communion, commemorating the Last Supper; (b) consecrated bread and wine used at such a ceremony

Evangelists—literally "bearer of good news" in Greek; the author of one of the four Gospels; more generally, one who brings the first news of the Gospel message

fade-out—in cinematography, a reduction in visibility of an image to signal a conclusion or transition

Feminism—contextual method that works from the basis that an artwork's meaning is influenced by the gender of both the artist (usually female) and viewer

ferroconcrete—see **reinforced concrete**

figurative—representing a human (or animal) figure in a recognizable way

flashback—a theatrical technique, often used in movies that involves the interruption of a chronological sequence by interjecting earlier events or scenes

fleur-de-lys—(a) a white iris, the royal emblem of France, or (b) stylized representation thereof used in art or heraldry

flying buttress (or flyer)—buttress in the form of a strut or open half-arch

foreshortening—use of perspective to represent an object extending back in space

form—overall plan or structure of a work of art

Formalism—method that regards form as inseparable from content, placing emphasis in the interpretation of an artwork's meaning on its arrangement of visual elements such as line and color rather than on its subject matter

forum—civic center of an ancient Roman city, typically containing a marketplace, official buildings, and temples

found object—object not originally intended as a work of art, but presented as one

frame construction—method by which the framework of a building is constructed

fresco—technique of painting on the surface of a wall or ceiling while the plaster is still damp. As the paint dries it bonds with the wall.

frieze—central portion of an entablature in the Classical Orders, often containing relief sculpture

frontal—facing front

gable—roof formed by the intersection of two planes sloping down from a central beam

garbha griha—literally "womb-chamber," the inner sanctuary of a Hindu temple

genre—scenes of everyday life

geodesic dome—dome-shaped framework consisting of small, interlocking polygonal units

gesso—white coating made of substances such as chalk, plaster, and size that is spread over a surface to make it more receptive to paint

glaze—in ceramics, a material applied to a ceramic object that, when fired, fuses with the surface to produce a nonporous, usually glossy surface

Gospels—one of the first four books of the New Testament, which describe the life of Jesus

gouache—opaque, water-soluble painting medium

graphite—mineral consisting of soft black carbon used in lead pencils

graver—type of engraver's burin

Greek Cross—cross with four arms of equal length

groin vault (or cross vault)—vault formed by the intersection of two barrel vaults

ground—in painting, the prepared surface of a support to which paint is applied

guild—organization of workers

hard-paste—mixture of kaolin with china stone or with feldspar and flint

harmika—square railing on the dome of a stupa

Happening—event in which artists give an unrehearsed performance

hatching—close parallel lines used in drawings and prints to create the effect of shading on three-dimensional forms

heiau—Hawaiian temple

hierarchical scale—representation of more important figures as larger than less important ones

hieroglyphics—script used in ancient Egypt whose characters are pictorial representations of objects

high relief—relief sculpture in which the figures project substantially from the background surface

hip-roof—gabled roof

icon—sacred image portraying Jesus, the Virgin Mary, or a saint

iconoclast—one who destroys or opposes religious images

Iconography—meaning literally the "writing of the image," this method focuses on the layers of meaning of an artwork's subject matter

Iconology—method that takes as its basis the significance of an artwork within its broader cultural or artistic context.

iconophile—one who favors religious images

idealized—represented according to ideal standards of beauty rather than to real life

illuminated manuscript—handwritten book with painted illustrations produced in the Middle Ages

image—reproduction of a person or a thing

impasto—thick application of paint, usually oil or acrylic, to a canvas or panel

implied line—movement in a linear direction caused by a visual element other than an actual line

impost—block, capital, or molding from which an arch springs

installation sculpture—three-dimensional environment or ensemble of objects presented as a work of art

intaglio—printmaking process (including engraving and etching) in which lines are incised into the surface of a plate

intarsia—mosaic design or pattern formed through the inlay of decorative pieces of wood

intensity (or saturation)—degree of purity of a color

interlace—form of decoration composed of strips or ribbons that are intertwined

Ionic Order—see **Orders of architecture**

isometric perspective—system of perspective in which diagonal lines convey the effect of distance

jatakas—events in the Buddha's previous lives

kalyx-krater—wide-mouthed bowl for mixing wine and water in ancient Greece

key block—one of a set of color-printing blocks that contains greater details than the others (also key plate)

keystone—in a round arch, the top center stone which holds the voussoirs in place

kiln—oven used to bake (or fire) ceramic objects**kinetic**—having to do with, or incorporating, movement

kiva—large round covered room for ceremonies in Anasazi culture

kondo—main hall of a Japanese Buddhist temple or monastery

lancet window—tall, narrow arched window

landscape—image of natural scenery

lantern—structure crowning a dome or tower and often admitting light to the interior

Latin Cross—cross in which the vertical arm passes through the midpoint of a shorter horizontal arm

lens—a lozenge-shaped piece of glass commonly used in an optical instrument (camera, microscope, etc.) to form an image by focusing rays of light

linear—style in which lines are used to depict figures with precise, fully indicated outlines

linear perspective (also known as **geometric perspective** or **scientific perspective**)—mathematical system devised in the Renaissance to create the illusion of depth in a two-dimensional image through the use of straight lines converging toward a vanishing point in the distance

linocut—print made from a design cut on a piece of linoleum

lithography—printing medium using a stone press on which areas are made receptive to ink

load-bearing construction—system of construction in which solid forms are placed one on another to form a tapering structure

lobed arch—arch containing lobes (or rounded projections)

local color—color sensation imparted by a nearby object in clear daylight

lost-wax (*cire-perdue*) process—sculptural technique for casting bronze and other metals

low relief (or bas-relief)—relief sculpture in which figures and forms project only slightly from the background surface

lunette—(a) a semicircular painting, relief sculpture, or window; (b) a semicircular area formed by the intersection of a vault or wall

mana—supernatural force that may be concentrated in an object or a person

mandala—Hindu image of the cosmos

mandorla—oval of light surrounding the body of a holy person

manuscript—book written by hand; mainly referring to medieval and Renaissance books. A manuscript having painted images is known as an **illuminated** manuscript.

Marxism—method that interprets artworks in the light of their economic and social contexts

masonite—type of fiberboard used in insulation and paneling

masquerade—(a) gathering of people wearing masks; (b) costume worn at such a gathering

mass (or volume)—three-dimensional form, often implying bulk, density, and weight

meander pattern—fret or key pattern originating in the Greek Geometric period

medium—material of a work of art

melon dome—dome in a shape resembling a melon

Mesolithic—relating to the Middle Stone Age

metalpoint—technique in which an instrument with a point of gold, silver, or other metal is used to draw on a specially prepared ground

metope—square area between the triglyphs of a Doric frieze, often containing relief sculpture

mezzotint—method of engraving in which parts of a roughened surface are burnished to produce an effect of light and shade

mihrab—a bay in a mosque that accentuates the *qibla*, which is oriented to Mecca

mimi—Aboriginal spirit hunters

minaret—tall, slender tower attached to a mosque, from which a *muezzin* calls the Islamic faithful to prayer

mixed media—use of more than one medium in a work of art

moai—carved stone statues on outdoor platforms on Easter Island

mobile—sculpture that hangs from the ceiling and is moved by air currents

modeling—(a) in two-dimensional art, the use of value to suggest light and shadow and thus create the effect of mass and weight; (b) in sculpture, the creation of form by manipulating a pliable material such as clay

modernism—expression, practice, or usage characteristic of modern times; the philosophy of modern art

monochromatic—having a color scheme based on shades of black and white or on values of a single hue

monogram—character consisting of two or more letters combined or interwoven

monotheism—religious system based on belief in a single god

monotype—unique impression on paper from a design painted on a metal or glass surface

montage—a process of combining several distinct pictures to produce a blended composite picture

mosaic—image made by embedding small glass or stone tiles into a flat surface, such as a floor or wall

mosque—characteristic place of worship for Muslims

mudra—symbolic hand gesture made by a deity in Buddhist or Hindu art

mullion—vertical bar or pier (usually nonstructural) separating the lights of doors or windows

multiple-point perspective—system of perspective in which there are a number of vanishing points caused by multiple buildings or other objects

mummification—process of embalming a dead body in the manner of the ancient Egyptians

mummy—mummified body of a human or animal

mural—painting applied to, and made integral with, the surface of a wall

Muse—one of nine daughters of Zeus in Greek mythology who inspire creativity; more generally, a source of inspiration

narthex—porch or vestibule in early Christian churches

naturalistic—representing objects as they appear in nature

nave—in basilicas and churches, a wide central aisle separated from the side aisles by rows of columns

Neolithic—relating to the New Stone Age

nkisi nkondi–literally "medicine hunter," a type of royal Kongo sculpture

nonsite—form of environmental art in which a picture or photograph of a site is decorated with objects (e.g. earth, rocks) taken from that site

obelisk—tall, pointed square pillar

objective—representing the visible world

oculus—round opening in a wall or at the top of a dome

one-point perspective—system of perspective in which every orthogonal leads to a single vanishing point

onion dome—dome in a shape resembling an onion

opaque—not allowing light to pass through

optical mixing—tendency for the eyes to blend individual colors placed close to one another and to see a different, combined color

orans (or **orant**)—figure in a posture of prayer in ancient Greek or early Christian art; usually, but not always, a female

Orders of architecture—one of the architectural systems (Doric, Ionic, Corinthian) used by the Greeks and Romans to decorate their post-and-lintel system of construction, especially in the building of temples

orthogonals—converging lines, perpendicular to the picture plane, that meet at the vanishing point in the system of linear perspective

pagoda—multistoried Buddhist reliquary tower

Paleolithic—relating to the Old Stone Age

pan—(a) to rotate a movie camera so as to keep an object in the picture or to produce a panoramic effect; (b) a sequence of shots taken by means of panning

Panathenaia—festival (which included a great procession) held every four years in ancient Athens in honor of the goddess Athena's birthday

papyrus—paperlike writing material used in ancient Egypt and made from the pith of a plant

parchment—paperlike writing material made from bleached and stretched animal hides

pastels—crayons made of ground pigments and a gum binder

patron—person or group that commissions a work of art

pattern—repetitive arrangement of forms or designs

pediment—(a) in Classical architecture, the triangular section at the end of a gable roof, often decorated with sculpture (see Chapter 16); (b) a triangular feature placed as a decoration over doors and windows

pendentive—architectural feature resembling a curved triangle that transfers the weight of a circular dome to a cubed support

Pentecost—Christian festival on the seventh Sunday after Easter commemorating the descent of the Holy Ghost on the apostles

peristyle—colonnade surrounding a building

pharaoh—ruler of ancient Egypt

photo essay—a photographic narrative consisting of a series of related images

photogravure—a printing process in which an image is photographed through a screen on to a sensitized printing plate that after development is etched

piazza—open public square in an urban space

picture plane—flat surface of a drawing, painting, or relief

picture stone—in Viking art, an upright boulder with images incised on its surface

piece-mold—process method of bronze-casting used in ancient China

pigment—powdered substance used to give color to dyes, inks, and paints

pilaster—architectural feature resembling a flattened, rectangular version of a column, sometimes load-bearing but often purely decorative

pixels—in digital photography, a small light-sensitive square which transmits electronic signals based on the intensity of received light

plain stitch—basic knitting stitch

plan—representation of a horizontal section of a building, usually at ground level (a ground plan)

planographic process—printmaking technique (e.g. lithography and monotype) in which the image areas are level with the surface of the printing plate

plate—in printing, a smooth, flat surface (usually of metal) to which a design is to be applied by engraving or other means

podium (pl. **podia**)—masonry forming the base (usually rectangular) of an arch, temple or other building

pointillism—technique developed by Seurat and his followers in the late nineteenth century of applying to a surface dots of color that, when seen from a distance, seem to blend together

polytheism—religious system based on belief in multiple gods

pommel—ornamental knob found, for example, on the hilt of a sword or on a saddle

porcelain—type of hard, high-quality ceramic fired at a very high temperature

portal—doorway of a church and the architectural composition surrounding it

portico—(a) colonnade; (b) projecting porch with its roof supported by columns, often forming the entrance to a building

portrait—likeness of a specific person; can also be a likeness of an animal

post-and-lintel—elevation system in which two upright posts support a horizontal lintel

Post-Structuralism—branch of the semiotic method where the response of the viewer and the role of the artist are taken into account when interpreting an artwork

poster—image intended for display in a public place to advertise an event

potter's wheel—revolving horizontal disk that a ceramist uses to model clay objects

pounce—fine powder used to transfer a design from a perforated pattern to another surface

prana—in Indian and Southeast Asian art, the quality of appearing to have breath

press—apparatus or machine for transferring an image from one surface to another by compression

primary colors—the pure hues (blue, red, and yellow) from which all other colors can in theory be mixed and that cannot be created by mixing other hues

primer—in painting, a preliminary coat applied to a support in order to improve the adhesion of the paint

principal colors—the five main colors (red, violet, blue, green, yellow) in the color wheel of Albert Munsell

print—work or art produced by one of the printmaking processes—engraving, etching, and woodcut

profile—side view

proportion—relation of one part to another, or of parts to the whole, in respect of size, height, width, and scale

Psychoanalysis—method that considers the underlying unconscious meaning of an artwork.

putto (plural **putti**)—chubby male infant, often naked and winged, popular in Renaissance art

pylon—one of a pair of trapezoidal towers flanking the entrance to an Egyptian temple

pyramid—(a) monumental burial place of ancient Egyptian pharaohs; (b) in geometry, a regular three-dimensional shape having four triangular sides and a square base

qibla—wall oriented to Mecca inside the prayer hall of a mosque

radiating chapel—one of a number of chapels placed around the ambulatory or transepts of a medieval church

rayograph—a photograph made without a negative by exposing objects to light on light-sensitive paper (a technique used by Man Ray)

red-figure—technique of ancient Greek pottery in which the decoration is red on a black background

ready-made—everyday object presented as a work of art (especially by Duchamp)

realistic—representing objects from everyday life as they actually appear

registration—bringing together of two or more images in color printing, animated films, etc., so that their positions match precisely

reinforced concrete (or **ferroconcrete**)—concrete strengthened by embedding an internal structure of steel mesh or rods

relic—object (such as a bone or an article of clothing) venerated because of its association with a martyr or saint

relief—in printmaking, a process in which the areas not to be printed are carved away, leaving the desired image raised

relief sculpture—type of sculpture in which an image is developed outward (high or low relief) or inward (sunken relief) from a background surface

reliquary—casket or container for sacred relics**seascape**—image of a scene of, or at, the sea

representational—representing natural objects in recognizable form

rhythm—relationship, either of time or space, between recurring elements of a composition

rib vault—vault formed by the intersection of pointed arches

rocking instrument (or **rocker**)—instrument with a serrated edge used to roughen the surface of the plate

rosette—stylized rose

rotunda—circular building, usually surmounted by a dome

roundel—circular panel, window, or niche

rune stone—in Viking art, an upright stone with characters of the runic alphabet inscribed on it

Sabattier effect—the effect produced by exposing a partly developed negative to light

sahn—the courtyard of a mosque

scale—size in relation to the real size of some object or to some objective standard

schism—division or breach of unity within the Church

screenprinting (also **serigraphy**, **silkscreen**)—printmaking technique in which the image is transferred by forcing ink through a fine mesh of silk

or other material

sculpture-in-the-round (also called **freestanding**)—sculptural figures carved or modeled in three dimensions

secondary colors—hues produced by combining two primary colors (e.g. red and yellow to form orange)

self-portrait—likeness of the artist

Semiotics—method that interprets an artwork according to a system of signs perceived in the artwork; each sign is further broken down into two parts: the signifier and the signified. Structuralism, post-structuralism, and deconstruction are all branches of this method.

sfumato—"vanished in smoke" or "toned down" in Italian; the definition of form by using gradations of light and shadow to produce a hazy effect

shade—to darken a color by adding black

shading—gradual change from light to dark on a surface

shadow—area of dark created when an object blocks light

shaft—vertical cylindrical part of a column that supports the entablature

shaman—member of society believed to have spiritual qualities, including the power to heal and to change into animal form

shape—two-dimensional area enclosed by lines or denoted by changes in color or value

shikhara—tower in a Hindu temple

shutter speed—the amount of exposure time in taking a photograph

silhouette—outline of an object, usually filled in with black or some other uniform color

simultaneous contrast—phenomenon in which two complementary colors, if juxtaposed, intensify each other

size (or **sizing**)—mixture of glue or resin that is used to make a ground (such as canvas) less porous so that paint will not be absorbed

site-specific—referring to an environmental or other form of sculpture that is integral with a particular site

slip—in ceramics, a mixture of clay and water used (a) as a decorative finish or (b) to attach different parts of an object

solarization—the exposure of a photograph to light during the developing process

spacer—attachment used in piece-mold bronze-casting to separate sections of the mold from the core

special effect—in cinematography, a feature (often artificial or illusory) that is added to a film during its processing

sphinx—in ancient Egypt, a creature with the body of a lion and the head of a human

springing—(a) architectural member of an arch that is the first to curve inward from the vertical; (b) point at which this curvature begins

stained glass—pieces of colored glass held together by strips of lead used to form windows

steel-frame (or **skeletal**) **construction**—method of construction in which the walls are supported by a steel frame consisting of vertical and horizontal members

stele—upright stone pillar or slab, usually carved or inscribed for commemorative purposes

stencil—sheet of material (e.g. paper or fabric) that is perforated with lettering of a design and through which pigment (ink, paint) is forced on to a surface to be printed

still life—representation of inanimate objects such as fruit, flowers, or pottery

storyboard—in cinematography, panel(s) to which is attached a series of rough drawings depicting the principal changes of scene or action in a story

Stone Age—prehistoric period dating from approximately 1,500,000 B.C., when people used stone tools

stoneware—opaque, nonporous ceramic, in many respects intermediate between porcelain and earthenware

story boards—horizontal strips containing symbolic narratives of village history on men's houses in Micronesia

straight photography—photography in which pictures are printed directly from the negatives with no cropping or other manipulation

Structuralism—branch of the semiotic method that maintains that artists impart no meaning to their artwork, and that interpretations should be devoid of all such considerations

stupa—in Buddhist architecture, a mound or dome-shaped structure having cosmological meaning

style—in the visual arts, a manner of execution that is characteristic of an individual artist, a school, a period, or some other identifiable group

stylization—distortion of a representational image as a simplified surface detail to conform to certain artistic conventions or to emphasize certain qualities

stylobate—top step from which a Doric column rises

subject matter—underlying content (figures, incident, scene, etc.) of a work of art

subtractive process—sculptural process in which parts of a hard material such as wood or metal are removed through carving or cutting

sunken relief—type of relief sculpture in which the image is recessed into the surface

support—in painting, the surface to which pigment is applied

suspension bridge—bridge in which the roadway is suspended from two or more steel cables which usually pass over towers and are anchored at their ends

symbolic proportion—sizing of an object within a composition based on its relative importance as a symbol

symmetry—aesthetic balance that is achieved when parts of an object are arranged about a real or imaginary central line (the axis) so that parts on one side correspond with those on the other like a mirror-image

syncretism—reconciliation of conflicting beliefs (especially religious) into an integrated system

tactility—quality of being perceptible by the sense of touch

tapu—related to taboo, meaning ritually unclean and sacred

technique—way in which an artist creates a work of art

tempera—water-based painting medium made with egg yolk, often used to paint fresco and panels

tenebrism—use of dark in a painting as a background to highlighted forms; a style of painting practiced by Caravaggio and his followers

tensile strength—internal strength of a material that enables it to support itself without fracturing

terracotta—earthenware material, or an object made thereof

tertiary colors—colors made by combining a primary and a secondary color that are adjacent on the color wheel (e.g. yellow and orange to form yellow-orange)

tesserae (sing. *tessera*)—small tiles arranged to create a mosaic

tholos (pl. **tholoi**)—circular tomb of beehive shape

three-dimensional—having height, width, and depth

tiki—protective ancestors

tint—color that is lighter than a hue's normal value (e.g. pink is a tint of red)

tipi—conical tent characteristic of the Plains Indians

torana—gate one of the four corners of a *vedika*

tracery—decorative, interlaced design, as in the stonework of Gothic windows

transept—cross arm of a Christian church, placed perpendicular to the nave

transfer—(a) image produced by affixing to a support an image originally on another temporary support; (b) technique for transferring an image from one surface to another

traveling shot—in cinematography, a sequence in which the camera moves from front to back of a scene, or vice versa

trefoil—ornament in the form of a leaf with three lobes (such as a clover)

tribhanga—in Indian art, a characteristic sensuous pose, also called the "three-bends" pose

triforium—in Gothic architecture, part of the nave wall above the arcade and below the clerestory

triglyphs—three verticals between the metopes of a Doric frieze

trilithon—a single post-and-lintel

triptych altarpiece or painting consisting of one central panel and two wings

trompe l'oeil—literally "fooling the eye," referring to illusionistic imagery

true porcelain—porcelain ceramics made from a mixture of kaolin and feldspar

trumeau—in Romanesque and Gothic architecture, the central post supporting the lintel in a double doorway

truss construction—system of construction in which the architectural members are combined, often in triangular units, to form a rigid framework

totem—ancestor

tufa—porous volcanic stone often used as a building material

two-point perspective—system of perspective in which there are two vanishing points

ushnisha—conventional topknot of hair on images of the Shakyamuni Buddha, symbolizing his wisdom

value (or **tone**)—degree of lightness (high value) or darkness (low value) in a hue

vanishing point—in the linear perspective system, the point at which the orthogonals, if extended, would intersect

vantage point—point of view of the observer

vault—masonry roof or ceiling constructed on the arch principle

vedika—round fence surrounding a stupa or on its dome

vehicle—liquid in which pigments are suspended to form paint

vellum—smooth, cream-colored writing surface made from calfskin

vignette—decorative, symbolic image or design accompanying texts such as the ancient Egyptian *Book of the Dead*

visual metaphor—association (usually formal) between one image and another

voussoir—wedge-shaped stone used in round arches

warp—vertical threads in a weaver's loom

weaving—process of making cloth through the interlacing of threads on a loom

web-fed machine—machine designed to print a continuous roll of paper

woodblock—technique in which images are carved on the surface of wooden blocks before being printed on paper

woodcut—relief printmaking process in which an image is carved on to the surface of a wooden block by cutting away the parts that are not to be printed

weft—horizontal threads in a woven cloth, often representing most of the decorative pattern

yakshi—Hindu tree goddess

yasti—in Hinduism, a pillar representing the World Axis

ziggurat—stepped, trapezoidal structure representing a mountain, as in ancient Mesopotamia

zimbabwe—originally a court or palace; today refers to the ruins of a great city

Picture credits

vi, xviii l MOMA. Given anonymously. © ADAGP, Paris and DACS, London 2006. © MOMA/Scala Florence
vi r Musée Guimet, Paris. © Photo RMN/Hervé Lewandowski
vii BL #Add 18113, f18v
viii Louvre, Paris/© Photo RMN/Jean-Gilles Berizzi
ix l Image by Andy Goldsworthy
ix r Museo Nacional del Prado, Madrid. © All Rights Reserved
p2 Isabella Stewart Gardner Museum, Boston/Bridgeman Art Library, London
1.1 Photo Science & Society, London
1.3 © Scala, Florence
1.4 Werner Forman Archive, London
1.5 © Trustees of the British Museum #1948 Af 9.1
1.6 University of Pennsylvania Museum, Philadelphia #150205
1.7 © ARS, NY and DACS, London 2006. Photo by Sandak, Inc
1.8 Araldo De Luca, Rome
1.9 Vatican Museums, Rome
1.10, 1.11 © Photo Josse, Paris
1.13 Bridgeman Art Library, London
1.14 © Succession Picasso/DACS 2006
p15t Photo RMN/Hervé Lewandowski/Thierry Le Mage
1.15 © Succession Marcel Duchamp/ADAGP, Paris and DACS, London 2006. Photo Lynn Rosenthal
p17, 2.6 MOMA. Mrs. Simon Guggenheim Fund. © Succession Picasso/DACS 2006. © MOMA/Scala Florence
2.2 AKG-images, London/Jean-Louis Nou
2.3 Österreichische Nationalbibliothek, Vienna *Cod. 2554, fol 1v
2.4 © Paul MR Maeyaert PMRMAEYAERT@terra.es
2.7 RHPL, London/Robert Frerck
2.8 Image © Board of Trustees, National Gallery of Art, Washington #1983.1.46.
2.9 Alamy/Paul Doyle Pics/Paul Bernhardt
2.10 Photo © 1989 The Metropolitan Museum of Art
2.11 © V&A Images
2.12 © Estate of Richard Diebenkorn
2.14 Photo © 1980 The Metropolitan Museum of Art
2.15 © Scala, Florence, courtesy Ministero Beni e Att. Culturali
2.17 © ADAGP, Paris and DACS, London 2006
2.18 © MOMA/Scala Florence
2.19 Archaeological Survey of India
p34 Musée Guimet, Paris/© Photo RMN/Hervé Lewandowski
p36 National Museum of the American Indian, NY
3.1 Minneapolis Institute of Arts #52.14
3.2, 3.9, 3.12, 3.23 © Scala, Florence
3.3, 3.10 © Scala, Florence, courtesy of the Ministero Beni e Att. Culturali
3.4 Deutsches Archäologisches Institut, Rome
3.5 Bridgeman Art Library, London/Giraudon
3.6 © MOMA/Scala, Florence
3.8a&b © Romare Bearden Foundation/DACS, London/VAGA, NY 2006. Photo © 1992 The

Metropolitan Museum of Art
3.11 AKG-images, London/Torquil Cramer
3.13 © Photo RMN/Hervé Lewandowski
3.14 The Nelson-Atkins Museum of Art, Kansas City #44-40/2
3.15 BL #Cott. Nero D.IV, f.211
3.16 Corbis/Ted Spiegel
3.17 Photo Bobby Hanson
3.18 Amt für kirchliche Denkmalpflege. Trier. Photo Rita Heyen/Bistum Trier
3.19 © Vincenzo Pirozzi, Rome fotopirozzi@inwind.it
3.21 © Photo RMN/Droits réservés
3.22 © All rights reserved
3.24 Photo © 1992 The Metropolitan Museum of Art
p51t © Araldo De Luca, Rome
3.25 © Succession Picasso/DACS 2006. Archivo Fotográfico Museo Nacional Centro de Arte Reina Sofía, Madrid
3.27 © NASA/Neil Armstrong
3.28 Berkeley Art Museum, University of California #1972.84. Photo Benjamin Blackwell
3.29 Bridgeman Art Library, London
p56, 4.10 © Scala, Florence, courtesy of the Ministero Beni e Att. Culturali
4.1 Dominique Darbois. Courtesy Edimages, Paris
4.2 AKG-images, London
4.3 © Trustees of the British Museum #19.4.2.19.3
4.4 John Pemberton III, Amherst, NJ
4.5 Photo John Bigelow Taylor, NYC
4.6 from Malcolm Norris "Brass Rubbing" (Studio Vista, London 1965)
4.7 Doran Ross, Los Angeles
4.8 Bridgeman Art Library/Giraudon
4.9 Photo © 1986 The Metropolitan Museum of Art
4.11 Alessi s.p.a., Crusinallo, Italy
4.12 Photo © 1982 The Metropolitan Museum of Art
4.13 Photo © 1998 The Metropolitan Museum of Art
4.14 Photo Angela Bröhan
4.15 Photo Giles Rivest, #D93.259.1
4.16 Jurgen Liepe, Berlin
4.19 © Scala, Florence
4.20 Photo courtesy David Finn, NY
p70t © Succession Marcel Duchamp/ADAGP, Paris and DACS, London 2006. Photo Lynn Rosenthal
4.21 © 1984 estate of Keith Haring, NY
4.22 Ford AG, Cologne
4.23 Greyhound Museum, Hibbing, MN
4.24 Randy Leffingwell
p74, 5.19 BL #Add 18113, f18v
p76t, 5.21, 5.24 ADAGP, Paris and DACS, London 2006. © MOMA/Scala Florence
5.2 (#1943.3.9073), 5.23 (#2002.1.1), 5.34 (#1942.9.8) Image © Board of Trustees, National Gallery of Art, Washington
5.4, 5.36 © Succession H Matisse/DACS 2006
5.5 © Photo RMN/Hervé Lewandowski/Thierry Le Mage
5.8 Bridgeman Art Library, London
5.12, 5.13, 5.26 AKG-images, London
5.17 Princeton University Art Museum #y1946-186. Photo Bruce M White
5.20 © Trustees of the British Museum #EA10470/33
5.22 © Craig & Marie Mauzy, Athens mauzy@otenet.gr
5.23, 5.35 © Succession Picasso/DACS 2006.
5.25 © Claes Oldenburg. Photo Geoffrey Clements
5.27 © Karel Appel/Licensed by DACS 2006
5.28 © Succession Marcel Duchamp/ADAGP, Paris and DACS, London 2006
5.29 LOC
5.30 © ARS, NY and DACS, London 2006
5.31 © Photo RMN/Harry Bréjat
p97b, 5.32, 5.33, 5.38 Scala, Florence
5.35 Photo © 1996 The Metropolitan Museum of Art
5.37 © Photo Scala/HIP
5.40 Photo John Hammond
5.46 Guggenheim Museum #51.1309
5.50a-c Photo © 1989 The Metropolitan Museum of Art
5.51 © MOMA/Scala Florence
p108, 5.4 The Estate of Roy Lichtenstein/DACS 2006. Photo Malcolm Varon, NY
6.1, 6.2 ADAGP, Paris and DACS, London 2006.
6.1 © 2005 Museum Associates/LACMA, #78.7
6.2 Guggenheim Museum #37.245

6.4, 6.19 © ARS, NY and DACS, London 2006
6.5 AKG-images, London/Erich Lessing
6.6 © Vincenzo Pirozzi, Rome fotopirozzi@inwind.it
6.8 The Colonial Williamsburg Foundation, Williamsburg #1979.609.14
6.9 Photo © 1996 The Metropolitan Museum of Art
6.10 Courtesy Jo Ann Callis. Photo ©2005 Museum Associates/LACMA M.85.120.6
6.12 Superstock/Steve Vidler
6.13 LOC
6.14 © Claes Oldenburg. Photo Robert R. McElroy
6.15 © Romare Bearden Foundation/DACS, London/VAGA, NY 2006
6.16 Brooklyn Museum #39.602
6.17 © Scala, Florence, courtesy of the Ministerio Beni et Att. Culturali
6.19, 6.23 © MOMA/Scala Florence
6.20 © Succession Picasso/DACS 2006. © Photo RMN/René-Gabriel Ojéda
6.21 Alinari, Florence
6.22 Arcaid, London/Richard Bryant
6.23, 6.24 © ARS, NY and DACS, London 2006.
p.125cr, 6.28 © 2006 Mondrian/Holzman Trust. c/o HCR International, Warrenton, VA.
p125cr Guggenheim Museum #51.1309
6.28 Bridgeman Art Library, London
6.29 © ADAGP, Paris and DACS, London 2006
p128, 7.14 © Estate of Grant Wood/DACS, London/VAGA, NY 2006. Art Institute of Chicago #1930.934. Photo Bob Hashimoto
7.1 V&A Images
7.2 © Scala, Florence
7.3 © Licensed by the Andy Warhol Foundation for the Visual Arts, Inc/ARS, NY and DACS London 2006. © The Andy Warhol Foundation/Art Resource/Scala, Florence
7.4 Photo © 1992 The Metropolitan Museum of Art
7.5 Walters Art Gallery #37.1225
7.6 © Vincenzo Pirozzi, Rome fotopirozzi@inwind.it
7.8 Fogg Art Museum #1943.252. Photo Katya Kallsen
7.9 © Scala, Florence, courtesy of the Ministero Beni e Att. Culturali
7.10 © Photo RMN/René-Gabriel Ojéda
7.11 (#1970.253), 7.12 (#1970.253) Photo © 2006 Museum of Fine Arts, Boston
p139 © Photo RMN/Hervé Lewandowski/Thierry Le Mage
p140l, 7.13 © ADAGP, Paris and DACS, London 2006.
p140l © MOMA/Scala Florence
7.13 © Photo CNAC/MNAM Dist. RMN/Jacques Faujour
p144 © Photo RMN/Jean-Gilles Berizzi
p146, 8.10 © Photo RMN/Hervé Lewandowski
8.1 RMN/Béatrice Hatala
8.1, 8.2 © Succession Picasso/DACS 2006
8.2 Cleveland Museum #1945.24
8.4 Centre des Monuments Nationaux, Paris
8.5 Getty Museum #85.GB.224
8.7 © 1990 Photo Scala, Florence
8.9 © Ellsworth Kelly
8.11 Galerie Nichido, Tokyo
8.12 © Photo RMN/Jean-Gilles Berizzi
8.15 © Photo RMN/René Gabriel Ojéda
8.17 © The Saul Steinberg Foundation/ARS, NY and DACS, London. © MOMA/Scala Florence
8.18 Photo © 2006 Museum of Fine Arts Boston #58.1263
p159, 9.3 © Craig & Marie Mauzy, Athens mauzy@otenet.gr
9.1 © Trustees of the National Museums of Scotland A.1951.160 (Petrie excavation, 1911)
9.2 © DACS, London/VAGA, NY 2006. Photo Geoffrey Clements
9.4, 9.22 © Scala, Florence
9.5 © Photo Josse, Paris
9.6 Image © Board of Trustees, National Gallery of Art, Washington
9.7 Worcester Art Museum #1922.12
9.8 © The Willem de Kooning Foundation, NY/ARS, NY and DACS, London 2006. Carnegie Museum #55.24.4
p166t Photo © 1989 The Metropolitan Museum of Art
9.9 Photo © 2006 Museum of Fine Arts Boston #47.268
9.11 © ARS, NY and DACS, London 2006. National Academy Museum #1977.15
p168b © Photo RMN/René-Gabriel Ojéda
9.12 © 1959 Morris Louis. Fogg Art Museum #1965.28. Photo Junius Beebe

9.13 © Hannah Höch/Licensed by DACS 2006. Photo BPK, Berlin/Robin Guerleim
9.14, 9.18 © Succession H Matisse/DACS 2006.
9.14 Photo Hans Petersen #KMSR.189
9.16 Photo Philipp Scholz Rittermann
9.17 Sonia Halliday Photos, Weston Turville, Bucks/Bryan Knox
9.18 © Photo RMN/H. Del Olmo
9.19 © George Meistermann/Licensed by DACS 2006. Photo Stadtverwaltung Bottrop
9.21 Alix Barbet
9.23 Art Archive, London
p180, 10.17 © Licensed by the Andy Warhol Foundation for the Visual Arts, Inc/ARS, NY and DACS London 2006. Photo Corbis
10.1 BL #Or. 8210 f.2
10.4, 10.19 ADAGP, Paris and DACS, London 2006
p183t V&A Images
10.5 Brooklyn Museum #30.1478.44
10.6 © Succession Picasso/DACS 2006. Museu Picasso #Geiser/Baer V, 1278
10.7 (#ANE 121544), 10.9 (#1912,12-27.182), 10.12 (#1931,11-14.357) © The Trustees of the British Museum
10.13 Image © Board of Trustees, National Gallery of Art, Washington #1963.10.250
10.16, 10.19 Bridgeman Art Library, London
10.19 © Disney Enterprises, Inc.
11.3 Photo P. Faligot-Seventh Square
11.5 © Photothèque des Musées de la Ville de Paris Photo # 1993 CAR 3288 A
p218t, 11.7 LOC
11.8 Sheffield Hallam Univererity, Psalter Lane Library
11.9 © ARS, NY and DACS, London 2006.
11.9 (#93.XM.25.67), 11.21 (#84.XM.839.5) Getty Museum
11.10 Centre des Monuments Nationaux, Paris © Arch.Phot. Paris/CMN. #MH 87005N
11.11 Corbis
11.13, 11.15 LOC
11.14 Getty Images/Time Life Pictures
11.17 Magnum Photos, NY
11.19 Copyright © 1955 The Richard Avedon Foundation
11.20, 11.21 © Man Ray Trust/ADAGP, Paris and DACS, London
11.20 Telimage 2006
11.24 © ADAGP, Paris and DACS, London 2006
11.26 © Estate of Harold Edgerton, Palm Press, Concord, Massachusetts. Photo Science & Society, London
11.27 Méliès/RGA
11.28 Epic/Kobal Collection
11.29 United Artists/RGA
11.30 Goskino/ Photofest, NY
11.31 RKO/RGA
11.32 Selznick/MGM/Kobal Collection
11.33 Svensk Filmindustri/BFI Stills Posters and Designs
11.34 Paramount/Kobal Collection
11.38 New Line/Saul Zaentz/Wing Nut/RGA
11.39 Photo Yong-woo Lee
11.40 Photo Christian Nguyen
11.41 Photo Kira Perov
11.42 All rights reserved, The Metropolitan Museum of Art
p232, 12.11 By kind permission of the Trustees of the Wallace Collection #OA1683
12.1 V&A Images
12.3 © Photo RMN/Hervé Lewandowski
12.4 © The Trustees of the British Museum #OA 1973,7-26.360
12.6 © Succession Picasso/DACS 2006. Photo Edward Quinn Archive
p236cl AKG-images/Torquil Cramer
12.7 RHPL/David Lomax
12.8, 12.15 Photo © 1996 The Metropolitan Museum of Art
12.9 Montreal Museum of Fine Arts #D87.184.1a-b. Photo Denis Farley
12.10 Photo Lois Ellen Grank
12.12a Photo © 1997 The Metropolitan Museum of Art
12.13 © ADAGP, Paris and DACS, London 2006. Photo Christie's Images, London
p241t Bridgeman Art Library, London/Giraudon
12.14 South American Pictures, Woodbridge, Suffolk/Tony Morrison
12.17 © Faith Ringgold. Guggenheim Museum #88.3620
12.18 Sonia Halliday Photos, Weston Turville, Bucks/Bryan Knox
12.20 Chihuly studio, Photo Claire Garoutte
p247t © Estate of David Smith/DACS, London/VAGA, NY 2006
13.1 Photo Grant Smith, New Millennium

Index